ONE THOUSAND BUILDINGS OF PARIS

ONE THOUSAND BUILDINGS OF PARIS

PHOTOGRAPHY BY
JORG BROCKMANN
AND JAMES DRISCOLL

TEXT BY
KATHY BORRUS

BLACK DOG
& LEVENTHAL
PUBLISHERS
NEW YORK

Contents

Author's Note

"One thousand buildings?" my architect friend asked. "How can I get an assignment like that?"

Other friends also salivated at the idea of writing about one thousand Paris buildings and immediately began offering resources and suggestions.

Armed with everyone's recommendations and my own passion for art and architecture, I traipsed off to Paris with a different perspective: looking up, while simultaneously watching my step. (Parisians love their dogs as much as their buildings.)

Creating a list and wading through layers of architecture and history to write about a thousand buildings inevitably required the assistance of many people along the way. First and foremost, I cannot find enough superlatives to describe the immeasurable ways Gaël Lesterlin contributed to this book. His expertise, guidance, research, fact-checking, list review, encouragement, and tireless efforts were invaluable. As an architect and Ph.D. candidate in the history of architecture, his passion for exploring the history behind the façades was contagious and affected me in ways I could not anticipate. I appreciate his insight, dedication, friendship, and good humor in cheering me on and seeing this project to conclusion. Thanks to Florence Lloyd, Claude Baudez, and Basile Baudez whose cumulative recommendations led me to Gaël.

Next, Thirza Vallois, author of the *Around and About Paris* guides and *Romantic Paris*, deserves special mention for her initial interest and her expert knowledge of the city, along with my thanks for wandering the Parisian streets with me. Her guides, chock full of history, are among the many sources I consulted for information.

My thanks also go to Karyn Marcus. Her sustained enthusiasm and early background work on the book were essential to its success. Her numerous suggestions, contacts, translations, and organizational ability aided me in creating and researching the initial list. Our walks through the city knew no bounds and increased our camaraderie. And I'd like to extend our mutual thanks to Jean Connehaye for his support of the project and list review. He lent his time and expertise, as well as his valuable research books; chief among these was the excellent *Dictionnaire Historique des rues de Paris* by Jacques Hillairet. For all of Mr. Connehaye's efforts, I am sincerely grateful. Our additional thanks for consultation go to Julia Trilling and Olivier Amat.

Ultimately, the text drew inspiration from the photographic artistry of Jorg Brockmann and James Driscoll. Adept at finding frequently difficult addresses and weaving their way through narrow streets, they brought their creative vision to each of the one thousand buildings in the book.

To all of my family and friends at home, thanks for your encouragement and patience while I disappeared to explore Paris. My special thanks and love to my son, Josh, who helped research literary references when needed and reviewed numerous paragraphs before I submitted them.

Finally, my appreciation extends to J.P. Leventhal for his faith in me and the opportunity to contribute to this book, as well as to Laura Ross for her editorial guidance, encouragement, and gentle pressure throughout the writing process. My thanks also to the staff and freelancers of Black Dog & Leventhal for their efforts, especially Dara Lazar, Sheila Hart, Iris Bass, True Sims, and Magali Veillon.

KATHY BORRUS

Photographers' Note

I'd like to dedicate this book to the memory of Alain Colomb, my father-in-law, a man of great courage and integrity, and to Aline; to my wife Celine, my kids Leo and Sasha, my grandmother Oma Lisa, and above all, to my parents, who moved to Paris in 1970, as a young couple, and brought us up there. They are responsible for my love of the city.

After spending the last decade in New York, I was able to approach Paris with a fresh eye. I was eager to rediscover a city that I had known from a comfortable, day-to-day perspective: the traffic hassles, the noise, the agitation. (I had found that when I shot the photographs for *One Thousand New York Buildings* I wanted to reduce these extraneous factors to a minimum to allow readers to concentrate on the essence of each building.) I will never forget the weekend when the center of the city was closed to traffic. Walking through the streets without the fear of getting run over, and the unusual quietness, afforded me a unique perspective.

I did not approach Paris with an idealized, romantic vision. The work remains first and foremost a factual record. And yet, through choices of perspective, framing, and the time of day that I took the shot, each photograph takes on a mood or quality of its own. When photographing restaurants, it often seemed more interesting to portray the interior, where the history of the place had unfolded.

For those interested in the technical side of things, all of the photographs in this book were shot with a Sinar F2 4 x 5 camera shooting Agfa APX 100 film.

I would like to extend my thanks, first, to my collaborator, James Driscoll; to my assistants, Fanny Dupont and Matteo Venet; and to Nicolas Spuhler of the Geneva-based lab Actinic, for their hard work and enthusiasm. I am grateful to Maryvonne Deleau at the Mairie of Paris for helping me get access to certain sites; to Catherine and Michel Devos and Francoise and Philip Proust for lodging, and to Marie Françoise Deslandes, Alain Bled, and Jean Connehaye for their help. Congratulations to Kathy Borrus for her thorough research and writing job. My gratitude also goes to the whole team at Black Dog and Leventhal, especially to J.P. Leventhal, for giving me the opportunity to take on this project. Thanks to Laura Ross, my editor, for her strong (moral and practical) support, and to True Sims and Dara Lazar for their painstaking efforts on this complex undertaking. Thanks also to Thomas Palmer, a master separator, and to Sheila Hart for completing the design equivalent of the Rubik's Cube with great style and good cheer.

Dear reader, enjoy this walk through Paris!

JORG BROCKMANN

The year 2002 was an interesting one in my life: it was the year that I became the archetypal "American in Paris." I'm sure I'll look back on it later in life with much joy and humor.

My journey to shoot this book was the first time this "New York Boy" had ever left the USA, and I have to admit that I had my reservations. I tend to have a bad attitude about places other than the five boroughs of New York City—but being in France turned out to be a very enlightening experience.

After living and working in Paris for four months, I can say that most of the stereotypes about the city and its residents are untrue. Sure, I ran into some rudeness but what city is free of it? What I did find was a beautiful city that is rich with history, pride, and old-world ways of life. I believe that the buildings and structures of Paris reflect the pride that Parisians have always felt about their city. It was this quality that I tried to capture in my photographs.

My work on this book was completed with the assistance and support of many people. I begin by thanking my family for all the encouragement they have given my photography over the years. I must offer grateful thanks to friend and photographer Mike Falco, who first put a camera in my hands and was always there with advice and support when I needed it most. Deep thanks to fellow photographer Jorg Brockmann for seeing in me what I now see—it was his eye and ability that inspired me throughout this project. Thanks to Ursula Jaroszewicz, for her years of help and love. A humongous thanks must go to J.P Leventhal, Laura Ross, True Sims, and Dara Lazar of Black Dog & Leventhal, who dreamed up this book and supported our work on it. Thanks to the people at Fotocare in New York City, Le Grand Format in Paris, and Arnie Duren of Brooklyn Camera Exchange for their help on the technical side. Thanks to our Paris assistants, Fanny Dupont and Matteo Venet, for their invaluable help in navigating the streets of Paris and for being my two best friends during my time in Paris, and gratitude to the Devos family for allowing me to use their apartment as a base of operations during my stay. Author Kathy Borrus, designer Sheila Hart, and separator Thomas Palmer must be commended for the skill and creativity they have brought to the project.

Last and certainly not least, I would like to thank my wife-to-be, Stacy Lucas, for the time she took out of her life to take care of mine, and for being my main inspiration on this wonderful project. Without her love and support, my work on it would not have been possible.

JAMES DRISCOLL

ONE
THOUSAND
BUILDINGS OF
PARIS

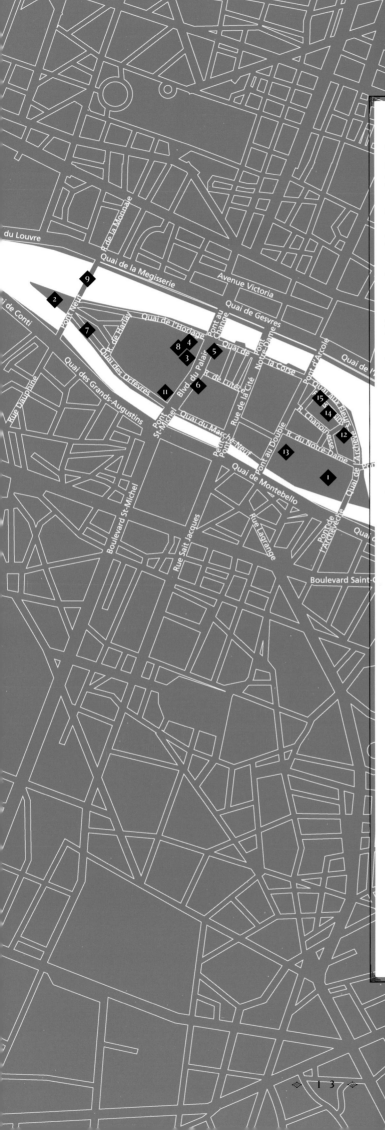

ÎLE DE LA CITÉ

Two hundred and fifty years before Julius Caesar pulled up to shore and camped on Île de la Cité in 53 B.C., a Celtic tribe known as Parisii (boat people) occupied the island and the land on both its banks, and cruised the waters of the Seine in lucrative trading. They called the land Lutetia, which meant "boatyard on the water." Caesar expanded his empire by crushing a Parisii rebellion, and the Romans renamed their settlement Lutetia Parisiorum. They rebuilt the town, walled it off, and constructed a temple to Jupiter and Caesar on the site of the future Notre-Dame cathedral. They also built bridges to connect the banks, and the city spread outward from Île de la Cité through centuries of struggle and warfare, bombardment and occupation. Christianity intervened, then the Franks invaded, and Charlemagne ruled benevolently from afar but encouraged trade and commerce. Enter the Vikings in the ninth century. Their repeated sackings caused a retreat to the island as the outlying areas were not defensible. In the twelfth century, the Knights Templer assumed control and Bishop Maurice de Sully began construction on Notre-Dame.

The French monarchy developed and took command in reaction to the repeated Viking incursions and the lack of effective action by the foreign rulers: Governor Hugh Capet ascended the throne and made Paris his capital; Île de la Cité became the site of his home, where now stands the Palais de Justice. Philip II occupied the medieval palace complex that today includes Sainte-Chapelle. He developed Paris into being the center of what was considered Europe during the Middle Ages, and expanded the old Roman wall around the island and beyond. Medieval life on Île de la Cité was a tangled web of streets and markets and buildings. By the mid–nineteenth century, when Napoléon III named George Haussmann his prefect of Paris and placed him in charge of urban renewal, life on the island had deteriorated: Streets were narrow, twisted, and filthy—crowded and squalid. Haussmann engineered new routes, widening streets and razing old buildings. The result of his tinkering left Notre-Dame with breathing room, while opening the door to a twentieth-century maze of tourist buses. Essentially, he created modern Paris. Though its actual administration was divided into the first and fourth arrondissements, Île de la Cité is its heart.

Notre-Dame de Paris

PLACE DU PARVIS–NOTRE-DAME

c.1160, ORIGINAL ARCHITECTS UNKNOWN; c.1250–58, JEAN DE
CHELLES; SECOND HALF OF THIRTEENTH CENTURY, PIERRE DE
MONTREUIL; 1296–1325, PIERRE DE CHELLES AND JEAN RAVY;
1699–1715, ROBERT DE COTTE, CHOIR DECORATION; 1728–29,
GERMAIN BOFFRAND, CROSSING VAULT REBUILT AND RESTORATION;
1841–64, RESTORATION OVERSIGHT BY JEAN-BAPTISTE LASSUS AND
EUGÈNE VIOLLET-LE-DUC

Notre-Dame soars over Île de la Cité and spans history with its stony symmetry and Gothic exuberance. Its famed flying buttresses, along the exterior of the nave, provide a means of structural support not previously realized in Gothic design and, like open wings, appear to give it weightlessness and lift. Notre-Dame became the model of religious architecture from the twelfth century. In 1163, Bishop Maurice de Sully broke ground over Roman ruins and construction began on the choir. Subsequently, Notre-Dame withstood the ravishment of the Revolution and saw the coronation of Emperor Napoléon Bonaparte and the Empress Joséphine in 1804, among many events. Thanks to a revival of Gothic style and Victor Hugo's efforts to encourage restoration, architects Viollet-le-Duc and Lassus overhauled most of the cathedral in the nineteenth century. Many of its medieval-style treasures—its interior furnishings, gargoyles, and statues, for example—are not originals, but reproductions and reinterpretations that owe their design to medieval-era drawings. On the western façade, replicas of the twenty-eight Kings of Judah statues replace their medieval originals, which the Revolutionaries decapitated in the mistaken belief that they represented the kings of France. Despite centuries of reconstruction, Notre-Dame remains a paradigm of Gothic engineering.

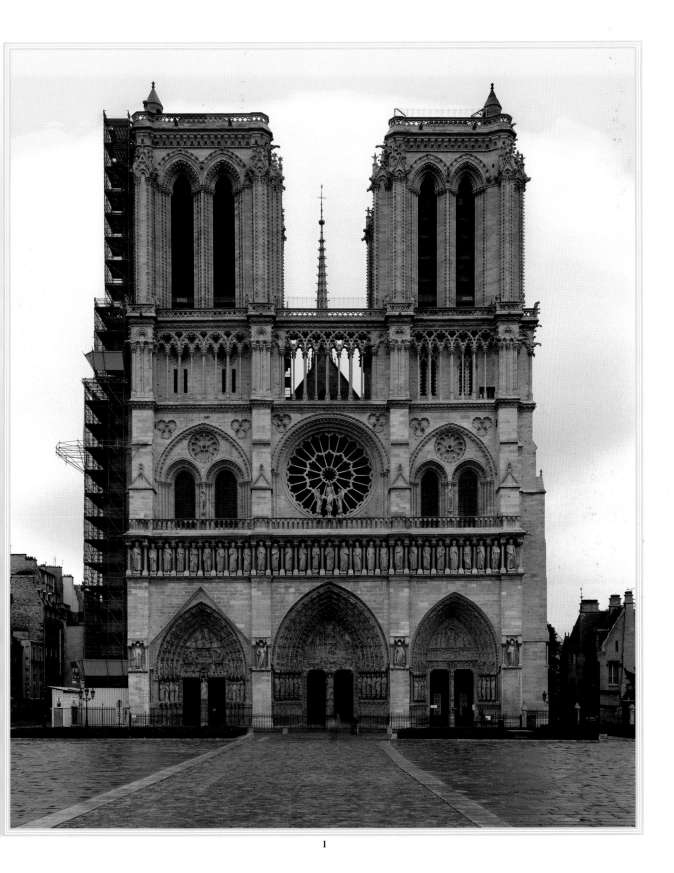

1

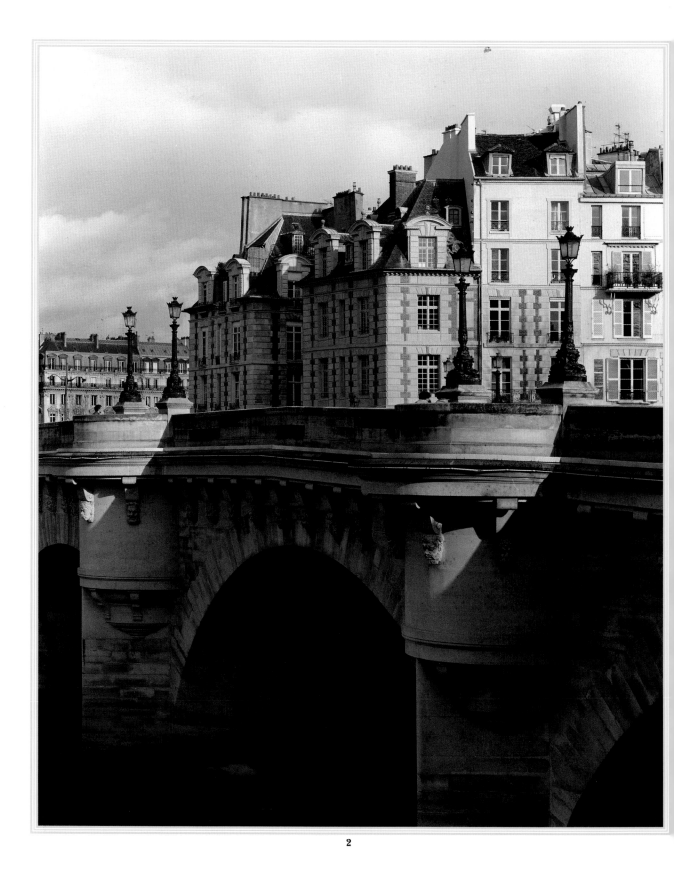

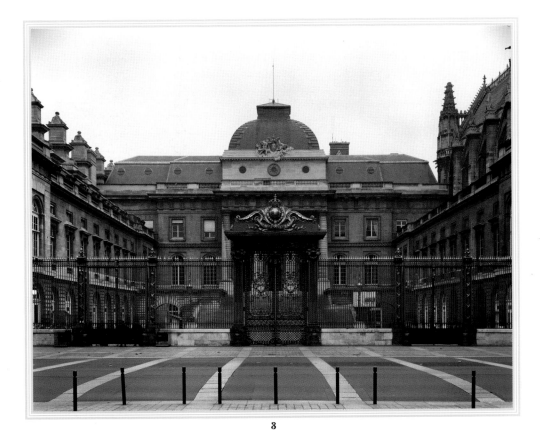

3

Place Dauphine

WEST TIP OF ÎLE DE LA CITÉ

1607–19, ATTRIBUTED TO LOUIS MÉTEZEAU

Thirty-two identical houses originally transformed this triangular plaza—wedged between the Pont-Neuf and Palais de Justice—into a fashionable center of commerce. King Henry IV commissioned these uniform stone and brick buildings in 1607 and named the space Place Dauphine, after his oldest son, the Dauphin. Over the centuries, subsequent renovations have modified the residences and changed the nature of the plaza. An area that previously bustled with trade and up-and-coming artists is now a quiet cluster of restaurants and boutiques, an ideal spot for serene strolling. While romancing the stones, young lovers might be forgiven for nicknaming the triangular space "the vagina of Paris"—a fitting tribute nonetheless to Henry IV's vision of city modernity.

Palais de Justice

4, BOULEVARD DU PALAIS

1776–83, JOSEPH-ABEL COUTURE, PIERRE DESMAISONS, JACQUES-DENIS ANTOINE, COUR DU MAI SIDE

Once fortified by moat and drawbridge, the Palais de Justice stands on land previously occupied by Roman rulers and French kings. This medieval palace complex encompasses Sainte-Chapelle with its seventy-five-meter spire, La Conciergerie, and watchtowers. These fortifications, however, did not deter Etienne Marcel and his men from pursuing a bloody revolt inside the palace, in 1358. After Charles V witnessed the murder of his counselors, he high-tailed it to Hôtel Saint-Pol, in the Marais, and moved his residence to the Louvre. After it had been abandoned as a royal residence, the Palais de Justice became the seat of Parliament. Rebuilt after many fires and various extensions, the Palais is an accumulation of buildings from different times throughout French history. Today, multiple courts here try both civil and criminal cases.

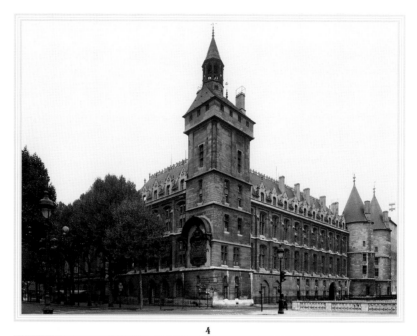

4

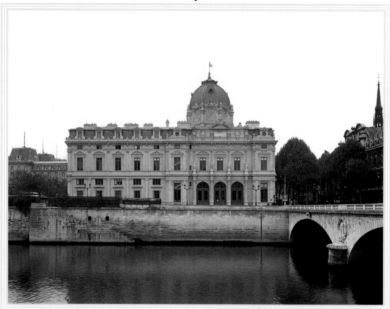

5

6

4

La Conciergerie

1, QUAI DE LA CORSE

1296–1313, ENGUERRAND DE MARGINY

A residence built by King Philippe le Bel, but abandoned in 1358–60 by Charles V, this palace—part of the Palais de Justice complex—became the seat of Parliament in 1431. Until 1914, it was a prison: During the Revolution, dungeons beneath the vaulted rooms held unfortunates awaiting trial and execution. Among its notable inmates, Robespierre, Danton, and Marie-Antoinette did time here.

5

Tribunal de Commerce

3, QUAI DE LA CORSE

1860–65, ANTOINE-NICHOLAS BAILLY

Under the direction of Napoléon III, Baron Haussmann reconfigured Paris in the mid-nineteenth century. As one of Haussmann's special projects, this building provided a place for the administrative trade courts. Both the immense staircase and the dome are noteworthy features. The dome—initially designed for the center of the building—appears in a strange position. For Haussmann, a city perspective with points of reference on either end was critical. So he persuaded the architect to shift the dome, to align with the new boulevard Sébastopol.

6

Préfecture de Police

7, BOULEVARD DU PALAIS AT RUE DE LUTÈCE

1862–65, VICTOR CALLIAT

Until 1879, the police headquarters contained two barracks. Now, four wings surround the center court, Court of August 19, so named to honor the police force for its role during liberation in 1944. The original construction was part of Baron Haussmann's massive reconstruction plan for Île de la Cité as an administrative center for the city of Paris.

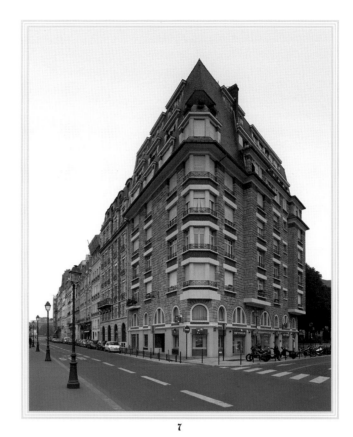

7

Sauvage Building

PLACE DAUPHINE AT QUAI DE ORFÈVRES

1929–32, HENRI SAUVAGE

Architect Sauvage did not see the completion of this, his last work. Construction stopped in 1929 while the project was reevaluated. Renovation of the houses on Place Dauphine caused discontent over the material used and the need to conform to city regulations. Moreover, controversy arose over a need for coordination (without compromising design) with the two previously renovated entrance pavilions facing Pont-Neuf. Development began again in 1932 with material modifications that produced comfortable apartments with modern conveniences. The structure and the floors are fireproof with reinforced concrete to the second floor and then metal structure and flooring above. The façades above the cement ground floor are rock and brick.

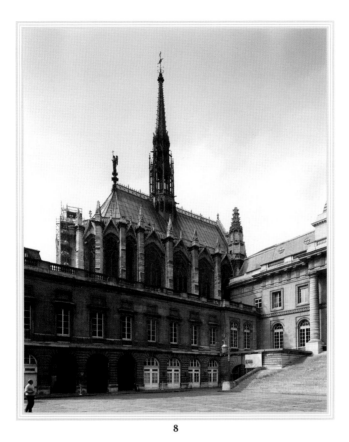

8

8

Sainte-Chapelle

4, BOULEVARD DU PALAIS

1241—48, ATTRIBUTED TO PIERRE DE MONTREUIL, THOMAS DE CORMONT, OR ROBERT DE LUZARCHES

Known as the "jewel box" for the brilliance of its stained-glass windows, La Sainte-Chapelle is a thirteenth-century treasure hidden inside the Palais de Justice. When its windows, which contain the oldest stained glass in Paris, are illuminated by sunlight, 1,134 biblical scenes glow with a depth of color seen only in expensive claret and gems. At sunset, the immense rose window depicts a scene of the Apocalypse. Stained-glass artistry reached its height in the mid-thirteenth century, at about the time Sainte-Chapelle was commissioned by King Louis IX, and these stained glass tracery windows—with delicate, radiating spokes —are typical of the Rayonnant period in Gothic design. In its original time, the expanded window surface and the reduced masonry gave this Gothic structure an impression of unusual lightness.

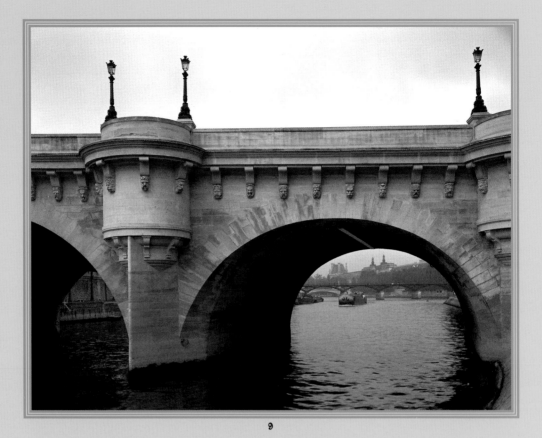

9

PONT-NEUF/PONT DES ARTS

In 1985, after ten years of study, sculptor Christo Javacheff wrapped the Pont-Neuf in cloth for two weeks as a conceptual work of monumental art. Unraveled, it now stands in its original form, linking the right and left banks as it slices across the west tip of Île de la Cité.

More than a bridge, it represents a French Renaissance symbol of reverse urban planning. Pushing Paris toward modernism, Henry IV developed Pont-Neuf as a building project between 1578 and 1607, and it immediately attracted loyal fans. Merchants, musicians, and medicine shows flocked to the bridge and it became a scene of daily entertainment. It was the first bridge built without houses on it and, as such, it opened up the river landscape of Paris. Previously invisible, the river had nonetheless been the lifeline of the city — a living and working space with houses and businesses, a dumping ground, and a harbor. With the completion of the Pont-Neuf, Parisians rediscovered the beauty of their river. The construction or expansion of other

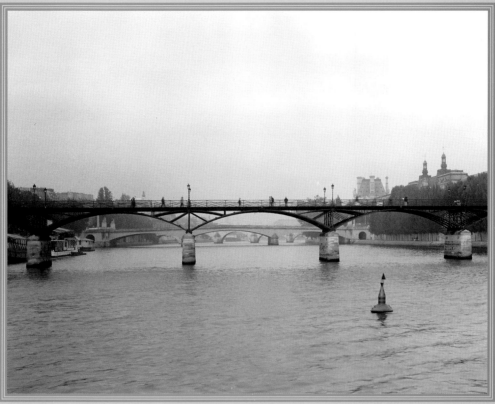

10

buildings such as the Louvre, the Institut de France, banks, private mansions, and various Haussmann projects followed suit, maintaining the view of the Seine. The river became a "landscape," and the Pont-Neuf, a symbol of urban revolution.

Pont des Arts opened two hundred years later, in 1803, and succeeded in replacing the Pont-Neuf as a favorite hangout. Sixty thousand spectators attended its inauguration. Creating this bridge achieved two milestones: It became the first footbridge across the Seine, and the first iron bridge. But it has required many renovations, as barges have often damaged it while trying to negotiate the close space between this bridge and the Pont-Neuf. Today, tourists, bird-feeding locals, backpackers, lovers, and other pedestrians regularly stroll across it or congregate on the bridge to watch artists at work or musicians performing *al fresco*. Most often, crowds just linger, looking up or out across the Seine to take in the breathtaking view of the Île de la Cité to the east, the Pont-Neuf and central Paris to the west, and the expanse of open sky all around.

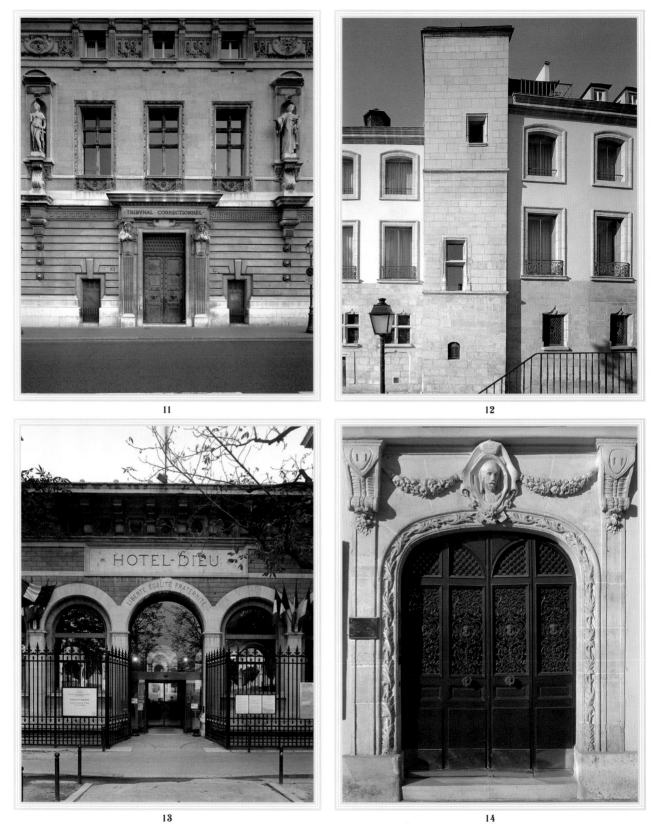

11

12

13

14

11
Tribunal Correctionnel

14, QUAI DES ORFÈVRES AT BOULEVARD DU PALAIS

1904–14, ALBERT TOURNAIRE

The magistrate's court of the Palais de Justice replaced one that had become too small to handle all of its trials. The new building allows more public space, and the façade is more expressive than the previous one. Two towers flank the main building and recall the Gothic turrets on the north side of the Palais de Justice. Architect Tournaire created a decorative frieze along the highest level with four allegoric statues in the niches: Truth, Law, Eloquence, and Clemency.

12
One, rue des Chantres

AT 1–3, RUE DES URSINS

1958, FERNAND POUILLON

Fernand Pouillon mixed a jumble of architectural elements to create a modern, medieval house. He demolished the original ruin "bit by bit, [and] replaced [it] by a clever pastiche of deliberately ill-assorted architectural items, which have been both envied and admired ever since by people dreaming of a view over the Seine." Despite the self-evident pleasure in his own work, Pouillon lived here only a year. The Aga Khan took up residency next in this fake medieval wonder.

13
Hôtel-Dieu

1, PLACE DU PARVIS NOTRE-DAME

1864–74, JACQUES GILBERT; 1874–77, STANISLAS DIET

Founded in the ninth century by Bishop Landry (later Saint-Landry) just south of Notre-Dame, the old medieval Hôtel-Dieu served for centuries as the only city hospital, taking on charity cases and caring for the ailing poor and aged. Regular overcrowding usually meant five to a bed. By the time that number dwindled to three, it was commonly said, the ill, the dying and the dead shared a bed. In the harsh winter of 1708–09, hundreds of corpses were carted off to the hospital's cemetery and buried en masse; over 2,500 infants were abandoned, most at the doorstep of Hôtel-Dieu. During Baron Haussmann's nineteenth-century civil reengineering, the Hôtel-Dieu was demolished and rebuilt on its present site.

14
9-M, quai aux Fleurs

1849, RECONSTUCTION

Paris's version of Romeo and Juliet features seventeen-year-old Héloïse and thirty-nine-year-old Pierre Abélard. The legendary lovers met in 1108 when Héloïse's uncle, Canon Fulbert, hired Abélard to tutor Héloïse here, in his home. The charismatic scholar soon charmed his way into her bed, and she bore him a son, Astrolabe. Although the lovers then secretly married, Abélard packed Héloïse off to a convent, and a furious Fulbert hired thugs to castrate Abélard to avenge the family's name. Two medallions created in memory of the star-crossed lovers are affixed to the door of 9, quai aux Fleurs in 1849.

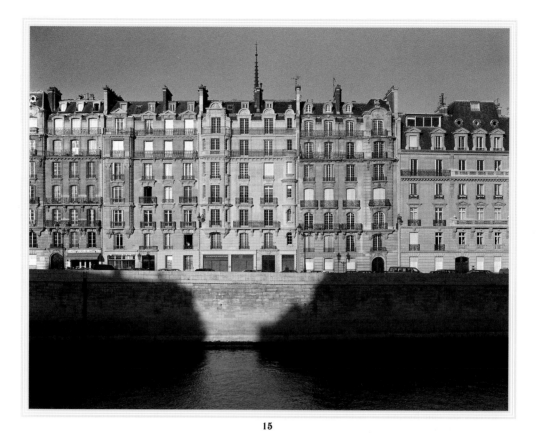

15

Buildings on quai aux Fleurs

1769, PIERRE-LOUIS MOREAU

In 1570, Parliament ordered a conversion of the houses at quai aux Fleurs, then known as Saint-Landry Harbor, into shelters for abandoned children. At the time many institutions—Hôpital de la Trinité, Hôtel-Dieu, Hôpital des Enfants-Dieu of the Saint-Esprit—engaged in social assistance, and several were located on Île de la Cité because Notre-Dame cathedral was here. Constructed in 1769, the quai—then one of the three harbors on Île de la Cité—was rebuilt during Napoléon Bonaparte's era in neo-Classic design, as it appears today. Situated on the eastern edge of Île de la Cité, quai aux Fleurs (in addition to the property just north of Notre-Dame) is the only land on the island to belong to the 4th arrondissement—an administrative division derived from the medieval neighborhood that had separated the western, independent royal side of the island from the church.

1ST ARRONDISSEMENT

Grand squares, ancient buildings, and modern additions all shape this royal arrondissement. The sweeping vista of water, sky, and greenery includes Pont-Neuf and place Dauphine on the tip of Île de la Cité, and extends north from the Seine, encompassing the Jardin des Tuileries and the Louvre. World-renowned since its twelfth-century origins through I. M. Pei's bold, twentieth-century glass pyramid addition, the Louvre was a royal residence long before it evolved into a museum. Nearby, the revitalized gardens of Palais-Royal —former private home of Cardinal Richelieu— also represent the area's regal heritage, as well as its common roots as a place of revelry. At the eastern edge of the first arrondissement, Forum des Halles—a subterranean shopping mall— replaced Paris's medieval food market, Les Halles, razed in 1969, and is a modern reminder of those rousing days and nights.

Running straight through the old city, rue de Rivoli became an elegant nineteenth-century showcase for both its homogenous frontage and the arcaded galleries behind the façades. To its north, on the western end, the elegant place Vendôme remains true to its pre-Revolutionary, aristocratic origins with stately architecture. Haute couture houses developed here and around the royal square of place des Victoires and on rue Saint-Honoré, catering to the needs of the nobility. Today, upscale fashion houses still reign here.

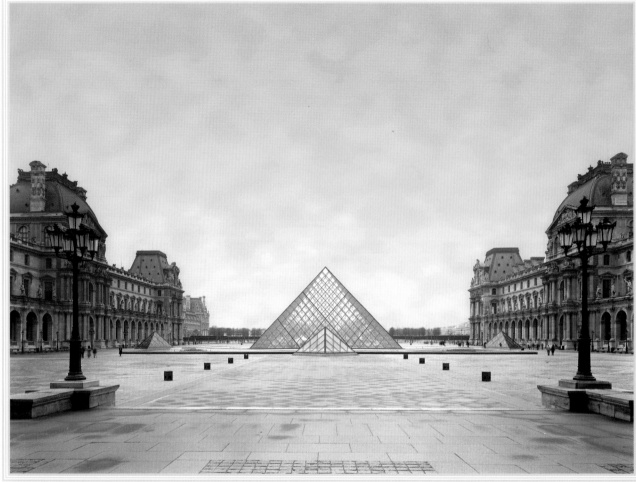

16

Louvre

Between rue de Rivoli and quai du Louvre, entrance cour Napoléon

1190, construction; 1528, Pierre Lescot and Jean Goujon, palace (cour carrée); 1624, Jacques Lemercier, additions; 1654, Louis Le Vau, additional work; 1668, Claude Perrault, colonnade; 1804–48, Charles Percier and Pierre-François-Léonard Fontaine; 1852–53, Louis-Tullius-Joachim Visconti; 1853–80, Hector-Martin Lefuel; 1984–93, Ieoh Ming Pei, pyramid

In 1983, when President François Mitterrand commissioned I. M. Pei to create a new entrance to the Louvre, Mitterrand was following in the footsteps of French kings. During its many incarnations—former defense tower, repository of crown treasures, royal residency, artist commune, first royal library, Renaissance Palace, home to Leonardo's *Mona Lisa*, and mega-museum extraordinaire—the Louvre evolved with the times and the whims of its leaders. Since 1191, when Philippe Auguste deposited in the Louvre his bounty from the Third Crusade, treasures have amassed to fill 225 galleries and 3 main wings. Inside the museum, you'll also find the basement of Philippe Auguste's medieval castle. This ruler also built a wall that excluded the Louvre from Paris proper. But on the other side of the mall at the Carrousel-du-Louvre, you can see another wall—dating from 1358 and Charles V's reign—that pulled the Louvre inside the one that encircled Paris. Outside, Pei's geometric entrance commands your attention and invites you in. Bold and transparent, yet not without controversy, Pei's pyramid energizes the central courtyard while minimizing its visual impact on the existing historic wings. In dealing with the problem of access, Pei conceived of a large underground space illuminated by natural light, and built a 45,000-square-meter exhibition and mall area, accessed by this transparent pyramid.

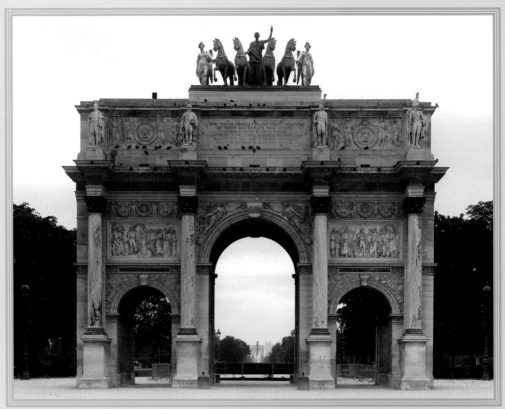

17

Palais des Tuileries

Fragments are all that exist of this palace, built in 1564 by celebrated French Renaissance architect Philibert de l'Orme for Catherine de Médicis, widow of Henri II, on the former site of tile kilns *(tuileries)*. For the pleasure of the royal residents, André Le Nôtre designed elaborate gardens that adjoined the palace. Two hundred years of architectural alterations had occurred by the time Louis XVI and his family moved here from Versailles in an effort to demonstrate awareness of and sympathy for the plight of poor Parisians. But it didn't help. Revolutionaries stormed the royal estate and overthrew the monarchy. Afterwards, Napoléon I used the Palais des Tuileries for his official residence; but in 1871, as the next revolution was brewing, the Communards set the buildings ablaze and destroyed the compound. Although the walls remained standing until 1884, they were eventually torn down for safety reasons. Some portions were preserved elsewhere about the city; fortunately, the gardens remain.

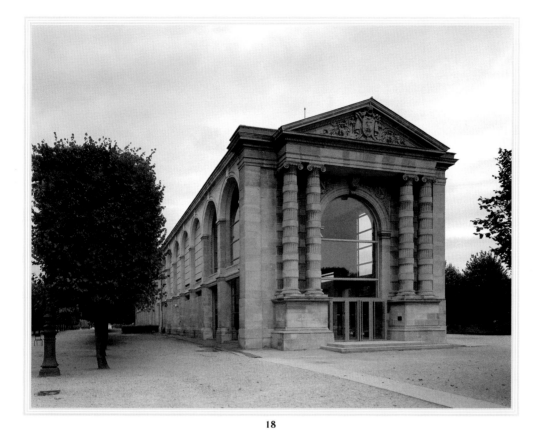

18

Arc de Triomphe du Carrousel

PLACE DU CARROUSEL, BETWEEN LOUVRE AND TUILERIES GARDENS

1806—08, CHARLES PERCIER AND PIERRE-FRANÇOIS-LÉONARD FONTAINE

Napoléon I commissioned this arch to celebrate his military victories in 1805. Architects Percier and Fontaine modeled their design after the Roman arch of Septimus Severus. The inscription was conceived by Napoléon himself. The bronze casting atop the arch—a Goddess of Victory quadriga—replaced the original Venetian sculpture of Four Horses of San Marco, seized by Napoléon but later returned to Venice by the Austrians. Today, the arch stands isolated, an informal gateway to the Tuileries gardens and the Louvre. Originally, Napoléon positioned it as the triumphal courtyard entrance to the now-defunct Tuileries Palace. At the time, the triumphal arch—a symbolic threshold for returning Roman warriors—marked the successful end to military campaigns. This one is not to be confused with the Arc de Triomphe of the Champs-Elysées—a larger triumph of Napoléonic ego.

Musée du Jeu de Paume

TUILERIES GARDENS, RUE DE RIVOLI SIDE AT RUE DE RIVOLI

1861
1991, ANTOINE STINCO, RENOVATION

As its name implies, the Jeu de Paume was used as a royal tennis court. Commissioned by Napoléon III in 1861, it was reclaimed by the state and served as a temporary exhibit space, then as a museum of contemporary French art, and, from 1947–86, as an annex to the Louvre, housing its Impressionists collection. Unfortunately, this space proved too small and inadequately ventilated, ill-serving both the artwork and the masses of visitors pressed too close to be able to appreciate the paintings' plays on light. Fortunately, the Impressionists were then moved to a better space in the renovated Musée d'Orsay. Later remodeled to have ample sky-lighting and open views of the gardens, Jeu de Paume is now used for temporary exhibitions of contemporary art.

19

Fontaine de la Croix-du-Trahoir

111, RUE SAINT-HONORÉ, CORNER OF RUE DE L'ARBRE-SEC

1776, JACQUES-GERMAIN SOUFFLOT

To French royalty, Rome was a model of modernity and wealth with its abundance of water and aqueducts. If citizens can see water, or its representation, that will mean the city is healthy and working and rich. This concept became a particularly important policy for France during the eighteenth century. Construction, replacements, copies, and restorations of fountains have sustained this tradition. This corner fountain is no exception, as it replaces one built by Jean Goujon in 1529. Architect Soufflot borrowed his relief design of nymphs from Goujon's previous work. Fontaine de la Croix-du-Trahoir was restored 1968.

20

Hôtel de Villeroy

34, RUE DES BOURDONNAIS AT RUE DE RIVOLI

1699–1708

Given to the administration by the Villeroy family, their former hotel was reconfigured for employees of the Post Office that, as a newly formed commission, provided essential services for the city's people and government at the beginning of the eighteenth century. The building is typical of private architecture of this period, with a large entrance under a low ground-level arch, continuous embossment, and a central balcony. The building's severity betrays the heaviness of style that was in vogue at the end of the Sun King's reign.

21

Saint-Germain-l'Auxerrois

2, PLACE DU LOUVRE AT RUE DE L'ARBRE

TWELFTH–SIXTEENTH CENTURIES
1754, CLAUDE BACCARIT, INSIDE TRANSFORMATIONS
1838–55, JEAN-BAPTISTE LASSUS AND VICTOR BALTARD, RESTORATION

From the bell tower on August 24, 1572, "Vincent," "Germain," and "Marie" heralded the Saint Bartholomew's Day Massacre of some 3,000 Huguenots. Of the three bells that rang out that night, only Marie survives. Built in the thirteenth century and remodeled in the fifteenth, Saint-Germain-l'Auxerrois was the parish church for the kings of France when they resided at the nearby Louvre. It was also a model for Claude Monet, who painted this church from a nearby balcony in 1867.

22

Mairie

4, PLACE DU LOUVRE AT RUE PERRAULT AND RUE DE RIVOLI

1858–60, JACQUES-IGNACE HITTORFF, MAIN BUILDING
1858–62, THÉODORE BALLU, TOWER

The construction of this town hall so close to the Louvre (former royal residence, now museum and masterpiece of French architecture) and Saint-Germain-l'Auxerrois (the royal parish church) created a challenge that was not easily resolved. The neo-Gothic tower helped resolve the problem of producing something complementary and noble. Architect Hittorff created a symmetrical design using the profile of the church's façade to balance one side of the town hall. In the end, the church perceived the tower as its bell tower, and the town hall duly designated it as its belfry. And so, the Louvre finally had a respectable neighbor.

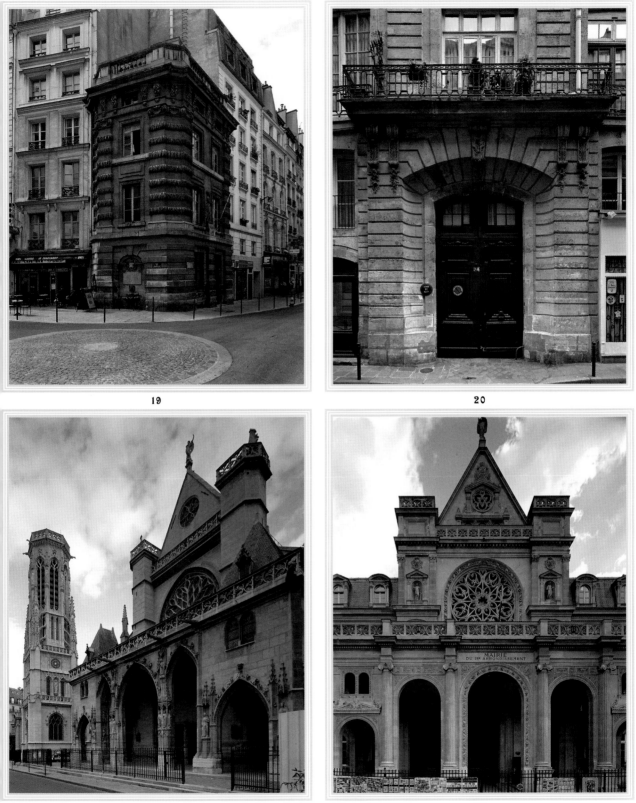

19

20

21

22

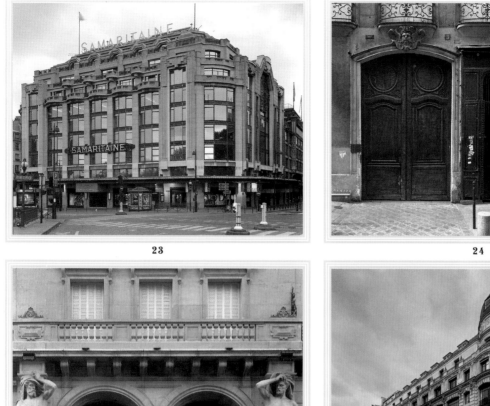

23

24

25

26

27

28

23

La Samaritaine Department Store

75, RUE DE RIVOLI BETWEEN RUE DE LA MONNAIE AND RUE DE L'ARBRE

1905, FRANTZ JOURDAIN
1926–28, FRANTZ JOURDAIN AND HENRI SAUVAGE, EXTENTION

Founded by Ernest Cognacq and his wife Marie-Louise Jay in 1869, and notable for its stylish blend of Art Nouveau and Art Deco architectural décor, the landmark Samaritaine has one of the best views of Paris from its balcony facing the Point-Neuf. An old water pump inspired the name of this department store, featuring the carved relief of a Good Samaritan offering a drink to Christ.

24

Maison Boucher

1–3, RUE DES PROUVAIRES AT RUE SAINT-HONORÉ

1715

Built following the death of the Sun King, these two houses express the prosperity of business couple Louis-Paul Boucher and Marie-Anne Galois. After the austerity of the previous era, commerce again thrived, encouraged by the new regime. The bourgeoisie built their homes to flaunt their new status. Reserved for the rich in the seventeenth century, fancy ironwork now became a sign of ostentation, and wonderful balconies appeared with light and elegant lines using sensual curves to denote their owners'—and architects'—emancipation.

25

15, rue du Louvre

AT RUE SAINT-HONORÉ

1889, HENRI BLONDEL

Architect Blondel created this apartment complex as one of his last projects. Situated on the site of the former Hôtel des Fermes, this large complex crosses the block between rue du Louvre and rue du Bouloi with two entrances. One, flanked by two busts of Atlantis, is made of stone—a noble sign of richness—and leads you into a sizable courtyard. The other, by contrast, is composed of metal. Traveling from one side of this building to the other transports you from a nineteenth century world to old Paris streets.

26

32, rue du Louvre and 112, rue Saint-Honoré

c. 1900

Parisian street corners were typically "hot spots" of prestige, and so the Saint Brothers developed a tall, monumental building at this juncture to create a formidable presence. In the business of producing jute at the beginning of the twentieth century, the brothers were in competition with a British monopoly. Their company, Saint-Frères, flourished. They expanded their business and constructed this large-windowed, three-story building of metal and concrete—the latter being the trendy new building material of the period.

27

68, rue Jean-Jacques Rousseau

AT RUE ETIENNE MARCEL

c. 1640–50 ORIGINAL CONSTRUCTION; c. 1740, RESTORED

This seventeenth-century construction was transformed in the first part of the eighteenth century. It still features its original, beautiful door. The dormer above it was created as a hayloft—a rare sight in modern Paris. Inside, the Louis Quinze style dominates the courtyard, which features an impressive wrought-iron staircase and elegant carved keystones at the "noble story". In the 1740s, Madame Dupin employed Jean-Jacques Rousseau as her secretary here, and ran a salon at which gathered brilliant personalities of the times.

28

Le Comptoir

37, RUE BERGER AT RUE VAUVILLIERS

c. 1870

Carrying on the glory days of Les Halles nightlife inside this basic mid–nineteenth-century Haussmann building, Le Comptoir mixes exotic Moorish touches of North Africa with iridescent lighting and a ritzy, curved bar. You can listen to canned music and hang out with the beautiful and the chic till two A.M. on school nights, four A.M. on the weekends.

29

Hôtel de Jaucourt

43, RUE CROIX-DES-PETITS-CHAMPS AT CORNER OF RUE LA VRILLIÈRE

1733, PIERRE DESMAISONS, ARCHITECT AND PIERRE-JEAN VARIN, MASON

Remarkable for two overhanging half towers, this corner building is a rare example of Rococo architecture in Paris. Hôtel de Jaucourt, also known as Hôtel de Portalis, has a voluptuous quality with its curves and rounded shape. This suggestive and fluid architecture is a reaction to the severity of the Sun King's reign. As such, in the spirit of the period, this architecture expresses sensuality, drunkenness, and pleasure—sending every classical architectural rule to hell.

30

Oratoire du Louvre

4, RUE DE L'ORATOIRE

1621–30, CLÉMENT MÉTEZEAU II & JACQUES LEMERCIER

The domed chevet of this chapel rises above an arched portico and is partially hidden behind a monument erected to honor Admiral Gaspard de Coligny, assassinated in 1572 during the August 24th Saint Bartholomew's Day Massacre. The gallery entrance faces rue Saint-Honoré, and the chapel's rectangular chamber on each side of the nave extends to the rue de Rivoli side of the building. The church itself served the French branch of the Oratorians, whose congregation was founded by Pierre de Bérulle in 1611.

31

Caisse d'Épargne de Paris
(HÔTEL TOYNARD DE VOUGY)

19, RUE DU LOUVRE AND 9, RUE DU COQ-HÉRON

1735, FRANÇOIS DEBIAS-AUBRY

This corner entrance is a late nineteenth century realignment. A savings bank has occupied the building since 1865 but, when the rue du Louvre was constructed in 1880, the bank's gated entry was moved to its current position to align with the street. The curved portal strikes a charming pose offsetting the uniformity of the building's lateral façades.

32

Au Chien qui Fume

33, RUE DU PONT-NEUF AT RUE SAINT-HONORÉ

1854

Parisians have a love affair with their dogs—fact born out by any glance at their city sidewalks. With equal tolerance for smoking in restaurants, it's no surprise, then, to discover a restaurant named "The Dog Who Smokes." The top part of the decorative sign features pooches in various stages of inhaling: a spaniel puffing a pipe à la Sherlock Holmes, a terrier chomping on a cigar, and a boxer dangling a cigarette from its lips in Bogey fashion. Inside, small painted panels depict other dogs in smoking poses.

33

Tour de Montlhéry

5, RUE DES PROUVAIRES AT RUE SAINT-HONORÉ

C. EIGHTEENTH CENTURY

À la Tour de Montlhéry occupies the site of a half-timbered house, formally a coach inn from the eighteenth century. In the lively days of the Les Halles food district, this street thrived as a fruit and vegetable market; farmers from Montlhéry, a village south of Paris, gathered here. Inside the restaurant's stone walls, a legacy to those days remains: Legend has it that, behind the zinc bar, beneath the tile floor, a trapdoor conceals an underground passageway to the street.

34

19, rue des Halles

AT RUE DES BOURDONNAIS

1869, P. LOBROT, BUILDING
1869, CHARLES GAUTHIER, CARYATIDS

The nineteenth century created a new typology of building in Paris, based on rules that mixed commerce and housing in the same place, as seen here. This building also blends several decorative styles. On the second and fifth floors along the façade, the balconies express a rhythm by means of ornamentation produced by vertical lines. The use of caryatids monumentalizes the façades—a reflection of the growing bourgeois society and its tastes.

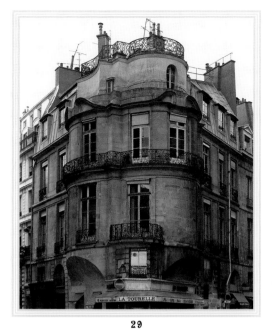
29

30

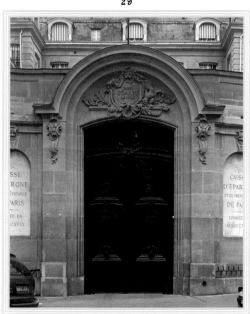
31

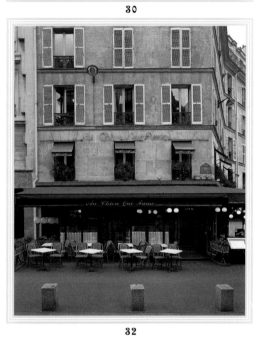
32

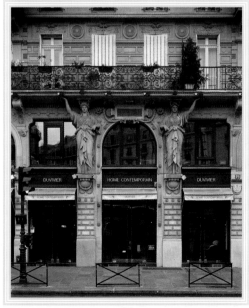
33

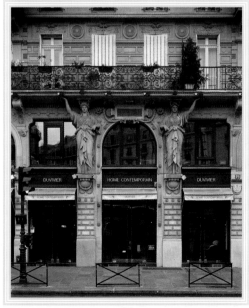
34

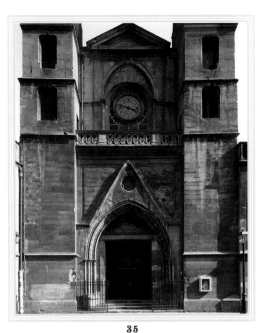

35

Saint-Leu-Saint-Gilles

92, RUE SAINT-DENIS AT BOULEVARD SÉBASTOPOL

1319, NAVE; 1611, SIDE AISLES AND CHOIR;
1858–61, REWORKED BY VICTOR BALTARD

Like Rome, this church wasn't built in a day. In Paris, ecclesiastical construction often spanned centuries—as was the case here. Begun in 1319, this small church finally acquired aisles some two hundred years later, and a choir after an additional three hundred years. Add another two hundred years of modifications to its apse, façade, and bell towers, and voilà! Give or take five hundred years, mission accomplished.

36

2–14, rue de la Ferronnerie

1670

Originally the burial site for the Cimetière des Innocents, this street also was the undoing of Henry IV, who was assassinated here. Afterwards, under the auspices of Saint-Germain-l'Auxerrois, the vestry demolished the charnel house. Later, it was replaced by this extremely long, uniform apartment building featuring endless arches—an early model of Parisian apartment and commercial development until Haussmann instituted his changes during the mid–nineteenth century.

37

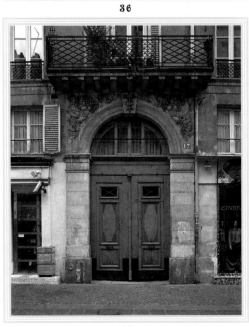

17, rue Pierre-Lescot

AT RUE DU CYGNE

LATE EIGHTEENTH CENTURY

Typical of buildings from the Revolutionary period, this house has a very basic, geometric structure, without any ornamentation. The political turmoil at the end of the eighteenth century is often perceived as having been a slow period for new construction; but, in fact, private projects brought regular speculation. The new order and morality was linked to classical Greek culture, and architecture followed suit, evoking—by the use of mass and simple columns—the temples of Ancient times.

38
Théâtre du Châtelet

1, PLACE DU CHÂTELET AT AVENUE VICTORIA

1860–62, GABRIEL DAVIOUD

Two theaters flank the Fontaine du Palmier to the east and west in place du Châtelet. Commissioned by Baron Haussmann, these typical nineteenth-century buildings, with their balconies and arched windows, are almost indistinguishable except for the differences in their size and decoration. The larger of the two is the Théâtre du Châtelet. After extensive interior renovations, the old Châtelet, which had staged simple operettas, expanded its repertoire to include more ambitiously-scaled concerts and operatic productions.

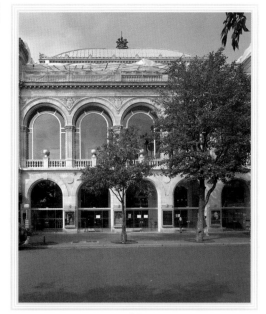

38

39
Place du Châtelet with Fontaine du Palmier

AT AVENUE VICTORIA

1806–07, NICOLAS BRALLE, FOUNTAIN; 1851–56, GABRIEL DAVIOUD, MOVED THE FOUNTAIN AND ENLARGED THE PLACE; 1855–57, J. A. PELLECHET AND CHARLES ROHAULT DE FLEURY, CHAMBRE DES NOTAIRES; 1899, JEAN-CAMILLE FORMIGÉ, RESTORATION OF THE FOUNTAIN

In 1807, Napoléon I commissioned this fountain to enhance place du Châtelet, a square named after a small defense fort that watched over the then Grand Pont, now called Pont-au-Change. The square replaced the medieval stronghold in 1802, and when it was enlarged in the 1850s, the original decorative column was elevated on a base with water-spouting sphinxes—the flow of water being a symbol of city prosperity.

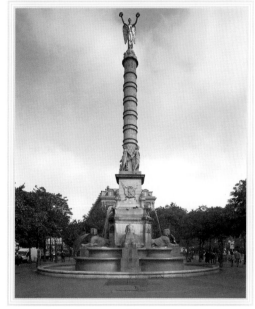

39

40
Cador André

2, RUE DE L'ADMIRAL DE COLIGNY AT 30, QUAI DE LOUVRE

1853

The perfect tea salon for ladies who lunch, Cador André caters to discriminating locals despite its tourist location next to Saint-Germain-l'Auxerrois and proximity to the Louvre. Among Parisian patisseries, window display is an art form: Meticulous care is taken to the arrangement of cookies, candies, and cakes. At Cador André, it is picture-perfect. No wonder the salon has attracted loyal customers for 150 years.

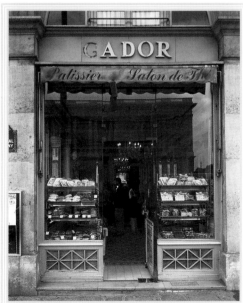

40

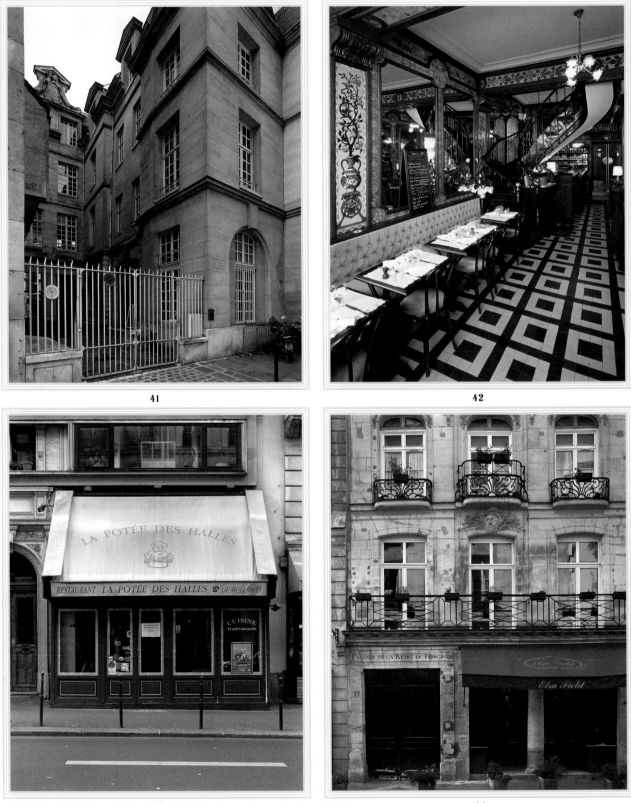

41

42

43

44

41

Hôtel de la Porte

25-29, RUE DU JOUR

c. 1640

Off rue du Jour, a passage between two buildings opens into the small enclosure where Hôtel de la Porte hid as a perfect royal getaway. The street and *hôtel* served Charles VI in 1370 as a kind of rural pied-à-terre. Then, from 1641–42, Antoine de la Porte, a fish merchant who had bought this site, reconstructed the residence to suit his refined bourgeois tastes. He carefully installed moldings around the dormer windows and decorated the façade with an ornamental cornice and a charming pediment depicting a garland of flowers, oak and acanthus. His initials, ADP, are visible above the gate, and today the *hôtel* is a museum of the bar (the justice variety).

42

Le Pharamond

24, RUE DE LA GRANDE TRUANDERIE AT RUE PIERRE LESCOT

1879
c. 1900, PICARD AND CIE, INTERIOR REDECORATION

When Alexandre Pharamond opened this restaurant in 1879, it became known for serving the best tripe. The second floor, with its special salons, offered great intimacy and privacy, and discreet access was possible from the building next door. But Pharamond also took to his horse-and-buggy out on the streets of Paris, to sell his specialty—a beef stew simmering in cider. The façade of the present incarnation of this restaurant, the result of the regionalist trend of the 1930s, is a fake wooden structure that imitates the architectural style of Normandy.

43

La Potée des Halles

3, RUE ETIENNE-MARCEL AT BOULEVARD DE SÉBASTOPOL

c. 1900

At the turn of the twentieth century, the glass-and-iron food pavilions at Les Halles swirled with activity. Licensed porters pushed their food carts from stall to stall, and a host of restaurants, cafés, and bistros, including la Potée des Halles, sprang up in the vicinity. Whether a household cook was planning a dinner menu or a restaurant chef sought fresh ingredients, this market was their prime source. Named for its own 1903 *potée* recipe—a hearty stew of salt pork, carrots, white beans, cabbage, and smoked sausage—La Potée pays homage in name and decor to down-home French cooking and the food pavilions of Les Halles. And its interior tile murals pay tribute to the bar and coffee maidens who kept life humming along these streets.

44

15-19, rue Montorgueil
(ROBILLARD HOUSE, DUMET HOUSE, GOBIN HOUSE)

BETWEEN FORUM DES HALLES AND RUE RÉAUMUR

1729, MARTIN GROUPY, ROBILLARD AND DUMET HOUSES
1776, TREFFEUILLE, GOBIN HOUSE

Eighteenth-century apartment buildings—the Robillard and Dumet Houses at numbers 15–17 and the Gobin House at number 19—reflect an evolution in style: As seen in the Robillard and Dumet houses, the homes were first built lower, with just four stories and single balconies for each window, indicating independent rooms and separate tenants. At the Gobin House, the balcony above the entresol (in-between floor) means that there was an independent main apartment for that entire floor, not just single rooms. Also, the earlier houses are in Rococo style, while Gobin House is à la Grecque.

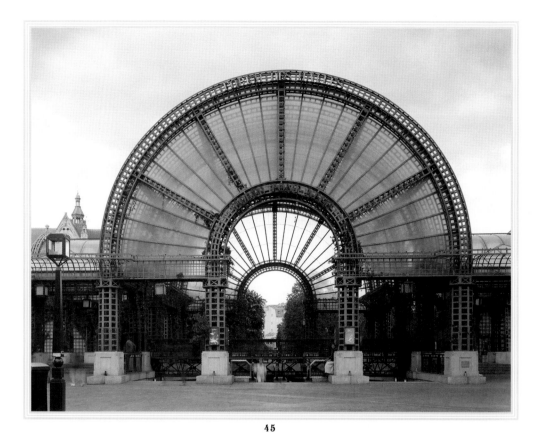

45

45

Forum des Halles

RUE PIERRE-LESCOT, BETWEEN RUE BERGER AND RUE RAMBUTEAU

1853–74, VICTOR BALTARD, LES HALLES; 1835,ADDITIONS;
1979–88, C. VASCONI AND G. PENCRÉACH, FORUM DES HALLES;
C. AND F.-X. LALANNE, GARDENS;
1985, PAUL CHEMETOV, INTERIOR OF PLACE CARRÉE AND EQUIPMENT

The city's central markets originated here with the influx of craftsmen and traders between the tenth and twelfth centuries. As early as 1183, Philippe Auguste permitted the first fish market, and, by the 1850's, Les Halles had become a thriving and colorful marketplace with cast-iron and glass pavilions that were a marvel of engineering. Unfortunately, in 1969, bureaucratic wisdom transferred the food markets south, to Rungis, to relieve city congestion. Their replacement, a subterranean shopping mall called Forum des Halles, was an architectural and cultural disaster at first, but has since energized the neighborhood with its extensive gardens, library, movie theater complex, Olympic swimming pool, and cultural activities.

46

Bourse de Commerce

2, RUE DE VIARMES AT RUE DU LOUVRE

1574, JEAN BULLANT, COLUMN
1765–68, NICOLAS LE CAMUS DE MÉZIÈRES, GRAIN MARKET; 1782–83,
JACQUES-GUILLAUME LEGRAND AND JACQUES MOLINOS, FIRST WOOD
DOME; 1809, FRANÇOIS-JOSEPH BÉLANGER, SECOND IRON DOME;
1885–89, HENRI BLONDEL, BOURSE DE COMMERCE

During the late sixteenth century, when court astrologist Riggieri informed Queen Catherine de Médicis that she would die by Saint-Germain, she assumed that he meant Saint-Germain-l'Auxerrois. She promptly moved to a new residence, Hôtel Soissons—now the site of the Bourse de Commerce. In 1765, Louis XVI commissioned a grain market here, called Halle au Blé, for the commercial exchange of wheat, corn, flour, and similar commodities. The structure used to have an arch so people could see through the center to ascertain the level of food and grain in the middle. One of the first structures to use a wooden dome, it was influenced by Roman temples and their glorification of food.

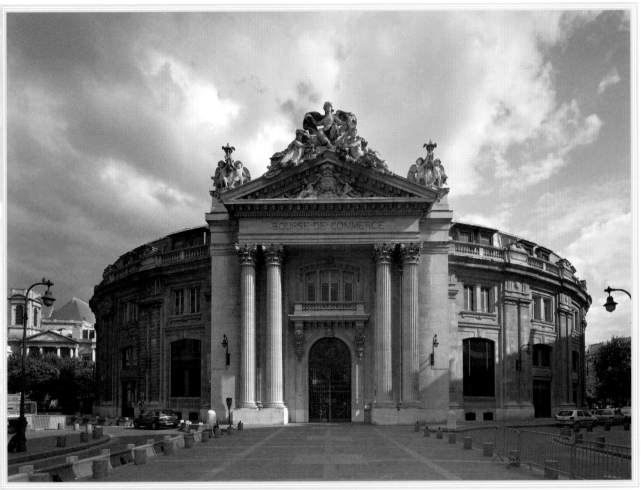

46

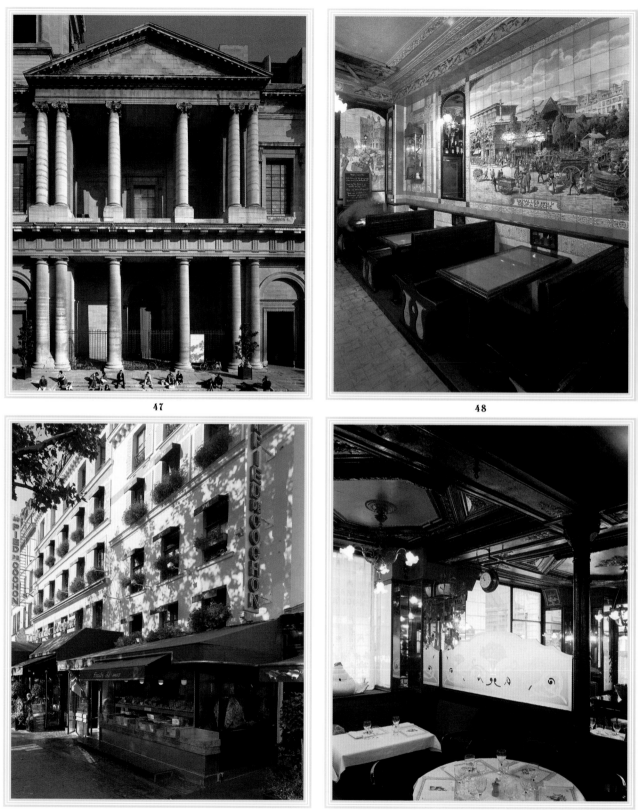

47

48

49

50

47

Saint-Eustache

1, RUE DU JOUR

1532–1640, JEAN DELAMARRE OR PIERRE LE MERCIER; 1754, JEAN
HARDOUIN-MANSART DE JOUY, FAÇADE, THEN PIERRE-LOUIS MOREAU;
1844, VICTOR BALTARD, FEW RESTORATIONS

Although French dramatist Molière is buried in the cemetery of Saint-Joseph's church, his funeral caused quite a stir here at Saint-Eustache. Because he was an actor—then a socially unacceptable profession—the local clergy refused his confession and denied his burial on church grounds. Louis XIV interceded four days later, persuading the priests of Saint-Eustache to bury Molière at Saint-Joseph's cemetery under the cover of darkness. The second largest church after Notre-Dame, Saint-Eustache served the common folk from Les Halles as well as the great and the talented.

48

Le Cochon à l'Oreille

15, RUE MONTMARTRE AT RUE DU JOUR

1910

The restaurant name, "The Pig's Ear," harks back to the market days of Les Halles, when farmers set up stalls to sell everything from sides of beef, chickens, produce, and dairy, to sea creatures and the spices of Provence. Parisians flocked here to shop from the twelfth century until 1969, when Les Halles was dismantled and the farmers took their wares south to Rungis. In 1873, Emile Zola called this market area "the belly of Paris." Since 1910, Le Cochon à l'Oreille has survived as a classic bistro whose tiled murals on its walls depict the market's halcyon days, the literally colorful exchanges between buyers and sellers.

49

Au Pied de Cochon

6, RUE COQUILLÈRE AT RUE DU JOUR

c. 1830

Evoking the days (and nights) of the old Les Halles district, with its all-night wholesale food markets, Au Pied de Cochon, translated as "at the foot of the pig," is a 24-hour brasserie. For early risers, late night wanderers, or all-nighters, this famous restaurant hits the spot. Its traditional fare for the past fifty years: T-bone Salers – steaks, French onion soup, fresh seafood platters, and profiteroles with hot bitter chocolate sauce.

50

L'Escargot Montorgueil

38, RUE MONTORGUEIL AT RUE ETIENNE-MARCEL

1875, RESTAURANT

The giant, golden snail above this restaurant's gold-lettered name and black façade entrance tells the tale. You want snails, they've got them—prepared in ways you've never dreamed of. Inside this registered historic building, a spiral staircase links two dining levels. A ceiling painting, by G.-J.-V. Clairin, that once hung in Sarah Bernhardt's dining room, now graces the entrance. In 1919, André Terrail, founder of the Georges V hotel, bought the original 1832 establishment, then called Escargot d'Or. Today, his daughter, Mrs. Saladin-Terrail, hosts customers from the worlds of arts, literature, and show business. Notables who have dined here include Charlie Chaplin, Jean Cocteau, Picasso, Salvador Dali, and Barbra Streisand.

51

Le Grand Véfour

17, RUE DE BEAUJOLAIS, BETWEEN RUE DE VALOIS AND MONTPENSIER

1820, PURCHASED BY JEAN VÉFOUR

As the oldest Parisian restaurant serving clients at its original location, Le Grand Véfour is entitled to name-drop: Napoléon and Joséphine, Victor Hugo, George Sand, and Honoré de Balzac are just a few of its diners whose names are engraved above their supposed seats. In 1820, Jean Véfour bought the Café de Chartres—the name can still be seen over the garden entrance—and renamed the restaurant after himself. Today, the resplendent and romantic Grand Véfour offers its Michelin three-star courses in a stunning setting.

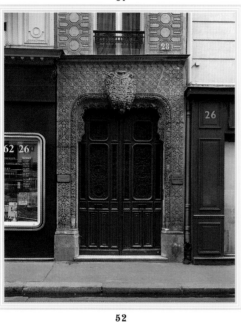

52

52

28, rue de Richelieu

AT RUE MOLIÈRE

c. 1835–40

This building features two entrances off to the side rather than one middle door—an unusual characteristic in Parisian architecture of the nineteenth century. Customarily, one main door in the middle of a façade connect to a courtyard flanked by two wings. The unique decoration of Spanish arabesque figures contributes to the originality of this building, especially in contrast to housing of its period. The carvings here are in hard Parisian stone—as opposed to more traditional, softer materials.

53

53

Maison de Molière

40, RUE RICHELIEU AT RUE VILLEDO

c. 1660; 1765, PÉRARD DE MONTREUIL, REBUILT

When Louis XIV assigned Molière to the Le Petit Cardinal Theater, the dramatist had lived in four different places in the neighborhood of the Palais Royal. Forty rue Richelieu was his last home. The actual house was rebuilt in the severe architectural style of the 1760s by Pérard de Montreuil, but the building next door, number 38, is contemporaneous with Molière's home and gives an idea of its original design.

54
Banque de France
(FORMER HÔTEL DE LA VRILLIÈRE, THEN HÔTEL DE TOULOUSE)

ONE RUE DE LA VRILLIÈRE AT RUE CROIX DES PETITS-CHAMPS

1635–40, FRANÇOIS MANSART; 1713, ROBERT DE COTTE;
1853–65, GABRIEL CRÉTIN; 1870–74, CHARLES QUESNEL

Built by François Mansart for Louis Phélypaux, Lord of la Vrillière, this mansion was known for its beautiful portal and its art gallery, which housed la Vrillière's Italian collection. In 1808, the Banque de France, created by Napoléon I in 1800, moved into this building. Charles Quesnel reconstituted the Galerie Dorée with copies of the original paintings, and Raymond and Paul Balze recreated François Perrier's first ceiling.

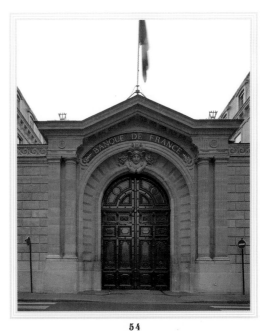

54

55
Kiosque des Noctambules
(NEW METRO ENTRANCE)

PALAIS-ROYAL–MUSÉE DU LOUVRE METRO ENTRANCE AT PLACE COLETTE

2000, JEAN-MICHEL OTHONIEL

Filled with 800 glass beads, this cast aluminum structure sparkles like a piece of faux jewelry. Gemstone hues of fire red, crystal, yellow, night blue, sky blue, violet, and amber glow at sunset and mark the entry to the Palais-Royal–Musée du Louvre metro in front of the Comédie-Française theatre. Jean-Michel Othoniel created these controversial globs of color for the Paris transit system, in celebration of the metro's centenary—a joint redevelopment project backed by the City of Paris and the Mairie of the first arrondissement.

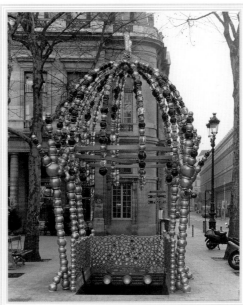

55

56
Hôtel de Bezons

39, RUE RICHELIEU AT RUE THÉRÈSE

1660–70, MICHEL VILLEDO; C.1700, REBUILT

Maybe because of the city's density, Paris seems generally flat to those who walk in the central part of the Right Bank. Time has slowly erased the hills that used to exist in various areas. The land between rue Thérèse and rue des Petits-Champs was once hilly until master builder Michel Villedo leveled the hill and developed *hôtels* as a business venture. The Hôtel de Bezons, one of the private mansions he constructed, takes its name from the first owner.

56

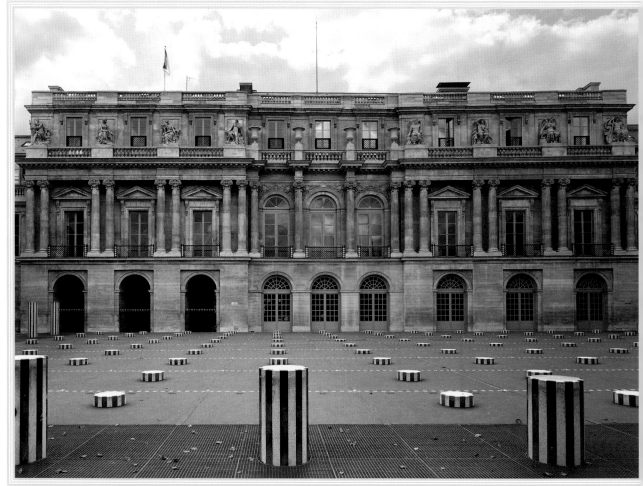

57

Palais-Royal

PLACE DU PALAIS-ROYAL BETWEEN RUE DE VALOIS AND RUE DE MONTPENSIER

1620, MARIN DE LA VALLÉE AND JEAN THIRIOT; 1625–39, JACQUES LEMERCIER; 1766–70, PIERRE-LOUIS MOREAU AND CONTANT D'IVRY, PARTIAL REBUILDING; 1781–84 AND 1786–90, VICTOR LOUIS, ADDITIONAL BUILDINGS; 1817, PIERRE-FRANÇOIS FONTAINE, ADDITIONAL BUILDING; 1849–75, PROSPER CHABROL; 1986, DANIEL BUREN, INSTALLATION IN THE COURTYARD

Once, on sunny days at precisely noon, Parisians used to set their watches by the boom of a little cannon in the Palais-Royal gardens. This tradition had started in 1786, when a Monsieur Rousseau had fastened a magnifying glass to a small cannon he had placed in the gardens on Paris's meridian line. The attached lens would ignite the fuse. The cannon, long a subject of poetry and lithographs, stopped booming in 1914, but the ritual resumed in 1980 when it was restored...only to be silenced again by its 1998 theft from the gardens. Today, you'll find tranquillity in the gardens and elegance within the cannon-free arcade. But this respite from the city rush belies the building's past. Built as a private home for Cardinal Richelieu, Palais-Royal was transformed multiple times by its revolving occupants. The Sun King romped on the grounds as a child. Camille Desmoulins stirred passions here on July 13, 1789, and Revolutionaries stormed the Bastille the next day. Diderot and other intellectuals argued in the vicinity. Literary denizens Colette and Cocteau waved to each other from their Palais apartment windows. Sinners and saints, chess players and prostitutes, duelers and revelers all hung out here, creating a lively atmosphere and dissonance in the gardens and arcade cafés. Today, Daniel Buren's black and white columns—a conceptual art grid—have revitalized the gardens.

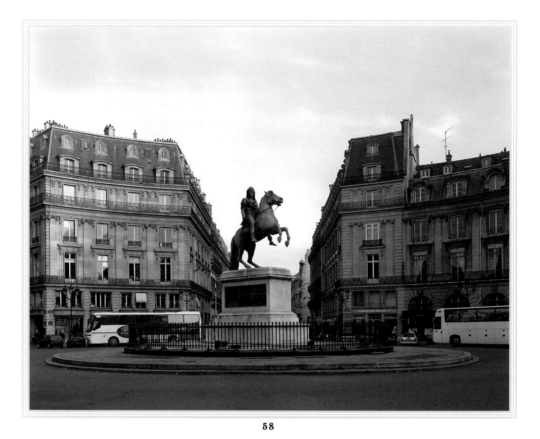

58

Place des Victoires

At rue de la Feuillade, rue Etienne-Marcel, rue Notre-Dames
des Victoires, and rue Croix des Petits Champs
At the boundary of the first and second arrondissements

1685–86, Jules Hardouin-Mansart

This place royale praises the glory of the Sun King. A mounted figure of him—in his wig and, oddly, Roman attire—graces the horseshoe-shaped plaza, now home to stylish fashion houses. Marshall François d'Aubusson, the duc de la Feuillade, had this monument built at his own expense to honor his beloved Louis XIV after the Treaty of Nimwegan in 1678. The original bronze statue of the king, designed by Desjardins, was installed in 1686, but was melted down in 1792 by Revolutionaries. To commemorate the hero of the battle of Marengo, Napoléon replaced the destroyed bronze with a nude statue of General Desaix de Veygoux, which so shocked Parisians that they fenced the general out of sight. Later, during Restoration, François Joseph Bosio created the sculpture currently mounted.

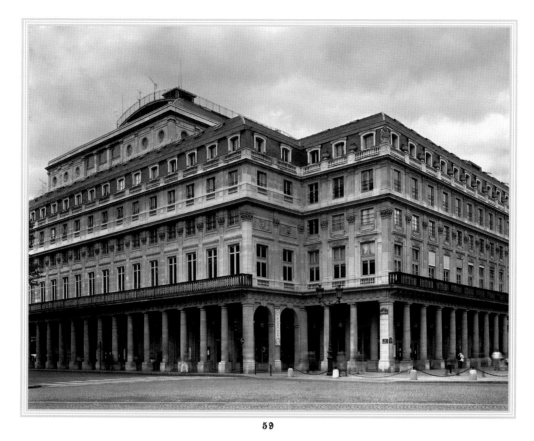

59

Comédie-Française

2, RUE DE RICHELIEU AT AVENUE DE L'OPÉRA

1786–90, VICTOR LOUIS; 1861, PROSPER CHABROL, SOUTH FAÇADE;
1900, REBUILT PARTIALLY

Founded by Louis XIV near Palais-Royal, Comédie-Française inaugurated this theater in 1799 performing *Le Cid* and *L'Ecole des Maris* in a double-bill. Today, this is where one can see performances of plays by Molière, Camus, Shakespeare, and Ibsen, among others. Long past its glory days, the theater nonetheless revives tradition with historic celebrations on Bastille Day and on the February anniversary of Molière's death. It was on February 17, 1673, at the nearby Palais-Royal in Richelieu's Le Petit Cardinal Theater, that Molière, playing the hypochondriac Argan in *Malade imaginaire (The Imaginary Invalid)*, collapsed and died onstage in mid-performance.

60

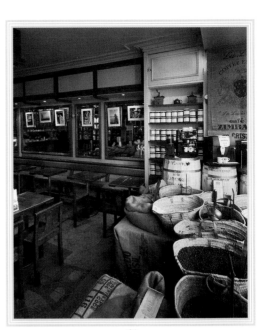

61

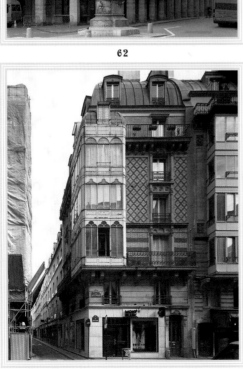

62

63

64

65

60
Musée de l'Orangerie

TUILERIES GARDENS, SEINE SIDE AT QUAI DES TUILERIES

1664, ANDRÉ LE NÔTRE, REDESIGN OF GARDENS; 1853
L'ORANGERIE; 1991, PASCAL CRIBIER AND LOUIS BÉNECH,
REFURBISHMENT, TUILERIES

Both Musée de l'Orangerie and its opposite neighbor, Musée du Jeu de Paume, are situated near place de la Concorde. L'Orangerie—so named for its original purpose, as a greenhouse for growing oranges—was refurbished in the early twentieth century and decorated with Monet's Water Lilies paintings. In 1984, the museum acquired, the art collections of Jean and Domenica Walter, and Paul Guillaume.

61
Café Verlet

256, RUE SAINT-HONORÉ AT RUE DE L'ECHELLE AND PLACE ANDRÉ MALRAUX

1880

Café and coffee *brûlerie* par excellence, Verlet has been roasting beans since 1880. Over two dozen varieties—from high test to mild—spill out from burlap bags, and the well-informed staff advises you on which caffeine dose and grind to choose. If you crave a spot of tea instead, have a seat in their wood-paneled café, and Verlet will dispense your tea from vintage canisters.

62
Sloped Apartments

PLACE DE LA PYRAMIDES AT RUE DE RIVOLI AND RUE DE LA PYRAMIDES

1802, CHARLES PERCIER AND PIERRE FONTAINE, FAÇADES;
1874, EMMANUEL FRÉMIET, STATUE OF JOAN OF ARC

These apartment buildings, with identical façades, feature an arched colonnade and curved roofs. Commissioned by Napoléon I, construction began in 1802 along rue de Rivoli and continued until 1835. Originally their roofs were low and double-sloped. They frame the place de la Pyramides on three sides, looking out toward the Tuileries gardens and the Louvre. At the center stands a statue of Joan of Arc, which sculptor Emmanuel Frémiet added in 1874.

63
Eglise Saint-Roch

298, RUE SAINT-HONORÉ

1653, JACQUES LE MERCIER; 1705–39, JULES HARDOUIN-MANSART,
ROBERT DE COTTE, FAÇADE; 1754, ETIENNE-LOUIS BOULÉE,
CHAPEL DU CLAVAIRE (DAMAGED) AND ETIENNE-MAURICE FALCONET,
DECORATION IN THE VIRGIN CHAPEL

Jacques Lemercier conceived plans for Saint-Roch but died before Louis XIV developed this site. Lack of funding caused further delays, until Scottish financier John Law came to the city's rescue. This parish church with its column-heavy façade—built about eighty-five years after construction of the site began—represents an example of Baroque religious architecture in Paris.

64
306, rue Saint-Honoré at rue Sourdière

1892, A.-J. SELLERIER

Decorative brickwork, an unusual feature in Parisian architecture, enhances the façade of this late nineteenth-century building. Red, beige, and a strip of light blue form an alternating pattern on the lower floor. Above this level, the layout of the bricks creates a repeating diamond motif that appears to be textured. Along the corner, a massive bay window in metal recalls a medieval castle's watchtower controlling the streets.

65
208, rue de Rivoli

AT RUE DU VINGT-NEUF JUILLET

1802–35, CHARLES PERCIER AND PIERRE-FRANÇOIS FONTAINE

This double glass-and-iron entrance leads to an elegant nineteenth-century arcade that runs along the north side of rue de Rivoli. The area was once an enclave for English-speaking expatriates who gathered in the nearby English bookstores. Today, because of its location opposite the Tuileries Garden and the Louvre, the mile-long arcade attracts tourists. Although a few hotels and shops along rue de Rivoli maintain a tradition of high quality, others, once glamorous, have acquired a decidedly commercial bent, selling overpriced souvenirs.

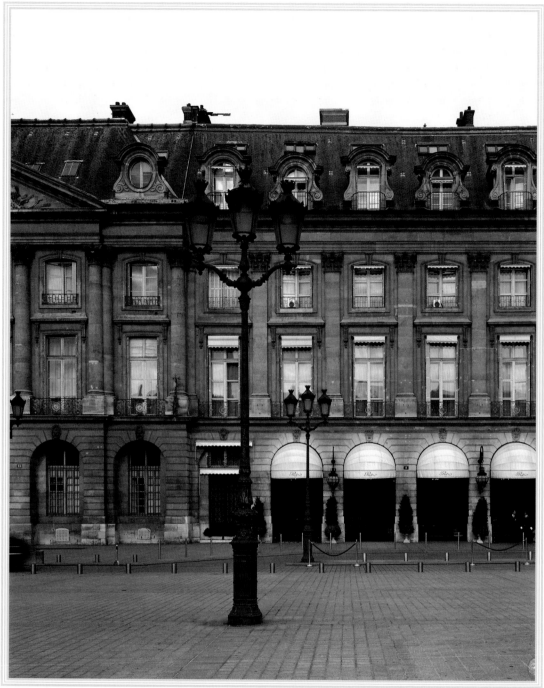

66

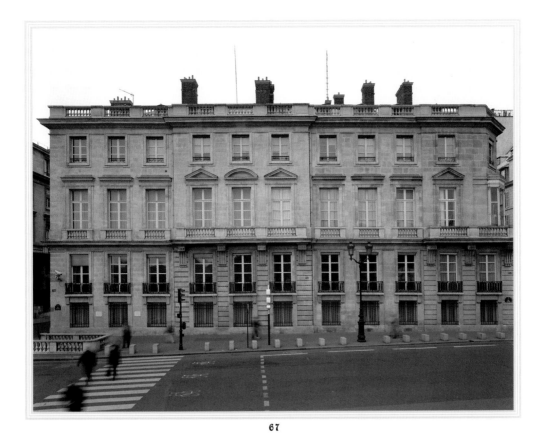

67

Hôtel Ritz

15, PLACE VENDÔME AT RUE DE LA PAIX

1705, FIRST ARISTOCRATIC HOME; 1896, CHARLES MEWÉS, TRANSFORMATION AS AN HOTEL FOR TRAVELERS

The Ritz Hemingway bar, a legendary watering hole for writers, was the scene for Fitzgerald's drinking as well as the favorite of his *Tender is the Night* character Abe North. Other literary associations, from fact and fiction, include *Babylon Revisited*, *The Bridal Party*, and *News of Paris–Fifteen Years Ago*. In 1944, the story goes, Papa Hemingway, whose photos adorn his namesake bar inside Hôtel Ritz, "liberated" the Ritz with a band of thirsty soldiers, treating them to a round of ninety-three dry martinis. But long before Hemingway made the Ritz famous, Scott and Zelda Fitzgerald—along with other wealthy American patrons—took up residence here in the 1920s, when they threw lavish pre-Depression parties. A guest suite is name for Scott Fitzgerald, but Charles Ritz renamed "Le Petit Bar" to honor his friend Ernest.

Hôtel de Saint-Florentin

(HÔTEL DE TALLEYRAND-PERIGORD)

2, RUE SAINT-FLORENTIN AT RUE DE RIVOLI

1767–69, JEAN-FRANÇOIS-THÉRÈSE CHALGRIN; 1860–70, E. PETIT AND LÉON OHNET, TRANSFORMATION

Named for its patron, the Lord of Saint-Florentin, who later became duc de la Vrillière, this mansion is a rare example of architecture from the time before the city's transformation in the nineteenth century. According to a law of 1758, the *hôtel*'s façade was considered part of the decoration of the new place Louis XV (place de la Concorde, today). From 1813 to 1838, French statesman Talleyrand lived here and welcomed French and European high society to his Salon de l'Aigle. In 1940, German naval authorities connected the building to the ministry of the navy, on the other side of the street, via a bridge suspended across their respective first levels, nicknamed the "Bridge of Sights" because prisoners were walked across it. After World War II, the U.S. Embassy bought the building to use for administering the Marshall Plan.

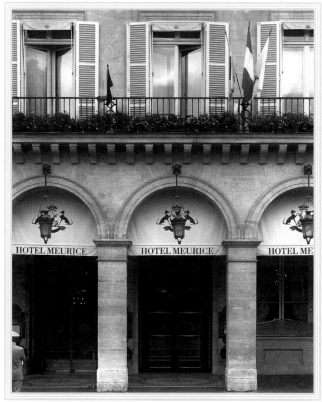

68

Hôtel Meurice

228, RUE DE RIVOLI AT RUE DE CASTIGLIONE

1907, HENRI-PAUL NÉNOT; 2000, JEAN-LOUP ROUBERT AND NICOLAS
PAPAMILTIADES, RENOVATION

Used as Nazi headquarters during the Occupation, Hôtel Meurice has had a happier history in French cinema. In the 1966 caper, *Paris-brûle-i-il? (Paris is Burning)*, director René Clément stoked the flames by using Hôtel Meurice as his setting from which views of the Tuileries Gardens and the Eiffel Tower served as quintessential Paris images. Established elsewhere in 1817 by a Calais postmaster who transported British tourists back and forth after the Napoléonic Wars, Hôtel Meurice moved to this location in 1835. A recent renovation uncovered the original floor and woodwork of the hotel's bar. As directed by architects Roubert and Papamiltiades, more than five hundred artisans restored its antiques, mosaics, stained glass and friezes. With its new, lavish décor of silk brocaded drapery and Italian marble, the hotel attracts the stars again.

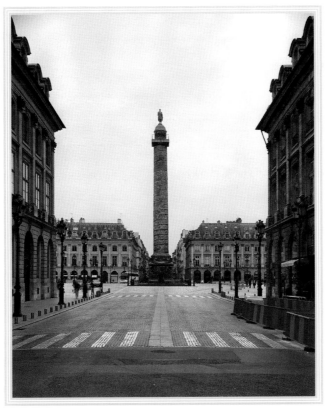

69

Place Vendôme

BETWEEN RUE DE CASTIGLIONE AND RUE DE LA PAIX

1699–1720, JULES HARDOUIN-MANSART

All the *places royales* (royal squares) around Paris shared this basic concept: They honored a king by placing a statue of that king at their center. The buildings created around them were intended as showcases for the statue—to elevate the stature of the king and express his glory. And so the façades around place Vendôme—featuring chamfered corners, triangular pediments, and Corinthian pilasters—created a stage setting for the central statue of the Sun King, which literally rose and fell with the turbulence of history: Revolutionaries knocked down the first equestrian statue, and it was replaced frequently with others depending on the whim of the current reigning power. The current statue that can be seen there today finally secured its place atop the column in 1874, when the victorious National Assembly rebuilt it to depict Napoléon Bonaparte's military exploits.

70

Manège Duphot

10–14, RUE DUPHOT BETWEEN RUE SAINT-HONORÉ
AND BOULEVARD DE LA MADELEINE

1806–10, EMMANUEL-AISMÉ DAMESME

Although built in the early 1800s, this site derives its name from a riding school that occupied the premises from 1860 to 1914. Today, an apartment building blocks off entry to its semicircular court hidden behind the façade. On the first two floors at number 14, five sets of windows mimic the shape and design of the arched entry. The spacing and design of the three centered windows, offset by one on each side, plays with positive and negative space and gives the building symmetry.

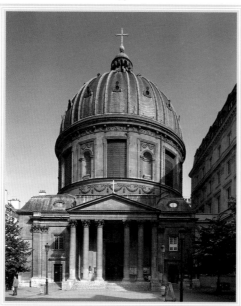

71

71

Notre-Dame-de-l'Assomption

263 BIS, RUE SAINT-HONORÉ AT RUE CAMBON AND RUE DUPHOT

1670–76, CHARLES ERRARD

Infamous for its oversized dome, this church is the work of Charles Errard who perhaps spent too much time in Rome. As the director of the French Academy in Rome, he was clearly and disproportionately influenced by the Baroque architecture there. Or maybe he just needed glasses! Whatever its inspiration, this church's extravagant design has not affected its function, as the Polish Catholic community of Paris has worshipped here since 1850.

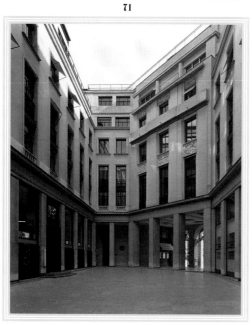

72

72

Cour Vendôme

BETWEEN PLACE VENDÔME AND RUE SAINT-HONORÉ

1934

Decorated with Art Deco high relief, this courtyard connects rue Saint-Honoré and place Vendôme. Decorative friezes surmount the windows on one side and decorative ironwork adorns the windows on the opposite side; 1930s columns frame the classy passage where elegant boutiques and galleries hold sway under the arcades.

73
Hôtel Costes

239, RUE SAINT-HONORÉ AT RUE DE CASTIGLIONE

1995, JACQUES GARCIA, INTERIOR RENOVATION

Designed by brothers Jean-Louis and Gilbert Costes, Hôtel Costes exudes hipness: a hot spot where visitors can hang out, drink in hand, to ogle models and rock stars. Staying guests can bunk down in luxuriously outfitted Baroque rooms. Plush brocade with fringe, lavish mahogany-and-gold wallpaper, and antique armchairs help conjure Napoléonic dreams, in this boutique hotel for the MTV crowd.

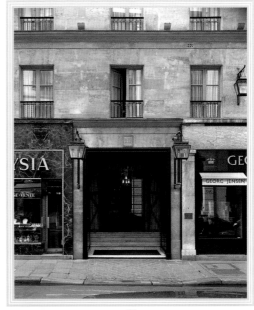

73

74
Paribas office building

37, PLACE DU MARCHÉ-SAINT-HONORÉ BETWEEN RUE GOMBOUST AND RUE DU MARCHÉ-SAINT-HONORÉ

1997, RICARDO BOFILL

In homage of sorts to Victor Baltard, architect of the now-defunct iron-and-glass market pavilions of Les Halles, Bofill created a transparent link to the past. His fluid glass building, with a triangular pediment, replaces the space of the former Saint-Honoré market and features a central pedestrian walkway reminiscent of the covered *passages* of nineteenth century Paris. Unfortunately, the complex lacks shops and feels deserted.

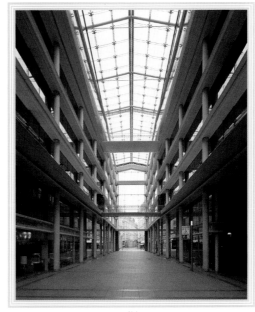

74

75
Aux Trois Quartiers

17, BOULEVARD DE LA MADELEINE AT RUE DUPHOT

1932, LOUIS FAURE-DUJARRIC

The façade of Trois Quartiers is atypical for a Parisian department store. It has more in common with the Bauhaus architecture. Flat, white strips wrap horizontally around the building, and vertical black lines give it an industrial and graphic aesthetic. The result is a streamlined, futuristic effect —a glass and grid fabrication in stone and steel. Inherent in this Spartan design is the visible absence of commercial goods. The architect juggled the concept of clean store presentation with the conflicting merchant philosophy of piling up goods.

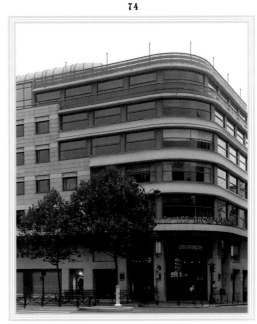

75

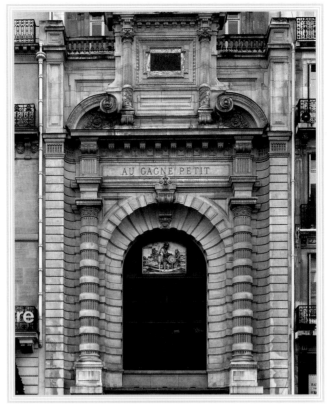

76

Au Gagne Petit

23, avenue de l'Opéra at rue Saint-Roch

1878

When Baron Haussmann broke ground on avenue de l'Opéra in the latter half of the nineteenth century, during the reign of Napoléon III, he left his trademark signature—a uniformity of façades. Within those uniform rules, Haussmann did allow freedom, however, and this façade is an example of creativity that triumphed over restriction. Though he demolished many buildings to achieve his urban objectives, some were rebuilt, as was this nineteenth-century department store. Its unique façade breaks the monotony of traditional Haussmann design, by the addition of two Corinthian columns flanking the decorative entrance. Today, a Monoprix chain store occupies the building. (So much for individuality.)

Blvd. Montmartre
Blvd. des Italiens
Blvd. Poissonière
Boulevard des Capucines
Blvd de Bonne Nouvelle
Blvd. St. Denis
Rue Saint Marc
Rue d'Uzes
Rue Feydeau
Rue des Jeuneurs
Rue de la Lune
Place de la Bourse
R.Ménars
R.St.Augustin
Avenue du Quatre Septembre
Rue Beauregard
Rue Sainte Foy
pass. Limoire
Rue Blondel
Rue de la Paix
Rue de Louvois
R. de Colbert
Rue du Mail
Rue Réaumur
Rue de Cléry
Rue St Denis
Rue de tracy
Rue de la Richelieu
Avenue de l'Opéra
R. des Petits Champs
Rue la Feuillade
R. d'Aboukir
R. Léopold Bellan
Rue Saint Sauveur
Rue Bachaumont
Rue Mandar
Rue Granéta
Rue Etienne Marcel
Rue de Turbigo
Boulevard de Sébastopol
Rue du Louvre

2ND ARRONDISSEMENT

From the French Revolution in 1789 through the end of the Belle Epoque in 1914, Paris was arguably the capital of Europe—and, the second arrondissement, the crossroads between the capital and the rest of the world. Driving this hub of international activity, the Paris stock exchange and the media defined the business character of this district. Capitalism swept into Paris via La Bourse, the Greek temple to finance initiated by Napoléon I but opened in 1825, ten years after his removal from power. Close by, in the Sentier area, the textile industry took root and supplied the country with clothes and fashion. Having made their fortune in commerce and the stock market, the rising middle class replaced the aristocracy in the neighborhood, sparking a need for entertainment. The theaters and restaurants that lined the Grands Boulevards, along the old northern fortification border, provided amusement, as did the prostitution that developed along rue Saint-Denis on the eastern side. The Revolution also gave rise to freedom of the press—journalists, though periodically stifled, established a presence in the second arrondissement and reported on the political progress of France, often instigating progressive reforms. Thus, the district still resonates to the sounds of money, communications, and entertainment.

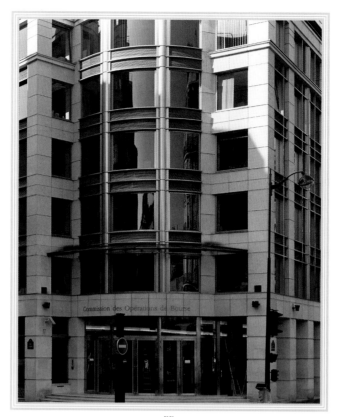

77

Commission des Opérations de Bourse

17, PLACE DE LA BOURSE AT RUE VIVIENNE

c. 1990

In a neighborhood much transformed at the turn of the 20th century, this building—a pastiche of Haussmann and post Haussmann architecture—was created when the city organized a competition to promote and re-energize the typical Parisian façade. While the building takes its inspiration in the angle treatment, its structure reverses the concept of an imposing corner frontage. Instead of a looming tower over the corner, two façades frame the grid tower of metal and glass, recessing it, which simultaneously generates the entrance. The contrast between the fake stone and the metal recalls an architectural style of one hundred years ago, when metal wasn't considered noble enough to constitute an entire building.

78

Bourse

PLACE DE LA BOURSE
BETWEEN RUE NOTRE-DAMES-DES-VICTOIRES AND RUE VIVIENNE

1809–26, ALEXANDRE-THÉODORE BRONGNIART, ORIGINAL BUILDING;
1813–26, ELOI LABARRE; 1902–07,
JEAN-BAPTISTE-FRÉDÉRIC CAVEL, EXPANSION

The opening of the Bourse, the Paris stock exchange, solidified the position of the second arrondissement as being the financial center of the city. This building—a neoclassical Greek pastiche nicknamed the "Palais Brongniart" after its first architect—resembles a temple, lined with a seemingly endless and orderly row of columns. At its entrance, four statues represent Agriculture and Industry on the eastern side, and Justice and Commerce on the western side. Built on the former site of the convent Filles Saint-Thomas, which the Revolutionaries shut down and Napoléon razed, the Bourse fed Paris's budding capitalist initiatives. For a time, it also housed the Commerce Court until the latter moved to its present location in the first arrondissement.

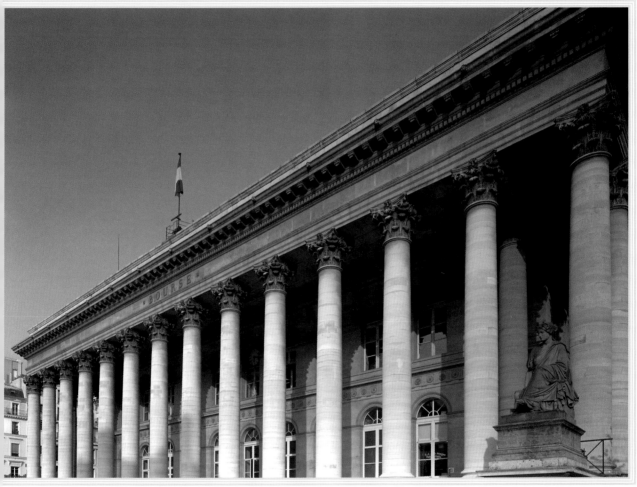

78

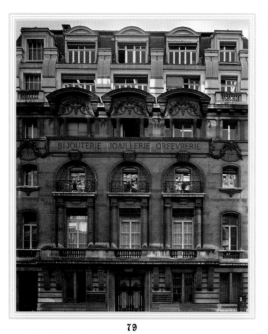

79

Chambre syndicale de la Bijouterie

58, RUE DU LOUVRE AT RUE D'ARGOUT

C. 1900; C. 1930, ADDITION OF TWO STORIES

In the tradition of big nineteenth-century companies, the jewelry union commissioned their chamber in the capital to establish their presence. The façade architecture mixes a heavy Italianate style dear to the architects of the former Ecole des Beaux-Arts, who studied in Italy. In the 1930s, the building was extended two stories that respected the primary design. The white stone bridges the two time periods, yet, minus the ornamentation, emphasizes the powerful lines and volume of the Art Deco period.

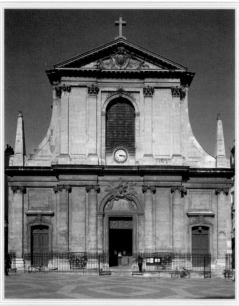

80

80

Basilique Notre-Dame-des-Victoires

PLACE DES PETITS-PÈRES AT RUE DU MAIL

1628–29, PIERRE LE MUET, DESIGN; 1629–66, JACQUES BRUANT, ROBERT BOUDIN AND GABRIEL LE DUC, CONSTRUCTION; 1737–40, SYLVAIN CARTAUD, COMPLETION

Constructed over the course of a century, Notre-Dame-des-Victoires is the only extant remnant of a convent that had been demolished in 1859. Inside the church are a few noteworthy works of art and craftsmanship: paintings by Carle Van Loo; an eighteenth-century organ case; and, by sculptor Jean Collignon, the tomb and bust of composer Jean-Baptiste Lully.

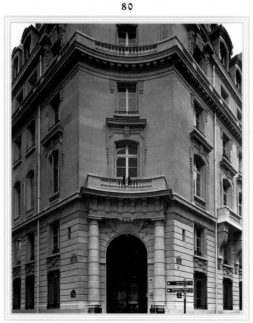

81

81

Ministère de la Culture et de la Communication
(ADMINISTRATION CENTRALE)

4, RUE DE LA BANQUE AT RUE DES PETITS-PÈRES

1905, PIERRE-HENRY NENOT

Currently housing a division of the ministry of culture and communication, this administrative building has a typical, ridged stone construction at the lower level; a small, mildly decorative stone balcony at the center of the first story above the mezzanine; and a mansard roof. Its angled façade shows more creativity, however, boasting a concave configuration; rounded columns flank the entrance. Though it is not a massive building, its presence on the short, small street looms as monumental.

82

Legrand Filles et Fils

1, RUE DE LA BANQUE IN PASSAGE VIVIENNE

1919, THE SHOP

According to legend, the catacombs of the nearby Notre-Dame-des-Victoires became the wine cellars of Legrand Filles et Fils. For three generations the Legrand family has dispensed wine along with cognacs, candy, cookies, teas, coffees, and jars of confiture. The entrance on rue de la Banque takes you back in time to an old-fashioned candy store, but once you follow the recently renovated interior rooms through to the Passage Vivienne side, you come upon a classic yet contemporary wine bar.

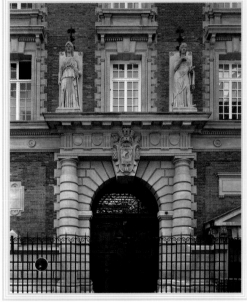

82

83

Infanterie

10–12, RUE DE LA BANQUE AT PASSAGE DES PETITS-PÈRES

1852–57, JEAN-LOUIS-VICTOR GRISART

This building is typical of nineteenth–century architecture in that it mixed multiple styles from different times. The objective was to be different while simultaneously adhering to tradition. Architect Grisart used brick in this building, looking back to the Louis Treize style that pre-dated it, in a design that was hated by those who disliked polychrome façades. As this building is a soldier's residence, the architectural reference to Louis XIII and his military reign seems an appropriate gesture.

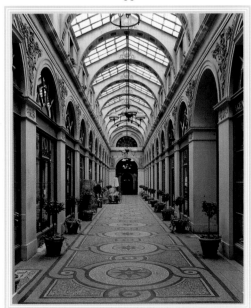

83

84

Galerie (Passage) Vivienne

4, RUE DES PETITS-CHAMPS, 5, RUE DE LA BANQUE AND 6, RUE VIVIENNE
BETWEEN PLACE DES VICTOIRES AND BIBLIOTHÈQUE NATIONALE

1823–26, FRANÇOIS-JACQUES DELANNOY

Shopping the corridors of the renovated Galerie Vivienne is an excursion to an era when time moved slower and the city streets were unpaved. A few storefronts survive from the early days, including the oldest bookstore in Paris. Roofed, vehicle-free *passages* like this facilitated movement while also protecting customers from inclement weather. Galerie Vivienne boasts a structure typical of the *passages* of nineteenth-century Paris.

84

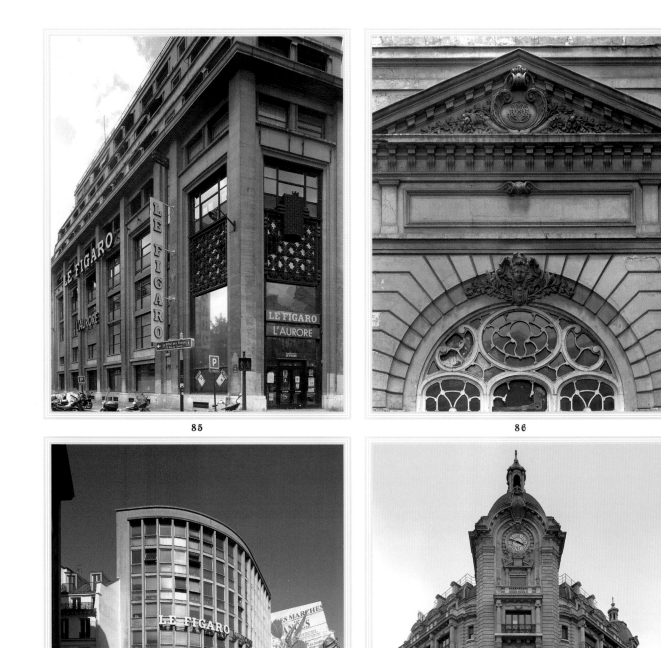

85

86

87

88

85

Le Figaro

37, RUE DU LOUVRE AND 25, RUE D'ABOUKIR AT RUE MONTMARTRE

1936, F. LEROY AND J. CURY

Known as the communications and finance quarter, the second arrondissement—and this area in particular—has long been home base to various newspapers such as *La France*, the *Journal du Soir*, and *La Presse*. In 1936, the news journals, *Paris-Midi* and *Paris-Soir*, operated in this building and, since 1976, *Le Figaro* has dispensed news from the premises. More recently a new press, *La Tribune*, built its own office next door at place de la Bourse.

86

Hôtel

2 BIS, RUE DE LA JUSSIENNE AT 40, RUE ETIENNE-MARCEL

1752, DENIS QUIROT

From saint to sinners, if only this street could tell its tales. Rue de la Jussienne, a tiny cobblestone street between rue Montmartre and Etienne Marcel, was home to a chapel dedicated to Sainte-Marie-l'Egyptienne, a repentant sinner whose name, in popular vernacular, became Jussienne. Young girls, hoping for good times or perhaps bad, used to come to pray here. The *hôtel* at 2, bis, was occupied by Countess du Barry, mistress to Louis XV, until his death. During the Revolution, the chapel became national property and was destroyed. During the nineteenth century, this mansion was given a cohesive Louis Quinze style and became a national monument for its beauty.

87

mur peint

83–85 RUE MONTMARTRE AT RUE DU MAIL

1993, TAÏNE GRAS, WALL PAINTING

One entire side of this building is a three-dimensional collage. The lower portion of the wall is a colorful tile mural featuring an aquatic and a floral arrangement. On the upper part of the wall, giant carved tulips are superimposed over a painting of newsprint. The entire *mur peint* (painted wall) is dedicated to the establishment of the press in this neighborhood. Although many media offices have moved to other locations, the *Figaro* building in the foreground attests to their former presence here.

88

Société Générale

132-134, RUE RÉAUMUR

1901, JACQUES HERMANT

This corner building features two symmetrical façades anchored by a clock tower. Imposing and elegant, this building is also perfectly aligned to the spirit of the times, the Belle Epoque, catching the attention of contemporaries. In *Amours Enfantines*, Jules Romain writes about life on rue Réaumur in 1908: "Its name resembles a song of *roues* (wheels) and *murailles* (high walls), a fear of buildings, to the vibrations of the *beton* (concrete) under asphalt, the hum of the subway convoy . . ." This artery capped nineteenth-century Paris with ambitious construction projects, the way the La Défense defined Paris at the end of the twentieth century.

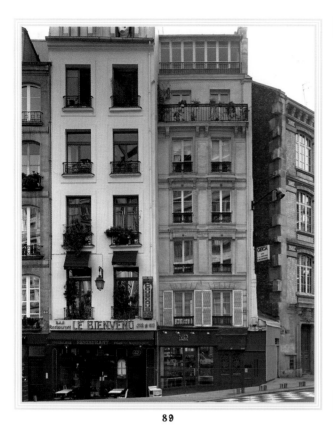

89

40-42 rue d'Argout

AT RUE DU LOUVRE

NUMBER 40 C. EARLY 18TH CENTURY; NUMBER 42 1830-40

Constructed on an old Parisian street that ran parallel to the former wall of Charles V, these two domestic buildings illustrate the architectural evolution of different generations. From the early part of the eighteenth century, the building on the left accommodated four stories while the adjacent building on the right maximized the same space to express an additional floor, and the last-floor balcony is typical of pre-Haussmann architecture. This corner construction—set back about two meters from the older alignment—allowed a wider street, which was preserved by chance when rue du Louvre was pierced in 1880. The connection of the two streets and these buildings reflects the architectural disruption as well as the challenge inherent in creating a city where modernity confronts history.

90

10, place de la Bourse

BETWEEN NOTRE-DAME DES VICTOIRES AND RUE VIVIENNE

1834, A.-J. PELLECHET

This building exemplifies a new mode of construction that combined commercial and residential planning in a friendly environment. The ground floor was designated for commercial use with offices *entresol* (on mezzanines in between floors). The upper floors were developed for living quarters. Larger apartments were on the first floor, for convenience: It was tiring to climb to higher levels, which were subdivided, cheaper, and reserved for poorer people. With the introduction of the elevator, the construction logic changed: Partitions were removed at higher floors, creating desirable, spacious apartments with more light, and the wealthy moved up.

91

23, rue du mail

BETWEEN RUE MONTMARTRE AND PLACE DES VICTOIRES

c.1880

Built in the mid–nineteenth century, this site is an important part of Erard's history: Nearby at number 13 is the first Erard townhouse, purchased by piano dealer Sébastien Erard in 1781. As business expanded, however, the company wanted to establish a greater presence in the neighborhood. Rue du Mail had been built along the fifteenth-century wall of Charles V. However, nineteenth-century regulations demanded that any subsequent constructions be set back from the street. The positioning of number 23 conforms to that ruling. Decorated with stone, this industrial building has a metal structure, which provided support for the combined weight of the pianos and harps that were assembled here.

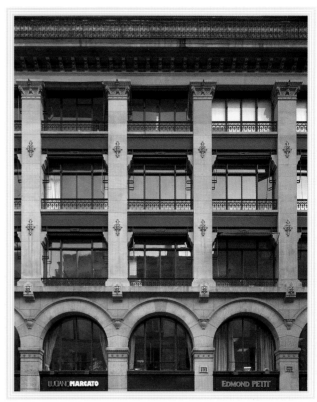

91

92

Ancienne salle de concert

11, RUE PAUL LELONG
BETWEEN RUE MONTMARTRE AND RUE NOTRE-DAMES-DES-VICTOIRES

c. 1844

The piano dealer Sébastien Erard began his business in 1781 at 13, rue du Mail, where he had a home, a showroom for pianos and harps, and a concert hall. The auditorium opened onto a street that was then known then as *petit chemin herbu* (the small grassy way), but which we now know as rue Paul Lelong. The Erard reputation attracted numerous artists to this hall, including composer and pianist Franz Liszt, who lived next door on rue du Mail.

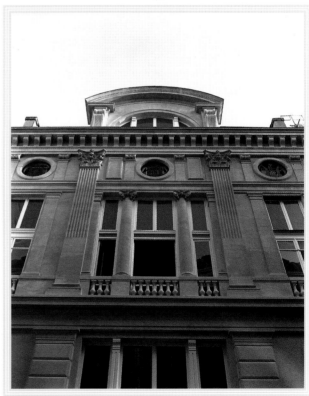

92

93

Hôtel de Rambouillet

2–4, RUE VIDE-GOUSSET AND 3–4, RUE D'ABOUKIR
AT PLACE DES VICTOIRES

1634

As the city of Paris evolved, so did this house. Originally built for Général Nicolas de Rambouillet, seigneur de La Sablière, this residence has a side façade at rue Vide-Gousset, but faces the royal square, place des Victoires. It was transformed to fit in with this new royal place as was the mansion across the street, the now-defunct Hôtel de Pomponne, which was destroyed in the nineteenth century when rue Etienne Marcel was opened.

94

Agence France Presse

11–15, PLACE DE LA BOURSE
BETWEEN RUE VIVIENNE AND RUE DE LA BANQUE

1961, ROBERT CAMELOT AND JEAN-CLAUDE ROCHETTE

Claiming authority as the world's oldest established news agency, Agence France Presse's worldwide network gathers today's news from 165 countries and distributes it from this building to newspapers, radio, television, and other national news media. The second arrondissement, known as the financial center of the city, also carries the reputation as a center for communications, which expanded in this area as commercialism grew.

95

Café le Croissant

146, RUE MONTMARTRE AT RUE DU CROISSANT

1850

This nondescript mid–nineteenth-century café distinguishes itself by its early twentieth-century history of political intrigue. A marble plaque hanging outside and a bust inside attest to its having been the scene of a political assassination. Opposed to war with Germany, socialist Jean Jaurès was murdered while dining at Café le Croissant in 1914, three days before the declaration of war.

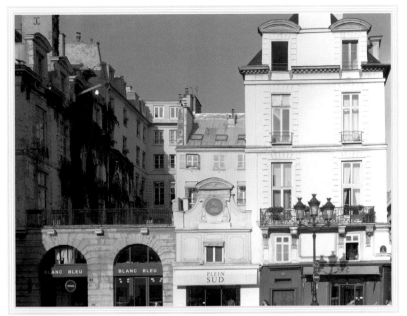

93

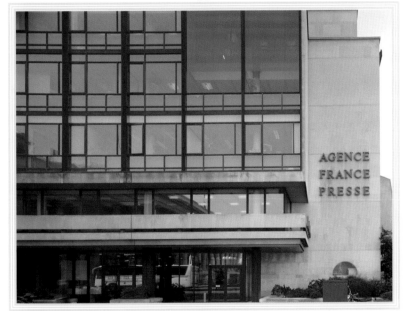

94

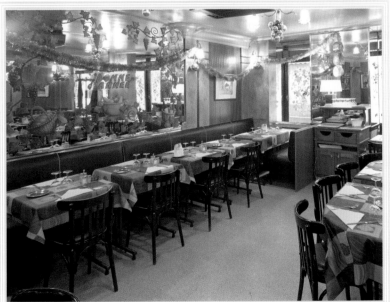

95

96

7, rue du Mail

1669, THOMAS GOBERT

Rue du Mail and rue d'Aboukir emanate like small spokes from place des Victoires. A walk down these two narrow streets transports you to old Paris, formerly the section where jewelry polishers and setters had their workshops. The townhouses along rue du Mail are now occupied by textile showrooms. These townhouses, though modified over time, display classic elements of design and balance. Arches at ground level support the façade of two window levels with decorative pilasters.

97

116, rue Réaumur at rue du Sentier

1897, ALBERT WALWEIN

From the mid-nineteenth century, Parisian architects typically used metal for a building's framework while, for the façade, stone remained traditional. This street features buildings whose creators, no doubt, were inspired by the annual competitions that exempted the six best projects from any city taxes. Many owners of textile businesses used this tax shelter to commission famous architects to develop innovative designs. Another law, in 1882, gave architects more decorative freedom in their design of façades, as can be seen here.

98

118, rue de Réaumur

AT RUE MONTMARTRE AND RUE DU SENTIER

1900, CHARLES DE MONTARNAL

In his metal, glass, and stone building, architect Charles de Montarnal cleverly intermingled material, creating flourishes of Art Nouveau motifs with classic lines. He achieved a solid yet playful design with an ironwork inset bordered by stone. The result defies gravity with its weightless appearance.

99

124, rue de Réaumur

AT RUE MONTMARTRE AND RUE DU SENTIER

1904–05, GEORGES CHÉDANNE

This unusual glass-and-metal building is a visual delight. Though it incorporates elements of Art Nouveau, its façade suggests a creative, futuristic vision. It is most likely the first building in Paris to eliminate traditional stone construction. Iron supports on the ground level sinuously branch outward and upward to meet a linear, riveted-metal framework, and then extend to become part of the building's narrow windows. Finally, the design reaches out three-dimensionally to bay windows supported by consoles.

100

95, rue Montmartre at rue Réaumur

1899, SYLVAIN PÉRISSÉ

This building distinguishes itself from its neighbors by its uneven windows and vertical, glass-and-iron composition. Two double-window bays stretch the length of the building above the first level: One side is flush with the façade, and the other extends beyond the building surface. In this case, the extended bow window looks like an open drawer, which serves to enlarge the interior space. The height and material of the twin-tiered window column gives this building an industrial edge, in contrast to the traditional feel of the adjoining buildings.

101

121, rue de Réaumur

AT RUE NOTRE-DAME-DES-VICTOIRES

1900, CHARLES RUZÉ

The central three floors of this metal structure are designated for commercial and industrial activity, with additional floors above for residential housing. The graceful curves and flowing lines of the bay windows on the façade give this building distinction and elegance. The complexity of decoration is intriguing, given the industrial nature of the workshops here.

96

97

98

99

100

101

102

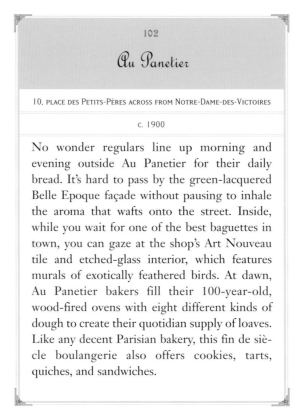

102

Au Panetier

10, PLACE DES PETITS-PÈRES ACROSS FROM NOTRE-DAME-DES-VICTOIRES

c. 1900

No wonder regulars line up morning and evening outside Au Panetier for their daily bread. It's hard to pass by the green-lacquered Belle Epoque façade without pausing to inhale the aroma that wafts onto the street. Inside, while you wait for one of the best baguettes in town, you can gaze at the shop's Art Nouveau tile and etched-glass interior, which features murals of exotically feathered birds. At dawn, Au Panetier bakers fill their 100-year-old, wood-fired ovens with eight different kinds of dough to create their quotidian supply of loaves. Like any decent Parisian bakery, this fin de siè-cle boulangerie also offers cookies, tarts, quiches, and sandwiches.

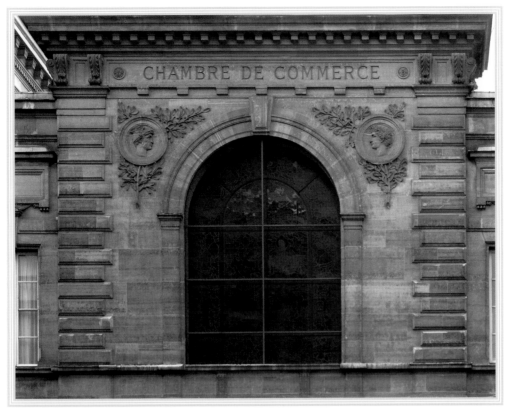

103

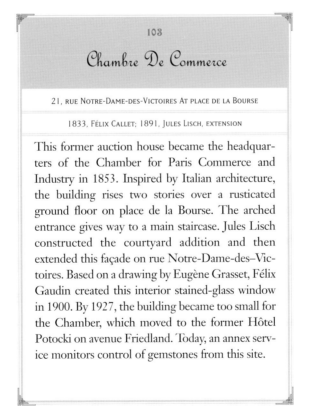

Chambre De Commerce

21, RUE NOTRE-DAME-DES-VICTOIRES AT PLACE DE LA BOURSE

1833, FÉLIX CALLET; 1891, JULES LISCH, EXTENSION

This former auction house became the headquarters of the Chamber for Paris Commerce and Industry in 1853. Inspired by Italian architecture, the building rises two stories over a rusticated ground floor on place de la Bourse. The arched entrance gives way to a main staircase. Jules Lisch constructed the courtyard addition and then extended this façade on rue Notre-Dame-des-Victoires. Based on a drawing by Eugène Grasset, Félix Gaudin created this interior stained-glass window in 1900. By 1927, the building became too small for the Chamber, which moved to the former Hôtel Potocki on avenue Friedland. Today, an annex service monitors control of gemstones from this site.

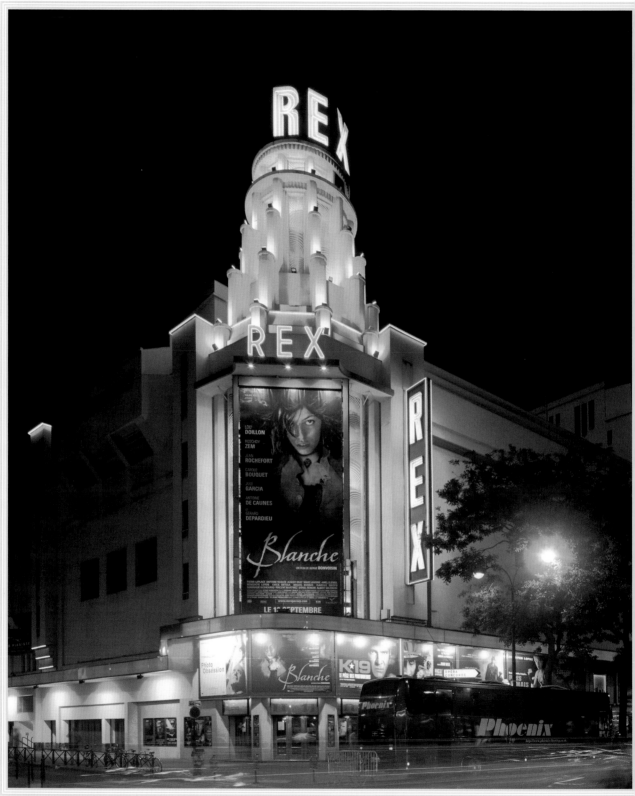

104

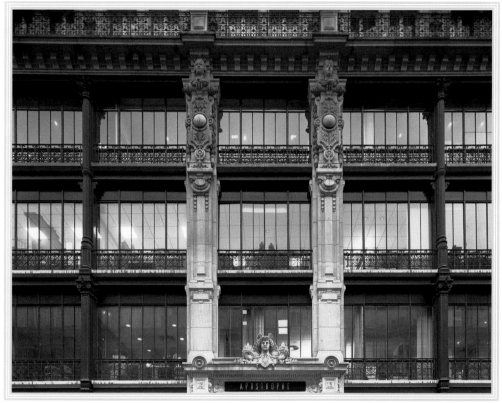

105

Le Rex

1-5, BOULEVARD POISSONIÈRE

1931, ANDRE BLUYSEN AND JOHN EBERSON

This landmark temple to the silver screen, with its atmospheric Art Deco marquee, stretches to the stars. And on December 8, 1932, 3,500 blazing lights announced its presence on the corner of boulevard Poissonière and rue Poissonière. The structure required 20,000 tons of cement, plaster, and sand, and about 1,500 tons of steel. Possibly the largest cinema in Europe when constructed, its baroque interior recalls an era when moviegoing was an experience beyond the latest film. It houses a Grand Hall and bars and foyers on three levels, and has a seating capacity of 2,750 people: 990 in the orchestra, 490 on the mezzanine level, and 1,270 in the balcony. Its monumental proportions extend to the screen, nearly sixty feet high and over forty feet wide. This gigantic screen is surpassed only by the awesome stars rotating above your head.

13 &15–17, rue d'Uzès

BETWEEN RUE MONTMARTRE AND RUE SAINT-FIACRE

NUMBER 13, 1885–86, GUSTAVE RAULIN
NUMBERS 15–17, 1887, ETIENNE SOTY

When it was constructed, rue d'Uzès replaced a beautiful hotel belonging to Claude-Nicolas Ledoux dating from 1768. Opening to the street, with a monumental portal and two triumphal columns, the entrance of its main building was flanked with statues in the style of ancient temples. After the Revolution, which frowned upon such opulence, no one could afford to maintain such property. So, the huge land parcel from rue Montmartre to rue Saint-Fiacre (250 meters long) was sold and, in 1870, textile works and printing presses moved in. Number 13 is the headquarters of a publishing group. Iconography relating to the news business and prosperity decorates the façade. The building at 15–17 is the main office of the Moniteur group, which specializes in books about construction and architecture. Its façade employs traditional motifs to symbolize abundance.

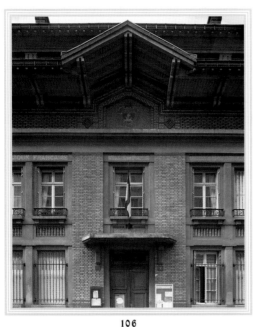

106

École Beauregard

5, RUE BEAUREGARD BETWEEN RUE DE LA VILLE NEUVE
AND RUE NOTRE-DAME DE RECOUVRANCE

1921–28, ROGER BOUVARD

This primary school, built between the wars, was developed in a neighborhood called Waste Hill—most likely composed from the construction waste of stones and plaster. The school building itself is marked by regionalist impulses of polychromic architecture using bricks and a fake, wooden roof structure—a picturesque style reserved for school construction in Paris.

107

107

11–31, boulevard de Bonne-Nouvelle

AT RUE THOREL

NUMBER 11, 1805; NUMBER 31, 1835, JEAN-BAPTISTE CICERONE
LESUEUR

Legend has it that number 11 was built with stone from the demolished Bastille. Traditional allegories of the Four Seasons are depicted on the stone bas-relief over each window. A public assistance organization owned the building, and rented shops as a means to raise money for the poor. The bourgeois businessmen who operated the stores lived on the first floor, from whose balconies they viewed their regular customers wandering the boulevards.

108

108

Église Notre-Dame-de-Bonne-Nouvelle

25, RUE DE LA LUNE AT RUE DE LA VILLE NEUVE

1823–30, ETIENNE-HIPPOLYTE GODDE

This neoclassical church features a seventeenth-century bell tower from an earlier church in the ancient village of Villeneuve. The façade has a classic pediment and four supporting Doric columns. Built during the Restoration, its modesty reflects the austerity of the times. Particularly noteworthy are the interior paintings: One, created by Abel de Pujol in 1836, depicts visions of Saint Jean; others, by Giovanni Lanfranco (1620) and Philippe de Champaigne (1670), are depictions of the Virgin Mary.

109

House of André Chénier

9, RUE CHÉNIER AT CORNER OF RUE DU BEAUREGARD AND RUE DE CLÉRY

C. EIGHTEENTH CENTURY

In 1793, a year before he was guillotined, poet André Chénier (1762–94), a forerunner of the Romantic poets, lived in this narrow, corner building, the meeting point of two streets that once bordered the wall around Paris. Falsely accused of writing in defense of tyranny, Chénier was executed three days before Robespierre's death ended the Reign of Terror. Chénier's life inspired a Victor Hugo poem and Giordano's opera Andre Chénier.

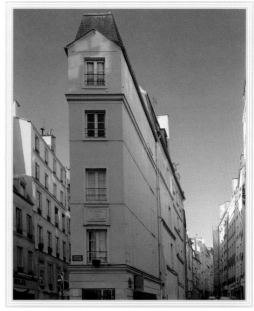

109

110

Ancien hôtel

2, RUE POISSONIÈRE AND 31, RUE DE CLÉRY

1740, ATTRIBUTED TO JEAN-BAPTISTE VAUTRAIN

Corner buildings in Paris were often built to resemble monuments, to indicate the stature of the street. A registered historic building, this old and elegant *hôtel* has a façade divided into two images, public and private, by the corner turn. Along rue de Cléry, the building has no decoration on its private façade. But, at the top, there is still a dormer to which supplies were once hoisted. By contrast, the portion that faces rue Poissonnièret has a richer façade, with a pediment and Rococo patterns.

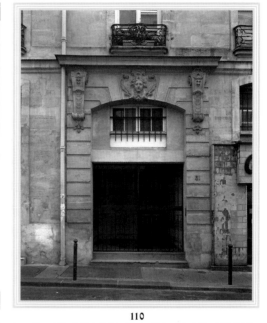

110

111

Ancien Hôtel Masson de Meslay

32, RUE DU SENTIER AT BOULEVARD POISSONNIÈRE

C. 1700

For the past two centuries, the manufacturing activities within studios in the main courtyard have damaged neighboring buildings. Nonetheless, the wonderful portal of this hotel, with its Rococo pattern, has survived quite well. The gate was shaped to help carriages ease into the courtyard from a street overcrowded with textile plants. Once inside the hotel courtyard, you'll find the ambiance of the nineteenth century, a rarity in the midst of the second arrondissement's industrial nature.

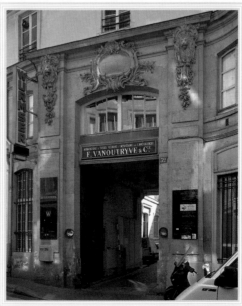

111

112

Passage du Bourg-l'Abbé

120, RUE SAINT-DENIS AT 3, RUE PALESTRO

1828, AUGUSTE LUSSON, PASSAGE; 1863, HENRY BLONDEL,
ENTRANCE ON RUE PALESTRO; AIMÉ MILLET, SCULPTURES

Sculpted stone figures by Aimé Millet grace the entrance of Passage du Bourg-l'Abbé and invite you back to the era of nineteenth-century covered arcades. The statues represent allegories of Commerce and Industry, and an emblem of a bee above the entrance attests to the economic activity inside the *passage*. Until the construction of boulevard Sébastopol, the *passage* extended into the third arrondissement and connected to Passage de l'Ancre that still exists.

113

174 & 176, rue Saint-Denis
(MAISONS A PIGNON)

AT RUE RÉAUMUR

C. SIXTEENTH CENTURY

These gabled houses were common constructions until the sixteenth century. Only around twenty gabled houses still exist in Paris today. These were narrow, connected, one-family homes; each gable represented a different family. A pattern of odd angles and jutting extensions mark layers of time. The ground level of these buildings accommodated commercial enterprises, above which businessmen lodged in one room, while a loft served as their stockroom.

114

Passage du Grand-Cerf

10, RUE DUSSOUBS AND 145, RUE SAINT-DENIS

1825–35, CONSTRUCTION; 1989, RESTORATION

This *passage* derives its name from a hotelier that had stood next to it in the first part of the nineteenth century. The highest, glass-covered passage in Paris, Passage du Grand-Cerf is almost forty feet tall. Constructed on this site by an unknown architect, the arcade has a light neoclassic decoration and metal structure that covers two floors and an attic. Restored in 1989, the *passage* connects the very hip Montorgueil quarter with the old Saint-Denis area filled with sex shops.

115

100, rue Réaumur

BETWEEN RUE DUSSOUDS AND RUE DES PETITS CARREAUX

1924, PIERRE SARDOU; 1993, JEAN-JACQUES ORY, RESTORATION

Architect Sardou designed this building for the news journal, *L'Intransigeant*, whose director, Pierre Lazareff, introduced techniques of modern journalism. The structure features two triangular bas-reliefs of a reporter, typesetter, and printing engineers. Today, the big, funnel-shape in the atrium is reminiscent of the building's 1933 lighting system, called Arthel, which illuminated the lower level via a heliostat—an axis-mounted mirror—that transmitted sunlight down from the building's roof.

116

51, rue Réaumur

AT BOULEVARD DE SÉBASTOPOL

1910, CHARLES HENRY-CAMILLE LE MARESQUIER

Distinguished by its original lantern dome, this is one of two Art Nouveau buildings constructed by food magnate Félix Potin. Today, the much-altered ground level houses a Monoprix store, but the upper portion retains the flavor of its earlier days. Its neo-Baroque style features cornices with abundant carvings of fruit garlands and caducei, and portends prosperity. Reflecting the bounty of Hermès, the god of commerce, the exterior décor is an exuberant testament to the heyday of the grand department stores.

117

Couvent des dames de Saint-Chaumond

224–226 RUE SAINT-DENIS AT 131, BOULEVARD SEBASTOPOL

1734, JACQUES HARDOUIN-MANSART DE LÉVI
1782, PIERRE CONVERS, CHURCH DESTROYED TODAY

In 1683, a religious order took over a building on this site and kept the name of the first owner, the marquis de Saint-Chaumond. This convent took care of girls who had converted to Catholicism, giving them an education. In 1734, the order commissioned the construction of an additional, Rococo building right next door, which welcomed rich widows or women separated from their spouses. The high relief placed at the angle memorialized historian Jules Michelet.

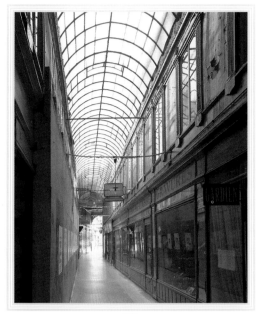

112

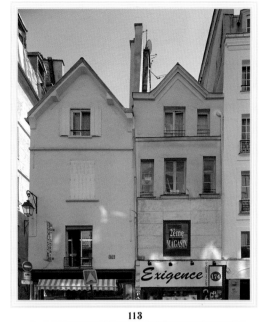

113

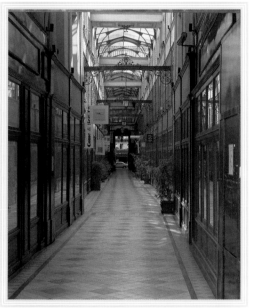

114

115

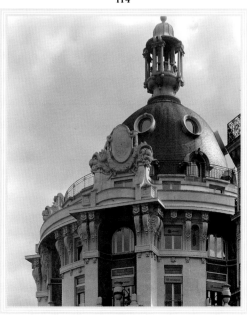

116

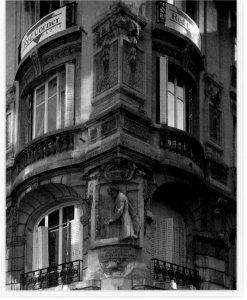

117

118

10–12, rue des Petits-Carreaux

AT RUE BELLAN

C. EARLY NINETEENTH CENTURY

Mid–nineteenth-century manufacturing rediscovered ceramics and its esthetic application as a material to decorate interiors of commercial establishments, especially cafés. Many of these ceramic-tiled paintings depicted exotic or imaginary landscapes. Registered as a national historic landmark, the front of this building has a dilapidated wood façade with a painted ceramic sign. This one depicts a colonial scene from a foreign land: an indigenous character deferentially serving coffee to his cushion-seated Western master.

119

61–63, rue Réaumur

AT RUE SAINT-DENIS

C. 1900, G. SIRGERY AND P. JOUANNIN

One of the only modern buildings on the south side of rue Réaumur, formerly rue Thévenot, this monumental building is inspired by Gothic architecture. A medieval church portal marks the entrance, and a giant clock that resembles a rosette surmounts the geminated windows. Sculptor F.-A. Jacquier decorated the building with carvings of the Four Seasons, the twelve months, and zodiac signs. An industrial textile firm still operates from the premises.

120

82–92, rue Réaumur

AT RUE SAINT-DENIS

1897, F. CONSTANT-BERNARD

This imposing building stands at the site of the old department store, À Réaumur, whose builders deliberately designed a lengthy façade to maximize the visibility of the enterprise. As the first department store in the second arrondissement, the building still serves as a symbol of power within the textile industry. Its metal construction uses stone on the façade for added prestige. Today, wholesale clothing dealers operate from the premises, where multicultural accents abound along with the clothes.

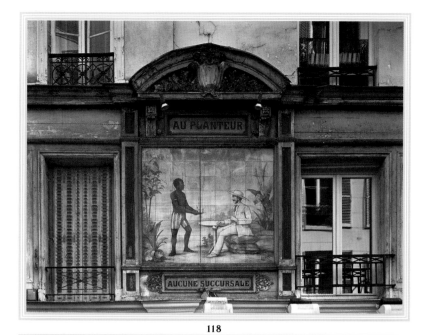

118

119

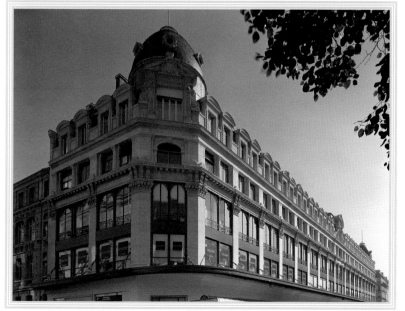

120

121

Place du Caire/Passage du Caire

2, PLACE DU CAIRO AT RUE SAINT-DENIS

1799, PHILIPPE-LAURENT PRÉTREL

The name of this space initially paid homage to Napoléon's victories over Cairo; in 1799, it was consecrated as "Foire du Cairo." Above the portal to Passage du Cairo, the neoclassic Egyptian façade features sphinx heads, arched windows, and evocative wall décor, and nearby streets commemorate the Egyptian theme with such names as rue du Nil, rue de Damiette, rue d'Alexandrie, and rue d'Aboukir. Passage Cairo is the city's longest covered arcade, and the first with a wood-support glass ceiling.

122

122

227, rue Saint-Denis

AT RUE DU CAIRE

The only distinguishing feature of this flat, windowed, three-story façade is on the roof, which has dormers and an odd loft extension. From right to left, the first dormer is a double one, the addition of an extra story, which has been covered by yet another double dormer. The next two dormers, in stone, are similar, but a circular pediment crowns one; a triangular one, the other. The last dormer on the left side is probably the oldest, with a wooden structure. This, too, is covered by another one.

123

123

Tour de Jean-Sans-Peur

20, RUE ETIENNE-MARCEL AT RUE DE TURBIGO

1409–11, ROBERT DE HELBUTERNE

After he ordered the assassination of his cousin, the duc Philippe d'Orléans, Jean-Sans-Peur, the duc de Bourgogne, climbed up a spiral staircase to a room in this tower that he had had the foresight to build for his own protection. Despite his precautionary measures, this tower proved a only temporary hideaway, as he was murdered eleven years later. An example of feudal architecture, the south façade and tower originally ran along the wall built by Philippe Auguste, as part of the Hôtel de Bourgogne.

124

10, rue Tiquetonne

BETWEEN RUE DUSSOUDS AND RUE SAINT-DENIS

C. SEVENTEENTH CENTURY

This building is notable for its iron sign: L'Arbre à liege. One of the oldest extant signs in the city, its image of the cork tree dates from the seventeenth century. Commonly used between the thirteenth and the sixteenth centuries, these decorative devices designated the commercial trade of a building's occupant and served as a means of identifying a home address before the numbering system appeared in the eighteenth century. Ceramic signs eventually replaced the iron ones.

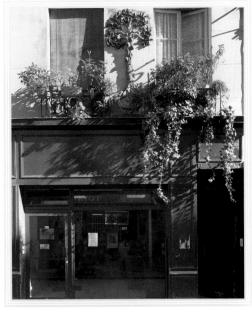

124

125

13 & 15, rue Tiquetonne

BETWEEN RUE DUSSOUDS AND RUE SAINT-DENIS

NUMBER 13, C. 1730, PIERRE CAQUÉ AND GILLES-MARIE OPPENORD; NUMBER 15, C. 1600

Named in the fourteenth century for Rogier de Quinquetonne, a rich baker who lived in the neighborhood, this street follows an old route outside Philippe Auguste's ancient bulwark. Today, beautifully restored seventeenth- and eighteenth-century residences line the street. Hidden in a courtyard, the main building of number 15 has high, stone-framed windows and a triangular pediment above the dormers, elements all of the Louis Treize style.

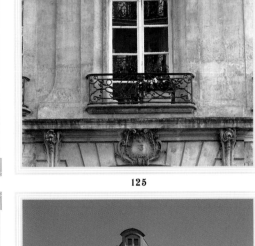

125

126

142, rue Saint-Denis

AT CORNER OF RUE GRENETA

1732, JACQUES-RICHARD COCHOIS

Though the Seine winds through the city, its presence is not always evident. So, in the sixteenth and seventeenth centuries, the city supported a campaign to place fountains around Paris to show the special relationship of water to the city—as a symbol of prosperity. Originally, a sixteenth-century fountain occupied this space. Then, Fontaine Greneta, also known as Fontaine de la Reine, replaced it as part of the construction of this apartment building in 1732.

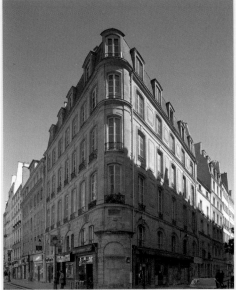

126

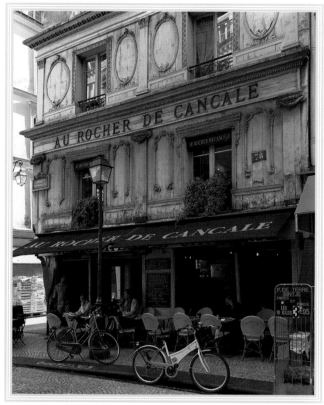

127

127

Au Rocher de Cancale

78, RUE MONTORGUEIL AT RUE GRENETA

1850

In the old market days of Les Halles, rue Montorgueil was an artery along which fish merchants from the north hawked their wares to buyers from the local restaurants. The fishermen have since packed up, put their fish on ice, and now sell it south of Paris, but restaurants and merchants still spill out onto the lively rue Montorgueil, offering a wide range of seafood and its savory culinary necessities. Au Rocher de Cancale, in the same location since 1850, provides sidewalk service and, inside, its pale mustard-color walls and wooden-beamed ceiling make for cozy dining. The exterior ground-floor level is finished in a soft green and still has the original sign from 1850, while other decorative details date from the end of the nineteenth century.

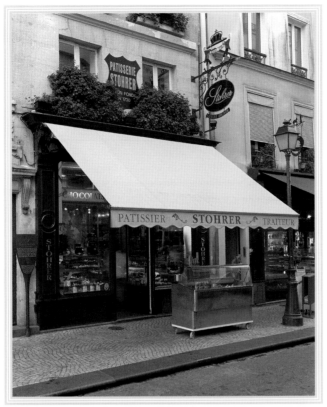

128

128

Stohrer

51, RUE MONTORGUEIL AT RUE MARIE STUART

1730

When Polish Princess Marie traveled to Paris to marry Louis XV, she took her royal father's French baker, Monsieur Stohrer, with her. He baked for the king at Versailles for five years, before opening his own private enterprise on rue Montorgueil. A national historic monument, Stohrer distinguishes itself as Paris' oldest patisserie. Interior paintings, added in 1864 by Paul Baudry, the famous painter of Opéra Garnier's foyer ceiling, provide a period atmosphere.

129

130

131

129

Parti Socialiste

73, RUE MONTORGUEIL
CORNER OF RUE LÉOPOLD-BELLAN AND RUE MONTORGUEIL

c. 1720

That a leftist political party should set up shop on this corner seems downright anachronistic, especially given the area's recent gentrification: bars, bistros, sidewalk cafés, news kiosks, fashion boutiques, and *traiteurs* spill out onto the street—all modern reminders of the legendary days of the all-night Les Halles marketplace. But the presence of the Parti Socialist expresses its long-held position that, even in this popular neighborhood, workers have traditionally earned low wages.

130

La France

142, RUE MONTMARTRE AT RUE RÉAUMUR

1885, FERDINAND BAL

Etched into the stone ledge of this building is the name of the old evening journal, *La France*. Four allegoric stone statues—two of Atlantis and two caryatids (representations of journalism and typography)—support this ledge and the balcony above it. In 1836, Emile de Girardin, a famous journalist of the nineteenth century, established a press presence in the second arrondissement with a publication called *La Presse*. In 1876, he created *La France*, a daily newspaper for the masses.

131

Franz Liszt house

13/15, RUE DU MAIL BETWEEN RUE MONTMARTRE AND PLACE DES VICTOIRES

C. NINETEENTH CENTURY

Sébastien Erard, piano and harp maker, founded his firm in 1781, and the family business used this location from 1821 to 1878. Here in his workshop, he invented the piano with double escapement, the harp with double pedals, and the mechanical harpsichord. This stone construction with its double arched entryways housed not only his studio and concert hall, but also served as a home where he welcomed musicians such as Franz Liszt, who lived here periodically when in Paris.

132

Galopin

40, RUE NOTRE-DAME-DES-VICTOIRES AT PLACE DE LA BOURSE

1876

With his pulse on the heart of commerce and news, Gustave Gallopin opened his brasserie in 1876 to deal makers and media types. An interior mix of French Art Nouveau and English Victorian décor sets the stage for business transactions. Colorful stained-glass panels, copper beer pumps, brass railings, smoke, and mirrors, along with black-vested and white-aproned waiters, contribute to the ambience.

133

La Tribune

46, RUE NOTRE-DAME-DES-VICTOIRES, AT PLACE DE LA BOURSE

1991, JEAN-JACQUES ORY

A twentieth-century, metal-and-glass contraption plunked down in the midst of nineteenth-century Paris seems an anachronism. But this symbol of technology reinforces not only the continuation of journalism's role from the past to the future in reporting world events, but also the historic evidence of the press as having taken a hand—along with the financial aspect of the quarter—in shaping the character of the second arrondissement.

134

One, rue Leon Cladel

AT 111 RUE MONTMARTRE

c. 1890

Broad windows and an imposing corner angle give this building a commanding presence on the block. Though the sides are an uneven width, it has well-balanced proportions. Typical of the nineteenth-century corner construction that marked streets, this building hovers over rue Leon Cladel and rue Montmartre. It serves as headquarters for SAEMES: Le stationnement de la ville de Paris, a quasi-public company that operates parking facilities for the City of Paris.

135

167, rue Montmartre

AT RUE D'UZÈS

1909, VICTOR BLAVETTE

Constrained by old rules, architects were slow to use modern material for apartment construction, especially in the façade. A new law in 1882, however, allowed for balcony projections of up to eighty cm (2.63 feet), thus permitting more liberty and imagination in façade design. Bay windows brought more light into apartments and became quite common, and metal was emphasized as a noble material. Architects finally had more artistic freedom of expression, as demonstrated by this building.

136

101, rue Réaumur

AT RUE DE CLÉRY

1895, ALBERT WALWEIN

This elaborate building is typical of imperious nineteenth-century structures that distinguished corners. The high dome, the ornate iron balconies, and the caryatids and the other carved-stone window detailing all contribute to the impressive edifice. In addition, the massive Corinthian pilasters that create a rhythm to both sides of the façade enhance the grandeur of the construction.

137

Hôtel de Mantoue

136, RUE MONTMARTRE BETWEEN RUE RÉAUMUR AND RUE LÉON CLADEL

1820–30

Following the traditional French Academy route to Italy—a move started by Louis XIV to emulate what he thought was the ideal—this architect attempted an imitation of an Italian Beaux Arts model, but without much success. Formally known as Hôtel de Mantoue, this building replicates the ornamentation of the Mantoue Palace in Italy. Were it not for the placement of decorative stone statues in niches on its façade, this otherwise nondescript building would not catch your attention.

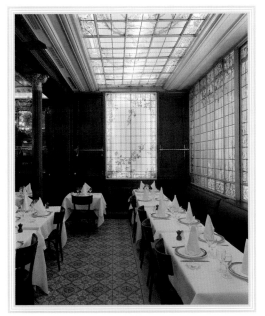

132

133

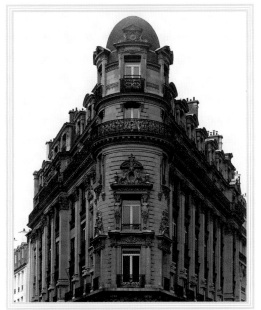

134

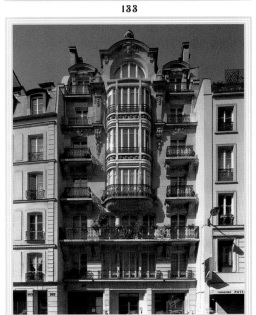

135

136

137

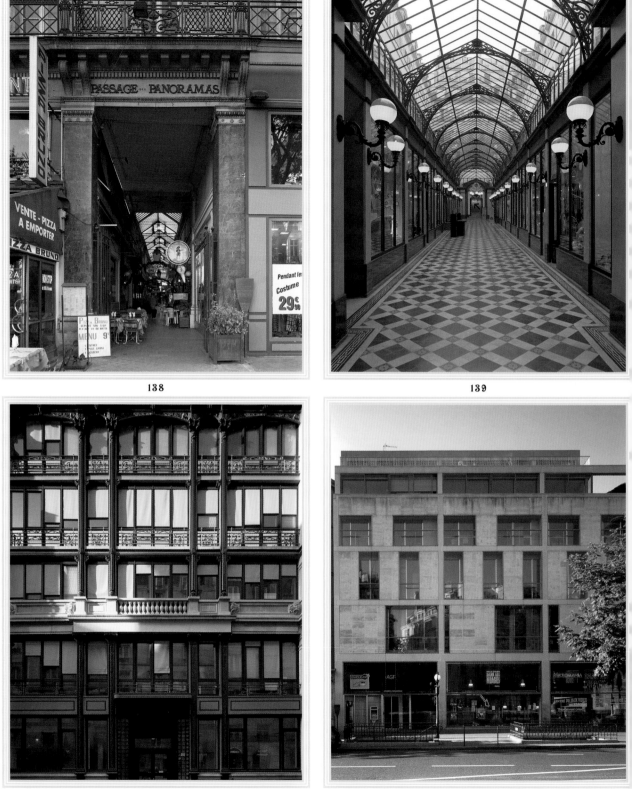

138

139

140

141

138

Passage des Panoramas

11, BOULEVARD MONTMARTRE AT 10, RUE SAINT-MARC

1800; 1834, JEAN-LOUIS GRISART, REBUILT

Irish painter Robert Barker (1739–1806) coined the word "panorama" to describe his patented circular paintings that prefigured the mass appeal of modern cinema. Perfectly suited to *passages*, the oversized circular paintings surrounded the viewer, creating the illusion of escape to remote times or places. Passage des Panoramas must have been magnificent when gas fixtures illuminated its painted interior in 1816. This was the first covered walkway in Paris to feature indoor lighting, in of itself something of a wonder. Crowds eager for a look inside were also hungry for food and shopping, and businesses boomed. Sterns, a printing firm, still works from its original 1840 shop front here.

139

Passage des Princes

5, BOULEVARD DES ITALIENS AND 97–99, RUE DE RICHELIEU

1860; 1990–94, RESTORED

Though originally conceived and named to honor a brilliant businessman, Mirès, who made his fortune in the news and finance trade, this *passage* no longer honors him. In 1859, the bank of Mirès and Cie bought the old Grand Hotel des Princes and de l'Europe, an 1807 European palace at 97, rue Richelieu. They bought another building nearby to allow for the passageway and a courtyard. But, disgraced in 1861, Monsieur Mirès spent five years in prison and the p*assage* was renamed. Passage des Princes marked the end to such structures' construction, at least in Paris. From 1990 and 1994, the passage was restored, and is today devoted to children's stores.

140

Commercial Building

24, RUE SAINT-MARC AT RUE VIVIENNE

1894, LOUIS THALHEIMER

This Belle Epoque structure is typical of commercial and industrial buildings constructed in the second arrondissement during the late nineteenth century. An ironwork window grid bordered by stone pays homage to the turn-of-the-century technology and the future of the Industrial Age. This building and others like it housed warehouses and studios and introduced new principles of architecture. Using metal framing created advantages in construction, obviating extra wall partitions and permitting work in open spaces with an optimal penetration of light. The iron and glass composition balances the stonework, producing a harmonious façade on the street.

141

Immeuble Devillers

3, BOULEVARD DES ITALIENS AT BOULEVARD HAUSSMANN

1994, CHRISTIAN DEVILLERS, AGF ARCHITECTS

Working within a restrictive space, architect Devillers produced an unusual, contemporary sight on this historic street: a double façade. Just two feet of empty space stand between the exterior public face and the second, private façade. Using white stone, Devillers created a flat exterior wall that is unadorned, except for the windows: Framed in stainless steel, the uneven distribution of window shapes on the different levels lends a serendipitous rhythm to the façade, as if played across the frontage like musical notes. The lack of contrasting colors gives the building unity, and Devillers synchronized its levels to those of the building next door, respecting the second building's frontage.

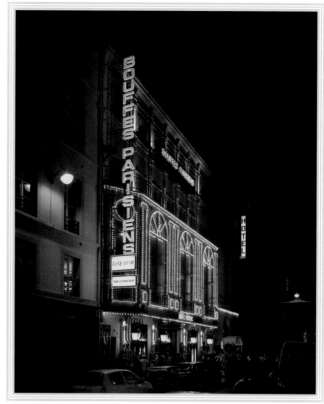

142

Théâtre des Bouffes-Parisiens

4, RUE MONSIGNY AT RUE SAINT-AUGUSTIN

1826, BRUNETON ET ALLARD, FIRST THEATER; 1862, THÉODORE
CHARPENTIER, REBUILT; 1913, AUGUSTE BLUYSEN, BAY WINDOWS

In Paris, theater particularly hit its stride during the mid-to-late nineteenth century, and at least fourteen venues in this district provided audiences with light-hearted entertainment. In 1826, magician and ventriloquist Louis Conte directed a successful school of comedians here for young children. From 1855 to 1862, Jacques Offenbach was director of the theater and adapted it to the popular Bouffes-Parisiens. The stage door to the theater, through which Offenbach would enter each night, still stands at 73, Passage Choiseul. When Offenbach left to direct the Théâtre des Variétés, Theodore Charpentier took over and ran the Bouffes-Parisien, until World War I intervened. Maurice Chevalier, Arletty, and Michel Simon entertained here between the wars.

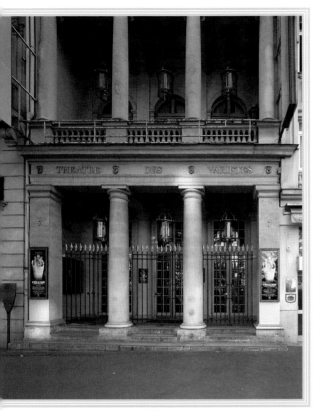

143

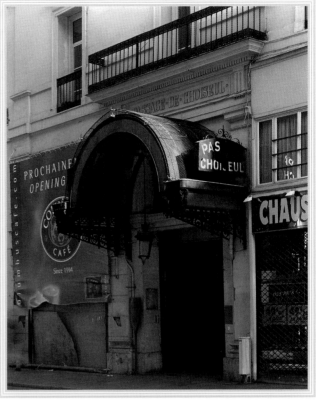

144

143

Théâtre des Variétés

7, BOULEVARD MONTMARTRE AT RUE MONTMARTRE

1806–07, JACQUES CELLERIER

To see-and-be-seen was the entertainment in the nineteenth century, the golden age of theater. Hortense Schneider wowed them here at Théâtre des Variétés, in her 1864 performance of the leading role in Jacques Offenbach's *La Belle Hélène*, and again in 1867 as the star of his *La Grand Duchesse de Gérolstein*. This building alone must have provided theatergoers with considerable visual interest, from the play of shadows on its neoclassical, receding façade, to its imposing Doric and Ionic columns.

144

Passage Choiseul

40, RUE DES PETITS-CHAMPS AND 23, RUE SAINT-AUGUSTIN

1826–27, FRANÇOIS MAZOIS, ANTOINE TAVERNIER

Worn down and long past its heyday, this narrow passage nonetheless claims a bit of cultural and literary history. From the nineteenth century until the 1930s, poets, authors, editors, and publishers convened here. Writer Louis-Ferdinand Céline lived here as a child and used Passage Choiseul in two of his novels—*Death on the Installment Plan* and *Journey to the End of Night*. For ten years, Anatole France worked as an editor at a publishing house in this *passage*.

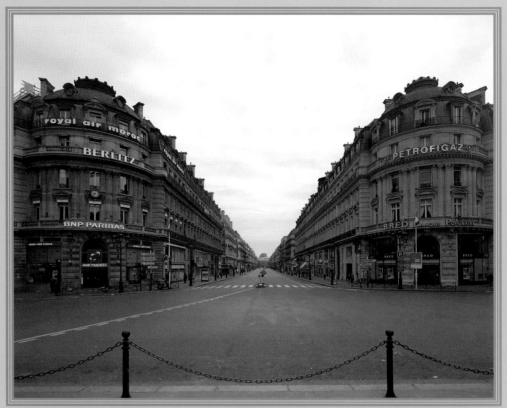

145

THEATERS

Beginning with the early mystery plays of the Middle Ages, French theater was more spectator sport than high culture. Rowdy medieval audiences imbibed spirits, whistled, hooted, shouted, stomped, and generally disrupted one another and the performers. Playwrights and players mocked the aristocracy, religion, family, and the bourgeoisie with innuendo, lewd posturing, and social commentary. In the seventeenth century, Molière, born Jean-Baptiste Poquelin, wrote and acted in his own satiric comedies ridiculing French life. The son of a wealthy tradesman to Louis XIV, Molière used his connections to become a favorite of the Sun King, writing and producing such enduring plays as *The Misanthrope, Tartuffe, The Miser,* and *School for Wives.* He performed with his troupe in the Palais-Royal Theater until 1673, when he collapsed onstage and died shortly thereafter. In 1680, Louis XIV merged Molière's company with another to form the Comédie-Français which, based at the Hôtel de Bourgogne, was the only theatrical troupe that he permitted to perform in Paris during his reign.

By the mid–nineteenth century, however, a modern Paris was emerging, thanks to the massive civil re-engineering of the city by Napoléon III's minister, Georges-Eugène Haussmann. Opérette and opéra bouffe became popular with the pleasure-seeking public, and Jacques Offenbach convulsed his audiences with such comedies as *La Vie Parisienne, La Grande Duchesse de Gérolstein,* and *Les Brigands*, which satirized society life and the Court, the army, and business, respectively. By the late nineteenth century, the rising bourgeoisie, wearing the latest fashions, came to the theaters not only to see the entertainment but one another. Théâtre National de l'Opéra was the pinnacle of such venues of that period. Parisian society also flaunted their status at Théâtre des Variétés, Théâtre des Bouffes-Parisiens, and Opéra-Comique, among others. Later in the 1920s, Art Deco halls such as Théâtre Daunou and Théâtre de La Michodière became venues for theatrical antics and, in the 1930s, the Rex became a temple to the emerging cinema scene.

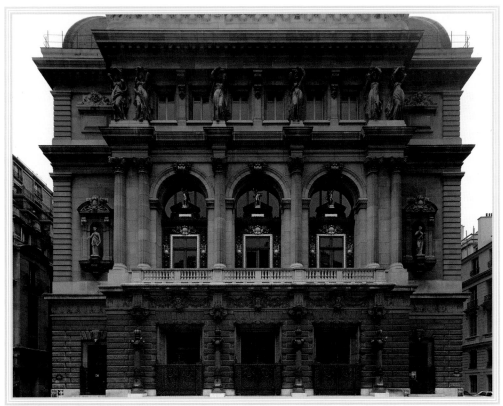

146

Taken together, these buildings create a harmonious entity along the avenue de l'Opéra. The effect achieved is deliberate, with the two rounded angles marking the street as propylaea, and identical Haussmannesque façades. Interspersed by decorative Corinthian pilasters, the buildings at this artery align symmetrically. The height of these buildings, dictated by ordinance, also contributes to the uniformity of design. In this case, by contrast and size, the homogeneity heightens the appearance of the Opéra itself, setting it up like a play on a stage, making it bigger and better and higher.

In 1714, two companies of performers collaborated to form Opéra-Comique, which parodied the conventions of grand opera. Lacking an official venue, this company moved some dozen times between Saint-Germain and the St. Lawrence Fairs, as well as to other sites, until 1762 when, under the auspices of the l'Opéra-Italien, they relocated here. The first two theaters on this site were consumed by fire, in 1838 and in 1887. Then architect Bernier won a competition to create this neo-Baroque new home for the Opéra-Comique. It is often referred to as Salle Favart after playwright Charles Favart, who had been Opéra-Comique's first director at this address. He and his wife, singer Justine Duronceray administered that company in the style of Italian opera buffa. The latter troupe played here until the early 1780s, when they relocated to boulevard des Italiens.

147

Bibliothèque Nationale

58, RUE DE RICHELIEU
BETWEEN RUE DES PETITS-CHAMPS AND RUE COLBERT

1635, JEAN THIRIOT, HÔTEL DURET, HÔTEL TUBEUF; 1644–45,
FRANÇOIS MANSART, REMODELING OF HÔTEL TUBEUF; 1646, PIERRE LE MUET,
REMODELING; C. 1650, MAURIZIO VALPERGA, GALERIE MANSART AND GALERIE
MAZARIN; 1731, ROBERT DE COTTE AND SON, ENTRY COURT, NORTH
AND EAST WINGS; 1854–75, HENRI LABROUSTE, MAIN READING ROOM AND
ADDITIONS; 1906, JEAN-LOUIS PASCAL, PERIODICAL READING ROOM

Housed within the massive quadrangle of 175,000 square feet, the old national library's innovative reading room still exists: thin iron columns support nine vaulted, metal domes and skylights, creating a surprisingly light and delicate effect despite the vast size.

148

Le Grand Colbert

2, RUE VIVIENNE AT RUE DES PETITS-CHAMPS AND GALERIE COLBERT

1826, J. BILLAUD, THE GALERIE COLBERT, BUILDING

Housed in a nineteenth century building, Le Grand Colbert takes its name from Louis XIV's finance minister, Jean-Baptiste Colbert, who once lived in the same building. In the 1930s this restaurant opened in a former draper's shop as a *bouillon*, a working class canteen. An intricate mosaic-tiled floor, high ceilings, globe lighting, columns, and painted panels fill the restored interior with period atmosphere.

149

4–12, rue du Quatre-Septembre

BETWEEN RUE DE LA BOURSE AND RUE FEYDEAU

1793, LOUIS-JOSEPH BERNARD, ALTERED LATER BY NICOLAS-JACQUES-
ANTOINE VESTIER

When first constructed, rue des Colonnes facilitated access for theatergoers on their way to Théâtre Feydeau, providing a sheltered walkway on rainy days and protection from dangerous horse carts which often killed pedestrians. Inspired by Etruscan architecture, considered the precursor of Greek style, the façade must be considered in conjunction with the Revolutionary times.

150

Siège des Assurances générales de France
(AGF)

87, RUE DE RICHELIEU BETWEEN RUE SAINT-MARC AND RUE FEYDEAU

1979, JOSEPH BELMONT AND PIERRE-PAUL HECKLY

Instead of designing, for one of the largest insurance companies in France, a large-scale headquarters with monumental towers, architects Belmont and Heckly created several medium-size buildings to better blend in with the existing neighborhood. Each building stands on a hollow base, supported by pillars at each corner, which permits a free flow of pedestrians on the ground floor and creates a sense of airiness in an area already dense with architecture.

151

Aux Lyonnais

32, RUE SAINT-MARC

1890

As the name implies, this classic bistro serves specialties from the city of Lyon. White lace curtains hang from the windows and offset the deep red façade. Dishing out lunch and dinner for over a hundred years, Aux Lyonnais caters to a business crowd in the financial center of Paris and, in tune with its clientele, closes on Sunday and in August, when business in Paris takes a holiday.

152

Café Runtz

16, RUE FAVART AT BOULEVARD DES ITALIENS

C. 1880s

Mirrors and murals decorate the interior of this restaurant in tribute to the Opéra-Comique productions performed across the street, at Salle Favart, in the late nineteenth century. Specializing in Alsatian fare for well over a hundred years, Café Runtz still caters to an evening theater crowd, business people, and afternoon teetotalers who crave pastries of the region.

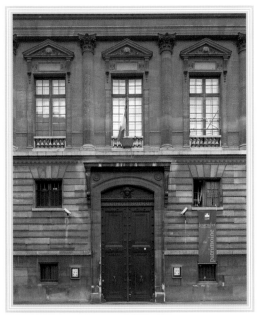

147

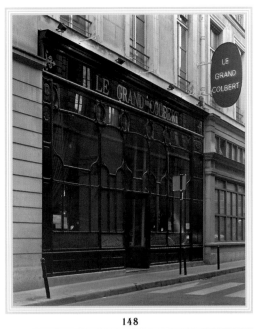

148

149

150

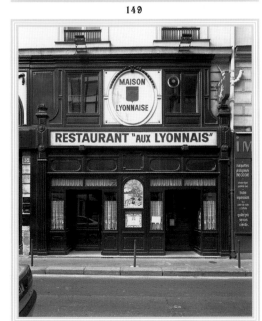

151

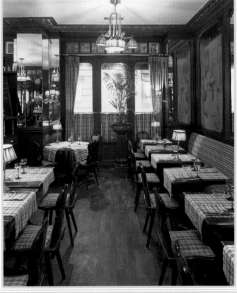

152

153

154

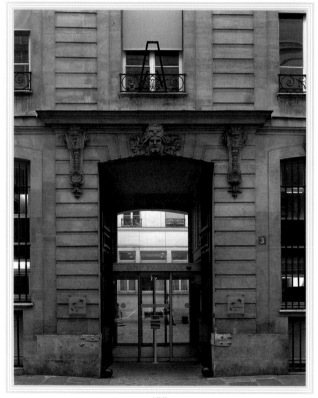

155

156

153

12, rue Gaillon at place Gaillon

1913, Jacques Hermant

The rue Gaillon takes its name from an area in the second arrondissement where, during the Second Empire, the textile industry expanded to meet the demand for luxury goods. Lower levels of buildings such as this one housed retail stores for the savvy customers looking for the latest fashions. A heavy metal framework, riveted onto the façade, gives it an industrial feel; this design was in fact the norm for prewar urban factories. Following World War I, poured concrete would replace metal as the material of choice for commercial structures.

154

Harry's New York Bar

5, rue Daunou at avenue de l'Opéra

1911

In the 1920s, Hemingway and Fitzgerald hung out here, as did other American expatriates. Supposed birthplace of the Bloody Mary and the Sidecar, Harry's speakeasy exterior with its neon sign gives way to polished tables, a dark-painted ceiling of curlicues, and cherrywood-paneled walls. Devotees ignore the tourists and high prices while barmen in spotless aprons pump beer from copper taps and a pianist taps out tunes at the circular piano bar downstairs.

155

3, rue Louis-le-Grand

At rue Danielle Casanova

c. 1680

Madame de Montespan, paramour to Louis XIV, lived here before losing his favor. He later tossed her aside for the governess of her eight illegitimate, royal children. The building is a national landmark; decorative, carved masks line the façade, and it has a monumental portal and door knocker.

156

Atelier of Hyacinthe Rigaud

One, rue Louis-le-Grand at rue Danielle Casanova

c. 1700

If you were anyone of importance in the mid–seventeenth or early eighteenth century, Hyacinthe Rigaud (1659–1743) probably did your portrait. Although he was royal painter to Louis XIV, Louis XV, and Philippe V of Spain, as well as director of the Royal Academy, Rigaud also worked at this studio (with the help of assistants) to appease his other noble and bourgeois clients.

157
Kitty O'Shea's

10, RUE DES CAPUCINES AT RUE VOLNEY

Authentic as James Joyce or nearly so, Kitty O'Shea's rocks with the best of the pubs. Almost any nationality will find someplace in Paris that will feel like home, if only for a meal. This restaurant, decorated with stained glass and Gaelic street signs, will bolster up homesick Irishmen with hearty home-style cooking. No blarney.

158
Théâtre de La Michodière

4 BIS, RUE DE LA MICHODIÈRE AT RUE SAINT-AUGUSTIN

1923, AUGUSTE BLUYSEN

The antics of Arletty and Michel Simon, in Fric & Frac, rank among the more inane theatrics performed here. For the interior of this Art Deco theater, Jacques-Emile Rhulmann created an imaginative landscape of red flowers on a gold backdrop.

159
One, place Gaillon

AT RUE SAINT-AUGUSTIN AND RUE DE LA MICHODIÈRE

1828, LOUIS VISCONTI, BUILDING AND SCULPTURE DESIGN
GEORGES JACQUOT, SCULPTOR

Drawing on the image of water as a metaphor for prosperity, this particularly impressive sculpture, designed as part of the building, enhances place Gaillon with a figure of a young Triton, trident in hand, riding a dolphin. Restaurant Pierre à la Fontaine Gaillon occupies the ground level.

160
Siège de Paribas

3, RUE D'ANTIN AT RUE CASANOVA

1720

The marquise de Mondragon originally owned this lovely, eighteenth-century building constructed for Etienne Bourgeois, who headed the royal bank. Confiscated during the Revolution, it was the site of the wedding of Napoléon Bonaparte and Joséphine de Beauharnais in 1796. The well-preserved façade at the lower level features delicate iron work at the balconies, carved brackets, and a sculpted mask of a woman over the entrance.

161
Boucherie

58, RUE SAINTE-ANNE, CORNER OF RUE SAINTE-ANNE AND RAMEAU

C. NINETEENTH CENTURY

This butcher's shop on rue Sainte-Anne has a façade of painted-black glass with decorative, gold-leaf lines. Propped on the window ledge are a few vintage photos and an old gravure print: One photo shows a butcher with his family, posed in the shop with sides of beef hanging above their heads; another depicts a working slaughterhouse. And the gravure print reveals an imaginary butcher dressed in the elements of his profession, in a manner Hieronymus Bosch might have conceived.

162
Salle Ventadour
(BANQUE DE FRANCE)

RUES MEHUL, MARSOLLIER AND DALAYRAC
BETWEEN RUE MARSOLLIER AND RUE DELAYRAC

1826–27, JEAN-JACQUES HUVÉ

Home to the Opéra-Comique until 1832, Salle Ventadour later became a venue for drama. The first play to open here was Victor Hugo's *Ruy Blas*, in 1838. Successive troupes performed at Salle Ventadour until the theater was closed down in 1878. Today, Banque de France owns this classic rectangular building.

157

158

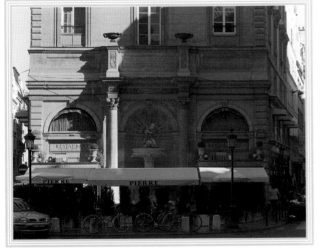

159

160

161

162

163

Théâtre de la Pépinière Opéra

7, LOUIS-LE-GRAND
BETWEEN RUE DANIELLE CASANOVA AND RUE DAUNOU

1919, BOUTEILLE

A successor to the former Théâtre de la Potinière, built after World War I by architect Bouteille and designer Mélano de Cassina, this concrete building houses the current playhouse. During the 1970s, plays by Duras and Ionesco were performed here and, since 1984, behind this nondescript façade, up-and-coming television comics have amused audiences in a show called "Petit théâtre de Boulevard."

164

8, rue de Port-Mahon

BETWEEN RUE DU QUATRE SEPTEMBRE AND RUE SAINT-AUGUSTIN

1936, LOUIS FILLIOL AND ANDRÉ MOREL

A modern, red brick and black mosaic façade faces this tiny street, replacing the 1795 Hôtel de Lorges. Created in the style of the day, the ground floor was built for commercial use, while the upper levels accommodated residences. At that time, the city of Paris imposed height and façade restrictions, so the architects used bay windows to break the monotony of the building, and the black band of mosaic tiles trimming the windows punctuates this short street with personality.

165

Atelier Nadar

35, BOULEVARD DES CAPUCINES AT RUE DAUNOU

1860, ETIENNE SOTY; 1993, TRANSFORMATIONS

Site of the first Impressionists exhibition in 1874, Atelier Nadar opened its doors to art that had been rejected by the mainstream. The photographer Félix Tournachon Nadar lent his support to friends from the Salon des Indépendants, in the face of the traditional art community that called them lunatics who dabbled in "dribbles." Covered today by an overpowering, modern glass structure, Nadar's former studio is the triangular shape on the left, of which only the façade has been preserved.

166

Hôtel Soltykoff

10, RUE VOLNEY BETWEEN RUE DES CAPUCINES AND RUE DAUNOU

1856, CHARLES ROHAULT DE FLEURY

When this street was developed in 1854, building speculation was at its height, and the new neighborhood around avenue de l'Opéra attracted the rich and famous. Prince Soltykoff, a medieval art collector, commissioned Charles Rohault de Fleury to construct his *hôtel* in a neo-Renaissance style on the site of an earlier eighteenth-century hotel. A special room on the second level exhibited his medieval collection, which was so enticing that Napoléon III bought weapons from it when it was sold in 1861.

163

164

165

166

167

167

Drouant

18, RUE GAILLON AT PLACE GAILLON

1880

Drouant has treated its clients to Alsatian special-ties since 1880. Emile Zola found inspiration in the vicinity, setting his novel, *A bonheur des dames*, at place Gaillon. Monet, Rodin, Renoir, Toulouse-Lautrec, George Clemenceau, and Edmont de Goncourt gathered with Zola at Drouant for Friday suppers. In fact, since 1914, Drouant has hosted the annual dinner for the Goncourt Prize, the French literary award that honors the brothers Goncourt and acknowledges talented authors.

168

168

Ancienne Samaritaine de Capucines

27, BOULEVARD DES CAPUCINES AT RUE DAUNOU AND RUE SCRIBE

1914–17, FRANTZ JOURDAIN

One of the first branch stores, this one was a spinoff of the successful Samaritaine depart-ment store, which had opened in 1905 in the first arrondissement. The delicate design of the elegant façade fit the spirit of the area, marrying the modern with the traditional. Its decorative, iron-framed window treatment shows off traces of Art Nouveau, but the balanced proportions of the building are rooted in tradition.

169

Théâtre Daunou

7, RUE DAUNOU BETWEEN RUE DE LA PAIX AND RUE LOUIS LE GRAND

1920, AUGUSTE BLUYSEN

Stone carvings of winged sphinxes line the upper levels of Théâtre Daunou's façade. Perched atop columns and alternating between windows, they give the building a distinct Art Deco look. Carved stone masks above its arched windows are references to the building's use as a theater, with a capacity of 500. Jeanne Renouardt directed the theater's construction; Armand Rateau was responsible for its interior decoration that included blue velour tapestries and scenes of stylized animals in bas-relief.

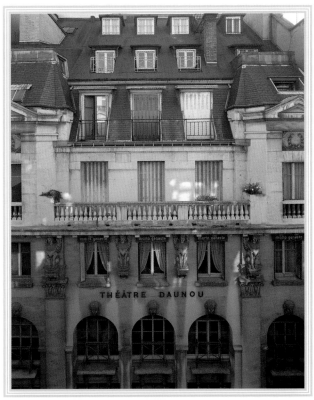

169

170

Bijouterie Maty

4, PLACE DE L'OPÉRA AT AVENUE DE L'OPÉRA

1875

The black granite storefront of this jewelry boutique, with its gilded bronze trim, recalls its nineteenth-century origins as Bijouterie Bourguignon, built in 1875. During the Second Empire, this area catered to an elite clientele from the rapidly growing upper middle class. Luxury hotels and boutiques increased their presence in the vicinity of the Opéra, and commerce flourished as it strove to satisfy the desires of the affluent. Today, Bijouterie Maty carries on this glittering tradition.

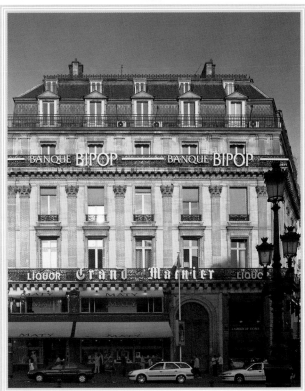

170

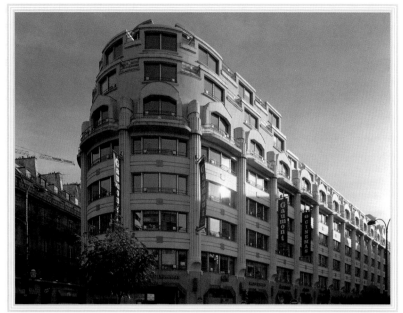

171

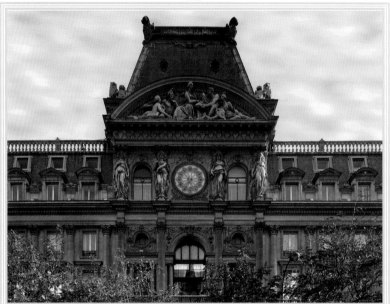

172

173

171

Palais du Hanovre

31–33, BOULEVARD DES ITALIENS AT 26, RUE LOUIS-LE-GRAND

1932, CHARLES LEMARESQUIER AND VICTOR LALOUX

In 1926, architect Lemaresquier, a traditionalist, collaborated with Victor Laloux, father of the Gare d'Orsay, in building one of the rare Art Deco complexes in Paris. The fluted pillars recall the giant columns of Laloux's earlier work, giving this corner building an angled rhythm that seems to undulate along both sides of the street. The building rests on the site of the former place of the pavillon du Hanovre, built by architect Chevotet in 1758 for the duc de Richelieu.

172

Crédit Lyonnais

19, BOULEVARD DES ITALIENS BETWEEN RUE DE CHOISEUL, RUE DE GRAMONT, AND RUE DU QUATRE SEPTEMBRE

1876–78, WILLIAM BOUWENS VAN DER BOIJEN

In the late nineteenth century, banks established their presence—physically and financially—as active participants in the city's growth, especially in the second arrondissement. Inspiration for the grand style of this bank's central façade derives from the Louvre. Three mysterious fires have recently damaged part of the bank but it has since been restored.

173

Hôtel de Montholon

23, BOULEVARD POISSONNIÈRE AT RUE MONTMARTRE

1785, JEAN-LEQUEU LEQUEU AND FRANÇOIS SOUFFLOT LE ROMAIN

Extending along the old northern border of Paris, the Grands Boulevards entertained fashionable strollers amid its tree-lined promenades since the time of Louis XIV. From the late seventeenth through the nineteenth centuries, these broad boulevards attracted the construction of beautiful townhouses. Hôtel de Montholon, a surviving example of those days of urbanization, fronts boulevard Poissonnière. Its preserved, though slightly altered, classical façade now has one additional level; numerous shops occupy the ground level.

174

174

4-6, rue Gaillon

BETWEEN AVENUE DE L'OPÉRA AND RUE SAINT-AUGUSTIN

1730

This austere building, that once belonged to Prince Sulkowski, typifies a nineteenth-century transformation of an eighteenth-century building. The original eighteenth-century stories are stone, while the upper level is a nineteenth-century construct: painted plaster in a Rococo pattern. The loose stonework framing the double doorway contrasts with the iron grillwork over the ground-level windows, a later addition from the nineteenth century. The banister of the interior stairs carries through the ironwork décor of this renovation.

3ᴿᴰ ARRONDISSEMENT

In the thirteenth century, the Knights Templar drained the remaining swampland here and settled into what is now the northern portion of the historic Marais (literally, "marsh"). They were followed by the French aristocracy, who erected private mansions in the neighborhood and remained until the mid-seventeenth century when the royal court moved to Versailles. Largely ignored through the nineteenth century and first part of the twentieth, the third arrondissement next attracted an influx of poor Jewish immigrants from Eastern Europe, and many of the former aristocratic homes were converted to workshops and tenements. By the 1960s, the area was an infested slum and in danger of mass demolition. Saved by then Minister of Culture, André Malraux, the Marais became a protected historic site and many of the magnificent private mansions, known as *hôtel particuliers*, were restored and became museums.

175

Place de la République

AT THE BOUNDARY OF THE 3RD, 10TH AND 11TH ARRONDISSEMENTS

1854–59, A. LEGROM, VÉRINES BARRACKS; 1866, GABRIEL DAVIOUD, MAGASINS RÉUNIS; 1883, LÉOPOLD AND CHARLES MORICE, SCULPTORS OF STATUE OF THE RÉPUBLIQUE

Slicing through a web of medieval alleyways and streets, the nineteenth-century city planning of Baron Haussmann opened up broad vistas and brought uniformity to the city. His ambition had both aesthetic and practical application: In the case of place de la République, he transformed the old crossroads of Château-d'Eau at the northeastern edge of the third arrondissement, to create speedy access to the train stations and boulevards. He also commissioned architect Legrom to develop Vérines Barracks, which provided adequate housing for the occasional troops needed to quell worker rebellion. Davioud was hired to put up a similar building opposite it, for symmetry. In 1883, the Morice brothers sculpted the giant statue of the Republic that lords over the square representing Liberty, Equality, and Fraternity. Today, following tradition, political protesters gather at place de la République as their departure point, then march to the Bastille.

176

Hôtel de Montrésor

52-54, RUE DE TURENNE AT RUE SAINT GILLES

1637–54, MICHEL VILLEDO AND DUBLET;
1742, JACQUES-RICHARD COCHOIS

Originally developed in the mid–seventeenth century as two adjacent residences, this property probably was remodeled about one hundred years later. A classic triangular pediment, added circa 1742, encompasses the doorway to number 54 where Claude de Bourdeille, the comte de Montrésor, lived. Iron balconies added Rococo cartouches and consoles to the façade, for a surprising contrast. The entry to number 52 remains unchanged.

177

Hôtel de Hesse

62, RUE DE TURENNE AT RUE VILLEHARDOUIN

C. 1640, MICHEL VILLEDO

Chancellor Boucherat must have liked this neighborhood, but wanted a slight change of scenery. After living at 60, rue de Turenne for about twenty-four years, he moved next door to this residence, built by the same architect. In the nineteenth century, Franciscan nuns altered the street façade, which still masks the original hotel. Viewed from Square Saint-Gilles-Grand-Veneur, however, both garden façades are visible.

178

Hôtel de Rohan

87, RUE VIEILLE-DU-TEMPLE AT RUE BARBETTE

1705–08, PIERRE-ALEXIS DELAMAIR

Armand-Gaston-Maximilien de Roha Soubise —son of Prince Soubise, and then himself bishop of Strasbourg and a future cardinal—decided to build a residence around the corner from his father's home, with the help of the family architect who had designed both the Hôtel de Soubise and Hôtel de Rohan. While the courtyard façade is rather modest, the garden façade is larger and more elegant, with columns and statues. Four successive Cardinal Rohans occupied this family home.

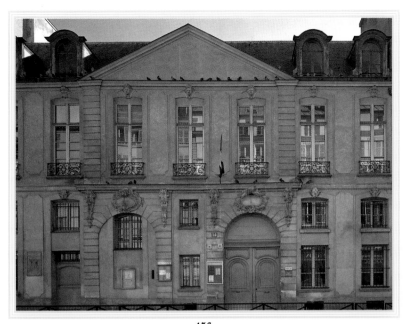

176

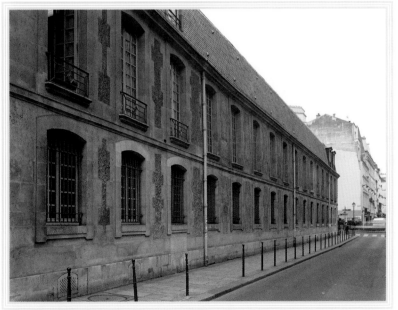

177

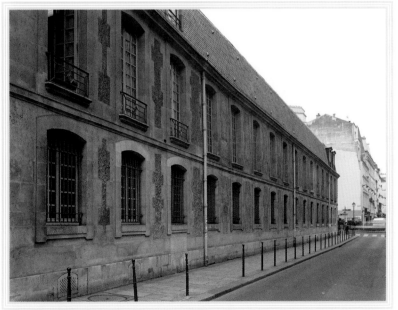

178

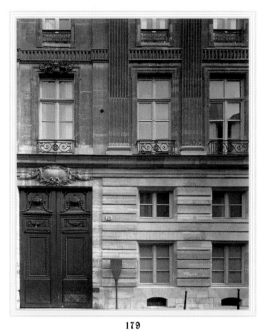

179

180

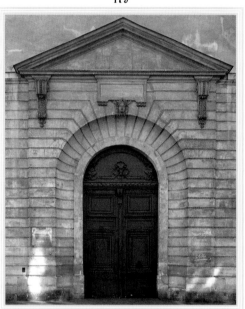

181

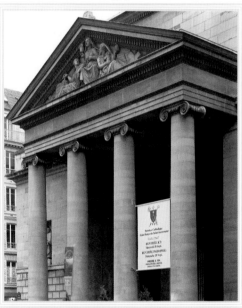

182

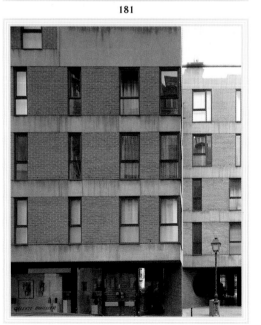

183

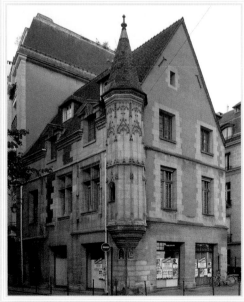

184

179

Hôtel de Sandreville

26, RUE DES FRANCS-BOURGEOIS AT RUE ELZÉVIR

C. 1585, ATTRIBUTED TO BAPTISTE ANDROUET DU CERCEAU

When original owner Claude Mortier died in 1604, his heirs divided his property in half. As often happens in Paris, subsequent owners restored or rebuilt the Hôtel Mortier. In 1635, the western portion took on the name of its new owner, Sandreville. In 1767, Charles-Louis Le Mayrat rebuilt the same side in the style of Louis Quinze. In a nineteenth-century demolition, a new corner building replaced the eastern half of the 1585 hotel; the garden façade is a twentieth-century restoration of the original.

180

7, rue Saint-Gilles

BETWEEN RUE DE TURENNE AND RUE DES TOURNELLES

1987, DOMINIQUE HERTENBERGER AND JACQUES VITRY

Reverting to tradition while introducing modern functionality, the architects deliberately created recesses, open spaces, and courtyards that were reminiscent of the Marais before Haussmann's uniform realignment of the streets. They also incorporated classic material and design elements to evoke the spirit of this ancient district. Inspired by place des Vosage, they created a deceptively simple brick façade, with a traditional, triangular-shaped pediment.

181

Hôtel d'Ecquevilly

(HÔTEL DU GRAND VENEUR)

60, RUE DE TURENNE AT RUE VILLEHARDOUIN

1636, MICHEL VILLEDO; 1733, JEAN-BAPTISTE AUGUSTIN BEAUSIRE;
1985, LE FERRIER AND LE DU, RESTORATION

Inspired by the hunt, Augustin Hennequin—the marquis d'Ecquevilly—got architect Beausire to adorn his home with hunting motifs. A hundred years after the first architect Villedo built this house, the marquis d'Ecquevilly was master of the hunt for Louis XV, bearing the title *Capitaine général de la vénerie*. It would appear from the hotel's secondary name that he was a grand hunter. The façade dates from 1636.

182

Saint-Denis-du-Saint-Sacrement

70, RUE DE TURENNE AT RUE SAINT-CLAUDE

1826–35, ETIENNE-HIPPOLYTE GODDE

Faith, Hope, and Charity reign above the entrance of this former convent of the Benedictines of the Holy Sacrament. Sculptor J.-J. Feuchères sculpted the tympanum of these personifications into the pediment of this neoclassic church. Inside, a Delacroix painting from 1844 hangs on the right, after the entrance.

183

13, rue Thorigny

AT RUE DU ROI DORÉ

1973, JACQUES VITRY, DOMINIQUE HERTENBERGER,
AND JACQUES IVORRA

To accomplish an integral design rather than a pastiche, in this ancient quarter of the Marais, the architects conceived a series of courtyards for their luxury flats. Recalling the essence of the Marais, these courtyards "run deep into the city and open into hidden gardens." In addition, they used a brick and concrete construction to evoke the royal place des Vosage nearby.

184

Hôtel d'Héroët

54, RUE VIEILLE-DU-TEMPLE AT RUE DES FRANCS-BOURGEOIS

1500–20

Until 1965, *hôtels* in the Marais quarter were routinely destroyed without regard to the district's historic significance. Most of these buildings were damaged when used for industrial purposes in the nineteenth century. Finally declared a protected quarter in the 1960s, the Marais now preserves and restores its townhouses. Almost completely reconstructed after World War II, this sixteenth-century *hôtel* barely resembles its original building, although it has retained its corner tower.

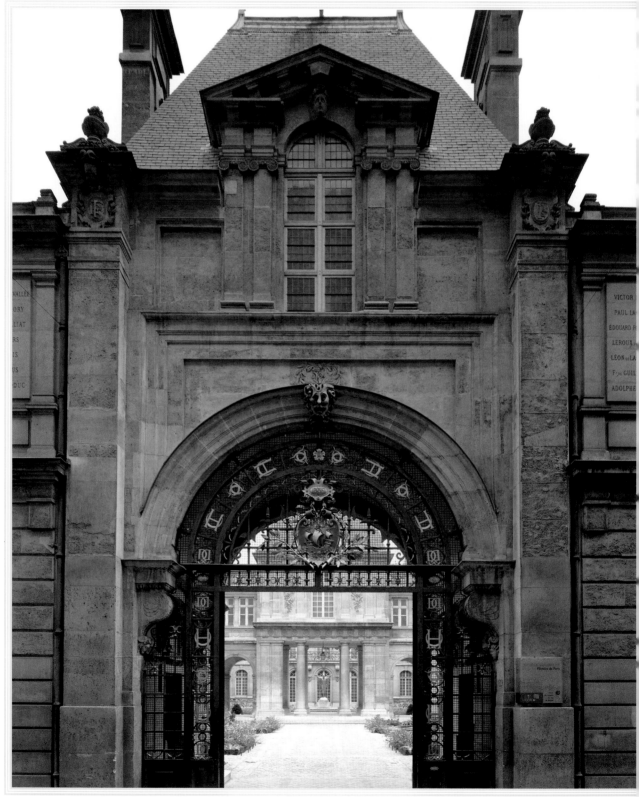

185

186

185

Musée Carnavalet

23, RUE DE SÉVIGNÉ AT RUE DES FRANCS BOURGEOIS

1547–49, NICHOLAS DUPUIS, MASON; DESIGN ATTRIBUTED TO PIERRE LESCOT; C. 1660, FRANÇOIS MANSART, EXTERIOR RESTORATION

This museum houses everything from priceless treasures to the mundane: Napoléon's cradle, Proust's bedroom, Renaissance portraits, Revolutionary memorabilia. It also contains an Art Nouveau shop. Devoted to the history of the City of Paris from its origins to the present, the Musée Carnavalet divides its collection between two adjoining mansions: Hôtel de Carnavalet and Hôtel Le Peletier de Saint-Fargeau. From 1677 to 1696, Madame de Sévigné, for whom the street is named, lived in and had a salon at the Hôtel de Carnavalet. Today, that building showcases the evolution of Paris and its artifacts from prehistory to the eighteenth century. The other hotel displays the city's modern history. Around 1660, Mansart modified the façade but retained its detailed, Renaissance portal, which Lescot probably sculpted with help from his students.

186

Hôtel de Soubise

60, RUE DES FRANCS-BOURGEOIS AT RUE DES ARCHIVES

1705–09, PIERRE-ALEXIS DELAMAIR; 1735, GERAIN BOFFRAND

In the days of horse-drawn carriages, this hotel accommodated guests with its recessed entry off rue des Francs-Bourgeois. Through this gate, a huge U-shaped colonnade borders Hôtel de Soubise's forecourt and leads to its stately inner façade. On the ground floor, double columns support a second level of sculptures, more paired columns, and a pediment decorated with seated sculptures on top. The original statues are the work of Robert Le Lorrain. To the left of this façade, two medieval turrets arise from the old Hôtel de Clisson, the previous *hôtel* on this site. Keeping the old, high roof behind the new one expressed family prestige. Today, the Musée de l'Histoire de France occupies the property.

187

Pharmacie des Francs Bourgeois

36, RUE DES FRANCS-BOURGEOIS

C. SEVENTEENTH CENTURY

Inset into a simple building façade, next to the plain wooden-arched entry, this graffiti–spray-painted storefront stands in sharp contrast to the rest of the structure, adding an element of humor to an otherwise nondescript building. Pharmacie des Francs Bourgeois has changed ownership and has not been occupied since 1820.

188

Hôtel d'Alméras

30, RUE DES FRANCS-BOURGEOIS AT RUE ELZÉVIR

1611, LOUIS MÉTEZEAU; 1981–83, RESTORATION

A grand Mannerist pediment marks the street entrance to this early seventeenth-century building. Hung above the double doors, like curtains rising on an elaborate stage setting, it presents a stately and balanced composition, opening onto a forecourt and garden. The inner building construction is brick and stone, and contains a staircase dating from the time of Henry IV.

189

Hôtel de Donon
(MUSÉE COGNACQ-JAY)

8, RUE ELZÉVIR

C. LATE SIXTEENTH CENTURY

Ernest Cognacq and his wife Marie-Louise Jay, who founded the department store La Samaritaine in 1900, amassed enough wealth to share over 65% of their profits with their employees—and to collect art. Behind the austere façade of a mansion orginally built for Mederic de Donon, are period rooms and furnishings that reflect Cognacqs' life and passions, and the temper of the times in which they lived.

190

Hôtel Marle
(SWEDISH CULTURAL CENTER)

11, RUE PAYENNE AND 10, RUE ELZÉVIR

1572, REMODELED; 1640, REMODELED

A decorative mask on the main entrance gateway invites you to enter the ancient Hôtel Marle, now the Swedish Cultural Center. In 1572, Christophe Hector de Marle, then a legal advisor to Parlement, redesigned and enlarged the existing structure, which was again remodeled in 1640. Ultimately, between 1969 and 1971, the Swedish government restored this mansion and reconstructed its roof and side pavilions for use as its cultural center.

191

Hôtel Libéral-Bruant

ONE, RUE DE LA PERLE AT RUE ELZÉVIR

1685, LIBÉRAL BRUANT

Winged putti sporting cornucopias frolic on the triangular pediment that covers this entire building. Architect Libéral Bruant built this *hôtel* for himself, though he never lived in it. Representative of private architecture of the 1690s, the façade is decorated with arched windows and a balanced classic design of circular niches that contain sculpted busts of Roman emperors. In 1965, the Société Bricard acquired this building, which now houses the Musée de la Serrure, a museum of metalwork and locksmithing.

192

Hôtel Salé
(MUSÉE PICASSO)

5, RUE THORIGNY

1656–59, JEAN BOULLIER DE BOURGES; 1974–84, BERNARD VITRY
AND BERNARD FONQUERNIE, EXTERIOR RESTORATION;
1976, ROLAND SIMOUNET, INTERIOR RESTORATION

Derisively dubbed "the salted *hôtel*" by Parisians after its first owner, Pierre Aubert de Fontenay, who collected salt taxes, this magnificent mansion today houses the Picasso Museum. Fontenay was the object of royal envy as well, and ran afoul of the monarchy. He lost his luck, his fortune, and his connections when the Sun King's treasurer, Nicolas Fouquet, lost his. Fontenay died before seeing his residence completed.

187

188

189

190

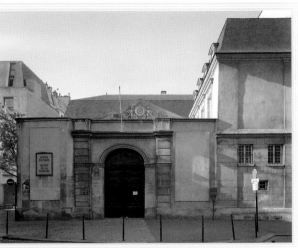

191

192

193

HÔTELS PARTICULIERS
(PRIVATE MANSIONS)

Voltaire once observed that the abundance of opulent *hôtels* in Paris gave Parisians a measure of comfort "unknown to our parents and not yet attained by other nations." His reference was to private middle-class homes—not guest hotels—though the terms "hotel" and "hostel" are derivative. With the rise of the bourgeoisie, moderate homes were commissioned that emulated the *hôtels particuliers*, or private mansions, of the aristocracy. Constructed in a style referred to as *entre cour et jardin*, these *hôtels*—built between an entrance courtyard and a garden—usually featured a main building and wing extensions, but could be much grander with multiple additions. Sometimes several families, as well as servants, occupied the various buildings and suites.

Depending on the monetary position of the family, the architecture of middle-class *hôtels* varied in design and in the size of the land parcel. Often, rooms were rented out to subsidize the construction. Typically, there were commercial shops on the ground floor, along with the kitchens for the homes above, and servants brought food up main and secondary stairways—a classic "upstairs-downstairs" arrangement. Over time, many of these private homes evolved into rental units, and the word "*hôtel*" began to take on its more conventional modern-day meaning. In Paris, the term has now become almost completely interchangeable, referring sometimes to an old mansion and sometimes to a temporary lodging for tourists.

Hôtels particuliers are abundant in the Marais quarter that spans the third and the fourth arrondissments. In the 1960s, when writer André Malraux was Minister of Culture under Charles de Gaulle, he not only gave Paris a facelift by washing off centuries of grime and coal soot, but he also initiated "Malraux's Law." The Marais was a chief beneficiary of this 1962 edict, which in effect declared whole districts as historic sites, not just individual buildings. Malraux's decree preserved the historic character of the district before too many *hôtels* were reduced to rubble.

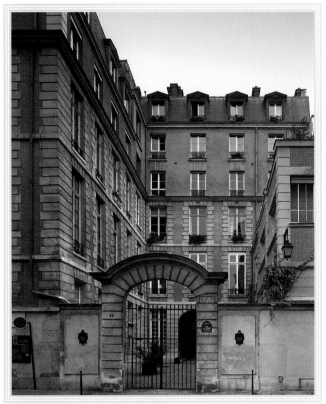

194

Hôtel de Canillac

4, RUE DU PARC ROYAL AT RUE DE SÉVIGNÉ

1620–1625, JEAN THIRIOT

Until his death in 1608, gardener René Jacquelin owned the land on the north side of rue du Parc-Royal. Jacques Berruyer, financier and royal consultant, bought the two plots of land and with his architect constructed a typical seventeenth-century mansion on the site. Various owners occupied the premises, but the hôtel retains the name of the marquis de Canillac, who owned the home between 1752 and 1778. Built in Louis Treize style, the main building is between the courtyard and garden, but it was damaged by the later construction of two stories and covered by pink surface filler. The interior staircase is preserved, as is a portion of the painted ceiling.

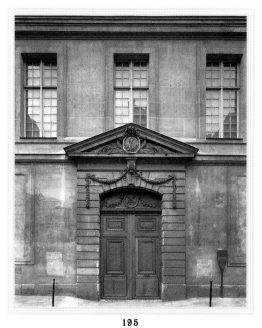

195

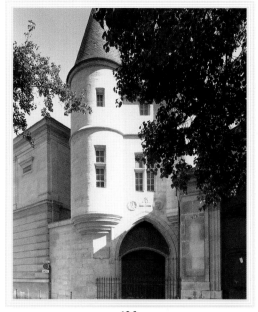

196

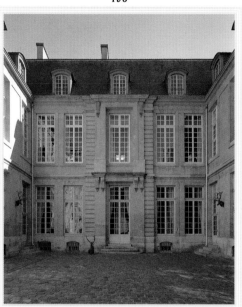

197

198

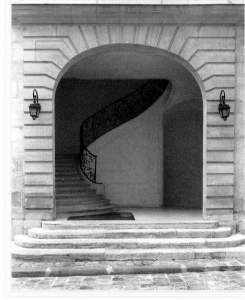

199

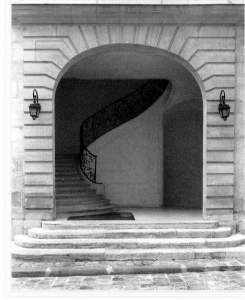

200

195
Hôtel Le Peletier de Saint-Fargeau

29, RUE DE SÉVIGNÉ BETWEEN RUE DES FRANCS BOURGEOIS
AND RUE DU PARC ROYAL

1686–90, PIERRE BULLET

Part of the Musée Carnavalet, the Hôtel Peletier de Saint-Fargeau presents the history of Paris from the Revolution to the present day. Viewed from these gardens, the pediment depicts an allegory of Time, and its orangerie features a sculpted pediment of Truth. The gardens face Square Georges-Cain, where the Musée Carnavalet has unloaded its stash of old stones and statues of historical significance.

196
Hôtel de Clisson

58, RUE DES ARCHIVES AT RUE DES QUATRE-FILS

c. 1375

Olivier de Clisson, Constable of France in 1380, built a large medieval mansion on this site in the fourteenth century. In the 1550s, the duc de Guise acquired the property and hired Italian artist Nicolo dell'Abate to decorate it. Subsequent owner François de Soubise transformed the complex of which only the tower portion survives. This section, ornamented by a pointed, arched entry gate and rounded turrets, was integrated into the Hôtel de Soubise, thus perpetuating its medieval appearance.

197
Hôtel de Guénégaud
(MUSÉE DE LA CHASSE ET DE LA NATURE)

60, RUE DES ARCHIVES AT RUE DES QUATRE-FILS

1653–55, FRANÇOIS MANSART

The City of Paris bought this dilapidated property in 1961 and leased it to Société Sommer for ninety-nine years. The society restored the residence to its former elegance. It has simple lines and a well-proportioned façade, in a severe style without decoration. The grandeur of the place rests on its stone staircase that—supported by stone vaulting—is so light it appears aerial. The hotel's elongated windows give the house a see-through effect, visually connecting the public courtyard with the private garden.

198
Centre d'accueil et de recherches des Archives Natoinales
(CARAN)

11, RUE DES QUATRE-FILS AT RUE DES ARCHIVES

1984–87, STANISLAS FISZER

Building in the heart of a historic district, architect Fiszer managed to preserve the historic integrity of the area through his use of material and by altering structural proportions according to their placement on the site. This contemporary, postmodern building stretches horizontally, then rises slightly and expands where it adjoins large nineteenth-century warehouses, only to shrink again where it juxtaposes the early eighteenth-century Hôtel de Rohan.

199
La Poste

65, RUE DU ARCHIVES AT RUE PASTOURELLE

1927-1928, FRANÇOIS LECOEUR

Four concrete piers divide this building into three parts, giving it a linear and vertical shape despite the curving façade. Lecoeur, the official architect of the ministry of Post and Telecommunication for over twenty years, opened up the ground level with entry stairs and capped the frontage with a cornice. This unusual building is a surprising bit of architecture in the Marais: Composed of concrete, the building is functional and aesthetic.

200
Hôtel d'Hozier

110, RUE VIEILLE-DU-TEMPLE AT RUE DE DEBELLEYME

1623, JEAN THIRIOT; 1731, MODIFIED BY DENIS QUIROT

Modifications and multiple ownerships often mask the original structure or alter the characteristics of Parisian homes, referred to as *hôtels*. Architect Thiriot completed this *hôtel* in the brick and stone style of Louis Treize in 1623. About a hundred years later, Denis Quirot altered the street entry. A nineteenth-century modification changed the street front with the addition of one floor. Somewhere beneath the restored surface, the original brick and stone façade from Thiriot's seventeenth-century *hôtel* lies hidden.

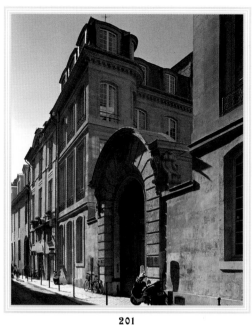

201

201

Hôtel de Montmort

79, RUE DU TEMPLE AT RUE DE BRAQUE

C. 1623, GIRARD GIPPON; 1752–54, REBUILT, PIERRE-ETIENNE DE BEAUMONT

Jean Habert de Montmort, whose name the hotel retains, built this seventeenth-century residence, but then Laurent Charron restructured it in the style of Louis Quinze in the mid–eighteenth century. A sculpted mask, supposedly of Charron's wife, decorates the reverse side of the grand portal on rue du Temple. This entryway gives access to two inner courtyards, one of which was a garden, probably added in 1840 along with the buildings in the second court.

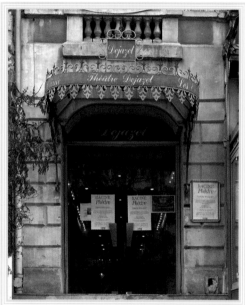

202

202

Théâtre Libertaire de Paris Déjazet

41, BOULEVARD DU TEMPLE

1786, BELANGER

In 1786, Théâtre Libertaire de Paris Déjazet began life as a royal tennis court for Count d'Artois. Since then, its incarnations have included bathhouse, ballroom, and follies theater. Before Haussmann demolished buildings in his town planning campaign, boulevard du Temple was a swinging area with theaters galore. Happily, the wrecking ball stopped short of this theater, which actress Virginie Déjazet acquired in 1856 and named after herself. It remains a theater.

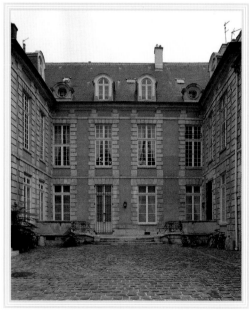

203

203

Hôtel Mégret de Serilly

106, RUE VIEILLE-DU-TEMPLE AT RUE DE THORIGNY

1620–21, JEAN THIRIOT; 1686 JEAN COURTONNE

The name of this hotel derives from a tax farmer, Jean-François Mégret de Serilly, who purchased it in 1776. Its original stone and brick design is in the style of Louis Treize, but the street façade is a late seventeenth-century alteration. A pediment adorned with two lions hangs over the street gatehouse entrance, and a garden façade faces rue de Thorigny.

204

Ecole Primaire Communale de Jeunes Filles

8, RUE DE MONTMORENCY

c.1881

Originally, a small hotel constructed over an ancient playing field existed on this site and was sold to architect Nicholas Blondeau in 1642. It passed through several hands before Charles Bernard acquired it, and it remained in the Bernard family until 1712. By 1881, the City of Paris had purchased it and replaced the hotel with a primary grade school for young boys. The decorative façade is divided by vertical pilasters composed of stone, brick, and metal. Bands of color on the bricks accent the floor divisions, piers, and windows.

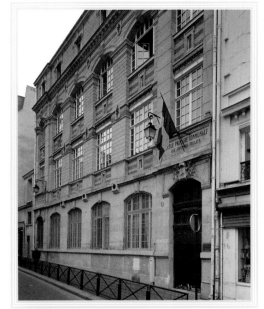

204

205

Musée de la Poupée

IMPASSE BERTHAUD

1994

Musée de la Poupée (The Doll Museum) exhibits the culture and customs of a period when dolls were collected and displayed. The growth of the doll industry coincided with the rise of commerce and the economic fortunes of the Third Republic, toward the end of the nineteenth century: Jumeau, a leading French porcelain doll manufacturer, produced about 10,000 dolls in 1878. By the turn of the century, that number exploded to about three million and included *Parisiennes* (French fashion dolls).

205

206

Maison du Pastel

20, RUE RAMBUTEAU

C. MID—NINETEENTH CENTURY, BUILDING
1912, STORE

Around 1874, chemist Henri Roché began mixing colors according to the advice of his artist friends and customers. Within two years, Roché stocked about 500 colors. At the time, his son, physician Henri Roché II, took command of the family's expanding business, and Maison du Pastel increased their offerings to an astonishing 1,650 tints. A cousin, Isabel, now runs Maison du Pastel and maintains the family's secret, ancient recipe for colors.

206

207

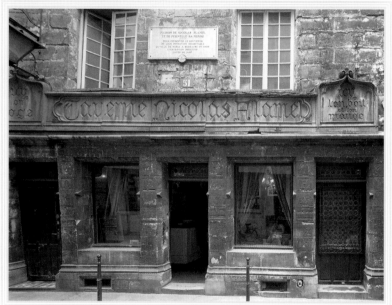

208

209

207

Théâtre Molière Maison de la Poésie

PASSAGE MOLIÈRE | AT 57 RUE SAINT-MARTIN

1791; 1993–95, REBUILT

Jean-François Boursault-Malherbe, a former lawyer who became an actor and director of theaters in France and Italy, profited from a 1791 law that allowed any citizen to open a public theater. He inaugurated this theater under the patronage of Molière and staged *Le Misanthrope*. The former Passage des Nourrices thus became Passage Molière. In the 1990s, the City of Paris bought the theater—in a state of total ruin by then—and rebuilt everything as it had been in the eighteenth century.

208

Auberge de Nicolas Flamel

51, RUE DE MONTMORENCY AT RUE SAINT-MARTIN

1407

Ora et labora (pray and work) is the motto that Nicolas Flamel coined for his austere, stone house—thought to be the oldest in Paris. Along the façade of his house Flamel enscripted these additional words: "We men and women, living under the roof of this house built in fourteen hundred and seven, are in honour bound to recite one Paternoster and one Hail Mary every day, and to ask God, in His grace, to forgive the sins of the poor departed. Amen."

209

Hôtel de Tallard

76, RUE DES ARCHIVES AT 10, RUE PASTOURELLE AND 3, RUE DE BEAUCE

1702–04, PIERRE BULLET

In French classical architecture, the grander the staircase, the more highly regarded the family. Hôtel de Tallard is also known as Hôtel Amelot de Chaillou, after its first owner, who commissioned Pierre Bullet, architect to the king, to build the main house. Bullet positioned it perpendicular to the rue des Archives, but because it was not possible to fit in a large staircase—the essential element of prestige—he added a wing. The three windows in the wing provide a view of the stairs from the beautiful garden.

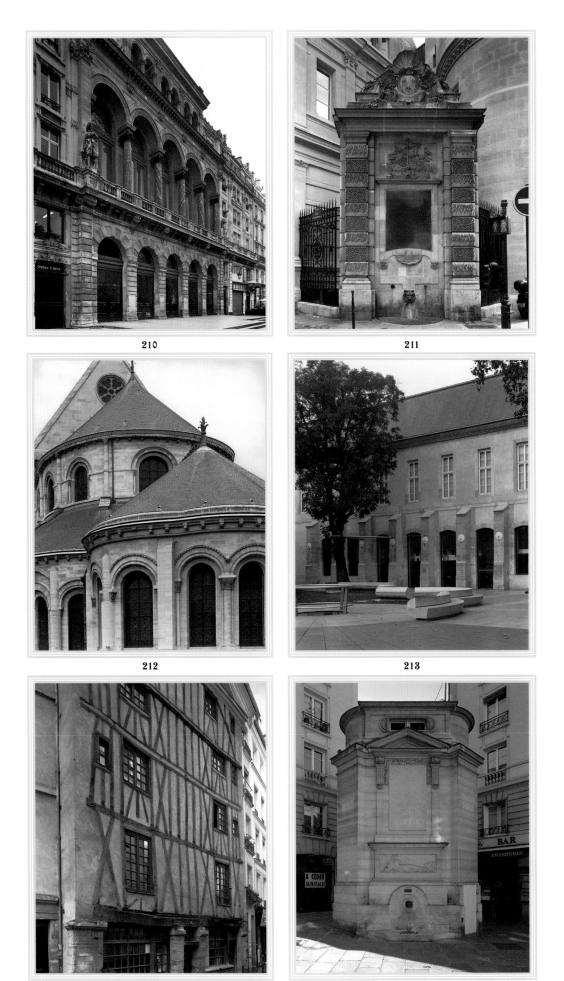

210

211

212

213

214

215

210
Théâtre de la Gaîté Lyrique

3-5, RUE PAPIN OPPOSITE SQUARE EMILE-CHAUTEMPS

1861–62, ALPHONSE CUSIN

In the glory years of grand theater, this was one of several that welcomed Jacques Offenbach's productions, and also played host to the Ballets Russes under its directorship of Sergey Diaghilev. Balanced by two linear side buildings, the theater—no longer in existence—was contained in the arched-windowed, central portion of this huge structure.

211
Fontaine de Vertbois

CORNER OF RUE SAINT-MARTIN AND RUE DU VERTBOIS

1712; 1882, RESTORED

A remnant of the fortified wall from the priory of Saint-Martin-des-Champs, this fountain survived the Revolution. According to its inscription, it was restored along with the adjacent tower in 1882 by the state, "in accordance with the wishes of Parisian antiquarians."

212
Conservatoire National des Arts et Métiers

270-292, RUE SAINT-MARTIN AT RUE DU VERTBOIS

1060–67, PRIORY AND FIRST CHURCH; C. TWELFTH CENTURY, FIRST NAVE AND CHOIR; C. MID–THIRTEENTH CENTURY, REFECTORY AND REBUILT NAVE; 1794, CONSERVATOIRE ESTABLISHED; 1845–96, LÉON VAUDOYER AND GABRIEL-AUGUSTE ANCELET, NEW BUILDINGS; 1885, CHURCH FAÇADE

A tower from Saint-Martin-des-Champs—a thirteenth-century Benedictine monastery—rises from the corner of rue Saint-Martin and rue du Verbois. When demolition loomed, Victor Hugo saved it with his words: "Demolish the tower? No! Demolish the architect? Yes!" This tower and a fountain survive as relics of the fortified wall of the former abbey.

213
Musée des Arts et Métiers

60, RUE RÉAUMUR AT RUE SAINT MARTIN

C. EARLY TWELFTH CENTURY, MID–THIRTEENTH CENTURY, AND 1885, CHURCH; 1886, GABRIEL-AUGUSTE ANCELET, BUILDING RUE VAUCANSON

Where else but Paris might you find a Blériot monoplane hanging from the rafters of a church nave along with Bell's telephone and Pascal's calculating machine? This museum of science and technology is housed in the medieval confines of the former monastery Saint-Martin-des-Champs.

214
Timber House

3, RUE VOLTA AT RUE AU MAIRE

C. SEVENTEENTH CENTURY

In the sixteenth century, in the interest of fire prevention, Parisian city regulations ordered the use of stone for house façades, in place of wood. This half-timbered fire hazard, once thought to be the oldest house in Paris, actually managed to survive since the seventeenth century—proof that the restrictions were regularly ignored. (Often, buildings' original wood façades were merely covered by plaster, even after the late eighteenth century, to fake compliance with the law.)

215
Fontaine des Haudriettes

CORNER OF RUE DES HAUDRIETTES AND RUE DES ARCHIVES

1764–65, PIERRE-LOUIS MOREAU-DESPROUX

The construction of fountains as part of building design during the sixteenth and seventeenth centuries was not just for their decorative elements, but rather presented a conscience effort to use water as a metaphor for the City's prosperity. Often the fountain survived a building's demolition, as was the case with Fontaine des Haudriettes. No longer attached to a building, this fountain was moved out from its original place in 1933, and today decorates the corner of rues des Haudriettes and des Archives.

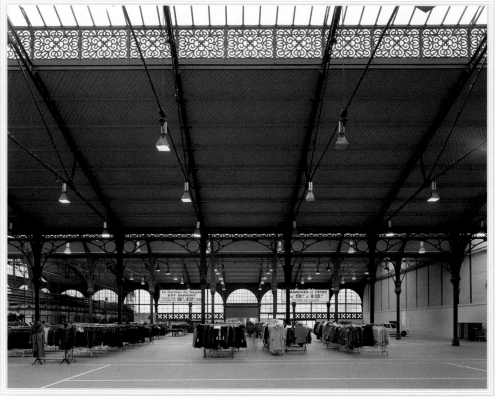

216

Marché du Temple

At rues Picardie, Perrée, Eugène-Spuller, and Dupetit-Thouars

1808, Molinos; 1863, Jules de Mérindol and Ernest Legrand

The marketplace of a twelfth-century Temple complex—a walled city within a city—this belonged to the Knights Templar, who derived great wealth from its activities. Philip the Fair dissolved it in 1307, but activity continued under its rotunda and arcades that housed four wooden halls known as the "Old Clothes" market. Transformed into a prison during the Revolution, the original tower on the Square du Temple for a time held captive Louis XVI and his royal family: Marie-Antoinette, the Princess, and the young Dauphin. The king remained in the tower until his execution; Marie-Antoinette stayed for a year before her transfer to the Conciergerie; the Princess was there until her exchange for Republican prisoners, and the Dauphin withered away in an isolated cell until his supposed death. In 1863, Napoléon III demolished both the rotunda and the Temple towers.

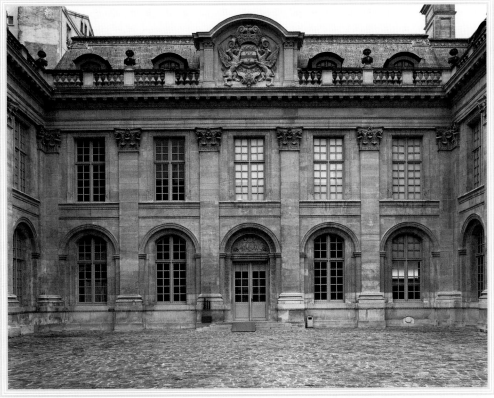

217

Musée d'Art et d'Histoire du Judaïsme
(Hôtel de Saint-Aignan/Hôtel d'Avaux)

71, RUE DU TEMPLE AT PASSAGE SAINT-AVOIE

1644, PIERRE LE MUET, HÔTEL DE SAINT-AIGNAN

Devoted to Jewish heritage, this museum showcases the Diaspora and features such objects as Torah scrolls and marriage certificates. Along with paintings by Chagall, Soutine, and Modigliani, it displays a wooden sukkah and furniture from an Italian synagogue. Built in 1644 for the comte d'Avaux, *surintendant* of finances for Mazarin, this townhouse has classic broad proportions, carved pilasters, a mansard roof, and courtyard gardens. Paul de Beauvilliers, duc de Saint-Aignan, acquired the hotel in 1688. In 1792, it became a town hall where, four years later, Napoléon Bonaparte married Joséphine de Beauharnais in a civil ceremony. From 1842 onward, it declined and eventually became an investment property, with shops and craft studios at which photographer Eugène Atget photographed immigrant Jewish craftsmen. In 1986, Jacques Chirac decided to convert it to a museum of Judaism.

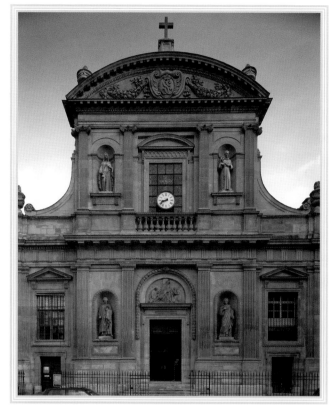

218

Eglise Sainte-Elisabeth

195, RUE DU TEMPLE AT RUE DE TURBIGO

1628; 1643, MICHEL VILLEDO;
1830, E. H. GODDE, ONLY THE CHANCEL

Marie de Médici founded this convent of Franciscan nuns in 1628. As happened with many other Parisian buildings, additions and alterations shaped changes in this structure over centuries. Early seventeenth-century Doric columns support an upper level of Ionic columns in a classical façade, which features four nineteenth-century statues set into niches and a pièta carved in the tympanum above the entrance. When it was originally built in the first part of the seventeenth century, the church had only one aisle; a second was added early in the nineteenth century but was destroyed during road construction mid-century. Additional modifications included construction of a nave and choir, completing this amalgam of centuries.

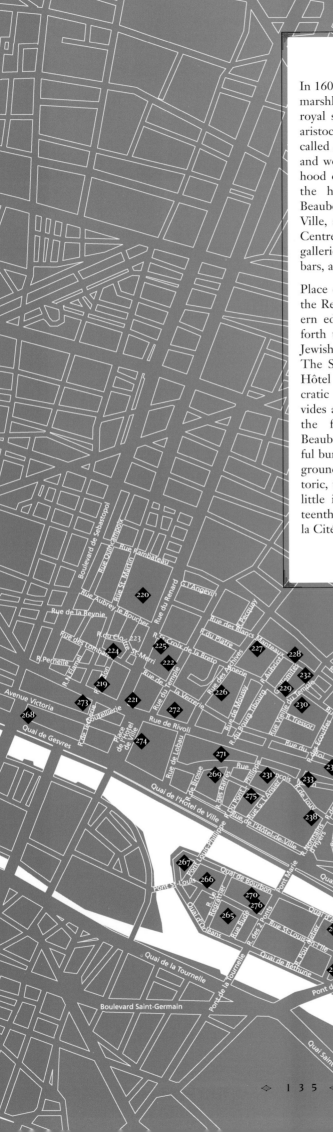

4ᵀᴴ ARRONDISSEMENT

In 1605, When Henri IV claimed the southern marshland of the Marais and created the first royal square, place des Vosges, he ignited an aristocratic building boom of private mansions called *hôtel particuliers*. Defined by royal legacy and working-class immigration, the neighborhood of the fourth arrondissement comprises the historic districts of the Marais and Beaubourg, the city hall known as Hôtel de Ville, and a symbol of postmodern Paris, the Centre Pompidou. Today, it's also home to art galleries, fashion outlets, funky boutiques, gay bars, and kosher delis.

Place des Vosges, where royalty romped until the Revolution, dominates the district's northern edge; restaurants and galleries now hold forth under its regal arches. Nearby, the old Jewish quarter thrives around rue des Rosiers. The Seine forms the southern border, where Hôtel de Ville commands a civil but bureaucratic presence. The Centre Pompidou provides a museum and cultural entertainment at the fourth's eastern quarter, known as Beaubourg. Derisively nicknamed the "beautiful burg," this area was in fact once a dumping ground for refuse. Lively and cultural and historic, this arrondissement also claims both the little island, Île Saint Louis, with its seventeenth-century architecture, and a slice of Île de la Cité, including Notre-Dame Cathedral.

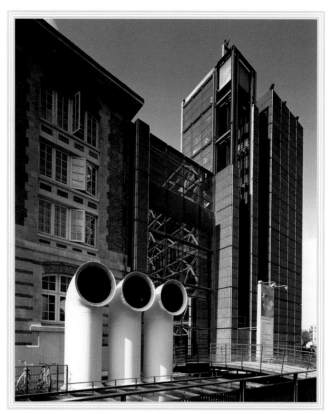

219

219

IRCAM

(INSTITUT DE RECHERCHE ET DE COORDINATION ACOUSTIQUE-MUSIQUE)

1, PLACE IGOR STRAVINSKY AT PLACE GEORGES-POMPIDOU

1989, RENZO PIANO

IRCAM, an acoustic music research institute created by Pierre Boulez, has the same objective as its administrative parent, the Centre Georges–Pompidou: to provide a public "window" to contemporary art. In a dual role, IRCAM promotes and supports high technology research within the industry, and it produces concerts and workshops for the public. Out of deference to nearby housing and respect for the scale of the neighborhood, the aptly named architect Piano placed most of the music studios underground, within this brick and metal annex to the Centre Georges–Pompidou.

220

Centre Georges-Pompidou

PLACE GEORGES-POMPIDOU AT RUE DU RENARD

1971, RICHARD ROGERS AND RENZO PIANO

Like a shirt worn inside out, the Centre Georges-Pompidou shows its seams. In a bold and controversial move, the architects relegated all normal building infrastructure to the outside of the complex: Launch-pad–like metal scaffolding wraps around the outside of the rectangular building and provides structural support. Exposed ductwork contains the building's mechanical systems, with different colors for water, heating, electricity, and air. A great escalator enclosed in glass tubing inches up the side of the building like a caterpillar, revealing an exciting view of Paris. A meal on the rooftop is worth the trip alone. This colorful complex of external guts is itself an exhibit. Inside, you'll find twentieth-century art in the Musée National d'Art Modern on the fourth floor, a center for industrial design, a concert hall, a public library, a video shop, and TV rooms.

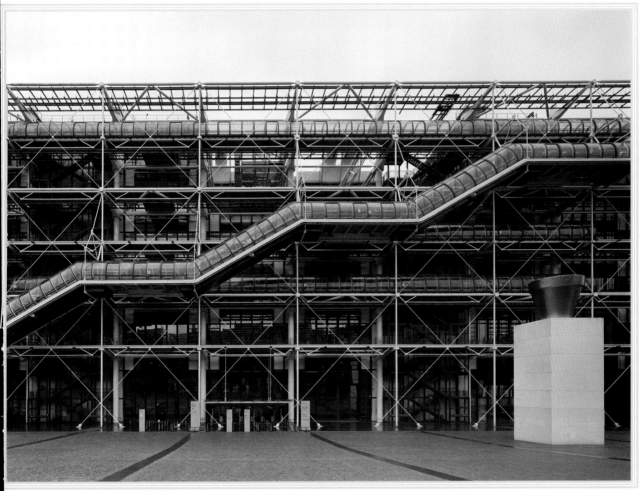

220

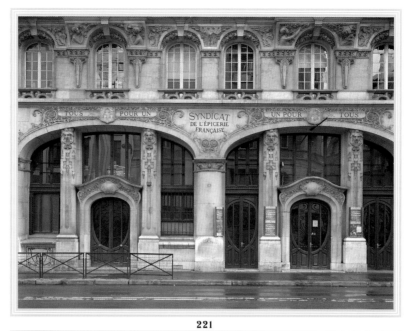

221

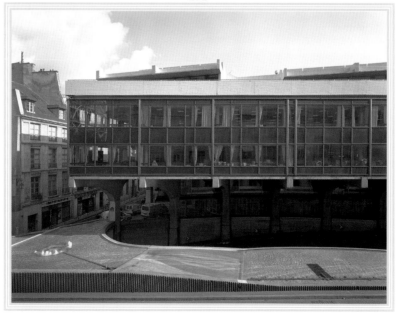

222

223

221

Syndicat de l'Épicerie et de l'Alimentation Générale

12, RUE DU RENARD

1901, RAYMOND BARBAUD AND EDOUARD BAUHAIN
SCULPTURES BY JULES-LOUIS RISPAL

This austere building marks the last period of Haussmann architecture that mixed many styles to fight against homogeneity. The huge arches retain the traditional shape of commercial buildings, on this headquarters for the trade union that governs grocery and food stores. Sharing the building, Théâtre du Renard, founded in 1791, was the theater used by Jean-Jacques Rousseau's company.

222

Hôtel de Berlize

41, RUE DU TEMPLE AT RUE SIMON LE FRANC

C. EARLY SEVENTEENTH CENTURY; 1640, ENLARGED

The original home was built for Guichard Faure with a main building, left wing, and an entrance on rue Pierre au Lard. In 1640, Nicolas Faure expanded it with an additional parcel of land on rue du Temple. Then, he changed the entrance to the street and built two rental houses on each side, partly to finance the project. He turned the logic of the hotel upside down: The old garden became the courtyard, and the courtyard was transformed to a garden with a new wing on its side.

223

Ecole Maternelle

CORNER RUE RENARD AND RUE SAINT-MERRI

1968

This elementary school typifies the irreverent architecture of the 1960s, which often did not respect the historic nature of original buildings. The construction of this concrete building destroyed a seventeenth-century private mansion on the site. Although the school typifies the spirit of modernity, it illustrates the threat to the Marais that these kinds of structures posed before the Marais was declared a protected historic district.

224
Bains-Douches Municipaux

33, RUE SAINT-MERRI AT PLACE STRAVINSKY

C. 1930, NO ARCH KNOWN

Words etched into this façade describe the building's former use as a municipal bathhouse. The polychromatic mosaic of the floral motifs and the city emblem further enhance the exterior décor. Constructed of brick for filler and cement for the structural portions, this three-story building typifies the architecture of the 1930s. The cement lintels and piers define the symmetrical façade with large windows separated into three parts by double piers. Today, this charming building houses a police office and the services of the Pompidou Center.

225
Hôtel le Rebours

12, RUE SAINT-MERRI AT RUE DU RENARD

C. SIXTEENTH CENTURY, FIRST BUILDING; 1624–25, CLAUDE MONNARD;
1738, ATTRIBUTED TO VICTOR-THIERRY DAILLY, MAIN FAÇADE

Located near the Centre Georges-Pompidou, this stately mansion, in Louis Seize style, spreads out around a courtyard. Jean Aubery occupied the home in 1624, and then it belonged to Thierry Le Rebours. The main façade was changed in 1737, and the entire building is an accumulation of many periods. But part of the picture is missing, namely the nineteenth-century industrial occupation of the building. When the Marais was declared a historic district, those who restored it totally erased its industrial past, simply because it wasn't noble enough for them. It is virtually impossible to piece together the *hôtel*'s history from that lost era.

226
Couvent des Billettes

24, RUE DES ARCHIVES BETWEEN RUE DE LA VERRERIE
AND RUE SAINTE-CROIX DE LA BRETONNERIE

1755–58, DOMINICAN BROTHER CLAUDE, PRESENT CHURCH

The story goes, in the late thirteenth century, when a profaned wafer gushed forth blood on this very site, the miracle led to the construction of an expiatory chapel, la Chapelle du Miracle. Later in the fifteenth century, the convent of the Brothers of Charity occupied the premises. In 1758, the Carmelite Order of the Billettes built the current church, which became a Protestant sanctuary in 1812 and survived the Revolution with its inherited, medieval cloister intact. Completed in 1427, this late Gothic, pillared cloister is the last of its kind in Paris.

227
École Maternelle
(HOUSE FOR THE FAMILY OF JACQUES-COEUR)

38-42 RUE DES ARCHIVES AT RUE DES BLANCS-MANTEAUX

C. LATE FIFTEENTH CENTURY

Today, children frolic on the premises of one of the oldest brick-and-stone homes in Paris. The house, converted to a day care center, at one time belonged to the granddaughter of Jacques-Coeur, silversmith to Charles VII. (Jacques-Coeur, or perhaps his son, may have once owned it, but no records exist to verify such assumptions.) The lower portion is stone; the upper, brick, was used as a building material for the first time in the Paris. The slanted rooftop is capped with tiny dormers.

224

225

226

227

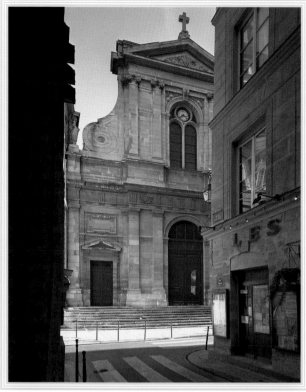

228

Notre-Dame-des-Blancs-Manteaux

12, RUE DES BLANCS-MANTEAUX AND 53, RUE DES FRANCS-BOURGEOIS

1685–1720, CHARLES DUVAL; 1703, EDME-SYLVAIN COURTAUD,
FAÇADE ; 1863, REBUILT BY VICTOR BALTARD

Rue des Blancs-Manteaux honors religious beggars who followed Saint-Louis to Paris in 1258 and wore white mantles (*blancs-manteaux*). The Guillemites, or brothers of Saint-Guillaume-de-Malval, who wore black robes, assumed control of the church a few decades later but not the name of the street. In the seventeenth century, the Benedictines occupied the site and built the present church, but the façade itself is a construct from the Barnabite church on Île de la Cité, which has been destroyed. In 1863, Victor Baltard relocated the façade to its current place on rue des Blancs-Manteaux, to become part of this church.

229

229

Au Petit Fer à Cheval

30, RUE VIEILLE-DU-TEMPLE AT RUE SAINTE-CROIX-LA-BRETONNERIE

c. 1900

The name of this restaurant—still visible on the street front—derives from its horseshoe-shaped bar. Au Petit Fer à Cheval is a turn-of-the-last-century café serving typical French fare to hip crowds who have made the Marais home—after years of neglect and its having drifted far from its aristocratic origins. Inside, intimate wooden booths lend this café an atmosphere from another era.

230

Hôtel Amelot de Bisseuil

47, RUE VIEILLE DU TEMPLE

1657–60, PIERRE COTTARD

In 1776, playwright Pierre-Augustin Caron de Beaumarchais threw a party here in support of the American Revolution and supplied arms to the cause, in a secretly financed deal with the Spanish and French governments. Beaumarchais also completed his famous drama *Le Mariage de Figaro* at this *hôtel*. Named for its original patron, Jean-Baptiste Amelot de Bisseuil, this magnificent Marais mansion is also referred to as the Hôtel des Ambassadeurs de Hollande, after an eighteenth-century Dutch ambassador who had resided here. Though closed to the public, the portal facing rue Vieille du Temple is visible, and worth a visit for its relief sculpture of War and Peace by Thomas Regnaudin.

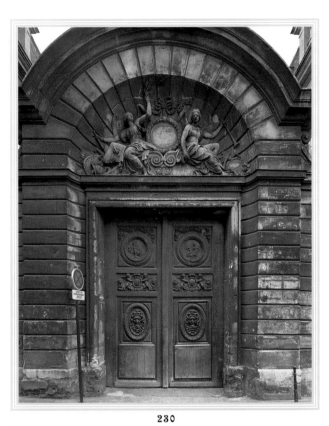

230

231

Hôtel de Châlon-Luxembourg

26, RUE GEOFFROY-L'ASNIER AT ALLÉE DES JUSTES DE FRANCE

c. 1625

Medieval weavers once plied their trade in workshops along this street. In the early seventeenth century, Guillaume Perrichel, treasurer of Paris, built this *hôtel*, then sold it in 1659 to Marie Amelot de Béon-Luxembourg. The elegant portal, with its scalloped stone carving featuring a lion's head, dates from this period. Converted to apartments in the nineteenth century, the mansion is of brick-and-stone construction with a steep roof. Gabriele D'Annunzio rented the first floor between 1914 and 1915, and the *hôtel* was dubbed "the thousand *bouddhas* house" because he was crazy about small trinkets, especially Buddha statues. The Institut d'Histoire de Paris currently occupies this stately residence.

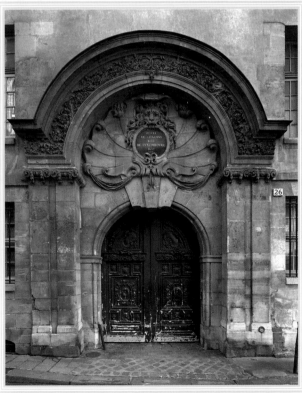

231

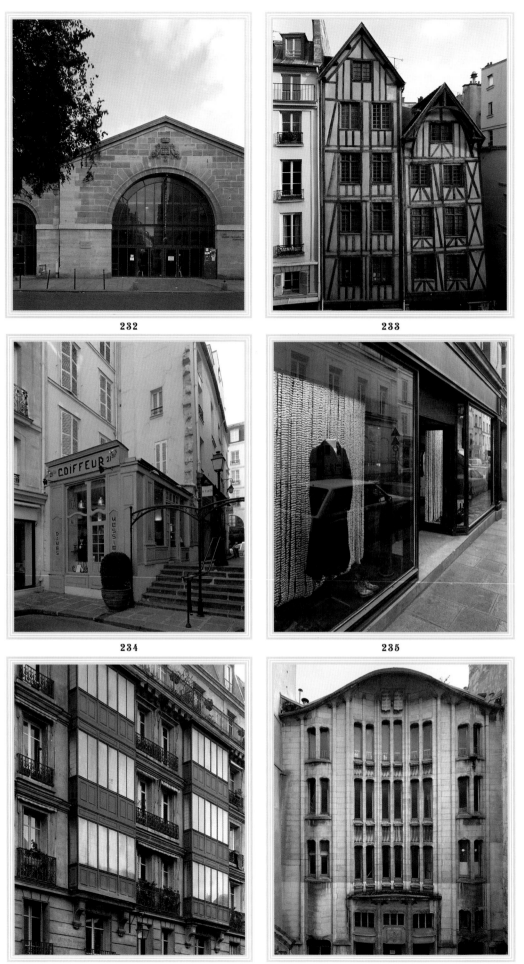

232

233

234

235

236

237

232

Marché des Blancs-Manteaux

48, RUE VIEILLE-DU-TEMPLE AT RUE DES BLANCS MANTEAUX

1813–19, ELOI DE LA BARRE AND JULES DELESPINE

Mandated by Napoléon I to further commerce, this marketplace consisted of one hall, originally a wooden structure that was reinforced with a metal framework in 1837. The market operated here until 1912. The City of Paris bought the building in 1992, and today the space serves as a cultural center for local activities and a sports gymnasium.

233

11–13, rue François-Miron

AT RUE CLOCHE PERCE

C. FOURTEENTH TO SEVENTEENTH CENTURIES
1967, RESTORATION AND INVENTIONS

Among the few remaining timber-framed houses that survive in Paris today, these two restored homes recall the Middle Ages, when gabled houses faced the street. In the early sixteenth century, an edict prohibited such frontage and stipulated that plaster cover any timbered framing to minimize the potential fire hazard these homes created. Almost a century later, a new regulation mandated that stone replace the wooden façades.

234

Hair shop

21 BIS, RUE DE RIVOLI AT RUE CLOCHE PERCE

C. 1880

This quaint hair salon, wedged into the corner on the ground level between two nondescript buildings, looks lost in time. Dwarfed by the two stone buildings, it resembles a doll's house with curving window trim and wood paneling.

235

L'Eclaireur

3TER RUE DES ROSIERS AT RUE PAVÉE

C. 1840

This long and basic corner building contains apartments on the upper levels and a storefront on the ground floor. And it extends next door, where a tiny building survives, wedged between two large buildings, covering the passage, impasse Coquerel, from the street behind rue Ferdinand Duval. This shop, with iron girders, is a former warehouse.

236

19 rue Pavée

AT RUE MALHER

1890, P.-M. LATRUFFE

Two sets of metal-framed glass windows punctuate the exterior of this nineteenth-century building, bringing animation to the severe stone façade. Before building rules changed, the jutting structure of these bow windows did little to increase the inside space until the law allowed deeper extensions. This metal framework was quite light, but it marked the beginning of an evolution in the Haussmann typology that allowed more interior illumination and opened the building to the exterior.

237

Synagogue

10, RUE PAVÉE BETWEEN RUE DES ROSIERS AND RUE DU ROI DE SICILE

1913, HECTOR GUIMARD

Constructed from adobe stone and reinforced by a concrete structure, this synagogue for a Jewish community of Russian-Polish descent is a model of balanced and composed Art Nouveau styling. The curved rooftop gently undulates above the façade, recalling a simple temple dome, and mimics the wave-line of the portal below. Playing with shadow and light, the slender horizontal lines add dimension to the façade, while the narrow, top-rounded, double windows resemble the shape of the stone tablets from Sinai.

238

Hôtel d'Aumont

7, RUE DE JOUY (GARDEN SIDE FACING SEINE)
AT RUE NONNAIS-D'HYÈRES AND SQUARE ALBERT-SCHWEITZER

1631–50, FRANÇOIS MANSART; THEN VILLEDO AS MASON; 1655,
EXTENSION LIBÉRAL BRUANT, INTERIOR DECORATION CHARLES LE BRUN;
1703, GEORGES MAURISSART EXTENSION

In 1957, the City of Paris restored this building. This magnificent façade is visible from rue Nonnains-d'Hyères. François Mansart originally decorated the home for Michel-Antoine Scarron, and then his son-in-law, duc Antoine d'Aumont, mayor of Paris, moved in and remodeled it in 1657 with décor enhancements by Charles Le Brun. The Le Brun ceiling still survives.

239

Hôtel Hénault de Cantobre
(MAISON EUROPÉENNE DE LA PHOTOGRAPHIE)

82, RUE FRANÇOIS-MIRON AND 7, RUE DE FOURCY

1704–15, HÔTEL; 1995, YVES LION, ASSISTED BY ANNIE LE BOT, AND
ALLAN LEVITT, EXTENSION

When constructing a modern extension for the old Hôtel Hénault de Cantobre, architect Lion opted to complement the existing building by employing similar proportions and materials for the new wing: He created its façade with the same dimensions of the old *hôtel*, and used Saint-Maximin stones as in the mansion. Lion separated the two buildings with a glass panel and capped the extension with an overhanging tin cornice.

240

Hammam Saint-Paul Turkish baths

4, RUE DES ROSIERS AT RUE PAVÉE

C. NINETEENTH CENTURY

In 1856, the Société des Israélites polonais de la loi rabbinique occupied this place; next, a *hammam*. From Polish Jews to Turkish baths, the strange destiny for this nineteenth-century building awaited yet another odd turn: a luxury shop opened here in 1991.

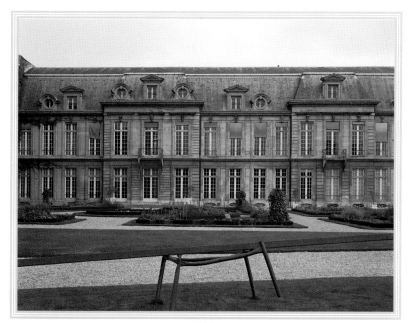

238

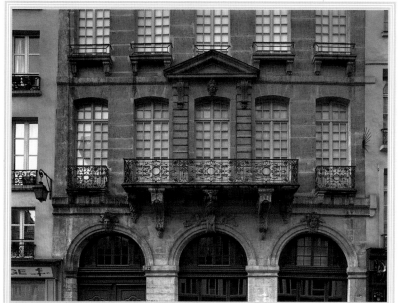

239

240

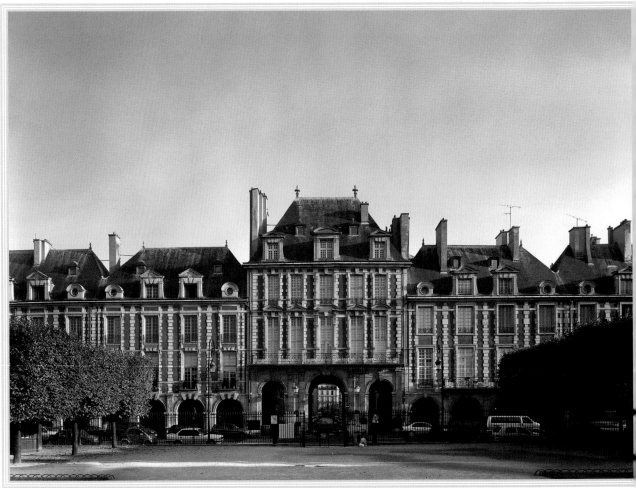

241

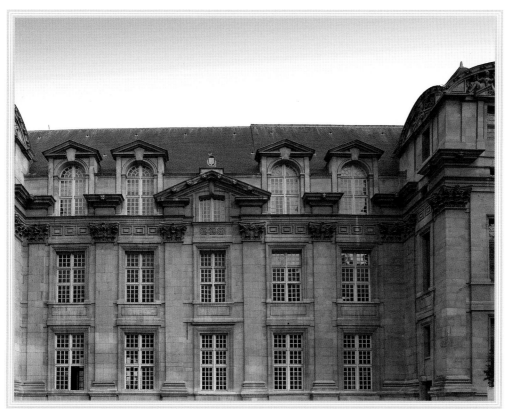

242

Place des Vosges

NORTH AND SOUTH SIDES OF PLACE DES VOSGES
BETWEEN RUE SAINT-ANTOINE AND RUE DES FRANCS BOURGEOIS

1605, ATTRIBUTED TO LOUIS OR CLÉMENT METEZEAU, OR JACQUES II
ANDROUET DU CERCEAU, OR CLAUDE CHASTILLON; 1818, JEAN-PIERRE
CORTOT AND LOUIS-MARIE DUPATY, REPLACEMENT STATUE OF LOUIS XIII

Place des Vosges, known as place Royale in the seventeenth century, was a favorite spot to determine one's fate by the sword. Celebrations of a more noble cause also graced this royal place. In 1612, the double wedding of King Louis XIII to Anne of Austria, and of his sister Elizabeth to Philip IV of Spain, inaugurated this open-air square—the oldest of its kind in Paris. As first conceived in 1605 during the reign of Henry IV, its façade borders an open-air square on all sides, anchored by the King's Pavilion (*Pavillon du Roi*) on the south end and the Queen's Pavilion (*Pavillon de la Reine*) on the north side. The resultant uniformity has survived to this day even through turbulent times, though the Revolutionaries melted the square's original Louis XIII statue.

242

Hôtel de Lamoignon

24, RUE PAVÉE CORNER OF RUE DES FRANCS-BOURGEOIS

C. 1610, POSSIBLY THIBAULT MÉTEZEAU

In a determined effort to enforce his ban on dueling in place des Vosges (then place Royale) in 1626, Cardinal Richelieu ordered the execution of two who defied his orders, and promptly displayed their severed heads and bodies in the main hall of Hôtel d'Angoulême. Originally built for Diane de France, duchesse d'Angoulême, it became Hôtel de Lamoignon in 1688 when president of the parliament of Paris, Chrétien-François de Lamoignon, resided there. Additions and remodeled wings have altered the mansion since its early owners occupied it. The overhanging turret on the corner dates from 1624, and the decorative portal featuring two putti dates from 1718. The City of Paris acquired this building in 1928, but restored it only in the 1960s in order to house the Bibliothèque Historique de la Ville de Paris, the history library of Paris.

243

Hôtel Bouthillier de Chavigny

7-9, RUE SÉVIGNÉ AT PLACE DU MARCHÉ SAINTE CATHERINE

C. 1580; 1642–43, FRANÇOIS MANSART

Only a single western bay of the original six-teenth-century *hôtel*, acquired by Léon Bouthillier, exists today. Bouthillier commissioned architect Mansart to remodel and enlarge the earlier residence. The Mansart façades are still visible on the northern court. The house itself does not have much exposure, however, as it is contained within a firemen's barracks.

244

Saint-Paul–Saint-Louis

99, RUE SAINT-ANTOINE AT RUE SÉVIGNÉ

1627–41, FRÈRE MARTELLANGE, PLAN; PÈRE DERAND, FAÇADE AND
CUPOLA; FRÈRE TURMEL, INTERIOR

The name of this church derives from a double dedication: first, to Saint-Louis and second, to Saint-Paul. Originally conceived in 1627 as a monastery for the Jesuits, the church honored Saint-Louis alone. In 1797, the nearby church of Saint-Paul was demolished, but in 1802 its clock replaced the elliptical window in the center of the façade of Eglise Saint-Louis, which thus acquired its additional name. It was modeled after the layout of Gesù in Rome, from which it borrowed the domed structure then used for the first time in Paris. The façade directly replicates that of the very Parisian church, Saint-Gervais, with its three levels, Corinthian columns, and niches with statues.

245

Wall fragment of Philippe Auguste

ANNEX OF LYCÉE CHARLEMAGNE AT RUE DES JARDINS-SAINT-PAUL

1190

Running seventy meters along the rue des Jardins-Saint-Paul, this is the largest existing relic of the wall erected to protect Paris while Philippe Auguste gallivanted off to the Crusades. Composed of two sides of freestone, with a mixture of sand and rubble filling the empty spaces, the remains of this enclosure were often preserved and concealed behind various court-yards and workshops around Paris. Today, the buildings of the antique village of Saint-Paul are on one side of this particular fragment, while a ground surface used for sports and a children's play space occupy the other side.

246

Lycée Charlemagne

14, RUE CHARLEMAGNE AT RUE DU FAUCONNIER

C. 1622, FRÈRE TURMEL

Originally built as a Jesuit monastery, this building lodged novice monks as they completed their studies. It became a school site in 1802 when Napoléon I granted the buildings to Lycée Charlemagne. Noteworthy features include its interior seventeenth-century staircase and the Giovanni Gherardini fresco, *The Apotheosis of Saint Louis*, which adorns the cupola. The Lycée Charlemagne is part of the current church of the Saint-Paul–Saint-Louis complex.

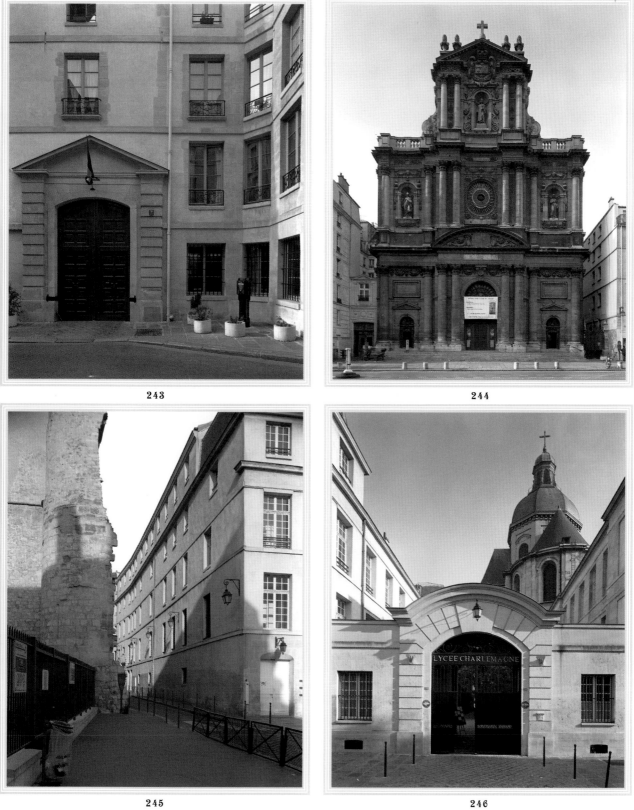

243

244

245

246

247
Hôtel de Sens
(Bibliothèque-Mediathèque Forney)

1, rue du Figuier at rue du Fauconnier

1475–1507, transformation of the first hôtel;
1843, L. Bénouville, restoration;
1934–60, Charles Halley, restoration

On July 28, 1830, a stray cannonball pierced the eastern façade of Hôtel de Sens, lodging itself permanently in the wall. Built originally for the archbishops of Sens in the fourteenth century, this *hôtel* was remodeled completely by Archbishop Tristan de Salazar. The building has seen many more changes since but its façade still has the cannonball.

248
14, quai des Célestins

1935, Georges Bourneuf; 1981, Franco Cesari

Inspired by the peaceful courtyard of the nearby place des Vosges, architect Cesari refurbished this building to serve as warehouses for the Samaritaine department store. In trying to recreate the scale of traditional neighborhood residences, Cesari subdivided the building into five small sections, between which he positioned large, recessed bay windows. Floodlit and tiled, the inner courtyard space has a quiet ambience but with the odd sensation of being inside an aquarium.

249
Building with Watchtower
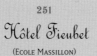

Corner of 8, rue Saint-Paul and 18, rue des Lions

c. 1700

This watchtower on the corner of rue Saint-Paul and rue des Lions is one of the few to survive in Paris today. Though the tower itself dates from the late sixteenth or early seventeenth century, the building façades supporting it on both sides had facelifts a century later.

250
Hôtel de La Cossaye

6, rue Charles-V between rue Saint-Paul and rue Beautreillis

c. 1642

This mid–seventeenth-century building has a rather plain façade and is typical of the layers created by centuries of construction and transformation. When the kings moved from Île de la Cité, they resided near this site in the royal mansion, Hôtel Saint-Pol. After Catherine de Médici's husband, King Henry II, died accidentally in a jousting tournament nearby, she moved away and the former royal area was replaced by a regular neighborhood.

251
Hôtel Fieubet
(Ecole Massillon)

2 bis, quai des Célestins at rue du Petit Music

1678–82, Jules Hardouin-Mansart; 1857, Jules Gros;
1892, P. Wallon, right wing

This old mansion, now a school, has a history of remodeling that never quite got the job done. In 1676, Gaspard III Fieubet worked on the home improvement of an existing *hôtel*, and in 1858, Adrien de La Valette began his Baroque-style additions with architect Gros, but these were never finished. The mishmash result stands today.

252
Ecole Massillon
(Gratry annex)
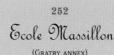

9, rue Petit-Musc at rue Beautreillis

1935–36, Gaston Bouzy and Jean Giraud

The development of the Massillon religious school on nearby quai des Célestins necessitated an annex for boarders. Canon Pradel, the school's director, hired architects Bouzy and Giraud to design this dormitory. Because of its proximity to the river, the architects built the entire structure, except for the roof, out of concrete. They covered the façade with a hard, clear pink stone called Serrigny. The corner rises in the shape of a severe, rectangular tower as a reflection of the studious atmosphere inside.

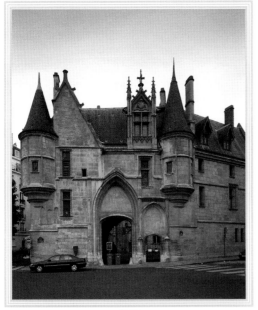

247

248

249

250

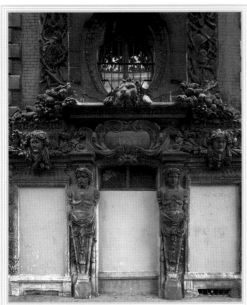

251

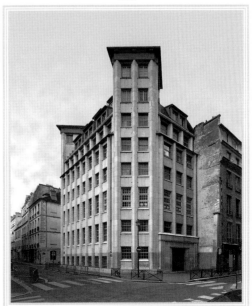

252

Hôtel de Sully

62, RUE SAINT-ANTOINE AT RUE DE BIRAGUE

1624–30, JEAN 1ST ANDROUET DU CERCEAU; 1651, FRANÇOIS LE VAU, INSIDE LEFT WING COURTYARD; 1660, SIMON LAMBERT, RIGHT WING GARDEN

After the first owner squandered his gambling fortune, his creditor, the duc de Sully, minister to Henry IV, assumed control of this house. In his mid-seventies when he moved into this mansion, the duc de Sully, also known as Maximilien de Béhune, marquis de Rosny, had a rousing good time here, as did his heirs. The old duke loved dancing with young women of ill-repute under the arcades of Place Royale, now the nearby Place des Vosges, while he accommodated his young wife and her lovers by building them separate apartments within this residence. His daughter, the duchesse de Rohan, fooled around here, too, and had an illegitimate son. A century later, Voltaire challenged the then-prince de Rohan who lived here to a duel, but Rohan had Voltaire thrown in prison instead. Today, the Caisse Nationale des Monuments Historiques occupies the building and maintains the history of Hôtel de Sully as well as the cultural heritage of France. Their restoration preserves the original building configuration between the court and garden. The horseshoe-shaped *hôtel* consists of a main building with an entry court framed by two identical wings and a garden with a former orangerie. Allegorical sculptures of the Four Seasons adorn the façades of the main building, and the Four Elements—Fire, Earth, Air, and Water—are divided into pairs to decorate the two wings. The carvings, no doubt, were favorites of Sully's for their year-round entertainment value.

253

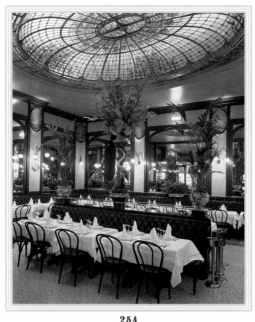

254

Brasserie Bofinger

3, RUE DE LA BASTILLE AT PLACE DE LA BASTILLE

1864

This quintessential brasserie is the genuine article from the Belle Epoque. Bofinger is famous as both the oldest brasserie in the city and the first Parisian restaurant to serve draft beer on tap. Inside, under a colossal stained-glass cupola, turn-of-the-century–attired waiters serve up enormous seafood platters and other traditional dishes such as onion soup, classic *choucroute*, and a dessert of crème brûlée.

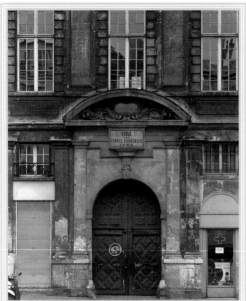

255

Hôtel de Mayenne

21, RUE SAINT-ANTOINE AT RUE DU PETIT MUSC

1606–09, OVERSEEN BY MASTER MASON, THEN ARCHITECT JACQUES II ANDROUET DU CERCEAU; 1707–09, GERMAIN BOFFRAND, INTERIOR

This renovated mansion typifies the slated-roof and brick-and-stone construction of Louis Treize style. Charles de Lorraine, the duc de Mayenne, began construction on his *hôtel*, but his son Henry altered its appearance, presumably with designs by architect Du Cerceau. In 1812, the Institution Favart refitted it to accommodate school classrooms. Later the Brothers of Christian Schools acquired it, converting it to the current Ecole de Francs-Bourgeois.

256

Post Office

12, RUE DE CASTEX AT RUE SAINT ANTOINE

1935, JOSEPH BUKIET;
1995, MARIE-ANNE BADIA AND DIDIER BERGER, RESTORATION

This original post office and its up-to-the-minute restoration sixty years later reflect how much Parisian architecture had changed in the intervening years. Composed of ceramic, glass, and metal, the 1935 façade hid its concrete structure, and the building was designed with a classically heavy base. Sixty years later, architects used a light metal framework, added floors, and exposed the interior space to the outer world by means of large glass windows.

257

Sous-station Bastille

5, RUE DE LA CERISAIE AT BOULEVARD BOURDON

1911, PAUL FRIESÉ

When the flood of January 1910 temporarily knocked the Bercy power station out of commission, the electric substation at rue de la Cerisaie (named for the cherry orchards here) assumed general control for the Company of the Subway of Paris (now RATP). The original frontage in sand-lime brick, with its medieval/Islamic flavor, was refitted with dull windows at its lower portion facing rue de la Cerisaie.

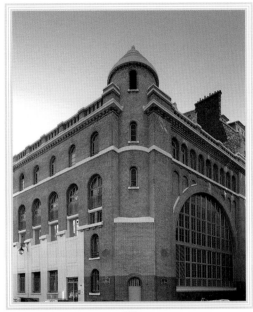

257

258

Bibliothèque de l'Arsenal

1, RUE DE SULLY AT RUE MORNAY

1715–25, GERMAIN BOFFRAND;
1745, ANTOINE-NICOLAS DAUPHIN, INTERIOR

In the sixteenth century, the Royal Arsenal, where cannons were made, controlled an area from the banks of the Seine to the Bastille. This remaining portion of the arsenal served as a residence before being converted to a library. Originally, the duc de Sully lived here as the grand master of the artillery; then architect Boffrand enlarged it for a new grand master, the duc de Maine. In 1755, the Guard of the Arsenal, Voyer d'Argenson, established the library.

258

259

Pavillon de l'Arsenal

21, BOULEVARD MORLAND AT BOULEVARD HENRY IV

1878–79, A. CLÉMENT; 1988, BERNARD REICHEN AND
PHILIPPE ROBERT, REMODELING

Laurent-Louis Borniche, a wealthy wood merchant and art lover, commissioned this building to house his collection of over 2,000 works of art. But, when he died in 1883, his daughter sold the collection and rented the building out. In turn, it became a liqueur store, a restaurant, and a garment factory for the Samaritaine department store. In 1954, the City of Paris used it for archives. Now this glass, stone, and metal structure serves as a venue for architectural events.

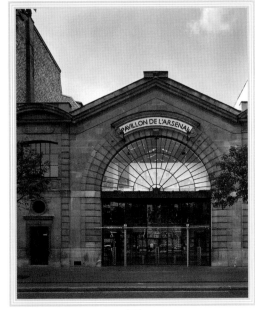

259

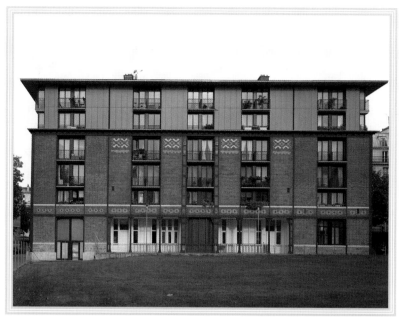

260

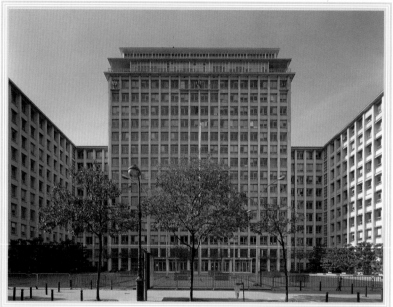

261

262

260

Housing for Republican Guard

2, RUE DE SCHOMBERG

1883, JOSEPH BOUVARD; 1998, YVES LION, RESTORATION AND EXTENSION

Designed by architect Bouvard, these buildings house 450 men—three groups each of 150—of the Garde républicaine. Bouvard's polychromatic brick façade created a decorative wall pattern, and his use of metal to tighten the brick walls was an unusual construction technique, considering hard stone was then the norm. For the late twentieth-century restoration, Yves Lion respected the original design and added modern extensions using contemporary material.

261

Préfecture de Paris

17, BOULEVARD MORLAND BETWEEN RUE DE SCHOMBERG
AND RUE AGRIPPA D'AUBIGNÉ

1955–75, ALBERT LAPRADE

To concentrate the services of the administration of the prefecture, the State built this ugly tower in 1955. Because it was a public construction, conceived for basic functions, no frills were added, and so it looms above all the buildings around it, reminiscent of utilitarian structures that appear in Soviet-style cities. Totally dedicated to administrative work, the Préfecture has the flexibility to adapt to different distribution services and daily routines.

262

Hôtel Lambert

2, RUE SAINT-LOUIS-EN-L'ÎLE AT QUAI D'ANJOU

1640–44, LOUIS LE VAU, BUILDING; EUSTACHE LE SUEUR, CHARLES LE
BRUN, AND FRANÇOIS PERRIER, INTERIOR DECORATION

Once Hôtel Brentonvilliers was destroyed to make room for the construction of boulevard Henry IV, this *hôtel* became the residence of choice on Saint-Louis-en-l'Île. The entrance to Hôtel Lambert faces rue Saint-Louis-en-l'Île, but its garden terrace overlooks the Seine at a higher level. The building contains the Hercules Gallery and a library, both of which have magnificent painted decorations by Charles Le Brun, Eustache Le Sueur, and François Perrier.

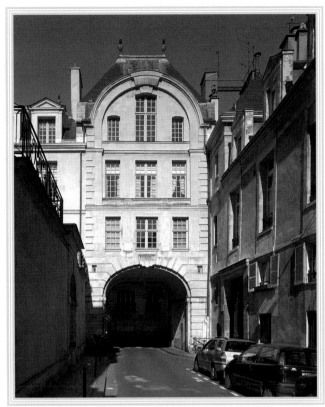

263

263

Arch

AT ENTRANCE TO RUE DE BRENTONVILLIERS
AND RUE SAINT-LOUIS-EN-L'ÎLE

1637–42, JEAN ANDROUET DU CERCEAU; 1643, SIMON VOUET, DECORATION;
1663, SÉBASTIEN BOURDON, GALLERY DÉCOR; 1840, HOTEL DESTROYED

This preserved arch is all that remains of a *hôtel* that no longer exists. When Baron Haussmann cut streets in the mid-nineteenth century to modernize the city, he did so with the thought of perspective: He wanted a clear line of sight with awesome buildings on both ends of the street. If a building did not exist in the right place, he ordered one built. If one was in the way, he had it demolished. Such was the rationale for destroying the Hôtel de Brentonvilliers—deemed an interference in the sight line from the Bastille to the Panthéon—when ground was laid for boulevard Henry IV. Haussmann preserved the arch, today the entrance of a private street. It is flanked by a series of houses built at the same time to finance the former Hôtel Brentonvilliers, which opened to a river view at the end of the island with a large garden.

ÎLE SAINT-LOUIS

Once called Île aux Vaches ("Island of the Cows") for its grazing bovines, Île Saint-Louis was basically uninhabited meadowland. For a time, in the fourteenth century, a defense tower existed on part of the island, surrounded by a moat. But by the seventeenth century, the aristocracy was clamoring for development to expand their neighborhood, and looked across the Seine to this little pasture in the backyard of Notre-Dame. The Church at first objected, but seeing a way to increase its coffers, sold off the property to Louis XIII and condoned development. Bridge engineer Christophe Marie spearheaded the project but eventually went bankrupt and La Grange assumed financial control. Louis Le Vau, architect to the Louis XIV at Versailles, left his imprint on the island as classic hotels sprang up with narrow stone façades and deep interiors. Builders filled in the old moat with just two layers of sand joined artificially, and the new island became Île Saint-Louis, renamed for the King's ancestor and patron, Louis IX.

The artificial creation of the island necessitated a connection to Île de la Cité and the banks of the Seine. Bridge-building was slow to develop but, finally, Pont-Marie joined this island to the Right Bank in 1635. With the link to the fourth arrondissement on the Right Bank, hotel building flourished and other bridges followed. Pont-Saint-Louis connects Île Saint-Louis to Île de la Cité, and Pont-de-la-Tournelle (a continuation of Pont-Marie) joins it to the Left Bank. In the nineteenth century, Baron Haussmann sliced through the eastern tip of the island while constructing boulevard Henry IV, so he could create a visual axis from the Bastille on the Right Bank to the Panthéon on the Left. Today, with its bridges and narrow streets, the island provides a romantic stroll from another era.

264

265

266

267

268

269

264

Hôtel de Lauzun

17, QUAI D'ANJOU ON L'ÎLE SAINT-LOUIS

1656, CHARLES CHAMOIS

A series of infamous owners endowed this *hôtel* with a colorful history. Charles Gruyn, a rich tavern owner's son, built this as a residence but lived here just a short time before serving a prison term for embezzling state funds. The next owner, the comte de Lauzun, acquired the house that now bears his name after a ten-year prison term for courting Louis XIV's cousin, la Grande Mademoiselle. Today, the city of Paris uses this restored seventeenth-century townhouse for its own functions.

265

Hôtel de Chenizot

51, RUE SAINT-LOUIS-EN-L'ÎLE BETWEEN RUE LE REGRATTIER AND RUE BUDÉ

C. FIRST PART OF THE SEVENTEENTH CENTURY;
1719, PIERRE VIGNÉ DE VIGNY, STREET BLOCK

Two spread-winged dragons support an elaborate, iron-foundry balcony and flank a central, decorative mask carved above the entrance of this *hôtel*. The over-the-top, Rococo-style façade represents a reaction to the austerity of the Sun King, who set all the rules and condemned everyone to stay at Versailles. After this boring period, homes were deliberately rebuilt to make them fashionable, sensual, fascinating, and demonstrative.

266

Eglise de Saint-Louis-en-l'Île

19 BIS, RUE SAINT-LOUIS-EN-L'ÎLE

1622, FRANÇOIS LE VAU; 1656–79, FRANÇOIS LE VAU THEN FROM 1675 DANIEL GITTARD AND LIBÉRAL BRUANT; 1702, GABRIEL THE DUC THEN JACQUES DOUCET, NAVE; 1765, BELL TOWER

Built when development began on Saint-Louis-en-l'Île in the early seventeenth century, this church was finally dedicated in 1726 though still minus its tower. Competition for the original project had inspired discussion of "modern" alternatives, because at the time Gothic style was considered old-fashioned. Le Vau died without finishing it, which allowed completion in modern style.

267

Brasserie de l'Île St.-Louis

55, QUAI DE BOURBON ON THE WESTERN TIP OF L'ÎLE ST.-LOUIS

C. 1870

Alsace-Lorraine refugees from the Franco-Prussian war fled to Paris in the 1870s, in search of new opportunities. Many of them opened restaurants offering their hearty country specialties to local residents. Brasserie de l'Île St.-Louis is still dishing out traditional Alsatian meals from its rustic interior whose décor includes folk art–painted windows and mounted animal heads. Diners on this old brasserie's outside terrace have the good fortune to gaze out over the Seine and at Notre-Dame on Île de la Cité.

268

Théâtre de la Ville

PLACE DU CHÂTELET AT PONT AU CHANGE

1860–62, GABRIEL DAVIOUD

Théâtre de la Ville stands opposite its mirror image in the 1st arrondissement, the Théâtre du Châtelet. As part of his vision for the city, Baron Haussmann wanted two symmetrical theaters situated on that square, and the Baron got what he commissioned. He also moved the Fontaine du Palmier, one of the seventeen fountains ordered by Napoléon I, to the center of Place du Châtelet, and decorated its base with sphinxes spouting water.

269

Eglise Saint-Gervais-Saint-Protais

PLACE SAINT-GERVAIS AT RUE DE BROSSE AND FRANÇOIS-MIRON

C. THIRTEENTH CENTURY, BASE OF BELL TOWER;
1494–1540, CONSTRUCTION FROM THE CHOIR TO THE TRANSEPT;
1616–21, SALMON DE BROSSE ARCHITECT, FAÇADE

In medieval Paris, an old elm—positioned slightly to the left of the current one, planted in 1914—was a favorite spot for settling old scores and meting out justice. The subject of many paintings, engravings, and carvings, the elm motif decorated home furnishings, balcony ironwork, workshop signs, and four wooden choir booths within this church. The façade dates from the early seventeenth century.

270

Hôtel de Charron, Hôtel de Jassaud

15–19, QUAI DE BOURBON ON L'ÎLE SAINT-LOUIS

¢15, HÔTEL DE CHARRON, 1637–40, SÉBASTIEN BRUAND
¢19, HÔTEL DE JASSAUD C. 1635, ARCHITECT UNKNOWN

In a letter to Camille Claudel, Rodin wrote: "My very dearest, I am down on both knees before your beautiful body which I embrace." Claudel met Rodin in Paris in 1883, but, by end of the nineteenth century, he had abandoned her and gone back to his wife. From that time until about 1913, Claudel lived and worked in a studio on the ground floor of Hôtel de Jassaud at the back courtyard of 19, quai de Bourbon. Named for Nicolas de Jassaud, secretary of state to Louis XIV, who had owned Number 19 in 1660, this mansion has a typical stone façade, but a graceful, wrought-iron balcony hangs just above a center door, and three sculpted pediments distinguish it from its neighbors.

271

2-12, rue François-Miron

AT THE NORTH SIDE OF CHURCH SAINT-GERVAIS AND RUE DES BARRES

1733, JACQUES VINAGE;
1943–45, ALBERT LAPRADE, PRESERVATION

As was the norm in fifteenth-century Paris, churches were the big landlords. It was not uncommon for a church to rent out apartments to increase its monetary position, and this is what happened here. Typical of the period's architecture, the housing—built on a hill constructed as protection from the river when it overflowed—was all quite similar, featuring staircases up the front. A cemetery once existed here as well. But when the houses were rebuilt in the mid–eighteenth century, it was closed, as burial was forbidden within town limits during this period. In 1939, the City of Paris had plans to demolish these row houses, but Albert Laprade launched a preservation effort to save them.

272

BHV

(BAZAR DE L'HÔTEL DE VILLE)

52–64 RUE DE RIVOLI AT RUES DU TEMPLE, DE LA VERRERIE AND DES ARCHIVES

1902–04, GRANON AND ROGER; 1912–13, AUGUSTE ROY

In 1856, Xavier Ruel, a small entrepreneur with big ideas, tested the market for knickknacks by positioning peddler carts in various locations around Paris. Sales boomed at the site of the current BHV store, and he opened Bazar Napoléon across from l'Hôtel de Ville in a prescient move that foreshadowed the busy retail activity that exists in this location today. Legend has it that Napoléon III rewarded Ruel financially for saving Empress Eugenie, when her horses bolted in front of his store—thus the name Bazar Napoléon. After Napoléon's death, the name was changed to Bazar de l'Hôtel de Ville, but today it's known simply as BHV.

273

Tabac des Templiers

35, RUE DE RIVOLI AT RUE DE LA TACHERIE

One of the quirkier bars in Paris, Tabac des Templiers dispenses cigarettes and, as its name implies, showcases a secretive order of medieval Crusaders know as the Knights Templar. Relics from the past cram interior glass cases, along with photos of uncrowned princes (Bourbon line, no Orléanists here), plaster busts of Louis XVI and Marie Antoinette, and a statue of Joan of Arc in armor. Each year, the bar mourns the beheading of King Louis XVI with a special ceremony. It also mourns the demise of its own Templar leader who met with an untimely execution on the Pont-Neuf bridge. It seems the bar owner prefers royalty over Revolutionaries and, as one of about 75,000 royalists in Paris, waits for the return of the would-be Louis XX.

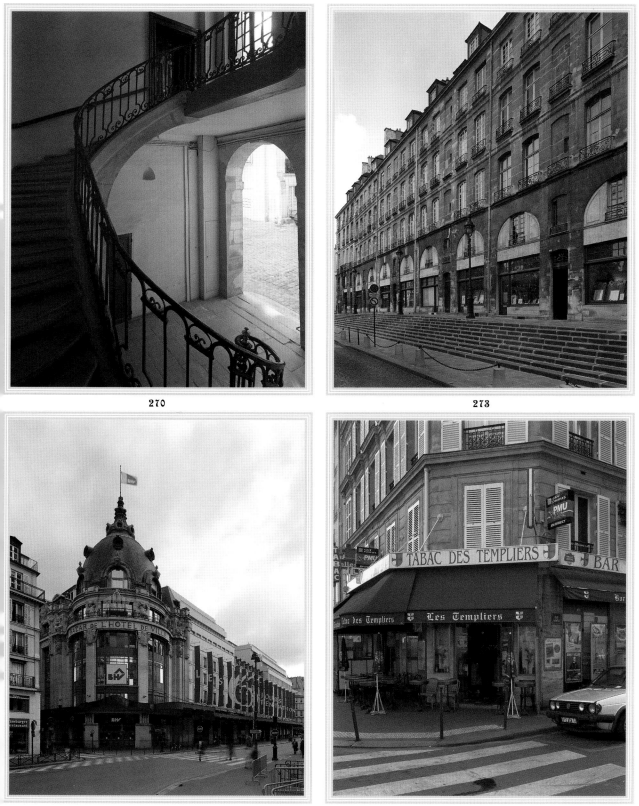

270

273

272

273

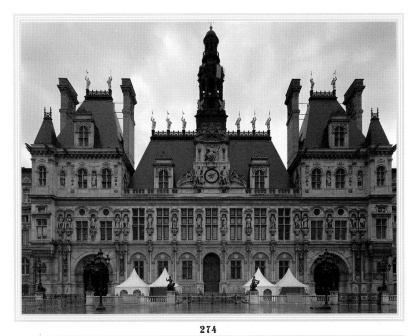

274

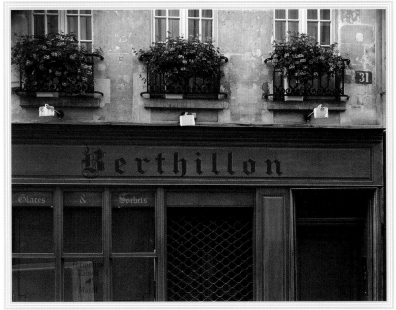

275

276

274

Hôtel de Ville

PLACE DE L'HÔTEL DE VILLE
BETWEEN QUAI DE L'HÔTEL DE VILLE AND RUE DE RIVOLI

1533, DOMENICO DA CORTONA (AKA LE BOCCADOR), ORIGINAL BUILD-
ING; 1836–50, ETIENNE-HIPPOLYTE GODDE AND J.-B. CICERON
LESUEUR, ADDITIONS; 1873, THÉODORE BALLU AND EDOUARD
DEPERTHES, CURRENT BUILDING

Countless criminals, heretics, murderers, witches, and other ignoble characters met their demise in Place l'Hôtel de Ville, known as Place de Grève until 1830. It began as a wooden two-story town hall in 1357, and went throught several incarnations. Rebuilt between 1873 and 1882 as the current City Hall, Hôtel de Ville is a sumptuous neo-Renaissance complex.

275

Chez Julien

ONE, RUE DU PONT LOUIS-PHILIPPE AT RUE DE L'HÔTEL DE LA VILLE

C. NINETEENTH CENTURY

A registered, national landmark for its façade, Chez Julien combined a bar and a bakery to beget a bistro. The bakery's unique glass-painted landscapes adorn one side of the eatery while the bar's original 1820s grillwork enhances the other. The carved oak bar fills the front dining room, and pastoral scenes of peasants and cherubs decorate the back room. Positioned on a cobblestone street with a view of the Seine and its two islands, Chez Julien transports you to the nineteenth century.

276

Berthillon

31, RUE SAINT-LOUIS ON L'ÎLE SAINT-LOUIS

1954

Contributing to the uniformity of architecture on the entire Ile Saint-Louis, this seventeenth-century building hosts the well-known Berthillon café on the ground level. Boasting the best ice cream in Paris, Berthillon has long been a famous fixture on Île de Saint-Louis. Though others may vie for that honor, the long lines of people queuing for their favorite flavor attest to its well-earned reputation. Here's the scoop: over sixty flavors and no artificial ingredients.

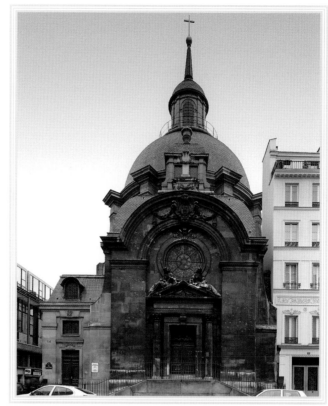

277

La Visitation

1632–34, FRANÇOIS MANSART

Long before this historic Marais site became a church, a fifteenth-century mansion stood here, and enjoyed a succession of noble occupants. It was here, in 1628, that the Bishop of Geneva, Saint-François-de Sales, established Les Visi-tandines, the Order of Sainte-Marie-de-la-Visi-tation—a convent dedicated to educating girls and aiding the sick. Inspired by the chapel of the Château d'Anet of Philibert Delorme (of Santa Maria de Loreto in Rome), this was the first of Mansart's important buildings. It features a domed rotunda supported by eight buttresses and a crypt sustained by a single pillar. Until 1660, Father Superior Saint-Vincent-de-Paul presided over the convent which doubled as a retreat—voluntary or forced—for exemplary members of society as well as those with ques-tionable morality and conduct. Similarly, the burial crypt holds the remains of numerous famous and infamous characters.

5TH ARRONDISSEMENT

In May 1968, rioting students shattered the scholarly environment of the 5th arrondissement with massive demonstrations that culminated in tear gassing, crushed cars, and general political upheaval. This was a far cry from the days when students sat quietly outdoors, at their teachers' feet, soaking up words of wisdom taught in Latin (which is what gave the quarter its name). For many tourists, the Latin Quarter and the dome of the Sorbonne chapel are synonymous, representing the embodiment of learning. Long home to students, professors, and left-leaning intellectuals and politicians, the Latin Quarter revolves around the Sorbonne, founded in 1253, as well as other Grandes Ecoles, cultural institutes, medieval churches, cafés, and bookstores. From the Seine, where the Institute du Monde Arabe and Jardin des Plantes are situated, to the Roman ruins of the Cluny baths, the Panthéon, and Val-de-Grâce at the southern edge, the buildings all bear evidence of the 5th arrondissement's illustrious roots. Although fast-food joints and cheap clothing chains now vie for attention with bookstores, galleries, and art house cinemas on the boulevards Saint-Michel and Saint-Germain, the neighborhood still retains its historic and academic charm.

278

Sorbonne Chapel

PLACE DE LA SORBONNE
BETWEEN RUE DE LA SORBONNE, RUE DES ECOLES,
RUE CUJASAND, AND RUE SAINT-JACQUES

1253, FOUNDED; 1635–42, JACQUES LEMERCIER;
1881–1901, HENRI-PAUL NÉNOT

The Sorbonne's seventeenth-century chapel, which has an exquisite dome, personifies scholarship as a visual symbol of the Latin Quarter. In 1210, several centuries after the Norsemen devastated Paris, Philippe Auguste financed and encouraged redevelopment on the Left Bank to balance city growth on both sides of the Seine. Business was already thriving on the Right Bank; on the Left, where earlier Christian sites existed, religious orders—primarily responsible for education in those times—taught classes in open forums. Theologians and intellectuals preached while standing on wooden benches in the vicinity of place Maubert and rue de Fouarre, and students plunked down seats around them, to absorb their teachings. Permanent colleges gradually replaced open-air learning and, in 1253 Robert—a scholar, chaplain, and confessor of Saint-Louis, who hailed from the village of Sorbon—established a college to house and educate poor students. It became La Sorbonne, the seat of the theological faculty. Its size and reputation grew over the next several centuries despite its limited religious teachings in Latin. In fact, until the Revolution, the Sorbonne's curriculum was restricted to theology, leaving the teaching of humanism to the College de France from the Renaissance. In 1626, Cardinal Richelieu commissioned architect Lemercier to expand and rebuild the Sorbonne. Today, the chapel, with its street and courtyard façades, is the only surviving portion from that period.

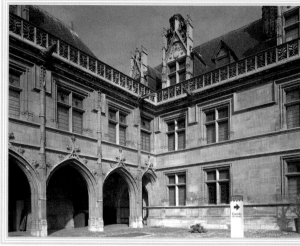

279

280

281

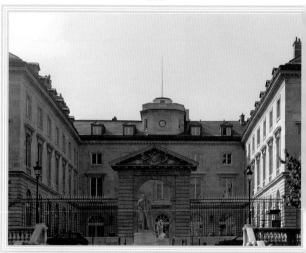

282

283

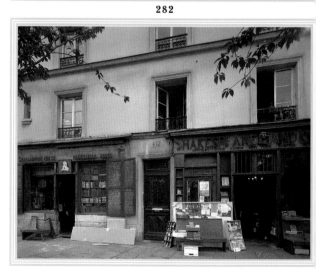

284

279

École élémentaire

28, RUE SAINT-JACQUES AT RUE PARCHEMINERIE

c.1880

Between 1870 and 1914, three hundred schools were constructed in Paris to support the growing demand from the immigrant, working population. The minister of education established new building regulations: rooms had to be well-lit from one side and buildings had to be raised sixty centimeters above the ground and constructed of brick and tile. Thus it was easy to recognize these buildings with their stone foundations, the well-marked ground level of two materials, the large windows, and the use of brick and stone for the lintels and frames.

280

Hôtel and Musée de Cluny

6, PLACE PAUL-PAINLEVÉ AT RUE DU SOMMERARD

1485–1510, CONSTRUCTION;
1843–56, ALBERT LENOIR, REMODELED AND ENLARGED

One of the oldest, secular monuments in Paris, this Gothic mansion—once home to the affluent abbot of Cluny—is like a charming castle from a fairy tale. Its spires and arcades, winding staircases and stained-glass windows, courtyard gargoyles and story-telling tapestries virtually celebrate Paris of the Middle Ages. The six-paneled *Lady and the Unicorn*—the most famous of the woven tapestries—is an allegorical work upon the six senses.

281

Brasserie Balzar

49, RUE DES ECOLES AT RUE SAINT-JACQUES

LATE 1890S

A classic among scholars, this landmark brasserie has endured over one hundred years in the area of the Sorbonne and other nearby colleges. Despite fickle students and the fast food joints that have cropped up over the last generation, Brasserie Balzar remains a holdover with few changes in its menu or in its décor over the years. Inside its Art Deco interior, waiters dressed in long white aprons serve its Parisian regulars.

282

Collège de France

11, PLACE MARCELIN-BERTHELOT AT RUE DES ECOLES

1610, PROBABLY CHASTILLON; REBUILT 1774–80, JEAN-FRANÇOIS-THÉRÈSE CHALGRIN; 1831–32, PAUL LETAROUILLY, EXTENSIONS; 1928–33, ALBERT AND JACQUES GUILBERT, AND LECONTE; 1941–52, LECONTE

This college sits on the grounds of the old Roman baths. Around 1530, François I was pressured to expand the horizons of the dogmatic religious teachings at the University of Paris. Thus, at the urging of humanist Guillaume Budé, who wanted to instill new teaching methods, François I established the Collège du Roi, or Royal College, which became the Collège de France.

283

Le Piano Vache

8, RUE LAPLACE BETWEEN RUE VALETTE
AND DE LA MONTAGNE-SAINTE-GENEVIÈVE

C. 16TH CENTURY, BUILDING TRANSFORMED; 1969, BAR INSTALLED

Dark and dated and densely filled with smoke, this dive attracts an outsider crowd that gathers on Wednesday nights for gothic intrigue. Posters dating from the 1970s paper the walls and cover the plaster, but the bar inside has survived over a hundred years. On most evenings, this rustic Latin Quarter tavern is a Sorbonne student stronghold.

284

Shakespeare & Co.

37, RUE DE LA BÛCHERIE AT SQUARE RENÉ VIVIANI AND QUAI DE MONTEBELLO

c.1600

At the address of 12, rue de l'Odeon, Sylvia Beach first published James Joyce's *Ulysses* and used to welcome Hemingway and other writers into her home and the original bookshop called Shakespeare & Co. She would often give them books and extend credit to them. Though this bookshop on rue de la Bûcherie is not the real McCoy, it is legendary in its own right. Named for Sylvia Beach's Shakespeare & Co, this one sits on the bank of the Seine, and is crammed with new and used books.

285

Hôtel de Laffémas

14, RUE SAINT-JULIEN-LE-PAUVRE
AT RUE GALLANDE AND RUE SAINT-JACQUES

c. 1640

With a reputation as a hanging judge, Isaac de Laffemas, the owner of this mansion, was not well regarded by the people, who imagined that every morning he awakened saying, "It will be good to hang [someone] today." They even wrote songs against him, though he probably was a diligent city official in charge of the law from 1637 to 1643. Directly opposite the Saint-Julien-le-Pauvre church, this hotel has had extensive renovation, but its entrance and sculpted portal are original. The tympanum within the curved portico represents the figure of Justice—a reflection of course, on its owner.

286

Église Saint-Julien-le-Pauvre

1, RUE SAINT-JULIEN-LE-PAUVRE
AT RUE GALLANDE AND RUE SAINT-JACQUES

c. 1165–1220, LONGPONT BENEDICTINE MONKS; c. SEVENTEENTH CENTURY, BERNARD ROCHE, FAÇADE; 1826, GAU AND HUVÉ, RESTORATION

According to legend and prophesy, Julien killed his parents and fled, but he devoted his life to the poor and helped a beggar cross the Seine. Unbeknownst to Julien, the pauper was Christ in disguise who ultimately redeemed Julien. The site where they crossed the river became the location of the church, Saint-Julien-le-Pauvre, just opposite from the Square René Viviani. Several earlier chapels existed here, prior to this small, rustic twelfth-century church, one of the three oldest in Paris.

287

27-39, rue Galande

BETWEEN RUE DANTE AND RUE LAGRANGE

1202, STREET; c. SIXTEENTH–SEVENTEENTH CENTURIES, HOUSES

In Roman times, when Île de la Cité was Paris, and Paris (founded by the Parisii boat people) was known as Lutetia, this now-picturesque street followed the Roman route that linked Lyons to Lutetia. First developed in 1202, the current road, though reconstructed over time, retains the essence of old Paris with its charming sixteenth- and seventeenth-century houses that have narrow façades and a few gables.

288

Rue de la Huchette

BETWEEN RUE DE LA HARPE AND RUE SAINT-JACQUES

c. 1200

Originally named rue de Laas, this narrow, partially cobble stoned street begins at Place du Petit-Pont and ends at the well-known Place Saint-Michel. In 1284, it took its name from a sign, Huchette d'Or, and was renamed rue de la Huchette. Once one of the most beautiful streets on the Left Bank, it housed the l'hôtel de l'Ange, where foreign ambassadors stayed in the sixteenth century. At the beginning of the seventeenth century, it became a popular area for grillrooms and delicatessens and was known as rue des Rôtisseurs (sellers of roasted meat). Today, sadly overrun with tourists, it is filled with Greek restaurants and fast food joints, but also the famous wine cellar and jazz bar, Cave de la Huchette.

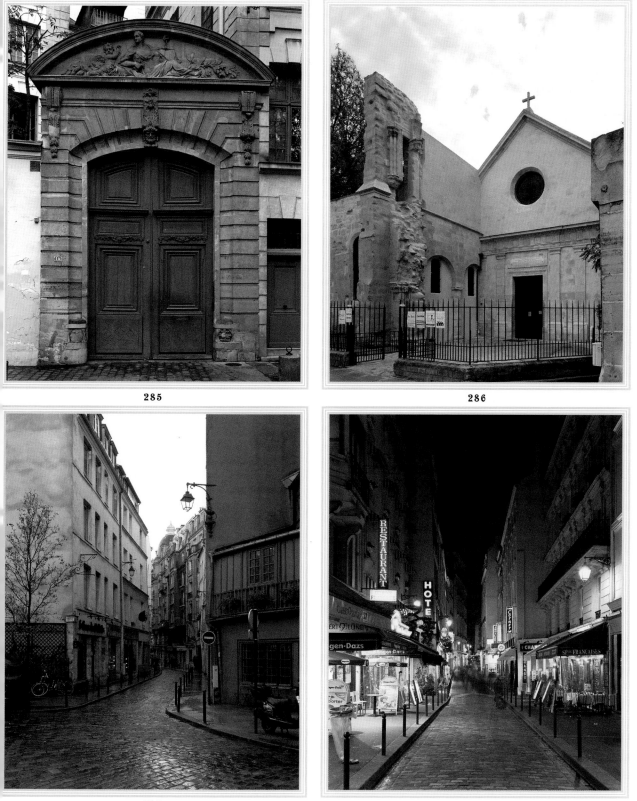

285

286

287

288

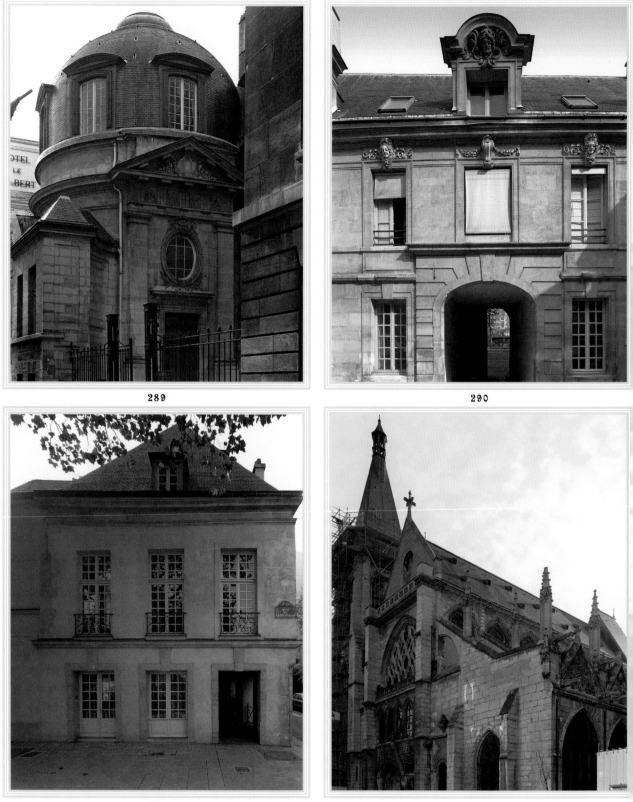

289

290

291

292

289

Former Faculté de Médecine

13–15, RUE DE LA BÛCHERIE AT CORNER OF RUE DE L'HÔTEL-COLBERT

1472; 1604, FIRST AMPHITHEATER; 1620, SECOND AMPHITHEATER,
JACQUES LEMERCIER; 1743–45, BARBIER DE BLIGNIÈRES,
AMPHITHEATER; 1909–12, GEORGES DEBRIE, RESTORATION

Before Philippe le Bel established Paris's first medical school in 1331, students gathered at the feet of professors outside on the streets of the Latin Quarter. Superstition, ignorance, and the Church limited the study of anatomy and of medicine, which at the time were two separate disciplines. But by the early fifteenth century, Le Bel's medical facility made inroads here and, by 1745, Jacquers-Benigne de Winsolow inaugurated the anatomy amphitheater designed by Barbier de Blignières. Reconstructed several times and abolished during the Revolution, the medical school reestablished its presence on rue de l'Ecole-de-Médecine (then called rue des Cordeliers).

290

Hôtel de Miramion

47, QUAI DE LA TOURNELLE AT RUE DE PONTOISE

C. FIFTEENTH CENTURY; 1522–29, PARTLY REBUILT; 1631–33, REBUILT
BY MASON JEAN THIÉRY; 1812, DESTRUCTION OF THE LEFT WING

Transformed over time, the façade of this residence on quai de la Tournelle looks out over the Seine to Île St.-Louis. In 1675, Madame de Miramion, whose name remained with the Hôtel, purchased this building as a home for the congregation of the Filles de Sainte-Geneviève. The central pharmacy of Parisian hospitals used the building in 1812. Today, the Musee de l'Assistance Publique occupies Hôtel de Miramion.

291

Hôtel de Nesmond

57, QUAI DE LA TOURNELLE AT RUE DES BERNARDINS

C. SEVENTEENTH CENTURY

This building dates to the thirteenth century, when the abbey Saint-Victor developed this plot of land for a medieval house called l'hôtel du pain (the bread hotel). The owner, the grand panetier, baked bread for the royal court of King Philippe the Fair. In 1643, Charlotte de Fourcy sold it to François Théodore de Nesmond, president of the parliament and the attendant of the Prince of Condé. Nesmond acquired additional plots of land and increased the garden's size. In 1847, it became a distillery, but a violent explosion in 1885 severely damaged it. Behind walls and a closed gate, a sober seventeenth-century building still stands, the oldest portion of which is the gate and two pavilions on each side that probably date from the sixteenth century.

292

Saint-Sevérin

RUE DES PRÊTRES-SAINT-SEVÉRIN AT RUE SAINT- SEVÉRIN

C. THIRTEENTH—FOURTEENTH CENTURIES; C. LATE FIFTEENTH CENTURY,
RECONSTRUCTION; 1489–1520, APSE AND OSSUARY, SIDE CHAPELS;
1673, JULES HARDOUIN-MANSART, COMMUNION CHAPEL

The small square next to Saint-Sevérin church contains a bizarre, Gothic sight: An arched corridor with pointed roofs curves around the square. Built in the late fifteenth century around the church's cemetery, this medieval arcade served as a charnel house—a repository for communal remains. High-ranking corpses were buried beneath the corridor, while the laity was dumped under the open spaces. Later, in the seventeenth century, when the arches were redesigned and closed off by stained glass, the clergy held meetings there, and a few resided above the arches in newly developed lodgings.

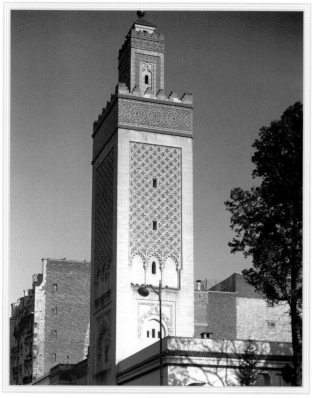

293

Paris Mosque

PLACE DU PUITS-DE-L'ERMITE AT RUE GEOFFROY

1922–26, M. TRANCHANT DE LUNEL, C. HEUBÈS,
R. FOURNEZ, AND M. MANTOUT

A traditional Moorish minaret rises from this complex, evoking North Africa and the Muslim world. The architects designed the center courtyard and prayer hall to have a border of arched columns, and a marble patio and fountain. To achieve a faithful interpretation of Middle Eastern décor, they brought in artisans and craftsmen from participating countries to decorate the mosque with tiles, mosaics, and marble. This collaboration between the French government and several Muslim countries respects the three traditional components of Islamic architecture: religion, culture, and commerce.

293

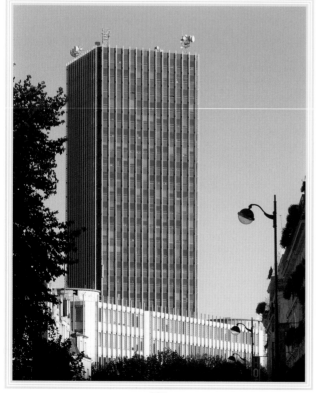

294

Universités Paris 6 et Paris 7

PLACE JUSSIEU
BETWEEN RUE DES FOSSÉS SAINT-BERNARD AND RUE CUVIER

1965, EDOUARD ALBERT, URBAIN CASSAN,
RENÉ COULON, AND R. SEASSAL

Serving 70,000 students, the Jussieu campus is the biggest in France. Inspired by the Escurial "grill" in Madrid, this checkerboard-patterned building encompasses twenty-one patios and covers almost 3,000 square feet. Like a giant Erector set, the structure of vertical and horizontal beams connects gondola-like cubes that float on stilts and leave wide-open spaces below. The repetition and enormity of the construction does not quite realize architect Albert's intention of a "cloistered environment" that would foster small academic gatherings.

294

295

La Tour d'Argent

15, QUAI DE LA TOURNELLE AT RUE DU CARDINAL LEMOINE

C. 1870; 1937, ADDITION FOR EXTRA HEIGHT

The notables who have dined at this restaurant include: George Sand, Napoléon III, Honoré de Balzac and Alexandre Dumas. Famous for its view of Notre-Dame, La Tour d'Argent also stakes its reputation on history and legend. Supposedly, the fork was invented on this spot, in a sixteenth-century inn. Later, in 1789, the Revolutionaries sacked the restaurant that stood here and, when it opened again, it drew literary and political crowds with its specialty: a duck dish called "*canard au sang*." Since 1890, close to one million ducks have met a delectable fate in this recipe (which is actually available online, at www.tourdargent.com/fr/cuisine/canard.html.). Half that many bottles of wine (500,000) are stored in ancient wine cellars beneath the restaurant.

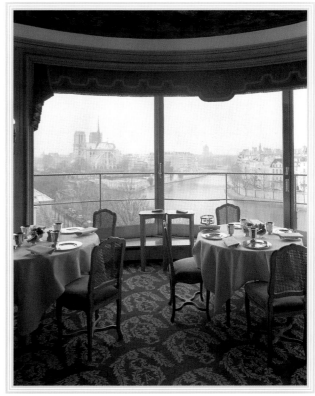

295

296

Parisienne de Distribution d'Électricité

5, RUE VÉSALE BETWEEN RUE SCIPION AND RUE DE LA COLLÉGIALE

C. 1910

Now boarded up and shut down, this anachronistic building on a quiet, neighborhood street was once a substation that supplied power to the Gobelins quarter. Composed of metal, brick, and glass, the facade features the industrial characteristic of a riveted metal framework. Iron bars define the long, triple windows, and a thin, brick border surmounts arched windows at the ground level.

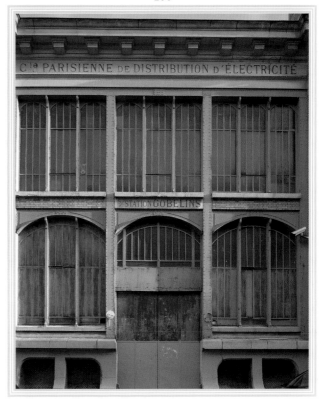

296

297

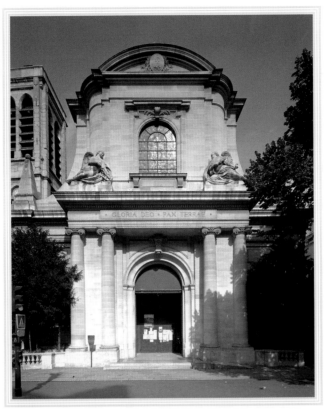

298

Boulevard construction, demolition, ownership transfer, and various efforts at remodeling have conspired to destroy most of what was the Bernardine College at this site. Only the refectory remains. Founded in 1244 by the Abbot of Clairvaux, an Englishman named Etienne de Lexington, the order lost its mandate to the Citeaux Abbey in 1320. Reconstruction occurred periodically due to regular flooding and a first-floor fire in 1698. In the 1800s, only the papal living quarters survived the new construction on rue de Poissy and boulevard Saint-Germain, when the remaining buildings were demolished. Subsequently, from 1845 to 1993, the refectory has transitioned from being a street-lamp oil shop, the archives for the City of Paris, and a home for the Frères des Ecoles Chrétiennes, to serving as a fire station.

This church—a reactionary center of French Catholics—derives its name from the blue thistles (*chardons*) that grow here. A thirteenth-century chapel, then one from the fifteenth-century, occupied the grounds before architects Levé and Noblet reconstructed the site in 1656. Painter Charles Le Brun, who bought one of the chapels, probably decorated its interior and the west portal on rue des Bernardins. His tomb, and his mother's, are inside this chapel. Because of the construction of the newly built boulevard Saint-Germain, the main chapel was reduced by Baltard in 1862 and threatened by Haussmann's demolitions. But, fortunately, the boulevard made its turn just short of the church, thus saving it from Haussmann's wrecking crew.

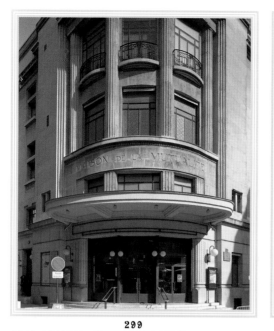

299

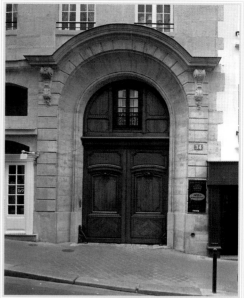

300

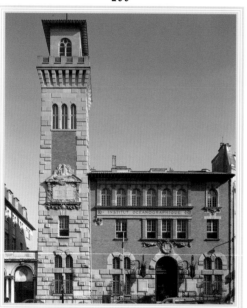

301

302

303

304

299

Maison de la Mutualité

24, RUE SAINT-VICTOR AT SQUARE DE LA MUTUALITÉ AND RUE MONGE

1928–31 BY ROBERT LESAGE AND CHARLES MILTGEN

The Art Deco corner entrance of this stone building leads to numerous meeting rooms, lecture halls, and Restaurant La Fontaine Saint-Victor. Built on the former site of the Séminaire of the Saint-Nicolas-du-Chardonnet Church, it was intended as a gathering place for insurance societies. Later, its grand lecture room accommodated large crowds for political meetings. The windows and balconies, flanked by four columns, lend a rhythm to the façade and extend over two stories above the bold, fan-shaped, corner entrance.

300

Former Seminary of the 33 Courtyard

34, RUE DE LA MONTAGNE-SAINTE-GENEVIÈVE

1746–47, PIERRE DE VIGNY;
C. NINETEENTH CENTURY, ADDITIONAL BUILDINGS

Before the mid–nineteenth century, Paris was a jumble of narrow, winding streets. Many still exist, and one such street leads to a cobblestone courtyard belonging to the former Seminary of the Thirty-three—a small college for indigent students, established in 1633, which derives its name from Jesus Christ's age when he died and, coincidentally, the number of scholarships awarded. Today, the garden façade is visible from rues Descartes and Clovis.

301

Institut d'océanographie

195, RUE SAINT-JACQUES AT RUE GAY-LUSSAC

1911, HENRI-PAUL NÉNOT

Created in 1906 by Prince Albert of Monaco, the Institut d'océanographie was one of two buildings (the other in Monaco) constructed as part of a foundation he established. Architect Henri-Paul Nénot, influenced by sixteenth-century Italian architecture, designed a façade of brick and rusticated white stones with plant and marine images. Nénot marked the angle of rues Gay-Lussac and Saint-Jacques with a high tower reminiscent of a medieval Toscana tower, and decorated it with a seascape pediment of flora and fauna.

302

74, rue du Cardinal-Lemoine

AT PLACE DE LA CONTRESCARPE

In 1922, Ernest Hemingway and his young bride Hadley lived in a tiny, walk-up flat on the fourth floor of this building. The dimly lit space had no running water, and they used a toilet located on the landing—typical for apartments in those days. Or, as he described in *A Moveable Feast*, inside, they used "an antiseptic container, not uncomfortable to anyone who was used to a Michigan outhouse. With a fine view and a good mattress and springs for a comfortable bed on the floor, and pictures we liked on the walls, it was a cheerful, gay flat."

303

Eglise Saint-Ephrem

17, RUE DES CARMES AT RUE DES ECOLES

1733–38, PIERRE BOSCRY

Dedicated to Saint-Ephrem, this church was built as a chapel for the Irish College, then also located at rue des Carmes. Now situated at rue des Irlandais, the Irish College was separated from this chapel to distinguish the education of lay students from the religious training for future priests. Influenced by Italian Baroque churches in general, and inspired by Bernini's Chiesa di Sant'Andrea al Quirinale in particular, architect Boscry created this church with a concave pediment above the portal.

304

Chapel of the Collège de Beauvais

9 BIS, RUE JEAN-DE-BEAUVAIS
BETWEEN RUE DES ECOLES AND RUE DU SOMMERARD

1374–80, RAYMOND DU TEMPLE

This chapel is the only surviving structure of the Collège de Dormans-Beauvais. The college's other buildings were destroyed in 1881. Today, this simple church, with its pointed roof and tall steeple, serves a Romanian Orthodox congregation. Of note is the 1926 mosaic above the entry.

305
Ecole Sainte-Geneviève

65, RUE DU CARDINAL-LEMOINE AT RUE CLOVIS

1662–72, ROBERT BARCLAY

The strange double doorway—an entry-over-an-entry—is the result of street reconfiguration in 1685. Just after the completion of this building, the street was lowered by several feet, requiring the installation of a new doorway below the original. The ground floor thus became the main level of the building. A chapel on this level contains the tomb of the Stuart king James II, who died in 1701 while in exile from England at Saint-Germain-en-Laye. Female students receive training here today to prepare for higher education.

306
Presbytery of Saint-Etienne-du-Mont

30, RUE DESCARTES AT RUE CLOVIS

C. 1740, JEAN-SYLVAIN CARTAUD

Compared to his father's turbulent life, Louis le Pieux, duc d'Orleans, desired a peaceful life of learning. So he built this stately mansion, devoted to the abbey of Sainte-Geneviève, and retired here. He studied Greek, Hebrew, and Syrian, and collected botanical and mineral specimens. His pavilion also contained a library, a chemical and natural science laboratory, and a medal collection (since 1787, in l'Ermitage). Today, his home serves as a presbytery for the clergy of Saint-Etienne-du-Mont nearby at place Sainte-Geneviève.

307
Bibliothèque Sainte-Geneviève

10, PLACE DU PANTHÉON AT CORNER OF RUE CUJAS AND RUE VALETTTE

1844–50, HENRI LABROUSTE

The names of 810 writers and scientists are etched into the stone façade of this library. And preserved within are thousands of manuscripts rescued during the Revolution by scientist Alexandre-Guy Pingré from Sainte-Geneviève abbey, now the Henri IV high school. In another stunning achievement for the age, architect Labrouste constructed this library, which predated and influenced the famous ironwork of Les Halles market pavilions, the railway stations, and particularly the National Library.

308
Université Panthéon-Sorbonne

12 AND 21, PLACE DU PANTHÉON AT RUE SOUFFLOT

NORTH BUILDING (¢12): 1771–74, JACQUES-GERMAIN SOUFFLOT;
1897, ERNEST LHEUREUX, RUE SAINT-JACQUES EXTENSION;
SOUTH BUILDING (¢21): 1844–50, (COPY OF THE NORTH BUILDING);
1923–32, RENÉ PATOUILLARD-DEMORIANE, INSIDE NORTH BUILDING

When architect Soufflot created the Panthéon, he designed a semicircular space in front of it to accommodate two buildings with concave façades. The façade of the south building matches the curving lines of the north one almost perfectly, although built nearly a century later. The south building has an Art Deco interior décor.

309
Au Port du Salut

163 BIS, RUE SAINT-JACQUES AT RUES DES FOSSÉS SAINT-JACQUES

1690, CONSTRUCTION; 1779, COUESNON (ARCHITECT AND OWNER),
TRANSFORMED BUILDING; C. 1900, WINE DEALER; 1947, RESTAURANT

An iron portcullis decorates this old stone building that once housed a cabaret of the same name. Inside, three floors offer eclectic décor and traditional French cuisine. Upstairs, geraniums enliven a quiet, non-smoking room, while a boisterous crowd gathers at the piano bar on the *rez-de-chaussée* (ground floor); and, at the lower level, the basement resembles a cave, with its Roman-style wall frescoes.

310
Eglise Notre-Dame du Val-de-Grâce

1, PLACE ALPHONSE-LAVERAN

1645–46, FRANÇOIS MANSART; 1646–48, JACQUES LE MERCIER;
1654–69, PIERRE LE MUET AND GABRIEL LE DUC

Childless until she was thirty-six, Anne of Austria vowed to build a church if she gave birth to a son. After her baby, Louis XIV, was born, she commissioned François Mansart for the project. Impatient with the architect's slow progress, Anne replaced him with Le Mercier, who died in 1654. It then fell to Pierre Le Muet, in collaboration with Le Duc, to complete the work.

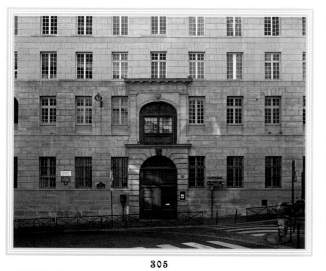

305

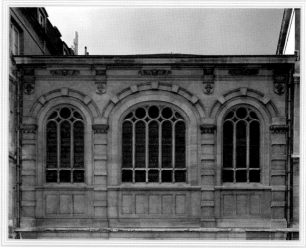

306

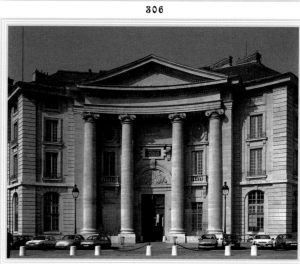

307

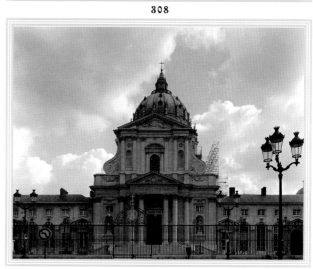

308

309

310

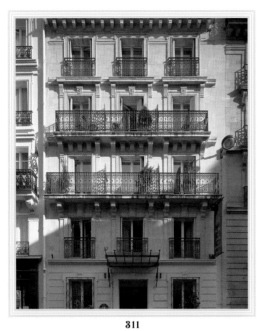

311

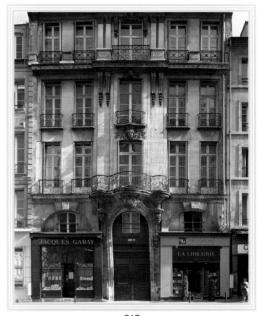

312

313

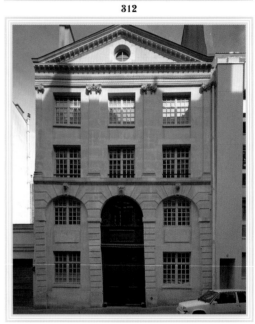

314

315

316

311

Hôtel des Jardins du Luxembourg

5, IMPASSE ROYER-COLLARD AT RUE GAY LUSSAC

This nondescript building hides away on a short and quiet dead-end street. Perhaps this location provided a psychological, if not physical, retreat from the bustling nearby boulevard Saint-Michel when Sigmund Freud stayed here from 1885 to 1886. Legend has it that, when Freud resided here as a student, he removed the green curtains, paranoid that they contained arsenic. Today, the hotel's refurbished rooms are comfortable and quiet, but the nearby Luxembourg Gardens are the real appeal—and a perfect retreat.

312

House of Lepas-Dubuisson

151 BIS, RUE SAINT-JACQUES

1718, CLAUDE-NICOLAS LEPAS-DUBUISSON; 1727, BALCONY

Above the arched entryway, an elaborately carved and curvy console dominates the façade of this eighteenth-century townhouse and supports a lovely wrought-iron balcony. Typically, then as now, the ground floor was reserved for commercial space while the upper levels were converted to living quarters. Currently, a cultural bookstore occupies the ground level, with apartments above.

313

Institut de Biologie

13, RUE PIERRE-ET-MARIE-CURIE
BETWEEN RUE SAINT-JACQUES AND RUE D'ULM

1930, GERMAIN DERBRÉ AND NICOLAS KRISTY

Inspired by contemporary Dutch architecture of the period, this building's interlocking planes suggest Cubist influences, but it veers from that tradition by having a brick construction rather than a simple white façade. An academic committee oversaw the development plans; and, therefore, the building design incorporated about fifty different laboratories. One was sunk thirty-six feet below ground, to keep a constant temperature.

314

7, rue Valette at place du Panthéon

1673–77

Built for owner Frédéric Léonard, this *hôtel*'s rusticated façade is similar in detail to the façade elevation of the 1670s architectural style of place des Victoires and place Vendome, which launched the use of classical architecture in Paris. The challenge here was to find a balance between horizontal and vertical lines. The horizontal lines in the stone of the arched basement provide a sense of shadow and weight that settle the building, giving it solid grounding. The monumental pilasters that support an upper level cornice frame the stories.

315

Former Ecole Polytechnique

5, RUE DESCARTES AT RUE MONGE AND RUE D'ARRAS

1838, A. M. RENIÉ, PORTAL AND N. ROMAGNESI, SCULPTURE

Over two hundred years old, this state-supported institution of higher learning is the most prestigious engineering Grande Ecole in France. It first occupied the premises here in 1838, but relocated in 1976; and this building now houses the Ministry of Research and Technology, and other government offices. The former college courtyards have, in part, become a public garden with a reflecting pool and a delightful walkway that links rue Descartes to rue du Cardinal-Lemoine.

316

Crèche Collective (Kindergarten) and Bains Douches Municipaux

50, RUE LACÉPÈDE AT RUE DU CARDINAL LEMOINE

1985, JACQUES CASANOVA

On two sides, this building resembles the old, restored buildings of its neighborhood but, in the center of the façade, rounded forms, like pregnant women welcome children to this kindergarten, and the large windows provide its classrooms with light. The building also houses municipal baths, thus accommodating two social activities: one for children and another for the homeless.

Jardin des Plantes

A cross-section of a 2,000-year-old California Sequoia is among the many specimens in Jardin des Plantes. This botanical garden originally nurtured herbs—royal medicinal herbs, to be precise. Initiated in 1626 by Louis XIII on the advice of his physician, it was originally known as Le Jardin de Roi (Garden of the King) and then as the Jardin Royal des Plantes Médicinales. Situated as it is in the academic environment of the 5th arrondissement, university science students have used it as a resource for their studies. Over time, the gardens expanded to include a Ménagerie (zoo) and a natural history museum. Actually, the zoo was a byproduct of the decision by city officials to ban animal-taming as a street entertainment, ordering the removal of the performers' animals to the safety of the gardens. In 1826, Charles X received, as a gift from Egypt, the first giraffe to step on French soil. In the harsh winter of 1870–71, starving Parisians raided the zoo and claimed its animals for food. Now boasting more than 10,000 species flora and fanna, the garden complex also contains a tropical greenhouse featuring rare orchards and a roomful of cacti, a micro-zoo of insects, and a vast rose garden—all within an exceptionally clean 60-acre expanse. At the entrance, climbable sculptures and ice cream vendors await visiting children.

317

Eglise Saint-Etienne-du-Mont

PLACE SAINTE-GENEVIÈVE AT RUE CLOVIS

1492, ETIENNE VIGUIER AND OTHERS; 1492–1500, JEAN TURBILLON,
LOWER LEVELS OF BELL TOWER; 1530–45, BEAUCORPS AND OTHERS,
CHOIR AND CHOIR SCREEN, AND ROOD SCREEN; 1545–85, PIERRE
NICOLLE, THOMAS DE GRENEUZE AND CHRISTOPHE GUÉRIN, NAVE,
TRANSEPT; 1606–1622, CLAUDE GUÉRIN, FAÇADE;
1624, UPPER LEVEL OF BELL TOWER; 1630–32, LEFT PORTAL;
1861–65, VICTOR BALTARD, FAÇADE RESTORATION

A Gothic structure with a Renaissance façade makes this building unique. The last rood screen, or stone choir, in Paris is preserved in near-perfect condition inside this church. Before pulpits existed, rood screens provided a place from which to read the Gospel. This screen dates from 1541, and Beaucorps designed it to leave the nave fully visible. Also noteworthy within the interior of the church are the 1630 organ case, the pulpit, the winged female sculpture, and the elaborate open-carved, spiral balustrade.

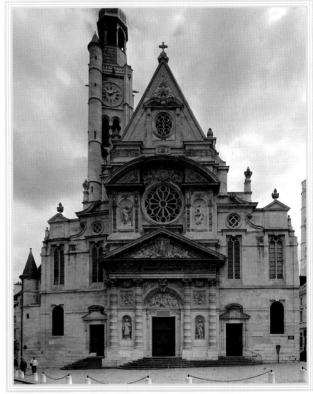

317

318

Panthéon

PLACE DU PANTHÉON
AT RUE SOUFFLOT, RUE D'ULM, RUE VALETTE, AND RUE CLOTILDE

1757–80, JACQUES-GERMAIN SOUFFLOT; 1780–90, JEAN-BAPTISTE
RONDELET AND MAXIMILIEN BRÉBION, DOME AND FINAL STAGES; 1791,
QUATREMÈRE DE QUINCY, TRANSFORMATIONS (FROM WINDOWS)

In 1744, a seriously ill Louis XV prayed to Sainte-Geneviève for his recovery, vowing to build a church dedicated to her. He lived and commissioned a church with a dome and portico in monumental Gothic style. During the Revolution, the Panthéon became the resting place for great men of France. The inscription over the pediment reads: *Aux Grands Hommes La Patrie Reconnaissante*. The building swung back to its church roots when Napoléon I ruled; it then reverted to being a national monument during the regime of Louis-Philippe, who commissioned the patriotic sculpture in the pediment.

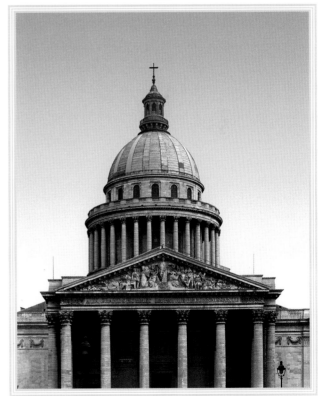

318

319

Congrégation du Saint-Esprit

30, RUE LHOMOND, CORNER OF RUE RATAUD

1732–35, RENÉ BAUDOUIN; 1769, NICOLAS LE CAMUS DE MÉZIÈRES,
CHAPEL; 1778, JEAN-FRANÇOIS CHALGRIN, FINISHED CHAPEL;
1782, JEAN-FRANÇOIS CHALGRIN, BUILDING ON RUE LHOMOND
AND STAIRCASE ATTRIBUTED TO J.-G. SOUFFLOT;
1879–78, CHAPEL INSIDE RESTORATION

Founded in 1703, this Congregation of the
Holy Spirit trained seminary students in mis-
sionary work. The building itself is a composite
accomplished over about fifty years: René Bau-
douin, master mason, constructed the corner
building on rue Rataud; Nicolas Le Camus de
Mézières designed the chapel; Jean-François
Chalgrin completed the chapel and the building
on the side of rue Lhomond; and sculptor
François-Joseph Duret created the relief—*Mis-
sionaries to India Preaching and Baptizing*—on the
chapel façade in 1776.

320

Studio des Ursulines

10, RUE DES URSULINES
BETWEEN RUE SAINT-JACQUES AND RUE GAY-LUSSAC

Documentaries and obscure films are the fare
here. The theater claims to be the oldest cinema
for avant-garde movies and retrospectives in
Paris and the first to show Chaplin. In the
1960s, Truffaut shot a scene here, when he
directed *Jules et Jim*. The interior, renovated in
1996, has Dolby sound and seating for 100 in
the orchestra, plus a small balcony.

320

321

Église Saint-Jacques-du-Haut-Pas

252, RUE SAINT-JACQUES AT RUE DE L'ABBÉ-DE-L'EPÉE

1630, BASEMENT OF THE CHOIR;
1675–84, DANIEL GITTARD, NAVE AND FAÇADE;
1688–90, LIBÉRAL BRUANT, AXIAL CHAPEL

Pilgrims from the order of Hospitalers of Altopascio established a lodge on the *haut pas* (high pass) nearby this church, which was so named because they were on their way to the cathedral of Santiago de Compostela in Spain to view the supposed remains of apostle Saint James the Greater. Only one tower from the initial project was built. This simple structure—the construction of which stopped and started with available funds—has elements of a classical façade with pillars and pediment.

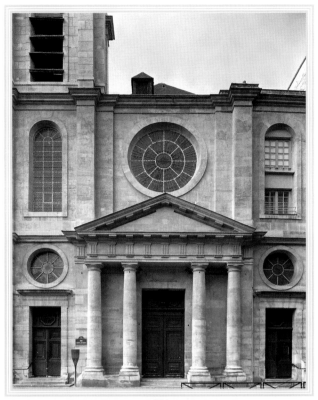

321

322

Bibliothèque Port-Royal
(MAIRIE DE PARIS)

AT RUE SAINT-JACQUES
88 BIS, BOULEVARD DU PORT-ROYAL

c. 1960–70

One of the monstrosities from the construction of the 1960s, this building is an annex of the Mairie (town hall) of the 5th arrondissment. It provides well-developed social services, such as kindergarten and library facilities, which benefit the urban fabric of Paris. As administrative centers, the town halls generally provide cultural activities and sports for citizens of all ages, public transportation, and maintenance of public gardens.

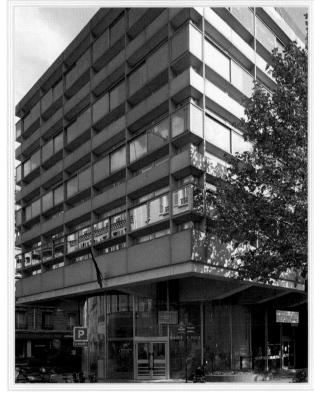

322

323
Maison de Facchetti

134, RUE MOUFFETARD AT RUE EDOUARD QUÉNU

1929, ELDI GUERI, FAÇADE PAINTING

Italian painter Eldi Gueri created this wild country scene on the façade of a former butcher shop, Maison de Facchetti, in 1929. Between the two windows of the mezzanine, he painted four pastoral panels over sheet metal advertising the butcher's wares. Inspired by Italian renaissance, Gueri then depicted deer and wild boar on an ochre background surmounted by an unrestrained floral and fauna pattern. This freewheeling plant motif fills the façade as well as the gables, providing a unique setting in this popular neighborhood known for political agitation as well as an abundance of food.

324
Eglise Saint-Médard

141, RUE MOUFFETARD

C. LATE FIFTEENTH CENTURY, NAVE, FAÇADE AND BELL-TOWER;
1609–22, CHOIR; 1640, LAST BAY VAULTS; 1689, LEFT CHAPEL;
1773, ALTERATIONS IN THE FAÇADE; 1784, LOUIS-FRANÇOIS PETIT-
RADEL, AXIAL CHAPEL; 1901, NEW CHAPEL (DES CATHÉCHISMES)

When Deacon Pâris—the Jansenist cleric of Saint-Médard at odds with the Jesuits, who thought him and the sect heretical—died in 1727, his death sparked collective convulsions among his followers who became known as the *convulsionaries*. In 1732, authorities closed the graveyard and sent the fanatics on their way. In 1875, a public garden replaced the second cemetery. In 1773, under the auspices of the abbey of Sainte-Geneviève, the original elaborate Gothic façade was transformed to an unadorned frontage. Since then, the façade has been changed back to Gothic style.

325
Passage Des Postes

BETWEEN RUE LHOMOND AND RUE MOUFFETARD (MEDIEVAL STREET)

On the market street of rue Mouffetard, vendors call out their culinary specials of the day. With their food cases lining the street, they tempt pedestrians with baked goods, fresh pasta and produce, and other specialties. Just off this lively street, the narrow, cobblestone Passage Des Postes is a delightful and tranquil turn uphill. Trees, overhanging vines, a few window flower boxes, and the occasional strains of someone practicing a sax are the only sensory details of note on this shortcut lined with apartments and small private gardens.

326
33-35, Rue Censier

AT RUE MONGE

C. 1960

Smoky glass balconies provide the only visual break to the repetitive frontage of these interlinking apartment blocks. The residents of this boring, prefab complex, however, have a lovely view across the angled street, overlooking a small patch of green and toward more interesting Haussmann stone apartments. The cement modules are marked by auto pollution on the lower levels.

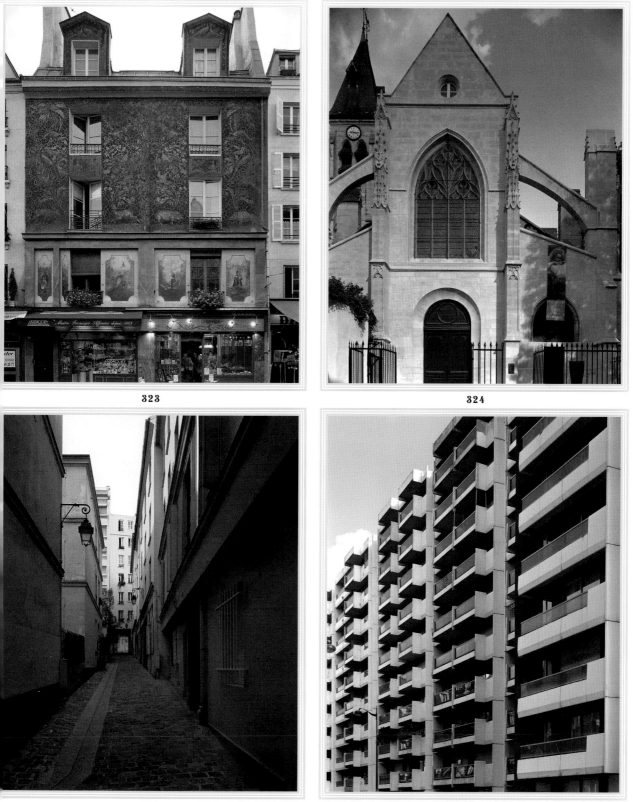

323

324

325

326

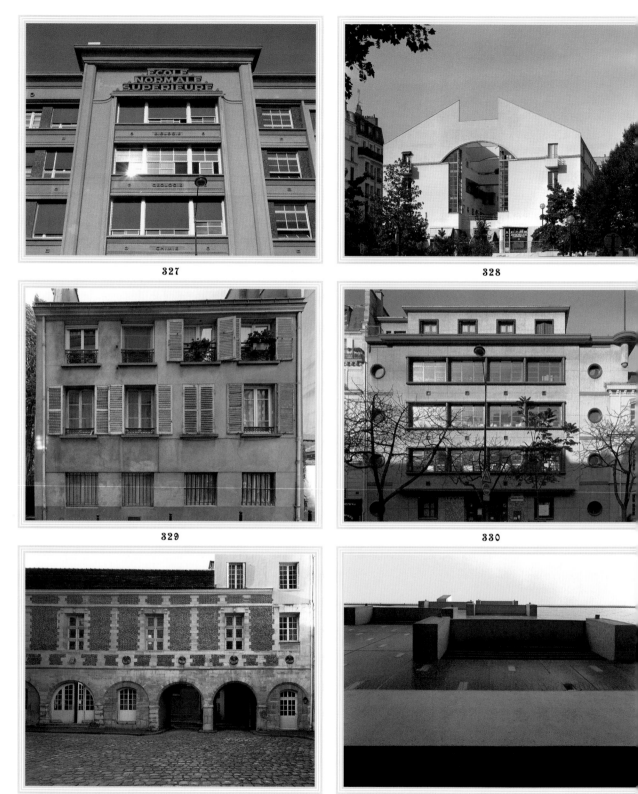

327

328

329

330

331

332

327

École Normale Supérieure
(E.N.S.)

45, RUE D'ULM BETWEEN RUE CLAUDE BERNARD AND RUE ERASME

1934, ALBERT AND JACQUES GUILBERT

By convention in 1794, the State established this teacher training school in Paris. The higher-education, teacher-training school of Sevres, founded in 1881, merged with Ecole Normale Supérieure in 1987 and was incorporated into these facilities. The building has multiple sides in various styles. As etched into this concrete façade, the school trains teachers in the sciences of biology, geology, and chemistry in addition to various academic disciplines.

328

7, place Bernard Halpern

AT RUE DAUBENTON

1980, ROBERT GROSJEAN, JEAN-PHILIPPE PARGADE AND GÉRARD VIARD

Until 1761, the Canaye family owned a house on this site. The next owner, the maréchal of Biron, permitted a vegetable market in the courtyard. In 1980, the architects won a competition to reinterpret the space, creating an urban project with activities and housing. Protected from traffic by a main staircase, the structure gives way to a ground level gymnasium above a five-level parking garage. Two symmetric buildings on each side of an internal garden contain sixteen apartments and open to the sky with interior terracing.

329

8, rue Scipion

BETWEEN RUE DU FER À MOULIN AND BOULEVARD SAINT-MARCEL

C. END OF THE 19TH CENTURY BUILDING, TRANSFORMED

This street was named for Scipion Sardini, a Tuscan, who came to France in Catherine de Médicis' entourage with nothing, but piled up a fortune while here. All the homes on this tranquil, residential street have slate roofs and nearly identical flat, tan façades with shabby shutters and peeling white paint. Across from the old Hôtel de Scipion Sardini, which is now the Hôpital Sainte-Marthe, the surprise is the little, terra-cotta tiled-roof annex and the tiny court.

330

École Raymond Queneau

66, BOULEVARD SAINT-MARCEL AT RUE SCIPION

1938, M. CUMINAL AND ROGER LARDAT

The building of new schools in the 1930s was part of a movement to elevate the status of public facilities and recognize them as monuments. As a result, most of these schools were imposing structures and used courtyard features that made impressive statements. This building is atypical because it was intended as a design extension of the adjoining nineteenth-century building. Though this newer school is not massive, it creates a broad impression with its three dominant bays of horizontal windows.

331

Hôtel Scipion

13, RUE SCIPION
BETWEEN BOULEVARD SAINT-MARCEL AND RUE DU FER À MOULIN

C. 1532, ESTIMATED CONSTRUCTION; 1598, GUILLAUME TURPIN, TRANSFORMATION OF THE GALLERY AND ROOF; 1656, ATTRIBUTED TO LE MUET, TRANSFORMATION OF THE BUILDING RUE SCIPION; C. 1660, LOUIS LE VAU, TRANSFORMATION OF THE COURTYARD BUILDING; 1669, PARTIAL DESTRUCTION, CONVERTED TO A CENTRAL BAKERY; 1985, RESTORED

Maurice de Bullioud built an original manor house in the sixteenth century. Scipion Sardini from Genoa then purchased it. Over the central portal's wrought-iron grillwork, an inscription identifies the house as "Sainte-Marthe, House of Scipion."

332

University Restaurant

3, RUE CENSIER AT RUE GOEFFROY SAINT-HILAIRE

1965, HENRY POTTIER

A striking building that plays with light and darkness, this university restaurant obscures on one side and enlightens on the other. Like a dark, scary cave with the power to intimidate, the front north façade uses black ceramic that completely blocks any sunshine. As students enter the "cave" they are then flooded with light from the opposite, south-side bay windows.

333

333
The Abbey Bookshop

29, RUE DE LA PARCHEMINERIE
BETWEEN RUE SAINT-JACQUES AND RUE DE LA HARPE

1736

Originally called rue des Escrivains when scribes copied manuscripts here, this road derives its current name from parchment merchants who worked along the street from the fourteenth century until the late fifteenth century, when a paper shortage from China jeopardized their business. The book trade continued to thrive on this street, however, throughout the seventeenth century. Today, this tall, narrow building, constructed in Rococo style for coin exchange controller Claude Dubuisson, houses the Abbey Bookshop—a Canadian-owned English- and French-language bookstore.

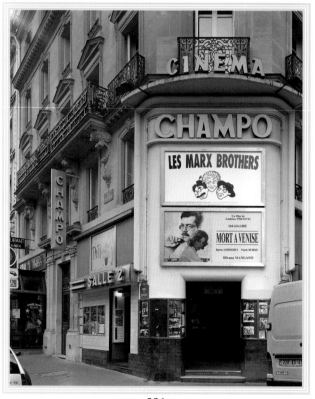

334

334
Le Champo

51, RUE DES ECOLES AT RUE SAINT-JACQUES

1939

Close to the Sorbonne, this art-house cinema has drawn movie buffs with offbeat screenings since 1939. The programming ranges from retrospectives of American and French directors to Far Eastern films—perfect fare for its Latin Quarter audience.

335
Le Cinéma du Panthéon

13, RUE VICTOR-COUSIN

1907

Founded in 1907, Le Cinéma du Panthéon distinguishes itself in the Latin Quarter as the oldest surviving movie house in Paris. It was the first, in 1930, to show films in their original English-language format without dubbing, allowing the English and American communities in Paris to view the movies as they would have in New York or London. Now, the theater holds meet-the-director sessions and functions as an art-house cinema, screening little-known-artists' and foreign films. The façade, with its fixed camera, is wedged between two higher buildings and seems to resist time.

335

336
Institut Curie

26, RUE D'ULM AND 8, RUE LOUIS THUILLIER
BETWEEN RUE GAY LUSSAC AND RUE D'ULM

1988-1992, JEAN BALLADUR

Resting on a foundation of gravel, this hospital entrance leads through a courtyard entry, to a series of connected buildings and odd shaped portals. The frontage of the reflective glass grid is repeated on the back façade of the buildings, which are linked by a tubular walkway. The random patterning created by these windows on this façade prompts imagination: The curious position of the open windows suggests a face with wide eyes. The street is aptly named for microbiologist Louis Thuillier, a student and collaborator of Louis Pasteur.

336

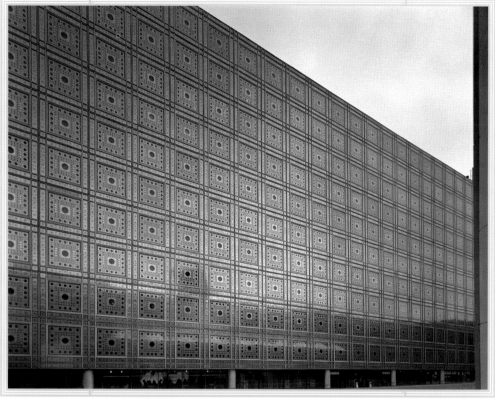

337

337

Institut du Monde Arabe

23, QUAI SAINT-BERNARD AT SAINT-GERMAIN

1982–87, JEAN NOUVEL, HENRI BERNARD, PIERRE SORIA,
AND GILBERT LEZÈNES

A split façade—the northern one glass, the southern one aluminum—creates a dynamic cultural center reflective of Middle-Eastern art. Like the aperture of a camera lens, mechanized panels on the photosensitive windows regulate the intensity of light in the building, while the aluminum varies the shadows, thus producing a lattice-screen effect reminiscent of early Muslim architecture. A central patio is a quiet oasis between the sliced façade, while the rooftop patio features a restaurant and a stunning view of Paris across the Seine to Notre-Dame. This building was an Arab-French collaboration under President Mitterand, in which architects from nineteen Arab countries participated.

6TH ARRONDISSEMENT

The Benedictine monks of the Abbey of Saint-Germain-des-Prés knew a good thing when they saw it. They owned most of this neighborhood in the Middle Ages, when they initiated the Saint-Germain Fair. Shopping and entertainment still thrive here today, along with the best people-watching park in Paris, Jardin du Luxembourg. *Uber*-chic and sophisticated, the district is the personification of the Left Bank (Rive Gauche). Whether you are a tourist, an academic, a shopper, an art lover, a cinema buff, or simply a *flâneur* (wanderer), this arrondissement offers many pleasures.

Often referred to as Saint-Germain-des-Prés or Saint-Germain, this is the Paris of legendary cafés, street markets, cinemas, fashionable digs, swank boutiques, art galleries, theaters, gardens, artistic haunts, and literary walks. This is the Paris of Hemingway and Gertrude Stein, of Sartre and Simone de Beauvoir, of nightclubs playing hot jazz, of the celebrated Café de Flore, Les Deux Magots, and Brasserie Lipp. The birthplace of Existentialism, the 6th arrondissement still thrives on its proximity to the Latin Quarter to the east, Montparnasse to the south, and the Seine at the north, where the Institut de France guards the French language under its noble, seventeenth-century dome. Art galleries line rue de Seine, rue Bonaparte, and rue Mazarine; and stylish clothing stores emanate from the vicinity of Saint-Sulpice.

Palais du Luxembourg

15, rue de Vaugirard between rue Guynemer and rue Médicis

1616–24, Salomon de Brosse; 1624–30, Jacques Lemercier;
1799–1804, Jean-François-Thérèse Chalgrin, transformations;
1835, Alphonse de Gisors, extensions

In 1616, Salomon de Brosse designed the Palais Luxembourg to indulge the whim of Marie de Médicis, widow of Henri IV and the mother of the future Louis XIII. She wanted a mansion reminiscent of the Pitti Palace, her former palatial home in Florence, Italy. While the stone rustication indeed resembles that of her Italian palace, the grand proportions, the simplicity and the classic *entre cours et jardin* styling of the building are all French sensibilities. She also commissioned Peter Paul Rubens to create a series of paintings, now in the Louvre, on the cycle of her life. In 1630, during the Day of the Dupes uprising against her, she fled this palace, never to return. In the next century, the Revolution confiscated it to use as a prison. Since 1852, it has served the Senate, and today the adjacent Musée du Luxembourg shows temporary exhibits. Two unadorned pavilions flank the main building and its courtyard, and Doric and Ionic columns support the austere façade. What it lacks in façade ornamentation, it gains in location: situated at the north end of Luxembourg gardens, it commands one of the most beautiful pieces of real estate in Paris. With its tennis courts, *jeux de boules*, tree-lined paths, beautiful gardens, pony rides, toy boats, and plenty of people-watching positions, this is definitely a democratic park, original intentions notwithstanding.

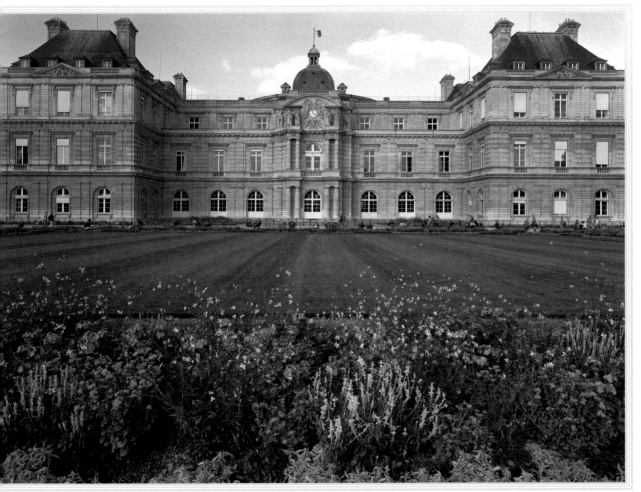

338

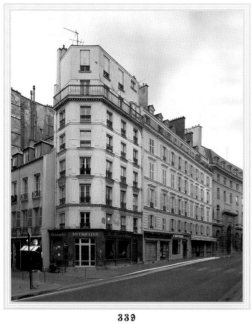

339

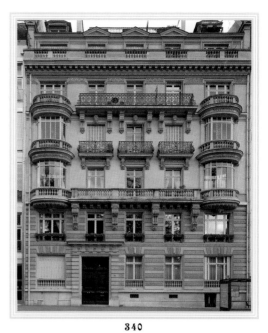

340

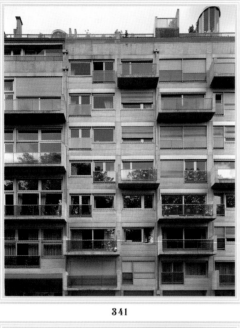

341

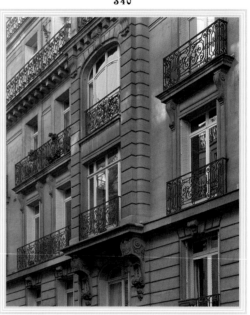

342

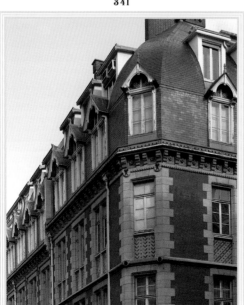

343

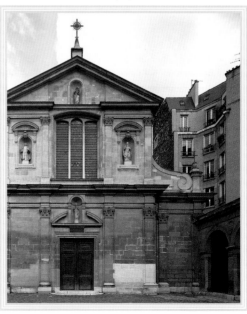

344

339
La Maison de Poupée

40, RUE VAUGIRARD AT RUE SERVANDONI

c. 1840

Just across from Luxembourg Gardens, this tall, white apartment complex has a forest green, ground-floor façade. Occupying the premises is a shop that buys and sells antique dolls. The building itself only just predates the architectural changes and developments of Haussmann's civil engineering. Its cut-off corners are typical of other regulations that came about between Louis-Philippe's reign and the Second Empire. The structure has five levels, plus one added probably at the turn of the last century.

340
4, rue Guynemer

AT RUE DE VAUGIRARD

c. 1900

Situated in a prime location in an upscale neighborhood, this bourgeois building faces Jardin du Luxembourg. Its bay windows add balance and dimension to the apartment building and allow residents a view of the gardens across the street. A new construction regulation reestablished a model that permitted deeper bay windows. The exposure of additional light in the living rooms expressed a transformation of life style: More light permeated the interior and the family became more open to the outside world.

341
8, rue Guynemer

AT RUE DE VAUGIRARD

c. 1970

This residential building from the early 1970s opens onto the Luxembourg Gardens, one of the most beautiful gardens in the capital. With an unobstructed view and nothing to disturb the privacy of the owners, the façade has large windows compared to similar buildings in Paris. The few balconies are placed strategically to insure the privacy of this exclusive construction.

342
27, rue de Fleurus

BETWEEN BOULEVARD RASPAIL AND RUE D'ASSAS

c. 1900

Between 1903 and 1937, Gertrude Stein lived here with Alice B. Toklas and held court with writers and artists. Her large, ground-floor apartment welcomed Hemingway, a frequent visitor whom she took under her tutelage. As he recalls in *A Moveable Feast*, he and his wife " . . . loved the big studio with the great paintings. It was like one of the best rooms in the finest museum except there was a big fireplace and it was warm and comfortable and they gave you good things to eat . . ."

343
Institut Catholique de Paris

21, RUE D'ASSAS AT RUE DE VAUGIRARD

1875

Built on the site of the 1792 September Massacres, the Institut Catholique de Paris was founded in 1875. Its repetitive brick-and-stone façade creates a textured pattern along rue d'Assas. A tower-like portion of the façade, with three levels of tall and narrow windows, breaks up the uniformity. Although deemed a university by the Catholic Church, an 1880 law mandated that only public establishments could hold the title of "university," hence the name change to Institut Catholique de Paris.

344
Saint-Joseph-des-Carmes

70–74, RUE DE VAUGIRARD AT RUE D'ASSAS

1613–20, FIRST BUILDING AND CHURCH; 1628–30, CUPOLA AND DOME; 1674, ADDITIONS; 1804–19, RESTORATION AND PORTAL REBUILT; 1894, GABRIEL RUPRICH-ROBERT, RUE D'ASSAS ADDITION

In 1611, the Carmelites arrived in Paris and two years later, settled into their monastery here on rue de Vaugirard. The façade of the completed structure is unremarkable, but a lovely Baroque fresco by Bertholet Flemael adorns the cupola. One of the many churches used as a prison during the Revolution, this one also was a site of the September Massacres in 1792, when 117 priests were killed here.

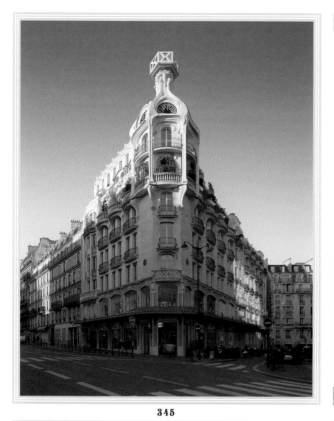

345

345

Building Félix Potin

140, RUE DE RENNES, 10–12 RUE BLAISE-DESGOFFE

1904, PAUL AUSCHER

Bulging with the beauty of sensuous shapes, flowing curves, and carved balconies, this former headquarters of the Félix Potin grocery chain, founded in 1844, towers with elegance and grace ten stories over rue de Rennes. Art Nouveau flourishes abound on the building as it undulates from the corner down both sides of the street. Decorative mosaics scattered on the façade announce, in Art Nouveau cursive, the former store's provisions and services. Individually, some translate to read, "tea, cocoas, buffets, pastry making, biscuits, chocolates, baptisms, coffee, fish of sea, and fresh water." The name of Félix Potin can also be found inscribed in the three oculi of the corner bell tower. The building is occupied today by the Tati chain.

346

346

Académie Julian

31, RUE DU DRAGON AT RUE DU FOUR

In 1868, Rudolphe Julien opened an art studio school that accepted women, who until 1897 were barred from training at the Ecole des Beaux-Arts, the official art school of France. Here, women students were permitted to paint from nude male models. An impressive list of artists emerged from this school including those in the rebellious Nabis group as well as Matisse, Léger, Duchamp, Pierre Bonnard, and Louise Bourgeois. In 1959, a Cultural Center for the Fine Arts, with workshops, was established within the academy. The success of this venture led to the creation of a new school in 1968: l'Ecole Supérieure d'Arts Graphiques (ESAG). Today, the school provides comprehensive training for creative artists in interior architecture, design, and visual communication.

347

Hôtel de Dreux-Brézé
(Petit Hôtel de Verrue)

One, rue du Regard and 64, boulevard Raspail at rue du Cherche-Midi

1719–35, Victor-Thierry Dailly

Throughout Paris, old city configurations lie just behind or at odds with the frontage of newer architecture. As the city grew and new streets were laid out, layers of construction created a pastiche of building angles and façades. As a result, many structures do not line up evenly on a street, and sometimes formerly private sections become public. As it is situated, the rounded entranceway of Hôtel de Dreux-Brézé, also known as Petit Hôtel de Verrue, on rue du Regard, stands flush with the street as part of a continuous low stone wall flanked by unadorned wings. The higher façade on boulevard Raspail, however, is in recess from the other buildings along this boulevard, and has a plain triangular pediment. The garden façade, previously private, is now visible.

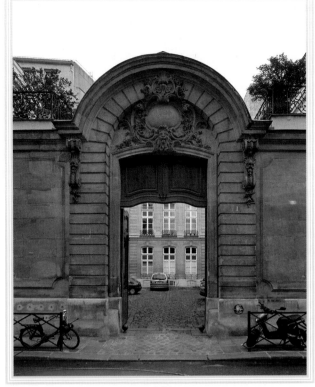

347

348

Maison des Sciences de l'Homme

54, boulevard Raspail at rue du Cherche Midi

1968, H. Beauclair, P. Depondt, and M. Lods

For this building, the architects conceived a metal structure on two levels: One, facing rue du Cherche Midi, conforms in size to the neighboring buildings; but the nine-floor portion on boulevard Raspail towers over the urban landscape. This construction, influenced by the architecture of Mies van der Rohe, utilizes mobile shutters on the façade. This device creates the impression of an abstract assemblage with its unpredictable opened-and-closed positions.

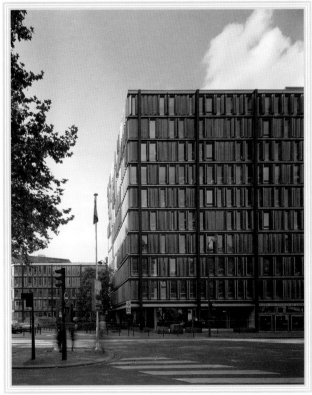

348

349
Hôtel de Marsilly

18, RUE DU CHERCHE MIDI AT RUE D'ASSAS

1738, CLAUDE BONNOT

Architect Bonnot built this eighteenth-century hotel for himself. Of particular interest is the portal with a Rococo cartouche above which Bonnot mounted a cornice balanced by two ornamental stone vases that offset a window. This window mimics the shape of the entry and is capped with a partial pediment that extends the façade. On the upper level, two decorative, oval windows flank the central rectangular one.

350
Société Générale

6, RUE DE SÈVRES

1901–02, M.G. BALLEYGUIER, RECONSTRUCTION

Established in 1864, Société Générale moved into this reconstructed building in 1902. A stone border surrounds an arched bay window above which a clock oculus adorns a partial pediment. On each side of the monumental pediment of white stone, ornamental script carved onto the stone recalls the date of the bank's foundation (1864) and the date of the building's construction (1902). Above the entrance a polychromatic, ceramic frieze depicts five medallions of women's heads and the Latin names of every continent.

351
Chapelle des Prêtres et des Frères de la Congrégation de la Mission

95, RUE DE SÈVRES AT RUE VANEAU

1827–28

Housed in this chapel of priests and brothers of the Congregation of the Mission is a reliquary created by goldsmith Odiot, which was placed here on April 25, 1830. The shrine contains the preserved body of Saint-Vincent-de-Paul. In the center of each window, dating from about 1864, two medallions recall the life and works of Saint-Vincent. This chapel has a history of missionary work in foreign lands and also contains the remains of the saints Jean-Gabriel Perboyre (1840) and François-Régis Clet (1820).

352
Hôtel de Choiseul-Praslin

2–4, RUE SAINT-ROMAIN AND 111, RUE DE SÈVRES

1732, SULPICE GAUBIER

This classic mansion recalls the pre–Industrial Revolution days when this quarter was in the countryside. But that rural setting did not last for long, as the city expanded quickly. Built in the early eighteenth century for the Countess de Choiseul, this *hôtel* has well-balanced proportions. Though its unadorned windows show only slight variations and its central pediment contains no decorative sculpture, the structure is beautiful in its simplicity.

353
13, rue Saint-Jean-Baptiste-de-la-Salle

BETWEEN RUE DU CHERCHE-MIDI AND RUE DE SEVRES

1993, PIERRE BOUDON, JACQUES MICHEL, AND YVES MONNOT

This building houses a post office and contains also twenty-four apartments for postal workers and their families. In developing the building, the architects sought to honor the integrity of the nearby Caisse d'Epargne. Thus, they devised a split building with the two vertical shapes that echo the tall windows of the bank, and structured the porch roof to echo the bank's ledges. The divided building creates a visual break in the aluminum façade and emphasizes the entrance with a rectangular, overhanging shape.

354
Caisse d'Épargne then Poste

8, RUE SAINT-ROMAIN
AT 5, SAINT-JEAN-BAPTISTE-DE-LA-SALLE

c.1880

This tall, long building has a stone-constructed lower level, with repetitive, arched windows along the façade and an elaborate stone carving above the rounded portal. On the second story, a brick-and-stone composition frames the tall windows.

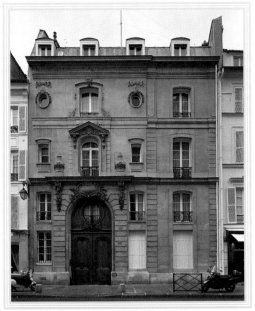

349

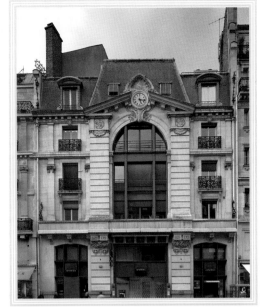

350

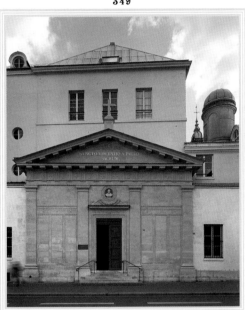

351

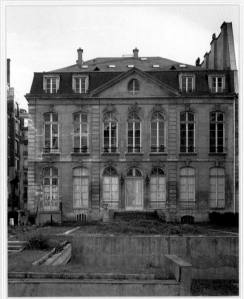

352

353

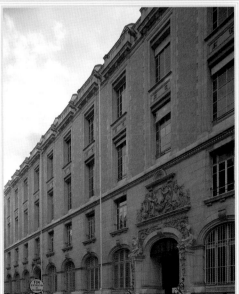

354

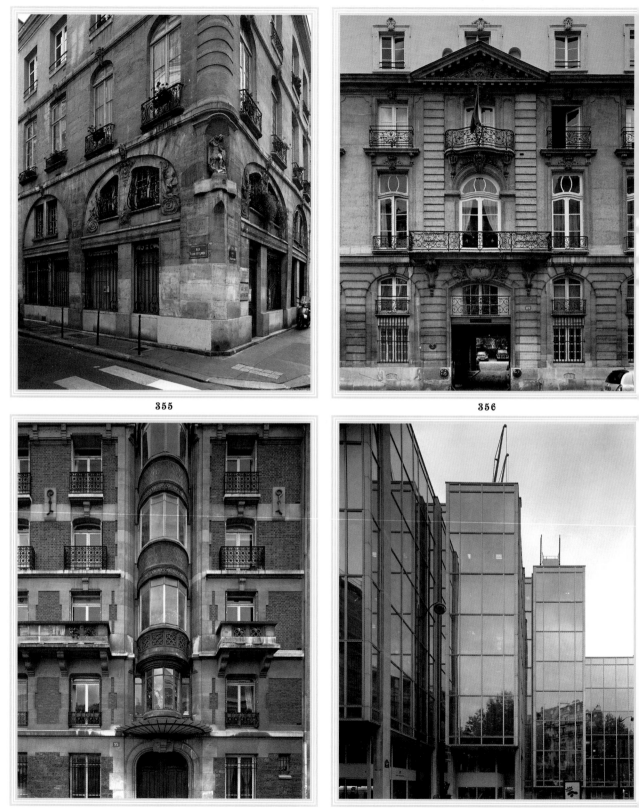

355

356

357

358

355

Musée Hébert

85, RUE DU CHERCHE-MIDI AT 2, RUE J. FERRANDI

1743, ADDITIONS OF SEVERAL EXISTING HOUSES

This eighteenth-century building houses the watercolors, paintings, drawings, and decorative arts of Ernest Hébert (1817–1908), a late nineteenth-century artist. Hébert studied in Rome under Ingres at the Academy of France, and used luminous colors to render his landscapes of the countryside, peasant scenes, and portraits. He was commissioned to enhance the apse of the Pantheon during the Third Republic. The building, a composite of styles from its adjacent structures, was the former Hôtel de Montmorency-Bours, also known as the Petit Hôtel de Montmorency to distinguish it from the home he owned next door. Old plaques on the façade feature street names, and a statue of the Madonna can be found on the corner.

356

Embassy of Mali

89, RUE DE CHERCHE-MIDI AT RUE J. FERRANDI

1757, CLAUDE LE CHAUVE

This is the former residence of the comte de Montmorency-Bours who, like most aristocrats, owned many homes though usually in different locations. This one is adjacent to another of his mansions, the current Musée Hébert, known in the count's time as Petit Hôtel de Montmorency. He named this own home Grand Hôtel de Montmorency, to avoid confusion. A small triangular pediment crowns the central portion of this eighteenth-century façade, which is also decorated with a Rococo balcony, ironwork, and patterns created by the horizontal rustication at the base. Although the upper story reflects the same style, it is probably a nineteenth-century addition.

357

95, rue Vaugirard

BETWEEN RUE LITTRÉ AND ALLÉE MAINTENON

1891, FERDINAND GLAIZE

This charming building, which contains offices and artists' workshops, mingles eclectic styles: brick-and-stone in a Louis Treize manner, some neo-Gothic patterning, and a Jules Verne–type bay window jutting vertically over the street and positioned as if to scout for oncoming enemies. Perhaps it is a metaphor for the artist-residents who might be attempting to break through the rigidity of society with their art.

358

128–130, boulevard Raspail

AT RUE VAVIN

1980, MICHEL HERBERT

Like a giant accordion, this building appears to unfold and expand at the angled juncture of boulevard Raspail and rue Vavin. Composed of mirrored glass, the façade sees everything on the boulevard, multiplying the lively action of the area while simultaneously catching the changing light of the sky, and casting back reflections and refractions onto the street.

86, rue Notre-Dame des Champs

AT RUE JOSEPH BARA

1880, PEDIMENT

The angle of these buildings is typical of the layering of different styles and materials that has occurred in Paris architecture over the centuries. Flush with the street, the flat façade of the building on the right has a partial, fake stone base and masonry-work on the upper level decorated with tall pilasters and a private rooftop garden. Its slanted wall is painted white brick with detailed molding. The classic entry sports a pediment with an oculus and leads to a studio or workshop lofts with grand windows.

26, rue Vavin

BETWEEN BOULEVARD RASPAIL AND RUE NOTRE-DAME-DES-CHAMPS

1912, HENRI SAUVAGE

Influenced by Viennese architecture, this building draws its modernity from its white ceramic façade and terraced construction. Architect Sauvage focused on the terraced pattern for the first time in home design almost as a sketch for buildings he would construct in the 1920s. Sauvage cleverly used the building's empty space—created inside by the terracing—for his own work studio. Developed on a small piece of land between two existing buildings, this particular apartment complex was possibly the first co-op built in Paris.

Le Sélect

99, BOULEVARD DU MONTPARNASSE AT RUE VAVIN

1925

When Le Sélect opened in 1925, it was the first all-night restaurant in Montparnasse, and it drew regulars at dawn. Here, between the wars, Russian refugees gathered under the back skylight to play chess; writer Harold Stearns almost drank himself to oblivion, inspiring the creation of the fictional Harvey Stone in Hemingway's *The Sun Also Rises*; and dancer Isadora Duncan argued the rights of Sacco and Vanzetti, instigating mayhem among sympathizers on both sides. This Art Deco café still fuels a writer's imagination if inhaling fumes from the passing cars' exhaust doesn't burn it out first.

96, rue Notre-Dame-des-Champs

AT BOULEVARD MONTPARNASSE

1939, LEON-JOSEPH MADELINE

At the edge of modernity, this building is typical of architecture between the wars. Halfway between tradition and modern construction, a layer of fine brickwork conceals the concrete frame of the apartments. The façade on boulevard Montparnasse recalls traditional principles while the side facing rue Notre-Dame-des-Champs leans more toward the future. In a daring move and to gain more sunlight, architect Madeline placed the traditional courtyard along the road and curved the façade around it, setting large glass windows at each corner. He achieved a vertical emphasis with a central staircase that is enclosed by glass panels and capped with a rotunda. The exaggerated chimneys add to the impression of architecture rising to new heights of expression.

359

360

361

362

363

363

La Rotonde

105, BOULEVARD DU MONTPARNASSE AT BOULEVARD RASPAIL

1911, RESTAURANT

In the heyday of literary café life in the sixth arrondissement, La Rotonde was one of the big four anchoring the Montparnasse neighborhood. Always in competition, these restaurants drew intellectuals from the political arena as well as the arts. The first owner, Libion, harbored Russian political exiles, including Trotsky and Lenin. Such international artists as Picasso, Modigliani, Derain, and Max Jacob were also among the patrons. Legend has it that the Dadists came to blows here, over what they perceived to be the owner's strict policies and general intolerance. Simone de Beauvoir was born upstairs in this building in 1908. Hemingway was a habitué, and his character Jake Barnes in *The Sun Also Rises* complained that taxi drivers in the Left Bank "always take you to the Rotonde" no matter which café you wanted to visit in Montparnasse. Once upon a time, La Rotonde offered one of the best places to people-watch.

364

Le Bistro de la Gare

59, BOULEVARD DU MONTPARNASSE AT RUE DE L'ARRIVÉE

1903, INTERIOR CERAMIC DECORATION BY LOUIS TRÉZEL

In 1903, in an oil merchant's old shop located near Gare Montparnasse, Chartier Bouillon originally opened as a restaurant with an interior Art Nouveau décor of woodwork, mirrors, and painted ceramic scenes of floral arrangements and French landscapes. This registered historic landmark was at the center of the avant-garde art world when it first gathered steam in the Montparnasse quarter of the Left Bank, while also attracting train travelers on their way to and from Brittany at the turn of the century. In 1923, the former director of the Vagenende restaurant acquired the place and, today, Le Bistro de la Gare is the "bar" of the train station.

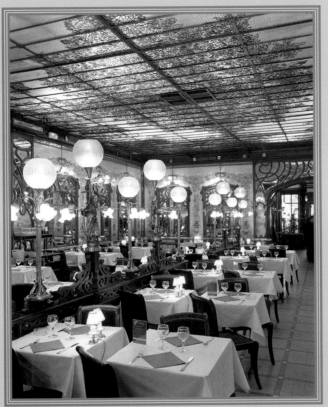

364

Saint-Germain Café Life

The history of café-sitting is irrefutably linked to Paris. The first cafés began appearing in Paris in the late seventeenth century, with the introduction of coffee, tea, and chocolate. Le Procope, established in 1675 by a forward-thinking Sicilian, was probably the first café to open its doors (moving to its present location in 1686). Though grand cafés with elaborate settings thrived on the Grands Boulevards during the nineteenth century, it was in Montmartre, Montparnasse, and Saint-Germain that artistic and literary café life took hold. Between the two World Wars and especially during World War II, writers, artists, and intellectuals gathered at cafés for such necessities as warmth, coffee, spirits, cigarettes, telephones, rest rooms, and newspapers. But they also gravitated to them to write, meet friends, argue philosophy, play chess, incite political debate, conduct business, and exchange news —or just to sit all day and contemplate nothing.

Café life has its own rhythm. Artists and writers often switch cafés, depending on the hour. Seasons also change the nature of café-sitting, which spills out onto the sidewalks at the first sign of warm weather and turns inward in winter. Famous cafés such as Café de Flore, Les Deux Magots, and Brasserie Lipp now cater largely to tourists but you can still spot Parisians in them, those who are willing to overpay for a café crème, that is. The names of Hemingway, Picasso, Man Ray, Fitzgerald, Simone de Beauvoir, Sartre, and countless others are forever linked to the heyday of literary café life in these legendary spots.

365

366

367

368

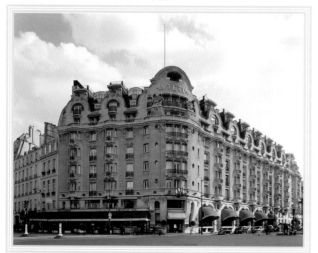

369

370

365
Université d'Assas

92, RUE D'ASSAS AT RUE NOTRE-DAME-DES-CHAMPS

1959–63, CHARLES LE MARESQUIER, A. LENORMAND AND F. CARPENTIER

Part of the Universite d'Assas, this building is not at a loss for windows. With a carved-out ground level and a recessed entry, this modern glass building appears to stand on stilts on the rue d'Assas side. The metal structure and stainless-steel cladding of the façades represents 1960s architecture, and the building expresses the construction development for public education at this time.

366
Hôtel de Croÿ / Caisse Nationale de Retraite du Bâtiment et des Travaux

5, RUE DU REGARD AND 68, BOULEVARD RASPAIL
BETWEEN RUE CHERCHE-MIDI AND RUE DE RENNES

1728–40, VICTOR-THIERRY DAILLY

Construction of boulevard Raspail necessitated the destruction of private gardens and reconfigured the street front of existing homes. The resulting layered look exposes unevenly aligned houses along boulevard Raspail. Hôtel de Croÿ was truncated to accommodate the street opening. Still a huge building, this eighteenth-century stone mansion now accommodates apartments and the National Office for Retired Construction Workers.

367
Sisters of Providence

13, RUE DU REGARD AND 76, BOULEVARD RASPAIL
BETWEEN RUE CHERCHE-MIDI AND RUE DE RENNES

1739, VICTOR-THIERRY DAILLY

In the early part of the eighteenth century, the Carmelites owned this residence and others on rue du Regard, and commissioned architect Dailly to build homes here so the religious order could lease them for income. When boulevard Raspail was built up in the mid–nineteenth century a number of the original houses were destroyed or altered. Here, a stone-carved pediment entrance and dormers jut out farther into the street than do its neighbors.

368
Studios Christine

4, RUE CHRISTINE AT RUE DES GRANDS AUGUSTINS

C. EIGHTEENTH CENTURY, FACADE

Around boulevards Saint-Germain and Saint-Michel, the sixth arrondissement, like the fifth, has a high concentration of theaters referred to as "cinéma d'art et d'essai" that present old or non-commercial movies. All the films are in original version, and the rooms are appealing in their ambiance. The Action Christine group specializes in classic American movies, but also shows new films (*cinéma d'auteur*) from little-known authors. This theater is situated behind a nice eighteenth-century façade.

369
Hôtel Lutétia

45, BOULEVARD RASPAIL AT RUE DES SÈVRES

1907–11, LOUIS BOILEAU AND HENRI TAUZIN

A Left Bank landmark, Hôtel Lutétia figures in the 1974 Louis Malle film, *Damage*, as the Art Deco location for decadent glamour and trysting between Jeremy Irons and Juliette Binoche. In real life, this magnificent combination Art Nouveau and early Art Deco hotel has also attracted the famous and infamous. Pablo Picasso, Henri Matisse, and Henry James all chose to stay at this hotel. And, during Occupation, the Nazis set up Gestapo headquarters here.

370
Lucernaire Forum

53, RUE NOTRE-DAME-DES-CHAMPS AT RUE VAVIN

1968, FORUM FOUNDED

Taking over a closed factory in 1968, Christian Guillochet and Luce Berthommé created a theater open to all artistic endeavors in a dead section of Montparnasse. Seven years later, a real estate developer took control of the property and expelled them. A new cultural forum opened here with broader ambitions and eventual support from the Ministry of Culture. In 1984, Lucernaire Forum received official recognition with the label, National Center of Art and Essai, for the creative work it still undertakes.

371

372

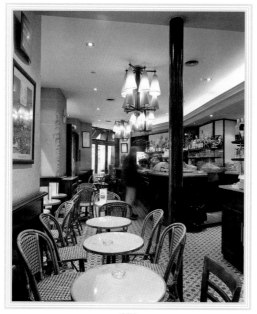

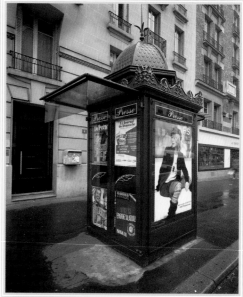

373

374

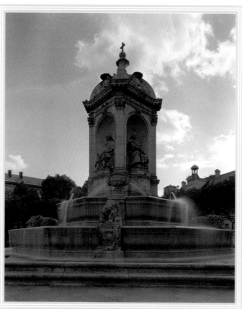

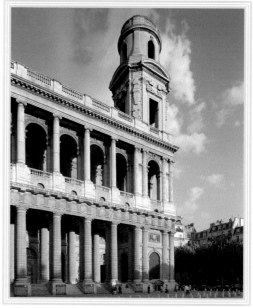

375

376

371
Café du Metro

67, RUE DE RENNES AT RUE DU VIEUX COLOMBIER

C.1870

This typical café on a busy commercial corner has served the neighborhood since the late nineteenth century. Immigrants from Aveyron, in the countryside of France, gravitated to Paris and became water carriers, coal and wine sellers, and then eventually opened cafés such as this one. Today, the old-fashioned interior of tile flooring, typical cane chairs, and bistro tables welcomes friends who gather for a café crème and the latest news.

372
Ecole Maximillien-Vox

5, RUE MADAME BETWEEN RUE DU VIEUX COLOMBIER AND RUE DU FOUR

1886, JEAN-HENRI ERRARD

Although this building held an elementary school for boys, the top floor was reserved for a girls' art school where tall, glass windows illuminated the drawing room. Four large stone arcs and pillars frame decorative brick alcoves with three windows above a ground floor of stone. The glazed brick support, above the two windows, serves as the base of the larger bay windows of the next level. A cornice with brackets crowns the building, and in the center of the composition is the escutcheon of the city of Paris.

373
Mairie

78, RUE BONAPARTE BETWEEN PLACE SAINT-SULPICE,
RUE DE MADAME AND RUE MEZIÈRES

1848, ROLLAND AND LE VICOMTE; 1886, LÉON GINAIN

When the architects began erecting this town hall in 1848, it was constructed in two parts, the first of which was actually in the eleventh arrondissement. Its original façade, facing Saint-Sulpice, was built on the site of Hôtel de Charost. Its central pavilion formed the *l'avant-corps* (the front part) of the present main building. Twenty-eight years later, in 1886, architect Ginain expanded the building toward rue de Madame and rue Mezières.

374
Newsstand

ONE, RUE DU FOUR AT RUE DE MONTFAUCON

C. 1960

The first kiosks were created by Haussmann back in the latter nineteenth century. Since then, several different models have been designed to service the public. Often located at subway entrances, these newsstands open like small books each day to service Parisians and tourists. This particular, forest green kiosk dates from around 1960, and stands in front of a massive building from the early twentieth century. The convex domed construction of the stand mimics the shape of the repeating bay windows of the building's façade.

375
Fontaine des Quatre-Evêques

PLACE SAINT-SULPICE AT RUE BONAPARTE

1843–48, LOUIS VISCONTI

In *A Moveable Feast*, Hemingway describes this fountain as follows: "…there were still no restaurants, only the quiet square with its benches and trees. There was a fountain with lions, and pigeons walked on the pavement and perched on the statues of the bishops." In this square in front of Saint-Sulpice church, alcoves sheltering four statues of bishops share the fountain with four sculpted lions. The lions rest at the base; at the next level, water-spewing *mascarons* (gargoyles) decorate urns.

376
Eglise Saint-Sulpice

PLACE SAINT-SULPICE
AT RUE MABILLON, RUE SAINT-SULPICE, AND RUE PALATINE

C. TWELFTH CENTURY, FIRST CHURCH; 1646–49, CHRISTOPHE GAMARD,
TRANSFORMATIONS; 1660–86, DANIEL GITTARD; 1719–45, GILLES-
MARIE OPPENORD, AND GIOVANI SERVANDOINI; 1774, CHARLES DE
WAILLY, CHAPEL DECORATION; 1777–80, JEAN-FRANÇOIS CHALGRIN,
BALUSTRADE AND LEFT TOWER

A parish church stood here in the twelfth century. Over time, a mismatched structure grew, the church compensating for this lack of unity in design and style with its imposing proportions: Ordered sets of Doric and Ionic columns support two successive levels, above which a balustrade borders a terrace.

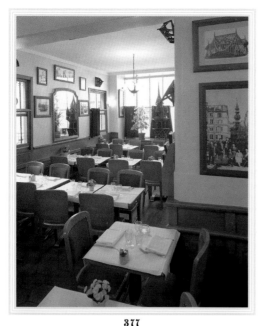

377

Aux Charpentiers

10, RUE MABILLON BETWEEN RUE DE FOUR AND RUE GUISARDE

1896, RESTAURANT

In existence for over 150 years, this watering hole served members of a local carpenter's guild and, in 1874, changed its name to reflect that association. Carpenters' wooden models worked to scale, kept from those days, are still part of the décor here. The carpenter-carved oak bar inside the entrance is original, but the zinc counter is a copy. During German occupation, the Nazis confiscated the original and melted it down for arms.

378

378

Hôtel de Sourdéac

8, RUE GARANCIÈRE AT RUE SAINT-SULPICE

1646, ROBELINI, NÉ ROBELIN

This impressive seventeenth-century home sports an unusual façade of Ionic pilasters with scroll-style ornamentation. Shaped like spiraling ram horns, the Ionic capitals support an entablature with a small, triangular pediment above the central portal.

379

379

Former Seminary of Saint-Sulpice
(MINISTRY OF FINANCE)

9, PLACE SAINT-SULPICE AT RUE BONAPARTE

1820, ETIENNE-HIPPOLYTE GODDE

In the early nineteenth century, the construction of place Saint-Sulpice destroyed a seminary that had belonged to Saint-Sulpice church. The state partially paid for another building opposite the square, which architect Godde designed in a neoclassical style with additional influences from Italian palaces. Seminarians used this building until a 1905 decree separated church and state. Today the Ministry of Finance occupies the premises.

380

Hôtel du Maréchal-d'Ancre

10, RUE DE TOURNON AT RUE SAINT-SULPICE

1607, FRANCESCO BORDONI; 1783, MARIE-JOSEPH PEYRE

Built originally as the residence for an army marshal of Ancre, it was then rebuilt in the next century for a duke. The mansion's neoclassical portal dates from the remodeling done in 1783 by architect Peyre. Today, harking back to its roots, the structure serves as barracks for the Garde Républicaine.

380

381

Hôtel de Beaumarchais

26, RUE DE CONDÉ BETWEEN RUE SAINT-SULPICE AND RUE DE VAUGIRARD

C. MID–SEVENTEENTH CENTURY

Constructed by owner Charles Testu, this private mansion passed along to his heirs and, in 1710, to Counselor Augé. Its wrought-iron balconies contain the initials "A. C." From 1763 to 1776, writer Beaumarchais lived here. During this period, he was married for the second time and wrote the dramas, *Eugénie*, *Les Deux Amis*, and the famous *Le Barbier de Séville*. During the late 1800s this was also known as Hôtel du Mercure de France, when it served as the home of a newspaper called *Mercure de France*.

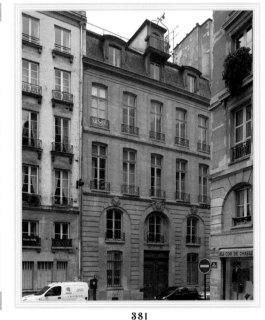

381

382

8, rue de Tournon

BETWEEN RUE SAINT-SULPICE AND RUE DE VAUGIRARD

C.1830–40, ARCH UNKNOWN

This street—named for François de Tournon, an archbishop of Lyon and an abbot of Saint-Germain-des-Prés—was opened in 1510. Tracks discovered while enlarging the corner of the perpendicular rue Vaugirard revealed the existence of a horse market along this road until the end of the sixteenth century. This neoclassic hotel is marked by two heavy balconies with period ironwork. Four brackets with figures of children uphold the first balcony, presenting an unusual friendly face to this Parisian frontage.

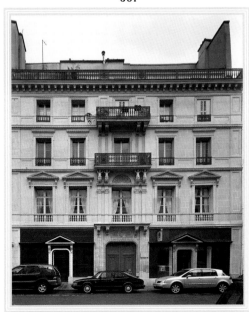

382

383

Hôtel de Brancas

6, RUE DE TOURNON AT RUE SAINT-SULPICE

C.1706–10, PIERRE BULLET

The Institut Français d'Architecture owns this former residence. Built in the early eighteenth century, its street façade features an entry pediment surmounted by the allegoric figures of Justice and Prudence. Prior to its current occupant, the Paris-based Institut Tessin—named for the seventeenth-century Francophile architect of Swedish origin—occupied the building.

384

Polidor

41, RUE MONSIEUR-LE-PRINCE AT RUE RACINE

1845

Opened as a *crémerie* in 1845 near the Sorbonne, Polidor served bohemian students for mere pennies. By 1890, it had evolved into a bistro, but retained its simple menu, affordable prices, antique mirrors, and old tiles. Between 1902 and 1903, James Joyce dined at this restaurant when money from his literary reviews arrived from Dublin. The bistro also attracted nineteenth-century writers Verlaine and Rimbaud, twentieth century author Richard Wright, and numerous others in the arts.

385

Chez Georges

11, RUE DES CANNETTES AT RUE DU FOUR

C. NINETEENTH CENTURY, BUILDING; 1952, RESTAURANT

Behind this maroon-painted façade, Chez Georges oozes ambience on two levels. With photographs galore and a mellow mood, the street-level bar began life as a cabaret. Downstairs, a grotto-like room featuring long wooden tables and low lighting welcomes expatriates and students on this quiet, narrow street with upscale specialty stores.

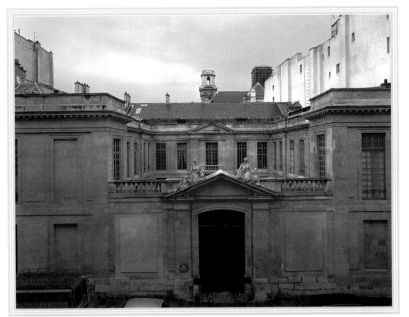

383

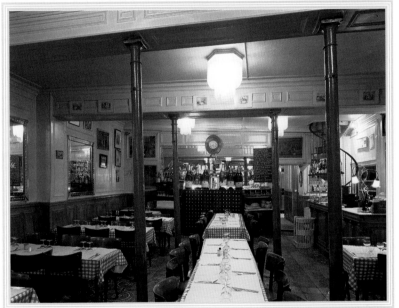

384

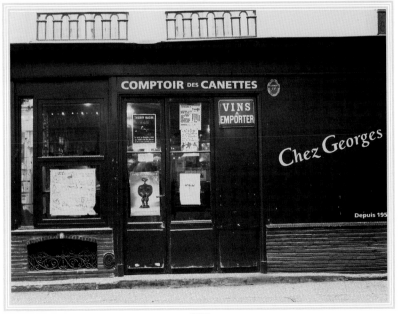

385

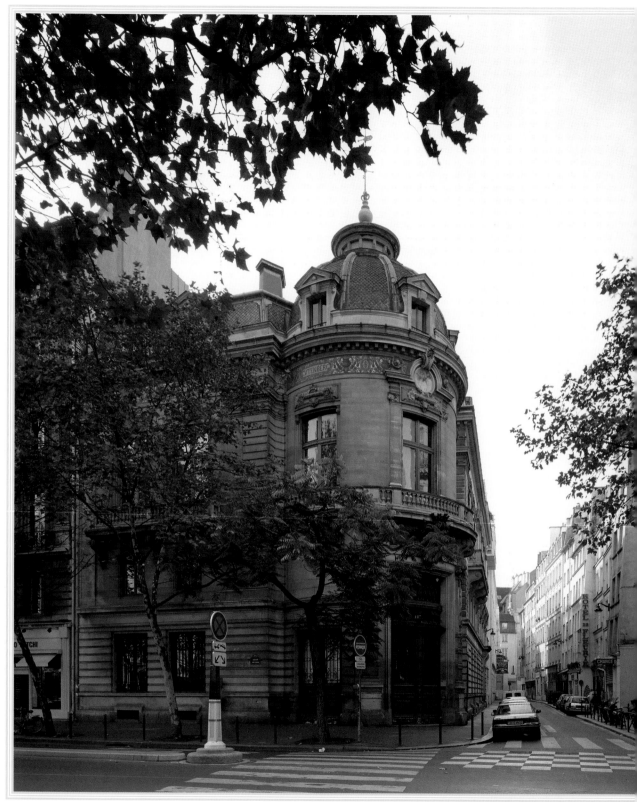

386

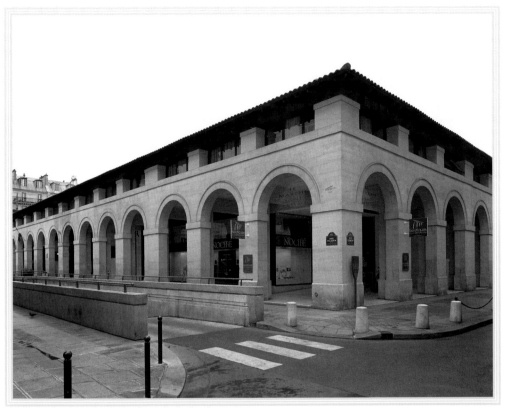

387

386

Institut National du Patrimoine

(ANCIEN CERCLE DES LIBRAIRES)

117, BOULEVARD SAINT-GERMAIN AT RUE GRÉGOIRE DE TOURS

1877–79, CHARLES GARNIER; 1992, REMODELING

This building is composed of two types of stone. Its design features an angled pavilion, a rotunda, and two wings. Above a simple ground floor, decorative windows open out to a balcony. A bronze attribution crowning the central door indicates its original mission as le Cercle des Libraires—a member association and union that brought together varied professionals to protect mutual interests and private properties. Between 1877 and 1879 this group built their headquarters *à aspect de palais* (in the style of a palatial mansion) in an attractive space owned by Charles Garnier (architect of l'Opéra), employing his plans for the design. Part of the completed space was then rented to engravers and printers. After the building was remodeled in 1992, the Ecole Nationale du Patrimonie—the historic monument division of the Ministry of Culture—moved in.

387

Marché Saint-Germain

BORDERED BY RUE MABILLON, RUE CLÉMENT, RUE FÉLIBIEN,
AND RUE LOBINEAU

1813–18, JEAN-BAPTISTE BLONDEL AND AUGUSTE LUSSON; 1994–96,
OLIVIER-CLÉMENT CACOUB, RECONSTRUCTION AND ALTERATIONS

Annual fairs were encouraged by both the clergy and royalty for their economic potential. Inaugurated in the fifteenth century, the Saint-Germain Fair was on the Church's grounds, and continued until end of the nineteenth century. A permanent covered market with a double-tiered roof was built nearby in 1511. Damaged by fire in 1762, it was redesigned on the square as an arched structure. Rebuilt on this same site in the late twentieth century, from the outside the current covered shopping arcade resembles the early nineteenth-century Saint-Germain marketplace. However, inside, brand-name chain stores and other modern shops, and other contemporary facilities occupy the retail space; and it is only the overall structure of the interior that bears even a faint reminder of the medieval fairs of long ago.

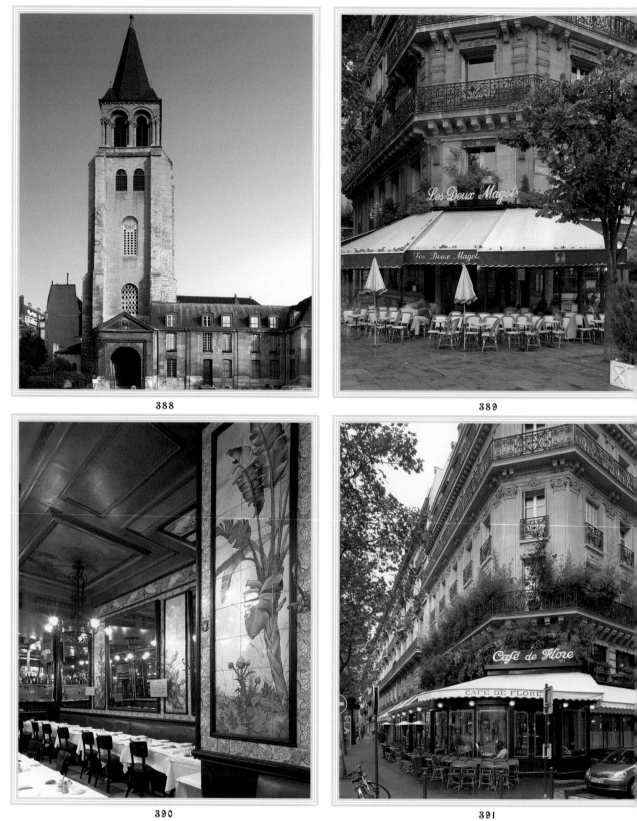

388

389

390

391

388

Église Saint-Germain-des-Prés

3, PLACE SAINT-GERMAIN-DES-PRÉS

542–59, FIRST CHURCH; 990–1014, RECONSTRUCTION (TOWER PORCH AND PROBABLY TWO TOWERS AT THE CHOIR); 1025–30, NAVE; 1145–60, CHOIR REBUILT; 1163, CHURCH OPENED, DEDICATED BY POPE ALEXANDRE III; 1607–08, MARCEL LEROY, PORTAL; 1644–46, CHRISTOPHE GAMARD, NAVE REMODELING; 1819–25, ETIENNE-HIPPOLYTE GODDE, RESTORATION; 1850, VICTOR BALTARD, RESTORATION

Originally built in the mid–sixth century and known then as Sainte-Croix-Saint-Vincent, most of this structure dates from the eleventh and twelfth centuries, thereby qualifying Saint-Germain-des-Prés as the oldest church in Paris. Overall, it combines Romanesque and Gothic features: Its nave, transepts, and three bell towers reveal Roman origins, while its flying buttresses and stained glass owe their style to Gothic influences. It became Saint-Germain-des-Prés after Germain, the Bishop of Paris, was buried there.

389

Les Deux Magots

170, BOULEVARD SAINT-GERMAIN AT 6, PLACE SAINT-GERMAIN

1873

The menu at Les Deux Magots reads, "*Rendez-vous de l'élite intellectuelle.*" Deux Magots established its reputation as a literary café from the late nineteenth through the mid–twentieth century. It figured prominently in the lives of many: Poet Paul Verlaine hung out here with Rimbaud and Mallarmé. During the last year of his life, Oscar Wilde breakfasted at the café and in the evening sipped absinthe on its terrace. Picasso met his lover, model, and muse Dora Maar here. In the 1920s, the Surrealists, led by André Breton, formulated their manifestos here and, in 1926, painter Grant Wood dined here with Chicago journalist William Shirer, where he announced his decision to go back home to Iowa and paint what he knew.

390

Brasserie Lipp

151, BOULEVARD SAINT-GERMAIN AT RUE SAINT-BENOÎT

1880, CREATION OF THE BRASSERIE

Alsatian refugees Léonard Lipp and his wife Flo (Florderer) left their province when France lost Alsace to the Germans in the 1870 Franco-Prussian War. They resettled in Paris, where they opened this eatery. Originally, they named their brasserie Edges of the Rhine, but customers habitually referred to it by the name of the owners, and that stuck. Its Belle Epoque interior features exotic ceramic designs by Leon Fargue. In 1920, Marcellin Cazes bought the restaurant, expanded it, and, in 1958, received the Legion of Honor for having the best literary salon in Paris. Literary and theater groups still meet here. Its celebrity past includes writers Thornton Wilder, Antoine de Saint-Exupéry, and Hemingway, of course.

391

Café de Flore

172, BOULEVARD SAINT-GERMAIN AT RUE SAINT BENOÎT

1887

Jean-Paul Sartre wrote that, during World War II, he and Simone de Beauvoir "more or less set up house in the Flore." These two lovers and fellow philosophers wrote volumes here, using the café's marble-top tables as desks and its sawdust-burning stove for warmth. Even when air-raid alarms sounded, they pretended to leave, but then continued writing upstairs. De Beauvoir wrote *The Mandarins* here, and parts of her journal, *The Second Sex*, as well. Picasso and Chagall exchanged political views and matchbook doodles. Apollinaire and his group founded their magazine, *Les Soirées de Paris*, at this café, and André Breton and his Surrealist buddies alternated between this and its rival café, Les Deux Magots.

392

Université René-Descartes, Faculté de Médecine

45, RUE DES SAINTS-PÈRES AT RUE JACOB

1936–40, 1947–53, LÉON-JOSEPH MADELINE

The Second World War interrupted construction on this building that had been previously plagued with problems. During the Occupation, Germans mounted canons on the terraces, and, in 1944, Allies placed weapons inside that exploded, causing damage. Construction finally ended in 1953 and the facility opened with 6,500 square meters of floor space for the university's medical faculty. Although the building appears gigantic, it is actually lower than the original design. Medallions placed on the exterior break the rhythm of the monotonous façade. The monumental bronze door by Landowski is the only distinguishing feature that rescues the building from totalitarian architecture.

393

Hôtel Bel Ami

7–9, RUE SAINT-BENOÎT AT RUE JACOB

C. EIGHTEENTH CENTURY, FIRST BUILDING; C. 1890, SECOND BUILDING

In the Middle Ages, a door in the middle of one of the halls that used to be on this site provided access to the Saint-Germain-des-Prés abbey. Allegedly, in the twelfth century, Pope Alexander III himself passed through the door in this manner to enter the abbey. Now, Bel Ami occupies two renovated buildings: a typically austere construction from the eighteenth century and an industrial workshop structure from the nineteenth century. Today's minimalist building originally housed a printing press that produced documents for the Assemblée Nationale. Designer Grace-Leo Andrieu, the same woman who remodeled the Montalembert Hotel, recently completed an interior renovation.

394

rue de l'Abbaye

AT RUE CARDINALE AND PASSAGE DE LA PETITE-BOUCHERIE

C. 1800

This quiet street is just around the corner from the bustling Saint-Germain-des-Pres Place with its historic Abbey. Established in 1800, the street was named rue de la Paix (Peace) from 1802 to 1809, then renamed Neuve-de-l'Abbaye until 1815, when it assumed its current name. Although shops fill the ground level of these buildings today, doorways at the crossroads of numbers 1, 2, and 2 bis once led to the main courtyard of the Abbey. In the 18th century, administrative houses for the bailiffs, civil and criminal judges, and police force were situated at the angle of these streets. Across the street, Charles de Bourbon, the abbot of Saint-Germain-des- Prés, originally occupied a palace at #3.

395

Musée National Eugène Delacroix

6, RUE DE FURSTENBERG BETWEEN RUE JACOB AND RUE DE L'ABBAYE

C. 1586, GUILLAUME MARCHANT, BUT SINCE TRANSFORMED

Seriously ill with tubercular laryngitis while painting three frescos for Saint-Sulpice church, Eugéne Delacroix found an apartment retreat within the former courtyard of the stables of the abbatial of Saint-Germain-des-Prés. The apartment owner added a spacious atelier in the garden and constructed a steel staircase so Delacroix had easy access from his apartment. He was able to work on his final public commission here, where the airy studio and quiet courtyard restored his vitality. Thanks to the preservation efforts of painters Paul Signac and Maurice Denis, who established in 1929 the Society for the Friends of Eugène Delacroix, his home and atelier became a museum, instead of being razed for the planned construction of a parking garage.

392

393

394

395

396

Le Petit Saint-Benoît

4, RUE SAINT-BENOÎT AT RUE JACOB

c. 1860

For nearly 150 years, Le Petit Saint-Benoît has served meals to a local literary crowd and its ordinary neighbors. During World War II, François Mitterrand and various writers met here to discuss their Resistance work; Albert Camus and Simone de Beauvoir discussed ways to prevent an atomic bomb threat and admirers of James Joyce dined here as well. If you were a regular back then, you might have had your napkin placed in one of the numbered drawers, still there against the wall. With a reputation for offering whatever was cheap at the former Les Halles markets, this traditional bistro still dishes out affordable meals.

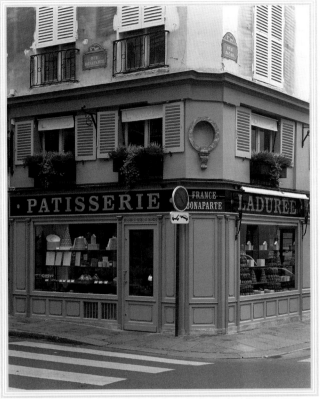

397

397

Ladurée

21, RUE BONAPARTE BETWEEN RUE JACOB AND RUE VISCONTI

C. 1700; 2000, INTERIOR DÉCOR, ROXANNE RODRIGUEZ

In 1862, when Louis Ernest Ladurée opened a bakery around the thriving commercial district of the Madeleine on the Right Bank, he probably never anticipated that his name would one day cross the Seine. Ladurée's breads and Viennese pastries were so successful, he opened a *salon de thé* in 1890 so ladies could lunch discreetly. A hundred years later, Francis and David Holder bought the period restaurant and began expanding. Their Ladurée tearoom in the heart of the Saint-Germain-des-Prés district on the Left Bank occupies a former antique shop, opened in 1947 by Madeleine Castaing, which had its own history of famous clientele, such as Chagall, Modigliani, and Soutine. Inspired by the Castaing's interior décor, designer Rodriguez blended neoclassical elements with the Second Empire style to create the feeling that one is dining in an elegant private home.

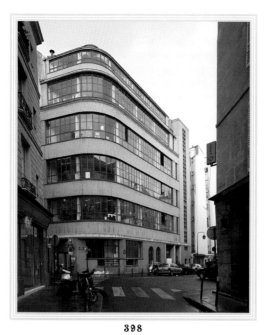

398

399

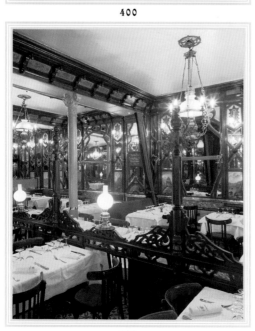

400

401

402

403

Grande Masse des Beaux-Arts

1, RUE JACQUES CALLOT AT RUE MAZARINE

1933, ROGER-HENRI EXPERT

This corner building juts out onto the street like a rounded glass luxury liner. Its mostly-window exterior curving around the corner gives weightlessness to the large and weighty structure. The large rooms inside face north and the horizontal windows allow good light on every drawing table, contributing to the building's function as an architectural school. Situated at a corner, the place also seemed ideal for mischievous students who had a reputation for pelting pedestrians below with water bombs.

La Palette

43, RUE DE SEINE AT RUE JACQUES-CALLOT

1930–40

Starving artists frequented this café around the turn of the last century. Here, along with students attending the nearby Ecole des Beaux-Arts (school of fine arts) and Paris-La-Seine (school of architecture), they found warmth and cheap café food. Picasso, Monet, and Renoir all had ateliers in the vicinity. The café was also an active player in the student uprisings of May 1968. The café's smoky bar is decorated with painters' used palettes, from which the name originates.

22, Passage Dauphine

AT RUE MAZARINE

C. 1850 ARCHITECT UNKNOWN

This brick house, in Louis Treize Revival style, crosses the former site of part of Philippe Auguste's wall, which ran parallel to rue Mazarine. Constructed between 1190 and 1220 to protect the city from invaders, this rampart crops up in the oddest places today. It is usually hidden by newer construction. Different portions have been well-preserved thoughout the centuries, however, because houses leaned up against them.

Hôtel des Comédiens du Roy

14, RUE DE L'ANCIENNE-COMÉDIE AT BOULEVARD SAINT-GERMAIN

1688–89, FRANÇOIS D'ORBAY

Two early theater troupes—Comédiens du Roy and the Théâtre de Marais—performed at Hôtel de Bourgogne on rue Mauconse, the first theater of Paris. Eventually the two troupes merged into the Comédiens du Roy, with an inaugural performance of Molière's *Tartuffe* at Théâtre Guénégaud in 1673. In 1689, the troupe moved into this new home on rue de l'Ancienne-Comédie, opening the season with a double bill: *Médecin Malgré Lui* by Molière, and *Phèdre* by Racine. They continued to perform here until 1770.

Restaurant Vagenende

142, BOULEVARD SAINT-GERMAIN AT ST RUE GRÉGOIRE DE TOURS

1878, BUILDING; 1904, RESTAURANT

A Belle Epoque atmosphere pervades this Saint-Germain-des-Prés brewery, preserved in the splendor of its Art Nouveau styling: carved arabesque woodwork, beveled mirrors, and painted-glass landscapes. Opened in 1904 by the Edouard brothers and Camille Chartier, the founders of the Chartier chain of Bouillon ("Bubble") restaurants, this site quickly became a popular gathering place. In the 1920s, the Vagenende family took over the premises, and ran it for more than fifty years until 1966.

Hôtel du Globe

15, RUE DES QUATRE-VENTS AT RUE GRÉGOIRE DE TOURS

C. SEVENTEENTH CENTURY

A suit of armor graces this seventeenth-century former abbey-turned-hotel. Featuring antique furnishings and four-poster beds, a night here would be a distinctive adventure…or perhaps a crusade around the globe. At the center of the historic 6th arrondissement, the street that had previously held several names became rue des Quatre-Vents ("Street of the Four Winds") in the seventeenth century because of a shop sign whose cupid's head could blow north, south, east, and west.

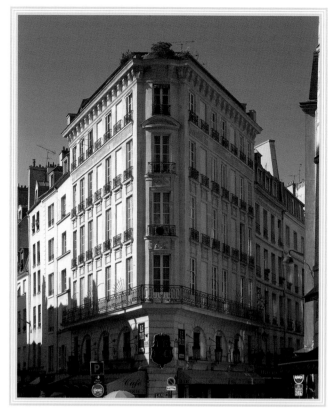

404

404

Le Buci

CARREFOUR DE BUCY ANGLE
52, RUE DAUPHINE AT RUE MAZARINE

1771, PIERRE DESMAISONS

Rue Dauphine is the first example of a regulated street developed by Henri IV to generate a modern city face. Buildings had to adhere to height and stone frontage requirements. The strategic site and shape of this building placed at the corner was perfect to express monumental architecture that would become a model for Parisian apartment buildings until the time of Haussmann in the nineteenth century. On the other side of rue Dauphine, the same architect reused his model with identical characteristics. Its crossing shaped like the prow of a boat, the building rests on a solid base level surrounded by a balcony, and a heavy cornice crowns the building and hides the roof. By its position and shape, this building, one of the most beautiful of its time, is reminiscent of the Flatiron Building in New York City.

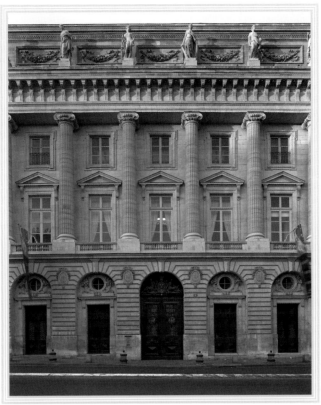

405

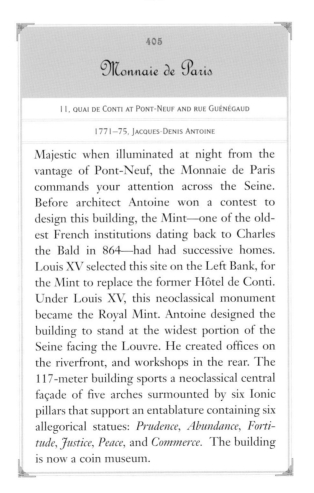

Monnaie de Paris

11, QUAI DE CONTI AT PONT-NEUF AND RUE GUÉNÉGAUD

1771–75, JACQUES-DENIS ANTOINE

Majestic when illuminated at night from the vantage of Pont-Neuf, the Monnaie de Paris commands your attention across the Seine. Before architect Antoine won a contest to design this building, the Mint—one of the oldest French institutions dating back to Charles the Bald in 864—had had successive homes. Louis XV selected this site on the Left Bank, for the Mint to replace the former Hôtel de Conti. Under Louis XV, this neoclassical monument became the Royal Mint. Antoine designed the building to stand at the widest portion of the Seine facing the Louvre. He created offices on the riverfront, and workshops in the rear. The 117-meter building sports a neoclassical central façade of five arches surmounted by six Ionic pillars that support an entablature containing six allegorical statues: *Prudence, Abundance, Fortitude, Justice, Peace*, and *Commerce*. The building is now a coin museum.

406

407

406

Institut de France

23, QUAI DE CONTI AT RUE DE LA SEINE AND QUAI MALAQUAIS

1663–70, LOUIS LE VAU; 1670–74, FRANÇOIS D'ORBAY II, COMPLETED AFTER LE VAU'S DEATH

Impressive by day but an exhilarating sight at night, this Baroque building features a central domed chapel overlooking the Seine. Inside, beneath the dome, the mausoleum of Cardinal Mazarin rests once again—having lost its place temporarily during the Revolution. Before he died, Mazarin established a grant in his will to fund the construction of the College des Quatre Nations, designed to educate noble students from the four foreign regions that France had recently acquired: Alsace (from Germany), Artois (from Flanders), Piedmont (from Italy), and Roussillon (from Spain). During the 1790s, this building was one of many to be confiscated and transformed into prisons. Among hundreds of others, Dr. Guillotin, of guillotine fame, occupied a cell here. In 1805, Napoléon converted the building back to being a seat of learning, and the chapel became an assembly hall.

407

Ecole des Beaux-Arts

14, RUE BONAPARTE AT 11–17, QUAI MALAQUAIS

1608–17, CHURCH AND CLOISTER; 1740–56, FRANÇOIS DEBIAS-AUBRY, HÔTEL DE CHIMAY; 1820–29, FRANÇOIS DEBRET, LOGES; 1832–72, FÉLIX DUBAN, CONTINUATION, AND PALAIS DES ETUDES, BUILDING ON QUAI MALAQUAIS; 1945, AUGUSTE PERRET, ADDITIONS

The aristocratic patronage of the arts in the 6th arrondissement led to the eventual creation of this art school complex. When Henry IV disavowed his first wife, Marguerite de Valois, she set up housekeeping across the Seine in a mansion she had built for herself. In 1608, she founded the convent of the Petits-Augustins for the Augustinian monks and constructed, on her estate, a church and chapel known as the Chapelle des Louanges. Its dome is the oldest in Paris. The Revolution closed down the convent and used it to deposit artwork in 1791, with Alexander-André Lenoir as its guardian. He converted it into a museum, the Musée des Monuments Français. In 1816, the museum was closed, renovated, and transformed into the Ecole des Beaux-Arts.

1–3, quai de Conti

At rue de Nevers and rue Dauphine

1930–1932, Joseph Marrast

The arch at rue de Nevers opens onto one of the narrowest streets in Paris and ends at a remnant of Philippe Auguste's twelfth-century fortification wall. The buildings on either side of the arch overlook the Seine and the Île de la Cité. Their construction in brick and stone visually matched the buildings originally at Place Dauphine on Île de la Cité. This view from Pont-Neuf suggests the problems this project created for city authorities because the architecture had to respect the site of Pont-Neuf, rue Dauphine, and the riverbank alongside it. As an extension of Pont-Neuf on the Left Bank, rue Dauphine is one of the first real urban planning projects in Parisian history thanks to Henry IV who, in the beginning of the seventeenth century, first tried to impose homogeneous buildings of the same height and stone facades on a straight street. This final project is an interpretation of seventeenth-century classical architecture with a stone base level, monumental pilasters, brick at the central portion and at the upper level of the façade, and a steep roof.

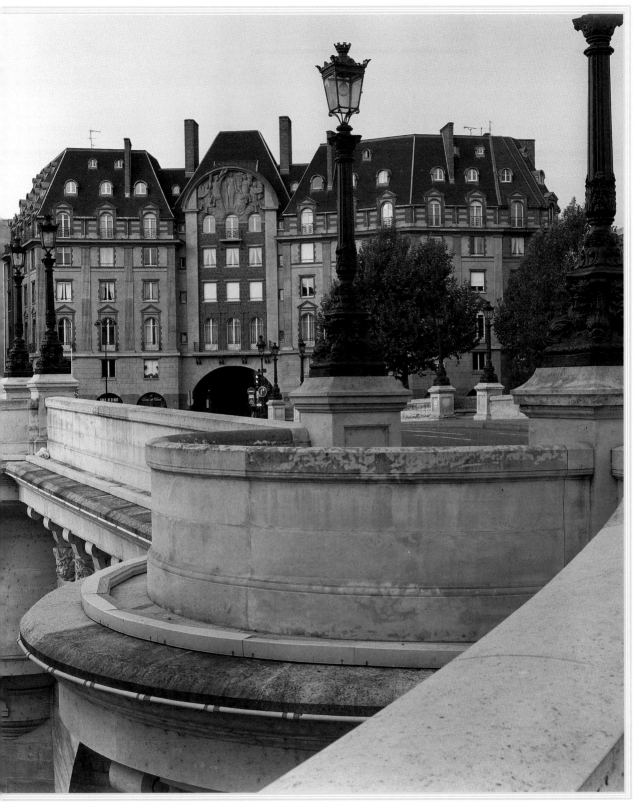

408

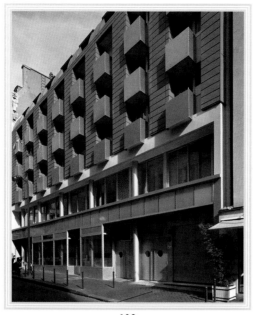

409

5, RUE ANDRÉ MAZET
BETWEEN RUE DAUPHINE AND RUE SAINT-ANDRÉ-DES-ARTS

2001, GEORGE MAURIOS

Part of the University Mazet, this modern building resembles a three-dimensional grid. These upper levels are reserved housing for university students who often experience difficulty in finding places to live due to the high demand for rental units in Paris. The modern materials, metal and painted zinc, fit well in this historic neighborhood, thanks to the building's simple proportions.

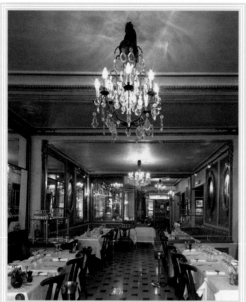

410

410

Le Procope

13, RUE DE L'ANCIENNE-COMÉDIE AT RUE SAINT-ANDRÉ-DES-ARTS

c.1686

Francesco Procopio dei Coltelli had the prescience to anticipate coffee's universal appeal, and introduced Parisians to the exotic beverage when he opened Le Procope. It was also possibly the first café in Paris to serve sherbet. With a three-hundred-year history, Paris's oldest café bills itself as the "*Le Rendez-vous des Arts et des Lettres*," and Diderot and d'Alembert, who conceived the *Encyclopédie* here, Voltaire, Rousseau, Beaumarchais Marat, and Danton wandered in now and then, among others.

411

411

Lycée Fénelon

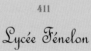

2, RUE DE L'EPERON AT RUE SAINT-ANDRÉ DES ARTS

1728; 1883–93, CHARLES LE CŒUR;
1911, ALBERT TOURNAIRE, ADDITION

Ten years of reconstruction work by architect Charles Le Cœur transformed this eighteenth-century mansion into Paris's first all-girls school. Previously known as Hôtel Villayer and Chateauvieux, the building was conserved in part, retaining its beautiful stairway as well as some original salon and bedroom décor. The street façades are reconstructions, and the old courtyard became a recreation space, but the courtyard façades correspond to the conserved building.

412

Cour de Rohan

At rue Jordinet and cour du commerce de Saint-André
Between boulevard Saint-Germain and Saint-André-des-Arts

C. SIXTEENTH CENTURY

Seen here from an approach down an adjoining passage, three picturesque courtyards convene in succession at a square known as Cour de Rohan. Near rue de l'Ancienne-Comédie, this area will charm you with its delightful tangle of terraces and trees. Street lamps overhang alleys, and balconies overflow with geraniums and ivy. The name derives from the fact that a residence here once belonged to the archbishops of Rouen.

412

413

Lapérouse

51, QUAI DES GRANDS-AUGUSTINS AT RUE DE GRANDS-AUGUSTINS

C. 1720–30, BUILDING; C. 1850, RESTAURANT

In the mid–nineteenth century, wine merchant Jules Lefèvre opened this restaurant in an eighteenth-century building facing the Seine. Its dark wood façade with gold trim and Louis Quinze balconies glows at night from chandelier light on the upper levels, where Lefèvre established private dining rooms. Proust and Colette dined here, as well as Robert Louis Stevenson, Hugo, Thackeray, Maupassant, and Dumas. Henry James may have used the restaurant as a setting in *The Ambassadors*.

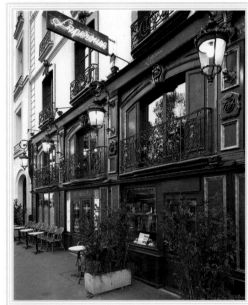

413

414

Hôtel de Hercule

5–7, RUE DES GRANDS-AUGUSTINS AT QUAI DES GRANDS-AUGUSTINS

C. FIFTEENTH CENTURY; C. SIXTEENTH CENTURY

Between 1936 and 1955, when Pablo Picasso lived at number 7, rue des Grands-Augustins, he painted his famous *Guernica*, among other works. The original fifteenth-century hotel on this site was destroyed and another replaced it in the late sixteenth century. The façade detailing, especially around the windows on the third level, is unusual for Parisian mansions of that time, and unique to this *hôtel*—the name of which refers to the previous residence on this site.

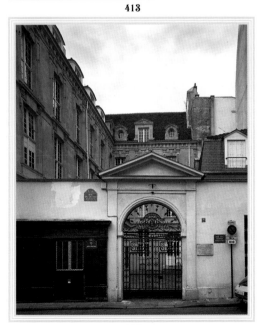

414

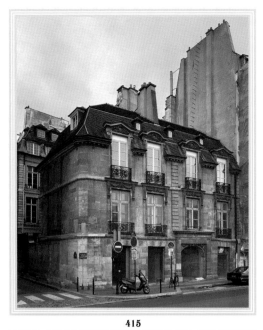

415

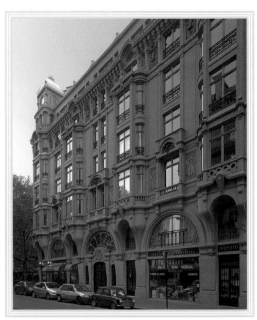

416

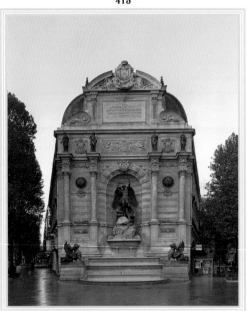

417

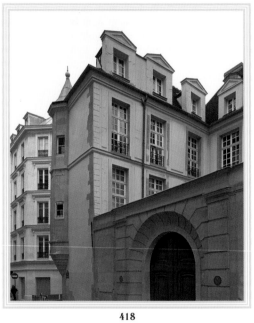

418

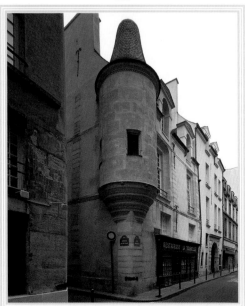

419

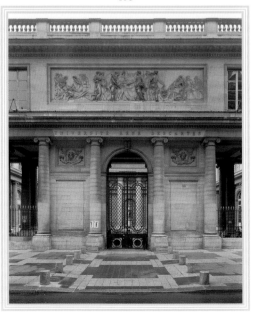

420

415

Hôtel de Montholon

35, QUAI GRANDS-AUGUSTINS AT CORNER 2, RUE SÉGUIER

C. 1650; C. 1673, ADDITION

In 1740, printer François Didot resided here. Despite the symmetry seemingly created by the series of pediments, the building's charm derives from the irregular composition produced by the placement of the entrance on the right side. Two slightly different piers—one with carved horizontal lines and the other without—flank the entry gate. Dormers also cross the roof adding a horizontal balance. The building typifies a time of research in French Renaissance architecture when vertical lines were still directing the shape of a building.

416

Hennebique building

1, RUE DANTON AT PLACE SAINT-ANDRE-DES-ARTS

1898, FRANÇOIS HENNEBIQUE, DESIGN EDOUARD ARNAUD

Engineer François Hennebique, father of the reinforced concrete building in Paris, created this striking Art Nouveau building. Hennebique, who began his career as a stonemason, started experimenting with the properties of concrete. Discovering that it was preferable to iron because it permitted expansion, he devised a system to fix its reinforcement in place and patented the method in 1892. This geometric building marks one of the first applications of his method.

417

Fontaine Saint-Michel

PLACE SAINT-MICHEL AT PONT-SAINT-MICHEL AND BOULEVARD SAINT-MICHEL

1858–60, GABRIEL DAVIOUD

A colossal statue of the archangel Michael (Saint-Michel) crushes the Devil, vanquishing evil and welcoming you to the Rive Gauche. One of the most impressive fountains in Paris, this one occupies the entire end wall of a building, gushing water at the juncture of Pont-Saint-Michel, quai Saint-Michel, quai des Grands Augustins, boulevard Saint-Michel, and place Saint-André-des-Arts. Francisque-Joseph Duret designed the energetic archangel at the center of the fountain.

418

21, rue Hautefeuille

AT RUE PIERRE-SARRAZIN

C. SIXTEENTH CENTURY

This tower survives on a small stretch of street between rue de l'Ecole-de-Médecine and boulevard Saint-Germain. One of the few existant corner turrets in Paris, this one dates from the sixteenth century, and the octagonal shape of its charming tower makes this even a rarer sight. Beneath the surface lie the remains of an old Jewish cemetery dating from the twelfth and thirteenth centuries, before Philippe Auguste and later Philip the Fair each confiscated the area and expelled the Jews.

419

Hôtels des Abbés de Fécamp

5, RUE HAUTEFEUILLE AT RUE SERPENTE

1292; C.1520–30, REBUILT

The abbots of Fécamp assumed this residence in 1292, but it was rebuilt in the early sixteenth century, and its corner turret dates from that period. Rumor has it that, in the mid–seventeenth century, calvery officer Godin—lover of the infamous mass murderer, the Countess de Brinvilliers—lived here. Godin learned all about using poisons in prison and passed the proportions on to the countess, who proceeded to do away with numerous relatives and perceived enemies.

420

Université René Descartes, Faculté de Médecine

12, RUE DE L'ECOLE-DE-MÉDECINE AT BOULEVARD SAINT-GERMAIN

1776–86, JACQUES GONDOUIN; 1878–1900, LÉON GINAIN, EXTENSION OF FAÇADE ON THREE SIDES

At one time, surgeons were members of the same fraternal society as barbers. This strange union lasted 100 years, when the education of surgeons was finally merged with that of medical doctors. This led to the founding, in 1794, of l'Ecole de Santé (School of Health), which Napoléon I rechristened the Faculté de Médecine. This neoclassical building has an inner court whose amphitheater contains Corinthian columns, a pediment, and a half dome.

421

Refectory of the Franciscans

15, RUE DE L'ECOLE-DE-MÉDECINE AT BOULEVARD SAINT-GERMAIN

C. LATE FOURTEENTH CENTURY

This refectory is all that survives from a Franciscan monastery founded in the thirteenth century, but destroyed in 1802. The merry monks abandoned their monastery just before the Revolution. Taken over by Revolutionary leader Camille Desmoulins, it became the headquarters for radical thinkers. It was a gathering of like minds here on July 14, 1791, that called for the deposition of the king. Today, the large ground floor hall is a venue for temporary exhibitions.

422

Hôtel Darlons

4, RUE MONSIEUR-LE-PRINCE AT CARREFOUR DE L'ODÉON

C. EARLY EIGHTEENTH CENTURY

Despite a rather austere upper level, this *hôtel*'s Rococo-inspired portal landed Hôtel Darlons on the national registry for historic monuments. Because the impressive carved entry faced the street, it was designed as a monumental achievement for so common a building. Pierre Darlons commissioned this mansion as his residence in the eighteenth century. Today, it houses an atelier, and a brasserie occupies the ground floor.

423

Trois Luxembourg

67, RUE MONSIEUR-LE-PRINCE

1966; 1986

Created to show classic movies and avant-garde films, this cinema premiered as a multiplex with three screening rooms. But after twenty years, it was no longer comfortable, and required renovation. The façade sculpture represents an amusing look at objects from the world of cinema.

424

Université Paris 3
(SORBONNE NOUVELLE)

5, RUE DE L'ECOLE-DE-MÉDECINE AT BOULEVARD SAINT-MICHEL

1691–95, CHARLES AND LOUIS JOUBERT

When built in the late seventeenth century, this amphitheater was used for training surgeons. At the time until the Revolution, surgery and medicine were separate and rival professions. So, medicine had its own amphitheater in the 5th arrondissement. The schools of Surgery and Medicine merged in 1794, but surgery moved to a new location earlier, and this amphitheater became a drawing school in 1775. Today, the University of Paris uses it for its modern language institute.

425

Bouillon Racine
(BUBBLE ROOT)

3, RUE RACINE AT BOULEVARD SAINT-MICHEL

1907, J.-M. BOUVIER AND LOUIS TRÉZEL, INTERIOR DECORATION

Although it is a registered historic French monument, this restaurant now serves Belgian fare. It has been faithfully and painstakingly restored to its original Art Nouveau splendor from the days when George Sand had once lived in the same building. From the crystal façade to the floor mosaic and floral ceiling of tile and glass, the refitting and replicating that was accomplished in 1996 by Belgian brewers has restored this Latin Quarter restaurant to the way it looked in the early twentieth-century.

426

3, rue Vaugirard

AT RUE MONSIEUR LE PRINCE

C. 1930

This tall and elegant building, Hôtel Trianon, stands at the corner of rues Monsieur-Le-Prince and Vaugirard. Elements of its sleek Art Deco façade are evident on one side and on the balcony portion. The hotel now serves as a conference center for seminars and meetings.

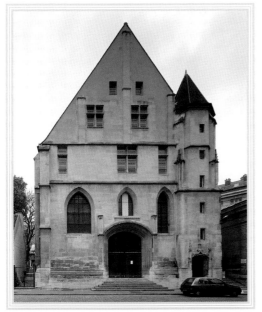

421

422

423

424

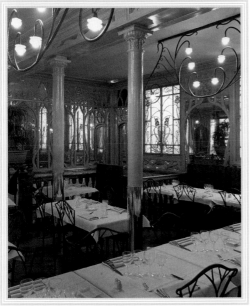

425

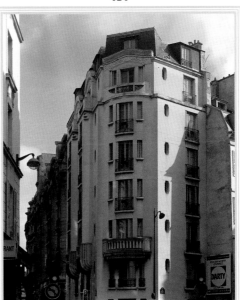

426

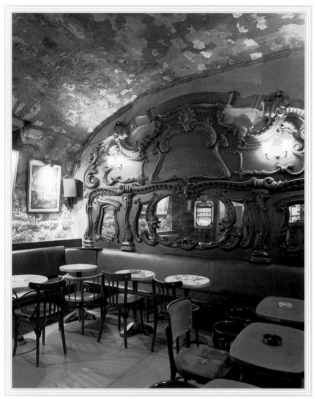

427

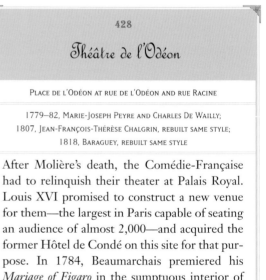

427

Le Bar Dix

10, RUE DE L'ODÉON
BETWEEN CARREFOUR DE L'ODÉON AND PLACE DE L'ODÉON

c. 1780, LOUIS DELARBRE

Occupying ground level of this eighteenth-century stone building, a maroon-painted façade identifies this hip dive with the name "Bar" and the number "10" scrawled discreetly across the front. Inside, Art Nouveau posters claim the décor, a jukebox plays Guns n' Roses as well as Pachelbel's Canon, and an expat crowd drinks sangria and hangs with the French hipsters.

428

Théâtre de l'Odéon

PLACE DE L'ODÉON AT RUE DE L'ODÉON AND RUE RACINE

1779–82, MARIE-JOSEPH PEYRE AND CHARLES DE WAILLY;
1807, JEAN-FRANÇOIS-THÉRÈSE CHALGRIN, REBUILT SAME STYLE;
1818, BARAGUEY, REBUILT SAME STYLE

After Molière's death, the Comédie-Française had to relinquish their theater at Palais Royal. Louis XVI promised to construct a new venue for them—the largest in Paris capable of seating an audience of almost 2,000—and acquired the former Hôtel de Condé on this site for that purpose. In 1784, Beaumarchais premiered his *Mariage of Figaro* in the sumptuous interior of this theater, which is a neoclassical gem. The architects achieved a harmonious setting for their Greco-Roman theater by constructing buildings on either side of the plaza, to create visual balance. Approached from rue de l'Odéon, the building itself seems set upon a stage.

429

École Supérieure des Mines

60–64, BOULEVARD SAINT-MICHEL AT RUE AUGUSTE COMTE

1706–14, JEAN COURTONNE, THEN ALEXANDRE LEBLOND, FIRST HÔTEL
VISIBLE FROM THE GARDEN; 1840–42, FRANÇOIS DUQUESNOY,
EXTENSION; 1860–62, VALET, MODIFICATION

Situated at the southeast corner of Luxembourg Gardens, this school has several façades: a typical, three-floor structure with a mansard roof fronts boulevard Saint-Michel; a former orangerie with large, arched windows and multiple panes repeat along the side of rue Auguste Comte; and one short façade faces the lovely Luxembourg Gardens. On the boulevard side, the building's arched, rusticated entry with a small curved pediment provides the only character to this otherwise unadorned building.

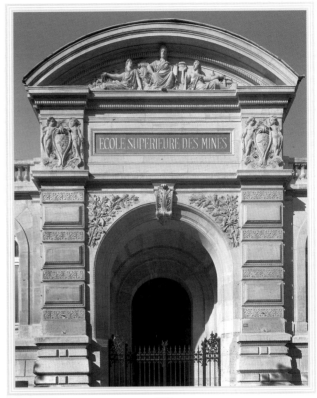

429

430

École Nationale d'Administration
(E.N.A.)

2, AVENUE DE L'OBSERVATOIRE AT RUE AUGUSTE COMTE

1895, ADOLPHE YVON

Like a travelogue from another time, this building—formerly the Colonial School, then the France of Overseas School—presents the chapter in French colonial history. Bringing civilization to other areas of the world made exporting French culture and knowledge a matter of duty, and this school was inspired by that movement, which also served to import design ideas from those places the colonists traveled to: The building's Moorish patterns in polychromatic brick over the windows evoke that influence, as do the multiple arches at the main door. Today, you'll find the International Institute of Public Administration at this site.

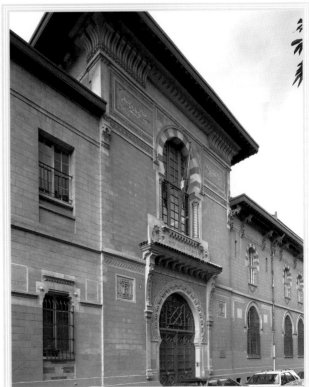

430

431

Lycée Saint-Louis

44, BOULEVARD SAINT-MICHEL
AT RUE DE VAUGIRARD, RUE MONSIEUR-LE-PRINCE, AND RUE RACINE

1820

A small second-century amphitheater—the architectural remains of the early Roman settlement Oppidum Lutetia—lies beneath the Lycée Saint-Louis. While above ground, the Lycée functions as a public college. This classic building with multiple façades on different streets has a rusticated lower level with brick construction above. A curved façade fronts its entrance on boulevard Saint-Michel.

432

Restaurant La Godasse

38, RUE MONSIEUR-LE-PRINCE AT RUE VAUGIRARD

C. 18TH CENTURY BUILDING

Situated around the block from the Sorbonne, this historic corner building has a solid stone foundation on one side and painted wood on the other. White lace curtains dangle daintily from the windows, but this French bistro whose name means "old worn shoe," serves up hearty grilled steaks to match its rustic interior and exposed-beam ceiling.

433

École Supérieure de Pharmacie

63, RUE D'ASSAS AT 4, AVENUE DE L'OBSERVATOIRE

1966, PIERRE SIRVIN AND CAMILLE CLOUZEAU

For this modern extension of an old building, the architects took a cue from Le Corbusier's 1953 project in Neuilly, where he used basic, inexpensive materials, such as concrete and brick, to show traces of the builders' work. Here, the architects decided to ignore traditional design in favor of providing an image of continuity between the old and new. They utilized brick to link the two buildings and grouped floors together in pairs to create a neoclassical aura of monumental proportions.

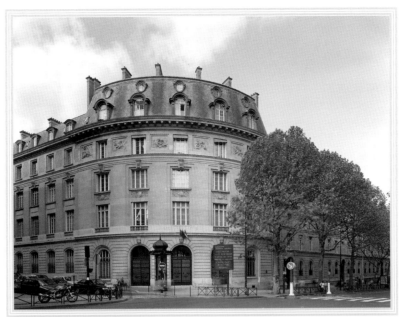

431

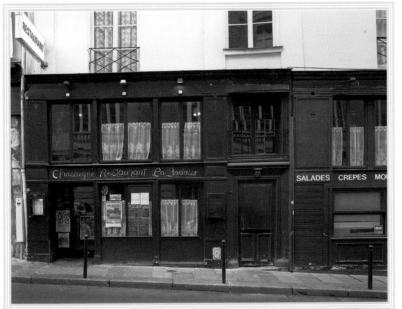

432

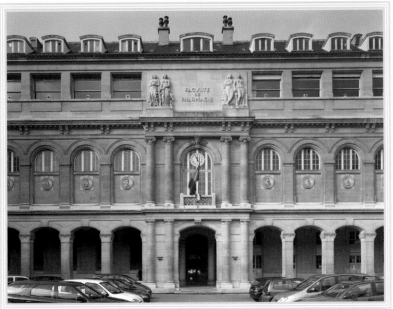

433

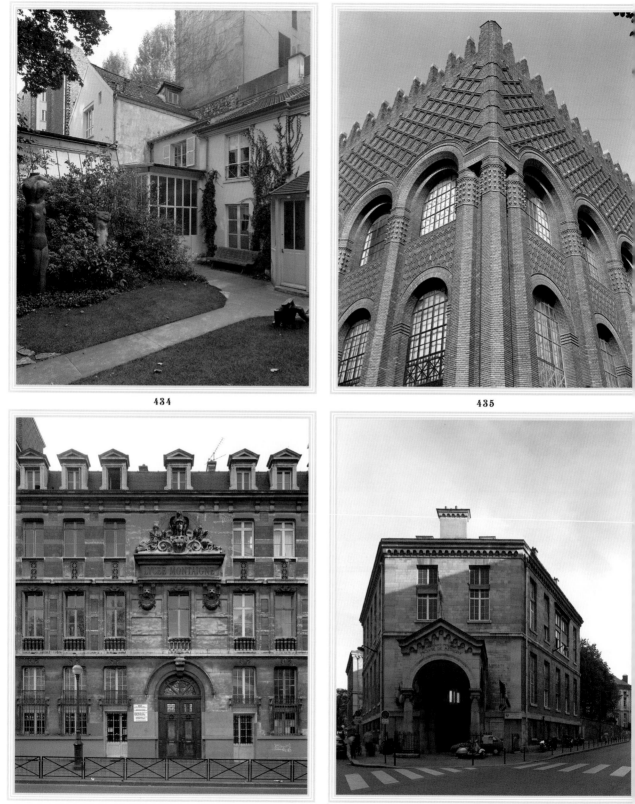

434

435

436

437

434
Musée Zadkine

100 BIS, RUE D'ASSAS AT RUE MICHELET

C. LATE NINETEENTH CENTURY

Russian sculptor Ossip Zadkine lived and worked in this house with his wife, painter Valentine Prax, from 1928 until his death in 1967. Hidden behind an alley, not far from Luxembourg Gardens, a small sculpture garden remains just as Zadkine had arranged it. In her book, *Avec Zadkine, Souvenirs de Notre Vie*, Prax describes her memory of her husband in his garden: "There in the open air, Zadkine shaped the granite and the stone of Pollinay, as well as the hardest woods. He gave the impression of being a worker, with his suit of gray velvet and his brown suede cap. He also wore big glasses to protect his eyes from the shards of wood and granite." The building is now a museum.

435
Institut d'Art et d'Archéologie

3, RUE MICHELET AT AVENUE DE L'OBSERVATOIRE

1927, PAUL BIGOT

A concrete pastiche of architectural styles, periods, and ethnic influences, this wondrous red brick building seems incongruous in its location near Luxembourg Gardens. Reminiscent of Moorish design, its lower level frieze also recalls the Roman origins of the Parthenon. Head of l'Ecole des Beaux-Arts, architect Bigot studied the buildings of the past, and was more interested in the restoration and history of architecture than in designing new buildings. Perhaps as a reaction to the Modernist Movement that he opposed, Bigot created this monument to eclectic traditions. But its anachronistic presence also expresses its function as an institute for art and archeology.

436
Lycée Montaigne

17, RUE AUGUSTE-COMTE
BETWEEN RUE D'ASSAS AND AVENUE DE L'OBSERVATOIRE

1886–90, CHARLES LE CŒUR; 1954, LUCIEN VAUGEOIS, ADDITIONS;
1997, UNDERGROUND GYMNASIUM

Situated at the southern end of Luxembourg gardens, this school enjoys a coveted location in the 6th arrondissement. A large vestibule opens to a winter garden that extends the traditional *cour d'honneur* (main courtyard). Architect Le Cœur incorporated classrooms and dormitories on the upper floors, allowing for day and boarding students. Inaugurated in 1885 as Le Petit Lycée Saint-Louis-le-Grand with connections to another school nearby on rue Saint-Jacques, it became independent in 1891 and was renamed Lycée Montaigne. An all-boys school until 1912, when girls joined the younger classes, it went completely coed in 1957.

437
Hôpital Cochin

89, RUE D'ASSAS AT RUE DES CHARTREUX

1881, LÉON GINAIN

Physician Tarnier was the first to recommend isolating pregnant women within medical facilities instead of placing them in highly infectious general wards. So, this building became a maternity hospital with seventy-four beds when inaugurated; it eventually expanded to hold 240 beds. In 1897, it became known as Hôpital Tarnier. This massive structure has multiple austere façades but a distinguished entrance: Surmounted by a triangular, scalloped cornice and supported by Ionic columns, the arched portal provides a drive-up entryway that juts out with character from these otherwise somber blocks of stone. Hôpital Tarnier is now a dermatology clinic and a treatment center for pain.

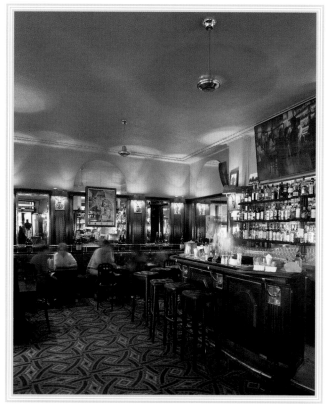

438

La Closerie des Lilas

171, BOULEVARD DU MONTPARNASSE AT BOULEVARD SAINT-MICHEL

1925, PAUL AND ALPHONSE SOLVET, BUILDING

One of the legendary literary cafés of the 1920s, this restaurant actually started out as a country inn during the days when stagecoach travelers stopped here on their route from Paris to Fontainebleu and Orléans. Long before Hemingway made it his neighborhood café, nineteenth-century writers, poets, and artists gravitated here. Brass markers inside testify to famous folk who frequented the establishment back then; they include Baudelaire, Verlaine, Balzac, and Chateaubriand. A photograph of the bar also verifies the twentieth-century presence of Man Ray, Apollinaire, Picasso, and Lenin, in addition to poet Paul Fort, and novelists James Joyce, John Dos Passos, and F. Scott Fitzgerald. After World War II, La Closerie was home to the Symbolists, the Dadaists, and the Surrealists. Today, a current crop of Montparnasse intellectuals mingle inside the dark, mosaic-floored café.

7TH ARRONDISSEMENT

The ritzy 7th arrondissement has a dual person-
ality: residential and governmental. The district
boasts Musée d'Orsay, upscale antique shops, a
sweeping view of the Seine from the Eiffel
tower, and Napoléon's final resting place under
the cupola of Hôtel des Invalides. Embassies,
ministries, and government offices now occupy
former aristocratic mansions in the area between
the 6th arrondissement and Les Invalides, which
was one of the most sought-after neighbor-
hoods in the seventeenth century and is still
home to the haute bourgeoisie. Au Bon
Marché, the oldest department store in Paris
and the only one on the Left Bank, caters to a
tony, residential crowd. The French prime
minister calls Hôtel Matignon home, and the
Assemblée Nationale convenes in the Palais
Bourbon at the bank of the Seine. Except on
rare days when they are opened to the public,
private courtyards and gardens lie hidden
behind high walls and massive, closed portals.
But you can picnic in the rectangular Parc du
Champs de Mars while gazing at the façades of
the Ecole Militaire at one end or, if you face the
opposite direction, at Paris's most famous mon-
ument, the Tour Eiffel.

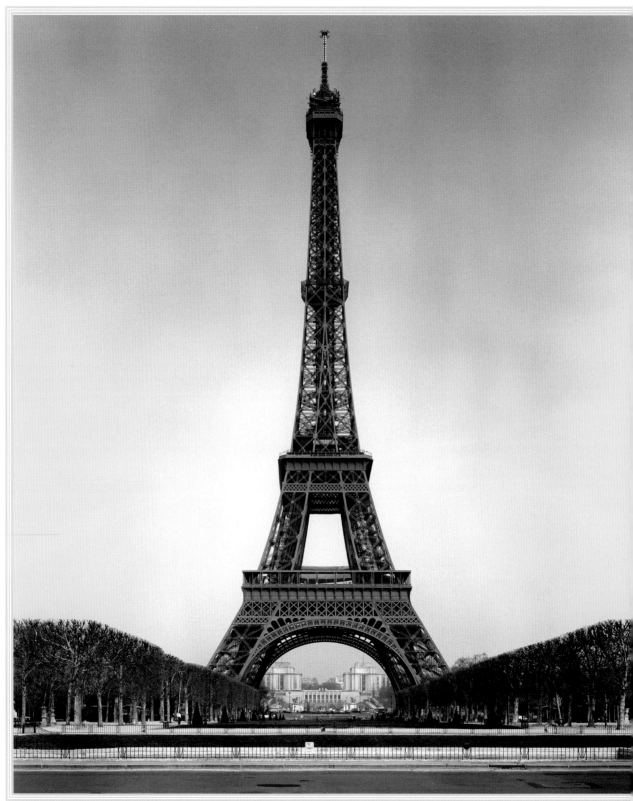

439

Eiffel Tower

Champ-de-Mars between quai Branly and avenue Gustave Eiffel

1887–89, Stephen Sauvestre (architect), Maurice Koechlin and Emile Nouguier, (engineers), and Gustave Eiffel (contractor)

This marvel of late nineteenth-century engineering stretches more than 1,000 feet above the skyline—the equivalent of ten football fields stacked vertically—and was the tallest building of its time. Composed of 7,300 tons of wrought iron and 2.5 million rivets, it was assembled from over 18,000 prefabricated parts, as if from some giant-scale Erector set. Horrified intellectuals dubbed it the "awful tower," a "truly tragic street lamp," a "belfry skeleton," and a "hole-riddled suppository," but several had the audacity to think it grand. On opening day, a broken elevator forced Gustave Eiffel and selected bureaucrats to hoof it up the tower's interior stairs. Most stopped before reaching the summit, but Eiffel hiked the full 1,665 steps to the top, where he and whatever hardy officials accompanied him there hoisted a flag, thus inaugurating the structure. Eiffel encouraged its use as an experimental scientific site and as a radio broadcast tower, in hopes of ensuring its survival past its originally intended twenty years, and the strategy worked: Today, the high platform continues to support various antennae including those used for television. Protected from oxidation with several layers of paint, the tower is repainted every seven years by a team of twenty-five painters. Variations in the façade color toward the top give the paint the appearance of a uniform coating against the sky. Originally conceived for the 1889 World Exposition, this graceful "Iron Lady" has remained the quintessential symbol of Paris.

440
La Fontaine de Mars
with Fontaine de Mars

129–131, RUE SAINT-DOMINIQUE AT RUE DE L'EXPOSITION

1806, NICOLAS BRALLE, FOUNTAIN; C. 1900, CAFÉ

Sculpted by Pierre Beauvallet, the figures of Mars and Hygeia—god of war and goddess of health—adorn this fountain; hence, the name of both the fountain and its adjacent café. Napoléon originally commissioned the fountain for a military hospital on the site. Some hundred years later, the fin de siècle café opened its doors to serve traditional cuisine amidst typical French ambience: Lace curtains hang in the windows, pink-and-white linens adorn the tables, and banquettes provide interior seating.

441
Lycée Italien Léonard-de-Vinci

12, RUE SÉDILLOT BETWEEN AVENUE RAPP AND RUE SAINT-DOMINIQUE

1899, JULES LAVIROTTE

Around the turn of the last century, architect Lavirotte advanced the style of Art Nouveau in Paris. For this Italian secondary school, he favored a modest combination of Art Nouveau flourishes tempered with elements harking back to eighteenth-century design. His later creations showed more exuberant façade work.

442
29, avenue Rapp

BETWEEN RUE DE MONTTESSUY AND RUE DU GAL CAMOU

1901, JULES LAVIROTTE

Alexandre Bigot, the owner of this building, was a ceramist who promoted the use of stoneware and sandstone in building construction, and his use of such material here was meant to flaunt the surface. Also noteworthy is the asymmetrical façade. In 1901, Jules Lavirotte's design for this won a municipal competition as the year's best. Its extraordinary portal is the ultimate in Art Nouveau exuberance. The carved elements feature a central bust of a woman with flowing hair, balanced by carved naked figures rising above the sides.

443
3, square Rapp

AT AVENUE RAPP

1899–1900, JULES LAVIROTTE

Built by the same architect who created the nearby Lycée Italien Léonard-de-Vinci and a residential building on avenue Rapp, this apartment house shows the full extent of Lavirotte's enthusiasm for Art Nouveau design. Lavirotte's elaborate façade features highly decorative windows and an ebullient turret.

444
Trésor Public
(TRÉSORERIE PRINCIPALE)

102, RUE SAINT-DOMINIQUE AT PASSAGE LANDRIEU

C. 1960

This urban institution is conveniently located near the Eiffel Tower. It is a private, undergraduate, liberal arts college based on the American educational model; its diverse student body and faculty represent over a hundred nationalities. This particular building houses the Bursar's office, summer programs, and a division of continuing education. A modern construction, its sleek, white, long façade, built as open layers, overhangs the ground level and is capped with a roof garden.

445
Saint-Pierre-du-Gros-Caillou

92, RUE SAINT-DOMINIQUE AT RUE CLER

1822–29, HIPPOLYTE GODDE

This chapel replaced a smaller eighteenth-century one built on this site nearly a hundred years earlier. This nineteenth-century façade is remarkably modern in its simplicity, a model of classical design: Four Doric columns support an entry that has a bare, triangular pediment. Inside, the aisles are square-shaped and topped with cupolas. Similarly, the square choir ends in a dome, flanked with two square sacristies and an apse. The overall effect is one of reserved beauty.

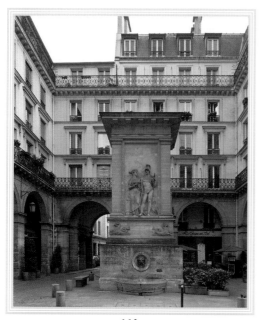

440

441

442

443

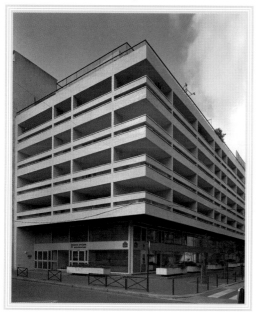

444

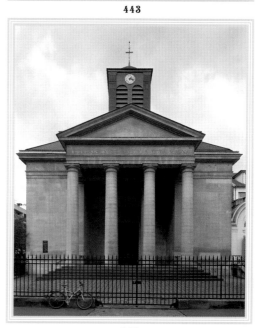

445

MUSÉE DES ARTS PREMIERS
(MUSÉE DU QUAI BRANLY)

In the early twentieth century, museums began to recognize the influence of non-Western cultures in art (particularly in the works of Cubists and Fauvists) as well as the importance of preserving ethnohistory in its purest forms. However, it was not until 1998 that the French government decided to establish a public museum devoted to the arts and civilizations of Africa, Asia, Oceania, and the Americas. It is still in construction on the quay Branly near the Eiffel Tower—one of the last available sites in the heart of Paris. Jean Nouvel won the international competition for this architectural project. To achieve a harmonious design within this historic urban location along the Seine, Nouvel, architect of the Institut du Monde Arabe and the Cartier Foundation in Paris, will set the building in a natural backdrop surrounded by trees. A silk-screened glass wall will protect it from traffic, and the auditorium will extend onto an open-air theater in the summer. Gilles Clément designed the 18,000 square meters of surrounding gardens, whose paths and pools are meant to inspire meditation. In both its internal space and the external gardens, the museum—which opens to the public in 2005—will bring together a collection of more than 300,000 objects and explore a post-Colonial view of other heritages, combining the traditional with the contemporary.

446

89, quai d'Orsay

AT PONT-DE-L'ALMA AND AVENUE BOSQUET

1929, MICHEL ROUX-SPITZ

In his design of these luxury apartments, Michel Roux-Spitz created what he termed a "French balance" between classic style and modern elements. To fulfill his vision, he framed the building with concrete, but then hid this skeleton beneath a façade of traditional white Hauteville stone. Roux-Spitz shaped the face of the building by applying touches of geometric forms to the kind of bay windows normally reserved for traditional-style living rooms. While employing such classic details as finely crafted metalwork in his work on the façade, he eschewed Old School ornamentation. In all, he created a contemporary-looking, neoclassic building typical of "The School of Paris" architecture that was to define the city between the wars.

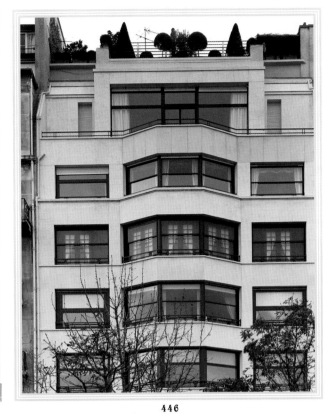

446

447

Ambassade d'Afrique du Sud
(SOUTH AFRICAN EMBASSY)

59, QUAI D'ORSAY AT RUE MOISSAN

1974, JEAN-MARIE GARET, GÉRARD LAMBERT, JEAN THIERRART

Challenged to maintain an open view of the Seine while protecting the privacy of the embassy, the architects for this structure found their solution in their choice of material: They installed aluminum sheets, shaped like armor, all around the building. Creating a pattern of diamonds and chevrons, this external aluminum shield serves as window blinds, allowing the diplomats within the embassy a measure of privacy, while not obstructing their view of the river and the rest of the outside world.

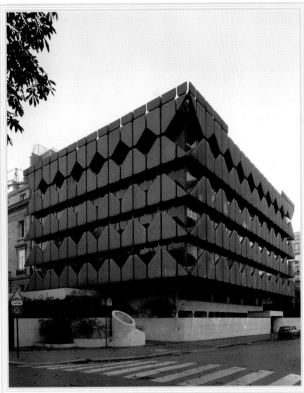

447

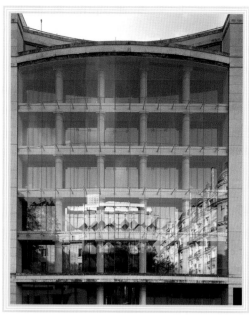

448

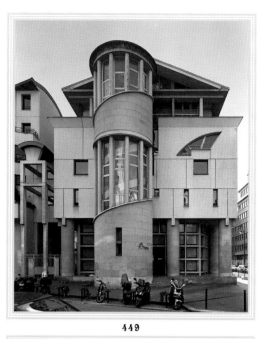

449

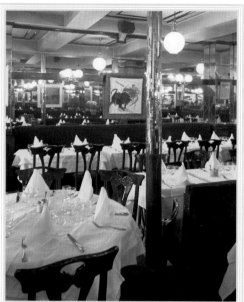

450

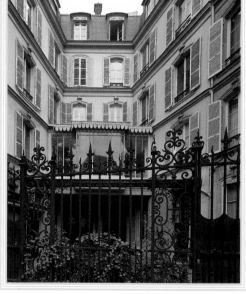

451

452

453

448
Gan Insurance Company

9, AVENUE ROBERT SCHUMANN AND 154 RUE DE L'UNIVERSITÉ
AT RUE JEAN NICOT

1993, RICARDO BOFILL

Inset into a border of smooth concrete, the curved glass frontage of this modern building sports a checkerboard pattern created by internal columns. Not only does it allow maximum light penetration for the employees to work by, but it also presents an open image to the city. As if viewing a giant television screen, pedestrians can glimpse the interior offices, while the occupants can observe the outside world behind their sleek, glass shield.

449
Conservatoire de Musique

7, RUE JEAN NICOT AT RUE DE L'UNIVERSITÉ

1984, CHRISTIAN DE PORTZAMPARC, ASSISTED BY FRÉDÉRIC BOREL

Christian de Portzamparc needed to house two very different entities: a center for the elderly and a music conservatory. He developed different shapes for each and even left an open space between them. The design for the center for the elderly, on the rue Jean Nicot, integrates well into the neighborhood, where the music conservatory, on the corner of rue de l'Université, is deliberately livelier than its adjacent buildings, and includes an asymmetrical staircase.

450
Hôtel Thoumieux

79, RUE SAINT-DOMINIQUE BETWEEN
BOULEVARD DE LA TOUR MAUBOURG AND PASSAGE JEAN NICOT

1923, OPENING

A third generation of the original owners runs this hotel and its historic brasserie, Café Thoumieux. Once a plot of farmland and then the site of an abbey, in 1910 the Thoumieux family purchased the building and it became a *chartier*, a butcher's shop. Eventually, it developed into a small hotel above a brasserie. This family legacy has seen a continuous flow of regulars and the walls of the brasserie are decorated with work from artists who have passed through the premises.

451
Ministry of Foreign Affairs

37, QUAI D'ORSAY AT RUE ROBERT ESNAULT PELTERIE

1845–56, JACQUES LACORNÉE

In 1852, Napoléon III opted for interior opulence here. Known as "quai d'Orsay" for its long neoclassical façade along the quai, the Ministry of Foreign Affairs building is an ornate structure inside and out. Only the white marble medallions above the main floor windows remain unadorned. The empty spaces—originally intended for decorative elements from friendly nations—attest to the fragility of alliances.

452
Hôtel du Châtelet
(MINISTÈRE DES AFFAIRES SOCIALES, DU TRAVAIL ET DE LA SOLIDARITÉ)

127, RUE DE GRENELLE AT CORNER BOULEVARD DES INVALIDES

1770–76, MATHURIN CHERPITEL

The aristocratic owners of mansions did not fair well during the Revolution. Most were carted off to the guillotine. The comte du Châtelet-Losmont who, with his wife, owned this residence, was no exception—and met that same fate. Since 1796, his monumental home, which has an arched courtyard and dominant Corinthian colonnade, has served various purposes; the Ministry of Labor has occupied the building since 1907.

453
272, boulevard Saint-Germain

BETWEEN RUE DE LILLE AND RUE DE L'UNIVERSITÉ

C. 1840

An oddity beckons in the midst of the bustling boulevard Saint-Germain. In an area where the neighboring façades are flush with the street, this residence recedes behind its decorative iron gate. The frontage, modified by a peculiar glass bay window, overhangs a recessed ground level and gives onto a vine-covered forecourt. Shaped by the border of the surrounding buildings, the lot of the inner court appears as a truncated triangle.

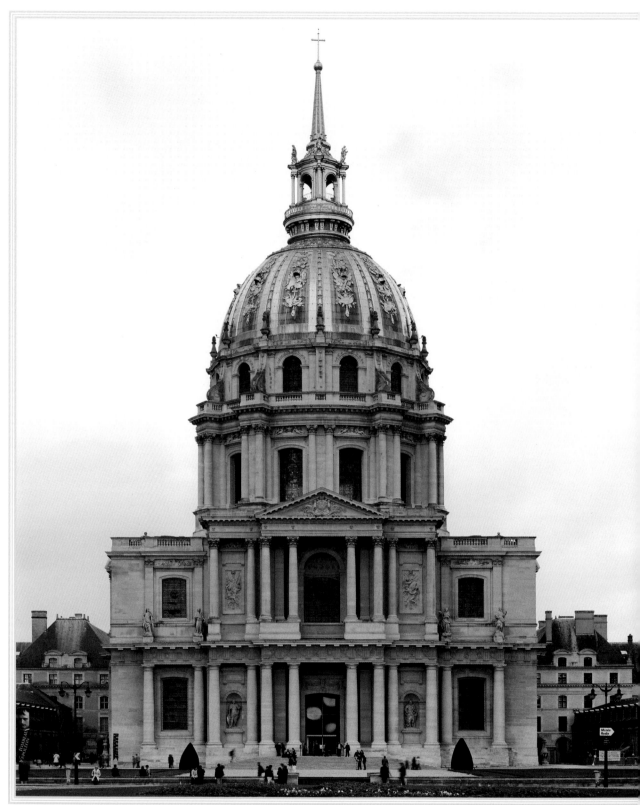

454

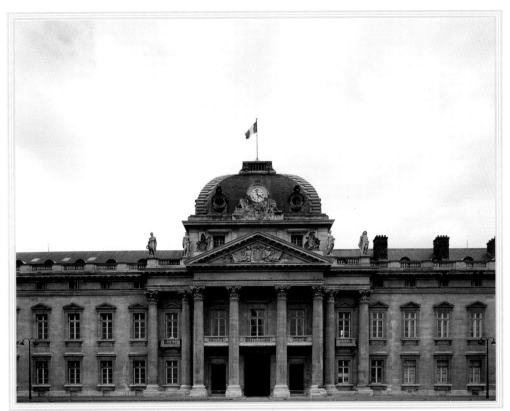

455

454

Hôtel des Invalides
with Dome Church of the Invalides

PLACE DES INVALIDES AND PLACE VAUBAN BETWEEN
BOULEVARD DES INVALIDES AND BOULEVARD DE LA TOUR MAUBOURG

1671–78, LIBÉRAL BRUANT, MAIN BUILDING;
1676–78, JULES HARDOUIN-MANSART, SOLDIER'S CHURCH;
1677–1706, JULES HARDOUIN-MANSART, DOME CHURCH

Louis XIV was only five when he became king. At twenty-three, he announced that he would govern France on his own. The Sun King spent thirty-five years of his reign at war, racking up military victories. As a patron of the arts and modernization, he also constructed new buildings. He conceived of this project as a residence for his disabled soldiers, and commissioned Libéral Bruant to construct it. Bruant designed the Hôtel des Invalides complex around a large portal topped with an equestrian statue of Louis XIV in a triumphant pose. This entrance leads to a magnificent courtyard that was used by old and infirm soldiers. In keeping with the military nature of the institution, the attic windows on the façade feature carved helmets and shields, but one displays a wolf's head.

455

École Militaire

43, AVENUE DE LA MOTTE-PICQUET BETWEEN
AVENUE DE SUFFREN AND AVENUE DUQUESNE

1752–73, JACQUES-ANGE GABRIEL, INITIAL PHASE;
1780–88, ETIENNE-LOUIS BOULLÉE, THEN ALEXANDRE-THÉODORE
BRONGNIART, SECOND PHASE

With some persuasion from Madame de Pompadour, among others, King Louis XV founded an officers' school here, to train sons of noble but needy families. Clearly preparing for bigger things, illustrious alumnus Napoléon graduated in 1786 as an artillery lieutenant. This enormous complex sits opposite the Eiffel Tower, built over a hundred years later, and serves as a visual bookend for the land extending from Champ de Mars. The four-sectioned, domed building features a forecourt façade with a carved, triangular pediment supported by four Corinthian columns.

456

457

458

459

460

461

456

Ministère de la Défense

231, BOULEVARD SAINT-GERMAIN AT RUE DE L'UNIVERSITÉ
AND RUE SAINT-DOMINIQUE

1876–77, BOULEVARD SIDE, H. BOUCHOT

This huge complex, which belongs to the Ministry of Defense, has many façades, but it is basically a typical stone construction from the nineteenth century. It encompasses the block of rue de l'Université, the Boulevard Saint-Germain and rue saint-Dominique and includes the Joint Service Defense College (CID), which trains officers, and the Hôtel des Brienne, where the minister of defense resides.

457

Eglise Sainte-Clotilde

12, RUE MARTIGNAC AT CORNER OF RUE LAS-CASES

1846–53, FRANÇOIS-CHRISTIAN GAU; 1853–57, THÉODORE BALLU

While the Eglise Sainte-Clotilde was being built, its architect was derided as having created a pastiche—rather than a revival—of the Gothic style. Gau nonetheless initiated a resurgence of neo-Gothic churches throughout Europe. Perhaps the controversy proved too stressful, however, as he died before the completion of the building. The project was given to his assisant, Ballu, who changed the design for the towers and added many sculptures to the portal.

458

La Poste

(BUREAUX DU 7ÈME ARRONDISSEMENT)

103, RUE DE GRENELLE AT RUE CASIMIR PÉRIER

c. 1840

The tower that arises from the building at the end of the street signaled the expanding telecommunications network that began when Claude Chappe invented the optical telegraph in 1791. The Revolution sparked a need for swift communication and construction of additional lines. But in 1800, Napoléon Bonaparte reduced the appropriations for additional development causing a despondent Chappe to throw himself into a well at age forty-two. By 1850, however, five hundred permanent stations existed in France.

459

Protestant Church of Pentemont

104–106, RUE DE GRENELLE AT RUE DE BELLECHASSE

1747–77, PIERRE CONTANT D'IVRY, THEN PETIT; 1783, COMPLETED;
1844, VICTOR BALTARD

The convent of the nuns of Pentemont owned this chapel, which was originally laid out in a Greek-cross design. In 1747, the Abbaye de Pentemont decided to rebuild the complex. During the Revolution, the state used the confiscated property, adding other buildings and converting it into barracks for the Cent-Gardes. In the mid–nineteenth century, Victor Baltard, architect of Les Halles, remodeled the chapel; and it has served a Protestant community since 1844.

460

Hôtel Rochechouart

(MINISTÈRE DE L'ÉDUCATION NATIONALE)

110, RUE DE GRENELLE AT RUE DE BELLECHASSE

1776, MATHURIN CHERPITEL; 1839, ALPHONSE DE GISORS, TRANSFOR-
MATION; 1912–18, A. CAGNÉ, ADDITION RUE BELLECHASSE

Built for the marquis de Courteilles, then willed to his daughter, the comtesse de Rochechouart, this residence is typical of the Louis Seize style: Giant Corinthian pilasters and buttress wings adorn this elegant building, which has a mirrored interior. Various bureaus of the Ministry of Education have remodeled it since the State acquired it in 1829.

461

Hôtel Amelot de Gournay

1, RUE SAINT-DOMINIQUE AT BOULEVARD SAINT-GERMAIN

1712, GERMAIN BOFFRAND

Amelot de Gournay acquired this dignified mansion from the highly creative architect Boffrand, in 1713. Though this hotel was built in the traditional style of *entre cours et jardin* (between courtyard and garden), the shape is unique. The entrance on rue Saint-Dominique opens to a magnificent oval forecourt. Colossal pilasters adorn the unusual curved façade of the main building. The oval shape of the forecourt gives the mansion a grand appearance despite its small size.

462

462

Palais Bourbon/Hôtel de Lassay

(NATIONAL ASSEMBLY)

126–128, RUE DE L'UNIVERSITÉ AT 29–35, QUAI D'ORSAY

1722, GIOVANNI GIARDINI; 1722–24, PIERRE CAILLETEAU; 1724–30, JEAN AUBERT AND JACQUES GABRIEL V; 1764, ANTOINE-MICHEL LE CARPENTIER AND CLAUDE BILLARD DE BELLISARD, WINGS ON THE SIDES AND ON THE FRONT; 1795, JACQUES-PIERRE GISORS AND EMMANUEL-CHÉRUBIN LECONTE, HALL OF THE FIVE HUNDRED; 1806, BERNARD POYET, RIVERFRONT FAÇADE, PALAIS BOURBON; 1828, JULES DE JOLY, REMODELING; 1843, ADDITION OF ONE STORY, HÔTEL DE LASSAY

When this Rococo mansion was built in 1722 for the duchesse de Bourbon, her lover Lassay built himself a mansion next door, connected to hers by tunnel. During the Revolution, the state confiscated the palace and added a large, semi-circular hall for the Council of the Five Hundred. In 1807, Napoléon changed the façade on the Seine side to match the style of the Madeleine church that faced it across the river. Later, in 1828, architect Joly remodeled the meeting hall that is now used for the French National Assembly.

463

Hôtel de Salm

(PALAIS DE LA LÉGION D'HONNEUR)

64, RUE DE LILLE AND QUAI ANATOLE-FRANCE
BETWEEN RUE DE SOLFÉRINO AND RUE DE LA LÉGION D'HONNEUR

1782–87, PIERRE ROUSSEAU, ORIGINAL BUILDING;
1804, ANTOINE-FRANÇOIS PEYRE, INSIDE TRANSFORMATIONS;
1866–70, A. LEJEUNE, EXTENSION

Frédéric III, the Prince of Salm-Kyrbourg, who commissioned this mansion in 1782, did not live long to enjoy it. Beheaded at the guillotine despite his sympathies with the Revolution, he was buried in the cemetery of Picpus, in the 12th arrondissement, along with other victims of the Revolution. While he was alive, he ran up enormous debts and could not afford the mansion he was building, and so had to lease the property. The next owner was Claude Lenthereau, a mere wigmaker who had passed himself off as the marquis de Beauregard. A hundred years later, during the Commune of 1871, the Hôtel de Salm was partially destroyed by fire, but it was restored to nearly its original grandeur. This *hôtel*, located directly across the Seine from the Musée d'Orsay, now houses the museum of the Légion d'Honneur.

463

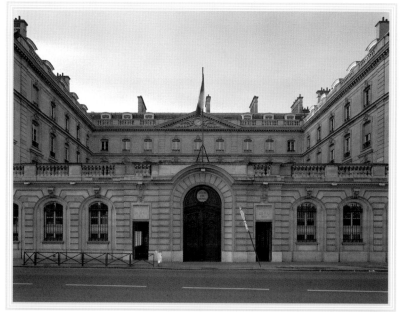

464

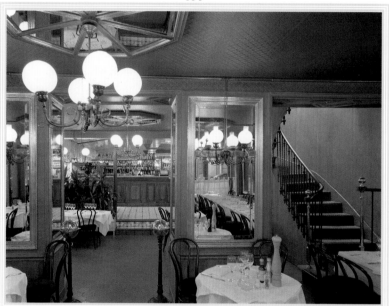

465

466

464

Caisse des Dépôts et Consignations

1–3, QUAI ANATOLE-FRANCE AT 2–4, RUE DU BAC AND
52–56, RUE DE LILLE

1722, FRANÇOIS BRUANT (FORMER HÔTEL DE BELLE-ISLE);
1890–96, EUDES

This massive structure, adjacent to the Musée d'Orsay, houses the state deposit and consignment bank established in 1816. In 1871, during the Commune, fire damaged two eighteenth-century *hôtels* on this site. The Caisse des Dépôts acquired the property, and enlarged the original mansions in the austere style of Louis XV.

465

Le Bistro de Paris

33, RUE DE LILLE BETWEEN RUE DE BEAUNE AND RUE DES SAINTS-PÈRES

c.1890

This typical Parisian bistro, complete with white lace curtains and a vintage interior, predates the neighboring Gare d'Orsay, now the Musée d'Orsay, by a decade. The restaurant's proximity to both the Seine and the old train station has made dining here a popular stop for more than a century. Its Provençal cuisine favors wild game in the winter.

466

Hôtel de Tessé

1, QUAI VOLTAIRE AT RUE DES SAINTS-PÈRES

1765–68, PIERRE-NOËL ROUSSET AND LOUIS LE TELLIER

Although this eighteenth-century residence was built for the comte de Tessé and his son during the decade before the reign of Louis XVI began, its plain façade typifies the style associated with that king. Oversized Ionic pillars support two interior levels, and a simple balustrade trims and hides the roof. The *hôtel's* former eighteenth-century grand salon (living room), covered by carved wooden paneling, has been removed for display in New York City's Metropolitan Museum of Art.

467

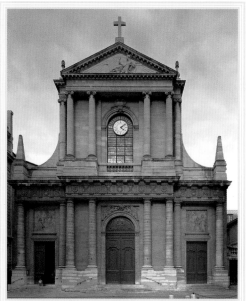

468

469

467
Hôtel de Beauharnais (Hôtel de Torcy) Hôtel de Seignelay

78–80, RUE DE LILLE AT QUAI ANATOLE-FRANCE

1714–15, GERMAIN BOFFRAND; 1837–38, JACQUES-IGNACE HITTORFF

Architect Boffrand was not only creative; he also excelled at business. He built two adjacent homes and then sold them immediately, one to the marquis de Torcy, the other to the comte de Seignelay. These two residences complemented one another, sharing similar façades and rooflines, but a later addition altered the harmony. The Egyptian-inspired façade on Hôtel de Beauharnais was added in 1807 by Eugène de Beauharnais, purchaser of the Torcy residence, who had participated in Napoléon's Egyptian campaigns.

468
Église Saint-Thomas-d'Aquin

PLACE SAINT-THOMAS-D'AQUIN AT BOULEVARD SAINT-GERMAIN

1683–88, PIERRE BULLET; 1769–70, BROTHER CLAUDE NAVAN, FAÇADE

A shortage of funds delayed the completion of this Dominican church for almost a century: The choir took about forty years to build; a ceiling fresco by François Lemoyne capped the lavish interior in 1724; and work on the modified Baroque exterior concluded in 1770. The church, dubbed a Temple of Peace during the Revolution, reverted to the Catholic Church in 1802. Redecorated during the nineteenth century, it remains well-preserved today.

469
Former home of Serge Gainsbourg

5 BIS, RUE DE VERNEUIL AT RUE DES SAINTS-PÈRES

C. EIGHTEENTH CENTURY

Whitewashed by city authorities, the scribblings on the former home of celebrity bad boy Serge Gainsbourg come from his adoring fans. From the 1960s until the 1980s, the words and public antics of this singer, songwriter, actor, and provocateur shocked and pleased audiences. When he died in 1991, his home became a cult attraction. Although the building is periodically "whitewashed," Gainsbourg's cult followers return frequently to write messages anew.

470

Hôtel de Villette

27, QUAI VOLTAIRE AT RUE DE BEAUNE

1766–71, CHARLES DE WAILLY, INSIDE DECORATION

After having moved outside of Paris in political exile, Voltaire returned to this quai in 1778, when he was eighty-four. Marquis Charles-Michel de Villette gave him a quiet courtyard room in Hôtel de Villette, where Voltaire received hundreds of admiring visitors, including Benjamin Franklin. The marquis honored him by replacing the "quai des Théatins" street sign with one that read "quai Voltaire," but the police removed it. In 1791, after Voltaire's death, the marquise initiated the official name change.

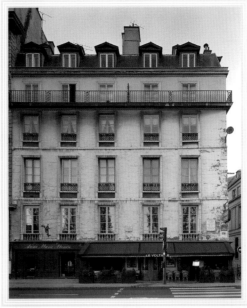

470

471

Ecole Nationale d'Administration
(E.N.A.)

13, RUE DE L'UNIVERSITÉ
BETWEEN RUE DU PRÉ AUX CLERCS AND RUE DE BEAUME

1643, BRIÇONNET DU MESNIL;
1713, GOBERT, RECONSTRUCTION; C. 1845, ADDITION;
1971–1978, INTERIOR AND COURTYARD RECONSTRUCTION

In 1699, Marie-Anne Voisin, widow of lord Feydeau, owned three carriage houses that were connected as one. After various incarnations, the Navy's hydrographic service then took over the premises from 1817 until 1971, preserving and restoring only the courtyard of the original structure. Since 1978, the French National School of Public Administration has used the buildings.

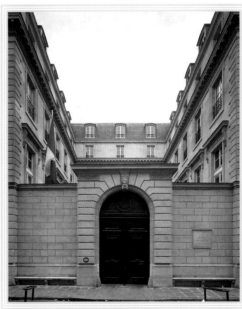

471

472

Debauve et Gallais

30, RUE DES SAINTS-PÈRES AT RUE DE L'UNIVERSITÉ

1800, ESTABLISHED; 1818, THIS LOCATION OPENING; 1829, CHARLES
PERCIER AND PIERRE-FRANÇOIS-LÉONARD FONTAINE, DECORATION

This legendary chocolatier has been a Paris fixture for over 200 years. Pharmacist to King Louis XVI, Sulpice Debauve established his first chocolate shop at 4, rue du Faubourg-Saint-Germain in 1800. In 1818, he moved his main store to this location and, with his nephew, Auguste Gallais, became purveyor to subsequent kings and such notable writers as Baudelaire, Balzac, and Proust.

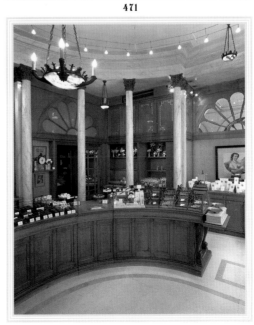

472

473

Musée d'Orsay

Quai Anatole-France

1898–1900, Victor Laloux, train station; 1983–86, Renaud Bardon, Pierre Colboc, and Jean-Paul Philippon, museum; 1983–86, Gae Aulenti, interior

Musée d'Orsay started life as the railroad station, Gare d'Orsay, which itself emerged from the ruins of Palais d'Orsay, burned down during the 1871 Commune. In 1898, architect Laloux gave the train station metal framework, but wrapped the terminal's exterior in classical limestone. For the interior, he designed a north lobby, a domed vestibule, and a central, grand iron-and-glass vaulted complex.

474

Hôtel de Fleury

28, rue des Saints-Pères between rue de l'Université and rue de Perronet

1768–72, Jacques-Denis Antoine; 1831, additions

Home to an enclave of antique dealers, rue des Saints-Pères divides the 6th and 7th arrondissements. Old mansions with hidden courtyards line this and other streets in the vicinity. This one, on rue des Saints-Pères, was remodeled when a school of civil engineering (Ecole Nationale des Ponts et Chaussées) took over the premises in 1831. Among other changes, the addition of a second level of central bays considerably altered the original façade.

475

Musée Rodin
(Hôtel Biron)

77, rue de Varenne at boulevard des Invalides

1727–30, Jean Aubert

Abraham Peyrenc de Moras hired architect Aubert to design this detached masterpiece of *rocaille* (loose stone) architecture on 7.4 acres. In 1753, the maréchal de Biron bought the residence, and completely transformed the property into one of loveliest parks in Paris. The duc de Lauzun inherited the estate, but he was guillotined during the Revolution, despite being a hero in the American War of Independence. Jean Cocteau, Henri Matisse, and Isadora Duncan worked here and, in 1908, sculptor Auguste Rodin rented the ground floor.

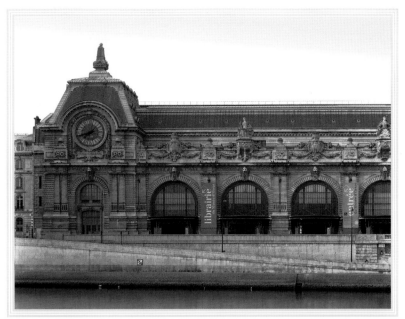

473

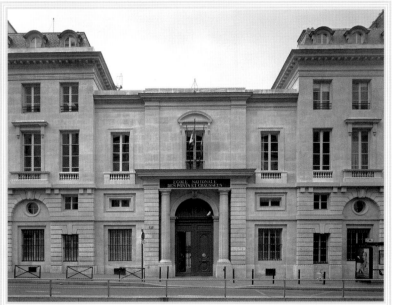

474

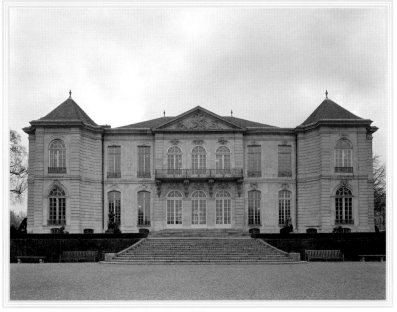

475

476

477

478

479

476

Institut d'Études Politiques de Paris

27, RUE SAINT-GUILLAUME BETWEEN
RUE DE GRENELLE AND BOULEVARD SAINT-GERMAIN

C. 1650, BUILDING; C. 1775, ALEXANDRE-LOUIS DE LABRIÈRE; 1880,
SCHOOL BUILDING; 1933, HENRI MARTIN, EXTENSION, 1951, EXTENSION

Tall, repetitive windows and a mansard roof give this building harmonious proportions. Established by Emile Boutmy in 1872 as the Ecole Libre des Sciences Politiques, the university uses an interdisciplinary method of merit-based leadership training in the social and political sciences. Originally created as part of the French educational system, this now-private university is composed of research centers, library facilities, and a university press, all housed in various seventeenth- and eighteenth-century mansions. This particular building accommodates the school's faculty and administrative offices.

477

Hôtel Montalembert

3, RUE MONTALEMBERT AT RUE DU BAC

C. 1900; 1989, INTERIOR RENOVATION

When Grace Leo-Andrieu and her husband, Stephane, renovated this mansion in 1989, it became one of the first contemporary luxury hotels in Paris and attained a five-star rating. Respecting the elegant architecture of the original building, their renovation successfully integrated modern innovations with history, encompassing restoration of the antiques collection that came with the mansion. Christian Liaigre designed the fifty-six guest rooms whose rich detailing is offered in two styles, consistent with the owners' blending of old and new: Guests can opt for high-tech décor, with modern lighting and chrome appointments, or can select a room with traditional, inlaid wooden furnishings.

478

Fontaine des Quatre-Saisons

57-59, RUE DE GRENELLE AT RUE DU BAC

1739–45, EDME BOUCHARDON

This monumental eighteenth-century fountain, constructed to glorify King Louis XV, sprinkles only a bit of water. What it lacks in gushing flow, however, is more than compensated by its massive size. Two huge curved wings extend from the central pavilion almost as if they were embracing the entire city. Niches carved into these wings hold bas-reliefs representing the Four Seasons. The central portion of Bouchardon's fountain, below the carved pediment, represents the City of Paris as a female figure, at the feet of which other statues personify the rivers of France—additional symbolic assurances of the wealth of the city. So popular was this fountain in its own day, that the City of Paris honored Bouchardon with a lifetime pension.

479

Hôtel de Gallifet

50, RUE DE VARENNE AND 73, RUE DE GRENELLE AT RUE DU BAC

1775–92, ETIENNE-FRANÇOIS LEGRAND;
1837, JEAN-LOUIS PROVOST, PORTAL

Statesman and ex-bishop Charles-Maurice de Talleyrand lived here four different times, during four distinct regimes of the late eighteenth through the early nineteenth century. After the *hôtel* was confiscated during the Revolution, it accommodated both Talleyrand and the Ministry of Foreign Affairs, from 1797 to 1807. The original entrance was on rue du Bac, but when the de Gallifet family regained possession of the premises in 1822, they sold off the rue de Bac portion and developed an entry on rue de Grenelle. The other portal, now on rue de Varenne, leads to the public garden of the Italian Cultural Institute. Since 1909, the Italian Embassy has occupied Hôtel de Gallifet.

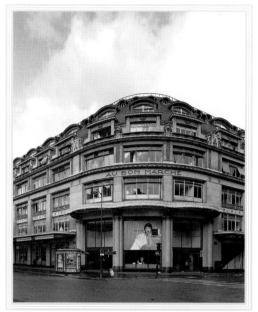

480

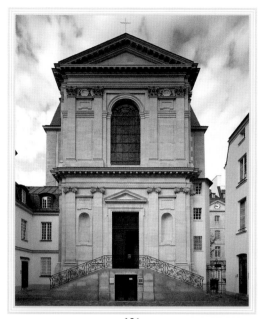

481

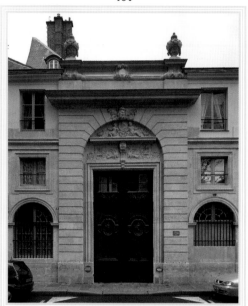

482

483

484

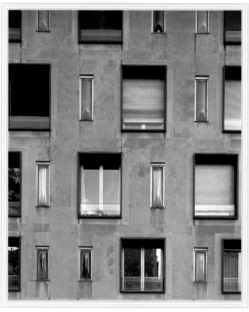

485

480
Au Bon Marché

22-36, RUE DE SÈVRES AT RUES VELPEAU, BABYLONE, AND DU BAC

1869–70, ALEXANDRE LAPLANCHE; 1872–74, LOUIS-CHARLES
BOILEAU, PHASE ON RUE VELPEAU; 1879–87, LOUIS-CHARLES BOILEAU,
RUE DE SÈVRES WITH METAL FRAME BY GUSTAVE EIFFEL; 1920–23,
LOUIS-HIPPOLYTE BOILEAU, NEW STORE WEST OF RUE DU BAC

In 1852, Aristide Boucicaut opened just a small store and sold hosiery there. When this store proved popular, Boucicaut invested his profits, expanded, and developed Au Bon Marché, the first department store in Paris—and the only major one on the Left Bank. An innovative merchant, Boucicaut offered "delivery to homes as far as a horse [could] travel in Paris," and "free delivery by train for any order over twenty-five francs."

481
Chapel of the Seminary of Foreign Missions

128, RUE DU BAC AT RUE DE BABYLONE

1683, PIERRE LAMBERT

The Congregation of Foreign Missions bought property in this quarter as early as 1650. Thirty years later, master mason Lepas-Dubuisson began construction on architect Lambert's design to create this chapel as well as a three-story dormitory to house priests studying for foreign missionary work in the Far East.

482
Hôtels Clermont-Tonnerre

118–120, RUE DU BAC BETWEEN RUE DE BABYLONE AND RUE DE VARENNE

1714, CHARLES-NICOLAS LEPAS-DUBUISSON

After his father had constructed the chapel for the Congregation of Foreign Missions at 128, rue de Bac, the congregation willingly hired the mason's son, Charles-Nicolas, to build these two rental properties in support of their missionary work in foreign countries. Known as the Hôtels Clermont-Tonnerre, the twin structures have matching façades and ornamental portals. The writer François-René de Chateaubriand chose number 120 as his residence in the last decade of his life, from 1838 to 1848.

483
La Pagode
(ART HOUSE CINEMA)

57 BIS, RUE DE BABYLONE AT RUE MONSIEUR

1895, ALEXANDRE MARCEL;
1930, TRANSFORMED INTO A MOVIE THEATER

In 1895, Monsieur Morin wanted to give Madame Morin a gift. As *japonisme* was then the rage in Paris—thanks in part to the Impressionists—he, naturally, built her a pagoda. Shipped in pieces from the Far East, reassembled in Paris, and plunked down in the midst of a residential district, this carved temple trumped the all-things-Japanese craze with its stone figures of dragons and lions and Buddhas and birds. In 1931, it was converted to an art house cinema.

484
Ryst-Dupeyron

79, RUE DU BAC AT BOULEVARD SAINT-GERMAIN

1804, BUILDING; 1880, BUILDING TRANSFORMATION;
1905, FOUNDATION OF THE STORE

Behind its carved oak façade, this century-old liquor store still specializes in vintage Armagnac. Registered as a historic national landmark, Ryst-Dupeyron also offers Bordeaux wines, cognac, port, champagne, and related items.

485
7, rue Vaneau

AT RUE DE VARENNE

c. 1980

The play of windows on this flat façade gives the building charm and interest. The varied window placement recalls a musical tone and sets up a rhythm that appears different at each floor. On closer inspection, however, the bottom level mirrors the pattern of the top floor, while the two middle rows reverse each other's image as well.

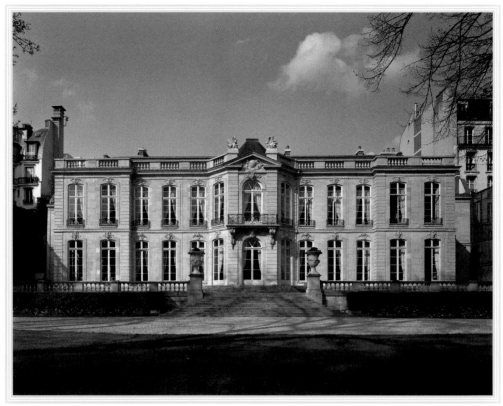

486

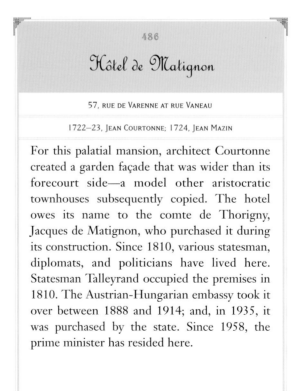

486

Hôtel de Matignon

57, RUE DE VARENNE AT RUE VANEAU

1722–23, JEAN COURTONNE; 1724, JEAN MAZIN

For this palatial mansion, architect Courtonne created a garden façade that was wider than its forecourt side—a model other aristocratic townhouses subsequently copied. The hotel owes its name to the comte de Thorigny, Jacques de Matignon, who purchased it during its construction. Since 1810, various statesman, diplomats, and politicians have lived here. Statesman Talleyrand occupied the premises in 1810. The Austrian-Hungarian embassy took it over between 1888 and 1914; and, in 1935, it was purchased by the state. Since 1958, the prime minister has resided here.

8ᵀᴴ ARRONDISSEMENT

From the Arc de Triomphe, the 8ᵗʰ arrondissement radiates down avenue des Champs-Elysées to place de la Concorde. This vista encompasses the Grand Palais and Petit Palais as well as the U.S. Embassy and the eighteenth-century Palais de l'Elysées, home of the French president. Once lined with grand hotels, chic stores, and designer-name boutiques, and touted as the most beautiful avenue in the world, the Champs-Elysées has deteriorated into a tourist promenade throbbing with the frenzied noise of commercial establishments, movie houses, overpriced cafés, fast-food restaurants, chain stores, and congested traffic. The lower landscaped portion of the avenue below Rond Point des Champs-Elysées and avenue Montaigne is still prime strolling territory, boasting a few stylish restaurants and the fabulous Art Deco Théâtre des Champs-Elysées. However, the streets to go for genuine, high-end haute couture houses and gourmet food boutiques are avenue Montaigne, rue du Faubourg-Saint-Honoré, rue Royale, and place de la Madeleine.

Arc de Triomphe

PLACE CHARLES-DE-GAULLE

1806, ARNAUD RAYMOND AND JEAN-FRANÇOIS CHALGRIN, PROJECT;
1809–11, JEAN-FRANÇOIS CHALGRIN, CONSTRUCTION;
1811–14, L. GOUST, CONTINUATION;
1826, JEAN-NICOLAS HUYOT, ENTABLATURE; 1832, ABAL BLOUET, ATTIC

Emperor Napoléon commissioned this impos-
ing arch in 1806 to glorify the military victories
of France's Grande Armée in 1792, but he didn't
live to see its completion. Thirty years in the
making, the arch was finally completed fifteen
years after his death. Plunked down at the top of
the Champs-Elysées, this colossal and classic
monument—inspired by Rome's Arch of
Janus—stands as the hub of twelve intersecting
roads and is a witness to history: Mourners
passed through it to view Victor Hugo in his
coffin in 1885. After World War I, returning
soldiers marched beneath the arch in celebra-
tion, and it became the site of the Tomb of the
Unknown Soldier. Later, Nazi soldiers also
stomped through it defiantly, during their occu-
pation of Paris. Its Napoléonic purpose all but
forgotten, in our own time the Arc de Triomphe
is ceremoniously remembered as a memorial to
all who died in World War I: Each evening at six
P.M., the dashing French military reignite the
flame at its top, in a tradition begun in 1929. On
clear evenings, tourists crowd the observation
deck to take in this ritual, as well as for one of
the finest 360-degree views of Paris at dusk.

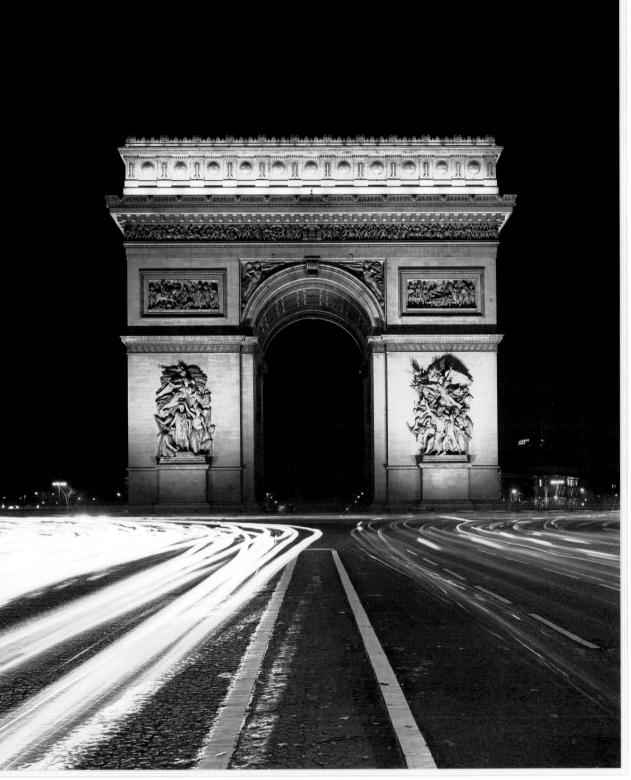

487

488

489

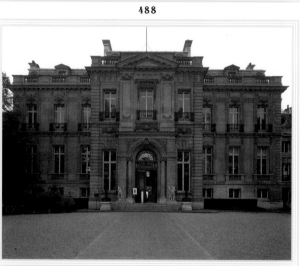

490

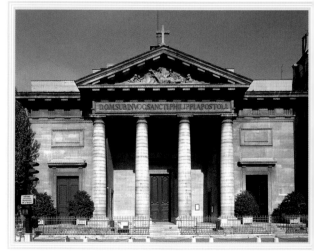

491

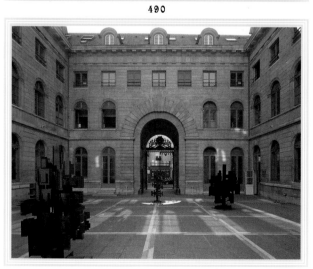

492

493

488

Groupe Publicis services

133, AVENUE DES CHAMPS-ELYSÉES AT RUE DE VERNET

1975, PIERRE DUFAU

In the 1870s, Empress Eugenia suggested a project to architect Hittorf: to wrap the Arc de Triomphe in a wreath of greenery. A hundred years later, Pierre Dufau granted her wish, with his terrace construction for the Publicis building. He topped this corner structure with a tiered garden and created an angled glass façade that reflects the Arc. The glass building itself looms over avenue des Champs-Elysées yet without seeming intrusive.

489

Le Balzac
(ART HOUSE CINEMA)

1, RUE BALZAC AT AVENUE DES CHAMPS-ELYSÉES

1935, INAUGURATION

Only two movie theaters existed in the Champs-Elysées area, prior to 1918. When this cinema opened in 1935, it did not yet compete with those that line the avenue today. Influenced by Art Deco, this accessible hall first showed American films in their original, undubbed version, then French works of *réalisme*. In the mid-1970s, two new rooms were created and foster broader programming. In 1990s, a bar, reception hall, new lighting, and an ersatz ocean-liner–style lobby were added.

490

Hôtel Salomon de Rothschild

9–11, RUE BERRYER AT AVENUE DE FRIEDLAND (GARDEN FAÇADE SIDE)

1872–78, LÉON OHNET, JUSTIN PONSARD AFTER OHNET'S DEATH

A hundred years after financier Nicolas Beaujon created a home here, Baroness Salomon de Rothschild built a classic mansion in Second Empire style on the site. In 1922, she bequeathed it to the State. Today, the Fondation Nationale des Arts Graphiques et Plastiques and Christie's Education Paris school share this grand residence.

491

Atelier

157, RUE DU FAUBOURG SAINT-HONORÉ AT BOULEVARD HAUSSMANN

C.1830; C. BEGINNING OF THE TWENTIETH CENTURY, TRANSFORMATIONS

In a city filled with stone buildings and only a few areas of green parks, courtyards such as this one, branching off a main street, are gems. Small, private gardens are often hidden just behind buildings and beyond doors. Designed to bring more light into apartments, courtyards also once served functional purposes, such as a place for the care of horses and for staff-run repair shops. As part of an evolutionary process, many of these workshops were eventually converted to artist studios.

492

Hospice Beaujon

208, RUE FAUBOURG-SAINT-HONORÉ AT AVENUE FRIEDLAND

1784–85, NICOLAS-CLAUDE GIRARDIN

Eighteenth-century financier-turned-philanthropist Nicolas Baujon wished to develop a facility for needy children. Girardin designed this solid, somber school and hospice around a central courtyard. The ground floor was divided into classrooms, and destitute children lived in the dormitories on the upper levels. Listed as a national monument for its façade and portal, this austere building became a hospital during the Revolution and, today, it operates as the Centre Beaujon, a facility for workshops and recreation.

493

Eglise Saint-Philippe-du-Roule

154, RUE FAUBOURG-SAINT-HONORÉ AT RUE LA BOÉTIE

1774–84, JEAN-FRANÇOIS CHALGRIN; 1845, ETIENNE-HIPPOLYTE GODDE, ENLARGEMENT; 1853, VICTOR BALTARD, ADDITIONAL WORK

Beautiful eighteenth-century mansions and chic ready-to-wear houses line rue Faubourg-Saint-Honoré today. When this road was first used, it was chiefly known as leading to the village of Roule. This eighteenth-century church, named for Saint-Philippe of Roule, evokes the architecture of ancient Rome, using as its model a Classical basilica. Its façade features a portico-supported pediment with a sculpted tympanum.

494
CCF Building

103, AVENUE DES CHAMPS-ELYSÉES AT RUE DE BASSANO

1899, GEORGES CHEDANNE

Hotel Elysées–Palace De Luxe was originally built on this site for the Paris Exposition of 1900. Composed of reinforced concrete in Art Nouveau style, Élysées-Palace remained a hotel until World War II; but, in 1922, the CCF bank established its central management and main services in the building. In 1995, the bank created a Foundation for Photography, which occupies part of the building today. The foundation supports the work of contemporary, realist photographers of various ages and nationalities. It awards two fellowships a year, organizes temporary exhibitions in Paris and the French provinces for the prizewinners, and copublishes monographs for the photographers. The foundation also advises the bank on its artistic acquisitions.

495
La Fermette Marbeuf

5, RUE MARBEUF AT RUE DU BOCCADOR AND AVENUE GEORGE-V

1898, EMILE HYRTRÉ, ARCHITECT, HUBERT AND MARTINEAU, PAINTING, AND JILES WIELHORKI, CERAMICS

Dragonflies hum, sunflowers stand tall, and peacocks strut their stuff in colorful, tiled and stained-glass scenes of winter gardens that decorate the sumptuous interior of this fin de siècle restaurant. From inside a gazebo supported by elegant, cast-iron columns, this establishment dishes out French specialties. The restaurant is located near the Pont de l'Alma, with a view across the Seine toward the Eiffel Tower. Its original Art Nouveau décor restored in the late 1970s, La Fermette Marbeuf is now a registered historic site.

496
Le Fouquet's

99, AVENUE DES CHAMPS-ELYSÉES CORNER OF AVENUE GEORGE-V

1863, BUILDING; 1899, BAR; 1958, JEAN ROYÈRE, DECORATION

This 100-year-old restaurant evolved from a simple grillroom to become a favorite of French celebrities. Taking advantage of his lucrative location on avenue des Champs-Elysées when the first metro line was introduced there, founder Louis Fouquet opened his bar in 1899. He promoted it to international visitors to the Universal Exposition by Americanizing the Fouquet name with the addition of an "apostrophe *s*." In 1906, Brazilian aeronaut Alberto Santos-Dumont installed another bar on the ground floor; and, in 1913, Léopold Mourier, successor to Fouquet, opened the restaurant.

497
Shell building

29, RUE DE BERRI AT RUE D'ARTOIS

1932, L. BECHMANN AND CHATENAY

Developing an office space for a rising corporation required creating a modern symbol of power. Influenced by a trip to New York City where buildings achieved that objective by sheer massive proportions, Bechmann and Chatenay produced one of the biggest buildings in Paris of the 1930s—occupying 60,000 square meters. They also imported much of the fittings of their ultramodern interior from America, including the central heating system, the electrical devices, and elevators. The imposing building holds 1,500 workers, and also accommodates a large shopping arcade. This is a striking structure whose strong proportions symbolize strength.

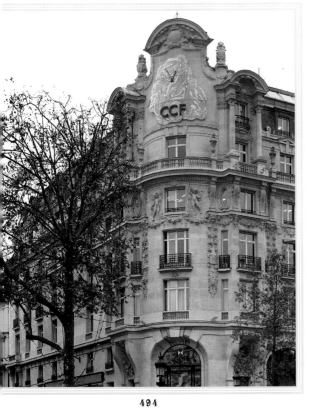

494

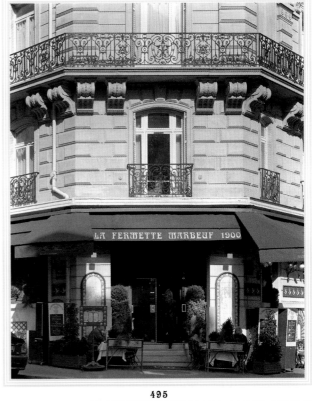

495

496

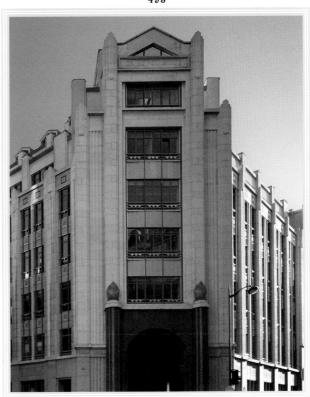

497

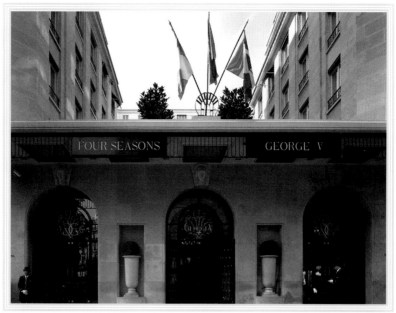

498

499

500

Four Seasons Hotel George V

31, AVENUE GEORGE-V AT AVENUE PIERRE 1ER DE SERBIE

C. 1920S, CONSTANT LEFRANC AND G. WYBO; 1997–1999, RICHARD
MARTINET, ARCHITECT AND PIERRE YVES ROCHON, INTERIOR DESIGN

American owner Joel Hillman, himself an architect, directed French architects in the design of this $31 million landmark hotel in 1928. The hotel's Art Deco white stone façade, atypical of the period, gave the building an elegant, minimal appearance that the press referred to as "modern French style." Designed around an interior courtyard, the hotel attracted Parisian society and heads of state. In 1997, a $125 million renovation recaptured its original charm.

Hôtel de Païva

25, AVENUE DES CHAMPS-ELYSÉES
BETWEEN RUE DE MARIGNAN AND AVENUE MONTAIGNE

1855–66, PIERRE MANGIN

Thérèse Lachmann, a Polish Jew, married her way up the social ladder, finally landing multimillionaire Count Henckel of Donnersmarck, who gave her this extravagant mansion. When she died in 1884, the marquise left the mansion to the City of Paris, as her legacy. It is now a private club, and one of the few residences to survive the commercialization of avenue des Champs-Elysées.

7–9, Rond-Point des Champs-Elysées-Marcel Dassault

AT AVENUE DES CHAMPS-ELYSÉES

1888

This hôtel particulier, typical of neo-Rococo style from the end of the nineteenth century, was built for the widow of Guillaume Sabatier d'Espeyran. Situated in the middle of one of the most prestigious avenues of Paris, the building links the open and green portion of this historical axis with the most urban section filled with the restaurants, shops, and movie theaters. Framed by an iron gate with gilt and candelabra, it resembles a small but pretentious urban castle.

501

502

503

504

501

Centre d'Affaires Georges V
(GEORGE V BUSINESS CENTER)

49–51, AVENUE GEORGE-V AT RUE VERNET

1974, NIKOLA ILIC, PIERRE SICARD AND PIERRE MOLINS

The architects devised each office and window block of this building as a product showcase for the seventy-member French union of shoe manufacturers. In fact, the lineup of square bay windows seems to replicate neatly stacked shoeboxes. Along its sides, the proportions of this building fit in well with those of more traditional neighboring buildings. Its flat glass panels reflect these nearby structures. A corner tower projected the union's prominence in the neighborhood. Time could not prevent the wear and tear upon the organization's financial soul, however; its high maintenance costs forced the sale of the building to a Middle Eastern bank in the late seventies.

502

Théâtre des Champs-Elysées

15, AVENUE MONTAIGNE AT PLACE DE L'ALMA

1911–13, AUGUSTE AND GUSTAVE PERRET, BASED ON DESIGN DRAFTED BY HENRY VAN DE VELDE; 1990, BRIGITTE DE KOSMI, ADDITIONAL LEVEL

The Perret brothers, as contractors, while adhering to architect van de Valde's basic plans for the building, decided to apply the new technology of reinforced concrete with orthogonal joist framing, to complete the building. Van de Velde's original design had used white Auvergne marble on the frontage. Pillar-like concrete slabs shape the façade with a geometric pattern of rectangles and squares, of which the top portion contains sculpted figures by Bourdelle. Classified in 1957 as a first "modern" work of architecture, this beautifully proportioned and understated building boasts an equally refined inner entrance that gives way to a double stairway leading to the upper levels.

503

Armenian Church

15, RUE JEAN-GOUJON AT PLACE FRANÇOIS-I

1903, ALBERT-DÉSIRÉ GUILBERT

Apparently the architect had a lock on this block. Having built the adjacent church as a memorial to the people who perished in the Bazar de la Charité fire, Guilbert once again tried for grand effect with the design and construction of this second church, also located on the site of the tragedy. The doomed market had been constructed on a narrow street, 30 feet wide and 250 feet long, and had contained twenty-two stores. Composed with a wooden frame covered by bituminous cardboard, it was a virtual tinderbox. The fire started in a small room, probably where an early film was being projected. Over 1,200 people, mostly aristocracy, were trapped; 250 people were injured and 135 died. Today, this church serves an Armenian community.

504

Théâtre du Rond-Point
(THE ROUNDABOUT/THÉÂTRE RENAUD-BARRAULT)

2 BIS, AVENUE FRANKLIN D. ROOSEVELT AT AVENUE DES CHAMPS-ELYSÉES

1858, GABRIEL DAVIOUD

This site first housed the Rotunda of the National Panorama, displaying paintings-in-the-round that commemorated Napoléon's victories. In 1894, the popularity of panoramas waned; ice-skating became the rage and the Rotunda interior was transformed into a 850-square-meter rink. Between 1981 and 1991, the company of Renaud-Barrault, established in 1948 by Madeleine Renaud and Jean-Louis Barrault, entertained audiences with contemporary works and traditional Asian spectacles. Renovated and expanded several times during the 1990s, the space retains much of the original décor of its forty-meter diameter, including a peristyle of four Corinthian columns and a pediment. The space also now has a garden, restaurant, and library.

505

Parfums Caron

34, avenue Montaigne at rue François-I

1927, Charles Plumet

Parfums Caron, a world-renowned Paris *parfumerie*, created many of their famous scents at the turn of the twentieth century. This elegant Art Deco boutique offers a romantic, old-world ambience for selling its fragrances, including recreations of its classics from 1911 through 1954, such as the spicy, Eastern rose scent, "Or et Noir."

506

Eglise Notre-Dame-de-la-Consolation
(La Missrou Catholique Italienne)

23, rue Jean-Goujon
Between place de l'Alma and place François-1er

1900, Albert-Désiré Guilbert

In 1897, a fire blazed in the Bazar de la Charité the day after it opened. Architect Guilbert designed this ornate, neo-Roman–Baroque church on the triangular part of the site, as a memorial to the victims—one of whom was the duchesse d'Alençon, sister to the Austrian empress. A Louis Quatorze–style virgin tops the church. The base level opens to the crypt; the double staircase that flanks it leads to the chapel.

507

5, place François-Ier

Place François-1er

Second half of the nineteenth century

In 1822, a real estate company created the neighborhood known as François-I. Most of the construction dates from the second half of the nineteenth century. One house from this period, originally located in a city called Moret, was transplanted and rebuilt here, and is an amusing example of Classical Revival architecture: It resembles a small castle, complete with its two pointed towers.

505

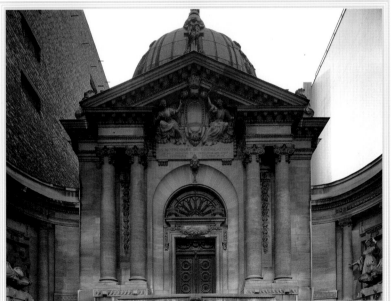

506

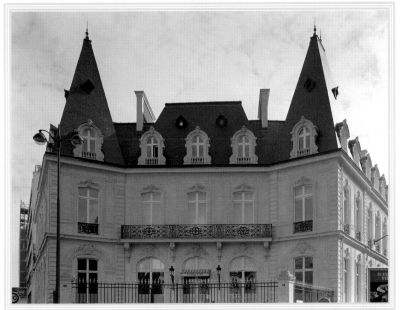

507

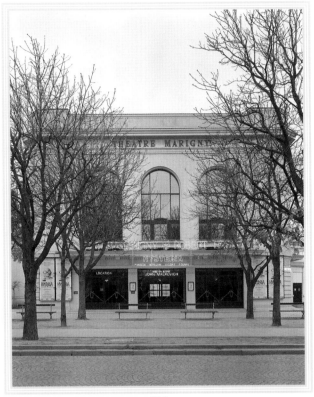

508

508

Théâtre Marigny-Robert Hossein

23, AVENUE DE MARIGNY
BETWEEN AVENUE GABRIEL AND AVENUE DES CHAMPS-ELYSÉES

1883–84, CHARLES GARNIER, PANORAMA; 1894, EDOUARD NIERMANS,
THEATER; 1925, ANDRÉ ULMER AND ALVARO DE GRIMALDI, DECORATION

Designed as a panorama in 1881 by architect Charles Garnier of l'Opéra fame, this building was transformed into a theater where, in 1925, Léon Volterra, a physicist, proposed to hold spectacles of "amusing physics, phantasmagoria, and curiosity" within Marigny Square. Thus began in the oldest of theaters on the Elysées Fields a variety of performances, including the "Marigny Madnesses" and other, "alternative" programming. When the space was remodeled in 1925, only the dodecagonal shape of the original building was preserved; and Grimaldi's Art Deco interior replaced Niermans' ebullient ornamentation of 1894.

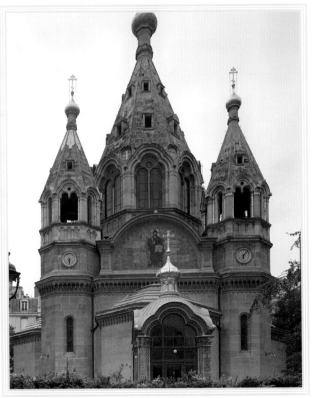

509

509

Saint-Alexandre-Nevski
(EGLISE CATHÉDRALE RUSSE)

12, RUE DARU AT RUE PIERRE LE GRAND

1859–61, R. KOUZMINE AND I. STROM

In 1922, under the gilded turrets of this Russian cathedral, Pablo Picasso married his first wife, Olga Khokhlova, who was the muse for many of Picasso's paintings from 1917 through the 1920s, and was the mother of his only legitimate child. In the mid–nineteenth century, Kouzmine—architect to the imperial Russian court and member of the St. Petersburg Fine Arts Academy, as was architect Strom—collaborated with Strom on this Russian-Byzantine–style chapel. Noteworthy is its central façade mosaic, a replica of one dating from the sixth-century Sant'Appolinare Nuovo church in Ravenna, Italy. The crypt was restored from 1955 to 1956, and its interior frescoes depict the Christianization of Russia.

510

Assurances St. Honoré / Compagnie de Conseils

22, AVENUE MATIGNON
BETWEEN RUE RABELAIS AND RUE FAUBOURG-SAINT-HONORÉ

1976, VITTORIO MAZZUCCONI

Walter Thompson, the advertising firm for whom the building was designed, wanted an impressive symbol of their creativity. But, at the same time, the City of Paris required a façade that would blend with the traditional neighborhood. Mazzucconi chose fake shards of ancient civilizations and introduced them into the lower portion of the glass façade. Then, he used metalwork to align the building and create a connection with the older cornices of adjacent structures. Rather than ignore or flout tradition, Mazzucconi successfully sought to integrate old elements with the ultramodern.

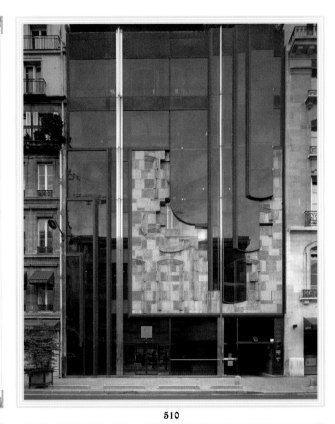

510

511

79, rue La Boétie

AT RUE D'ARTOIS

c. 1960s

Set back from the street because of city regulations in the 1960s, this structure typifies many similar office buildings constructed in this business district. The prefabricated metal façade creates a repetitive rhythm of horizontal and vertical planes. The vertical metal struts divide the dark glass windows creating a secondary grid pattern. The reflective quality of the windows casts additional images on the façade producing a three-dimensional effect and allowing pedestrians a view of outside; but, like a shield, the glass blocks internal scrutiny of the office workers.

511

512

34, avenue Matignon

BETWEEN RUE FAUBOURG-SAINT-HONORÉ AND RUE DE PENTHIÈVRE

1992, JEAN-JACQUES FERNIER

This elegant building recalls just a hint of the old iron-and-glass industrial buildings of the late nineteenth and early twentieth centuries. Balanced by simple, flat, ladder-like windows on each side, the central convex glass frontage rises five floors above a square atrium located at ground level. At this entrance, two Telamon (Atlas) figures—a common nineteenth-century Haussmann device—uphold an organic structure that climbs to a balcony and pergola, looming like a watchtower over the avenue.

513

Salle Gaveau

45, RUE LA BOÉTIE AT AVENUE DELCASSE

1905, JACQUES HERMANT; 2001, ALAIN-CHARLES PERROT, RESTORATION

Built in 1905 as a venue for classical music performances, the Salle Gaveau was conceived with particular care to the acoustics. It first opened its doors for the 1907–08 season. It was classified in 1992 as a historic site, and in the 2001 restoration architect Perrot remained faithful to the hall's origins in his reconstruction of the original metal armchairs and refurbishment of two reception halls. Today, the 1,020-seat Salle Gaveau hosts piano recitalists and chamber music groups, and occasionally even orchestras.

514

6, avenue Delcassé

BETWEEN RUE LA BOÉTIE AND RUE DE PENTHIÈVRE

c. 1930

This Art Deco-style building is located on a tiny avenue in the heart of the prestigious eighth arrondissement. Opened in 1932, Avenue Delcassé itself was named in 1934 for a French politician. The street connects rue La Boétie with rue de Penthièvre providing a short cut to Avenue Matignon in the popular area of the Champs-Elysées. This symmetrical building features a flat center with astrological carvings above the entrance, flanked by a line-up of vertical windows and stylized balconies which create the impression of columns. A rooftop garden softens the geometry.

515

Eglise Saint-Augustin

46, BOULEVARD MALESHERBES
BETWEEN RUE DE LA BIENFAISANCE AND RUE DE LABORDE

1860–71, VICTOR BALTARD

Master architect of the iron-and-glass Les Halles market pavilions, Victor Baltard also used metal to frame this, the second church in Paris to use this construction method. Because the building's shape had to conform to a narrow plot of land, Baltard eliminated braces and flying buttresses and wrapped the interior like a cocoon, positioning a huge dome above the altar. With its condensed shape and mélange of styles—Gothic, Romanesque, Byzantine, and French Renaissance—the church seems to defy the laws of both perspective and ecclesiastical design. Nonetheless, a frieze of Christ and the Apostles, carved above the three entry doors, focuses the building's purpose upon faith.

512

513

514

515

516

Former Trieste and Venise Company
(SOCIÉTÉ TRIESTE ET VENISE)

42, AVENUE DE MONTAIGNE AT RUE BAYARD

C. 1960, ROGER ANGER AND MARIO HEYMANN

The placement of horizontal and vertical windows creates a busy pattern on the avenue Montaigne façade of this building. Jutting angles on the rue Bayard side repeat the façade patterning and undulate down the street like a folded fan. It is easy to imagine a gentle tap that would send these stacked angles falling in the opposite direction like dominoes.

517

Rotonde de Chartres

BOULEVARD DE COURCELLES AT ENTRANCE TO PARC MONCEAU

1784–87, CLAUDE-NICOLAS LEDOUX

Originally part of the "Farmers General's Wall" that encircled Paris, this eighteenth-century tollhouse is one of the only four extant collection gates. Any merchant bringing goods into Paris had to pass through a structure like this, so taxes would be assessed on the merchandise before it was permitted to enter into the city. The shape of the dome has been altered since its initial construction, but the basic, round shape of the building remains the same.

518

Musée Cernuschi

7, AVENUE VÉLASQUEZ
BETWEEN PARC MONCEAU AND BOULEVARD MALESHERBES

1873, WILLIAMS BOUWENS VAN DER BOIJEN

Avenue Vélasquez extends from the east edge of Parc Monceau and attracted an enclave of wealthy homeowners in the latter part of the nineteenth century. This private mansion belonged to Italian financier Henri Cernuschi and housed his Asian art collection. Bequeathed to the City of Paris, it was inaugurated as a museum in 1898.

519

C. T. Loo Building

48, RUE DE COURCELLES AT PLACE DU PÉROU

1926, FERNAND BLOCH

Ching-Tsai Loo came to Paris at the end of the nineteenth century and opened a shop, selling objects he imported from China. He distinguished himself as an antique dealer, with galleries in Paris and New York, and was an expert in the field of Oriental art. Originally built as apartment buildings and an art gallery, this red Chinese pagoda-styled building still houses his collection of East Asian objects and furniture.

520

Céramic Hôtel

34, AVENUE DE WAGRAM BETWEEN VILLA NOUVELLE AND PLACE DES TERNES

1904, JULES LAVIROTTE

This reinforced concrete building, built by Jules Lavirotte, was nicknamed "Céramic Hôtel" for its glazed earthenware façade, created by Alexandre Bigot and sculpted by Laphilippe. Exemplifying the sensual Art Nouveau style of turn-of-the-century Paris, this residence won the city prize for the best façade of 1905.

521

Siège de la Banque Coloniale

53, RUE DES MATHURINS AT RUE D'ANJOU

1927, PAUL FARGE

This neo-Rococco styled building is the headquarters of the Colonial Bank. A carved balcony of ironwork creates an impressive street corner. Sculpted griffins and dragons with wings uphold the balconies. These symbols of fantasy mix with strange faces of spirits and sea-images, shellfish, and plants. The world was changing and these imaginative symbols evoked the prestige associated with the foreign commerce that had blossomed during the age of French colonialism at the beginning of the eighteenth century.

516

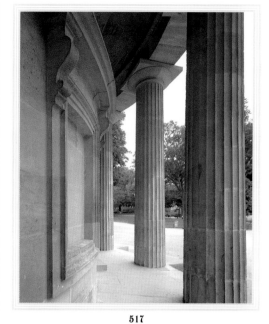

517

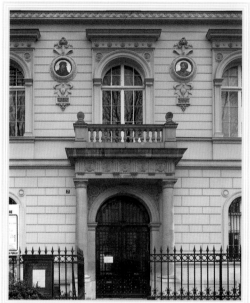

518

519

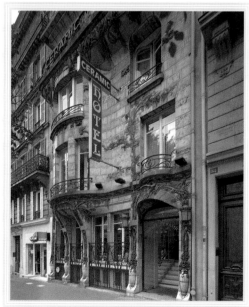

520

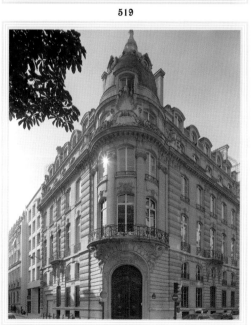

521

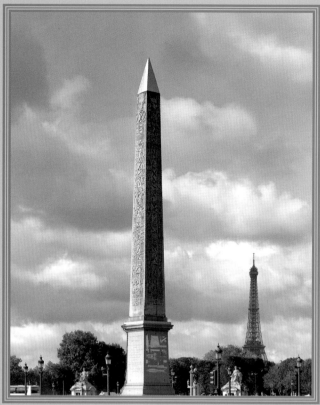

522

Obélisque de Luxor

At place de la Concorde
c. 13th century BC; 1836, chief engineer Appolinaire Le Bas

In a Herculean feat, on the morning of October 25, 1836, engineers raised the towering, pink granite Obélisque that graces the center of Place de la Concorde. The 23-meter (75 feet) high, 230-ton monument, a gift to Charles X from Mohammed Ali, Viceroy of Egypt in 1829, had originally marked the entrance to the Amon Temple of Luxor, and is over 3,300 years old. Its transport to Paris took more than two years and required the construction of a special boat. By the time it arrived in Paris, Louis Phillipe was king. Hieroglyphs in gold along the sides of the Obélisque proclaim the great deeds of Pharoahs Ramses II and Ramses III, while images on its pedestal depict its journey to France. Its landmark position was arranged by Jacob Ignaz Hittorff who installed two fountains and refurbished the statues that surround it, representing France's largest cities: Lille, Lyon, Marseilles, Rouen, Nantes, Strasbourg, Brest, and Bordeaux. Prior to this, the square, initially known as Place Louis XV, celebrated the king with an equestrian statue. Revolutionaries later toppled the statue, installing a guillotine where Louis XVI and Marie Antoinette perished. Following other transformations and name changes, Paris's first and largest open-air square was again renamed, and the Obélisque—the oldest monument in Paris—replaced the guillotine.

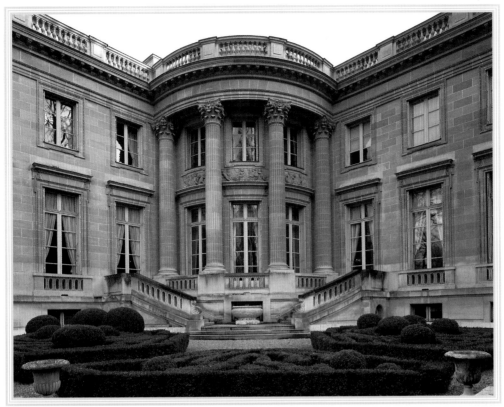

523

523

Musée Nissim de Camondo

61–63, RUE DE MONCEAU BETWEEN RUE DE VÉZELAY AND RUE DE

TÉHÉRAN

1911–14, RENÉ SERGENT

This spectacular mansion—home to the eighteenth-century art collection of the de Camondo family—tells the tragic tale of a transplanted Turkish Jew who became a French patriot. Comte Moïse de Camondo replaced another building that had been on this site since 1866, with a copy of the eighteenth-century Petit Trianon of Versailles. In 1935, he bequeathed this house and gardens, along with his entire collection of art and furnishings, to the Union des Arts Decoratifs—with the stipulation that the name of the museum must honor his son Nissim, who had been killed fighting for France during World War I. During World War II, the Vichy government forgot this act of patriotism and sent the de Camondo family to Auschwitz.

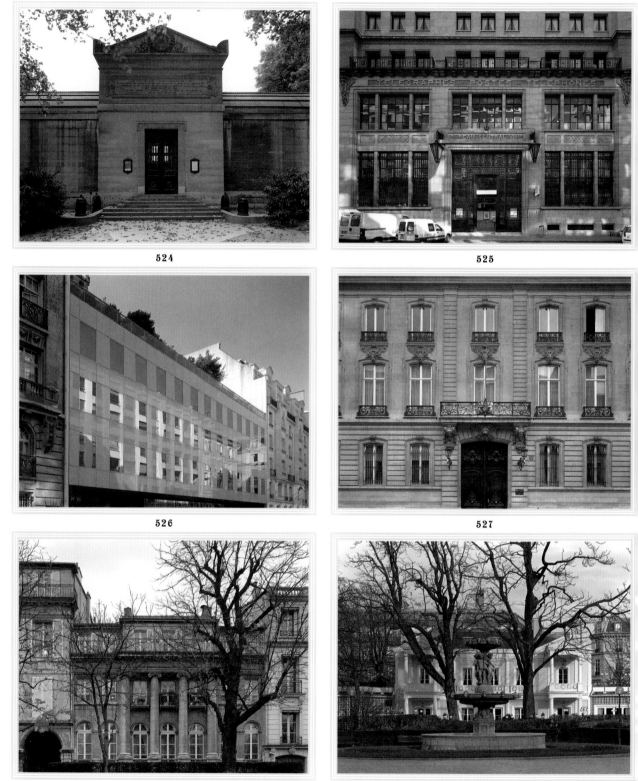

524

525

526

527

528

529

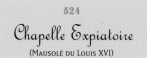

524

Chapelle Expiatoire
(MAUSOLÉ DU LOUIS XVI)

29, RUE PASQUIER AND SQUARE LOUIS-XVI,
PLACE DU GUATEMALA AT BOULEVARD HAUSSMANN,
AND RUES DES MATHURINS, D'ANJOU, AND PASQUIER

1818–26, PIERRE FONTAINE

This site was the burial grounds for Louis XVI and Marie-Antoinette, along with other guillotined victims of the Revolution. Louis XVIII commissioned Fontaine to design this Expiatory Chapel as a commemorative monument to the royal couple, whose statues, by sculptors François-Joseph Bosio and Jean-Pierre Cortot, can be found inside the chapel.

525

Poste centrale du 8eme

49, RUE DE LA BOÉTIE AT BOULEVARD MALESHERBES

c.1920

This severe building houses a post office for the entire arrondissement and owes more to American architecture than to Parisian. The façade is divided into three large bays on two stories and crowned by a balcony. The large windows and the first two levels provide maximum light and space for sorting and public services, and the other two stories above contain offices. Decorative ironwork protects the windows and marks the entrance.

526

Willkie Farr & Gallagher Building

21–23, RUE DE LA VILLE-L'EVEQUE AT RUE D'ASTORG

c. 1970

The international law firm of Willkie Farr & Gallagher, established in New York City in 1889, operates their Paris branch out of this crisp, white, three-level office building. Resembling a woven table runner, the building faces a larger version of itself just across the street, which reflected in the windows gives the Willkie façade even more of a cross-hatched effect. Fifty lawyers work out of the Paris office, founded in 1922, and handle a broad range of international and domestic cases for a variety of industries.

527

British Chancellory
(FORMER HÔTEL CHEVALIER DE MONTIGNY)

35–37, RUE FAUBOURG-SAINT-HONORÉ AT AVENUE GABRIEL

1715–16, PIERRE GRANDHOMME

As the official home of the British Embassy, this austere, utilitarian building seems the perfect place to get things done. It sits blandly among the more inspired haute couture houses that share the fashionable rue Faubourg-Saint-Honoré. In the early eighteenth century, Pierre Grandhomme developed this property under the patronage of the president de la cour du Parlement, Louis Chevalier, from which its original name, Hôtel Chevalier de Montigny, derives.

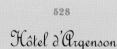

528

Hôtel d'Argenson

38, AVENUE GABRIEL AT AVENUE DE MARIGNY

1780–87, JEAN-PHILIPPE LEMOINE DE COUZON;
1840–45, JACQUES-IGNACE HITTORFF, TRANSFORMATIONS

In the eighteenth century, the aristocracy had a fondness for placing mansions along the border of the Champs-Elysées. The widow of the marquis d'Argenson was among those who commissioned a residence here. Overlooking the gardens of the Champs-Elysées, this *hôtel* was itself an impressive sight, for its neoclassic proportions. Its layout of gardens surrounding the house demonstrates a British influence in the use of the property.

529

Restaurant Laurent with Fontaine du Cirque

41, AVENUE GABRIEL AT AVENUE MATIGNON

1842, JACQUES-IGNACE HITTORFF, REDESIGN AND FOUNTAINS

Laurent had been the former hunting lodge of Louis XIV when this area was still considered countryside. In the era following the French Revolution, the site held a dance-hall/café. In 1836, architect Hittorff created on this site this neoclassical, peach-colored pavilion of metal and brick with polychromatic pilasters, columns, and capitals. Originally called Café du Cirque when Caroline Otéro, a star of the circus, gathered friends here, it became Restaurant Laurent in 1860, when Monsieur Laurent purchased it.

530

Hypo Vereinsbank

34, RUE PASQUIER

1929, PIERRE AND ALEXANDRE FOURNIER;
GEORGES SAUPIQUE, SCULPTOR

For the former Financial French and Colonial Society, eclectic architect Fournier used this corner site to shape a monumental building that expressed France's perspective of the African continent. Resting on a high base level, the piers between the windows of the three stories above are decorated with patterns of colored marble, enamel from Venice, and mosaics. Animal scenes of camel, elephant, shark, ibex, and fishing create a naïve expression of the exoticism of former French colonies rather than a true cultural understanding. Business was preeminent, and this building served as prime advertising about the continent.

531

SUEZ – Water Company

16, RUE DE LA VILLE-L'EVÊQUE AT RUE D'ASTORG

2001, DTACC (JÉRÔME DELAAGE, FERNAND TSAROPOULOS,
G. CARVUNIS, AND J.-A. CHOLET)

In a brilliant integration within the courtyard, the architects designed this contemporary, glass office building while preserving the original façade of the only hôtel remaining from architect Boullée. Previously named Hôtel Suchet for a marshal who lived here from 1802 to 1818, the old hotel was originally built for a banker. The façade retains the character of the eighteenth-century hotel with its beautiful restoration of the peristyle of four Ionic columns, balustrade, and carved stone décor. By enclosing this frontage with a glass wall and innovative sky-lighting, the architects achieved an open space that brings the outside in and gives the entire ensemble classic balance and modern lightness.

532

British Embassy

35, RUE FAUBOURG-SAINT-HONORÉ AT AVENUE GABRIEL

1720, ANTOINE MAZIN

In 1870, when the Prussians besieged Paris, the British Embassy converted one of its wings to a maternity ward to prevent eventual conscription of its subjects into the French army. Somerset Maugham—whose father worked at the Embassy—was one of the babies born there. Originally known as Hôtel Béthune-Charost, when architect Mazin built it in 1720 for Paul-François Béthune-Charost, this beautiful eighteenth-century mansion became the property of the British Government in 1814.

533

Le Pavillon Elysée

10, AVENUE DES CHAMPS ELYSÉES
AT AVENUE DE MARIGNY AND AVENUE GABRIEL

1898, ALBERT BALLU

Created for wealthy patrons of the 1900 World's Fair, this former pavilion is set in the gardens of the Champs Elysées and was once known as Pavilion Paillard, after the original owner. Architect Ballu designed the structure in Louis Seize shape and style with a stage, a rotunda, and a turret. Sculpted heads crown the pilasters around the façade, and, above the gilded tower dome, Jules Blanchard installed his graceful cast-iron statuette of a winged cupid. The restaurant was purchased in 1984 and renamed Le Pavillon Elysée.

530

531

532

533

534

535

Grand Palais

AVENUE WINSTON-CHURCHILL AT AVENUE DU GÉNÉRAL-EISENHOWER

1897–1900, HENRI DEGLANE, ALBERT LOUVET, AND ALBERT THOMAS,
UNDER SUPERVISION OF CHARLES GIRAULT

From an aerial perspective, this enormous building appears to rest on the lower Champs-Elysées like a giant airplane upon a runway, with the Petit Palais as its nose. Its massive stone façade—over twice the length of a football field—stretches down avenue Winston-Churchill, and the dome at its peak measures 144 feet from ground level. Monumental quadrigas, sculpted by Georges Récipon, surmount the side entrances. Unlike other palaces built for members of the aristocracy, the Grand Palais—constructed for the 1900 Universal Exposition—honored art, and as such became a showcase for emerging artists. Since 1937, the Grand Palais has allocated its southern portion for use as Le Palais de la Découverte, a science museum and planetarium dedicated to scientific discovery.

Petit Palais

AVENUE WINSTON-CHURCHILL AT AVENUE CHARLES-GIRAULT

1897–1900, CHARLES GIRAULT

Built for the 1900 Universal Exposition, the Petit Palais, along with the Grand Palais across the avenue Winston-Churchill, replaced a gigantic structure on the same site from an earlier World's Fair in 1855. Architect Girault designed both the Petit Palais and the Grand Palais as temples to art and culture. But unlike the Grand Palais, built for the temporary display of changing exhibitions, the Petit Palais was intended from the start to be a permanent museum. Presently undergoing extensive renovation, the Petit Palais features works from the collections of the City of Paris.

536

Restaurant Ledoyen

2, AVENUE DUTUIT IN THE CHAMPS-ELYSÉES GARDENS

C. 1730, AS AU DAUPHIN; 1848, JACQUES-IGNACE HITTORFF, REDESIGN

After the original owner, whose last name the restaurant still bears, sold his café, architect Hittorff, who redesigned the lower gardens of the Champs-Elysées and rebuilt fashionable restaurants there, moved this one to its present location. The restaurant has drawn such personages as Napoléon, and writers Guy de Maupassant and Henry James, all of whom were equally attracted by its sumptuous cuisine and verdant surroundings. Other patrons have included Edgar Degas and Edouard Manet.

537

Hôtel de Castiglione

RUE FAUBOURG-SAINT-HONORÉ/RUE D'ANJOU

1932, CHARLES SICLIS

Rosy polished stones cover the façade of the Hôtel de Castiglione and give it character. Its prestigious location near numerous embassies makes it a convenient hotel for foreign guests. The hotel contains 120 furnished rooms and apartments decorated in Art Deco style, with balconies, terraces, or patios that have views of the Eiffel Tower and rue Faubourg-Saint-Honoré.

538

Dalloyau

99–101, RUE FAUBOURG-SAINT-HONORÉ AT RUE ROYALE

1802

Three hundred years ago, brothers Charles, Richard, and Mathurin Dalloyau cooked at Versailles in service to the royal family. Their innovative recipes kept the family popular with the aristocracy through four generations of Dalloyaux. Came the French Revolution, descendant Jean-Baptiste guessed correctly that the bourgeoisie would have a hankering to sample how the aristocracy lived and ate. Thus, he created his first Maison de La Gastronomie (House of Gastronomy) for which he adapted royal recipes to be sold as takeout.

536

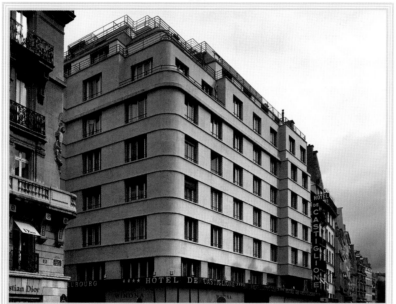

537

538

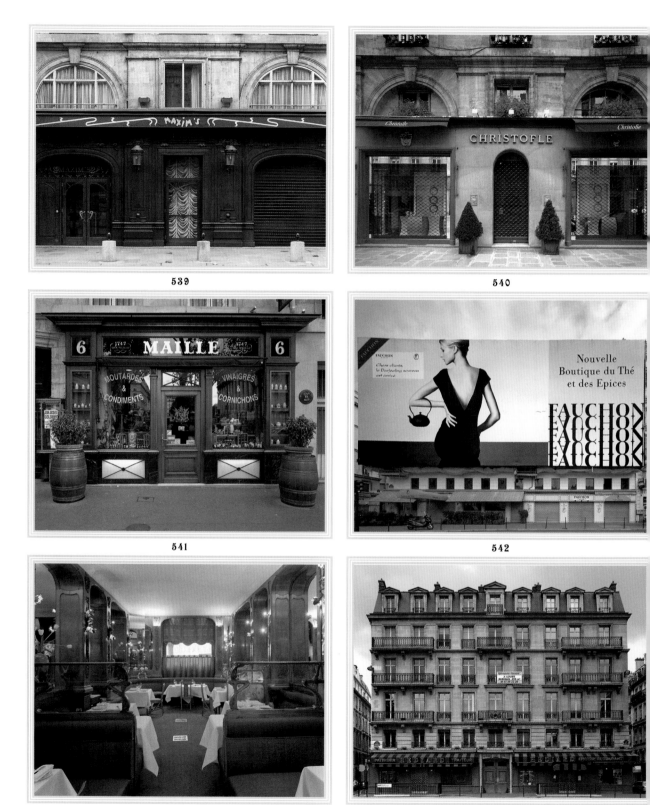

539

540

541

542

543

544

539

Maxim's

3, RUE ROYALE AT PLACE DE LA CONCORDE

1893, OPENING

In the early part of the twentieth century, Maxim's became a celebrity haunt. Originally started in 1893 by Maxime Gaillard, the business was eventually acquired by Max Lebaudy, who not only added an "apostrophe *s*" to the name but gave the restaurant the glitzy, Belle Epoque image we associate with it. The Prince of Wales was among those who helped put Maxim's on the map, as did Franz Lehár's 1905 operetta *The Merry Widow*, whose entire third act is set there.

540

Orfèvrerie Christofle

9, RUE ROYALE AT RUE DE RIVOLI

1758, LOUIS LE TELLIER; ANGE-JACQUES GABRIEL, FAÇADE

While working on the construction of place Louis-XV (now place de la Concorde), in the mid–eighteenth century, Ange-Jacques Gabriel designed façades for the entire length of rue Royal, and then various architects designed the mansions that would be behind them. Architect Le Tellier created this building in keeping with the original plans of Gabriel. This mansion today houses the Christophle showroom of fine silverware. Its museum, on the upper level, exhibits contemporary and vintage pieces.

541

Maille

6, PLACE DE LA MADELEINE AT BOULEVARD DE LA MADELEINE

C. MID–NINETEENTH CENTURY, BUILDING

In 1747, Antoine Maille, a vinegar distiller and mustard manufacturer, opened a shop on Saint-André-des-Arts, and supplied mustards and vinegars to the royal courts of Europe. Legend has it that Madame de Pompadour would commission his aniseed vinegar by the barrel. World famous for its Dijon mustard, packaged in a squat jar with a black label, this wood-trimmed gourmet shop opened on the prestigious place de la Madeleine in 1999, carrying on the condiment tradition started in the eighteenth century.

542

Fauchon

26, PLACE DE LA MADELEINE AT RUE DE SEZE AND RUE VIGNON

1829, BUILDING; C. 1886, BOTREL, ARCHITECT;
LEFEBVRE, CARPENTER, SHOP FRONT

Auguste Fauchon originally hawked his produce from a pushcart on the place de la Madeleine, alongside the flower merchants. From those humble beginnings, he rose to found the now-famous Parisian luxury food enterprise. Patrons can *emporter* (take out) their order, or sample their selections in a more leisurely fashion in either Fauchon's original tea salon or in their 1924 restaurant.

543

Lucas-Carton

9, PLACE DE LA MADELEINE AT BOULEVARD MALESHERBES

1890, LOUIS MAJORELLE, DECORATION

The Belle Epoque façade of this restaurant welcomes customers and offers excellent dining in an elegant period setting. Monsieur Scaliet, who bought the restaurant in 1890, commissioned Majorelle to decorate it in Art Nouveau style. Using citrus-tree wood from Ceylon, sycamore, and bronze, he created a quiet, warm-toned décor. The blond paneling is hand-sculpted with vegetable motifs. Wooden tracery set into glass panels at the back of the banquettes, and bronze wall lamps complete the interior.

544

Hédiard

2, PASSAGE DE LA MADELEINE AT RUE CHAUVEAU-LAGARDE

1880, INSTALLATION

An aspiring entrepreneur even at the age of 22, Ferdinand Hédiard decided to introduce Parisians to exotic fruits from the French-held colonies. In a prescient move, he chose place de la Madeleine to set up shop. His emporium attracted wealthy, fashionable clients in the heyday of the Napoléon III's Second Empire and Baron Haussmann's city redevelopment. By the turn of the century, place de la Madeleine became "the" place for restaurants and gourmet shops, in a quarter known for its lavish *hôtel particuliers*.

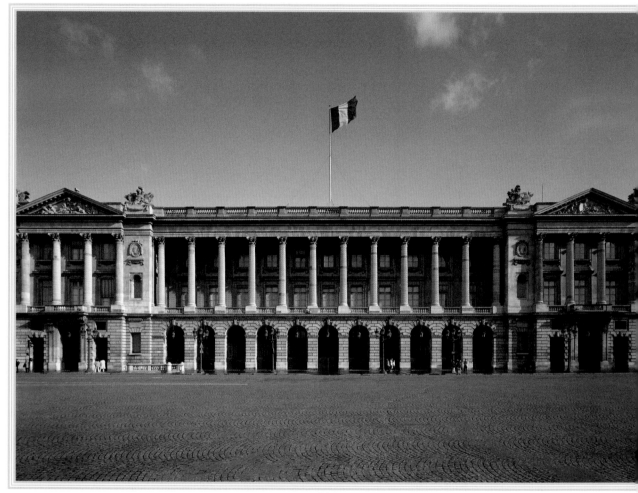

545

Hôtel Crillon

10, PLACE DE LA CONCORDE, AT RUE ROYALE

1766–75, JACQUES-ANGE GABRIEL; 1774, PIERRE-ADRIEN PÀRIS,
INSIDE DECORATION; 1907, WALTER DESTAILLEURS,
INSIDE RENOVATION; 1830–44, JACQUES-IGNACE HIFFORFF,
ALTERATIONS OF PLACE DE LA CONCORDE

From the glory of the king to the public execution of his grandson, this site's name has changed with the prevailing political winds. These twin palaces face a place originally named place de Louis-XV. Then along came the Revolution and the aristocracy—most notably Louis XVI and Marie Antoinette—literally lost their heads in the very square that had celebrated that royal marriage. Over one thousand people were guillotined at this site, which was renamed place de la Révolution. After the carnage, the place was again renamed, first becoming place de la Concorde, then, in 1813, place de Louis-XV, and finally, place de la Concorde again. Hôtel Crillon, on the west side, was home to wealthy, elite expatriates like F. Scott Fitzgerald in the 1920s and was also a famous site for historic and cultural affairs: The British and Americans used it during World War I; preliminary work on the Versailles Treaty occurred here; Presidents Woodrow Wilson and Dwight Eisenhower stayed here; Germans used it as headquarters during World War II; and in postwar years, it was a gathering place for such celebrities as Orson Welles and Jacqueline Kennedy Onassis.

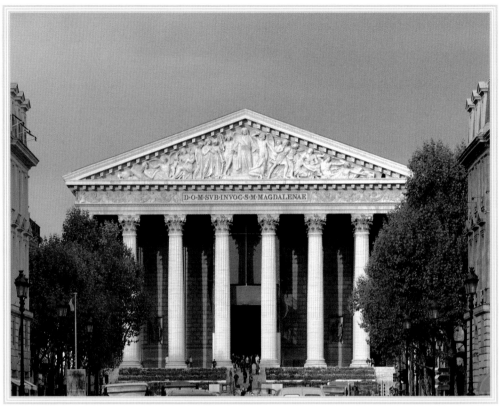

546

546

Eglise de la Madeleine

PLACE DE LA MADELEINE AT RUE ROYALE

1807–28, PIERRE VIGNON; 1828–42, JACQUES-MARIE HUVÉ

Napoléon I sought to build a *temple à la gloire*—a monument to the glory of his armies—and scouted around for a location. He settled on the site of a medieval parish church that had been transformed into one dedicated to Madelaine, but the Revolution interrupted construction. The temple was left without a dome or bell tower. When Napoléon's empire collapsed, the pagan temple reverted to its religious roots. Anchoring rue Royale on an axis with place de la Concorde, this building's location makes it a favorite place of worship for Parisians, despite its missing parts. The neoclassical church has also been host to famous funerals, including Chopin's in 1887, Joséphine Baker's in 1975, and Marlene Dietrich's in 1992.

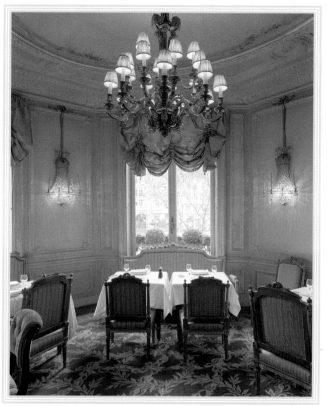

547

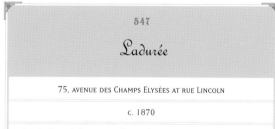

547

Ladurée

75, AVENUE DES CHAMPS ELYSÉES AT RUE LINCOLN

c. 1870

A civilized haven of marble-topped tables, velvet-draped windows, and gilded mirrors, this tea salon and patisserie catered to wealthy patrons—elderly ladies who lunch—in its early days, much as it does today. In 1862, Louis Ernest Ladurée, a miller from the Southwest, opened his first bakery at 16, rue Royale when new vistas just opened there in the glory days of Baron Haussmann's town planning. Following a fire in the bakery, the pastry shop was built. Artist Jules Cheret, influenced by the pictorial techniques of the Sistine Chapel ceiling and the Garnier opera house, painted its interior. It was Ladurée's wife who thought of combining a café and pastry shop, and she created one of the first tearooms in Paris, where unescorted ladies could dine without losing their respectability. The pastry shop still offers simple pleasures albeit in an ornate setting.

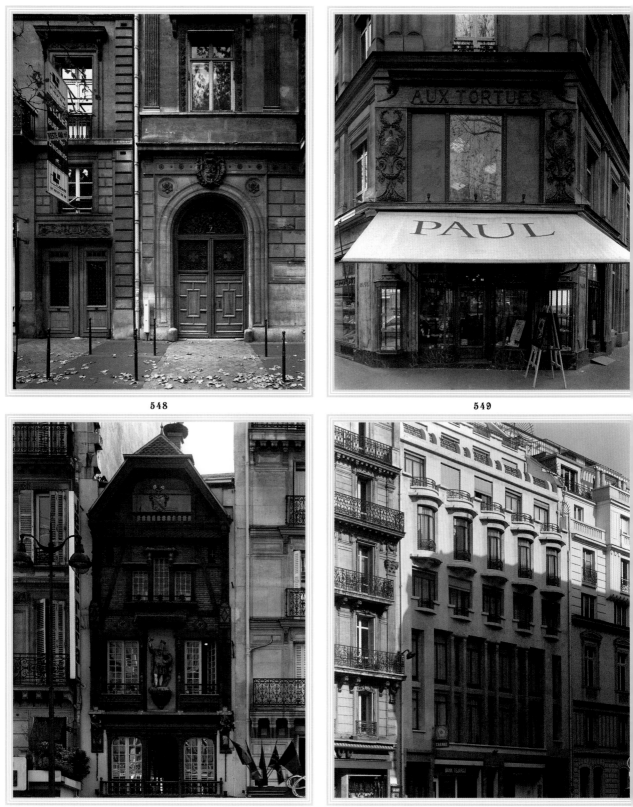

548

549

550

551

548

Hôtel de Pourtalès

7, RUE TRONCHET AT PLACE DE LA MADELEINE

1836, FÉLIX DUBAN

Inspired by Italian Renaissance palaces, Félix Duban built this little townhouse gem near the Church of the Madeleine. Although taller buildings on each side dwarf this residence, Duban's creation has a personality of its own. The building's distinct, two-level façade and lovely, almost square proportions fulfill the old adage—good things come in small packages.

549

Paul

CORNER 55, BOULEVARD HAUSSMANN AND 35–37 RUE TRONCHET

1864, BUILDING; 1910, DECORATION STORE

This famous bakery—founded in 1889 in Lille in the north of France by Charlemagne Mayot and his wife—replaced a store established in 1864 that specialized in the sale of ivory objects. Inspired by the Louis Seize, the marble decoration of the current frontage dates from 1910; it features two bronze heads of elephants, and two of tortoises. In 1953, new owners acquired a bakery from the family of Paul and their name remained; the owner's son expanded the manufacturing side of the business and opened an industrial *boulangerie* in 1965. In 1972, he installed the first bakery to have a furnace within view of customers; and in the late 1980s, he added to the original range of breads, tea service and pastries.

550

Mollard

115, RUE SAINT-LAZARE, BETWEEN RUE DE ROME AND RUE DU HAVRE

1884, EDOUARD NIERMANS

Although Edouard Niermans was Dutch by birth, he adopted France as his home and became the architectural darling of Parisian society. With a formal richness created by mixing paintings, sculptures, stained glass artistry, and Art Nouveau styling, Niermans's work generally catered to parvenus. The original frontage with columns and mosaics has disappeared, but the interior of polychromatic marble, figurative mosaics, and ceramic paintings remains intact. The ceiling depictions in raised gold mosaic with scenes of eating and drinking, as well as the exterior statue of a king raising his tankard, recall the establishment's origin as a brewery, despite its current fast food occupant at the ground level.

551

Parexel International France
(LABORATOIRES PHARMACEUTIQUES)

126, RUE DE PROVENCE AT BOULEVARD HAUSSMANN

1913, HENRI SAUVAGE AND CHARLES SARRAZIN

An eclectic architect who could move from Art Nouveau to modernity with ease, Sauvage designed buildings that showed his versatility. This one exemplifies a modern-industrial, multi-purpose structure. Built for furniture maker Majorelle, it combines offices, showrooms, and workshops prefigured by the façade. The first two levels, with long rectangular windows, house the showrooms. These extend to the rear, with a glass roof for natural light. The third and fourth levels, which have bay windows, contain intimate space for offices; and the upper floors are reserved for workshops. The façade creates both an orderly appearance and an upward momentum for each function.

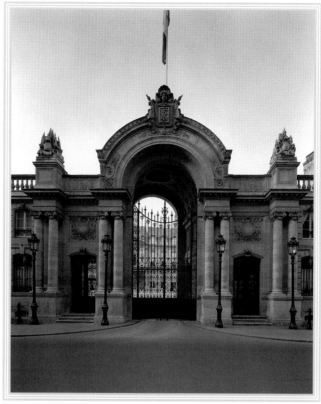

552

552

Palais de l'Elysée

55–57, RUE FAUBOURG-SAINT-HONORÉ
BETWEEN AVENUE MARIGNY AND RUE DE L'ELYSÉE

1718–20, CLAUDE-ARMAND MOLLET; 1753, JEAN CAILLETEAU (AKA
LASSURANCE), ALTERATIONS; 1773, ETIENNE-LOUIS BOULLÉE, INSIDE
ALTERATIONS, GARDEN; 1787, PIERRE-ADRIEN PÂRIS, INSIDE ALTER-
ATIONS, GARDEN; 1805–08, BARTHÉLÉMY VIGNON, ETIENNE-CHÉRUBIN
LECONTE AND JEAN-THOMAS THIBAULT, INSIDE ALTERATIONS; 1848,
JOSEPH-EUGÈNE LACROIX, FAÇADE ALTERATION AND WINGS

Originally known as Hôtel d'Evreux for its first
owner, comte d'Evreux, this palatial mansion
became the official residence of France's presi-
dent in 1873. At the northern edge of the
Champs-Elysées gardens, its arched entryway
opens onto a large, classical courtyard. Prior to
State ownership, illustrious residents occupied
the premises: Madame de Pompadour, the
building's second owner; Napoléon Bonaparte,
who abdicated here in 1815; and Napoleon III.

9TH ARRONDISSEMENT

Here's a bit of the real Paris with quaint mews and private mansions, all quietly tucked away from the average tourist. Beyond the Garnier Opéra and famous department stores Le Printemps and Galeries Lafayette, romance beckons in the village enclaves of the 9th arrondissement. The area above the old fortification boundary of the Grands Boulevards and below Butte Montmartre was once the countryside where, in the early nineteenth century, real estate developers created two artistic quarters: Saint-Georges and La Nouvelle Athènes. During a period that saw the revival of Greek and Egyptian styles of architecture and the rise of Romanticism, actors, writers, painters, and musicians flocked to these new neighborhoods and built lovely homes, charming squares, courtyards, and gardens. For a taste of this Romantic life, a number of former private mansions, converted now to little-known museums, are scattered around the 9th arrondissement. Just north of the Grands Boulevards border, the Folies-Bergère is a reminder of the swinging cabaret days of the nineteenth and early twentieth centuries when this district was the center of entertainment. Still popular today, the area contains clusters of great neighborhood restaurants, art galleries, other cabarets, small theaters, and the diverse and colorful market streets of rue des Martyrs and rue Cadet.

Théâtre National de l'Opéra
Palais Garnier

PLACE DE L'OPÉRA AND PLACE DIAGHILEV
BETWEEN BOULEVARD DES CAPUCINES AND BOULEVARD HAUSSMANN

1862–75, CHARLES GARNIER

"Now would I have a book where I might see all characters and planets of the heavens, that I might know their motions and dispositions." —Faust. On May 20, 1896, as if in answer to Faust's query, a performance of Gounod's *Faust* came to a terrifying halt as l'Opéra's chandelier suddenly came crashing down, killing one woman and injuring other members of the audience. This night at the opera inspired Gaston Leroux's novel, *Le Fantôme de l'Opéra*, which in turn became the source for movie and musical spinoffs that, while recreating the tragedy of its chandelier, also celebrated the splendor of this building's interior. In 1860, Charles Garnier won a city competition for his grandiose design with statues and pillars of marble and colored stones, anchored in a huge quadrangular space. Parisian society, led by Napoléon III, who initiated the project, flaunted its finery here amidst the grandeur Garnier created specifically for that purpose. The satin and marble interior matches the opulence of the exterior and dazzles the eye with its magnificent foyer and stairway, and its restored auditorium features a seven-ton crystal chandelier and a Marc Chagall ceiling painting. Today, this unrestrained, eclectic monument to the Second Empire shines in gilded glory at the end of avenue de l'Opéra.

553

554

555

556

557

554
La Maison du Miel

24, RUE VIGNON BETWEEN RUE TRONCHET AND RUE DE SÈZE

1898, FOUNDATION; 1930, INSTALLATION AT 24, RUE VIGNON

Like a honeycomb that attracts its share of bees, historic gourmet shops swarm around place de la Madeleine. Located just at the border of the 8th and 9th arrondissements, near place de la Madeleine, La Maison du Miel is a honey of a store amid other shops that specialize in offerings for the epicure. Espousing the health and nutritional value of honey, this store has dispensed the golden nectar and its related products since 1898.

555
Le Printemps

64-70, BOULEVARD HAUSSMANN AT RUE DU HAVRE AND RUE DE PROVENCE

1865, JULES JALUZOT; 1881–85, PAUL SÉDILLE; 1905, RENÉ BINET, RENOVATION AND CENTRAL STAIRCASE; 1907–10, RÉNÉ BINET, SECOND STORE; 1912, GEORGES WYBO, EXTENSION; 1921–24, GEORGES WYBO, RECONSTRUCTION OF THE SECOND STORE

Classified as a Parisian historic landmark, Le Printemps stands elegantly in a neighborhood of aristocratic townhouses. The Printemps name, inscribed in the multi-colored tiles above the entrance, almost dances off the grand corner façade, which features cast-iron columns, large bay windows, Renaissance domes, and an Art Nouveau copula added in 1923.

556
Lycée Condorcet and Eglise Saint-Louis-d'Antin

63–65, RUE CAUMARTIN AT RUE DU HAVRE

1780–82, ALEXANDRE-THÉODORE BRONGNIARD; 1805–08, ALEXANDRE-THÉODORE BRONGNIARD, ADDITIONS; 1865, JOSEPH-LOUIS DUC, ADDITIONS (RUE DU HAVRE)

In 1780, Louis XVI built a church for the Capuchins at the fortification wall of Antin, at the end of the current rue Caumartin. Influenced by the Greco-Roman style, architect Brongniard based the convent on the temple of Paestum, and its peristyle was inspired by the temple of Ségèste. Columns are ordered around a rectangular cloister with an east-west orientation. It was laid out with a single nave, but neither side chapel nor apse.

557
Square d'Orléans
(CITÉ DES TROIS-FRÈRES)

20, RUE TAITBOUT AND 80, RUE TAITBOUT

1829, EDWARD CRESY

In the 1830s, English architect Cresy designed square d'Orléans on property previously owned by actress Mademoiselle Mars. And the square attracted writers, singers, musicians, artists, and actors. Lovers George Sand and Frédéric Chopin lived here, though in separate homes. Opera singer/composer Pauline Viardot owned a house on this square as well, and Berlioz and Liszt listened to music in pianist Pierre-Joseph-Guillaume Zimmerman's house.

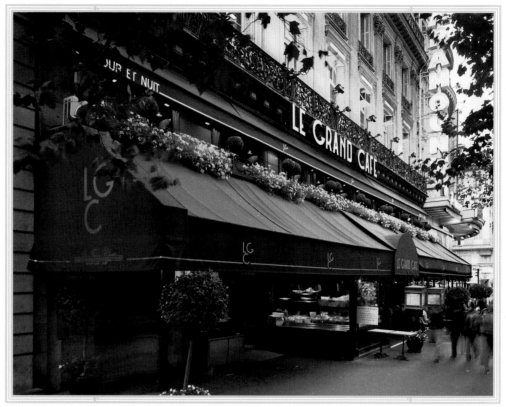

558

Le Grand Café des Capucines

4, BOULEVARD DES CAPUCINES AT RUE DE LA CHAUSSÉE D'ANTIN

c.1875

On December 28, 1895, a few dozen customers of Le Grand Café Capucines paid one franc each to witness cinematic history: The Lumière brothers—pioneers in French cinema—showed their first documentary in the café's Salon Indien downstairs. Today, if you are looking for a late-night stimulant, Le Grand Café Capucines would be your cup of tea, so to speak. Even without a film to keep you awake, it's easy to spend the entire night just looking at its lavish Belle Epoque interior of painted tile murals, exotic statues, and stained-glass ceilings. This all-night café has provided nourishment for late-night theatergoers and party-hoppers since its opening on the Grands Boulevards more than a century ago.

559

Restaurant Bouillon Chartier

7, RUE DU FAUBOURG-MONTMARTRE AT BOULEVARD MONTMARTRE

1895, EDMOND NAVARRE

Since restaurant Chartier opened its doors in the late nineteenth century, not much has changed inside this typical Parisian setting, just off the Grands Boulevards. The fashionable carriage trade has since moved out of the area, but simple Parisian fare at reasonable prices still survives here. Dubbed Bouillon (Bubble) by the Chartier brothers, this was a nineteenth-century precursor of today's restaurant chains whose inexpensive fare caters to city workers. An alley leading from the street opens onto a small cobblestone courtyard, where this old-time eatery still serves customers within its globe-lit, wooden-paneled interior. Waiters sport traditional black vests and white aprons; and details such as beveled mirrors, vintage woodwork, a painted mural landscape, and brass-and-wood coat racks contribute to the ambience. Set back from the bustle of the main drag, the restaurant transports its clientele to the dining experience they might well have encountered here a century ago.

559

Grands Boulevards

Although the annual medieval fairs of Saint-Germain and Saint-Laurent had once amused residents with revelries galore, come the middle of the eighteenth century Parisian society was ready for a change of both venue and entertainment. Lined with theaters, the boulevard du Temple, cutting through the center of the 3rd arrondissement, became the Broadway of the working class after the Revolution. On the street itself, a perpetual carnival atmosphere pervaded the area, with street performers, from mimes to animal-trainers, providing the masses with continuous, free spectacle. Meanwhile, farther west, the Grands Boulevards drew wealthier Parisians who in themselves became an entertainment, strolling or riding by to show off their fashionable clothing and new carriages.

Louis XIV had followed the boundary line of Philippe Auguste's medieval fortification wall when he created this tree-lined promenade for pleasure in the seventeenth century. By the mid–nineteenth century, when Baron Haussmann was expanding city limits and reconfiguring the urban landscape, the Grands Boulevards became the center for glorious theater palaces, public baths, shopping *passages*, elegant restaurants, and a rising bourgeoisie flaunting their new wealth.

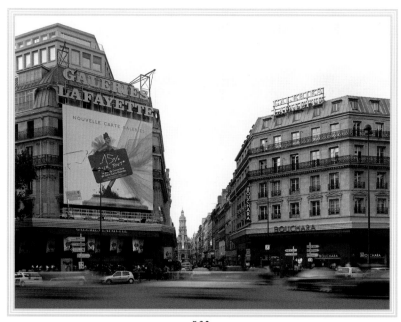

560

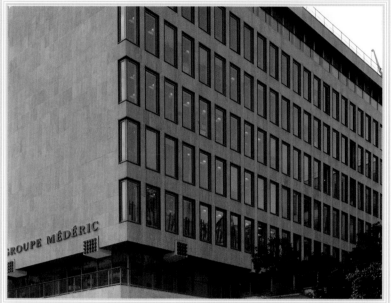

561

562

Galeries Lafayette

38–46, BOULEVARD HAUSSMANN AT RUE DE LA CHAUSSÉE D'ANTIN

1906–07, GEORGE CHEDANNE, FIRST PART (EXTENSION OF
TWO STORIES, 1960); 1910–12, FERDINAND CHANUT, BACK SIDE

Only slightly younger than its rival, Le Printemps, just down the boulevard, Galleries Lafayette department store compensates for its less-than-grand façade with a lavish Art Deco interior and a glorious, neo-Byzantine stained-glass cupola. Its awesome height measures almost 110 feet. And from the department store terrace, you can catch an exceptional view of Paris.

561

Banque Rothschild
(GROUPE MÉDÉRIC)

21, RUE LAFFITTE AT RUE ROSSINI

1969, PIERRE DUFAU AND MAX ABRAMOVITZ

For this building, the architects deliberately attempted to transform an old, austere building and a dull road into a warm and inviting space. Dufau and Abramovitz positioned the building perpendicular to the street and opted to give it a broad face with large windows, to demonstrate the bank's open concern for its customers. The architects suspended gardens about this otherwise ordinary building, to give the additional impression that the financial institution was environmentally friendly.

562

Au Petit Riche

25, RUE LE PELETIER AT RUE ROSSINI

1854; 1880, REBUILT; 1920, EXPANSION

In the mid–nineteenth century, while its cousin, the Café Riche restaurant, served the wealthy and the talented, this small bistro catered to the backstage crews who attended to the functioning of the nearby l'Opéra and the theaters on the Grands Boulevards. It was knocked out of commission by the Fire of 1873, which consumed the old opera house and other buildings that included the original Au Petit Riche. But, in 1880, the restaurant reopened.

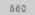

563

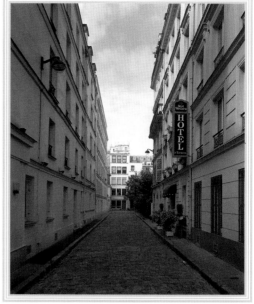

564

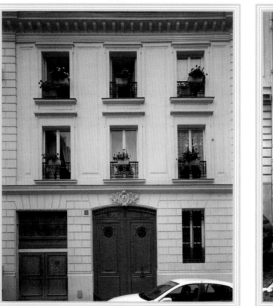

565

566

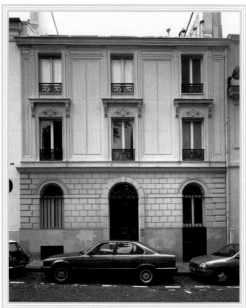

567

568

563

Former Confiserie à l'Étoile d'Or
(TODAY CONFISERIE DENISE ACABO)

30, RUE FONTAINE AT RUE DE DOUAI

c. 1900

Just down the street from Le Moulin Rouge and a short distance from the Butte Montmartre, this old-fashioned candy store may have helped to satisfy the sweet tooth of many an artist in its original day: Toulouse-Lautrec and Degas both lived on rue Fontaine in the neighborhood, where many other artists also lived at one time. Not much has changed—including the interior décor and the offerings—since this shop opened its doors more than 100 years ago.

564

Cité Pigalle

AT RUE JEAN BAPTISTE PIGALLE

At the end of this dead-end street, the façade at number 5 is adorned with a horseman sculpted in low relief. In front at number 8, beyond a small garden, Vincent Van Gogh took momentary refuge at his brother's fourth-floor residence. A few months later, Van Gogh left for Auvers-sur-Oise where he killed himself at thirty-seven years of age, in 1890. This tiny, cobblestone street is part of a popular, early nineteenth-century quarter called Saint-Georges that was developed specifically to attract artists and actors of the period.

565

Vernet House

5, RUE DE LA TOUR-DES-DAMES
BETWEEN RUE DE LA ROCHEFOUCAULD AND RUE BLANCHE

1822, LOUIS-PIERRE HAUDEBOURT

Neighbor to the famous actresses Mademoiselle Duchesnois and Mars, who lived on the same street, court painter Horace Vernet would often disturb the tranquillity of the rural area by extending invitations to marching cavalry: Accompanied by coaches and horses and loud drumming, troops stormed the street . . . to pose for the artist. Vernet used the men as models for his glorified battle scenes, meant to promote the grandeur of the Empire.

566

Hôtel de Talma

9–9 BIS, RUE DE LA TOUR-DES-DAMES
BETWEEN RUE DE LA ROCHEFOUCAULD AND RUE BLANCHE

1820, CHARLES LELONG

Actor François-Joseph Talma, one of the many stage figures drawn to this neoclassical neighborhood, lived here for a few years, until he died in 1826. Though he began his adult career by pulling teeth, he extracted himself from dentistry and gravitated to the theater, becoming one of the greatest actors of his generation. He played with the Comédie-Française at the Odéon Théâtre but left after provoking an altercation between Republicans and Royalists.

567

Delaroche House

7, RUE DE LA TOUR-DES-DAMES
BETWEEN RUE DE LA ROCHEFOUCAULD AND RUE BLANCHE

1835, AUGUSTE CONSTANTIN

The homes in the La Nouvelle Athènes quarter, which encompassed rues de Tour-des-Dames, La Rochefoucauld, and Saint-Lazare, were inspired by the then-trendiness of Greek culture among people in the arts. Many of the architects for this district were trained in the neoclassical style of Percier, an architect to Napoléon. In 1822, artist Paul Delaroche moved into this particular house, right next door to painter Horace Vernet, who lived at number 5.

568

Église de-la-Trinité

PLACE D'ESTIENNE-D'ORVES BETWEEN RUE DE CLICHY AND RUE BLANCHE

1861–67, THÉODORE BALLU

Religious architecture took an odd turn here, with an eclectic jumble of styles, predominantly neo-Gothic and French Renaissance. The elaborately detailed façade of this towering structure causes the church to resemble a parliamentary building rather more than a house of worship. In front of its monumental porch, three statues personify Faith, Hope, and Charity.

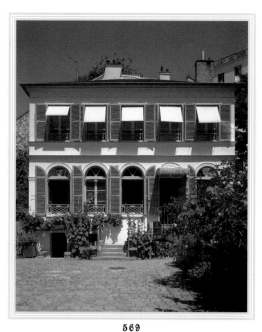

569

Musée de la Vie Romantique

16, RUE CHAPTAL AT RUE HENNER

1820

A tree-lined path reveals a garden hideaway where, in 1830, at the edge of the rural Nouvelle-Athènes quarter, Dutch painter Ary Scheffer settled with his family for almost thirty years. In this secluded setting, his ochre-painted, Italian-style home became a Friday-night gathering place for such luminaries of the Romantic Period as George Sand, Franz Liszt, and Frédéric Chopin, among others. Today, the museum recalls those times, with its careful restoration of his home and garden, and of one of his studios.

569

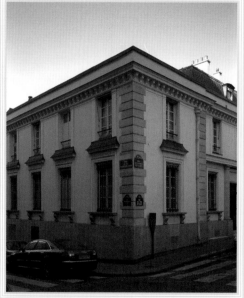

570

Hôtel de Mademoiselle Mars

1, RUE DE LA TOUR-DES-DAMES
AT THE CORNER OF RUE DE LA ROCHEFOUCAULD

1820, LOUIS VISCONTI; 1826, TRANSFORMED

Between 1820 and 1835, developers laid out an area bordered by rue de La Rochefoucauld, rue Saint Lazare and rue Blanche, specifically for new residences. It became known as La Nouvelle Athènes, or the New Athens, to capitalize on a trend for all things Greek. Rue de la Tour-des-Dames became a sought-after address in this new quarter. One of the early residents, actress Mademoiselle Mars, commissioned architect Visconti to embellish her abode.

570

571

Musée Gustave Moreau

14, RUE DE LA ROCHEFOUCAULD AT RUE DE LA TOUR-DES-DAMES

1895, ALBERT LAFON, ADDITIONS AND FAÇADE

Crammed wall-to-wall with painter Gustave Moreau's symbolic and phantasmagorical paintings and sketches, this townhouse-style mansion is both the painter's former home and a meticulously planned memorial to his own life's work. Moreau, known as a "writer's painter," bequeathed his house and estate, including hundreds of unfinished works, to the French state, in 1898. The double-decker studio and upper two levels that he had added to the original structure, became a museum in 1902.

571

Notre-Dame-de-Lorette

18 BIS, RUE DE CHÂTEAUDUN AT RUE DES MARTYRS,
RUE SAINT-LAZARE, AND RUE NOTRE-DAME-DE-LORETTE

1823–36, HIPPOLYTE LEBAS

Built in a period of neoclassic revival, Notre-Dame de Lorette is based upon the layout of a Roman basilica. It lies at the foot of rue des Martyrs, so named after the martyrdom of Saint-Denis and his followers. In its original day, the spiritual purpose of the church competed with the rollicking cabaret life of Montmartre just to its north. The building's pediment, supported by Corinthian columns, features a relief by Charles Leboeuf-Nanteuil, entitled *Homage to the Virgin*.

572

Fouquet

36, RUE LAFFITTE BETWEEN RUE DE PROVENCE AND RUE ROSSINI

1852, CREATION

For 150 years, five generations of the same family have enticed Parisians with sweet indulgences: chocolates, bonbons, caramels, and other assorted candies. The artful window display on rue Laffitte beckons you to sample a treat, still prepared by hand with meticulous care, and using original nineteenth-century recipes. Purchases are weighed and wrapped with the same attention to detail as had been given when painter Claude Monet satisfied his craving for bonbons here.

573

BNP building and Maison Dorée

2, RUE TAITBOUT AND CORNER OF RUE TAITBOUT
AT BOULEVARD DES ITALIENS

1838, MAISON DORÉE, VICTOR LEMAIRE; 1974–76, PIERRE DUFAU,
BNP BUILDING AND ADDITION TO MAISON DORÉE

From the latter part of nineteenth century until World War I, Parisian society strolled the Grand Boulevards for entertainment. Dining in the lush, elegant cafés along the boulevards was an integral part of an evening's outing. The BNP—Banque Nationale de Paris—building now stands next to one of those famous restaurants, La Maison Dorée where, in fiction, Proust's Swann pined for Odette.

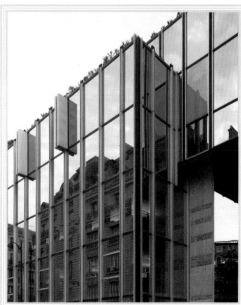

574

575
58, rue Saint-Lazare

AT RUE BLANCHE

1830

Once a glamorous street in the renowned quarter of La Nouvelle Athènes, rue Saint-Lazare attracted the fashionable and the famous, who built homes here in the Greek or the Italian Renaissance revival style. Painter Paul Delaroche lived here, in a dignified Italian-style residence. An alley at the back of the house leads to the garden façades of homes on the nearby rue de la Tour-des-Dames, where Delaroche also had a home at number 7.

576
Hôtel de Mademoiselle Duchesnois

3, RUE DE LA TOUR-DES-DAMES AT RUE DE LA ROCHEFOUCAULD

1820, AUGUSTE CONSTANTIN

As rue de la Tour-des-Dames became a fashionable address, it attracted stars of the Parisian stage. Among those was actress Duchesnois, who began her career as a maid but, having higher aspirations, entered the theatrical profession. At the age of twenty-two, she debuted as Phèdre at the Théâtre Français.

577
Hôtel de Lestapis

2, RUE DE LA TOUR-DES-DAMES AT RUE DE LA ROCHEFOUCAULD

1822–23

Much of the property development in La Nouvelle Athènes quarter initially occurred on the south side of its most desirable street, rue de la Tour-des-Dames. Hôtel de Lestapis—built in the same period though not part of the original layout—was placed on the opposite side of the street, allowing its wealthy residents to look out upon some of the hottest new façades in town.

578
Place Saint-Georges apartment building

28, RUE PLACE SAINT-GEORGES AT RUE NOTRE-DAME-DE-LORETTE

1840–42, EDOUARD RENAUD

Inspired by French Renaissance architecture, this elaborate building became the prestigious apartment address for those with expensive tastes. The marquise de Païva temporarily resided here while her multi-millionaire lover built her a residence on the Champs-Elysées. In the mid–nineteenth century, most rental apartments favored simplicity of style; for this particular one, however, architect Renaud deliberately created a sumptuous design that resembled a private mansion, to attract wealthy tenants.

579
À la Mère de Famille

35, RUE DU FAUBOURG-MONTMARTRE CORNER OF RUE PROVENCE, RUE CADET, AND RUE RICHER

1761

Peering into the green-painted, glass façade of this *confiserie* is like a trip to the distant past, when kids rolled hoops down the streets, and wore bows and sailor outfits. Vintage tins, apothecary jars, boxes, baskets, and burlap sacks spill over with marzipan biscuits, cookies and crackers, bonbons and spiced breads, chocolates and caramels, colorful liqueurs, honeys, and confitures. All this and more, in this old-fashioned store.

580
Massis Bleue

27, RUE BLEUE AT RUE DE TRÉVISE

c. 1830

This broad façade sets up a repetitive pattern, with its alternating window styles of the first two levels. Straight-edged ledges mingle with triangular and curved pediments to create a harmonious rhythm that plays like a musical scale on the face of this nineteenth-century building. Located at the ground level, the staff at Massis Bleue, a general provisions store, scoops out the best nuts and spices from the orient and Middle East.

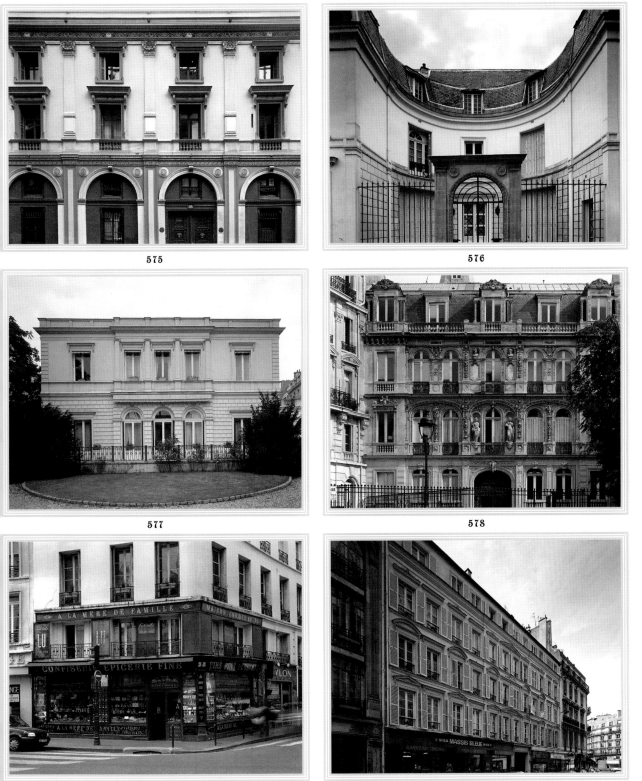

575

576

577

578

579

580

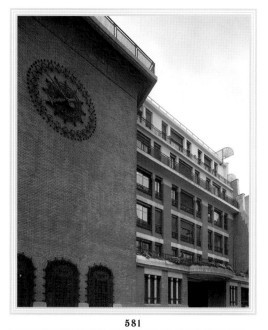

581

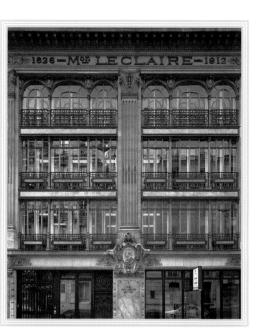

582

583

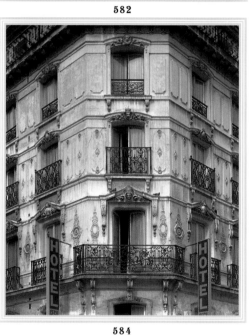

584

585

586

581
Centrale Téléphonique

17, RUE DU FAUBOURG-POISSONNIÈRE AT RUE BERGÈRE

1912, FRANÇOIS LE CŒUR

Widely criticized when it was built, this power-ful structure houses the telephone exchange. Architect Le Cœur, an early pioneer of modern architecture, created a monumental building covered by bricks, focusing upon function, with little regard to aesthetics. Nonetheless, he deserves special mention for the former entrance (no longer in use) that was crowned by a marquee formed by a block of glass.

582
Maison Leclaire

25, RUE BLEUE AT RUE DE TRÉVISE

1911, HENRI BERTRAND

This beautiful, industrial building from the early twentieth century, is the creation of architect Henri Bertrand, who devised the framework's fine, high stone pilasters that split the façade in two parts. The Cochi brothers created the build-ing's decorative sculptures. Originally used as a wallpaper workshop for the company of Maison Leclaire, founded in 1826, this glass-and-metal building now warehouses surgical and dental supplies, behind its large, iron-framed windows.

583
Cité de Trévise, residential complex

8, RUE RICHER AND 1, RUE AMBROISE THOMAS

1840–1844, EDOUARD MOLL

In the early nineteenth century, Cité de Trévise, an elegant and peaceful square in the Saint-Georges quarter, had the feeling of rural tran-quillity about it, and provided a working retreat while being sufficiently close to the action on Grands Boulevards. Each of the seventeen homes was designed in a different style. Today, the arty-literary crowd has moved on, but the solitude of this nook, with its center, nymph-decorated fountain, remains.

584
Hotel

6, RUE SAINTE-CECILE AT RUE DU CONSERVATOIRE

1860-1863, JANNIARD

A fan-shaped canopy marks the entrance to this decorative corner building, now a hotel. Elaborate lintels and ornate grillwork highlight the windows on all sides, and carved scrollwork decorates the stone facade between the windows. The smooth, unadorned ground level stands in sharp contrast to the fancy stonework employed at the higher floors and the highly decorative balcony that curves around the building on the second level. A church next door to this hotel is a Paris original, with an innovative metal framwork—a first for a church.

585
Banque Nationale de Paris

14, RUE BERGÈRE AT RUE DU CONSERVATOIRE

1878–81, EDOUARD-JULES CORROYER

In the late nineteenth century, banks competed with each other to win clients and subliminally influence them, by means of prestigious, over-the-top buildings. A firm's headquarters partic-ularly needed to signal wealth and inspire confidence. A large, sculpted figure graces the triple-arched entrance of this building, and two other sculptures flank its triangular pediment. The architect purposely centered this entrance on an axis with rue Rougemont, to maximize its visibility and leave a lasting impression.

586
Max Linder Panorama
(ART HOUSE CINEMA)

24, BOULEVARD POISSONNIÈRE BETWEEN RUE FAUBOURG-MONTMARTRE AND RUE ROUGEMONT

1914, FIRST OPENING

Burlesque actor Max Linder opened this 1,200-seat cinema in 1914 to show American films, including the first French releases of the movies of Charlie Chaplin. The actor-owner gave up pos-session of the building in the 1920s, but the new owner kept the name. Modernized in 1957, the interior framework of the screen had an unusual pentagonal shape, and doors on either side per-mitted an exclusive viewing area. It now has three levels and an eighteen-meter panoramic screen.

587

588

589

590

Grand Orient de France Librarie

16 BIS, RUE CADET BETWEEN RUE LA FAYETTE
AND RUE DU FAUBOURG-MONTMARTRE

This building has an inviting rhythm to its metal façade. Vertical struts, slanting up from the base, seem to raise and lower the horizontal planes of the building, like an unfolding awning. At the top, circular cutouts in the overhanging ledge extend the façade to the sky, at once giving unlimited access to the horizon while containing it to precise measures. This freewheeling yet structured building is an apt metaphor for its library collection of religious and philosophical texts.

Hôtel Bony

32, RUE DE TRÉVISE AT 13, RUE BLEUE

1826, JULES-JEAN-BAPRISTE DE JOLY

Located in the Saint-Georges quarter—a highly desirable nineteenth-century neighborhood—this building hides its charm from immediate view. To access its original entrance, you need to pass through an alley at rue Bleue. Today, the entryway is also accessible through the courtyard at 32, rue de Trévise. Influenced by the Italian Renaissance, it typifies townhouse residences during the Restoration period in France. A central triple portico, flanked by two lions, provides this townhouse with balanced proportions, elegance, and charm.

Au Général La Fayette

52, RUE LA FAYETTE
BETWEEN RUE DU FAUBOURG-MONTMARTRE AND RUE BUFFAULT

1886

In a country where wine is king, draft on tap made inroads in nineteenth-century Paris, when Alsatian entrepreneurs opened brasseries serving provincial food and beer to tourists from neighboring countries and the French provinces. Established in 1886, this lively tavern draws a business crowd and other patrons eager to wash down home-style French food with a sip of their favorite brew, selected from among a dozen or more choice beers and drawn mug by mug from shining brass pumps.

Musée Grévin
(WAX MUSEUM)

10, BOULEVARD MONTMARTRE BETWEEN PASSAGE JOUFFROY
AND RUE DU FAUBOURG-MONTMARTRE

1881, FOUNDATION OF MUSÉE GRÉVIN; 1900, ANTOINE BOURDELLE
AND JULES CHÉVET, THEATER, SCULPTURES; 1906, CREATION OF PALAIS
DES MIRAGES (MIRAGE/MIRROR PALACE); 2001, EXTENSIVE RENOVATION

Elvis rocks, Marilyn's dress flares up around her thighs, and the Three Musketeers duel, while Gandhi treads barefoot, with stick in hand. Musée Grévin presents these wax figures amid spectacular Gothic and Baroque displays that lead to unexpected encounters as visitors travel through time, history, and culture. Assisted by sculptor and costume designer Alfred Grévin and investor Gabriel Thomas, founder Arthur Meyer created the first representation of the famous "plastic journal" for the Grévin wax museum, opened on June 5, 1882.

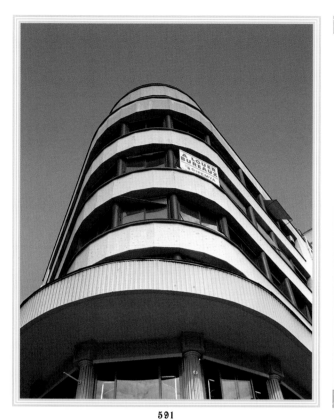

591

591

Magasin de bureaux et d'exposition Ford

36, BOULEVARD DES ITALIENS AT RUE HELDER

1929, MICHEL ROUX-SPITZ

Inspired to create a design that showcased the technological progress of its owners, Ford auto makers, Architect Roux-Spitz used chromium-plated sheet metal, an avant-garde material of the day, for the exterior of this structure. Roux-Spitz also employed neon signs and additional lighting systems to illuminate this building at night. Modifications over time have altered his original intent. But still, day or night, like the headlights of an advancing vehicle, this building still projects forward thinking.

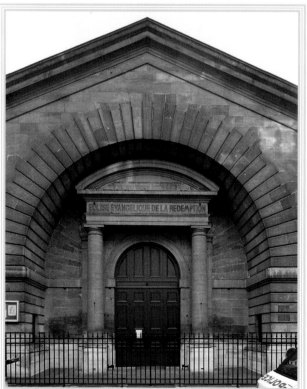

592

592

Lutheran Church of the Redemption

16, RUE CHAUCHAT AT RUE DE PROVENCE

1821–25, ADRIEN-LOUIS LUSSON, DEPOT;
1841–43, FRANÇOIS-CHARLES GAU, REMODELING

With the exception of its steeple, this building might be mistaken for a depot. In fact, it started life as just that: a depot for a nearby tollhouse. In 1841, architect Gau transformed the structure into a Lutheran church. To enhance the façade, he added a portico with a small, rounded pediment. But that did little to alter the building's general appearance: You might still be waiting for a delivery wagon to pull up, instead of a sermon to deliver you.

593

16, rue de la Grange-Batelière

AT RUE DROUOT

1876

In the mid–nineteenth century, this area attracted fine-arts galleries. Around the corner, on rue Drouot, the famous nineteenth-century auction house Hôtel Drouot still operates, albeit in a retro-style building. In 1876, the Impressionists—rejected by traditional salons—defected from the mainstream and first showed their unheralded masterpieces on rue Peletier, a few streets away. The bistro within this courtyard opened the same year that the Impressionists scandalized the art world.

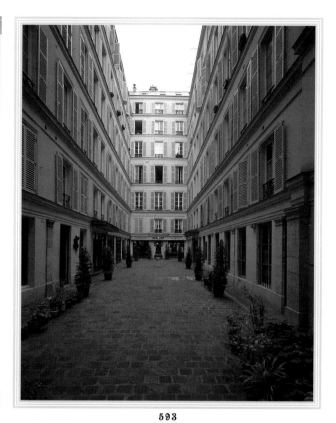

593

594

Mairie

(FORMER HÔTEL DE AUGNY)

6, RUE DROUOT AT RUE ROSSINI

1748–52, CHARLES-ETIENNE BRISEUX; 1825, INSIDE
TRANSFORMATIONS; 1870, ADDITION OF THE SIDE WINGS

This town hall for the 9th arrondissement occupies part of the former Hôtel de Augny, the eighteenth-century home of the Farmer General of Augny. Architect Briseux designed this building as a typical Rococo mansion, placing it between a long courtyard and a garden. During its 1825 transformation for Alexandre Aguado, a Portuguese banker who owned Chateau-Margaux vineyards, the Rococo patterning and carved keystones were destroyed, and a new staircase built.

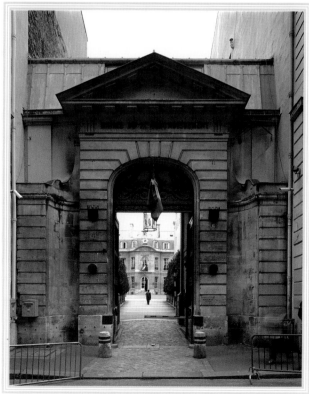

594

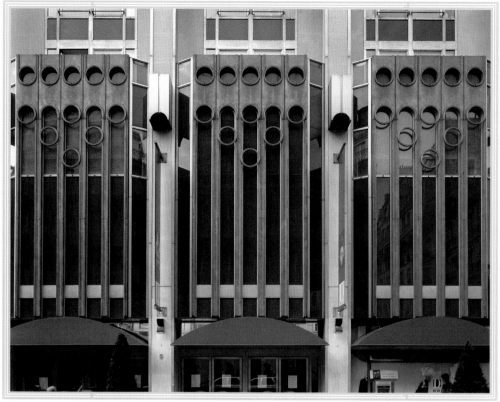

595

595

Hôtel des Ventes

9, RUE DROUOT ARRUE ROSSINI

1850–52 FIRST CONSTRUCTION, LEVASSEUR AND PALLARD; 1900, ADDITION; 1976, DESTROYED; 1980, JEAN-JACQUES FERNIER AND ANDRÉ BIRO

The architects of this retrofitted auction house—a redesign of the famous nineteenth-century Hôtel Drouot, the oldest auction house in the world—attempted to create, in their words, "a surrealistic reinterpretation of Haussmann." Inspired by fin de siècle lantern-like windows and macramé curtains, they retained the building's genuine window frames from 1856, while using molded aluminum panels for the façade, to achieve their desired affect. Unfortunately, the entire massive building resembles a metal accordion, with its fan-like folds extending down both sides of the street. Believed to be innovative in the 1970s, this building appears merely dated, rather than serving as an example of successful cohesive design incorporating the old and new.

10TH ARRONDISSEMENT

Industrial, gray and a bit downtrodden, the 10th arrondissement is dominated by the railway stations of Gare du Nord and Gare de l'Est. With the constant motion of people coming and going, the entire district seems governed by transience. But the area is also residential, and a popular crowd fills bars, nightclubs, and restaurants. Lending a bit of romance and poetry to the heart of the arrondissement, a singular bright path flows right through the center: Canal Saint-Martin. Also, Passage Brady at the southern edge brings a bit of India to the quarter. The neighborhood west of boulevard de Magenta boasts Marché Saint Quentin, the largest covered market in Paris and one of the last original halls of iron and glass.

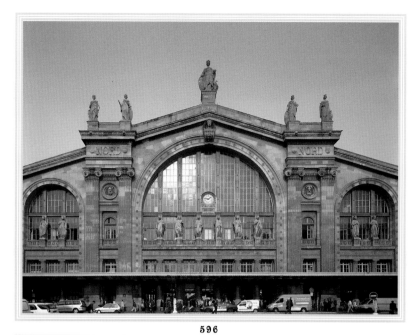

596

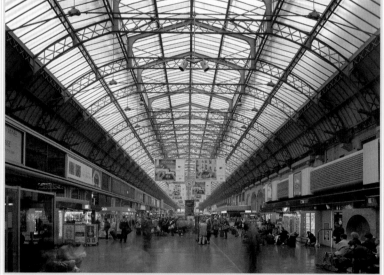

597

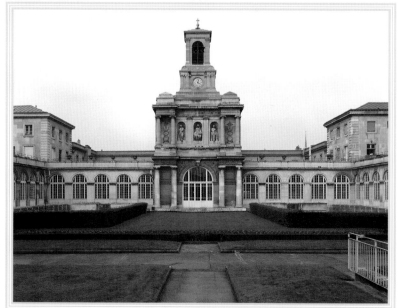

598

596

Gare du Nord

8, RUE DE DUNKERQUE BETWEEN RUE DU FAUBOURG-SAINT-DENIS
AND RUE DE MAUBEUGE

1861–66, JACQUES-IGNACE HIFFORFF; 1993–98, JEAN-MARIE
DUTHILLEUL AND JEAN-MICHEL WILMOTTE, EUROSTAR WAITING LOUNGE

The early nineteenth century brought to the 10th arrondissement a wave of industrial development, which in turn necessitated expanded railroad facilities. In 1864, Gare du Nord became the gateway to and from the north. Its impressive, triple-arched stone façade, with double Ionic pillars, is adorned with sculpted statues of nine European cities and twelve French destinations.

597

Gare de l'Est

PLACE DU 11-NOVEMBRE-1918 AT RUE DU 8-MAI-1945

1847–52, FRANÇOIS-ALEXANDRE DUQUESNEY;
1924–31, BERTAUT, (ENGINEER), ADDITION

This station received such an onslaught of travelers and industrial workers that it was enlarged several times between 1877 and 1931. Ironically, this increased space gave it the ability to send a hundred thousand French to their death during World War I; and to deport Jews east to concentration camps during World War II. In that latter regard, Gare de l'Est was a prime center for deportation because it connected with the Drancy and Bobigny stations.

598

Hôpital Lariboisière

2, RUE AMBROISE-PARÉ AT BOULEVARD DE MAGENTA,
BETWEEN RUE GUY PATIN AND RUE DE MAUBEUGE

1846–53, PIERRE GAUTHIER

Constructed in the mid–nineteenth century as part of an effort to create more sanitary conditions in the city, this huge hospital stands at the northwestern edge of the 10th arrondissement, where it services cross-cultural communities. Six pavilions surround a huge central courtyard connected by arched galleries around the border. Inside rests a funerary memorial sculpted by Charles de Marochetti, of the comtesse de Lariboisière, for whom the hospital is named.

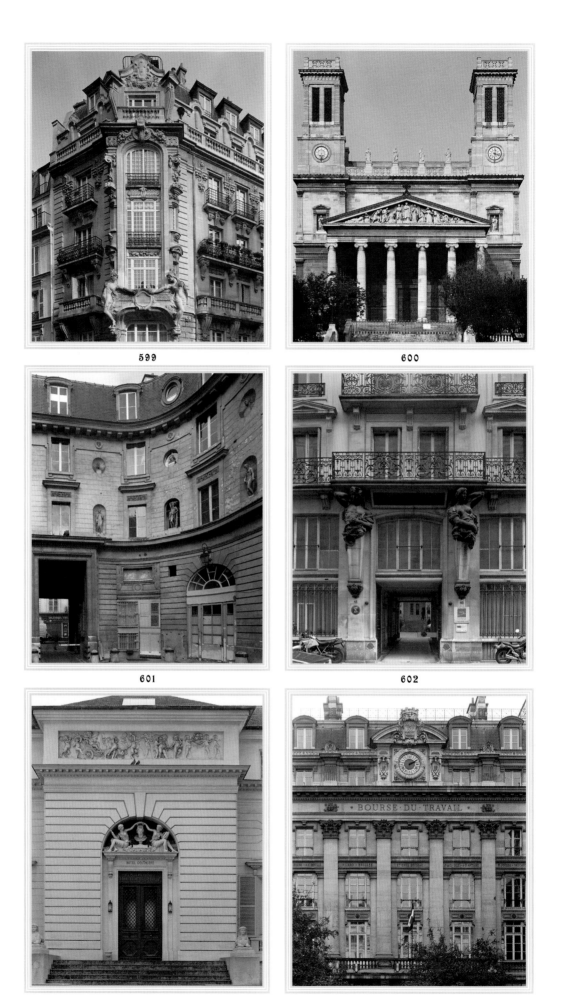

599

600

601

602

603

604

599

16, rue d'Abbeville

AT RUE DU FAUBOURG POISSONNIERE

1899, GEORGES MASSA, ARCHITECT; AND ALEXANDRE DUPUY, SCULPTOR

Two ornate, sculpted groups of scantily draped women adorn this façade and jut out over the street. This exuberance of Art Nouveau style was created during the period when rue d'Abbeville was extended to the rue du Faubourg Poissonnière five years earlier. It is similar to the adjacent Number 14, constructed in metal with almost identical decoration. Both express the liberation of the architects of the time.

600

Eglise Saint-Vincent-de-Paul

PLACE FRANZ LISZT BETWEEN RUE FÉNELON AND RUE BOSSUET

1824–31, JEAN-BAPTISTE LEPÈRE; 1831–44, JACQUES-IGNACE HITTORFF; 1861, POLYCHROMATIC DECORATION REMOVED

Commemorating the life of Saint-Vincent-de-Paul, who dedicated himself to the impoverished during the seventeenth century, this odd-looking nineteenth-century church appears neoclassical in its basilica layout and entry façade, yet its boxy side towers evoke a touch of Gothic style, perhaps a precursor to the neo-Gothic revival a few decades hence. From its elevated steps, the church maintains a panoramic view over place Franz Liszt.

601

Hôtel Titon

58, RUE DU FAUBOURG-POISSONNIÈRE
AT RUE DE PARADIS AND CITÉ DU PARADISE

1776–83, JEAN-CHARLES DELAFOSSE;
1814–15, ADDITION ON THE GARDEN SIDE; C. 1870–80, ADDITION
OF ONE STORY AND STREET FAÇADE TRANSFORMED

Though the owner of this hotel lost his head during the Revolution, Hôtel Titon retained the name of its former proprietor, if not its original glory. This stone mansion's original court façade features grooved rustications on the lower level and statues of deities in alcoves on the second story. The site is now part of a real estate housing development.

602

48, rue des Petites-Ecuries

AT RUE DE FAUBOURG-POISSONNIÈRE

c.1860

A travel agency now occupies this former mansion, which originally combined a workshop on the ground level and first floor, with a bourgeois apartment on the second story. Dark Art Nouveau sculptures of Atlas flank the entrance and support a wrought-iron balcony that identifies the apartment. The symmetrical composition of the façade creates a triangle that makes the building appear taller than it is.

603

Hôtel Gouthière

6, RUE PIERRE-BULLET
BETWEEN RUE DU CHÂTEAU D'EAU AND CITÉ HITTORFF

1772–80, JOSEPH MÉTIVIER

This severe, neoclassic, eighteenth-century mansion belonged to a goldsmith named Gouthière. Unfortunately, Madame du Barry, last mistress to Louis XV, owed him a sizeable debt that she reneged on, leaving him unable to pay for this *hôtel* he had commissioned. After the Revolution, du Barry's estate became the property of the State, and Gouthière sued; but subsequent attempts to recover the debt through the courts were unsuccessful.

604

Bourse du Travail

3, RUE DU CHÂTEAU D'EAU AT BOULEVARD DE MAGENTA

1888–96, JOSEPH-ANTOINE BOUVARD

Inspired by Louis Quarante style, this institutional building has a grooved, rusticated, triple entry façade topped by a balcony. The second level of Corinthian pilasters is surmounted by a small clock pediment. The building today houses the center for trade unions.

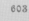

605

Hôtel Benoît de Sainte-Paule

30, RUE DU FAUBOURG-POISSONNIÈRE AT RUE SAINTE-CÉCILE

1773, SAMSON-NICOLAS LENOIR (AKA LENOIR LE ROMAN),
MAIN BUILDING; 1778, ANTOINE-FRANÇOIS PEYRE
(AKA PEYRE THE YOUNGER), WING EXTENTIONS

Owned since 1946 by Air France, this eigh-teenth-century mansion, the largest surviving *hôtel* on rue du Faubourg-Poissonnière, is now subdivided into apartments. Two Doric columns, supporting a simple pediment, flank the portal on the stone façade. The main build-ing, at the rear of the property, features an imposing portico supported by four Ionic columns and side wings.

606

Hôtel Botterel-Quintin

44, RUE DES PETITES-ECURIES (REAR OF COURT)
AT RUE DU FAUBOURG-SAINT-DENIS

1782, FRANÇOIS-VICTOR PÉRARD DE MONTREUIL

Charles-André de La Corée commissioned this house in 1782, then sold it three years later to Count Botterel-Quintin. Originally constructed with two stories, the residence now has a street façade with three additional levels. These addi-tions hide a forecourt that still retains the façade of the two initial stone stories. The interior décor includes the mansion's original oval din-ing room from the late eighteenth century.

607

Porte Saint-Denis

BOULEVARD SAINT-DENIS AND RUE DU FAUBOURG-SAINT-DENIS
AT RUE SAINT-DENIS

1672, FRANÇOIS BLONDEL

Looming at the crossroads of the Grands Boulevards, this monumental arch celebrated Louis XIV's triumph in the Rhine campaigns. François Girardon sculpted two allegories above the central arch: *The Capture of Maastricht* on the north side, and *The Crossing of the Rhine* on the south side.

608

19, boulevard de Strasbourg

1, RUE DE METZ

C.1900, CHARLES LEFEBRE (ARCHITECT),
GENTIL AND BOURDET (CERAMISTS)

A branch of the BNP Paribas Bank occupies these late Art Nouveau premises. Covered by a colorful pattern in enamel, this concrete struc-ture has Doric pilasters at its entrance. A grooved construction wraps around the lower level, grounding the bank with elegance and stature. Above, several extended bay windows and carved balconies heighten the building, giv-ing it lift and character.

609

Porte Saint-Martin

RUE DU FAUBOURG-SAINT-MARTIN AND BOULEVARD SAINT-MARTIN
AT RUE SAINT-MARTIN

1674, PIERRE BULLET

Built to honor the Sun King, Louis XIV, this triple triumphal arch commemorates victorious battle campaigns. The reliefs that flank the cen-tral arch along its south side are: *The Capture of Besançon*, sculpted by Martin Desjardins, on the right, and *The Breaking of the Triple Alliance*, by Etienne Le Hongre (left). Those on the north side of the arch represent *The Defeat of the Ger-man Armies*, by Gaspard Marsy (right), and *The Taking of Limburg*, by Pierre Legros (left).

610

Musée des Cristalleries de Baccarat
(CENTRE INTERNATIONAL DES ARTS DE LA TABLE)

30 BIS, RUE DU PARADIS AT RUE D'HAUTEVILLE

1979 JEAN-PAUL KOZLOWSKI, FRANCIS SACCOUN

Once, horse-drawn carriages stopped along Rue du Paradis on their way from the country. As the areas of Lorraine, Alsace, and the north of France developed earthenware, porcelain, glass, and crystal factories, Rue du Paradis evolved as a showcase for "Arts of the Table." Baccarat, world renowned for its crystal, established a presence here in 1831. The modern addition is placed behind the old façades of two famous stores, Cristalleries Saint-Louis and Maison Baccarat.

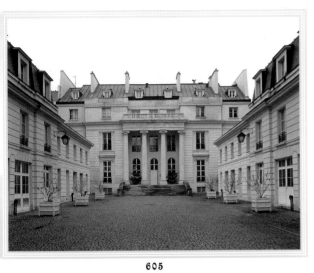

605

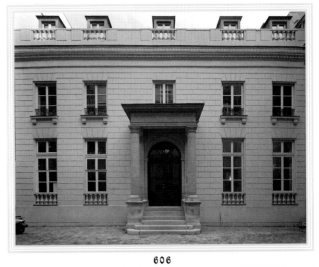

606

607

608

609

610

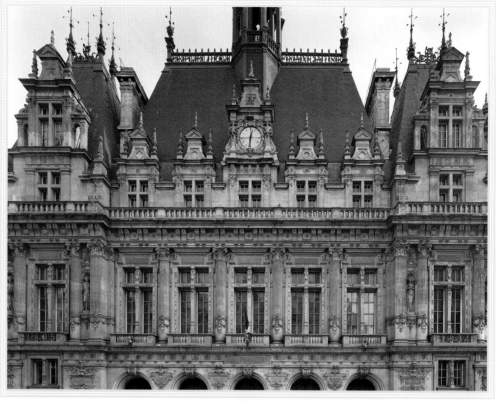

611

Mairie

72–74, RUE DU FAUBOURG-SAINT-MARTIN
AT RUE DU CHÂTEAU D'EAU

1892–96, EUGÈNE ROUYER

Demonstrating pretentious attention to ornament, architect Eugène Rouyer designed this late–nineteenth-century town hall with carving on the façade from the ground level to the roof. Having lost in the competition to renovate the Hôtel de Ville, Rouyer recreated a reasonable facsimile for this, one of the more remarkable town halls in Paris. This one is a perfect illustration of neo-Gothic architecture, with a high roof and peaked chimney that stretches toward the sky.

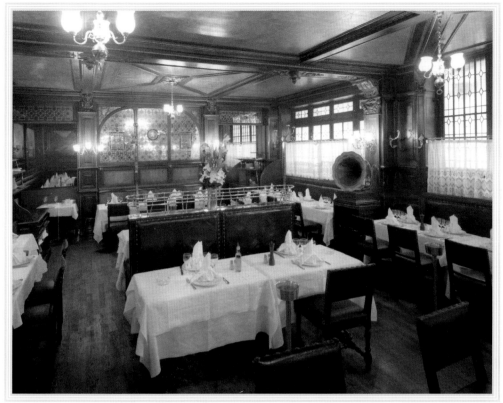

612

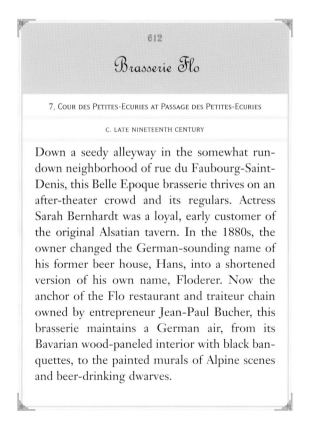

Brasserie Flo

7, COUR DES PETITES-ECURIES AT PASSAGE DES PETITES-ECURIES

C. LATE NINETEENTH CENTURY

Down a seedy alleyway in the somewhat run-down neighborhood of rue du Faubourg-Saint-Denis, this Belle Epoque brasserie thrives on an after-theater crowd and its regulars. Actress Sarah Bernhardt was a loyal, early customer of the original Alsatian tavern. In the 1880s, the owner changed the German-sounding name of his former beer house, Hans, into a shortened version of his own name, Floderer. Now the anchor of the Flo restaurant and traiteur chain owned by entrepreneur Jean-Paul Bucher, this brasserie maintains a German air, from its Bavarian wood-paneled interior with black banquettes, to the painted murals of Alpine scenes and beer-drinking dwarves.

613

614

615

616

613

Smallest House in Paris

39, RUE DU CHÂTEAU D'EAU AT RUE DU FAUBOURG-SAINT-MARTIN

C. BEGINNING OF THE NINETEENTH CENTURY

A family argument led to the construction of this tiny, two-story house, wedged into a space that previously provided a walkway between rues du Château d'Eau and du Faubourg-Saint-Denis. Heirs to this alley could not settle their dispute and so the owner blocked access to the property by building there. Looking more like a makeshift playhouse than a real home, it nonetheless contains a ground-floor workshop and a room on the second level. Two tall buildings on either side dwarf the little structure that measures just under 4 feet wide x 16.5 feet high.

614

Passage Brady/Passage du Marché

46, RUE FAUBOURG-SAINT-DENIS
AT 62/20, RUE FAUBOURG-SAINT-MARTIN

1827–28, CONSTRUCTION; 1854, DESTRUCTION OF THE ROTUNDA

Passage Brady extends from rue Faubourg-Saint-Denis across boulevard de Strasbourg and continues to rue Faubourg-Saint-Martin. Inside, you'll find a bazaar-like atmosphere of the subcontinent: Indian spices permeate the air, and silk fabric, beaded baubles, and inexpensive trinkets fill the shelves of the shops here, as well as the surrounding neighborhood and Passage du Marché, diagonally across the street.

615

Théâtre Antoine Simone Berriau

14, BOULEVARD DE STRASBOURG AT RUE GOUBLIER

1880–81, MARCEL DESLIGNIERES

Known for its colorful façade, this theater shows traces of Art Nouveau styling in polychromic patterns above the marquee. A modern canopy expresses the entrance, above which are stained glass windows of the foyer and stone balconies crowned by blue-glazed brick with red terracotta. Originally called Comédie-Parisienne, the theater is double-named for theater innovator André Antoine and for actress, singer, and producer Simone Berriau, who was active in theater in the mid–twentieth century.

616

Ecole de Filles

34, RUE FAUBOURG-SAINT-DENIS AT 6, RUE DE METZ

1910, CLÉMENT, CONSTRUCTION; 1914, RESTRUCTURATION

A public elementary school administered by the Mairie of the 10th arrondissment, this brick-and-stone-trimmed complex looks innocuous today—a lovely compound for elementary children to romp around in. But, between 1942 and 1944, Jewish children were deported from here to concentration camps. A sculpture on the inner court, seen from the rue de Metz side, stands in memory of them.

617

617

Conseil de Prud'hommes de Paris

27, RUE LOUIS BLANC AT QUAI DE VALMY

1990, JACQUES-HENRI BAJU

In a deliberate effort to create a building with a duality of purpose, architect Baju developed a breakaway design for the tribunal that resolves professional disputes. His use of gray-blue marble and a base of green granite gives the building grounding and represents the institution's durability. In contrast with these solid materials, a huge glass façade slants to the sky, emphasizing the building's monumental status while suggesting openness to the public. Behind the reflective glass shield, each department of this judiciary bureau works independently, and has its own balcony with visibility to the street. Playing with the spatial relationships of angles and planes, Baju designed a building that suggests justice will be meted out with expansive vision.

618

618

Foyer de Personnes Âgées et École Maternelle

126, QUAI DE JEMMAPES AT RUE DE L'HÔPITAL SAINT-LOUIS

1985, MICHEL DUPLAY

Composed of glass, concrete, pink brick, and gray-blue zinc, this building contains both an old-age home and an elementary school. Architect Duplay attempted to create a monumental building in proportion to the surrounding canal by putting a contemporary twist on traditional Haussman architecture. But many of the canal buildings were constructed before Haussman, and Duplay's design doesn't resemble these buildings despite his intentions. Reinterpreting the conventional bay windows typical of nineteenth-century Paris, Duplay developed studio apartments on one side, for the elderly; and glass houses on a another, to be used as classrooms. The massive building is a repetitive structure that resembles a church from the front. Fortunately, the canal setting gives the residents and students a lovely view to the outside.

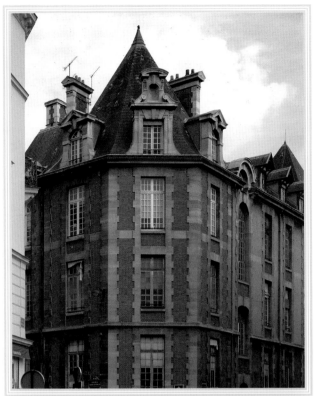

619

619

Hôpital Saint-Louis

40, RUE BICHAT BETWEEN RUE DE LA GRANGE AUX BELLES,
RUE JULIETTE DODU, RUE ALIBERT, AND AVENUE CLAUDE VELLEFAUX

1607–11, CLAUDE VELLEFAUX (PROBABLY FROM CLAUDE CHASTILLON DESIGN)

When outbreaks of the plague threatened the city in the early seventeenth century and over-whelmed the general hospital, contaminating its other patients, Henry IV wanted to quarantine those who were infected. So he ordered the con-struction of another hospital away from the cen-ter of the city, to demonstrate his command over the epidemic. Contained within a square court and enclosed by a wall with four corner pavilions, the brick and stone cloister-like con-struction was intended to keep personnel in and to thus confine the contagion, isolating illness pavilion by pavilion.

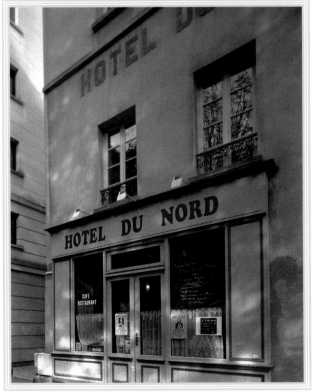

620

620

Hôtel du Nord

102, QUAI DE JEMMAPES AT RUE DE BICHAT

C.1825 ARCHITECT?

A film, a studio construct, a book, a façade—will the real Hôtel du Nord check in? For the "atmosphere, atmosphere" that actress Arletty craved in the 1938 Marcel Carné film, *Hôtel du Nord*, you might stroll along the nearby Saint-Martin canal instead—the only real-life area outside the studio where filming took place. Inspired by a collection of short stories published in 1929 by Eugène Dabit, the hotel-owner's son, Carné immortalized Hôtel du Nord on celluloid. But for most of the footage, he had the film's set designer recreate the hotel environment at the Boulogne-Billancourt studios west of Paris. In 1984, an association headed by Arletty rescued Paris's most famous budget hotel from demolition. Ironically, they were only able to save the façade, which now looks like a film set.

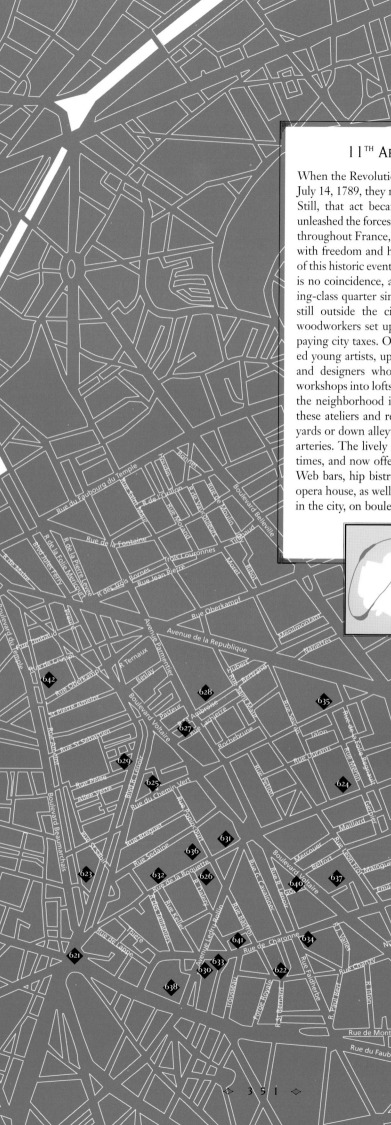

11TH ARRONDISSEMENT

When the Revolutionaries stormed the Bastille on July 14, 1789, they released a mere seven prisoners. Still, that act became the symbolic gesture that unleashed the forces of democracy and swept reform throughout France, forever associating the Bastille with freedom and human rights. The significance of this historic event in the eleventh arrondissement is no coincidence, as the area has been the working-class quarter since medieval days, when it was still outside the city walls. Cabinetmakers and woodworkers set up shops here in order to avoid paying city taxes. Over the years, this area attracted young artists, up-and-coming high-tech gurus, and designers who converted former carpentry workshops into lofts, studios, and galleries, turning the neighborhood into a Parisian Soho. Many of these ateliers and residences are hidden in courtyards or down alleyways just off the bustling main arteries. The lively district has kept pace with the times, and now offers trendy boutiques, wine and Web bars, hip bistros, voguish restaurants, a new opera house, as well as the largest open-air market in the city, on boulevard Richard Lenoir.

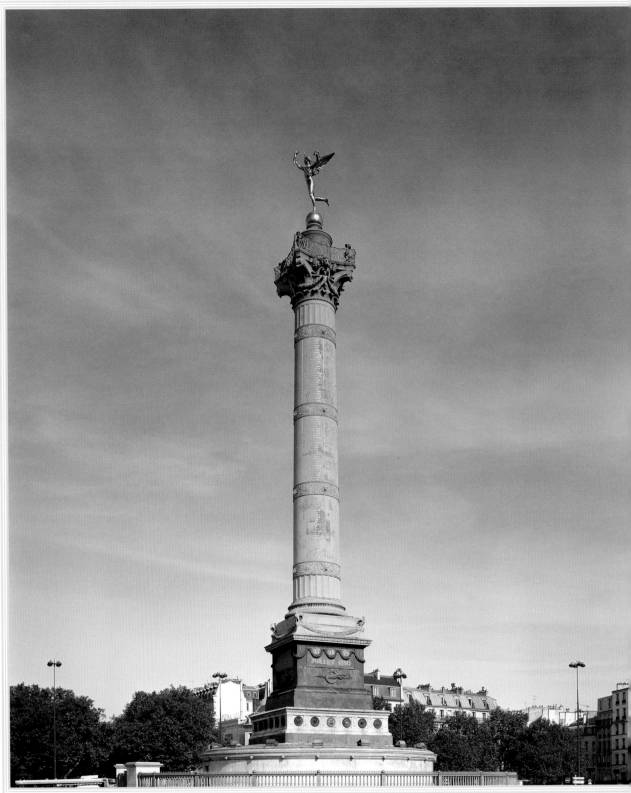

621

622

Colonne de Juillet
(JULY COLUMN)

PLACE DE LA BASTILLE
BOUNDARY OF FOURTH, ELEVENTH, AND TWELFTH ARRONDISSEMENTS

1831–40

Working-class discontent reached its peak on July 14, 1789, when Revolutionaries stormed the Bastille, liberated seven prisoners, and demolished the fortress. Earlier worker riots in the spring had caused disruptions, but liberating the Bastille was a major victory. Long a symbol of oppression, the stronghold occupied the site of the current place de la Bastille. Charles V built the fortification there between 1370 and 1372 as a defense for both the city and his residence at Hôtel Saint-Pol; in the fifteenth century, Louis XI transformed the fort into a prison. The destruction of the Bastille symbolized an end to the monarchy and the overreaching power of the church. Topped by the dainty, golden-winged "Spirit of Liberty," a graceful Colonne de Juillet (July Column) now stands at the center of place de la Bastille as a reminder of those heady days of freedom.

Église Sainte-Marguerite

36, RUE SAINT-BERNARD AT RUE CHARLES DELESCLUZE

1627, FIRST CHURCH; C. FIRST HALF OF THE SEVENTEENTH CENTURY, NAVE; 1760–65, VICTOR LOUIS, CHAPEL

The mystery of a child's corpse, buried here, has never been solved. Some say the remains belonged to the Dauphin, who supposedly died at the age of ten in the prison of the Temple during the Revolutionary turmoil of 1785. At that time, an unheralded funeral procession indeed deposited a young body and decapitated head into a common plot in the church graveyard. But, a hundred years later, forensic scientists claimed that the remains were those of an eighteen-year-old, not a ten-year-old. In 1980, when the church resolved to unravel the mystery, the remains had vanished. Later, those uncovered around the Temple tower were believed to be the Dauphin's. Although the case has yet to close conclusively, a garden has replaced the church's graveyard, and a tomb is still there, identified by inscription to contain the body of the Dauphin.

623

624

625

626

627

628

623
Le Lèche-Vin

13, RUE DAVAL
BETWEEN BOULEVARD RICHARD LENOIR AND RUE SAINT-SABIN

C. 1750, BUILDING WITH ADDITIONS

Though the literal translation is "lick wine," regulars call it the "Jesus Bar." An irreverent trip under the watchful yet tearful eye of the Holy Mother and a few Hassidic rabbi photos—just to be sure—this watering hole and kitsch shrine to the Virgin Mary and Jesus makes you wonder about the salvation of your soul. But, after you've knocked back a few great, cheap drinks, you'll reap earthly rewards in this bohemian, Bastille institution.

624
Logements Sociaux

3–11, RUE MERLIN AT RUE DE LA ROQUETTE

1980, JACQUES KALISZ AND JEAN-CLAUDE BERNARD

This apartment building was erected on the site of the old Petite Roquette prison. Architects Kalisz and Bernard deliberately planned the building around the park to take advantage of the setting. They divided the building into small units in a U-shape; and offer open areas of greenery, with several designated, small play-spaces for children. The building's features include façades that have cascading terraces—some covered, others left open facing the park.

625
57-59, boulevard Richard-Lenoir

BETWEEN ALLÉE VERTE AND PASSAGE SAINTE-ANNE POPINCOURT

C. 1808

When Baron Haussmann guided urban redevelopment toward modernization, his city planning and street restructuring did away with many narrow medieval roads. His broadened boulevards, such as this one, enhanced the appearance of Paris, but he had strategic reasons as well—creating thoroughfares to permit the quick arrival of troops to quell potential urban disturbances. This mansion is an unexpected example of neoclassicism.

626
Synagogue Don Isaac Abravanel

84–86 RUE DE LA ROQUETTE AT PASSAGE CHARLES DALLERY

1966, ARTHUR HEAUME AND ALEXANDRE PERSITZ

For the frontage of this Sephardic synagogue, the architects constructed a grid of pre-cast concrete set back from the street and positioned between two side walls also of concrete. The grid patterning, placed in front of a glass surface, takes its design from the repetitive element of the Star of David, which creates a complex play of geometrical figures. The screen effect inside suggests the shape of an accordion, and a platform on masts symbolizes the tent that sheltered the Ark with the Ten Commandments.

627
Eglise Saint-Ambroise

71 BIS, BOULEVARD VOLTAIRE
BETWEEN RUE SAINT-AMBROISE AND RUE LACHARRIÈRE

1865–75, THÉODORE BALLU

Inspired by Romanesque and Gothic models, architect Ballu combined those two styles in his design for Saint-Ambroise church. Tall, twin, squared-and-spired turrets anchor a central, Gothic entrance whose three arches support a balustrade. The gabled nave—vaulted by diagonal ribbing for more light, and pierced by a rose window—juts out above the entrance giving the church balanced proportion.

628
Ecole Supérieure de Gestion and flats

25, RUE SAINT-AMBROISE AT PASSAGE SAINT-AMBROISE

1965, LOUIS MIQUEL

Using concrete as a framework, Louis Miquel developed a project echoing the "Cité radieuse" of his mentor, Le Corbusier, albeit on a reduced scale. When the ground floor was designated as an exhibition hall, however, Miquel modified his plan, and functionality took over the design: He created a glass façade for the ground floor exhibition space, blinds to cover the upper offices, and balconies for the flats above. Currently, the Paris Graduate School of Management occupies the first three levels of the former exhibition hall.

629
Foyer pour Personnes Âgées
(OLD-AGE HOME)

61, BOULEVARD RICHARD-LENOIR BETWEEN ALLÉE VERTE AND RUE PELEE

1984, BERNARD BOURGADE AND MICHEL LONDINSKY

This stylish building plays with simple shapes in three dimensions, to create a classical but totally modern look. The individual proportions and the building's overall volume marry well in façades unique to each street front. Incorporated into the design is a circular pediment from a former construction here. Overall, the pieces fit so well together that the architects made building this commercial space look like child's play.

630
Le Bistrot du Peintre

116, AVENUE LEDRU-ROLLIN AT RUE DE CHARONNE

1902, JULES GALOPIN, BUILDING

Previously named Le Carrefour, then La Pallet Bastille, the bistro acquired its current name in 1997, and serves typical French fare such as pot-au-feu and onion soup. A wooden framework varnished with Art Nouveau arabesques opens to a well-appointed interior whose ambience evokes that of its turn-of-the-century past: richly carved wood, painted scenes of vineyards, a long zinc bar, tall mirrors, and glass partitions. The building itself was constructed in 1902.

631
130, rue de la Roquette

AT BOULEVARD VOLTAIRE

1861, BROUILHONY

Inspired by Henri Quatorze and Louis Treize styles, architect Brouilhony juxtaposed three buildings to create this symmetrical corner edifice which features six stories in stone with brick detailing and wrought-iron balconies. Characterized by Second Empire decoration, the façade is adorned with carved garlands of fruit and consoles with lion heads. On the third level, caryatids uphold the ornamental balcony; and, at the entry, a semicircular stone pediment with a lion mane and paws crowns the carved-wood door.

632
Eglise Notre-Dame-de-Bonne-Espérance

47, RUE DE LA ROQUETTE AT RUE DU COMMANDANT LAMY

1998, BRUNO LEGRAND

This monumental church presents a hierarchy in its façades. The main entrance plays with both traditional symbols and modernism on the side facing the rue de la Roquette. Alluding to Roman and Gothic influences in Parisian churches, two towers frame this façade. At the entrance a glass wall catches the light, and the window frames create a rhythm that fits with this popular neighborhood. The absence of decoration, except for the blue stone that covers the building, gives the church a commonplace ambience.

633
Boca Chica

58, RUE DE CHARONNE
BETWEEN AVENUE LEDRU ROLLIN AND PASSAGE DE LA MAIN D'OR

C. FIRST HALF OF THE NINETEENTH CENTURY, BUILDING

Latin music, sangria, a crimson interior, and an intimate front patio give this tapas bar its zing. Cordial and festive, it sports three rooms on two floors, plus a covered and heated courtyard. The ground floor is a favorite gathering place for backgammon and chess aficionados. But if you don't play, you can head down to the enormous zinc bar in the lower level, where the décor takes on acid tones of yellow, orange and purple. Not far from the Bastille, it's a neighborhood hot spot with an exotic flare.

634
Palais de la Femme

94, RUE DE CHARONNE AT RUE RICHARD LENOIR AND RUE FAIDHERBE

1910, AUGUSTE LABUSSIÈRE AND C. LONGEREY

Formerly a shelter for single men, this experiment in cheap housing was an attempt to keep its residents safe and sober. The architects constructed the façade's recesses and extensions with the deliberate intention of allowing maximum sunshine and air flow for its occupants. The linear proportions seem to move the building forward in a modern way. Since 1925, the structure has become a "palace for women," euphemistically speaking: Run by the Salvation Army, it is now a women's shelter.

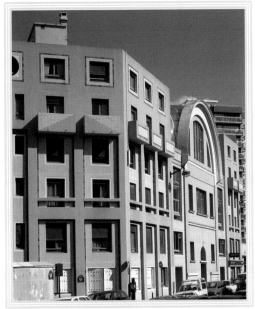

629

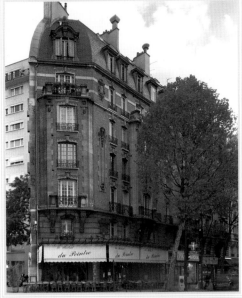

630

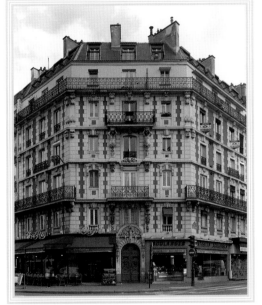

631

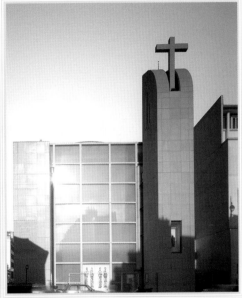

632

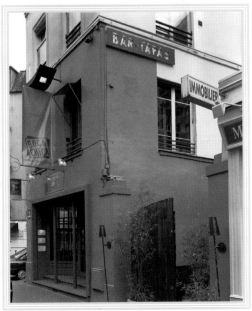

633

634

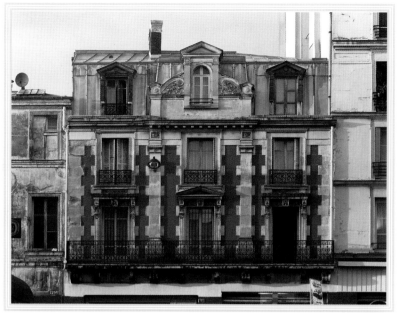

635

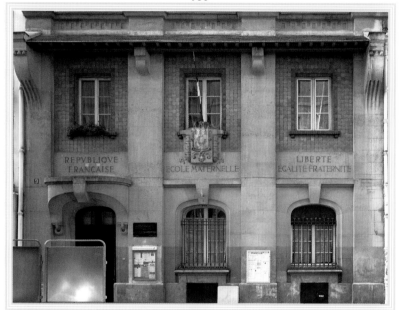

636

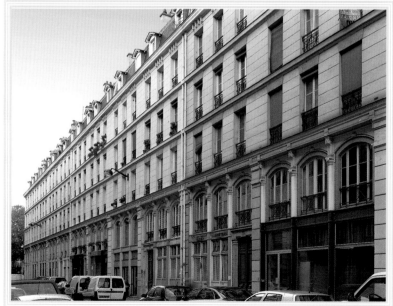

637

129, rue du Chemin Vert

AT RUE MERLIN

c. 1880

In the second half of the nineteenth century, architectural inspiration borrowed from many styles. This small building shows neo–Louis Treize influences, mixes brick and stone, and resembles a seventeenth-century Dutch hotel from a time when Holland was in vogue. With the construction of Place des Vosges nearby, those colored façades, normally unusual in Paris, became popular.

Ecole Maternelle

9, RUE POPINCOURT BETWEEN RUE DE LA ROQUETTE AND RUE SEDAINE

c.1900

This primary school was one of about three hundred built between the mid-nineteenth century and WWI. From the courtyard behind the building, the façade appears small for a school. Nevertheless, the frontage is quite respectable with its monumental pilasters framing the bays. Two stories are crowned by a balustrade that hides the roof and, in the spirit of French education, the symbol of Paris adorns the middle of the façade that features the French flag.

Rue des Immeubles-Industriels

At boulevard Voltaire

1873, Emile Leménil

Emile Leménil built the new industrial buildings of the Faubourg Saint-Antoine on this street in 1873. He wanted to integrate family life with small industry by creating buildings in the city that didn't look like factories. So he designed apartments and studios with steam machines in the basement that provided power to the 230 workshops upstairs. The brick is covered by cement to replicate stone, which gives the façades a richer appearance, and the cast iron piers at ground level bring a rhythm to the street.

638

Cour de l'Etoile-d'Or

Imagine, if you will, a time in the not-too-distant past…and a place where there were country roads and the hum of carpentry workshops instead of rushing cars and congested streets, a place where the digital world did not exist and you measured the hours of the day by the length of shadows. Go ahead, push back the heavy wood door at 75, rue du Faubourg-Saint-Antoine and step into this world. As you venture down a long cobblestone alley, you may not hear the clip-clop of horses' hooves, but birds sing, insects chirp, and an occasional cat slinks by. The passageway leads to open sky, garden walls overflowing with ivy, and country cottages. Etched on the far wall is a 1751 sundial. And you've just entered the Faubourg— the outskirts of Paris, a working-class area so named because it had been countryside—a "false burg" —outside the city proper.

Cour de l'Etoile-d'Or, one of the many hidden pockets off of rue du Faubourg-Saint-Antoine, was once known for its woodworking ateliers, and the houses here date from the mid-seventeenth century. In the past, if you wandered into the Faubourg, you would see craftsmen tapping, sanding, and gluing amid piled-up sawdust and armchairs hung drying in the open air. Having deteriorated into slums over the years, many of these workshops are being renovated by owners who have uncovered their original wood beams and ancient cellars. It's not the Twilight Zone, but "l'Etoile d'Or," which means "golden star," is still a kind of never-never land—a country treasure in the midst of a world rushing by.

639

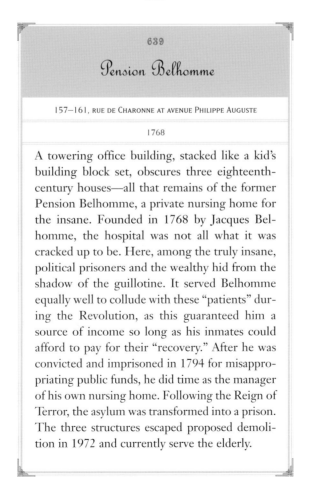

639

Pension Belhomme

157–161, rue de Charonne at avenue Philippe Auguste

1768

A towering office building, stacked like a kid's building block set, obscures three eighteenth-century houses—all that remains of the former Pension Belhomme, a private nursing home for the insane. Founded in 1768 by Jacques Belhomme, the hospital was not all what it was cracked up to be. Here, among the truly insane, political prisoners and the wealthy hid from the shadow of the guillotine. It served Belhomme equally well to collude with these "patients" during the Revolution, as this guaranteed him a source of income so long as his inmates could afford to pay for their "recovery." After he was convicted and imprisoned in 1794 for misappropriating public funds, he did time as the manager of his own nursing home. Following the Reign of Terror, the asylum was transformed into a prison. The three structures escaped proposed demolition in 1972 and currently serve the elderly.

640

641

640

Gymnase

2, RUE FRANÇOIS DE NEUFCHÂTEAU

1870, FIRST CONSTRUCTION OF MARKET;
1883, TRANSFORMED TO A GYM

Currently a municipal gymnasium, during Haussmann's era this building was a local market, a centralized point around which this district's life revolved. During the Nazi Occupation, it served as a holding station for the deportation of Jews. More recently, in 1996, African immigrants occupied the building and the nearby Saint-Ambroise church to protest administrative laws that concerned immigration status. Today, it serves the local community and, on occasion, is used as a venue for French boxing competitions.

641

51–53, rue de Charonne

AT PASSAGE CHARLES-DALLERY

C. 1960-1970

Smoky-colored balconies protrude from this façade as if a child had locked them in place while building with a snap-together toy kit. Indeed, they give the highrise the appearance of a three-dimensional assemblage created for a basic design class. Nonetheless, the contrasting balconies and the dark squares on the light-colored façade create a somewhat harmonious woven pattern. This boxy, modern construction partially obscures the façade of a mid-seventeenth-century mansion referred to as Hôtel de Mortagne, named for its 1711 owner. Hôtel de Mortagne can be viewed around the corner at the angle of passage Charles Dallery.

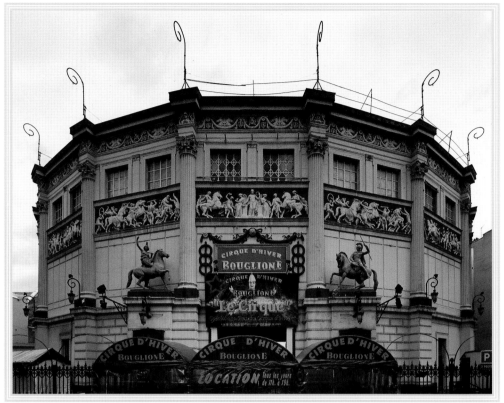

642

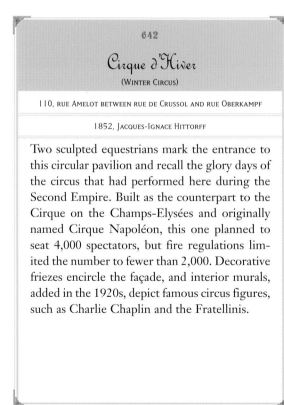

642

Cirque d'Hiver
(Winter Circus)

110, rue Amelot between rue de Crussol and rue Oberkampf

1852, Jacques-Ignace Hittorff

Two sculpted equestrians mark the entrance to this circular pavilion and recall the glory days of the circus that had performed here during the Second Empire. Built as the counterpart to the Cirque on the Champs-Elysées and originally named Cirque Napoléon, this one planned to seat 4,000 spectators, but fire regulations limited the number to fewer than 2,000. Decorative friezes encircle the façade, and interior murals, added in the 1920s, depict famous circus figures, such as Charlie Chaplin and the Fratellinis.

12TH ARRONDISSEMENT

The 12th arrondissement shares its northern border with the 11th at rue du Faubourg-Saint-Antoine— the old route of workers' protest marches from the Bastille to Place de la Nation. As such, this area extends the trendy neighborhood of bars, boutiques, and restaurants from the Opéra Bastille to the renovated Viaduc des Arts, which features an elevated garden promenade called La Coulée Verte, and stunning brick and stone arches. But as this arrondissement borders the Bois de Vincennes on its eastern edge, it also incorporates middle-class residences, the charming Aligre Marché, and an unfortunate slew of high-rise apartments from the 1960s, when they were constructed in a misguided attempt to architecturally modernize the city. The more recent renovation of Bercy, a quarter that was formerly a nineteenth-century wine depot, started with its sports arena, Palais Omnisports de Paris-Bercy, and includes the Ministry of Finance and the Parc de Bercy. This redevelopment, initiated in the 1980s, has begun to energize the diverse neighborhood of the 12th arrondissement.

643

Opéra de la Bastille

26, PLACE DE LA BASTILLE

1989, CARLOS OTT

As a world-famous symbol of class struggle and freedom, the place de la Bastille has seen a variety of buildings since Revolutionaries stormed and overthrew the monarchy in 1789. In keeping with its historical location, the Opéra de la Bastille was intended as *un opéra populaire*, a people's opera, welcoming the general public, not just the elite. Thus, architect Ott designed a functional building in which to introduce opera to an audience unfamiliar with this art form. Accordingly, he chose to deemphasize any grandiosity associated with such buildings, in favor of creating a worker's atmosphere replete with shopping, entertainment, and its own metro station—essentially marrying goods and services to art. The stepped exterior façade recalls a traditional opera stairway, and the large square arch over the entry stairs embraces ceremony, while yet encouraging the informal gathering of masses on its steps. Ott also downplayed the interior, by dividing the building into functional proportions. Overall, the architect chose to go with the accessible rather than the awesome—a fitting tribute to the place that symbolized workers' desire for a democratic society. Of course, what the Parisians may think of this controversial structure is another matter entirely, as it has become just as bourgeois as any other opera house in the city.

644

645

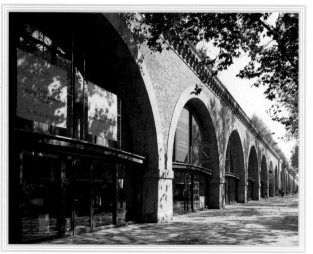

646

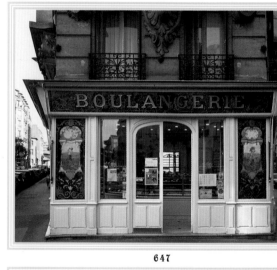

647

648

649

644
Hôpital des Quinze-Vingts

28–30 BIS, RUE DE CHARENTON AT RUE MOREAU

1699–1701, ROBERT DE COTTE, PORTAL AND CHAPEL, AND JÉRÔME BEAUSIRE, THEN TRANSFORMED MANY TIMES

The chapel and entrance portal are all that remain of the eye hospital built in the late seventeenth century on the site of the former, rural barracks of the Mousquetaires Noirs (Black Musketeers). Cardinal Rohan bought low and sold high when, as Great Chaplain of France in 1780, he purchased the barracks from the Black Musketeers for a fair price, then sold the original hospital facility near the Louvre for ten times what he had paid for this country setting.

645
Barrio Latino
(GOUFFÉ BOULEVARD)

46, RUE DU FAUBOURG-SAINT-ANTOINE AT PLACE DE LA BASTILLE

1999, RENOVATED

The thirsty, hip crowd venturing into the night on rue du Faubourg-Saint-Antoine will certainly aim to secure some of the 900 seats in this faux-Latin nightspot. Leaving its original façade intact, the owners spiced up an old industrial warehouse with a jivey jalepeño flavor. The central atrium supports three floors that contain bars, music, dancing, a pool table lounge, a spectator's balcony, and even a Che Guevara mural. As trendiness goes, the décor is decent and the lights dim.

646
52, rue de Charenton

BETWEEN AVENUE LEDRU-ROLLIN AND RUE SAINT-NICOLAS

1909, A. RAISIN

By evenly dividing the large arched windows, the tall brick pilasters create a framework for this industrial building and give the façade the appearance of symmetry. But the off-center entry subtly alters the balanced design. Decorative detailing around the arches, between the upper-level windows, and beneath the cornice enhances the building with geometric patterning.

647
Jacques Bazin

85 BIS, RUE DE CHARENTON AT RUE EMILIO CASTELAR

1906, T. LUC, DECORATION

This *boulangerie* occupies the ground floor of a lovely corner building from the turn of the twentieth century. The corner of this late-Haussmann building, composed of stone, bulges with Art Nouveau carving and wrought-iron flourishes, topped by a sensuous pediment. Like a many monumental buildings in Paris that mark street corners, this one recalls the prow of a ship proudly viewing Paris from its deck. The bakery that occupies the ground floor beckons with painted-glass panels of harvest scenes.

648
Le Viaduc des Arts

9–129, AVENUE DAUMESNIL

1855, CONSTRUCTION OF THE VIADUCT; 1994–95, PATRICK BERGER, RESTORATION; PHILIPPE MATHIEUX, PARK ABOVE

From 1855 until 1969, this viaduct carried train passengers along avenue Daumesnil to the garden of Reuilly and the Bastille. But competition from buses and the metro finally ended the service. Though the rest of Bercy fell to the bulldozers, the viaduct's beautiful arched structure and its eight-meter-high (26.3-foot) promenade were preserved. Constructed of brick and stone, its seventy-two broad arches span a length of 1,020 meters (3,346.5 feet).

649
Direction de l'Action sociale
(HEADQUARTERS OF SOCIAL ACTION)

94–96, QUAI DE LA RAPÉE AT AVENUE LEDRU ROLLIN

1991, AYMERIC ZUBLENA

Architect Zublena used the entire frontage of the building to make an abstract statement. Like giant masts on a ship, two large columns of elevators rise up from a hollowed interior square to create a visual shift in the building frontage. The right side has a fine, straight edge; the left side almost slides behind the elevator shafts, in a concave curve of glass. Within the massive façade of aluminum and stainless-steel paneling, windows become smaller with each successive level.

650

Corner of rue Van Gogh and rue de Bercy

NEXT TO GARE DE LYON

c. 1980

In the early nineteenth century, the wine trade thrived in the quai de Bercy quarter. In 1978, the City acquired the property and began redevelopment in the 1980s with the building of the Palais Omnisports de Paris-Bercy. The authorities zoned three areas for distinct use: residential property, park land, and commercial activity. This area and these buildings next to Gare de Lyon were designated a residential zone with social and cultural activities.

651

Eglise Saint-Antoine-des-Quinze-Vingt

66, AVENUE LEDRU-ROLLIN AT AVENUE DAUMESNIL

1898, JOSEPH VAUDREMER AND LUCIEN ROY

Commissioned by Abbot Rivière, this neo-Romanesque church boasts an imposing tower jutting up from a simple, two-level façade. With this church the architects linked ancient design with modern material. Its Roman style contributes to its decorative character, but the architects reinterpreted the building with concrete, brick, and metal.

652

71, avenue Ledor-Rollin

AT RUE MOREAU

1886, RENAULT

Along with rue Faubourg-Saint-Antoine, this ancient street—rue de Charenton, once known as via Carentonis—has been around since ancient times. During excavation for the site, a few oak canoes dating from c. 4500–4300 B.C. were uncovered. During the Industrial Revolution, this area was developed to maximize working ateliers with living quarters. The red brick of this façade, trimmed in white cement, creates a rhythmic and textured pattern on the building, and is inspired by the Louis Treize style.

653

Marché Beauveau

PLACE D'ALIGRE BETWEEN RUE D'ALIGRE AND RUE DE COTTE

1776–80, NICOLAS-SANSON LENOIR; 1843, MARC-GABRIEL JOLIVET, RECONSTRUCTION

This lofty, wooden-beamed structure with a two-tiered, tiled roof, traces its origins to 1643, when eight butchers set up makeshift stalls along rue du Faubourg-Saint-Antoine, in front of Abbey Saint-Antoine-des-Champs. The market grew, eventually swelling to block the abbey. In 1777, Abbess Madame Beauvau-Craon received permission from Louis XVI to have the market transferred to place d'Aligre, the site of the current covered market.

654

Caserne de Reuilly

75, BOULEVARD DIDEROT AT 26, RUE DE CHALIGNY

1885, CHARLES ROUSSI

This neoclassical fire station was the first of its kind in Paris to accommodate horse-drawn vehicles for fire equipment. Above this nineteenth century entrance sculptor Louis-Oscar Roty carved the portal keystone of a female head sporting a fire helmet surrounded by a fire hose and cords.

655

Eglise de l'Immaculée-Conception

34, RUE DU RENDEZ-VOUS AT RUE MARSOULAN

1874–75, EDOUARD DELABARRE DE BAY; 1994, INSIDE RESTORATION

Abbot Olmer commissioned the construction of this church in 1874. Influenced by Roman architectural style, its architect created an arched portal featuring a scene of the Virgin and Jesus in its tympanum, and a reproduction of a statue of the Virgin that exists in the cave of Lourdes, in the niche above. An octagonal spire with lanterns completes the upper level.

650

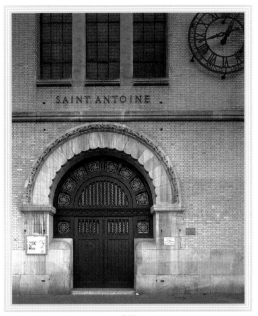

651

652

653

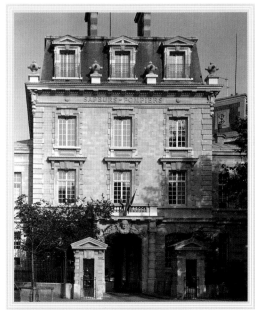

654

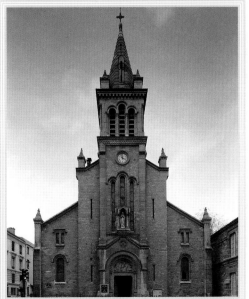

655

656

657

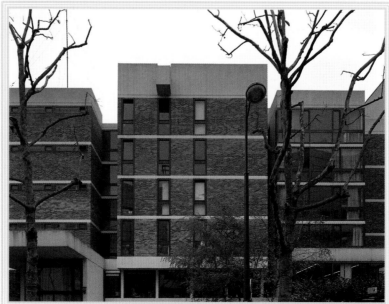

658

656

Place de la Nation
(TOLLHOUSE)

PLACE DE LA NATION

1785–87, CLAUDE-NICOLAS LEDOUX

Previously known as place du Trône, this site originally honored royalty, but its name shifted with political tides. The Barrière du Trône survives as one of four tollhouses in the Wall of the Farmers General, a tax revenue collection barrier for goods entering the city at different points.

657

Lycée Arago

4, PLACE DE LA NATION
BETWEEN BOULEVARD DIDEROT, RUE DE PICPUS AND AVENUE DORIAN

1879–80, JEAN-FERDINAND DECONCHY

Built by a student of Victor Baltard, architect of Les Halles fame, this building was meant to accommodate 500 students. Location influenced Architect Deconchy who drew his inspiration for this solid-looking school from the design of the nearby Barrières du Trône, the tollhouse structure at the place de la Nation.

658

Ecole d'Infirmières des Diaconesses
(NURSING SCHOOL)

95, RUE DE REUILLY AT RUE DU SERGENT BAUCHAT

1971, ROLAND SCHWEITZER

The diversity of this school's departments is reflected in its design. Each block, which has varied shapes and proportions, is also accentuated by an assortment of functional windows: Bay windows open up to lecture halls, vertical openings accommodate bedrooms, and strips of high, horizontal windows correspond to bathrooms. Architect Schweitzer enhanced the building's transitional space with a garden that adds a softening touch of greenery to the geometric blocks.

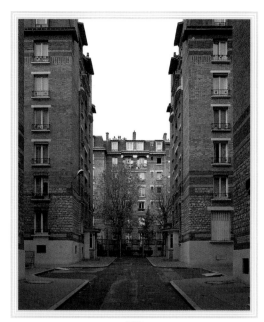

659

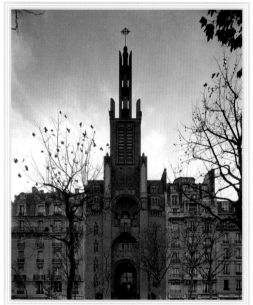

660

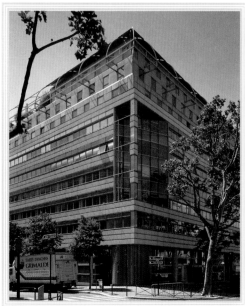

661

659
Cité HMB
(ENSEMBLE HBM)

41, RUE DE FECAMP AND 10, RUE TOURNEUX

1920–24, ALEXANDRE, MAISTRASSE, AND LÉON BESNARD

Low-cost housing complexes such as this one, though lacking in aesthetic imagination, served the populace well with hygienic facilities and airy, open courtyards. Many tenants of these quarters had heating, electricity, and running water for the first time in their life in Paris. The architects used brick—a signature of this type of housing—to structure the building's façade with different colors, and white stone to highlight the lintels of the windows and doors.

660
Eglise Saint-Esprit

186, AVENUE DAUMESNIL AT RUE DE CANNEBIÈRE

1928–35, PAUL TOURNON

To coincide with the Colonial Exposition of 1931, religious authorities decided to build a memorial church dedicated to the missionaries who pioneered colonialism. Drawing inspiration from Sainte-Sophie at Constantinople, Tournon created this church. The reinforced-concrete façade, made by François Hennebique and covered by brick, sports twelve arches for the twelve prophets and twelve apostles. The bell tower, the highest in Paris, soars eighty-five meters (279 feet) to the heavens.

661
Offices of Le Cap Levant

78, RUE DE REUILLY AT RUE HÉNARD

1991, BERTRAND BONNIER

This office building presented two challenges to its architect: The building had to conform to the neighboring nineteenth-century Hauss-mann buildings, and achieve a modern sensibility. Architect Bonnier created a strong horizontal line, accented by the balconies, which allowed a Haussmannesque uniformity, but he crowned the result with other, angled architectural details that give the building its unique character.

662

Mairie

130, AVENUE DAUMESNIL AT RUE DE CHARENTON AND RUE DESCOS

1874–77, ANTOINE-JULIEN HÉNARD

This elaborate entrance to the town hall resembles a decorative wedding cake. Its beautiful white stone mixes a variety of architectural ingredients—Gothic, Renaissance, Louis Treize, and Classic. Written on the pedestals are the names and symbols of the four quarters of the 12th arrondissement: Bel Air and Quinze-Vingts are adorned with a caduceus; ears of corn symbolize Picpus; and grapes depict Bercy's wine culture. The white stone piers are decorated with colored bricks.

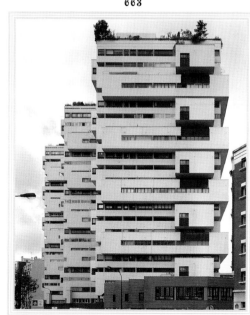

662

663

Église Saint-Éloi

3–7, PLACE MAURICE-DE-FONTENAY AT RUE DE REUILLY

1967, MAX LEBOUCHER

This modern church replaced one built in 1880 on this site. Named for Saint-Eloi, the patron saint of goldsmith and metallurgy workers, the church pays homage to him with its construction in metal. The use of this material allows for an open interior space in the vast and airy nave.

663

664

11–19, rue Érard

1969, MARIO HEYMANN, ROGER ANGER, AND PIERRE PUCCINELLI

Like stacks of interlocking Lego blocks, this apartment complex is an interconnected and dependent layering of separate buildings. Unlike other city projects, this one did not depend on integrating the new with the old. Instead, the architects razed the old and created a three-tower housing unit that consists of multiple dwellings linked together by bridges. With its interplay of recesses and balcony extensions, the buildings give the impression of individual houses piled atop each other.

664

665
Le Train Bleu

20, BOULEVARD DIDEROT/PLACE LOUIS ARMAND
IN GARE DE LYON

1899–1900, MARIUS TOUDOIRE

This celebrated restaurant made its debut at the turn of the last century, feeding the appetites of sophisticated rail passengers on the Paris-Lyon-Marseille line in the glamorous days of steam engines. The restaurant name derives from that of a rapid train that used to travel to la Côte d'Azur. Classified as a historic monument in 1972, this Belle Epoque dining hall on the mezzanine in Gare de Lyon train station still shines, with its glittering chandeliers and brass trim. If the staircase doesn't sweep you away, the interior décor whose paintings depict its namesake's southern destinations will: Marseille, Monaco, Villefranche, and Toulon.

666
Hôtel de Police

78, AVENUE DAUMESNIL AT RUE DE RAMBOUILLET

1991, MANOLO NÜNEZ-YANOWSKY

Fourteen colossal slaves encircle the top level of this building. These sculptures are reproductions of *l'Esclave mourrant* (The Dying Slave) by Michelangelo on the tomb of Pope Julius II. Architect Nünez-Yanowsky chose to decorate the summit of his building with these copies to show the suffering of the human condition—enslaved by the actions of heart and mind. He then introduced a triangle of light as a symbol of knowledge and hope.

667
Ministère de l'Economie et des Finances
(MINISTRY OF FINANCE)

86, BOULEVARD DE BERCY
BETWEEN QUAI DE RAPÉE AND RUE DE BERCY

1989, PAUL CHEMETOV, BORJA HUIDOBRO, AND
EMILE DUHART HAROSTEGUY

When the Grand Louvre project displaced the Ministry of Finance from its headquarters in the Louvre, the department moved to this area in a unique bridge-like structure that incorporates two nineteenth-century army facilities. A 360-meter-long bridgelike structure arches from its north end at rue de Bercy, to beyond the quai de la Rapée into the Seine on the south side. Behind this "wall," architects created lower buildings with patios. The entire innovative complex, built of traditional stone, accommodates 6,500 people, while a speedboat dock at the piers and a helicopter pad on the top of the building provide the minister of finance with quick access.

668
Former American Center

51, RUE DE BERCY

1994, FRANK GEHRY; 2003, DOMINIQUE BRARD, INTERIOR CONVERSION

Like Matisse with a pair of scissors, Gehry created a three-dimensional collage in his design for the American Center. This exuberant mélange of light shafts and sculpted shapes faces the park, while the street façade respects the more normal building line of rue de Bercy. Gehry also made some concessions as to material, using stone so that the building would not offend a Parisian sensibility. The American Cultural Center featured civic activities to foster understanding between French and American cultures. However, the building has lain empty for five years, for lack of funds and interest. Supposedly, by fall 2003, the structure will reopen as a film center, with a new name.

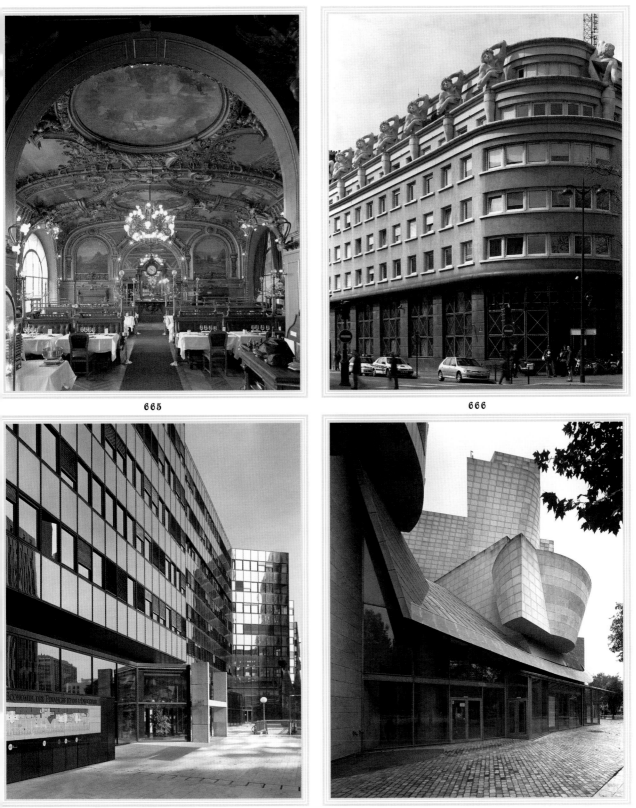

665

666

667

668

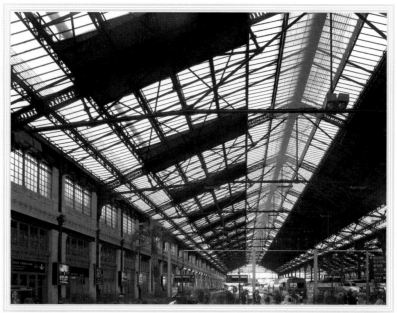

669

670

671

669

Gare de Lyon

20, BOULEVARD DIDEROT AT PLACE LOUIS ARMAND

1895–1902, MARIUS TOUDOIRE

Although the exterior of the building belies its function as a train station, this interior view leaves no doubt that passengers will find their destination. This perspective highlights the industrial glass-and-metal canopy that opens up the station with airiness and extends its lengthy corridor. Extremely light and wide, it was also a "temple" dedicated to modernity at that time. While gothic churches were designed to elevate the soul, the train station represented a new direction: movement, speed, and communication.

670

RATP Headquarters

191, RUE DE BERCY AND 54, QUAI DE LA RAPÉE
BETWEEN GARE DE LYON AND QUAI DE LA RAPÉE

1995, PIERRE SIRVIN AND MICHEL GUERRIER

In the 1970s, the City of Paris initiated a new phase of city planning with the construction of office towers in the Bercy district between Gare de Lyon and quai de la Rapée. This semi-circular building, in the midst of the urban redevelopment complex, is the headquarters of RATP, the organization that operates Paris's metro rail system. Inside, it contains a unique exhibition space designed by Pierre Sirvin.

671

Firehouse

5, PLACE LACHAMBEAUDIE AT RUE DU BARON LEROY

c. 1880

This austere, monumental firehouse expresses the role of a state institution organized to serve and protect. Rationalist architecture, typical of the period, is seen in the heavy stone ground level that houses the trucks and equipment. Above, the shared spaces and offices are built in meulière, the traditional stone of Paris. Like schools of the same era, this building was designed according to fixed standards of measurement, material, and shape.

672

QUARTIER BERCY

The demolition of the former wine storehouses of the Bercy district marked the first massive restructuring in the city since the Second Empire. In 1979, in an effort to re-balance Paris towards the east, the City Council charged architect Jean-Pierre Buffi to set the rules of the quarter of Bercy—the Parisian equivalent of New York's South Street Seaport. The landscape architects, managed by Bernard Huet, designed a rectangular park replacing an area that had bustled with wine trading for 150 years, though traces of this activity were preserved.

The Seine borders the park along the south side at quai de Bercy where barges filled with wine barrels used to drift. Contemporary houses designed by Christian de Portzamparc, Henri Ciriani, and other French architects (Franck Hammoutène, Philippe Chaix and Jean-Paul Morel, Yves Lion) line the opposite side. A sports arena, the first site developed here, anchors the north end, providing a venue for multiple sports events and cultural entertainment. A few of the warehouses that survived at Village of Bercy have been converted to restaurants and shops. An herb garden, plane trees, orange groves, roses, and chestnut trees fill the gardens at Parc de Bercy, which preserves a bit of the past with themed areas and a few old buildings that capture the romance of another era.

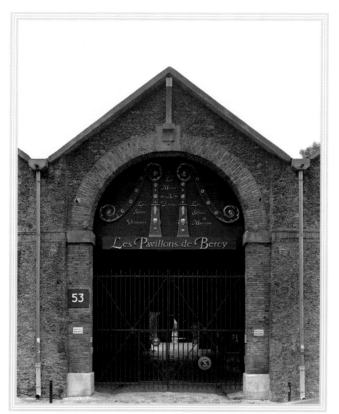

673

672

Palais Omnisports de Paris-Bercy

8, BOULEVARD DE BERCY AT QUAI DE BERCY

1984, PIERRE PARAT, MICHEL ANDRAULT, AYDIN GUVAN, AND JEAN PROUVÉ

Situated on the site formally occupied by wine warehouses, at the west edge of the Bercy Park, this stadium—an overwhelming steel structure with grass-covered siding—was the first of the redevelopment projects launched in the 1980s for Bercy Park. As the name suggests, the arena serves multiple sporting events as well as cultural happenings that offer some degree of spectacle. A 1979 design competition for the stadium stipulated that flexible usage. Accordingly, it can expand or contract, holding 3,500 to 17,000 spectators. Behind its steep façade pitched at a forty-five degree angle, it promotes more than 150 events and competitions each season, including those for soccer, ice skating, climbing, horsemanship, cycling, and skiing among others. For these events, configuration of the sports arena itself changes, along with the seating capacity.

673

Pavillons de Bercy

53, AVENUE DES TERROIRS-DE-FRANCE
BETWEEN QUAI DE BERCY AND RUE DU BARON LE ROY

1886, ERNEST LHEUREUX

In the seventeenth and eighteenth centuries, the aristocracy owned country homes in the Bercy quarter, where natural vineyards proliferated. As the Revolution, then the Industrial Revolution, wrought changes, the area experienced a growth of shipping and warehousing industries and transformed into a wine warehouse district. By the end of the nineteenth century, with the help of rail transportation, the Bercy quarter flourished with the addition of a wine market, open-air taverns, and entertainment along the Seine. It was a bustling neighborhood, with red-tile–roofed buildings and tree-lined streets. The old plane trees, preserved by ecologists, are still here, but the thriving market is long gone. Nonetheless, in a revitalization effort, the area of Pavillons de Bercy is attracting new customers to its current crop of wine bars and shops.

674

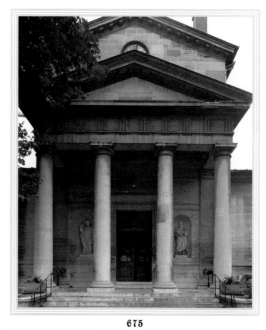

675

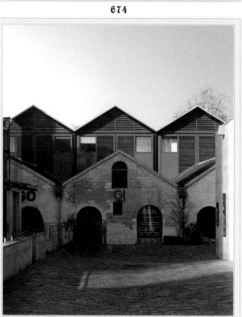

676

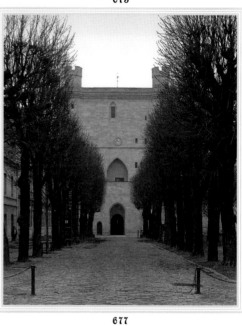

677

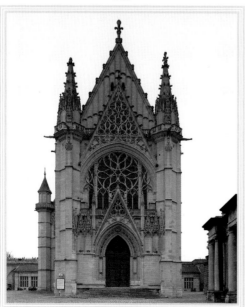

678

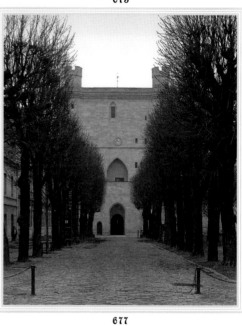

679

674

37–43 and 43–45, rue de Pommard

1994, NUMBERS 37–43 PHILIPPE CHAIX AND JEAN-PAUL MOREL,
BUILDINGS; 1994, NUMBERS 45–47 FRANCK HAMMOUTÈNE, BALCONIES

Vertical pillars intersect the horizontal balconies of this building's seventy-one apartments to create blocks that float on a clean surface. To add still more character, the architects varied the roof structure in both material and shape, using zinc and a spiral for one, and stone and an orthogonal projection for the other. They were also required by city planning to add large gardens. This structure is a part of five blocks organized with specific rules for redevelopment by Jean-Pierre Buffi, responsible for this area of the city.

675

Notre-Dame-de-Bercy

9, PLACE LACHAMBEAUDIE
AT RUE DE BERCY, RUE DU BARON LE ROY AND RUE DE DIJON

1823, ANDRÉ-MARIE CHÂTILLON;
1873, ANTOINE-JULIEN HÉNARD, REBUILT

Situated in the midst of an industrial area whose tangle of railroad tracks leads to Gare de Bercy, this simple church was built in the early nineteenth century, but a fire destroyed it in 1871. Architect Hénard reconstructed the building according to its original, neoclassical design, with unadorned pediments and Doric columns. The sculpted statues in the entrance alcoves represent Peter and Paul.

676

Bercy Village

COUR SAINT-EMILION
BETWEEN RUE DES PIROGUES DE BERCY AND RUE FRANÇOIS TRUFFAUT

1880, WINE WAREHOUSES; 1999-2000 DENIS VALODE AND
JEAN PISTRE, RESTORATION, BARS AND SHOPS

Cour Saint Emilion is the lasting remnant of this once lively wine marketplace. Although this restored village occupies the authentic stone warehouses of the former Bercy wine depot, it is so new and clean that it has the ambience of Disneyland's Main Street, a vacation spot far removed from the noise and bustle of the city. Slightly unreal, it is, nevertheless, a fine attempt to enliven the eastern part of Paris with restaurants and specialty retailers.

677

Tour Du Village

GROUNDS OF CHATEAU DE VINCENNES

1373–80

Conceived by Charles V, this medieval fortress provided residences for close relations of the king and members of his inner council. The construction of the external enclosure was one of the largest medieval building sites. Its immense proportions, covering more than one kilometer in length, included enormous walls flanked by towers and surrounded by moats. Charles V imagined the grounds of Vincennes as a closed world sheltering the elite of the kingdom.

678

Sainte-Chapelle

CHÂTEAU DE VINCENNES, AVENUE DE PARIS, VINCENNES

1379–1552, RAYMOND DU TEMPLE, CHAPEL

Inspired by the chapel of the same name on Île de la Cité, this one has just a single level with a nave and apse. In an innovative technique, the luminosity within comes from each corner of the church, where high windows allow light to stream in, to beautiful effect. The remains of duc d'Enghien, assassinated by Napoléon I, are interred here. Begun during the reign of Charles V, construction was not completed until 173 years later, in 1552, during the time of Henri II.

679

Tower

GROUNDS OF CHÂTEAU DE VINCENNES

1336–70

Looking much the same as it did when built in the fourteenth century, this tower—the highest of its kind in Europe, an imposing 52 meters (170 feet) above ground—stood guard over the Château de Vincennes complex. Perhaps this medieval tower (one of the few that survives intact, others being nineteenth-century reconstructions) owes its existence to durable construction: Its angles are flanked by turrets, each 6.6 meters in diameter, with walls 3.2 meters thick.

680

Zeus-Paris-Bercy

AVENUE DES TERROIRS-DE-FRANCE
BETWEEN QUAI DE BERCY AND RUE DU BARON LE ROY

1993, HENRI LA FONTA

Nicknamed "the banana" for its long, curved logo, this commercial exchange building is part of the 1990s urban redevelopment plan for the Bercy area. The effort to revive this quarter began with the Palais Omnisports arena and the Le Parc de Bercy. This building lies at the southeast portion of the park. Its broad glass façade and grand interior serves as a showcase for the local wine industry and facilitates trade transactions between firms buying and selling.

681

UGC Ciné Cité Bercy

2, COUR SAINT-EMILION AT QUAI DE BERCY

1998, DENIS VALODE, JEAN PISTRE AND ALBERTO CATTANI

Part of the Bercy project for urban renewal, this multiplex cinema waited ten years until the completion of the new district and the arrival of Météor, the newest metro line. The complex opened its doors on December 9, 1998, to ten hours of film programming. Eighteen rooms and graduated seating for 4,392 fill three stories. This cinema venue, the largest in France, shows original version (VO) films, and most of the projection is on curved, wall-to-wall screens.

682

Institut Bouddhique

40, ROUTE DE CEINTURE DU LAC DAUMESNIL

1931, LOUIS-HIPPOLYTE BOILEAU AND LÉON CARRIÈRE

Zen-like in the heart of the woods, this Buddhist Center stands on the site of the former French Togo and Cameroon pavilions from the Colonial Exposition of 1931. Inspired by palaces from the regions of Bamoun and Bamileké, in Cameroon, it is one of the six pavilions that remain from that time. In 1977, it was converted to a space dedicated to Buddha. Its symbolic details enhance the spiritual quality of the Tibetan temple. A large statue of Buddha, sculpted by Mozes, graces the interior.

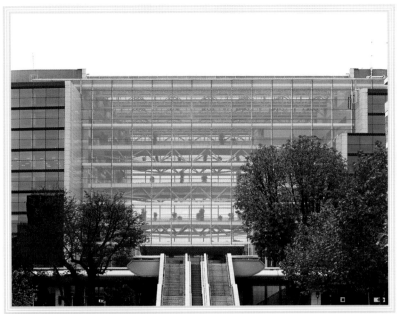

680

681

682

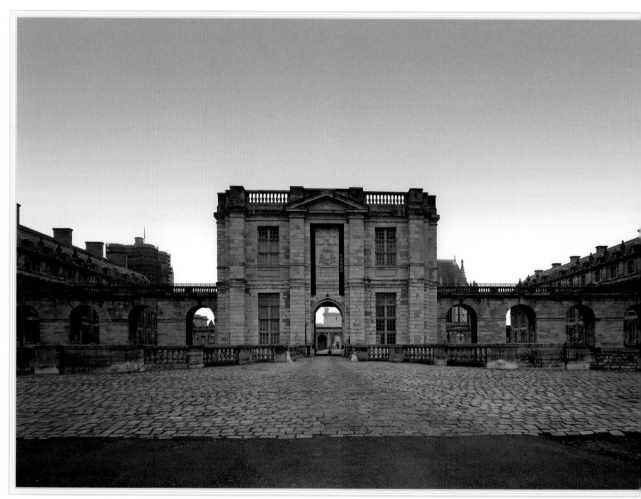

683

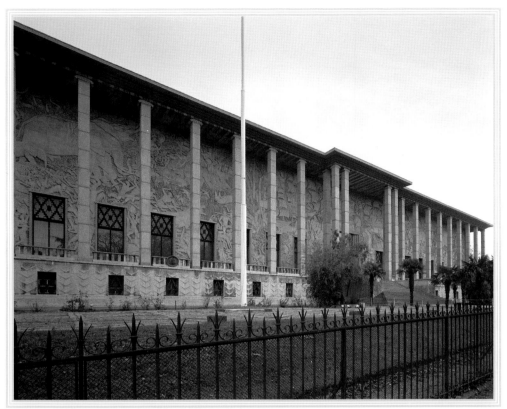

684

684

Château de Vincennes

AVENUE DE PARIS, VINCENNES

1336–40, PHILIPPE VI, TOWER; 1361–64, JEAN LE BON II, CONTINUATION; 1364–70, CHARLES V (THE KING WAS A BIT OF AN ARCHITECT) AND HIS ARCHITECTS FINISHED THE TOWER; 1373–80, WALL AROUND; 1379–1552, RAYMOND DU TEMPLE, CHAPEL; 1654–58, LOUIS LE VAU, PAVILLONS DU ROI AND DE LA REINE; 1945, JEAN- MARIE TROUVELOT, RESTORATION

The origins of this square go back to a destroyed château dating back to the reign of Philippe Auguste between 1180 and 1223. The current château survives from the Valois dynasty of Philippe VI, Jean le Bon II, and Charles V, who all used it as a royal residence. In 1610, Marie de Médicis, wife of Henri IV, added the Pavillon du Roi (king's pavilion) that architect Louis Le Vau later expanded. In 1658, he also built the Pavillon de la Reine (queen's pavilion), as well as a south and north portico to keep things symmetrical. At various times during the seventeenth century, when royalty was not living here, the château doubled as a prison surrounded by a moat.

Musée des Arts d'Afrique et d'Océanie

293–295, AVENUE DAUMESNIL
AT PLACE EDOUARD RENARD AND AVENUE ARMAND ROUSSEAU

1928–31, ALBERT LAPRADE AND LÉON JAUSSELY

Formally called the Palais de la France d'outre-mer, this stately, neoclassic stone building was conceived as a monument to celebrate the French colonial empire for the 1931 Colonial Exposition. At the time, the classic building drew criticism from the Modern Movement, which viewed a revival of neoclassical architectural as backward thinking. In 1987, it became a registered, historic monument. Its peristyle main façade and bas-reliefs depict cultures from the French colonies. Multiple artists worked on the project, including Alfred Janniot who sculpted the façade's "stone tapestry" of the civilizations then under French rule. In 1960, writer André Malraux, then France's Minister of Cultural Affairs, initiated plans to convert it to the Museum of African and Oceanic Arts. It now houses collections from north and sub-Saharan Africa as well as the South Pacific.

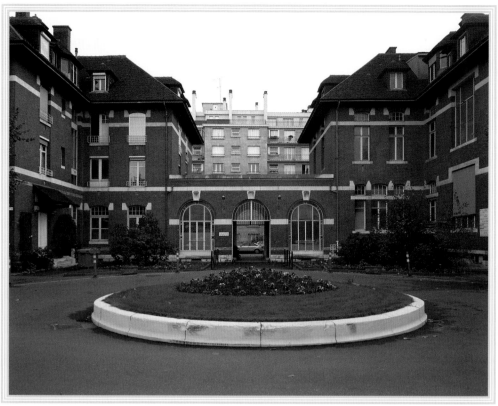

685

685

Hôpital Rothschild

9-29, RUE SANTERRE

1852, FOUNDATION OF THE INSTITUTION; 1912–14, LUCIEN
BECHMANN; 1970, REMODELING

Baron Edmond de Rothschild established this
hospital in 1914 to serve the Jewish community.
Since 1954, it has been administered by l'Assis-
tance publicque. Originally composed of thir-
teen red-brick buildings that date from the turn
of the last century, the hospital was created as
small villas, with separate gardens, along two
perpendicular axes. The brickwork provided
load-bearing walls, and the rustic stone filled
the base and the voussoirs of the front arches.
During World War II, these units were con-
verted to prisons, and its Jewish patients were
deported to concentration camps. In 1970, sev-
eral of these buildings were remodeled or
replaced with modern buildings to accommo-
date research, medicine, dental surgery, a school
of nursing, an amphitheater, and maternity and
social services.

13TH ARRONDISSEMENT

When Victor Hugo described this area in *Les Misérables* as ugly and sinister, it was not yet the high-rise wasteland it was to become in the 1960s and '70s. From the mid-fifteenth century, the old Gobelins dyeing workshops created tapestries for the royal court and the aristocracy, and dominated the vicinity of Place d'Italie. Although the company is still in business, their dyes and the waste from their tanneries, textile mills, breweries, and other factories severely polluted the river Bièvre, a branch of the Seine. By 1860, when the 13th arrondissement was annexed to the city, the entire district was quite squalid.

In a twentieth-century attempt to reinvigorate and modernize this lost district, the city paved over the river, destroyed old structures, and went on a spree of building massive apartment complexes. The area began to attract Asian immigrants and today is home to the largest "Chinatown" in Paris. Despite the clunky apartment towers, there are still pockets of cobblestone charm. Stucco houses and rambling gardens come into view on back streets where young artists have taken up residence. In an effort to revive this diverse arrondissement, city officials designated the 13th as the site for the high-tech Bibliothèque Nationale de France, constructed in the 1990s.

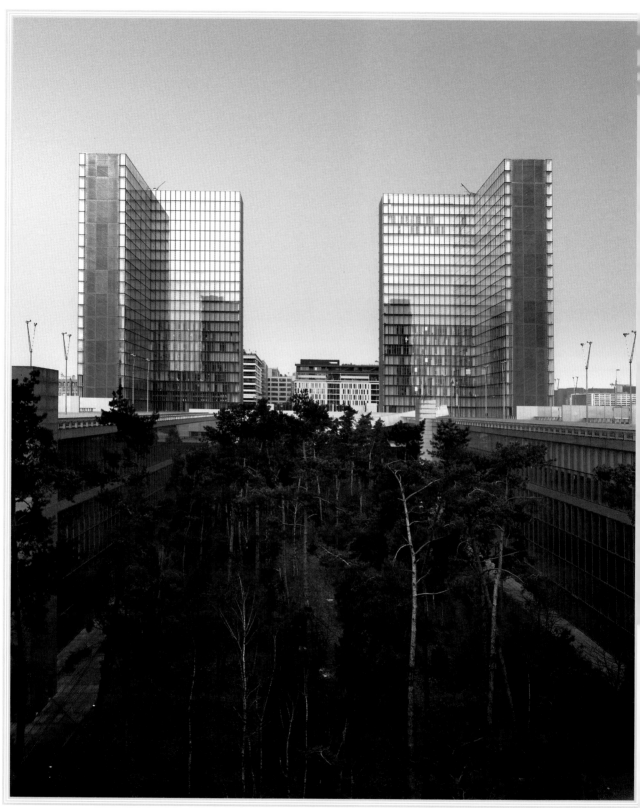

686

Bibliothèque Nationale François-Mitterrand
(BIBLIOTHÈQUE NATIONALE DE FRANCE)

11, QUAI FRANÇOIS-MAURIAC AT AVENUE DE FRANCE

1993–97, DOMINIQUE PERRAULT

Four giant L-shaped towers, meant to recall open books, rise from the corners of a vast underground platform—the new foundation of the French National Library. Long suffering from a serious shortage of space, Bibliothèque Nationale de France moved the majority of its holdings to this location, from the old library on rue de Richelieu. The last of president François Mitterrand's *grands projets*, its architectural designer was chosen in a formal competition. Dominique Perrault won the contract in 1989. Reading rooms overlook a central patio whose greenery brings a bit of warmth to this imposing, controversial space, which academicians and the media alike criticized as a "Disneyland of reading." Nonetheless, Mitterand's successor, President Chirac, inaugurated the building in December 1996 and named it Bibliothèque Nationale François-Mitterrand.

687

Hôtel Industriel Berlier

24–26, RUE BRUNESEAU AT QUAI D'IVRY

1990, DOMINIQUE PERRAULT

Here at the convergence of the Seine, railway lines, and the massive motorway of boulevard Périphérique, this vast transparent building redefines the words, "minimal" and "façade." A glass panel reveals the continual industrial workings within the building—a transparent, complex, and changing image of all the comings and goings of the technical world. The architect achieved a façade that changes with the light as well as its internal activity.

687

688

Accenture

118–120, AVENUE DE FRANCE AT RUE EMILE DURKHEIM

DUSAPIN AND LECLERQC

Working on the assumption that creating more prestigious office space would attract a wealthier population to this traditional working class area, city officials launched a campaign to increase business opportunities in the 13th arrondissement. The office design tried to democratize working space. Emphasizing vertical communication, the architects planned areas with double-height volume and open stairs. In season, niches filled with Japanese wisteria create hanging gardens that warm the cold steel and glass façade.

688

689

112, rue du Chevaleret

AT 3, RUE LOUISE WEISS

1990, EDITH GIRARD

Developed at an acute right angle on a triangular piece of corner property, this project was an effort to revive the feel of the old 13th arrondissement. In the background, taller buildings rise like a wall above and behind the foreground of three levels of artists studios. Constructed in white-plastered concrete, these buildings seem durable, yet bland and uniform—the opposite atmosphere one would expect for artistic endeavors.

689

690

Batofar

(FORMER LIGHTHOUSE BOAT)

11, QUAI FRANÇOIS-MAURIAC
BETWEEN PONT DE BERCY AND PONT DE TOLBIAC

1999

Floating at the dock between the Le Parc de Bercy and Bibliothèque Nationale to its the east and west, and the bridges to the north and south, this former lighthouse boat glides into nightlife with an excellent river view. And, in warm weather, the party drifts to the bar on the deck. One of only a few boats docked at the bay, the alternative sounds and electronic vibes of this trendy nightclub keep the crowds packed onto its dance floor.

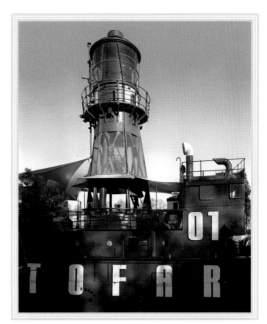

690

691

Distribution d'air comprimé

3–13 QUAI PANHARD LEVASSOR

1890–91, JOSEPH LECLAIRE, ENGINEER

Function followed form in this building: The external aesthetics include double, diagonal box-trusses and pillars, creating a pattern that suggests the industrial nature of this working factory, which was responsible for the workings of public clocks, elevators, and other technological equipment. The main clock on the façade controlled the other clocks in the building. Today, this building is the only metal structure that remains of the four original structures on this site.

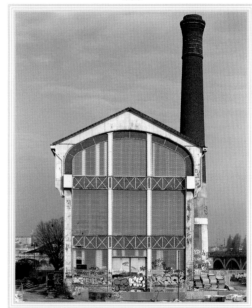

691

692

Ciments Calcia

15, RUE JEAN-BAPTISTE BERLIER AT BOULEVARD MASSÉNA

All around this area, just across the river from the restored park and village of Bercy, smoke stacks pump clouds into the air, abandoned mills wait for renovation projects, and multicolored cranes reach into the sky. Cement mixers churn, gravel piles stand in high funnels, and forklifts load cement blocks onto open skids. This is a part of Paris quite unfamiliar to tourists. Sand tankers are located near the freeway and the river, in order to fill trucks with gravel and sand for construction projects around the city.

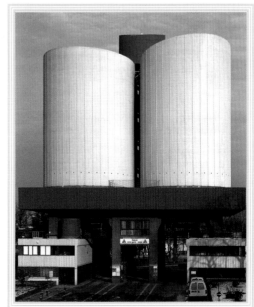

692

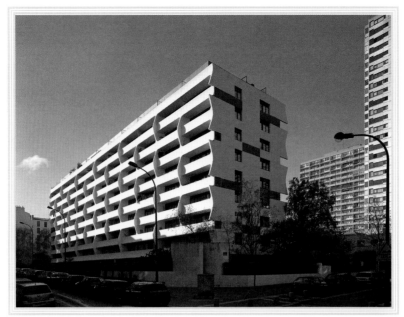

693

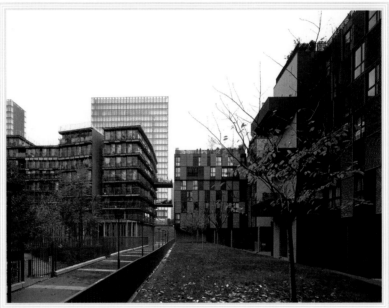

694

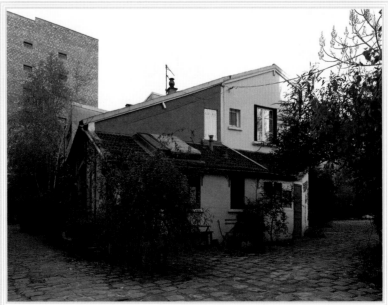

695

693

28–44, rue Clisson

BETWEEN RUE DUNOIS AND RUE JEANNE D'ARC

1975

This building—part of an urban project known as *l'îlot Say I*—exhibits a uniformity of design typical of the industrial construction of the 1970s. The logic then was to produce architecture that cleaned up the old city and organized it administratively, but the plan resulted in a generation of colossal, homogeneous buildings. The balconies perhaps distinguish this structure, as does its horizontal orientation, making it more sophisticated than other, conventional low-cost housing of its time.

694

3, quai François Mauriac

AT RUE EMILE DURKHEIM

1997, PHILIPPE GAZEAU

Part of the city's biggest redevelopment project to transform a neighborhood, this apartment complex has a prime location along the Seine. Architect Gazeau created separated units, each with suspended terraces and multiple views of the river. A white façade with wooden latticework overlooks the Seine. Recesses on the upper level look like stadium box seats offering a choice view. The entire composition on the river side appears to float above a seemingly disconnected white base.

695

129 bis, avenue de Choisy
(VOIE PRIVÉE ET MAISONS PARTICULIÈRES)

AT RUE DE TOLBIAC

This small, private dwelling stands as a last vestige of another time, not displaced by the encroaching urbanization of overpowering towers built in the postwar era. Here a contemporary structure fits into a space and a street that retains the feel of a village.

696
Maison Planeix

24 BIS, BOULEVARD MASSÉNA
BETWEEN RUE DU CHÂTEAU DES RENTIERS AND RUE NATIONALE

1924–28, LE CORBUSIER AND PIERRE JEANNERET

A peculiar cube, around which this home is organized, juts out from the second level and seems to defy gravity. This Cubist protrusion contains a living room, and serves as a base for the balcony. The horizontal band of windows on the façade plays with positive and negative space in opposition to the extreme whiteness of the wall. Le Corbusier and his brother designed this structure to become both the residence and studio of Antonin Planeix, a sculptor of tombstone memorials. Two workshops and a garage occupy the ground level of this nontraditional Parisian home.

697
Caserne de Pompiers
(FIRE STATION)

16, AVENUE BOUTROUX AND 37, BOULEVARD MASSÉNA

1971, JEAN WILLERVAL AND PRVOSLAV POPOVIC

Using reinforced concrete to create a building that resembles a ship, the architects launched shapes that diverge from the straight line. The building's rounded ends, which break from the monotony of traditional, linear buildings, give this fire station a unique presence in the city. In addition to its modern shape, the social aspect of combining attractive living quarters above a functional fire station was an innovative notion. The architects positioned the apartments to allow firemen quick access to their vehicles and equipment: The residential spaces are located directly above the garage level, with poles that permit the firemen to slide down to their trucks in twenty seconds. In the lower building are recreational facilities serving the residents of the fire station.

698
106, rue du Château-des-Rentiers

AT RUE JEAN-COLLY

1987, ARCHITECTURE STUDIO
(M. ROBAIN, J.-F. GALMICHE, R. TISNADO AND J.-F. BONNE)

Challenged to build on street corners and other leftover patches of real estate, the Architecture Studio laid out this structure on less than 100 square meters (only about 325 square feet). An odd piece of metal—emphasized by the sharp slant of the roof—protrudes from the building. It turns out that the innovative architects incorporated the construction's scaffolding crane right into the building's design, definitely giving new dimension to the term "scrap metal."

699
Médiathèque Jean-Pierre Melville
(JEAN-PIERRE MELVILLE MULTI MEDIA LIBRARY)

101-103, RUE DE TOLBIAC AT RUE NATIONALE

1989, CANAL (DANIEL AND PATRICK RUBIN)

Designed to be an open book, so to speak, Paris's first multimedia library reveals its audiovisual holdings—tapes, cassettes, records, books, photography: From the street the pubic has a clear view of the five floors. The convex glass façade showcases the library's interior activities, which seem almost suspended in air due to the floors' paper-thin appearance. Hanging inside on the rue Nationale side, a giant semi-transparent photograph, also visible through the exterior, filters light into the media's viewing rooms. As a whole, the building welcomes and intrigues the public, rather than intimidating them with a monumental, opaque storage facility.

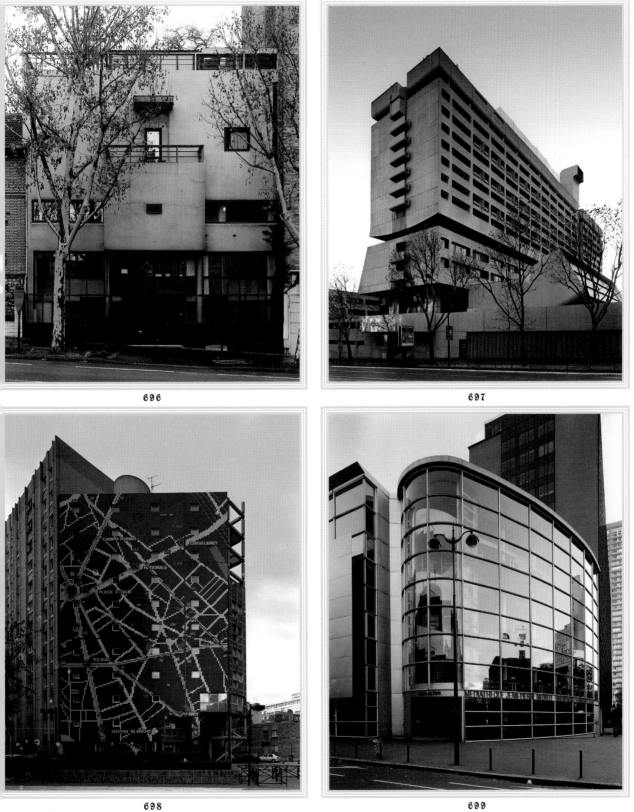

696

697

698

699

ASIAN NEIGHBORHOOD
(AVENUE D'IVRY)

Throughout Paris, Asian storefront signs light up with the words, "*plats à emporter*." This "takeout" food business attests to the thriving Asian population of about 250,000 scattered around different Parisian neighborhoods. The concentration of Chinese in the 13th arrondissement in particular has created a "Chinatown" along avenue d'Ivry, in a triangular area bordered by boulevard Massena and avenue de Choisy. Although the Chinese community predominates, comprising about fifty percent of the district's population, Le Triangle Jaune ("The Yellow Triangle," if you can believe it is still called that) is also home to Vietnamese, Cambodians, and Laotians who began arriving there between 1968 and the mid-'70s as war refugees, and to escape Pol Pot's brutal regime. Exotic boutiques, food emporiums, teahouses, artisan shops, and authentic restaurants create a lively Chinatown here.

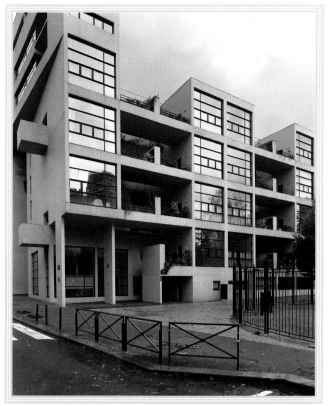

700

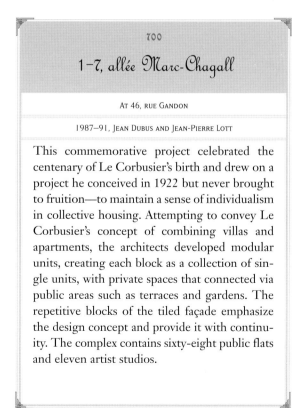

1–7, allée Marc-Chagall

AT 46, RUE GANDON

1987–91, JEAN DUBUS AND JEAN-PIERRE LOTT

This commemorative project celebrated the centenary of Le Corbusier's birth and drew on a project he conceived in 1922 but never brought to fruition—to maintain a sense of individualism in collective housing. Attempting to convey Le Corbusier's concept of combining villas and apartments, the architects developed modular units, creating each block as a collection of single units, with private spaces that connected via public areas such as terraces and gardens. The repetitive blocks of the tiled façade emphasize the design concept and provide it with continuity. The complex contains sixty-eight public flats and eleven artist studios.

701

Salvation Army Hostel

(CITÉ DE REFUGE)

12, RUE CANTAGREL AT RUE DU CHEVALERET

1929–33, LE CORBUSIER AND PIERRE JEANNERET; 1952, ADDITION OF
THE *BRISE-SOLEIL* (SUNSHIELDS); 1975, POLYCHROME RESTORED

With primary colors, Le Corbusier made child's play out of charity. Instead of creating an austere building for those in need, he gave them a lift, using color and shape and pattern—the basic building blocks of art. This dormitory—Le Corbusier's second public project and first significant building—contained housing for 500 occupants. Unfortunately, his air-conditioning ventilation system proved faulty, which necessitated the addition of polychrome sunscreens.

702

Large Mills of Paris

QUAI PANHARD ET LEVASSOR

1923, GEORGE WYBO

Built in classic style with grand arcades and a slate roof, this building is one of the large mills developed in the 13th arrondissement between 1919 and 1924. Among the biggest in the world, the mills crushed 1800 tons of corn per day. Threatened with destruction after their abandonment, the buildings were eventually repurchased in 1996 by the City of Paris's district development organization, with the idea that they would be preserved by transformation into part of The University Paris VII–Denis Diderot.

703

Mairie

1, PLACE D'ITALIE AT AVENUE DES GOBELINS

1866–77, PAUL-EMILE BONNET; 1893, ANTOINE SOUDÉE, EXTENSION

Surrounded by the crush of traffic, this town hall is situated at place d'Italie, where the four districts that form the 13th arrondissement meet. As the first of the town halls erected by Haussmann to reinforce strong city policy, it initiated a new style for public architecture that was repeated with subsequent city halls: The layout consists of a forecourt, with a marriage hall at the axis, and administrative offices around the periphery. The 3,000-square-foot wedding room dominates the building.

701

702

703

704

Tour Chambord

22, BOULEVARD KELLERMAN AT RUE DU COLONEL DOMINE

1975, MIKOL, HOLLEY AND BROWN-SARDA

The sales promotion brochure for Tour Chambord dubbed its tower "Renaissance," to lure customers to this residential building. They chose a sixteenth-century astrolabe—a tool that guided seafaring voyages toward grand discoveries—as the tower's symbol, hoping to convince tenants that living here would be an exciting adventure. Otherwise known as "block C3, Italy-Kellermann operation," the project tried to present a luxuriant image. Today, the tower stands alone and its car garage remains unfinished.

705

Tour Super-Italie

121, AVENUE D'ITALIE AT RUE CAILLAUX

1974, MAURICE NOVARINA

The construction of this tall, circular tower was part of the evolution of the place d'Italie, a coveted spot to build spectacular structures to fill the Parisian horizon. This area was supposed to be the Champs-Elysées of the 1980s; and this tower, the symbol of that redevelopment. Bands of thirty-seven floors appear to be strings of an instrument played against the sky. The Novarina design included a swimming pool that, at the top of his 350-foot-tall tower, offers a panoramic view of the city.

706

152, avenue d'Italie

2, RUE DU TAGE

1984, VITTORIO MAZZUCCONI

Seeking to conceal architectural disasters of the postwar period, Vittorio Mazzucconi drew on the powers of the distant past to create a fortress against future aesthetic aggressions. Like a fortification wall of ancient history, his façade of stone rubble creates a barrier that simultaneously hides recent history (the building next door) and guards the present against future excesses, while his use of traditional slate roofing pays homage to the past.

707

Rue du Docteur Leray and rue Dieulafoy

1921, HENRY TRÉSAL

Colorful, attached townhouses, each with a unique character, line these streets. Architect Trésal took out a patent for his design of these homes that, though small, were sophisticated and comfortable, each featuring its own bathroom, bedrooms, courtyard, garden, and car park. Developed with private capital, the project accomplishes a look that is close to the appearance that this arrondissement once had: small, individual houses for workers, rather than large and impersonal apartment buildings.

708

1, 2 bis, rue du Docteur Lucas Championnière

AT CORNER OF RUE DOCTEUR-LERAY
AND RUE DOCTEUR-LUCAS-CHAMPIONNIERE

1911

Comparing this picturesque house with the high-rise urban development after World War II presents a surreal contrast. This house was part of a new neighborhood, planned in 1911, that let each owner choose his own architect. Although the subdivision is consistent, the façades are all different, achieving an overall effect of a small-town neighborhood.

709

Eglise Saint-Marcel

80–82, BOULEVARD DE L'HÔPITAL AT AVENUE DES GOBELINS

1966, DANIEL MICHELIN; 1993, JEAN MICHELIN

In 1966, Daniel Michelin created a new church on the site of a former nineteenth-century one. Almost thirty years later, Michelin's son, Jean, built a new steeple for the church, and gave it a facelift, by means of a colored glass construction that hides his father's original façade. Square glass blocks shape the overall façade into a triangle, and the texture of its surface reinforces the design with a repetitive triangular motif. With the addition of this glass façade, the building now aligns with the street.

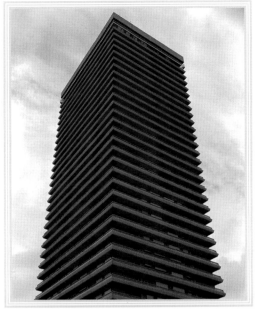

704

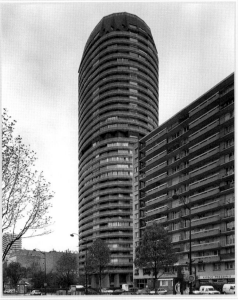

705

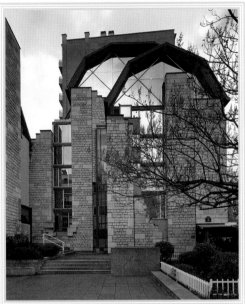

706

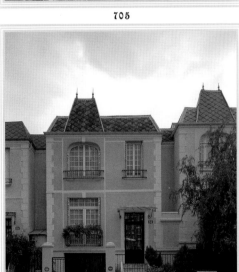

707

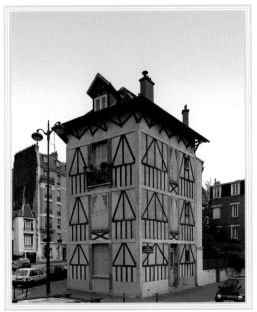

708

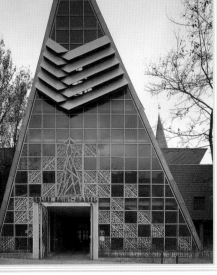

709

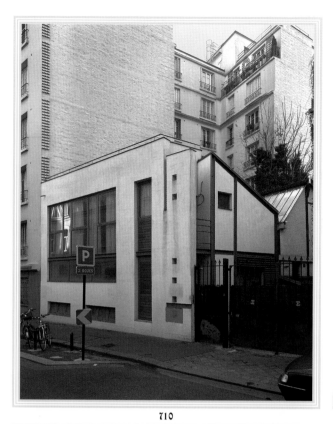

710

Cité Verte

147, RUE LÉON-MAURICE NORDMANN
BETWEEN RUE DE LA SANTÉ AND RUE DE LA GLACIÈRE

1983

Previously owned by a religious community, this property was redeveloped as artist studios in the late 1970s and early '80s. Occasionally graffiti-scrawled, the white façades are otherwise unadorned. The angled, sky-lighted roofs and large window frontage provide ample light for working in a space somewhat sheltered from the tumult of the city. As many artists live in the 13th arrondissement, this project follows workshop tradition, creating a small-scale space on a short dead-end street, in contrast to large commercial buildings commissioned by private businessmen.

710

711

Cité Fleurie

65, BOULEVARD ARAGO
BETWEEN RUE DE LA SANTÉ AND RUE DE LA GLACIÈRE

1880

Surprising and often secluded treasures surface in unexpected places around Paris. Often, they are steeped in history and, at some point, have usually also been threatened with extinction. A last-minute preservation fight may in fact be the very factor that lands them in a historic registry. Such is the case with this pocket haven of artist residences. Surrounded by modern high-rises, the enclave continues to hang on in the midst of an otherwise dreary part of the city. At one time, these two long, low, wood-trimmed houses, now subdivided into studios and apartments, had been occupied by such artists as Modigliani and Gauguin.

711

712

Armée du Salut, Palais du Peuple

29, RUE DES CORDELIÈRES AT RUE CORVISART

Founded in 1881, this organization, similar to the Salvation Army, originally constructed a hotel here in 1912 for indigent men. In 1926, Princess Edmond de Polignac, of the Singer sewing family fortune, arranged a renovation and had gardens added that enhanced and opened the space. Today, lace curtains hang in the windows and the façade features a pediment surmounted by an oculus and a slate-roof attic. A wooden door with minimal wrought iron opens onto a beige and brown brick corridor with tile flooring that leads to the interior court and housing. This classical façade hides one of Le Corbusier's buildings designed in 1926 for the social institution.

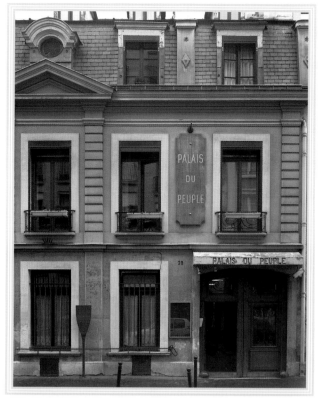

712

713

Hôtel particulier

14, BOULEVARD ARAGO AT RUE PASCAL

1901, EDMOND BEQUET

Built as a residence by Edmond Bequet, this small mansion preserves the style used for homes in this quarter at the turn of the last century. The decorative ironwork at the windows and on the door enhances the *hôtel*'s charm. Despite the otherwise Rococo styling, the metal-linteled ground story hosts large windows that expose the interior to maximum light. What with all the experimental building that occurred in the 1960s, it's something of minor miracle that this lovely residence has survived the wrecking ball.

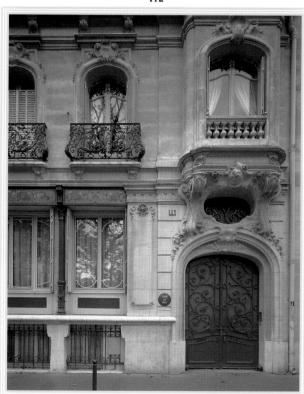

713

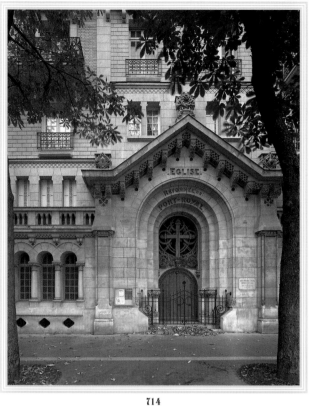

714

715

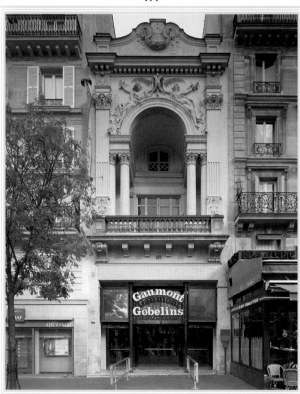

716

717

714
Église Réformée de Port-Royal

18, boulevard Arago at rue Berbier-du-Mets

1898, Adolphe-Augustin Rey

This structure is a mixed-use architectural project combining housing and religion. The church is actually part of the apartment complex, with an entrance in the middle of the building façade. Architect Rey made significant advances in Protestant religious architecture, with his use of reinforced concrete. Rey also illuminated the nave with a glass peak, and integrated the whole church by means of a neo-Roman design that is so well conceived that the central portion appears more a monumental civil entrance, than a church.

715
Hôtel de la Reine-Blanche

17–19, rue des Gobelins
At rue Gustave-Geoffroy and rue de la Reine-Blanche

Second half of fifteenth century; c. sixteenth century;
c. seventeenth century, eighteenth century;
2002, Dominique Hertenberger and Jacques Vitry

This picturesque medieval building, with a spire and cantilevered timbered extension over the archway, bears a name for which history has no record. Though nicknamed "the House of the White Queen," no White Queen ever lived there. It is, however, near a street called rue de la Reine-Blanche (White Queen). This building appears to have been built by the sixteenth-century Gobelin family of dyers, to use as a dyeing workshop, and it may have also been used as a tannery during the late nineteenth century. This house is a mix of architectural styles from various centuries.

716
Cinéma Gaumont-Gobelins

73, avenue des Gobelins

1869, Alphonse Cusin

Architect Alphonse Cusin, who also designed the Gaitée Lyrique Theater, employed Auguste Rodin, then a young student of the Beaux Arts movement, to sculpt the front of this ancient movie theater. Wedged between two similar buildings, Rodin's façade—his first work—features a carved and arched balcony space that is supported by Corinthian columns above the second-level balustrade. Beginning in 1904, the theater served as a venue for film, but collapsed in 1934. An interior renovation in 1969 created two cinemas. Bought by the Gaumont firm in 1993, it now screens commercially-produced movies.

717
Entrepôt du Métropolitain

29, rue Le-Brun at rue Nicolas Roret

c.1900, Hennebique company

Originally built for Compagnie générale des omnibus, the forerunner of RATP, Paris's transit authority, this building is characteristic of the industry and technology that developed in the 13th arrondissement around the turn of the last century. A model for other stations, it was composed of reinforced concrete and a red stone, *meulière*, typically used at the start of the twentieth century as filler around windows and doors. François Hennebique, whose company constructed this facility, began his career as a mason restoring churches. The carpentry of these churches inspired him, and he founded his own company that distinguished itself from others with its work in fireproof construction.

718

Gobelins Manufactory

42, AVENUE DES GOBELINS AT RUE CROULEBARBE AND RUE BERBIER-DU-METS

1447, JEAN GOBELIN, FIRST WORKSHOPS; 1607, INSTALLATION OF NEW DYER; 1662, MANUFACTURE OF GOBELINS, BY COLBERT; 1723, JACQUES GABRIEL V, CHAPEL; 1870, FRANÇOIS CHABROL, NEW CONSTRUCTION; 1894, JEAN-PAUL AUBE, NEARBY STATUE OF COLBERT; 1912–19, JEAN-CAMILLE FORMIGÉ AND LEON JAUSSELY, MUSEUM AT THE AVENUE JEAN-ANTOINE INJALBERT, CARYATIDS, AND PAUL LANDOWSKI, HIGH-RELIEF SCULPTURE

Known as the "scarlet dyer" in the mid-fifteenth century, Jean Gobelin begat a dynasty of dyers. By the seventeenth century, their workshops had become the Gobelins Manufactory, famous for its tapestries rather than its dyes. It was here, in the 1660s, that Colbert built a factory that produced royal furnishings and tapestries.

719

11, rue Émile-Durkheim

BETWEEN QUAI FRANÇOIS MAURIAC AND AVENUE DE FRANCE

1996, FRANCIS SOLER

The social housing projects in the Seine Rive Gauche area opened opportunities for the city to promote avant-garde architecture, of which this building is a good example. Instead of using classical sunscreens or shutters for protection, architect Soler experimented with glass surfaces that form the façade. These are largely covered with serigraphy based on themes from the nature, such as giant butterflies in bright colors, or on classical art such as Michelangelo's drawings.

720

Gare d'Austerlitz

BETWEEN QUAI D'AUSTERLITZ AND BOULEVARD DE L'HÔPITAL

1838–40, FÉLIX CALLET (ARCHITECT) AND ADOLPHE JULLIEN (ENGINEER), FIRST STATION; 1862–69, LOUIS RENAUD (ARCHITECT) AND LOUIS SEVENE (ENGINEER)

Suburban lines and southbound trains depart from Gare d'Austerlitz, so named to commemorate Napoléon's 1805 victory in Austria against Austro-Russian armies. Its large main hall is supported by a glass and steel framework. The metro line constructed at the turn of the last century crosses the station above the main hall, on elevated tracks that span the Seine and then arch into the side of the station with nineteenth-century grace.

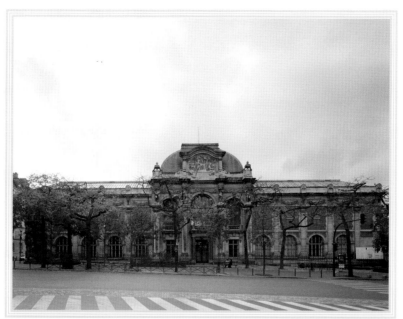

718

719

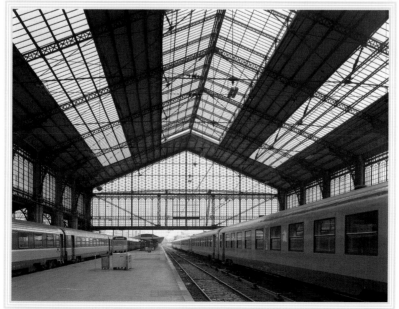

720

721

722

723

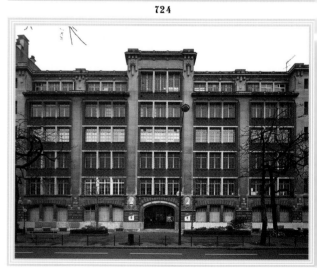

724

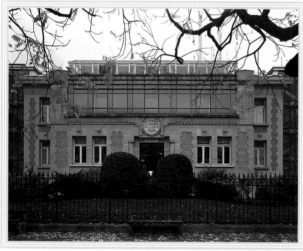

725

726

721
Stade Sébastien Charléty

83, BOULEVARD KELLERMAN AT AVENUE DE LA PORT DE GENTILLY

1992–94, HENRI AND BRUNO GAUDIN

This stadium was designed with the same qualities an athlete needs to succeed: grace under pressure, power and agility, strength and fluidity. The grace of the winged roof comes from its thin, fluid metal cables, while concrete blocks and steel rods demonstrate the strength needed to support the terraced seating. The architects created this multiple-sports facility with interior spaces that can adapt for concerts, dance competitions, and exhibitions.

722
Piscine de la Butte-aux-Cailles
(SWIMMING POOL)

5, PLACE PAUL VERLAINE AT RUE DE LA BUTTE AUX CAILLES

1924, LOUIS BONNIER AND FRANÇOIS HENNEBIQUE;
1991, JOHANNA FOURQUIER, RESTORATION

Constructed on the site of a hot-water artesian well, this swimming pool complex represents opposing directions in its design inspiration. Architect Bonner juxtaposed the modern behind the traditional—an innovative concept for its day —in a single building that appears to be composed of two separate units. A modified Art Nouveau façade of red brick is paired with an interior façade of reinforced concrete that rises above it—a dramatic splash of modernity behind the cover of tradition.

723
Maison de Santé des Sœurs Augustines

25–27, RUE DE LA SANTÉ

1840, CASIMIR CHALAND

Built on the site of a former hunting pavilion, this building was created for the Augustine order of nuns, who asked architect Chaland to design a courtyard parallel to rue de la Santé, with their chapel in the axis facing the portal entrance. The arched windows of the first level open to a terrace that covers a gallery. Upheld by fine piers, the gallery encircles the courtyard. Today, the former Augustine residence houses medical offices.

724
Institut de Paléontologie Humaine

21, BOULEVARD SAINT-MARCEL AND ONE, RUE RENE-PANHARD

1914, EMMANUEL PONTREMOLI

Formerly the location of an ancient horse market, this building was financed by the Prince of Monaco for the study of human origins. Mercifully, it escaped the 1960s' towering skyline alterations of the 13th arrondissement. The rusticated stone façade features a bas-relief frieze that runs in a band between the ground floor and the windows. Sculpted by Donstant Roux, it depicts various scenes, such as hunting and fishing, in the life of primitive man.

725
Hôpital du Gardien de la Paix
(HOSPITAL OF THE POLICEMEN)

35, BOULEVARD SAINT-MARCEL AND 6, RUE JULES-BRETON

1929, JEAN MICHEL AND ABEL MAHIEU; 1997–99, RESTORATION

In 1927, the Sacco and Vanzetti trial caused much civil unrest in Paris, prompting the Prefect of the Police of Paris, Jean Chiappe, to create a private hospital for the policemen wounded in the line of duty. Two years later, the president of the republic, Gaston Doumergue, inaugurated the hospital. Today, the hospital serves the police force and the personnel of the Prefecture of Police and the Ministry for the Interior. Composed of brick and stone, the building features Art Deco detailing.

726
Ecole Superiéure des Industries du Vêtement

73, BOULEVARD SAINT-MARCEL AT RUE MICHEL PETER

c. 1920–30

Many schools were built in the 13th arrondissement, especially between the two World Wars; the neighborhood's proximity to other universities and schools in the Latin Quarter made this side of the Saint-Geneviève hill a natural area in which to add educational facilities. This particular school, a concrete structure with brickwork at the base of the windows, sits on a massive base of stones. Its façade is a blend of Art Deco and the French tradition of rationalism.

727

728

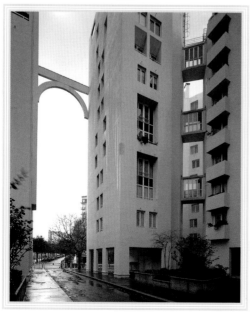

729

730

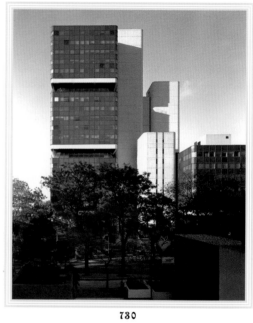

731

732

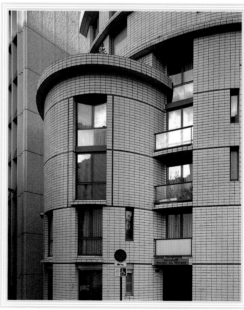

727

Place d'Italie et immeuble de logements

168–172, avenue de Choisy at place d'Italie

c.1960–70

This drab building is typical of the high-rise architecture of the postwar years. In an attempt to modernize the city and rejuvenate different quarters, the resulting uniformity of style created a travesty in the skyline of Paris. Unfortunately, the excesses of the 1960s, in particular, still stand as examples of bad aesthetics.

728

Immeubles cruciformes

205, boulevard Vincent-Auriol at 17, rue Albert-Bayet

1970, A. Ascher, G. Brown-Sarda, D. Mikol, and J. Chaillet

This giant cruciform in white overlooks place d'Italie, itself a crossroads between the old and the new in the 13th arrondissement. Identical grading of reinforced concrete composes the façade of this building, which has 340 residential units. The complex looms against the skyline as part of the architecture that was to define the postwar decades.

729

Immeuble de Bureaux

86, rue Regnault at rue du Château des Rentiers

1976, Jean de Brauer

A series of metal and glass office buildings line one side of rue du Château des Rentiers, but this one, set back on the corner at rue Regnault, breaks the monotony of the rhythm. The façade, composed of a double glass skin with an air conditioning space between, has no vertical or horizontal separations. Continuous folds create a frontage pattern that allows maximum light and a controlled ambiance for pleasant working space inside.

730

Université Paris I

Center Pierre Mendes-France
90, rue de Tolbiac at rue Baudricourt

1973, Pierre Parat and Michel Andrault

A concrete core filled with elevators, staircases, and corridors supports several identical glass cubes. These modules look as if they are interlinked toy blocks with a double, central chimney. Situated on a triangle of land of only 4,500 square meters, this university complex for arts and science has a 13,000 student capacity.

731

Rue des Hautes-Formes

BETWEEN RUE NATIONALE AND RUE BAUDRICOURT

1979, Christian de Portzamparc and Giorgia Benamo

With towering elegance, this housing project signaled a turning point in Parisian architecture. These eight low-rise buildings—interlinked at each third level by accessible galleries and tempered by the window design—achieve lightness, and provide open space for thought and comfort. Portzamparc's interplay of light and proportions helped bring an end to two decades of austere, cookie-cutter high-rise development in the 13th arrondissement.

732

Foyer de Personnes Âgées
(HOME FOR THE ELDERLY)

120, rue du Château-des-Rentiers

1984, Christian de Portzamparc

This building—a home for the elderly—marks a transition in the chaotic urban planning to affect Paris in the 1960s and '70s. With its smooth, curved surface, it serves as a literal as well as psychological bridge between two older, disconnected, impersonal buildings. De Portzamparc designed this project at a lower, more accessible level than its neighboring towers, creating it on a more intimate, human scale, not only for its architectural healing power, but also for its residents' comfort.

733

Impôts
(Centre des Impôts Fonciers)

6–16, rue de Clisson at rue du Chevaleret

c. 1980

Faithful to tradition, the French administration expresses its power with this heavy building that contains its offices for tax administration. Given its role in the French system, the organization is often criticized for failing to respond to the spirit of the Republic with equality for all. This huge complex appears impersonal from the outside also, as their building is based on a boring weft of windows and covered by old granite.

734

Immeuble d'Habitation

76–78, boulevard Vincent-Auriol
between rue Jenner and rue Bruant

c. 1970

In the 1970s, architects favored the technique of using prefabricated material, usually concrete or metal, because it made construction easy and inexpensive. The tendency, however, often created buildings that were boring and too systematic. This entire façade is treated without hierarchy, and the shape of the prefabricated module seems a very aggressive facing to the outside.

735

Immeuble d'Habitation

72–74, boulevard Vincent-Auriol at rue Jenner

1913, François Le Cœur

Using reinforced concrete, the architect showed off the material's versatility on the front of a traditional façade. Demonstrating its lighter properties, he matched it with ironwork on the balconies, giving the building a unique, decorative quality despite the harshness of the concrete. As an expression of the structural logic and architectural esthetic, the balconies designate the floor levels, the concrete is the framework that carries the building, and the brick is the filling.

736

École Nationale des Arts et Métiers

149–155, boulevard de l'Hôpital
between rue Pinal, rue Edouard Manet, and avenue Stephen Pichon

1909–12, Georges Roussi;
1960, Louis, Luc and Thierry Sainsaulieu, amphitheater

Built on the grounds of the former animal slaughterhouse of Villejuif, this site was ceded to the City of Paris in 1902. Architect Roussi required ten years of research before he created a complex that demonstrated the French tradition of classic rationalism. In 1960, an amphitheater was installed underground, shaped according to acoustic criteria.

737

Police Station

144 boulevard L'Hopital at rue Coypel

c. 1960

Situated on the old market site at place d'Italie, this police station brings together, in one facility, various services that were previously scattered in different buildings. A metal structure, like the framework of a modern tower, supports the building's façade, while the concrete ensures its vertical stability.

738

Habitations à Bon Marché

137, boulevard de l'Hôpital between rue Pinel and rue Campo-Formio

1922–26, Joseph Charlet and F. Perrin

The architects went overboard with the decorative detailing on this housing project. Unfortunately, the combination of excessive elements—the balconies, lintels, arches, and various window shapes—detracts from the overall impression of the façade, and the result is a hodgepodge. Despite the confusing frontage, the construction and mosaic work have held up well today.

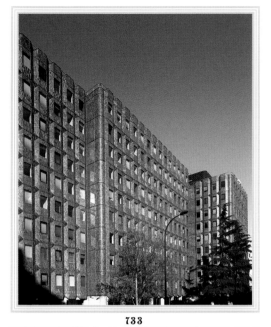

733

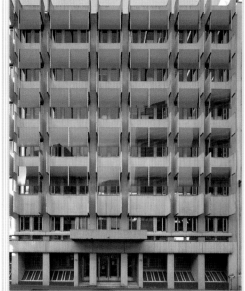

734

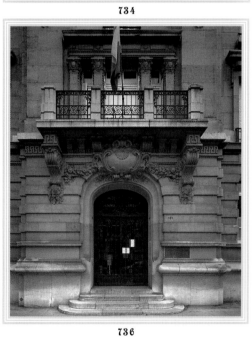

735

736

737

738

739

Ecole Nationale de Chimie, Physique et Biologie

11, RUE PIRANDELLO BETWEEN RUE LE BRUN AND RUE OUDRY

1972

Given this school's proximity to the Panthéon, it is viewed as an insult to architecture. Although not immediately visible, and constructed to fit the surrounding urban site, the building nonetheless accosts you the closer you get to it. Built high on top of the hill, it takes up considerable space on the block and, dating from the 1970s, its height is contrary to the scale of the older neighborhood. It is strangely disorienting. The school, built over a former Delahaye automobile factory, trains students in the sciences of chemistry, physics, and biology.

740

Temple du Droit Humain

5, RUE JULES-BRETON AT BOULEVARD SAINT-MARCEL

1912

Bringing a little bit of Egypt to Paris, this lodge features a balcony decorated with neo-Egyptian motifs: The symbol for fertility composes the balustrade, and Art Deco patterns top the pillars and roof edging. In 1893, G. Martin and M. Deraismes established a lodge here, dedicated to woman's rights. This organization inscribed in its façade words declaring that women deserved equal rights: *"Dans l'humanité la femme a les mêmes devoirs que l'homme. Elle doit avoir les mêmes droits dans la famille et dans la société."* ("As a human being, the woman has the same duties as the man. She must have the same rights [as he] in the family and in society.")

741

Ateliers de Reparation

9, RUE DES WALLONS AT BOULEVARD DE L'HÔPITAL

1919, ACHILLE CHAMPY

This building survives as a prime example of a bygone era: It housed early–twentieth-century industrial workshops whose industries essentially defined the 13th arrondissement. The use of the then-new material, reinforced concrete, created a façade that demonstrated the ability of the material to support and shape the third level arches, while illustrating its potential and versatility within the interior as well. The internal posts of concrete offered a vast floor surface that facilitated the use of machinery.

742

Centre Hospitalier Universitaire

91–97, BOULEVARD DE L'HÔPITAL AT RUE JEANNE D'ARC

1960, JACQUES-HENRI RIEDBERGER

One of the many medical buildings that, constructed during the 1960s in the 13th arrondissement, lack character, this one resembles grillwork, with a prefabricated metal façade. In contrast with the architecture of nearby La Salpêtrière, the repetitive grating gives this university hospital center a sterile image.

739

740

741

742

Mobilier National
(NATIONAL FURNITURE MUSEUM)

I ET I BIS, RUE BERBIER-DU-METS AT BOULEVARD ARAGO

1935–37, AUGUSTE AND GUSTAVE PERRET

Auguste Perret and his brother were commissioned to build this museum as a consolation prize, compensation for a rejected design on a previous project. Built on the site of the vegetable gardens of the Gobelins Manufactory, the museum was originally intended as a warehouse for state-owned furniture. The building itself represents Perret's desire to combine tradition with modernism: The symmetry and layout of the building, around a square court behind a colonnade, express tradition; while the placement of functional space and the choice of materials are modern touches. Beyond the curved, colonnaded portico, different blocks of the building border the main courtyard, and increase in size and distance relative to their function. For the construction, Perret mixed graveled concrete with traces of sandstone that allowed the building to age well. Son of a building contractor, Perret—who with his brothers carried on the family business—cared more about the technical aspects of a building, fine workmanship, and materials, than he did about artistic elements of design. He concentrated on developing the use of concrete in architecture, and believed the construction itself would result in beauty without any need for additional design enhancements. He referred to this as the "truth of structure."

743

744

744

Réseau Ferré de France

92 AVENUE DE FRANCE AT RUE THOMAS-MANN

2002, PAUL CHEMETOV AND BORJA HUIDOBRO

Supported at the interior ground level by flat, pierced steel columns that resemble slices of Swiss cheese, this all-window façade is punctuated with perpendicular, vertical cases that create a random pattern on the wide, otherwise bland glass frontage. Although this three-dimensional, abstract assemblage is one of the new constructions in the city's urban revival plans for the 13th arrondissement, the building looks a bit forlorn as it waits for new neighbors to arise from the massive construction sites in the surrounding area. Indeed, the neighborhood is a tangle of angles and lines created by railway tracks, bridges, cranes, cables, construction beams, and tension wires. The Université Paris is one of the early occupants here in a master plan that will include many others within walking distance of the Bibliothèque Nationale de France.

14TH ARRONDISSEMENT

Legions of artists, writers, and musicians have stirred passions in this residential quarter since the nineteenth century. The likes of Balzac and Chateaubriand gave way to Picasso, Modigliani, Man Ray, and a host of others in the early twentieth century. Now, boulevard Montparnasse stands as the quintessential symbol of this artistic and literary avant-garde scene, particularly at such notable surviving café-brasseries as La Coupole and Le Dôme. The boulevard also serves as the border to the 5th and 6th arrondissements, giving the 14th a stylish appeal by association.

Once an area of meadows and windmills, this area was incorporated into the city in 1860, when Haussmann plowed through Paris revamping its architecture. The district was largely spared that early restructuring, and remained a rural outpost with a maze of underground gypsum quarries that were later used as wine cellars for the cafés. Despite the gruesome Catacombs—where more than six million skeletons were deposited during the eighteenth century—and the Maine-Montparnasse project of 1960s that plunked a modern-day tower into the Paris skyline, the 14th arrondissement has retained a cozy, village atmosphere, with enclaves of artist studios and street markets. At the southern edge, Cité Universitaire and Parc Montsouris round out the district.

745

746

747

745

La Coupole

102, BOULEVARD DU MONTPARNASSE

1927, BARILLET AND LE BOUC, RESTAURANT;
1988, JEAN-LOUIS HANNEBERT, BUILDING RENOVATION

In 1927, René Layon and Ernest Fraux, former managers of Le Dôme café, bought an old coal shop and lumberyard on this site, and converted 1,000 square meters of it into what was then the largest brasserie in Paris. Josephine Baker performed in its famed basement dance hall; Hemingway, Henry Miller, Anaïs Nin, and Samuel Beckett also came here. The interior again looks as it used to: Thirty-two large square columns support a high ceiling covered with a cupola of glass flagstones.

746

Théâtre d'Edgar Quinet

58, BOULEVARD EDGAR-QUINET

1973, CAFÉ; 1975, THEATER

Founded in 1975 by Alain Mallet, the Théâtre d'Edgar Quinet is devoted to newly discovered authors, directors, and actors. This tiny space accommodates just seventy participants in its workshop, and has seating for only eighty in the theater, but it is an essential venue for exploring the theatricals not performed elsewhere. The café and the theater also represent a cultural activity source for the Montparnasse district, providing a gathering place, children's spectacles, and courses for theatrical study.

747

Théâtre Montparnasse

31, RUE DE LA GAÎTÉ AT THE CORNER OF RUE LAROCHELLE

1886, CONSTRUCTION

Originally outside the city boundary, this former theater was called La Nouvelle Troupe Comique du Mont-Parnasse. Performing semi-professional productions derived from commedia dell'arte theatricals, the company entertained a working-class audience who brought in their dinner while they watched the show. The theater's prestige rose in 1888, under the directorship of André Antoine. Its quality performances of plays such as *Cyrano de Bergerac* kept this a popular Parisian venue until the 1950s.

748

748

Place de Séoul

AT PLACE DE CATALOGNE

1983-1985, RICARDO BOFILL

Deeply transformed but partly conserved through local preservation efforts, this "new" neighborhood project, conceived in the sixties, was finally built in 1979. Architect Ricardo Bofill, who respected Parisian rules for building height, designed a circular center 100 meters in diameter. A monumental sculpture by Shamaï Haber dominates the huge, slanted ground floor. Resembling a stage set, the surrounding neoclassical buildings feature a carved ground level, monumental pilasters, and an attic. Columns fill two elliptical, inside spaces. Place de Séoul opens onto a pedestrian area and is patterned with a bow window design.

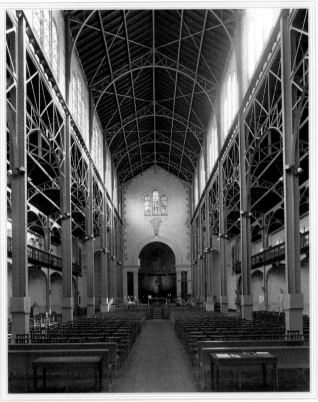

749

Notre-Dame-du-Travail (Our Lady of Work) was built in the midst of a working-class quarter and was dedicated to the workers of the world. Abbott Soulange-Bodin asked architect Astruc to convey a suitable ambience; hence, the iron-and-steel framework was used as a symbol of working materials. The façade is traditional stone and brick, and the surprising metal framework supports the interior vaulting. To top off this celebration of the dignity of industriousness, Astruc constructed his 135-ton metal nave using recycled material from the Palais de l'Industrie, built for 1855 Universal Exposition.

750

Hôtel Méridien

19, rue du Commandant Mouchotte at place de la Catalogne

1974, Pierre Dufau

The site of this hotel was once home to Gauguin, in the 1890s. He lived here with his Indonesian mistress, Annah la Javanaise. A glass entry door that he painted with a tropical scene was destroyed in transport, and the whole area was torn down for urban development. In 1974, Hôtel Méridien replaced a Sheraton hotel that had stood on this spot. Composed of white-painted steel plates and aluminum-framed windows over a concrete skeleton, this skyscraper rises to a dramatic height of 116 meters (377 feet).

751

L'Entrepôt

7–9, rue Francis de Pressensé at rue Losserand

Formerly a paper warehouse and now a restaurant, L'Entrepôt (*entrepôt* means warehouse) provides a cinematic atmosphere in which to eat, drink, listen to jazz, dance to salsa, or partake in a philosophical debate. It doubles as a music café and art house cinema. You can dine outdoors in the garden courtyard or inside on comfy couches under high-styled ceilings, within a black-painted interior adorned with movie posters.

752

Artist Ateliers

7, rue Lebouis at Raymond Losserand

1913, Emile Molinié

Two central bay windows and several large-scale picture windows provide ample light for these artist studios and residences. Architect Molinié created the façade as part of the City of Paris's contest of frontages in 1913. Beneath the ledge on the upper level, a frieze of yellow ivy on a brown base wraps around the building, in a process of mural decoration called *sgraffito*.

753

Société Municipale des Crèches du 14me

14, rue Jules Guesde At rue de l'Ouest and rue Raymond Losserand

1898

This charming kindergarten, set back from the street, typifies a domestic architecture of meticulousness. Attention to the detailing and the shape of the bricks on the walls, lintels, cornices, and the fine cast iron of the windowsills make this structure a little jewel. The terrace was a 1921–22 addition by architect Louis Marnez. This school accommodated a growing need in this poor district for a nursery during the mid-to-late nineteenth century.

754

17–19, rue des Suisses

Between rue Pierre Larousse and rue Jonquoy

2000, Jacques Herzog and Pierre de Meuron

Swiss-born architects Herzog and de Meuron achieved career recognition with the Pritzker Prize in 2001. They also won the French prize, Equerre d'Argent, for this building, which demonstrates their tendency for minimalism with straight-line detailing. This façade has a lattice of metal shutters that seems to dance along the rues Suisse and Jonquoy. Mixing wood and black metal, the architects created shutters that add texture to the building when they are closed.

755

Creche Collective
(Dispensaire Furtado-Heine)

10, rue Delbet between rue d'Alésia and rue Jacquier

1884, Paul Blondel; 1988, Christian de Portzamparc

In 1884, Madame Furtado-Heine, daughter of a banker and benefactress of several charities, founded this establishment for medical aid. The original portal, with its ridged Doric columns and pediment, expresses neoclassical design. Beyond this brick and stone wall, architect de Portzamparc created a modern building to serve as the dispensary.

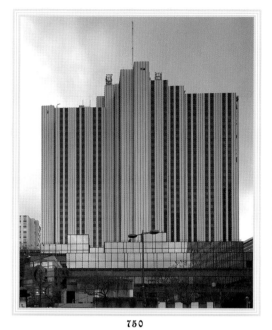

750

751

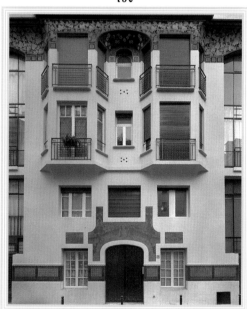

752

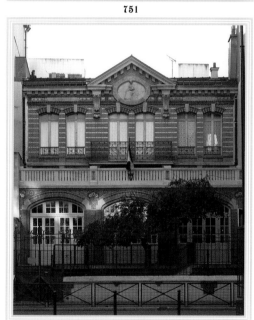

753

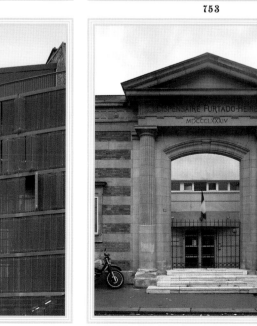

754

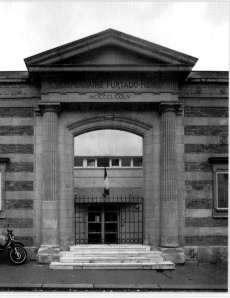

755

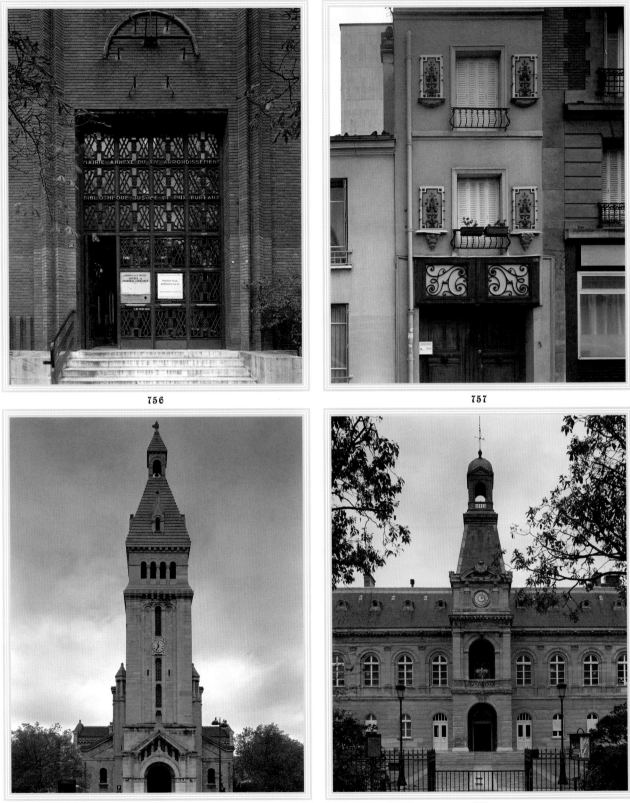

756

757

758

759

756
Conservatoire Municipale/ Tribunal d'Instance

26, RUE MOUTON-DUVERNET AT RUE GASSENDI

1933, GEORGES SEBILLE

In the years between World Wars I and II, the population of the 14th arrondissement outpaced the public assistance it required. This building, created as an annex to the old town hall, answered the need for increased services while, at the time, it symbolized the power inherent to public facilities. Providing these civil services was a monumental task, given the economic crisis of the day. Thus, the architect created an imposing structure to appear up to the task. Its symmetrical proportions and massive features—huge windows, a large balcony, marble hallways and staircases, and decorative friezes inside with the emphatic titles of *Action* and *Thought*—all conveyed a sense of power and contributed to a public feeling of security.

757
39, rue Hippolyte Maindron

BETWEEN RUE OLIVIER NOYER AND RUE DU MOULIN-VERT

C. NINETEENTH CENTURY, BUILDING

At the turn of the last century, a Monsieur Machin developed inexpensive huts and artists' workshops at the corner of rue du Moulin-Vert. In 1927, sculptor Alberto Giacometti and his brother Diego settled into one of these residences, number 46, rue Hippolyte Maindron, although it offered few comforts—just a small stove with coal, a gas burner, and a tap in the corridor. They intended to stay a short while, but lived here for thirty-nine years, until Alberto died. Situated near the sculptor's former workshop, this odd little house has been redecorated in Art Nouveau style. This quiet street is named for another sculptor, Hippolyte Maindron (1801–84), who produced the statue that ornaments the Luxembourg Gardens.

758
Eglise Saint-Pierre-de-Montrouge

PLACE VICTOR AND HÉLÈNE BASCH AT AVENUE DU MAINE AND
AVENUE DU GENERAL-LECLERC

1863–70, EMILE VAUDREMER

Architect Vaudremer, who also designed Notre-Dame-d'Auteuil, took liberties with this neo-Roman church, basically styled to resemble a Tuscan basilica, by adding Italian, Syrian, and Sicilian details. With austere dignity, the square clock tower reaches its full height atop the triangular plot of land on which it was built. Vaudremer topped it with a pyramid surmounted by a square lantern, to balance the base. The church also served as a model for his work on Notre-Dame-d'Auteuil later on.

759
Mairie

2, PLACE FERDINAND BRUNOT BETWEEN RUE SAILLARD
AND RUE DUROUCHOUX

1852–58, CLAUDE NAISSANT; 1889, EXTENSION

As had all the town halls built in the city during the mid-nineteenth century, this one promoted the expansion of Paris and expressed a particular idea of civic policy. Following conventional form, a high bell tower dominates the central façade, flanked by two wings extending to high-roofed pavilions on both ends. Between the clock and the flag the three words, "Liberty, Equality, Fraternity," are inscribed, and a balcony is positioned for speeches. This structure looked back to that of a medieval castle, whose symbol of power was its tower; while its Renaissance decoration expressed the more modern progress of ideas, arts, and peace. The entire building occupies one block.

760
Le Dôme

108, BOULEVARD DU MONTPARNASSE AT CORNER OF RUE DELAMBRE

1897; 1986, RENOVATION

A modest café now, but major watering hole during World War I and into the twenties and thirties, Le Dôme attracted such international expats as Picasso, Lenin, Trotsky, Beckett, Sinclair Lewis, and Henry Miller, among others. The café figured prominently in many works of literature including *The Sun Also Rises* and *Tropic of Cancer*. Henry Miller described Le Dôme "in the blue of an electric dawn" as "a shooting gallery that's been struck by lightning."

761
Passage d'Enfer

AT RUE CAMPAGNE PREMIÈRE AND BOULEVARD RASPAIL

1911, ANDRÉ ARFVIDSON, ARCHITECT AND ALEXANDRE BIGOT, CERAMIST

From boulevard Raspail, originally named boulevard d'Enfer (Hell), this tiny street makes an L-shaped right angle onto Campagne-Première. In 1911, architect André Arfvidson applied decorative earthenware tiles to the artists' studios at 31, rue Campagne-Première. Reminiscent of Art Nouveau styling, this ceramic-tiled façade, designed by Alexandre Bigot, covered a concrete frame with vast bay windows. It leads to the entrance of a private arcade named Passage d'Enfer.

762
Ecole Spéciale d'Architecture

254–266, BOULEVARD RASPAIL AT RUE VICTOR SCHOELCHER

1904, 254, BOULEVARD RASPAIL
1988, CUNO BURLLMANN AND ARNAUD FOUGERAS-LAVERGNOLLE

These buildings house an independent school of architecture, founded in 1865 by engineer Emile Trélat as a reaction to the Beaux Arts tradition that, for a long time, had dominated architectural education in France. At the only private school of architecture in Paris, students fully participate in the collective administration of the school. Architect Robert Mallet-Stevens, who built the homes on rue Mallet-Stevens, both studied and taught here. Other celebrity architects who have taught at ESA include Auguste Perret, Henri Prost, Paul Virilio, and Christian de Portzamparc, architect of Cité de la Musique and winner of the 1994 Pritzker Prize.

763
Studio Raspail

216, BOULEVARD RASPAIL AT RUE HUYGHENS

1929–32, BRUNO ELKOUKEN

Architect Elkouken, of Polish-Jewish descent, fled to the United States during World War II, and thus produced only five buildings in Paris. This one draws on abstract and Cubist notions. Situated in the heart of Montparnasse, the artist enclave of the period, these flats resemble modern artists' lofts in their surface appearance; but, in fact, they were conceived for bourgeois tenants seeking luxury residences. Like an artist's studio, they allow maximum light—though true artists would have required a northern exposure for consistent light during the working day. The interplay of white spaces on the façade, with the black metalwork on the rectangular bay windows, creates block-like cubes on the frontage and emphasizes the building's abstract roots.

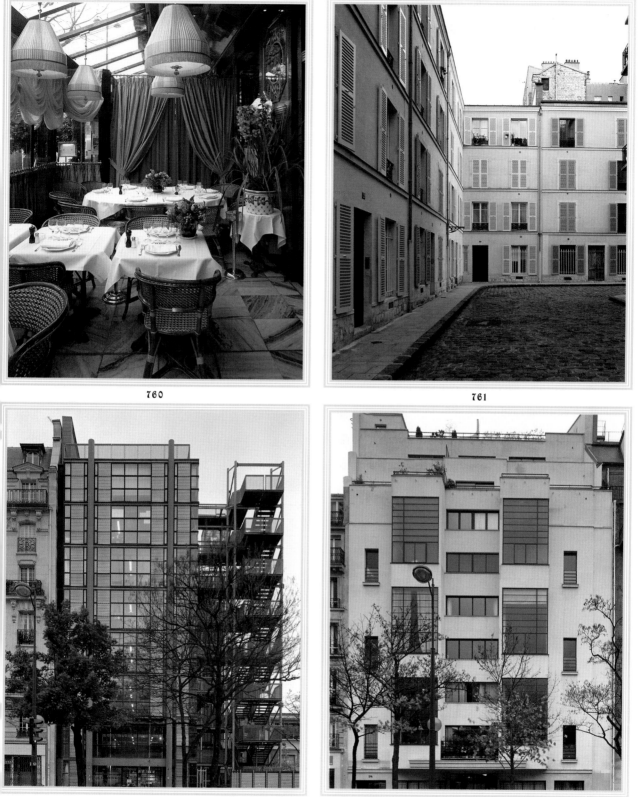

760

761

762

763

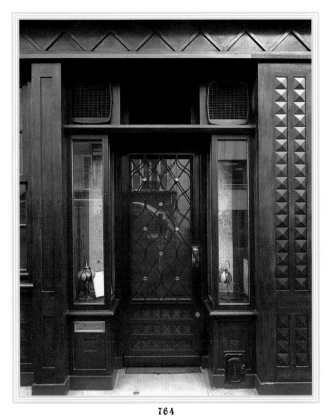

764

764

Le Rosebud

11 BIS, RUE DELAMBRE AT BOULEVARD DU MONTPARNASSE

C. 1900, BUILDING; C. 1930, BAR

Cinematic references aside, this bar reels in characters from central casting. Starlet hopefuls, hard-core Casanovas, and movie-star doubles rub elbows with martini-drinking locals in this low-lit Montparnasse hangout. Behind its geometric entrance, waiters in white jackets scurry between red-lacquered tables and black banquettes.

765

765

126, boulevard Montparnasse

AT RUE LÉOPOLD ROBERT

1908, LOUIS SÜE

Architect Süe created this private complex of artist ateliers and apartments. The structures have stone façades and the large, tiered windows of various shapes and proportions. In the absence of any additional decoration, this particular early twentieth-century building relies on purity of form. The vast lighting possibilities, as well as an elegant back entrance and the luxurious courtyard gardens, still make these living and working quarters an appealing environment.

766

Hotel Istria

31, RUE CAMPAGNE-PREMIÈRE AT BOULEVARD RASPAIL

1911, ANDRÉ ARFVIDSON

Ceramic detailing gives this industrial façade charm and helped the architect win an award for its frontage in 1911 from the Town of Paris. The sandstone tiling by ceramist Alexandre Bigot covers this reinforced concrete duplex of twenty workshops with residences. The three-dimensional floral elements add geometric patterning to the piers and around the window borders.

766

767

3–7 and 12, rue Cassini

BETWEEN RUE DU FAUBOURG-SAINT-JACQUES AND AVENUE DE L'OBSERVATOIRE

1903–06, LOUIS SÜE, NUMBERS 3–7; 1930, CHARLES ABELLA, NUMBER 12

Named for the four generations of astronomers who lived here, the street was also home to Honoré de Balzac, between 1828 and 1835. Painter Lucien Simon lived in the brick and reinforced-concrete building at number 3; architect Süe also created a neo-Gothic brick dwelling for artist Jean-Paul Laurens, and a classical-style house for painter Czernikowski. In 1930, architect Abella designed the overhanging structure, which boasts bay windows and a tower that encases a spiral stairway.

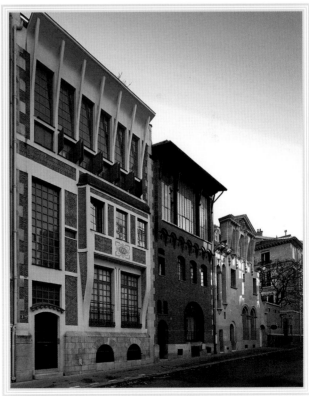

767

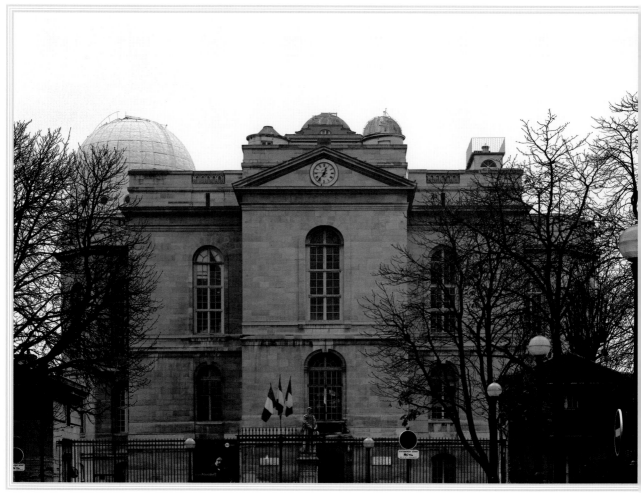

768

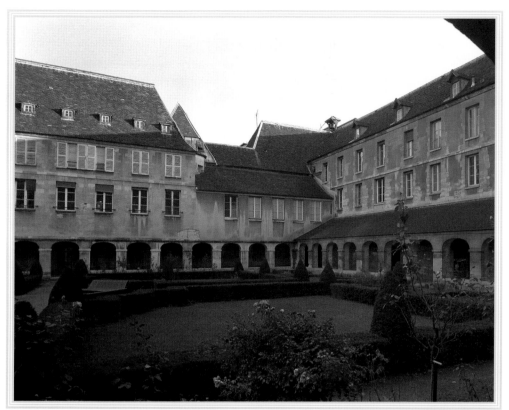

769

769

Observatoire de Paris

61, AVENUE DE L'OBSERVATOIRE
AT BOULEVARD ARAGO AND RUE DU FAUBOURG-SAINT-JACQUES

1667–72, CLAUDE PERRAULT; 1854, DOME

At Minister Colbert's insistence, Louis XIV founded the Académie Royale des Sciences for the pursuit of astrological sciences. The building's axis aligns with points of the compass—a crucial aid to seafaring navigation, which naturally figured in the success of French naval battles and ultimately in the glory of the kingdom. Built on the southern end of avenue de l'Observatoire, its north-south axis also aligns with the Palais du Luxembourg. Originally, Perrault designed this rectangular building with two identical octagonal towers, but in the nineteenth century a dome was added to the eastern tower to accommodate a telescope. Prior to this addition, a telescope had been positioned on the building's flat roof from which Jean-Dominique Cassini plotted a map of the moon and noted the rings of Saturn. Today, the observatory is used primarily to study of the earth's rotation.

Abbey of Port-Royal

123–125, BOULEVARD DE PORT-ROYAL
AT RUE DU FAUBOURG-SAINT-JACQUES

1648–53, ANTOINE LE PAUTRE

The origins of this cloister date to 1626, when it was the Cistercian abbey of Port-Royal des Champs, in the Chevreuse Valley. (Its roots date back even further, to 1204, but Mother Angelica, Marie-Jacqueline Arnaud, was responsible for major changes to the structure.) This abbey became home to a seventeenth-century reform movement known as Jansenism. As a center for intellectual religious thinking, it attracted the best and the brightest of the day: Pascal, Racine, and the Arnauds. In 1656, Pascal wrote *Provinciales*, in defense of Jansenism; and later, when his sister miraculously recovered here, he wrote *Pensées*, his apology for Christianity. The cloister was converted to a prison during the Revolution and then into a nursing home until, in 1812, it became a maternity hospital. The present hospital complex on this site includes the abbey's original cloister and chapel.

770

771

772

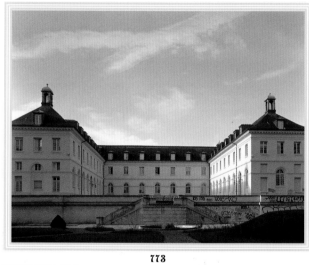

773

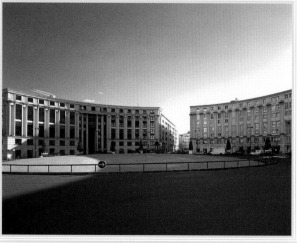

774

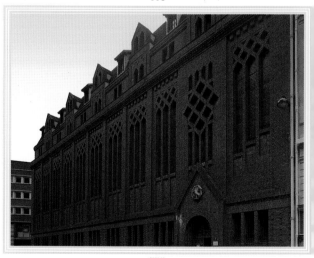

775

770

Fondation Cartier d'Art Contemporary

261, BOULEVARD RASPAIL AT RUE BOISSONADE

1992–94, JEAN NOUVEL

Architect Nouvel designed a contemporary structure on a historic site where Chateaubriand once lived, using parallel glass panels in succession, opening the space to imagination. The building's transparency links the park below with the sky above, creating a synergy between the two. When Chateaubriand had lived on the property, he had planted a cedar tree here, and it still grows on the premises, fostering a natural, organic connection with the contemporary art environment.

771

276–280, boulevard Raspail

AT PLACE DENFERT-ROCHEREAU

1903, THÉO PETIT AND EMILE DERRE (NUMBER 278);
1905, THÉO PETIT AND EMILE DERRE (NUMBERS 276 AND 280)

Although architect Theo Petit designed these three buildings simultaneously, they all look different. He won a prize for these façades at a time when city authorities tried to regenerate the Haussmann model. Petit created projecting balconies above bay windows; and the main rooms jutted out, as seen in number 280. The entire decorative scheme was quite sophisticated, and borrowed from a mix of Rococo and Art Nouveau patterning.

772

Gare Denfert-Rochereau

3, PLACE DENFERT-ROCHEREAU AT AVENUE RENÉ COTY

1846, DULONG (ENGINEER)

This is the oldest railway station in Paris, at the end of the southern Sceaux line, but it now welcomes the modern RER trains. Two curved wings flank the central forecourt with its three bays. One of the extensions ends in a square pavilion but the other was destroyed. Flat pilasters create a rhythm on the façade, and the central forecourt is crowned by a sculpted relief and a clock. The three arched bays open onto a hall which is upheld by fine, cast-iron piers.

773

Hôpital La Rochefoucauld and Villa Adrienne

15 AND 19, AVENUE DU GÉNÉR AL-LECLERC AT VILLA ADRIENNE

1781–83, CHARLES-FRANÇOIS VIEL OR JACQUES-DENIS ANTOINE;
1802, NICOLAS-MARIE CLAVAREAU, EXTENSION

Initially called the Maison Royale de Santé, Hôpital La Rochefoucauld was the former Royal Nursing Home for poor veterans, clergy officers, and government officials with no means of support. It stands next to the nineteenth-century Villa Adrienne. Composed of brick and stone, the private and provincial homes of Villa Adrienne border on a large, rectangular site where quiet prevails in the midst of this bustling arrondissement.

774

Place de la Catalogne

AT RUE VERCINGÉTORIX

1985, RICARDO BOFILL

This semi-circular place is one of the few well-conceived architectural achievements in the cement-pervasive 14th arrondissement of the last decades of the twentieth century. Here, Bofill created neoclassical buildings to surround a circular fountain created by sculptor Shamaï Haber. The place is particularly impressive when floodlit. Through an archway on rue Vercingétorix, two connected courtyards lead to the curved glass façades of the oval-shaped place de Séoul and, on the opposite side, the semi-circular place de l'Amphithéâtre.

775

Couvent des Franciscains

7, RUE MARIE-ROSE AT RUE DU PÈRE CORENTIN

1930, BLAVETTE ET GÉLIS, PROJECT;
1934–38, HULOT AND GÉLIS, CONSTRUCTION

Constructed around a large, square courtyard, this convent has two distinct buildings: The public section contains the chapel, the visitors' room, and a conference room; the other structure houses the convent itself. The chapel is of brick construction with a slate roof and a square tower above the choir. Stained glass windows fill the sanctuary with high colors, and seven small chapels in the back are each lit by three bays.

776

Eglise Saint-Dominique

16–20, RUE DE LA TOMBE-ISSOIRE AT VILLA SAINT-JACQUES

1914, LÉON-GEORGES GAUDIBERT

A sculpted figure of Saint-Dominique, created by A. Bourroux in 1946, welcomes parishioners to this Roman-Byzantine style church above which a dome of twenty-seven meters rises. The piers, colonnade, and mosaic interior décor contrasts with heavy and somber, external construction.

777

Maison Maternelle

41, AVENUE RENÉ COTY AT RUE D'ALÉSIA

1909, ETIENNE PERRIN AND JOSEPH CHARLET

Architects Perrin and Charlet designed this cheerful primary school to be like the yellow brick road of Oz. Its regionalist style uses yellow brick with brown patterns all along the façade, and the roofs jut out as if they belonged in the countryside. The building is far afield from the Haussmann stone architecture of the mid–nineteenth century, and equally far from the Modern Movement, which favored its white façades. At ground level, the building is constructed of indigenous stone.

778

Maison-atelier

50, AVENUE RENÉ COTY AT RUE DE L'AUDE

1927–31, JEAN-JULIEN LEMORDANT AND JEAN LAUNAY

Inspired by his native Brittany, Jean-Julien Lemordant became famous at the turn of the last century for his scenic paintings. During World War I, he lost his sight in the trenches, but subsequently designed and sculpted a clay model of this house, with the assistance of Jean Launay. Because of the layout of the land, this vast studio, which the artist never used as such, was constructed like a ship's bow and perched atop a steep wall.

779

Cité du Souvenir

11, RUE SAINT-YVES AT RUE DES ARTISTES

1926–30, LÉON BESNARD AND D. BOULANGER

Built at the initiative of Abbot Alfred Keller, this enclave of homes, constructed of reinforced concrete with a brick facing, was intended for the victims of World War I. George Desvallières, one of the founders, in 1919, of the Workshops for Sacred Art, created the religious painting and stained-glass décor, including the depictions of the *Dead Soldier carried by Christ*, and the *Holy Women at the Tomb*. After 1910, Desvallières, a portraitist, resolved to practice religious art exclusively.

780

Ozenfant House and Atelier

53, AVENUE REILLE AT SQUARE MONTSOURIS

1923, LE CORBUSIER AND PIERRE JEANNERET
1946, ALTERATION AT THE ROOF

With the construction of this house and studio, painter Amédée Ozenfant claimed to be Le Corbusier's first French client. With his cousin, Pierre Jeanneret, as his design partner, Le Corbusier conceived of a studio roof composed of tilted glass panels. An exterior spiral staircase gave an additional sense of open space; and large horizontal openings and bay windows infused the painter's studio with constant light.

781

Collège Néerlandais Cité Universitaire

47-63, BOULEVARD JOURDAN AT RUE EMILE FAGUET

1928, WILLEM-MARINUS DUDOK

The Modern Movement in the 1920s chose to explore industrial models of function and form, as did Dutch architect Dudok. In creating this dormitory for Cité Universitaire, Dudok decided to take a horizontal mass and divide it vertically, to create an interaction of planes. He played with the positive and negative space, wrapping the building with dark horizontal bands of windows in contrast to the solid mass of white. By these means, he shaped the dormitory without any need for additional decoration.

776

777

778

779

780

781

782

Parc Montsouris

In 1912, Bolshevik party leader Lenin chose the Pavillion du Lac in Parc Montsouris to bid his comrades farewell as he prepared to depart Paris for Switzerland. The leanings of the Russian Bolshevik notwithstanding, this park is known for romance, not politics. Modeled on an English garden, this enchanting park is host to a number of summer wedding ceremonies. In 1867, Napoléon III's busy landscape architect, Adolphe Alphand—who also designed several other Parisian parks including Bois de Boulogne—converted thirty-nine deserted acres on the hill of Montsouris to rolling garden paths with bridges and a lake. Today in the park, a puppet theater entertains children, musicians give strollers an earful, and the swans gliding upon the lake provide the perfect backdrop for a wedding reception.

783

783

Le Pavillon Montsouris

20, RUE GAZAN AT PARC MONTSOURIS

1880, CONSTRUCTED;
1889, OPENED AS RESTAURANT

A stylish crowd gathers at this restaurant, located on the eastern edge of Parc Montsouris. Set in the midst of picturesque, leafy green canopies, rolling hills, and winding paths, this glass-enclosed pavilion-style restaurant resembles a greenhouse. Its elegant, pastel-colored interior overlooks the romantic park built over quarries by Adolphe Alphand in 1867 and '78—the perfect setting for a lost afternoon brunch.

Cité Internationale Universitaire de Paris
(FOUNDATION ARGENTINE/FOUNDATION AVICIENNE)

27, BOULEVARD JOURDAN AT PARC MONTSOURIS

1968, CLAUDE PARENT, MOSSEM FOROUGHI, HEDAR GHIAI,
AND ANDRÉ BLOC

This suspended, double-decker building is an industrial purist's dream. The metal structure seems to float above a motorway as its four-floor building blocks hang from three massive steel porticos. Attached on the side, two inverted, double-spiral staircases bring reverse, vertical movement to the structure.

784

784

Villa Guggenbühl

14, RUE NANSOUTY AT RUE GEORGES BRAQUE

1927, ANDRÉ LURÇAT

Multiple colors, and horizontal and vertical lines initially shaped this residence. Architect Lurçat intended to create a functional villa with aesthetic appeal. Thus, he scattered windows around the façade in a subtle pattern of open and closed spaces, painted certain portions of the building white, and used bold blocks of color for the other facings. Today, altered over time, this villa has twice as many windows than had existed in Lurçat's original design, and a monochromatic paint scheme.

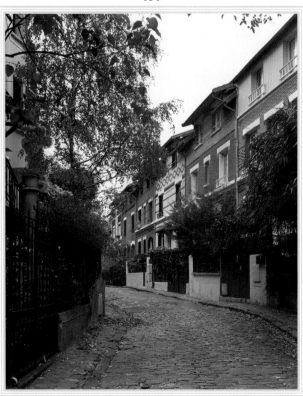

785

785

Square de Montsouris

BETWEEN AVENUE REILLE AND RUE NANSOUTY

1922, JACQUES BONNIER, ARCHITECTURAL PLANNER

Just off of the eastern edge of Parc Montsouris, charming row houses and studios line this curved, quaint road. Surrounded by lush vegetation, each home exhibits artistic and eclectic features. Skylights, gardens, and flower boxes mark the street and others nearby. The romance of this villa atmosphere among the ivy and wisteria and lilac drew artists and architects to these hideaway homes. Architects Guggenbühl and Le Corbusier designed residences here, and artist George Braque lived one block away.

786

Allée Samuel Beckett

AT AVENUE RÉNE COTY

Residential buildings of all shapes, sizes, and material line both sides of avenue Réne Coty. Allée Samuel Beckett, named for the Irish playwright, is the flat, central divide of the avenue. Roller-bladers, bikers, and children with foot-pedaled scooters maneuver past strollers and dog-walkers on this tree- and bush-lined, paved walkway. With cars streaming by on either side, it's not quiet, but it does provide unhindered pedestrian access to the lovely and serene Parc Montsouris just down the street.

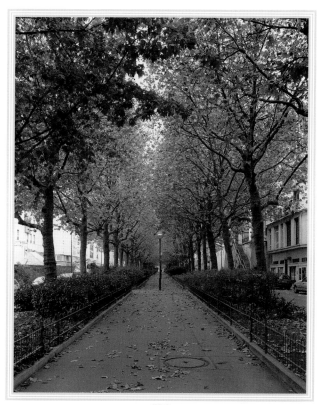

786

787

Building of Artist Ateliers

3, RUE DE LA CITÉ UNIVERSITAIRE

1930, MICHEL ROUX-SPITZ

Between the wars, architect Michel Roux-Spitz created what he referred to as his "white series," artist workshops and residences modeled on those constructed on rue Guynemer. Having views that overlook Parc Montsouris, these ateliers are structured with reinforced concrete, and feature bay windows and small ox-eye openings at the ground floor. Mosaics decorate the frontage at this level, and around the edges of the bays.

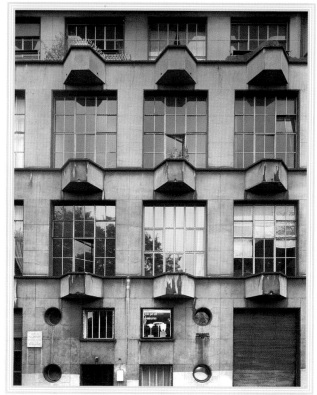

787

788

Institut du Judo

21–25, AVENUE DE LA PORTE DE CHÂTILLON AT BOULEVARD PÉRIPHÉRIQUE

1988–2001, ARCHITECTURE STUDIO

The Institute for Judo sits on a triangular site like a huge skullcap composed of oxidised copper. This partially sunken sphere, 100 meters in diameter, contains seating for 1,800 spectators. The Judo Federation's offices, on the side of Montrouge cemetery, occupy another, transparent building that, 130 meters long with a concrete frame, leads to the organization's training and competition areas.

789

Villa Seurat

7 BIS, VILLA SEURAT AT RUE DE LA TOMBE-ISSOIRE

1926, AUGUSTE AND GUSTAVE PERRET

Villa Seurat inspired Henry Miller's *Tropic of Cancer*. It was here that he met Anaïs Nin, and together they started the journal *La Revue Officielle de la Villa Seurat*. Hungarian photographer Brassai also lived in this cluster of studios. One of the earliest houses was built by architect Lurçat for his brother, Jean, known for his tapestry art. Sculptor Chana Orloff commissioned the Perret brothers to design her home at number 7.

790

11, rue du Parc de Montsouris

BETWEEN AVENUE REILLE AND BOULEVARD JOURDAN

This private residence anchors the turn of a U-shaped, cobblestone street. Slightly unkempt and overgrown with vines, the façade features rusticated stone, wooden trimming, and tiled gables. An arched stone entry leads to a private garden where a large, seated classic sculpture rests in a stone alcove.

791

Pavillon Suisse de la Cité Universitaire

7, BOULEVARD JOURDAN AT AVENUE PIERRE DE COUBERTIN

1932, LE CORBUSIER AND PIERRE JEANNERET; 1953, FAÇADE CHANGES

Part of the student accommodations for Cité Universitaire, this was the first housing project designed by Le Corbusier and served as his model for "Cité Radieuse," his prototype plan for public living quarters. This residence features his five points of architecture: thin round posts (*pilotis*), horizontal windows, a light façade of metal and glass, no visual structural supports (free layout), and roof terraces. He decorated the interior with a fresco, and also designed the furniture.

792

Cité Universitaire Internationale
(MAIN BUILDING)

19, BOULEVARD JOURDAN AT AVENUE ROCKEFELLER

1923, LUCIEN BECHMANN (ARCHITECT PLANNER)

Founded in 1920 by Emile Deutsche de La Meurthe, in memory of his wife, Cité Universitaire is the oldest university campus in Paris. Built on a former fortification site, the university is virtually an international student village, comprised of thirty-seven dormitories, the entrance of which is at 19, boulevard Jourdan. The Fondation Emile et Louise Deutsch de La Meurthe, which consists of seven gabled houses, was the first of the residences to be constructed.

793

Maison du Brasil

CITÉ UNIVERSITAIRE AT AVENUE DE LA PORTE DE GENTILLY

1959, LE CORBUSIER AND LUCIO COSTA

For these dorms, Le Corbusier merely cloned his Cité Radieuse development in Marseilles from seven years before, which he had based on his nearby Swiss Pavilion model from yet twenty-seven years earlier. He added sheltered loggias, whose sides were painted in the colors of the Brazilian flag, which extended the dorm rooms but did not serve the same purpose in Paris as they did in Marseilles, where they were sun shields. A smaller, adjacent structure, with an oblique roof, contrasts with the solid mass of the main building.

788

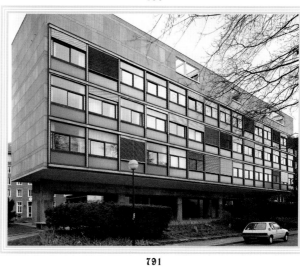

789

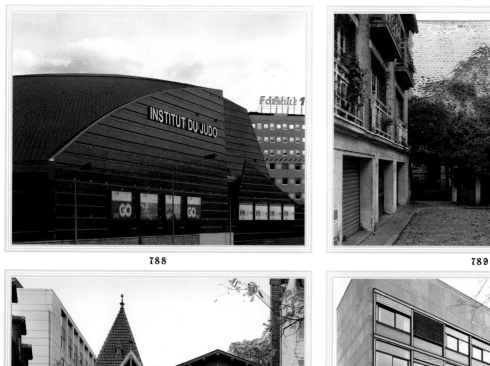

790

791

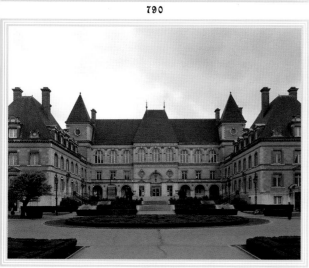

792

793

794

795

Hôtel de Massa

38, RUE DU FAUBOURG-SAINT-JACQUES AT BOULEVARD ARAGO

1777–78, JEAN-BAPTISTE LE BOURSIER

In 1929, real estate developers Théophile Bader and André Lévy eyed the Champs-Elysées as hot property. They decided to relocate this eighteenth-century mansion that had been built at 52–60 Champs-Elysées, when the area was still considered rural. The building was carefully dismantled in 1929, each stone numbered, and shipped to its present site near the Observatory gardens, where it was then reconstructed stone by stone to maintain its balanced proportions. Today, the building houses the headquarters of the Société des Gens de Lettres (Literary Society).

Hôpital Cochin

53, AVENUE DE L'OBSERVATOIRE AT 55, RUE H. BARBUSSE

1646–48, LEPAUTRE, CHAPEL

This maternity hospital sits on the site of the former Abbey of Port-Royal—the hotbed of Jansenism during the reign of Louis XIV. Originally this building had been located outside of Paris in Chevreuse Valley, where it was known as Port-Royal-des-Champs. Then a center for religious and scholarly retreat, it fostered ideas and adherence to principles that threatened the structure of absolutism as well as the Jesuits' beliefs. Branded as heretical, this abbey and cemetery were demolished, but the seventeenth-century chapel and other buildings, now part of the hospital, survived both the Revolution in 1793, when it was used as a prison, and German shelling in 1918, which hit the hospital's maternity ward causing twenty deaths of mothers and babies.

15ᵀᴴ ARRONDISSEMENT

In the Middle Ages, the Abbey of Saint-Germain-des-Prés owned the villages of Vaugirard and Grenelle, the east and west sectors of today's 15ᵗʰ arrondissement. The monks tilled the productive pastures of Vaugirard, planting vineyards, but in time the less desirable Grenelle ground proved fertile for rapid factory growth. Once these factories were relegated to the suburbs, development during the 1960s left this former working-class area with a hodgepodge of old and modern architecture. One of the bright spots to replace former industry is the Parc André Citroën, located along the quai of the same name, which was built over an old auto-manufacturing plant. The construction of towers at quai de Grenelle, which has been created over landfill, contrasts with the Vaugirard quarter that benefits from its proximity to the swanky 7ᵗʰ arrondissement. In front of quai de Grenelle, a miniature version of the Statue of Liberty, placed at the edge of Île aux Cygnes for the 1937 World's Fair, looks west to its grand New York sister.

796

797

798

799

796
Chemin de Montparnasse

21, AVENUE DU MAINE AT BOULEVARD DU MONTPARNASSE

Down a cobblestone passageway whose old ateliers are hidden by overgrown greenery, this studio museum provides the neighborhood with a local venue for what's current in the visual arts. This arty alley space, formally known as Musée de Montparnasse, keeps the spirit of Montparnasse's bohemian days alive just a short distance from Tour Montparnasse with exhibits of art and photography, and evening events featuring music and poetry.

797
Immeuble d'Habitation

81–91, RUE FALGUIÈRE AT RUE D'ARSONVAL

1991, J. CONNEHAYE, A. BLED AND A. LECLERCQ

Falcons claimed this as their living quarters before the staff of a renovation project, and architect Connehaye enlisted the aid of professional ecologists to remove the nests and the falcons, and to transfer them to Versailles. Demolition then proceeded on this site, a former aeronautic construction plant. Built for both commercial and residential use, the apartment complex that developed on an exceptionally large piece of property, allowed for a wide façade of almost ninety meters across. Beyond a large, transparent entrance are 202 apartments and two courtyards. Commercial space on the ground floor accommodates an exposition hall and a service station for BMW automobiles. Below ground level are 600 parking spaces.

798
Siège du Crédit Agricole

90, BOULEVARD PASTEUR AT RUE DU COTENTIN
AND SQUARE MAX HYMANS

1975, RENÉ GENIN AND JEAN-LOUIS BERTRAND

The accordion-like folds of this façade give this bank an appearance of animation on a playful, human scale, in a neighborhood dominated by the nearby, impersonal Tour Montparnasse. Conceived as open-plan offices, the extended sides also serve a practical purpose, in minimizing sound echoes—an effect achieved by the layout. Elevated on a two-story base, the building attains a monumental presence by its broad glass-mirrored façade.

799
Former head office of Le Monde

13–15, RUE FALGUIÈRE AT VILLA GABRIEL

1990, PIERRE DU BESSET AND DOMINIQUE LYON

The transparency of this building—a window on the world of ideas and people—was key to bringing light and hospitable space to the former headquarters of the newspaper, *Le Monde*. The architects transformed the ramp of a former garage into a glass-covered atrium surrounded by five floors of office spaces that are connected by overhead passageways and partitioned by glass panels. The convex glass frontage gives the building grace and enlarges the narrow street by reflecting the sky. Despite its height, the shape of the façade expresses discretion on this quiet street.

800

Notre-Dame de l'Arche d'Alliance

81, RUE D'ALLERAY

1998, ARCHITECTURE STUDIO

The external, cube-like shape of this church conceals its internal frame of a pyramid. At the top, thicker inside walls form meeting rooms and lodging for two priests. Conceived as a structure for contemporary worship, it was the first church built in Paris since the construction of Saint-Eloi in 1968. Twelve stone columns sunk twenty meters into a former quarry signify the twelve apostles, and raise the church above ground level. A stainless-steel screen provides for display of sculpture and paintings.

801

Villa Santos-Dumont

RUE SANTOS-DUMONT BETWEEN
RUE DE VOUILLÉ AND RUE DES MORILLONS

C. 1889, FIRST HOUSES

This vine-covered cul-de-sac of homes with diverse façades was built as an artists' haven in the midst of the city. Painter Victor Brauner resided here, as did Russian sculptor Ossip Zadkine. Artist Fernand Léger lived at number 4. In 1968, French singer-composer Georges Brassens moved into the area, and remained until his death in 1981. Housing projects by architects Antoine Lazo and Edouard Mure can be seen at numbers 16–18, 10 bis, and 28.

802

Immeuble d'Habitation

131, RUE DE VAUGIRARD AT IMPASSE GARNIER

1936, LÉON-JOSEPH MADELINE

Deep brown bands of self-cleaning earthenware tiling underline the rounded corners on either side of the entrance of this monumental apartment complex. The owners of the property, the Garnier publishers, originally conceived of this as a gardened apartment complex featuring additional side buildings with arcades. However, World War II interrupted construction, and only the first part of this project was completed.

803

Je Thé...me

4, RUE D'ALLERAY AT RUE FRANÇOIS VILLON

C. 1900, BUILDING

Once a neighborhood *épicerie* (grocery), this corner bistro still displays its original fin de siècle advertising signs that offered teas, coffees, cognacs, and other beverages. Beyond the red awning, the old grocery shelving inside holds a collection of vintage brass and ceramic kitchenware. A slate chalkboard lists the day's specialties and freshly baked pastries. Tea service is available, as the word *thé* suggests; but, in a play on the words *je t'aime*, the restaurant's name also implies "I love you."

804

Tour Totem

55, QUAI DE GRENELLE, FRONT DE SEINE AT RUE DU THÉÂTRE

1978, PIERRE PARAT AND MICHEL ANDRAULT, TOWER

Attached to a visible concrete column, square window blocks overhang the pedestrian walkway at ground level and almost appear as if they could rotate like a windmill. The blocks, grouped as units of three, hang off this circular tower at forty-five degree angles to allow a full view of the Seine. These luxury apartments have tight security measures in place, as they are occupied primarily by citizens of the Gulf States.

805

Tour Cristal
(CRYSTAL TOWER)

7, QUAI ANDRÉ-CITROËN AT PONT DE GRENELLE

1990, JULIEN PENVEN AND JEAN-CLAUDE LE BAIL

This reflective glass tower stands like a shining bullet in the sky. The lightly tinted bronze color of the glass façade changes with the position of the sun, and as light hits it at different angles, the intended effect is one of a sparkling crystal specimen. Conceived as a sculpture in glass rather than as a mere vertical tower, it nonetheless typifies tower constructions of the 1980s. Today, it functions as an office building instead of its original purpose as a high-rise apartment house.

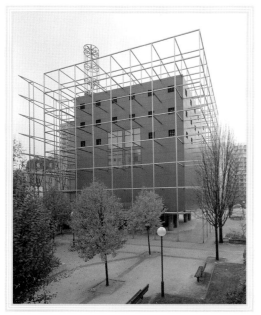

800

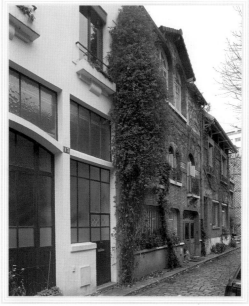

801

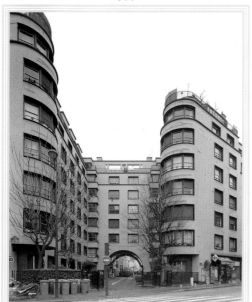

802

803

804

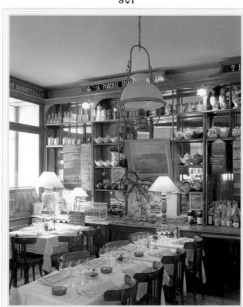

805

806

806

Musée de la Poste

34, BOULEVARD DE VAUGIRARD AT GALERIE VAUGIRARD

1973, ANDRÉ CHATELIN; 2000, BENOÎT LALLOZ, INSIDE RENOVATION

This museum became a division of the National Post Office in 1995. But its origins date back to the nineteenth century. As early as 1864, attempts were made to gather a collection of postage stamps from all over the world. In the 1920s, librarian Eugene Vaillé brought together additional ephemera on the history of the Post Office. The beginning of World War II deferred the formal creation of a postal museum until 1942. Originally housed in the Hotel of Choiseul-Praslin, the museum was inaugurated in 1946, with postal scholar Eugene Vaillé as director. In 1966, the museum moved to a private mansion at this location, which was later rebuilt to house an expanded collection. It underwent a complete renovation in 2000.

807

Tour Montparnasse

PLACE RAOUL DAUTRY/MAINE-MONTPARNASSE COMPLEX
BETWEEN RUE DU DÉPART AND RUE DE L'ARRIVÉE

1973, EUGÈNE BEAUDOUIN, URBAIN CASSAN,
LOUIS HOYM DE MARIEN, AND JEAN SAUBOT

Like the Eiffel Tower, this high-rise is visible from nearly every vantage point in the city; and, as in the early days of the Eiffel Tower, controversy loomed over its construction. For ten years, in fact, the project was mired in political-aesthetic debates that resulted in drastic modifications to the original plan. Unlike the Eiffel Tower, it has never become an endearing landmark of which countless souvenirs are bought. Rising 690 feet high, fifty-seven stories above street level, this glass-curtained office building pierces the skyline of Paris as a towering example of the mediocrity of the 1960s Maine-Montparnasse urban redevelopment project. But its commanding view over the city from the top floor is one of the best in Paris.

808

809

810

811

808

Musée Bourdelle

18, RUE ANTOINE-BOURDELLE AT RUE FALGUIÈRE

1949 AND 1961, H. GAUDRUCHE;
1991, CHRISTIAN DE PORTZAMPARC

A student of Rodin, Antoine Bourdelle, lived and worked here from 1885 until his death in 1929. This quiet hideaway, in the working-class neighborhood of Montparnasse—the former stamping grounds of legendary artists—became a museum in 1949, administered by the City of Paris that had rejected it twenty years earlier when Bourdelle's widow had first attempted to donate it. Today, you can discover his giant sculptures planted amid an unruly garden.

809

Institut Necker

156, RUE DE VAUGIRARD AT BOULEVARD PASTEUR

1968, ANDRÉ WOGENSKY

Wogensky, a student of Le Corbusier's, created this building as a dynamic, sculpted cube. The surface façades generate contrasts of color and texture: white on one side, grey on another; smooth and flat versus gritty and sculpted. With the unnecessary sunscreens, originally a practical addition, Wogensky turned function into creative form, to enhance the aesthetic quality of the building.

810

Ambassade d'Australie

4, RUE JEAN REY BETWEEN PLACE DE KYOTO AND AVENUE DE SUFFREN

1973–77, HARRY SEIDLER, PETER HIRST, MARCEL BREUER,
AND PIER-LUIGI NERVI

Built as two curved buildings, the embassy looks like a piece of sculpture, with openings that allow the play of light and shadow. The arc of the façades imitates the nearby Palais Chaillot, and permits a comprehensive view of the Eiffel Tower and the Seine. Pier-Luigi Nervi designed the ground-level entrance columns.

811

École Maternelle

22, RUE SEXTIUS MICHEL BETWEEN RUE SAINT-CHARLES
AND RUE DU DOCTEUR FINLAY

1912, LOUIS BONNIER

Over 300 schools were built in Paris between 1870 and 1914. Because brick was inexpensive, it became an identifying feature of Parisian school architecture of the time. This school represents one of the best examples of this type of decorative brickwork. Architect Bonnier created a façade of ochre-colored brick and cement inlaid with translucent glass. He also covered the entrance with ornamental mosaic, and the classrooms, with colorful friezes.

812

813

814

812
Maison de la Culture du Japon
(Japan Foundation)

101 bis, quai Branly at rue de la Fédération

1997, Masa Yuki Yamanaka and Armstrong Associates

Not wanting to compete with the overwhelming elements that surround this site—tall nineteenth-century buildings, a busy bridge, a quai, and the Seine—the architects constructed the Japanese Cultural Center to be unobtrusive: Built upon a small piece of property, this light and transparent structure blends with its environment. The smooth glass façade curves with the street, and mirrors the lines of the Australian Embassy across the way. The cultural center contains exhibition halls, a theater, and a library.

813
Centre de Chèques Postaux

16, rue des Favorites at rue d'Alleray and rue Bourseul

1932–36, Michel Roux-Spitz

To handle an increase in postal activity during the 1930s, the Central Post Office was created as a huge distribution center. Architect Roux-Spitz designed this concrete building in basic white, but divided the façade with ample windows for illuminating by natural light the tasks of sorting and distributing. He gave the building's horizontal form a vertical dimension by adding linear supports that divide the window spaces, creating a grid pattern both on the façade and within the windows.

814
Lycée Camille Sée

11, rue Léon Lhermitte at rue Mademoiselle

1933–34, François Le Cœur

The low, convex entry of this public college adds a bit of softness to the otherwise stern and linear building. The piers, lintels, and the windowsills are constructed of pink marble. When François Le Cœur created this girls' school, now coed, the media of the 1930s hailed it, his last project, as an alternative to modernity, and a breaking away from the white surface advanced by Le Corbusier. Le Cœur's designs for this building, in fact, were to influence school construction until 1939.

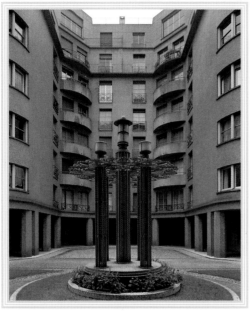

815

2–4, rue de la Convention and 7, rond-point du Pont-Mirabeau

AT RUE BALARD

1930–32, JOSEPH BASSOMPIERRE, PAUL DE RUTTÉ AND PAUL SIRVIN

This apartment building, erected between the wars, was also caught between tradition and modernity. The composition, however, recycled broken tiles for the façade, a compromise solution between traditional stone and modern concrete. Partially influenced by the technology of transportation design, the shape of the building evokes aerodynamic curves. The corner at 7, rond-point du Pont-Mirabeau is particularly interesting with its inside curve that increases the height of the façade.

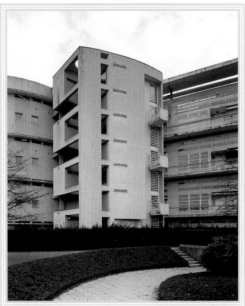

816

816

Cité d'artistes

69, RUE LEBLANC AT RUE SAINT-CHARLES

1992, MICHAEL W. KAGAN

Architect Kagan, a modernist with a passion for democratic buildings and geometric shapes, organized this low-rise building around a network of visible, covered passages and composed it with cubic and cylindrical forms. He set 100-meter-long, open-air thoroughfares at right angles to the main path that crosses André-Citroën Park. Overlooking the gardens, this expression of continuous inside movement leads to living and working quarters for artists.

817

817

3–5, boulevard Victor

AT AVENUE DE LA PORTE DE SÈVRES

1934, PIERRE PATOUT

Like a giant steamboat, this long building steers a course along a narrow plot of land. Its tiered balconies resemble passageways on a deck, and its five-block upper level recalls the smokestacks of ships. Architect Patout, in fact, designed several ocean liners. This building demonstrates not only his personal fascination with oceangoing vessels, but also typifies the Modern Movement, whose streamlined architecture equated modernity with machines and transport. Patout reserved the three-story end unit for his own residence.

818

Fondation Madame Jules Lebaudy

13, RUE DE LA SAÏDA BETWEEN RUE OLIVIER DE SERRES
AND PASSAGE DE DANTZIG

1913–19, AUGUSTE LABUSSIÈRE; 1997, A. FOURNIER, ALTERATION

In contrast to traditional housing built around a courtyard, this boxy, five-story building consists of many connected low-rise row houses whose arrangement maximizes light. The staircase that joins the buildings gives the residences a sense of animation. The construction has a concrete skeleton filled in with brick; yellow and red bricks with blue ceramics decoratively crown the last level.

818

819

La Ruche

2, PASSAGE DE DANTZIG AT RUE DE DANTZIG

1900–02, GUSTAVE EIFFEL, ROTUNDA STRUCTURE

Fernand Léger was among the first residents of this honeycomb of artist ateliers created by sculptor Alfred Boucher. Others who pollinated here in the early years of the twentieth century included Modigliani, Chagall, Zadkine, Archipenko, Soutine, and writers Cendrars, and Apollinaire. Having acquired the wine rotunda from the 1900 Exposition Universelle, sculptor Boucher rebuilt it on passage de Dantzig and created La Ruche (The Beehive) for painters and sculptors of little means. Now a historic landmark, it continues to house artists.

819

820

Garage La Motte-Picquet

6, RUE DE LA CAVALERIE AT AVENUE DE LA MOTTE

1929, R. FARRADÈCHE

With its two cool, angled sets of double windows shaped like the front grille of an oncoming car, this garage expresses the spirit of the 1930s. The architect patented his design for this eight-level parking garage, which uses two stories of symmetric and concentric entrance ramps to keep separate cars that are on their way up or down. The rooftop construction houses tennis courts and a clubhouse.

820

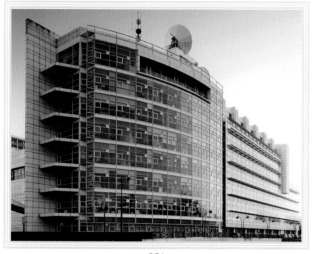

821

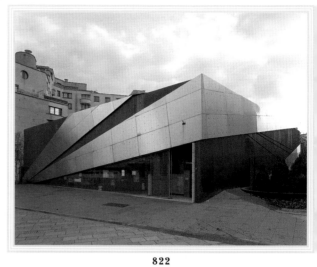

822

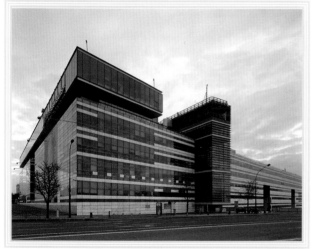

823

824

825

826

821
Siège de Canal Plus
(Headquarters)

85, quai André-Citroën at 2, rue des Cévennes

1991–92, Richard Meier

For the headquarters of this television station, New York architect Richard Meier separated the functions of administration and production. The convex, transparent glass façade showcases the managerial offices that overlook the river at quai André-Citroën. Connected to this building by a glass atrium, the lower perpendicular structure holds the TV studios and production facilities, while offering their workers views of Parc André-Citroën. White-enameled paneling covers the enclosed production workshops.

822
Bibliothèque municipale

8, rue de la montagne d'Aulas/186 rue Saint-Charles

1990, Franck Hammoutène

Composed of black concrete affixed with metal and glass, this isolated object invites inspection. Like the slits in a knight's helmet, the narrow glass openings on the façade reveal activity within, but the library space inside appears independent of the exterior: Light from a fifteen-meter cone on the roof is diffused through a glass column, and defines an interior space whose unlikely indoor garden sits at the center of an open reading room.

823
France Télévision

7, esplanade Henri de France
at boulevard du Général Martial Valin

1997–98, Jean-Paul Viguier

Architect Viguier vertically divided the headquarters of Public Television into a dual structure, unified by a two-level corporate "table," which oversees his two divisions. The smooth, translucent façade resembles a television set. The building materials of white Carrera marble, white frosted glass, and clear glass contribute to the overall balance of interests.

824
SNECMA Headquarters

2, boulevard du Général Martial Valin (formally
boulevard Victor) at quai d'Issy-les-Moulineaux

1976, Pierre Dufau

Architect Dufau created an aeronautical metaphor for the headquarters of SNECMA, one of the leaders in French aviation engineering. Using airplane materials and forms, Dufau shaped this building to reflect the basic elements of the industry: The leading edge of the roof forms a fuselage, the blinds move like flaps of a wing, and the façade—composed of aluminum panels—resembles the construction of the body of an airplane.

825
Parc des Expositions/Palais des Sports

Entrance, place de la porte de Versilles at boulevard Victor

1937, Boileau and Azéma, entrance, post office; 1959, Fournier,
exhibit hall; 1960, Pierre Dufau, Victor Parjadis de la Rivière,
and Buckminster Fuller, engineer, Palais des Sports;
1970, Gravereaux and Thin, hall

In the 1930s, using 1,100 aluminum panels, the architects and engineers built the largest self-supporting, light-alloy dome in the world, covering the only auditorium in Paris to have a seating capacity of 4,500 spectators. In 2002, a renovation refitted a new auditorium with more comfortable seats, state-of-the-art facilities, and modular space that can change to fit 2,000 to 4,200 attendees.

826
Crèche Collective

40, rue des Morillons between Parc Georges
Brassens and rue Brancion

1983, Alexandre Ghiulamila and Jean-Michel Milliex

Without actually constructing a pastiche, the architects of this school sought to preserve and enhance the structure of an old fodder warehouse for the Vaugirard horse market that had previously stood here. The brilliant white tiles offer a contrast to the old brick-and-iron structure of the ground floor. Although insufficient funds to complete the project left its triangular pediments unfinished, they nonetheless recall silhouettes of the lofts that had been inside the traditional market hall.

827

827

Ecole Maternelle

66, RUE DES MORILLONS, RUE DE CHERBOURG AND RUE FIZEAU

1934–36, PIERRE SARDOU

This huge public elementary school, administered by the Mairie de Paris, incorporates a bit of everything in its design: texture, curves, shapes, windows, and color. In short, it makes the thought of going to school inviting and fun. The child-friendly frieze above the entrance enhances this feeling, as does the strip of curved windows that seems like a toothy grin. This broad curvilinear entry, bordered by two bands of brick facing, gives the building a dynamic presence, and looks like the bow of a ship. Indeed, the architecture of the 1930s was often inspired by technology and the transportation industry: Buildings shaped like seagoing vessels were a common construct at that time. Schools erected between the wars were also intended to be monumental testaments to modern progress.

16ᵀᴴ ARRONDISSEMENT

Ooh, la, la, this is the arrondissement of wealth and luxury. If you live in the 16ᵗʰ arrondissement, you are surrounded by beautiful gardens, spacious apartments, and aristocratic sight lines from terraces. In short, this is the neighborhood of old money and new. Depending on your point of view, that's either fabulous or boring. Truth is, nothing much happens here and it's a distance from the heart of the frenetic city, save the traffic congestion around the Arc de Triomphe that stands at the arrondissement's northern perimeter. Located at the far western edge of Paris, it is bordered by the lush Bois de Boulogne, where Napoléon III hunted and carved out waterfalls, lakes, and gardens for Parisians' daytime pleasure. At night, however, in spite of the efforts by local law enforcement, these woods transform into a playground for transvestites and prostitutes. Modern influences of architects Mallet-Stevens and Le Corbusier are evident in the posh Passy quarter, where American statesman Benjamin Franklin lived for ten years. The lively but civil rue de Passy, which has a market street atmosphere, borders this sector and the southern Auteuil neighborhood. Nearby, Trocadéro at Pont d'Iéna creates a lovely vista across the Seine to the Eiffel Tower. In Auteuil, the princely sports arena and the red clay of the Roland Garros tennis stadium provide athletic entertainment.

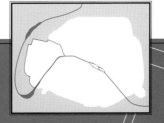

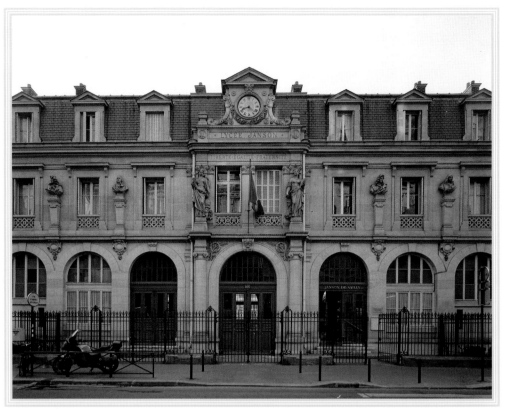

828

828

Collège-Lycée Janson de Sailly

106, RUE DE LA POMPE
BETWEEN RUE DE LONGCHAMP AND AVENUE GEORGES MANDEL

1881–84, CHARLES LAISNE; C. 1900, PETITGRAND, ADDITION;
1988, MICHEL SEBAN, TRANSFORMATION

This prestigious boarding school is notable for its many distinguished political, scientific, and artistic alumni. Its principles of teaching are based upon realism, will, confidence, and chance. The school was named for Alexandre Emmanuel François Janson de Sailly, a middle-class lawyer, born in 1785. Following a bitter divorce, Janson de Sailly helped to educate a young orphan, and thereafter granted the lion's share of his fortune to a university to create an institution named Collège Janson that would provide children at least eleven years old with an education in the humanities. His outraged widow contested the will until she died. Fifty years after the initial donation, the college was finally founded in Janson's name.

829

Musée Galliera

10, AVENUE PIERRE-1ER-DE-SERBIE
AT PLACE ROCHAMBEAU AND RUE FREYCINET

1878–94, LÉON GINAIN

The duchesse de Galliera waited sixteen years for her palace to be finished. Architect Ginain designed this Italian Renaissance–style mansion to house her art collection. But, when the city of Genoa inherited her collection, the city of Paris kept the museum and changed its purpose, converting it to the Musée de la Mode et du Costume (Museum of Fashion and Costume). Of note are the three statues under the arches of the central pavilion symbolizing Sculpture, Architecture, and Painting.

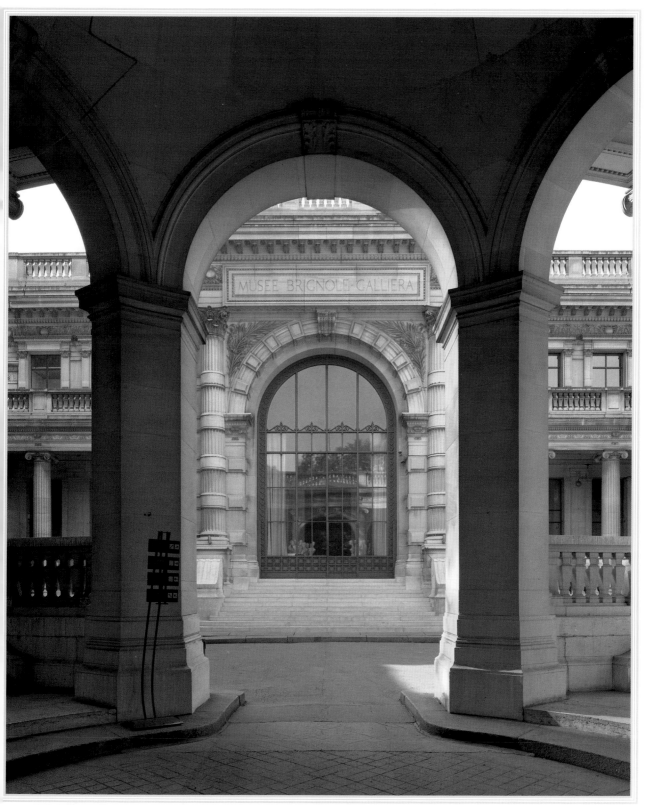

829

830
Palais de Tokyo
(Musée d'Art Moderne de la Ville de Paris
and Fédération Européenne des Métiers de l'Image et du Son)

11–13, avenue du Président-Wilson at avenue de New York

1937, Jean-Claude Dondel, A. Aubert, P. Viard and M. Dastugue

Situated on Chaillot Hill and built as part of its redevelopment for the 1937 Exposition, this neoclassic building houses two museums connected by a central portal: the Museum of Modern Art of the City of Paris in the east wing, and the Museum of Cinema and the European Federation of Image and Sound in the west wing. The architects worked with the slope of the hill to position the two wings around a vast open space, creating a terrace that overlooks the Seine, with a view of the Eiffel Tower.

830

831
25 bis, rue Benjamin-Franklin

At rue Scheffer

1903–04, Auguste Perret and Gustave Perret

Unlike traditional apartment buildings, this one rests solely on its concrete posts and has no interior supporting walls, thus allowing tenants to create their own room partitions. As is a feature of the Gothic architecture he admired, Auguste Perret left the concrete framework of the building exposed, decorating it only with glazed tile, which gave it a weatherproof coating. The floral Art Nouveau tile design is the work of ceramist Alexandre Bigot.

831

832
Fondation Singer-Polignac

43, avenue Georges-Mandel at rue du Pasteur Marc Boegner

1904, Henri Grandpierre

Built by Winnaretta Singer, aka princesse Edmond de Polignac, this stately stone mansion is the last of the neoclassical buildings constructed on avenue George Mandel. The princesse—of the Singer sewing machine family fame and fortune—received at her home many personalities from the world of arts and culture: Manet, Monet, Proust, Colette, Cocteau, Stravinsky, and Debussy, among others. This mansion became the Singer-Polignac foundation in 1928.

832

833

53, avenue Foch

AT RUE PICOT

1939, CHARLES ABELLA

A student of the Ecole des Beaux-Arts and winner of the Premier Grand Prix de Rome, architect Abella is virtually unknown today. He did most of his work in Limoges and Morocco, and this building, designed between the wars, is one of only three that he built in Paris. The porthole windows and the absence of decoration reflect moderate concessions to modernism, but the overall look he achieves with his concrete façade borrows from neoclassicism, as can be seen in the monumental curved balcony shape.

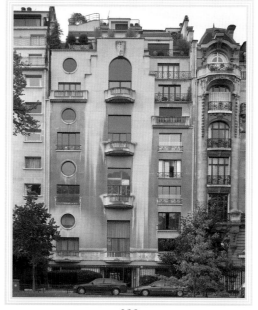

833

834

La Maison Prunier

16, AVENUE VICTOR-HUGO AT RUE DE TRAKTIR
AND PLACE CHARLES DE GAULLE

1924–25, LOUIS-HIPPOLYTE BOILEAU AND LÉON CARRIÈRE

Renovated in 2001 with comfortable banquettes, a new bar, and new upper levels, this legendary brasserie beguiles with its glamorous Art Deco décor. In 1925, Emile Prunier founded this elegant eating establishment not far from the Arc de Triomphe. Today, wealthy patrons enjoy spoonfuls of caviar in its first level *dacha*-styled dining room as well as traditional French food.

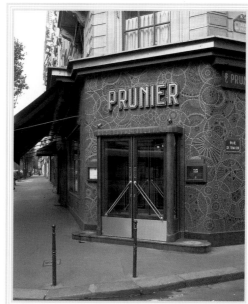

834

835

Guimet Musée national des Arts Asiatiques

6, PLACE D'IÉNA AT AVENUE D'IÉNA AND RUE BOISSIERE

1888, TERRIER; 1996-2001, HENRI AND BRUNO GAUDIN, RENOVATION

After a life-changing trip to Egypt and Greece plus additional journeys to Japan, China, and India, industrial tycoon and humanist Emile Guimet devoted his vast resources to the study of Ancient Egypt, Classical Antiquity, and Eastern religions. After Guimet died, this museum's focus upon Asian civilizations eventually superceded Guimet's own emphasis on the religions of antiquity.

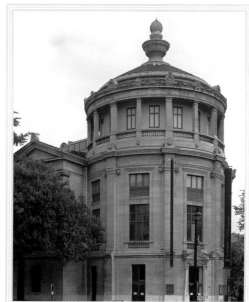

835

836

837

838

836

Musée Balzac

47, RUE RAYNOUARD AT RUE BERTON

C. SEVENTEENTH/EIGHTEENTH CENTURY BUILDING;
1910, TRANSFORMED AS A MUSEUM

Here, the phrase, "The plum season has arrived," gained you entry to Balzac's inner domain. Adding, "I am bringing lace from Bruges," meant you were among the privileged visitors who advanced past his housekeeper. Living under assumed names to avoid his creditors after a failed venture concerning a pineapple plantation, Balzac moved about the Paris environs, hiding out at 47, rue Raynouard, known then as rue Basse, between 1840 and 1847.

383

Palais de Chaillot
(MUSÉE DES MONUMENTS FRANÇAIS/MUSÉE DE LA MARINE)

ONE, PLACE DU TROCADÉRO ET DU 11-NOVEMBRE, AT AVENUE DE NEW YORK

1935–37, LÉON AZÉMA, LOUIS-HIPPOLYTE BOILEAU AND JACQUES CARLU

Situated on Chaillot hill, on the site of the old Trocadéro, this twentieth-century palace overlooks the Seine from the bank opposite the Eiffel Tower. Erected on the axis of Trocadéro-Montparnasse to coincide with the 1937 Exposition held there, the project was originally intended as a monumental entrance to the fair. The architects designed the horizontal complex with open space, in the interest of creating a broad sightline. The building houses multiple museums and theaters in two neoclassic structures that share a vast, open terrace.

838

Bureaux de Poste du 16ᵉ arrondissement

1, AVENUE D'IÉNA AT AVENUE DU PRÉSIDENT-WILSON,
AVENUE ALBERT DE MUN, AND PLACE D'IÉNA

1937–43, AUGUSTE PERRET; 1960–62, PAUL VIMOND, WING ON AVENUE
DU PRÉSIDENT-WILSON; 1995, GILLES BOUCHEZ, AVENUE ALBERT-DE-MUN

The circular colonnade that heralds the entrance of this building on avenue d'Iéna resembles a classical temple. The ridged but sleek columns widen out toward the top and form the line of its façade. The two wings of the building, added later, are composed of sanded concrete, which gives the building varied coloring. Designed by August Perret, the building was classified as a historic monument in 1993.

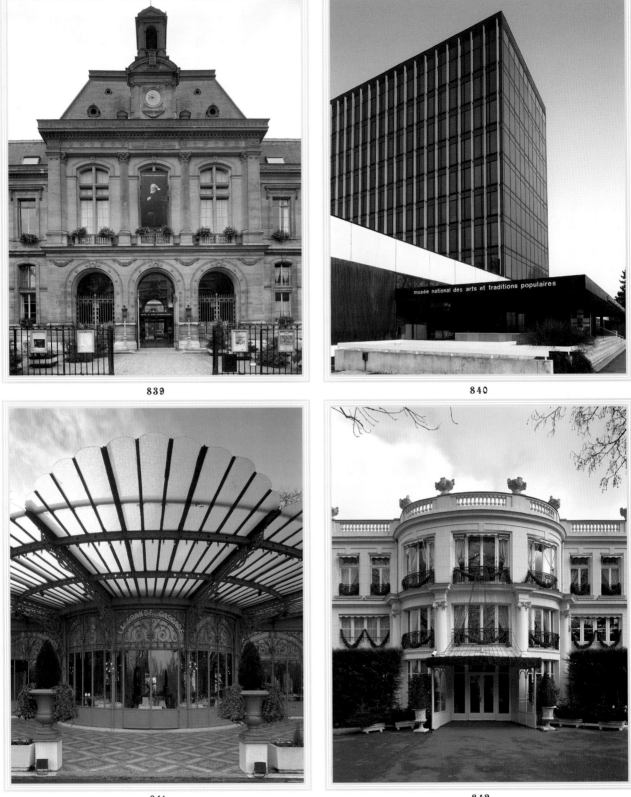

839

840

841

842

839

Mairie

71, AVENUE HENRI-MARTIN AT RUE DE LA POMPE

1868–77, ANTOINE-ISIDORE-EUGÈNE GODEBEUF

This is a typical town hall from nineteenth-century Paris as organized by Haussmann rules: a massive stone building with a forecourt entrance, wings on each side, and a bell tower. Inside, a grand staircase leads to the space devoted to the traditional wedding reception room on the second level, and expresses the formality of the service. Three large, neo-Gothic, mullioned windows provide the lighting for this room. Outside, monuments next to the building memorialize the victims of wars in Algeria, Tunisia, and Morocco.

840

Musée des Arts et Traditions Populaires

BOIS DE BOULOGNE
6, ROUTE DU MAHATMA GANDHI, NEAR THE JARDIN D'ACCLIMATATION

1969, MICHEL JAUSSERAND AND JEAN DUBUISSON; 1972, INAUGURATED

Behind this tall, sleek, modern façade lurks a museum that preserves old-fashioned traditions. Conceived by Georges-Henri Rivière, a French ethnographer, this museum collects materials relating to the rural and urban customs and culture of French society dating back to the Gallo-Roman times. In a project that proved useful in sparing Jews from deportation during World War II, Rivière sent Jewish research teams away from Paris, to gather for the museum rustic objects for display and also oral histories preserving the traditions of the countryfolk. Interactive exhibits are devoted to rural crafts and occupations, celebrations, popular culture, and even witchcraft.

841

La Grande Cascade

ALLÉE DE LONGCHAMP, IN BOIS DE BOULOGNE

C. SECOND HALF OF THE NINETEENTH CENTURY, PAVILION;
C. 1900, RESTAURANT

For nineteenth-century Parisians, leisure walking was the see-and-be-seen entertainment of the day, and La Grande Cascade (the great waterfall) in Bois de Boulogne drew its share of strollers, thanks to Napoléon III and Baron Haussmann, who cleared ninety-five kilometers of paths, adding lakes, islands, waterfalls, ponds, and an artesian well. For his visits to the Bois de Boulogne, the emperor reserved for his own use a small pavilion at the base of La Grande Cascade. For the 1900 World's Fair, this pavillon became La Grande Cascade restaurant. Despite its artificial, pumped-in rush of reservoir water, the great waterfall opposite its namesake restaurant still attracts diners as much for the view as the food.

842

Le Pré Catalan

ROUTE DE SURESNES
IN BOIS DE BOULOGNE

Horseback riders still trot through the paths of Bois de Boulogne, but the days are long past when they paused at a half-timber house for a treat of fresh milk. Instead, next to the old cottage, this stately building houses Le Pré Catalan, which serves more formal fare in the elegant, wooded setting. Considered a chic dining experience at the turn-of-the-century, it still projects style and inspires writers. In Colette's *Gigi*, hero Gaston Lachaille hosted a private party here.

843

844

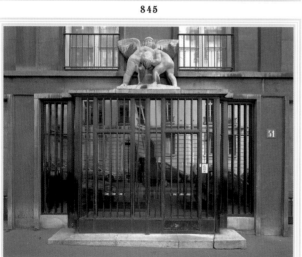

845

846

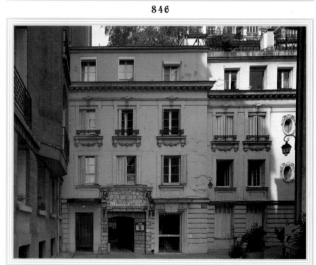

847

848

843

Eglise Saint-Pierre de Chaillot

33 AVENUE MARCEAU
BETWEEN RUE DE CHAILLOT AND AVENUE PIERRE 1ER DE SERBIE

1740 REBUILT, 1786 REINFORCED; 1931–1938, EMILE BOIS;
1931–1938, EMILE BOIS (ARCHITECT); BERNARD LISSALDE, (ARCHITECT);
HENRI BOUCHARD, (SCULPTOR)

Triple Roman arches supported by huge columns mark the principle entrance and lead to the church complex, which is composed of three parts: a bell tower, a low church and crypt, and the primary church. Both the low church and the high church take the form of a Greek cross with Byzantine influences: The framework—covered with white stone—is concrete, the modern material that allowed the construction of various angles and shapes.

844

OCDE

(ORGANIZATION COOPÈRTION ET DÉVELOPPEMENT ECONOMIQUE)

2, RUE ANDRÉ-PASCAL AT RUE DE FRANQUEVILE AND BOULEVARD SUCHET

1912–22, HENRI HESSE

Built for Henri de Rothschild in eighteenth-century style, this mansion sits at the edge of the former park of Chateau de la Muette and took a decade to build. Since 1961, the Organization for Economic Cooperation and Development (OCDE), which helps governments with economic and social challenges, has maintained its headquarters here on the northern edge of the Jardins du Ranelagh. This interior courtyard view expresses a stately presence with its classic revival façade.

845

La Gare Restaurant

19, CHAUSÉE DE LA MUETTE
AT DE LA MUETTE AND BOULEVARD DE BEAUSÉJOUR

1852–67, CONSTRUCTION; 1996, CHRISTIAN LÉVY (ARCHITECT),
AND MARC HERTRICH (DECORATOR)

A modest exterior belies the voguish interior of this train station-*cum*-hipster restaurant. In fact, La Gare takes advantage of its origins: wide, open spaces and high ceilings, waiting-room benches and a platform dining room, industrial lighting and giant windows, all capped with a glass roof. With its train-station acoustics, La Gare buzzes with activity.

846

Théâtre Le Ranelagh

5, RUE DES VIGNES AT AVENUE DE LANBALLE

1894–95, CHARLES GARNIER

Marie-Antoinette and her ladies of the court used to come to the former theater on this site to dance and listen to music. Originally built in 1755 by Poplinière, the Farmer General of Louis XV, it was destroyed during the French Revolution, rebuilt in a carved Flemish-Renaissance style during the 1890s, and reopened in 1900. In 1932, it became an art cinema; and, since 1985, it has been a venue for offbeat productions.

847

51–55, rue Raynouard

AT RUE BERTON

1929–32, AUGUSTE AND GUSTAVE PERRET

For this building, August Perret designed a traditional structure to use as his own office space and apartment. For the façade, he chose to replicate traditionally shaped stone blocks. Similarly, the entire building shows restraint, featuring classical proportions and traditional, vertical windows. The architect's one overt concession to modern times was his innovative use of glass as a lighting source for the concrete spiral staircase.

848

Musée du Vin

5–7, SQUARE CHARLES DICKENS AT RUE DES EAUX

C. FIFTEENTH CENTURY, WINE CELLAR

Garbed in his hooded monk's frock, Honoré de Balzac guides visitors into the preserved medieval wine vaults of this former Passy Monastery. Napoléon inspects the vats and Pasteur also puts in an appearance. As wax models, these historic figures and others in this museum educate visitors about viticulture and France's wine-making heritage. Shut down during the Revolution in 1789, the monastery opened as a museum and restaurant in 1984.

Bois de Boulogne / Stade Roland Garros

Once the private hunting ground for royalty, this 2,000-acre forest housed le Château de Madrid, built by François I. This romantic French Renaissance castle, covered with earthenware by Luca Della Robbia, hosted parties and hunts and other pleasures. Eventually, it was used for strategic and economic gain: Silkworms were grown here, and wood was cultivated for boats and carpentry. The woods were also a source of fuel for the Revolutionaries to stoke the flames of freedom. The park opened to the public in the seventeenth century under the Sun King, but Napoléon III cleared the way for its drastic transformation. His landscape architect, Adolphe Alphand, demolished the old city wall along the east side, then opened the woods for gardens, lakes, grottos, waterfalls, bridle paths, restaurants, a racetrack, and over forty acres of carriage roads. Packed with Parisians at play—picnicking, horseback riding, walking, jogging, biking—during the daylight hours, the landscape hides prostitution at night.

The twentieth-century addition of Stade Roland Garros, in the southern Auteuil quarter of Bois de Boulogne, introduced red clay to worldwide tennis fans. Originally named the Stade Français in 1925, the stadium was renamed in 1928 after one of its members, French aviator Roland Garros, who had died ten years earlier. The first event at that time featured Davis Cup play between France and the USA, which France dominated until 1933 with their "musketeer" team of Brugnon, Borotra, Cochet, and Lacoste. One of the four tennis venues for the Grand Slam competition of the modern era, Roland Garros hosts the two-week tennis tournament, also known as the French Open, on three main stadiums and seventeen side courts. The grounds also include the Tenniseum, a museum inaugurated in 2003, which exhibits the history of tennis in France and of Roland Garros in particular. Tennis professionals the world over find the red clay of Roland Garros is either tailor-made for their game or (ask Pete Sampras) they find it exasperating. Though the first matches were played elsewhere, the history of the Open dates back to 1891. And you can toss around this bit of trivia: During its fortnight of play, the French Open uses 60,000 tennis balls.

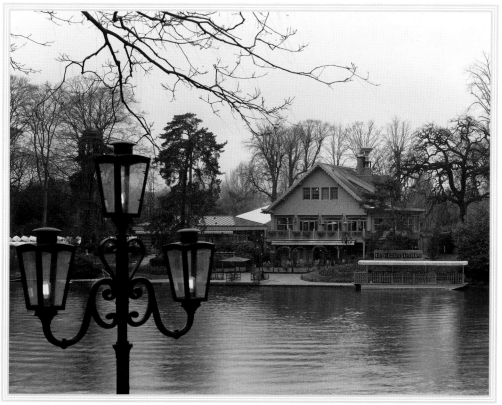

849

849

Chalet des Îles

LAC INFÉRIEUR, BOIS DE BOULOGNE

1894

Here, you can ferry back to the nineteenth century for a bite to eat, or row your own boat over Lac Inférieur for a pastoral repast. Situated on a thin island strip on Lac Inférieur—the largest lake in the Bois de Boulogne—this idyllic restaurant has the feel of a country inn. But its natural setting amid trees and water is an artificial construct of Napoléon III and his crew of engineers, who poured concrete into a pit and piped in artesian well water from about thirty miles away. Nonetheless, the serene setting attracts diners, who take in the artful view from beneath the cover of umbrellas. In the past, regular rowers on the lake included Marcel Proust and Emile Zola.

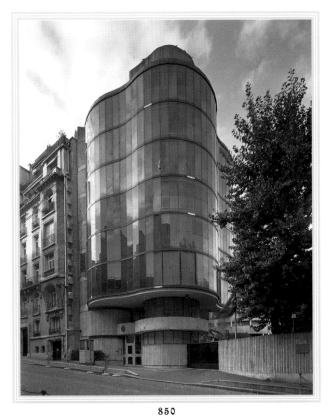

850

Three quiet, interlocking cylinders made it possible to position this ultramodern building on a triangular space between an eighteenth-century townhouse and Balzac's former home. The central concrete pillars support the overhanging stories, and leave ground-floor space for an opening to the building's underground garage. In creating this structure, architect Beauclair had several challenges before him: He could not displace any of the preserved trees—he had to leave a clear view from the garden; and, he needed to fit his modern creation into an otherwise bourgeois neighborhood. Using simple white concrete and slightly tinted glass, he designed an unobtrusive building.

851

Contemporaneous with Le Corbusier, Robert Mallet-Stevens did not engage in social deliberations about mass housing for the working classes, preferring to build modern villas for the bourgeoisie. Regarded as his major work, this real estate allotment consists of five private mansions plus a guardhouse. The architect lived at number 12. His design principles are clearly apparent in these buildings: Shapes rather than details of construction were what interested him. His use of white, smooth curves in the central portion of this building unified its overall appearance.

852

Villas La Roche et Jeanneret

8–10, SQUARE DU DOCTEUR-BLANCHE AT RUE DU DOCTEUR-BLANCHE

1924, LE CORBUSIER

Although Le Corbusier's intention was to create an entire row of his buildings along this street, his deal with the developers fell through and he designed only two of the homes here: Villa La Roche for his friend, a banker named La Roche; and villa Jeanneret for his brother (Le Corbusier was born Charles-Edouard Jeanneret). In later years, Le Corbusier developed his five canons of architecture, and here, in his design for Villa La Roche, he applied for the first time two of those five important features for a house: roof terraces and full-length windows. He organized the functions of the interior with promenades, partitions, walkways, and platforms. The frontages and roofs of the villa are registered as historic landmarks.

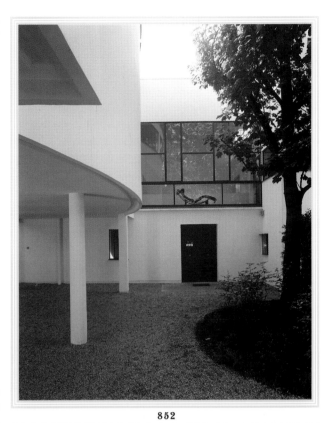

852

853

Musée Marmottan Monet

2, RUE LOUIS-BOILLY AT AVENUE RAPHAËL

C. 1860, CONSTRUCTION OF THE HÔTEL;
C. 1883, HEIGHTENED (RAISED EXTENSION);
C. 1913, WING AT THE STREET; C. 1970, JACQUES CARLU, PRESERVATION

In 1966, Claude Monet's son Michel donated his father's paintings and the property at Giverny to this museum, which added "Monet" to the name of Musée Marmottan. The donation filled out its already significant collection of works by Manet, Monet, Pissarro, Sisley and Renoir. Originally the old hunting lodge of the Duke of Valmy, this mansion, which overlooks the gardens of Ranelagh, was purchased as a home by Jules Marmottan in 1882. In 1934, the mansion, its art collections, and a library in Boulogne officially became the museum.

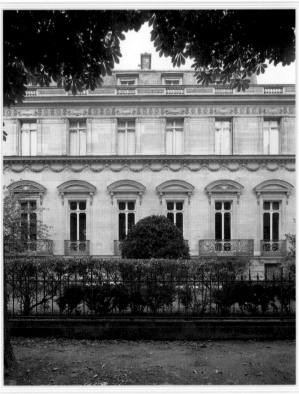

853

854

42, avenue de Versailles

AT RUE DES PÂTURES

1934, JEAN GINSBURG, FRANÇOIS HEEP AND MAURICE BRETON

This corner building, the second that architect Ginsburg constructed in Paris, shows the influences of his modern masters, Robert Mallet-Stevens and Le Corbusier. Ginsburg not only designed the exterior, but he also created such interior details as the skylights. While Mallet-Stevens's pupil at l'Ecole Spéciale d'Architecture, Ginsburg learned to pay attention to detailing and careful finishing, which he demonstrated in the stone façade and the curved rotunda entrance.

855

Hôtel Guimard

122, AVENUE MOZART AT AVENUE GEORGE SAND

1909–12, HECTOR GUIMARD

Architect Guimard built this private mansion to have all the curves and trim and ironwork flourishes characteristic of what became known as the "Guimard style" of Art Nouveau design. His architectural firm occupied the ground floor, and he also incorporated into the building studio space for his wife, Adeline Oppenheim, who was a painter. She unsuccessfully attempted to donate the house to the State in 1947. The mansion was finally protected in 1964.

856

40, rue Boileau

AT AVENUE DESPRÉAUX

1907, JOACHIM RICHARD AND HENRI AUDIGER

This street derives its name from poet and critic Nicolas Despreaux, known as Boileau. The present building was built, in 1907, on the site of Boileau's former home. This private mansion that replaced it, one of the first of a generation of concrete early twentieth-century constructions, is decorated by ceramists Alphonse Gentil and Eugène Bourdet of the Gentil & Bourdet Company.

857

Former Ecole du Sacré-Cœur

9, AVENUE DE LA FRILLIÈRE
BETWEEN CLAUDE-LORRAIN AND RUE PARENT DE ROSAN

1895, HECTOR GUIMARD

The unusual structural support system of this building—poles shaped as s—came from a proposal by Viollet-le-Duc, which architect Guimard incorporated into his design. The steep, forty-five degree piers uphold the brick façade, and the first level exposes the construction via a scheme of small, vaulted sections. The unique exterior has been well-preserved and now houses co-op apartments.

858

Villa Montmorency

10, RUE POUSSIN AT AVENUE DE MONTMORENCY

1853, PÉREIRE BROTHERS; C. 1935, JOSEPH BASSOMPIERRE,
PAUL DE RUTTÉ AND PAUL SIRVIN

Countess of Bouffers originally owned this property in 1773. She surrounded herself with intellectuals and artists who came to enjoy one of the first English gardens in Paris. Developed as a villa in the mid–nineteenth century, it became a registered landmark in 1972. On the front street, a typical, late Haussmann building marks one side of the entrance. Today, it remains one of the most beautiful enclosed areas with private homes and gardens in the Auteuil district.

859

3–5, rue Mallet-Stevens

AT RUE DU DOCTEUR-BLANCHE

1926–27, ROBERT MALLET-STEVENS

When designing the houses along this street, Robert Mallet-Stevens manipulated the white surface and the planes of each building to create a unified appearance within each façade and, by extension, along the street as a whole. This home belonged to filmmaker Aliatani.

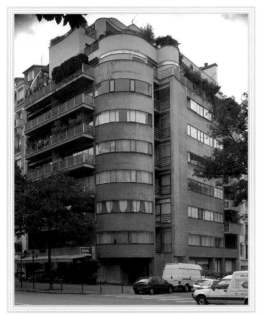

854

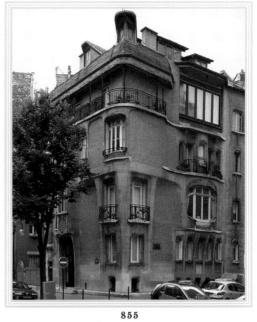

855

856

857

858

859

860

Former Collège Montmorency

15, RUE HENRI-HEINE AT RUE JASMIN

1931, POL ABRAHAM

This bulging, concrete corner building resembles a ship charging full steam ahead. Built on a small site of only 178 square meters, the building that once accommodated American high school students in Paris with classrooms and bedrooms now houses the architectural offices of Jean-Jacques Ory, among one of the largest in France. It is connected to the adjacent house, built in 1922, which formally held the school's administrative services.

861

5, square Mozart

AT AVENUE MOZART

1954, LIONEL MIRABAUD

At first glance, this mostly nondescript building appears to be a monotonous, prefabricated industrial block, but a closer inspection reveals awnings. Or are they guardrails? Perhaps they're blinds. In fact, they could be all three, depending on their occupants' desires. Designed by Jean Prouvé and composed of aluminum, these odd panels are mobile. This innovation, though functional and creative, creates a randomness which may or may not work: The panels play with the building's aesthetics and, on any given day, produce either a balanced design or simply a scattered, disorderly appearance.

862

Hôtel Mezzara

60, RUE LA FONTAINE AT RUE RIBARA

1910, HECTOR GUIMARD

Originally built for textile designer and manufacturer Paul Mezzara, this building now belongs to the State and is a registered historic monument. The wrought-iron trim of this *hôtel* displays the typically Art Nouveau flourishes of architect Guimard. He also designed the interior ironwork stairway, as well as the dining room furnishings and the large colored canopy that covers the central patio. In 1975, during the national campaign to protect architecture of the nineteenth and twentieth centuries, these façades and roofs were given government protection, as was eventually the entire *hôtel* in 1994. Since 1956, the building has been used as an annex of a girls' high school.

863

Castel Béranger

14–16, RUE LA FONTAINE BETWEEN RUE BOULAINVILLIERS AND RUE GROS

1896–98, HECTOR GUIMARD

Painter Paul Signac, who lived here in the late 1890s, called this the "Eccentric House." Other neighbors referred to it as the "Crazy House" or "Devil's House," because of design elements on the façade, which featured—among other strange detailing—caricatures of the architect's face in the ironwork of the balconies. The quirkiness notwithstanding, this building won design awards in 1898 and 1901. Though the entry gates and balconies exhibit the curving lines of Art Nouveau, the façade decoration is more abstract, and the interplay of shapes becomes distinctly modern. Not only did Guimard use an eclectic range of materials—brick, ceramics, stone, sandstone—but his window designs also contain a diversity of proportions.

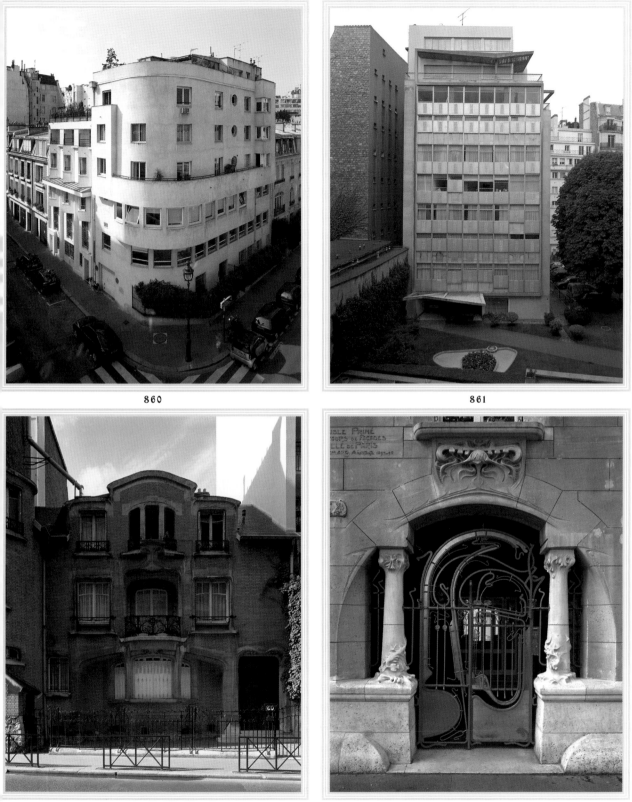

860

861

862

863

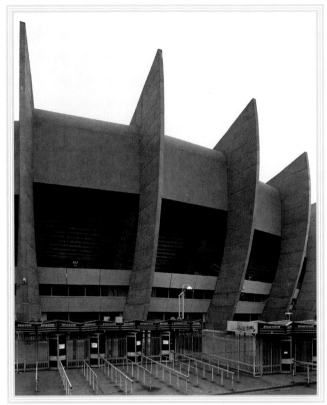

864

864

Parc-des-Princes stadium

24, RUE DU COMMANDANT-GUILBAUD
AT AVENUE DU PARC DES PRINCES AND RUE CLAUDE FARRÈRE

1971–72, ROGER TAILLIBERT

Using 6,000 tons of steel and 60,000 cubic meters of concrete, architect Taillibert suspended this stadium from fifty self-supporting, prefabricated consoles. His objective was to seat 48,000 sports spectators without obscuring anyone's view with posts or other structural obstacles. Thus, the bracketing sustains both the tiered seating and a hood of cantilevered-roof that protects the seating area. Originally a wooded area west of the capital, and reserved for the princely recreations from which it derives its name, this site was also once a center for the scientific study of the anatomical movements of men and horses in motion along a track. In 1897, a new track staged cycle-racing. Then, from 1932, professional soccer teams played matches here, and a stadium hosted the World Cup in 1938. Today, the track is home to the French soccer team, Paris-Saint-Germain.

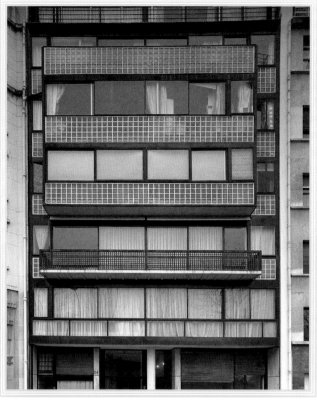

865

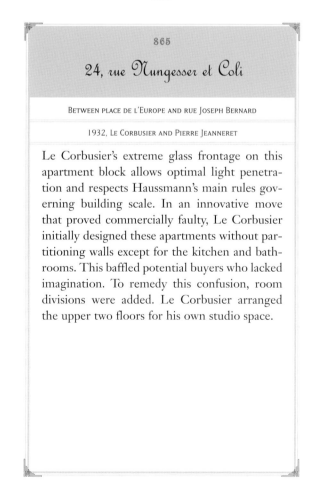

865

24, rue Nungesser et Coli

BETWEEN PLACE DE L'EUROPE AND RUE JOSEPH BERNARD

1932, LE CORBUSIER AND PIERRE JEANNERET

Le Corbusier's extreme glass frontage on this apartment block allows optimal light penetration and respects Haussmann's main rules governing building scale. In an innovative move that proved commercially faulty, Le Corbusier initially designed these apartments without partitioning walls except for the kitchen and bathrooms. This baffled potential buyers who lacked imagination. To remedy this confusion, room divisions were added. Le Corbusier arranged the upper two floors for his own studio space.

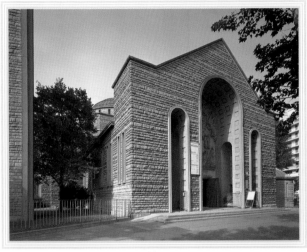

866

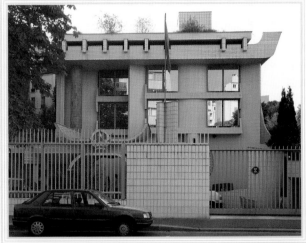

867

868

869

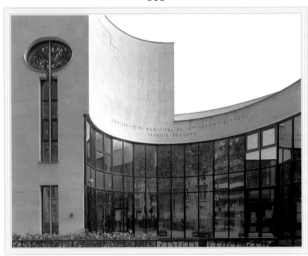

870

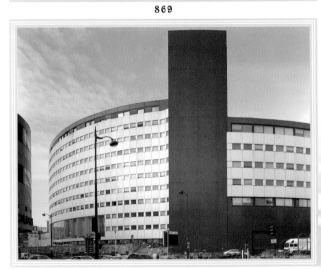

871

866

Eglise Sainte-Jeanne de Chantal

12, PLACE DE LA PORTE DE SAINT-CLOUD

1933, 1962, JULES BARBIER

Although Jules Barbier began construction on this Catholic Church in 1933, it was bombarded during World War II and was only completed in 1962. Ironically situated on the grounds of an old fortification site, this chapel was reconstructed in the neo-Roman–Byzantine style of Barbier's original design, with a broad cupola and a tall bell tower. Jacques Chevallier designed the interior stained glass in 1954, and Jean Touret decorated the church with sculpture in 1975.

867

Ambassade du Vietnam

62, RUE BOILEAU AT BOULEVARD EXELMANS

1977, VO THANH NGHIA

For this embassy, architect Vo Thanh Nghia intended to create a synthesis of contemporary French and traditional Vietnamese design. Thus, Vo Thanh Nghia, inspired by Asian temples, wed earthenware tiles to the modern material of white sandstone, and filled the interior with vegetation. The result is an embassy where personnel and visitors feel as comfortable as if they were home.

868

Laboratory Aérodynamique

67, RUE BOILEAU AT RUE DE MUSSET AND BOULEVARD EXELMANS

1912, GUSTAVE EIFFEL

Gustave Eiffel created this sleek building, one of the first aerodynamic laboratories in the world, as the place in which to do his own research. Framed in metal, this simple hangar contained Eiffel's technical equipment, including measuring and testing devices. In 1920, he opened the laboratory for use by aeronautical engineering departments and industries. Since 1997, the space has been used to test the aerodynamics of planes, cars, and buildings.

869

Studio High Building

65, RUE LA FONTAINE AT RUE GEORGE SAND

1926, HENRI SAUVAGE; 1990, FRONTAGE RESTORED

Architect Sauvage created a palette of hues for this block of split-level artists' studios, lit by canopy glass roofing. Influenced by Cubism, Sauvage played with the effects of different coloring on the tiled façade, using brown inside the balcony, a gray tone on the flat surfaces, and multiple colors on the extended portions. He produced a monumental effect with the large bay windows, while also achieving a more intimate scale with the smaller, square ones.

870

Conservatoire Francis Poulenc

11, RUE LA FONTAINE AT RUE GROS

1987, ROGER TAILLIBERT

In 1931, composer Francis Poulenc wrote to a friend, "It is more courageous to grow just as one is, than to force-feed one's flowers with the fertilizer of fashion." An elusive man, devoutly Catholic and a disciple of Stravinsky, Poulenc definitely followed his own rhythms. Poulenc set to music the poetry of such friends as Guillaume Apollinaire and Jean Cocteau. This building, composed of white stones and black glass, features some windows shaped in the form of musical symbols.

871

Maison de Radio-France

116, AVENUE DU PRÉSIDENT-KENNEDY
BETWEEN RUE DU RANELAGH AND RUE DE BOULAINVILLIERS

1956–63, HENRI BERNARD, NIERMANS BROTHERS, JACQUES LHUILLIER, GEORGE SIBELLE, AND M. COUTURIE (ENGINEER)

The company headquarters of Radio-France houses the Museum of the History of Radio and Television, whose collection includes the 1793 Chappe telegraph and crystal receivers. This aluminum-plated building has a 500-meter circumference (1,640 feet), and a broadcasting tower that rises to an impressive sixty-eight meters (223 feet).

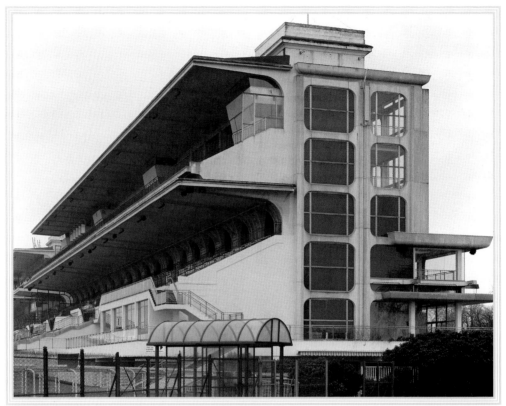

872

Hippodrome d'Auteuil

BOIS DE BOULOGNE

1873 CONSTRUCTION; 1924 REBUILT PARTLY;
1976 TRANSFORMATIONS, LIZERO, LERICHE, AND JEAN

As a young writer in Paris, newly married with a child, Ernest Hemingway was one of many fans addicted to this and other historic racetracks. Following the lead of the Hippodrome de Longchamp, established in 1855 during the fun-loving days of Napoléon III, also in the Bois de Boulogne, this stadium attracted fans with steeplechases, obstacle courses, and promenades. Originally opened in 1873, it was rebuilt in 1924 and then, about fifty years later, the architects Lizero, Leriche, and Jean extended the former construction using white concrete for the structure and stainless steel for the windows frames. The addition now accommodates 8,600 people whereas the original allowed for only 3,600. Although avid horseracing fans gather here from early March to late December, the space is also used for antique fairs and rock concerts.

17TH ARRONDISSEMENT

Divided into the villages of Ternes and Batignoles, the 17th arrondissement is a sleepy, residential area that was incorporated into Paris proper when Baron Haussmann was engineering the modernization of the city. In the second half of the nineteenth century, this area was part of that growth and creativity. The northwestern section of Ternes, next to the 16th arrondissement, developed into an upscale residential area with wide boulevards and imposing architecture, while the Batignoles section was home to city workers and the Impressionist painters.

Adjacent to the red-light district of Clichy in the 18th arrondissement, Batignoles sports an urban character. The tracks that extend from Gare Saint-Lazare slice through the narrower streets of this sector. Despite the cheap shops on boulevard Clichy, this quarter contains a few enclaves of charm: place du Docteur Félix Lobligeois, with its white chapel of Sainte-Marie-des-Batignoles; the market street of rue de Lévis; and Cité des Fleurs, which has pastel-stucco and sculpted-stone homes. The area also boasts the thriving Batignoles organic market.

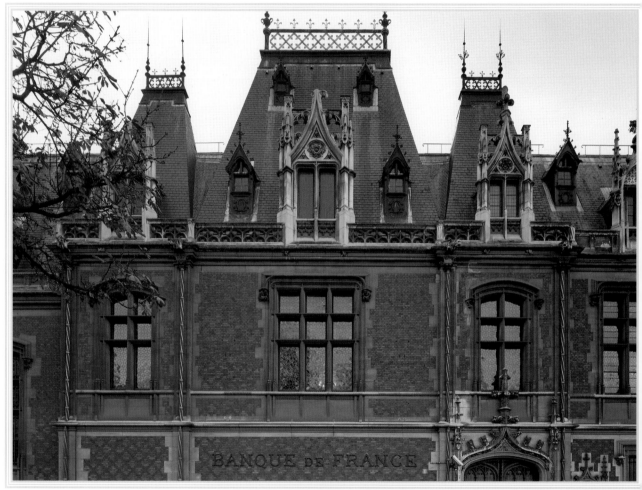

873

874

Hôtel Gaillard

One, place du Général-Catroux at avenue de Villiers

1878, Victor-Jules Février

Inspired by the castles of Blois and Gien in Loire, architect Février designed this house for Emile Gaillard, the Director of the Bank of France. In addition to gables, dormers with carved Gs, sixteenth-century paneling, sculpture, and opulent furnishings, the architect assured his immortality and that of his patron's with statues above the entrance: One resembles the banker carrying a money bag; the other contains a square featuring the architect's likeness. Gaillard died in 1904 and the Bank of France acquired the manor house in 1919, making necessary modifications to transform the residence into a bank, but not significantly altering the basic structure. They used the water buildup in the basement as the first line of security for their vault, and rumor had it that crocodiles protected the safe-deposit stash at night.

Château des Ternes

17–19, rue Pierre Demours at rue Bayen

1715; 1778, Samson-Nicolas Lenoir, transformation

This mansion rests on the site of a fifteenth-century farm and fortification, in what was then the countryside, outside the limits of an old property called Roule. In mid-century, a gazebo was built here for the Queen to allow her to watch the nearby horse races. Mirey de Pomponne, treasurer-secretary to the king, acquired the property and replaced it with a château in 1715. Over the years, other owners enlarged it with additions. In 1778, architect Lenoir acquired the property and divided it into salable units. To facilitate access to the development, he created a new street, now called rue Bayen, which runs right through the building under an arch. After many modifications, the Chateau now appears a mere shadow of its former grandeur: Its eighteenth-century façades, an entry, and a few relics are the only reminders of its past. Today, it accommodates town hall services, a restaurant, and housing for the elderly.

875

875

60, rue Jouffroy d'Abbans

BETWEEN RUE AMPÈRE AND AVENUE DE VILLIERS

C. 1880, MARCEL MORIZE

This brick-and-stone building features an unusual stone balcony at mid-level, surmounted by an ornately carved pediment. The balcony is off-center, as is the entry. Additional carved stone frames the main door, which is capped by a decorative oculus. The building houses the offices of John Arthur & Tiffen, now a real estate development agency but, in the nineteenth century, the family that lived here profited from the end of the Napoléonic trade blockade by supplying manufactured goods to the royal families of England and Russia. Descendants of that family also created France's first periodical to exclusively contain real estate advertisements, at the end of the nineteenth century.

La Petite Ceinture

One of the last steam locomotives to operate in Paris used to pull out of Gare de Lyon, wind through Bercy, the old wine warehouse district in the 12th arrondissement, cross Cours de Vincennes, and chug north up through the 20th and 19th arrondissements in east Paris. After looping around the 18th and across Batignoles, it would head south through dark tunnels. This circular train route, constructed in 1861 during the Industrial Revolution, began service ferrying goods through the Right Bank on December 11, 1852. It picked up steam and passengers over the next ten years and, by 1862, it carried over 180,000 travelers. Between 1867 and 1868, with the addition of tracks on the Left Bank, the loop was complete. By the 1900 World's Fair, La Petite Ceinture (the little belt) ferried about 39 million passengers. Its eight-car train worked six shifts each hour, morning and evening. Come the automobile revolution, competition from the metro, and the development of modern RER transport, service on La Petite Ceinture began to decline after 1934. Its last line, between Pont Cardinet and La Muette, closed in 1984. Today, the rusted tracks are overgrown with vegetation, but the abandoned rail station and the phantom train may make a comeback. Organized walks around the belt recall the era of steam and a petition underway could revive the old route and save the station.

876

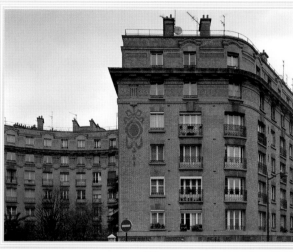

877

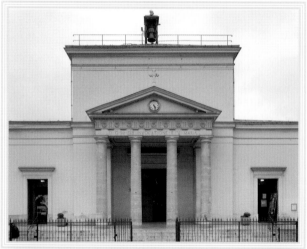

878

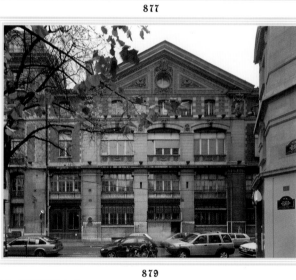

879

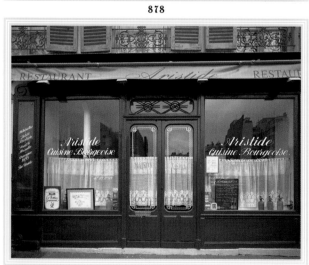

880

881

◈ 1 7 ᵀᴴ A R R O N D I S S E M E N T ◈

876

Marché Couvert Batignolles

96 BIS, RUE LEMERCIER AT RUE DES MOINES

1867, VICTOR BALTARD; 1979, REPLACED

Situated in a quiet residential quarter, this covered market was once worth a visit. Formerly one of the Victor Baltard's trademark glass-and-iron structures, the market was dismantled and replaced in 1979 with this ugly concrete building. The multi-storied structure contains about twenty vendor stalls that furnish the neighborhood with the basics, but the real action is on the market streets nearby at rue des Moines and rue Lévis, or on Saturday at the open-air Batignolles organic market on boulevard Batignolles.

877

75, rue Pouchet

AT 7 BIS, RUE ERNEST ROCHE

1914–21, L. CHEVALLIER

Like a giant armchair, this U-shaped complex of public housing, built at the old city wall, welcomed the growing population at the turn of the last century. Organized around a large courtyard that allowed circulation of air and light, the building is composed of brick, with decorative detailing and a stone foundation that conformed to architecture of the time. A neoclassical frieze breaks up the building's uniformity. Patterned in green, it drapes the façade like a garland, an expression of the city limit before the *périphérique* (freeway).

878

Sainte-Marie-des-Batignolles

PLACE DU DOCTEUR-FÉLIX-LOBLIGEOIS AT RUE DES BATIGNOLLES

1826–29, AUGUSTE MOLINOS;
1839–51, PAUL-EUGÈNE LEQUEUX, EXTENSION

This simple church exhibits just a trace of classic design on its exterior: Doric columns support a simple pediment with a clock. The equally unadorned interior contains a flat-painted ceiling that covers the basilica, its ordinary nave, and simple aisles. With very basic design, the church accommodated the elementary needs of the growing population in this quarter.

879

51–53, rue des Dames

AT 13, RUE DES BATIGNOLLES

1890–91, JULES DENFER AND PAUL-EMILE FRIESÉ

At the dawn of the twentieth century, a new style for industrial buildings took shape, as seen in this brick-and-stone power station, one of the first to feature such construction. At that time, the production and the distribution of Paris's electrical power had become insufficient, necessitating an increase in power-producing and -transmitting factories and transformer substations. Simultaneously, water-treatment plants and pumping stations multiplied, to accommodate those needs of an increasing population.

880

Aristide

121, RUE DE ROME BETWEEN RUE LEGENDRE
AND PASSAGE DU COMMANDANT CHARLES MARTEL

C. 1820, BUILDING; 1893, RESTAURANT

This vintage restaurant occupies the ground floor of a nineteenth-century structure wedged between two taller, Haussmann-era buildings. Inside, its warm wood paneling and globe lighting help maintain its old-fashioned charm and provincial ambience. Outside, its lace-curtained windows and an extended sidewalk café under a green awning soften the appearance of the otherwise unadorned building.

881

7, rue de Tilsitt

2, AVENUE MAC-MAHON AND 23, PLACE CHARLES DE GAULLE

1867, CHARLES ROHAULT DE FLEURY

The stately odd-numbered buildings on this street belong to a series of *hôtels* called Maréchaux, which surround place Charles de Gaulle. Their uniform stone frontages were built by Charles Rohault de Fleury, in his continuance of projects conceived by Jacques-Ignace Hittorff in 1833. Fleury built number 7 for the Baron Joseph de Gunsburg. Noteworthy façade decorations above the portal, by the sculptor Frederic-Louis Bogino, allegorically represent Agriculture and Industry.

882
Cinéma des Cinéastes
(Art House Cinema)

7, avenue de Clichy at place de Clichy

1996, opening

Situated in a cluster of neon lights and fast-food joints, pornography shops and glitter at the border of the 18th arrondissement, this building was transformed from a Pigalle cabaret into an art house cinema. Owned by an association of filmmakers and producers, it serves as a venue for foreign movies and such events as the Israeli Film Festival. It also features themed movie series, retrospectives, and discussions with directors.

883
Cave Pétrissans

30 bis, avenue Niel at villa Niel and place Aime Maillart

c. 1900, Tassu

A trellised sidewalk café welcomes you to the ground level of this otherwise quiet and stately apartment complex. With a hundred years of accumulated experience, Cave Pétrissans offers a well-stocked wine cellar and stands ready to offer any of its 600-plus bottles of wine as the perfect accompaniment to its savory, home-style cuisine. Authentic Third Republic décor, featuring burgundy banquettes and a checkerboard floor, sets the mood.

884
106, boulevard Malesherbes

2, place du General-Catroux and rue Georges Berger

1899, A. Fichet

The brick-and-stone patterning of this building sets up a contrasting rhythm at its base, distinct from the upper levels. Built in neo-Renaissance and Louis Treize style, the building is adorned with the kind of dormers and bay windows seen in castle towers. Carved brackets uphold the balconies, and figurative patterns embellish the pediment above the dormers. Artist Margotin contributed decorative sculpture to the façade.

885
Musée National Jean-Jacques Henner

43, avenue de Villiers at rue Fortuny

1840, Félix, Escalier and Guillaume, Dubufe, building; 1923, museum

Famous in his day for painting red-haired nudes, Alsatian painter Jean-Jacques Henner (1829–1905) worked here in the studio of painter Louis-Edouard Dubufe, who also admired the female form. This quaint, brick-and-stone mansion serves as a museum that preserves Henner's multi-faceted output. Outside, the balcony at the first level is embellished with an Arabic architectural device known as *moucharabieh*—a protective grillework.

886
Immeuble Fortuny

37, rue Fortuny at the corner of rue Fortuny and avenue de Villiers

1956, Jean Lefevre and Jean Connehaye

This building, which curves around the corner that connects to avenue de Villiers, is a prime example of constructions belonging to the Modern Movement, in its emphasis upon reinforced concrete. Internal posts, held by pre-stressed slab, give the building a clean appearance on its façade, without betraying any visible support of the structure. Built on the entire lot and partially on the ledge of the construction alignment, the building exudes an exceptional density.

887
Hôtel du Maître-Verrier Pousin

42, rue Fortuny at avenue de Villiers

1879, Alfred Boland

In 1879, Joseph Pousin, master glassmaker, commissioned a private mansion from Alfred Boland in neo-Renaissance style for use as a residence, showroom, and studio, where Pousin fabricated large, stained-glass windows and earthenware art for other private homes, castles, and hotels. Pousin became famous for his Palais lumineux (luminous palace) made of blown and molded glass that he created for the World's Fair of 1900.

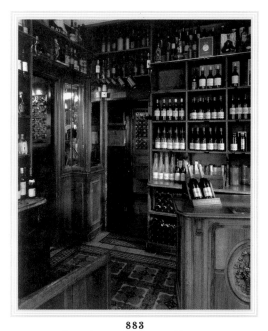

882

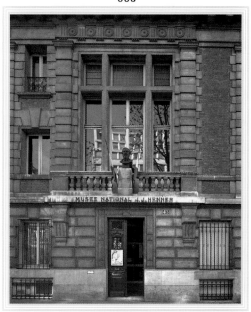

883

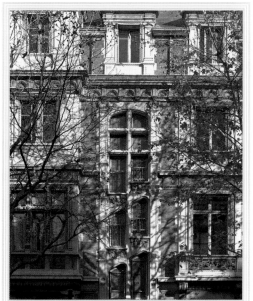

884

885

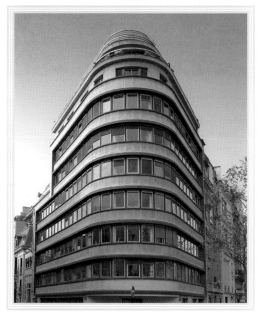

886

887

888

888

132, rue de Courcelles

AT 3, RUE CARDINET

1907, THÉODORE PETIT

This Art Nouveau building sports an unusual, monumental dome with oculi, the front of which peers out at the corner like the eye of a giant Cyclops. Artist Henri Bouchard produced the sculpted stone façade, and Léon Binet adorned it with Art Nouveau flourishes. Binet, who specialized in vegetal patterns, created at the top angle this leaf-and-branch design, which appears to grow out of the building.

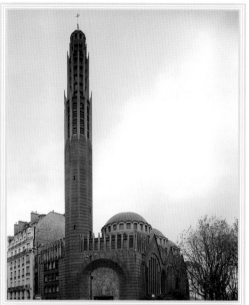

889

889

Eglise Sainte-Odile

2, AVENUE STÉPHANE-MALLARMÉ BETWEEN RUE JEAN MORÉAS
AND RUE DE COURCELLES

1934–46, JACQUES BARGE

A strange, disproportionate tower, seventy-two meters (236 feet) high, zooms above this Byzantine-inspired church as if to challenge the fates—raising a finger to the powers that be, or perhaps to modernism, which the church frowned upon. With its domed copulas and looming bell tower, oddly called futuristic by some, the church recalls the ancient fortifications built in this area.

890

890

42, boulevard Gouvion Saint-Cyr

AT RUE DU DOBROPOL

1931, RAYMOND PERRUCH

Distinguished by three vertical "pilasters" of stone that separate the balconies at each story, this Art Deco building is a monument at heart: Carved and curving balconies add to the feeling that the architect invested the exterior of the building with an importance and grandeur beyond its interior function as an otherwise average apartment building. It is, however, quite a slender building that was meant to conform to the uniformity of this residential neighborhood.

891

13, avenue de Verzy

AT AVENUE DES ARTS

1980, MICHEL LONDINSKY AND BERNARD BOURGADE

With its twin sloping roofs and semi-circular window treatment, this sugary-white structure looks like a modern-day fairy castle, or perhaps a cathedral. In fact, the building is a block of townhouses that share a common building. By the use of extended façades, slanted roofs, and transparent, spiral stairways, the architects tried to give the impression of a series of individual homes.

891

892

Le Bistrot d'à Côté

10, RUE GUSTAVE-FLAUBERT AT RUE RENNEQUIN

c. 1900, BUILDING

A red awning and white lace curtains typify this restaurant as a classic French bistro. Michel Rostang coined the name, Le Bistrot d'à Côté (bar on the side), because it was adjacent to an haut gastronomic restaurant. Inside, a collection of ceramic tiles and old Michelin Guides provide the picturesque décor for his inventive cuisine.

892

893

Magasins de la FNAC

26, AVENUE DES TERNES AT AVENUE NIEL

1912, MARCEL OUDIN AND EMILE ROBERT;
1992, PEROMN-DANGREAUX, RENOVATION

Modern architects' use of concrete demonstrated their ability to shape the material and a building's façade without further decoration. When architect Oudin created this building in 1912 and left its structure exposed, this concept was still considered novel and daring, especially in wealthy neighborhoods. Unfortunately, subsequent alterations—dormer windows, a tiled roof, an additional floor, and a different dome—have changed the face of Oudin's original design.

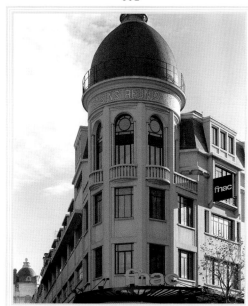

893

894

Palais des Congrès with Concorde-Lafayette Hôtel

3, PLACE DU GÉNÉRAL-KOENIG BETWEEN BOULEVARD PERSHING
AND BOULEVARD GOUVION-SAINT-CYR

1971–74, G. GILLET, H. GUIBOUT, AND S. MALOLETENKOV;
1998, CHRISTIAN DE PORTZAMPARC, EXTENSION

This enormous complex includes the Palais des
Congrès, Concorde-Lafayette Hôtel, almost
40,000 square meters of office space, a shopping
center, parking, nineteen auditoriums, and three
exhibit halls. The horizontal building is the seat
of the assembly for the Palais des Congrès, and
the hotel occupies the vertical tower. From an
aerial view this looks like a giant toilet, or perhaps
a gigantic *pèse-personne* (bathroom scale) which is
probably not what the architects had intended.

895

Eglise Notre-Dame-de-la-Compassion

2, BOULEVARD AURELLE-DE-PALADINES AT PLACE DU GÉNÉRAL-KOENIG
AND AVENUE DE LA PORTE DES TERNES

1843, PIERRE-BERNARD LEFRANC

A historic monument, this chapel memorializes the
accidental death of Ferdinand d'Orléans, son of
Louis-Philippe and heir to his throne. In 1842,
Ferdinand jumped or was flung from his carriage
and died at a nearby wine shop with the wine-mer-
chant Cordier at his side. Louis-Philippe ordered
the shop replaced with a memorial chapel. The
neo-Byzantine church, built in the shape of a
Greek cross, features stained-glass windows
designed by Jean-Auguste-Dominique Ingres.

896

Hôtel Le Méridien Etoile

75–77–81–85 BOULEVARD GOUVION-SAINT-CYR AT RUE BÉLIDOR

C.1960

Situated across from the Palais des Congrès,
this gigantic hotel has long accommodated busi-
ness people for its proximity to the conference
center at Porte Maillot, in addition to serving as
a well-known meeting place in and of itself. The
hotel has multiple facades on four streets, and
its prefabricated metal structure is typical of the
period. With its horizontal play of windows
interspersed with vertical metal strips, this
façade resembles an enormous, woven placemat.

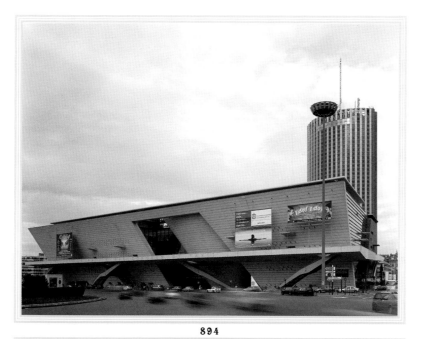

894

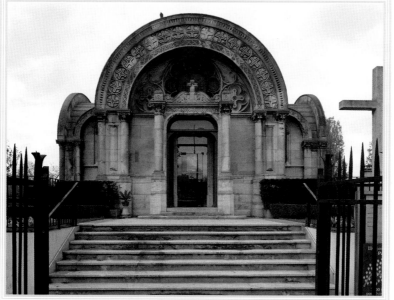

895

896

897

Eglise Saint-Ferdinand

27, RUE D'ARMAILLE
CORNER OF RUE ST-FERDINAND AND RUE D'ARMAILLE

C. 1930S–1957, PAUL THÉODON, FRÉDÉRIC BERTRAND
AND PIERRE DURAND

This Catholic church, which replaced an earlier church on the site, from the side appears to be a rather quiet, severe stone edifice, but its angled façade brings an imposing presence to the street corner. Composed as a triptych, this façade features bas-relief carving above the triple-arched entry, which rises to a multi-arched bell tower. The building is styled in a Roman-Byzantine fashion with cupolas. Its frescoes, created in the 1940s, illustrate the sacraments, in particular the life of the saints, and the Eucharistic rite in the choir section. In the 1990s, workers refitted the chorus with a new organ and an installation of the Way of the Cross in stone mosaic.

898

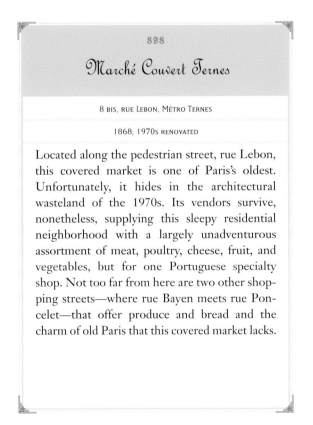

898

Marché Couvert Ternes

8 BIS, RUE LEBON, MÉTRO TERNES

1868; 1970S RENOVATED

Located along the pedestrian street, rue Lebon, this covered market is one of Paris's oldest. Unfortunately, it hides in the architectural wasteland of the 1970s. Its vendors survive, nonetheless, supplying this sleepy residential neighborhood with a largely unadventurous assortment of meat, poultry, cheese, fruit, and vegetables, but for one Portuguese specialty shop. Not too far from here are two other shopping streets—where rue Bayen meets rue Poncelet—that offer produce and bread and the charm of old Paris that this covered market lacks.

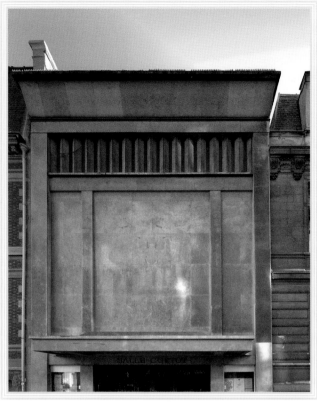

899

Ecole Normale de Musique
Salle de Concert Cortot

78, RUE CARDINET AT BOULEVARD MALESHERBES

1929, AUGUSTE AND GUSTAVE PERRET, SALLE CORTOT

Established in 1919 by pianist Alfred Cortot and his partner, Auguste Mangeot, this music institution earned an international reputation for its celebrity students and for the quality of its teaching faculty, whose instructors included Igor Stravinsky, Pablo Casals, and Arthur Honegger. In 1924, the school moved to this former private mansion, built in 1881 for the Rozard family by the architect Léopold Cochet. Its interior décor features decorative art from the end of the nineteenth century. Protected from demolition in 1965 and registered as a historic landmark, the concert hall, known as Salle Cortot, occupies the site of the mansion's former stables. This wood-paneled room, an Art Deco *chef-d'oeuvre* designed by the Perret brothers, resonates with an acoustic quality Cortot equated to that of "a Stradivarius." Students in this school train in classical music, theory, orchestra conducting, and composition.

18TH ARRONDISSEMENT

Long before the fictitious film character Amélie Poulain made Montmartre hip again, this picturesque neighborhood inspired artists of the nineteenth and early twentieth centuries. Picasso and many other painters, writers, and poets climbed the steps and made the cobblestone streets and hilly village their own community. But after inventing Cubism and Modern Art, they abandoned Butte Montmartre to the tourists who tote cameras up to record Sacré Cœur and its commanding views of Paris.

A workout to reach on foot, this spot was first discovered by the Druids. But there is more to the 18th arrondissement, beyond the touristy place du Tertre and place des Abbesses. The north side of the hill is quiet, with lovely residential streets, such as the tranquil cul-de-sac of Villa Leandre, the horseshoe-shaped streets of avenue Junot and rue Lepic, and the vine-covered rue des Saules. Filled with character and local color, the district stretches to include diverse neighborhoods: Markets around La Goutte d'Or and Chapelle offer a touch of north Africa, west Africa, Asia, and beyond. The calm market at rue Ordener caters to old-timers and young couples pushing strollers, while the action at the boulevard Barbès and the Marx Dormoy markets resembles the frenetic jumble of exotic lands. The 18th arrondissement also encompasses the famous antique and flea markets of Clignancourt and Saint-Quen. Architecturally, the old has managed to survive, even while the modern fills out the periphery.

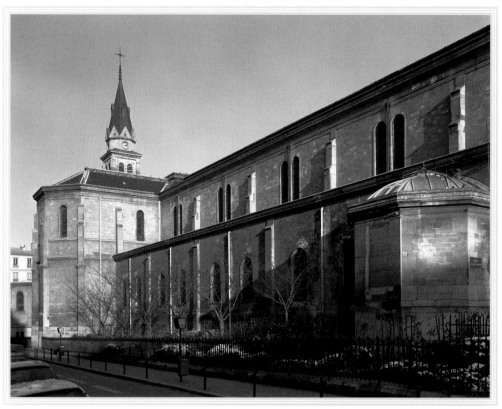

900

Eglise Saint-Pierre-de-Montmartre

2, RUE DU MONTE-CENIS AT RUE NORVINS

1133–47, FIRST CONSTRUCTION; 1775, FAÇADE;
1900–05, LOUIS SAUVAGEOT

From early Celt and Roman deification, through Norman invasions, to Christian worship, this site has undergone both religious and architectural transformation for almost 2,000 years. Four marble pillars remain from the time of the Romans, when they dedicated a temple here to Mercury. This Romanesque-influenced building is one of the three oldest churches in Paris. Because of its elevated position, the structure has also served a secular purpose: as an early telecommunications center. In 1794, Claude Chappe used the apse as a tower from which to send telegraph transmissions, successfully relaying a signal between Paris and Lille. As recently as 1980, sculptor Gismondi added three bronze doors depicting Saint-Denis, Saint-Pierre, and the Virgin.

Basilique du Sacré-Cœur

PLACE DU SACRÉ-CŒUR AT SQUARE WILETTE

1877–84, PAUL ABADIE; 1884–1905, HERVÉ RAULINE;
1905–23, LUCIEN MAGNE, TOWER

As the Eiffel tower represents Paris to the outside world, so is Sacré-Cœur the quintessential visual symbol of Montmartre. The site of this church was sacred long before Saint-Denis lost his head, picked it up, rinsed it off at a fountain, and carried it downhill. Tourists have long made the pilgrimage up the Butte, the highest of Paris's seven hills, to visit Sacré-Coeur. Dismissed by some as a whimsical plaything at best, a ridiculous wedding cake at worst, Sacré-Cœur's cluster of white onion domes illuminate the night sky like a sugar-coated northern beacon. Resembling a Russian Orthodox church or a mosque more than a Catholic basilica, this legendary Roman-Byzantine–style structure actually cleans itself. Built from local stone that releases white calcite whenever it rains, the church gets brighter and whiter with each drop that falls.

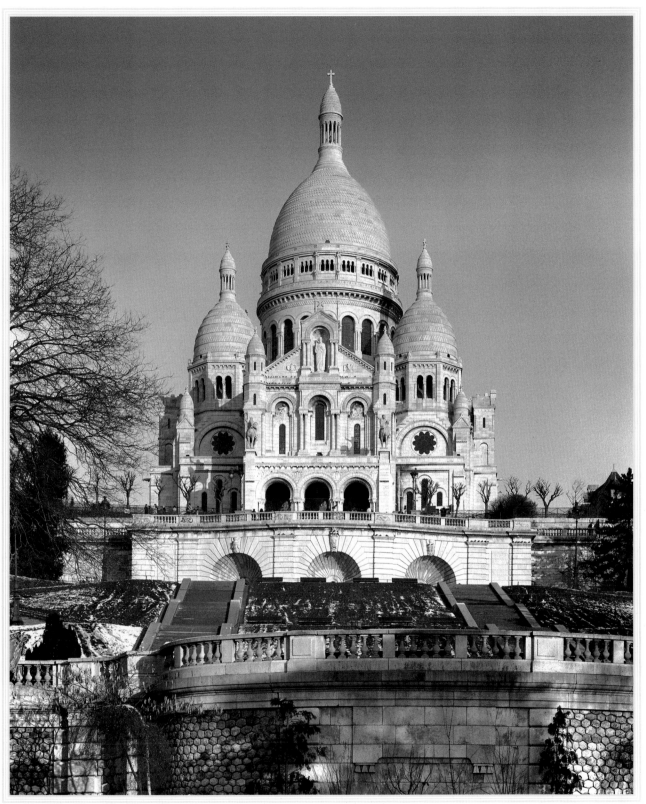

901

902

Musée d'Art Naïf Max Fourny
(Halle Saint-Pierre)

ONE, RUE RONSARD AT PLACE SAINT-PIERRE

1868, STUDENT OF BALTARD, NAME UNKNOWN;
1986, CLAUDE CHARPENTIER AND JACQUES VALENTIN

This surprising and delightful building, Halle Saint-Pierre, exudes a cozy, welcoming presence at the foothill of Sacré-Cœur. Once a covered market but, since 1986, a lively cultural arts center, the hall houses a café, book shop, and the Musée d'Art Naïf Max Fourny, which includes works collected by Max Fourny and his wife. The museum mounts also temporary exhibits. Its collection consists of over 500 paintings and about a hundred sculptures of naïve art.

903

La Folie Sandrin

22, RUE NORVINS AT PLACE JEAN-BAPTISTE CLÉMENT

1774

An institution for the insane, administered here by Dr. Prost from 1805 to 1820, kept the Cossacks at bay. In 1814, Russian troops in Montmartre almost used this site for headquarters but, after encountering the rage and hysteria of the inmates, decided to camp elsewhere. From 1820 to 1847, Dr. Esprit-Silvestre Blanche, and later his son, Emile, ran a different mental clinic out of this eighteenth-century mansion. Guy de Maupassant was a patient for a spell.

904

Le Lapin Agile

4, RUE DES SAULES AT RUE SAINT-VINCENT

C. 1860, BUILDING

In 1875, after painter-caricaturist André Gill created a sign of a rabbit jumping out of a saucepan *(lapin à gill)* holding a bottle of wine, the original name *Le Lapin à Gill* evolved into Le Lapin Agile. This favorite haunt of Modigliani, Picasso, Apollinaire, and others, became the site of an artistic hoax: In 1910, critic Dorgelès, no fan of Cubism, tied paintbrushes to the tail of Lolo, the cabaret-owner's donkey. Lolo swished over a large canvas. The resultant masterpiece, *Soleil sur l'Adriatique*, was accepted into the modern art exposition.

902

903

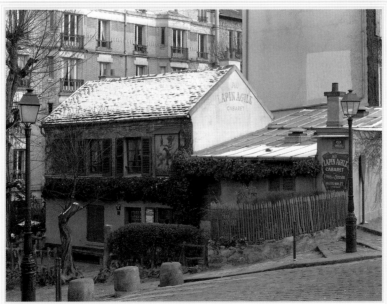

904

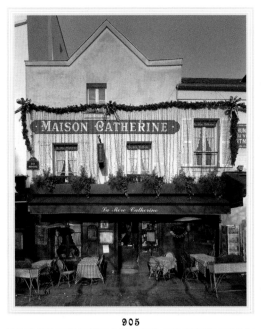

905

906

907

908

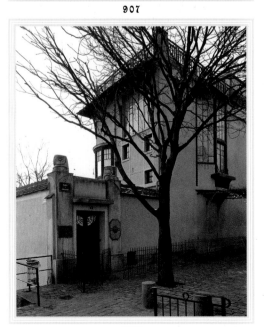

909

910

905

La Mère Catherine

6, PLACE DU TERTRE AT RUE NORVINS

1793

A sea of crisp, red-checkered tablecloths wow you upon entering—along with the words that Danton scrawled across the wall in 1793: *"Buvons et mangeons, car demain nous mourrons"* ("Let's drink and eat, because tomorrow we will die"). Likely, Danton and his disciples who met there believed in that motto as a perfect description for the clientele of this café and the times they lived in. This restaurant was founded during the French Revolution.

906

36, rue Gabrielle

AT PLACE JEAN BAPTISTE CLEMENT

1932, J. BOUCHER AND M. BOURIUET

Geometry and mass along with metal and concrete define this Art Deco building. Bulging balconies emerge from the base of reinforced concrete and the brick façade. The construction features stylized and geometric floral patterning in the iron railings around the balconies and windows.

907

29, rue Gabrielle

BETWEEN PLACE JEAN-BAPTISTE CLÉMENT AND RUE DU CALVAIRE

c. 1900

The charm of old Montmartre is evident in this little house tucked away behind a graffiti-marred, gated wall. Despite the changes in the neighborhood and pressure on this tourist area for more development, whether by chance, design, obstinacy or craziness of old people, a few holdouts remain preserved here to remind visitors of days gone by.

908

30 bis, rue Gabrielle

BETWEEN PLACE JEAN-BAPTISTE CLÉMENT AND RUE DU CALVAIRE

1900

This funny little house appears lost in the big city. It's either a vestige or fake vestige of the old neighborhood. Composed of wood framing and brick, this picturesque house, in need of repair, might have been built by someone who wanted to add charm to his environment, perhaps an artist who had his studio above and a small, precious garden behind the gate.

909

1–3, place du Calvaire

BETWEEN RUE GABRIELLE AND RUE POULBOT

c. 1930

Place du Calvaire, one of the smallest squares in Paris, was home to painter-lithographer Maurice Neumont (1868–1930). From this Art Deco home up the Butte, just east of Basilique du Sacré-Cœur, the artist enjoyed one of the prime views of Paris. A prolific menu illustrator for the Cornet Society, Neumont, along with a group of other artists, created war art posters for the French government, in an effort that helped mobilize France to action during World War I.

910

Picasso atelier

49, RUE GABRIELLE AT RUE RAVIGNAN

c. 1830–40, BUILDING, THEN TRANSFORMED AT THE END OF THE
CENTURY; 1900, INSTALLATION OF PICASSO

Lured by its cheap food and housing, not to mention its models, rather than by its country atmosphere, Picasso trekked to Butte Montmartre, as did other artists. His first studio here, at 49, rue Gabrielle, did have the trappings of village life, nonetheless, with its shady trees and quiet paths just west of the funicular and within sight of Sacré-Cœur. By 1907, he had moved uphill slightly to the connecting street of rue Ravignan, near place Emile Goudeau.

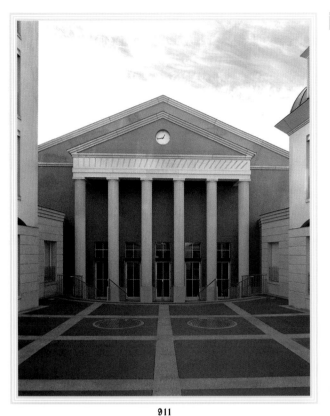

911

31, rue des Abbesses

AT RUE GERMAIN PILON

1996, CHARLES VANDENHOVE, JACQUES SEQUARIS
AND PRUDENT DE WISPELAERE

Like some joke, this peach-tinted, neoclassical theater pops out of nowhere. Set back from the action on rue des Abbesses, accessed through a narrow gateway, this complex, which houses a theater, a dance school, and private lodgings, is not immediately apparent from the street. Closer inside the square, you notice the charm. Halfway up Butte Montmartre, architect Vandenhove reinterpreted the historic, neoclassic surroundings with his own style of classic detailing that added modern twists: a series of triangular pediments, curved zinc roofs, and façades with columns that support nothing. Composed of slightly tinted concrete and Hauteville stone, the façades are delightful and full of wit.

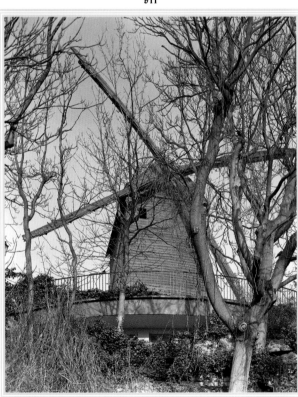

912

912

Moulin de la Galette

83, RUE LEPIC AT AVENUE JUNOT

C. 1620, MILL, REBUILT MANY TIMES; 1812, FARM

In the seventeenth century, vineyards and windmills dotted the landscape of Montmartre. This historic windmill was one of around thirty that milled flour for the locals. A clever miller at this *moulin* (windmill) decided to cook up *galettes* (flat cakes or pancakes), to serve to his customers while they waited for their ground flour, hence the name, *Moulin de la Galette* (Pancake Windmill). Capitalizing on a good idea, he added wine to his popular menu, and the windmill became a place to go for rollicking good times. Today, this historic mainstay is one of two surviving windmills on Butte Montmartre (the other, restaurant Le Moulin du Radet, is at 83, rue Lepic) and is part of the grounds of a private residence.

913

Musée de Montmartre

12, rue Cortot between rue du Mont Cenis and rue des Saules

c. mid–seventeenth century, house; 1922, City of Paris, restoration; 1960, creation of the museum

Situated on the last remaining vineyard in Paris, this museum, founded in 1960, occupies the former home of Claude de la Rose, known as Rose de Rosimond, an actor in Molière's troupe who died on stage while performing in *Le Malade Imaginaire* (as did Molière himself). When Rosimond lived here in the 1680s, Montmartre was not yet part of Paris. In the latter half of the nineteenth century, various artists used this house as both living quarters and ateliers. While working here, Renoir painted *Le Moulin de la Galette*. Today, the museum's collection of posters, period sketches, photographs, and manuscripts document the history of Montmartre.

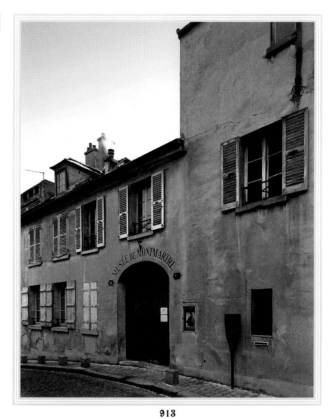

913

914

Musée Erik Satie

6, rue Cortot between rue du Mont Denis and rue des Saules

c. seventeenth century, then transformed in the eighteenth century

From 1890 to 1898, composer Erik Satie lived in this nondescript building in a room so tiny he called it "a closet." In 1893, he conducted an intense love affair with painter and model Suzanne Valadon, who lived next door. Supposedly, on January 14, 1893, the very night their liaison began, Satie proposed marriage to Valadon; and he wrote passionate letters about her "exquisite eyes, gentle hands, and tiny feet." Valadon dumped the obsessed musician after six months. One of the smallest museums in the world, Satie's house contains a desk, a chair, a lamp, and his art collection.

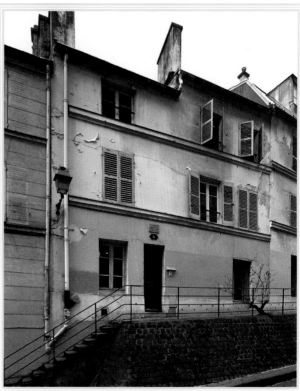

914

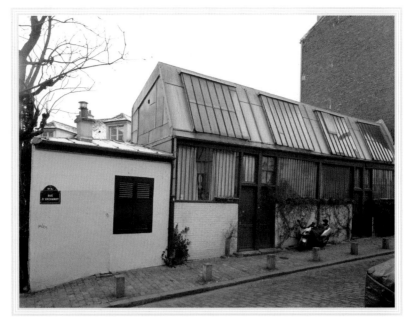

915

916

917

915

Le Bateau-Lavoir

13, RUE RAVIGNAN PLACE EMILE GOUDEAU

1899, CONSTRUCTION OF WORKSHOPS;
AFTER 1970, CLAUDE CHARPENTIER, REBUILT

Painters gravitated to this rundown, one-story building called Bateau-Lavoir (laundry boat or washhouse) in the 1890s, most of them settling in between 1902 and 1904. Picasso who, like Hemingway, seems to have turned up everywhere in Paris, moved in and worked here from 1904 until 1909, and retained a workshop here until 1912. This was also home or hang-out to Georges Braque, Henri Matisse, Otto Freundlich, Juan Gris, and Herbin (with whom Picasso shared a studio).

916

Cinéma du moulin de la galette

ONE, AVENUE JUNOT AT RUE DE GIRARDON

C. NINETEENTH CENTURY, BUT TRANSFORMED

At a time when sprawling multiplex theaters are becoming the norm, this neighborhood cinema in the center of historic Montmartre offers film-lovers the intimate setting of a private home. An hour before the show begins, the theater's director invites you into the projection room, or to take a comfortable seat in a settee or armchair, to relax with a glass of wine, or other beverages and snacks while you chat with him as if you were enjoying a casual visit with friends. Without commercials or trailers, the film follows.

917

2-4, rue des Amiraux

AT RUE DES POISSONNIERS

2001, GEORGES PENCREACH

Shaped like a wedge and looking sharp as a knife, this building seems poised to slice through anything. Ultra-linear, the roof structure with its sunscreens presents a contrasting horizontal plane to the three vertical volumes and windows on the lower level. The building contains city housing and a day-school nursery.

918

ABBESSES MÉTRO

The subway transportation system came late to Paris, following those already constructed in the 1860s and '70s in London, Berlin, New York, and Vienna. By 1895, when Paris was ready to relieve city congestion and join the underground movement, it did so with a flourish thanks to Hector Guimard. At the beginning of the twentieth century, Guimard, Art Nouveau architect par excellence, began installing covered Métropolitain entryways around the city. From 1900 until 1913, he created 141 entrances. Ranging from simple designs to elaborate

works of art, they all demonstrate the curving, organic style of Art Nouveau. Eventually regarded as obsolete, however, many of Guimard's original coverings have been dismantled and distributed elsewhere. The Museum of Modern Art in New York City acquired his masterwork from the Bastille metro. Fortunately, Guimard's artistry still covers a few stations: Châtelet in the 1st arrondissement, Port Dauphine in the 16th, and Abbesses in the 18th. Constructed in 1900, the Abbesses' ornamentation was initially located at the Hôtel de Ville metro station.

919

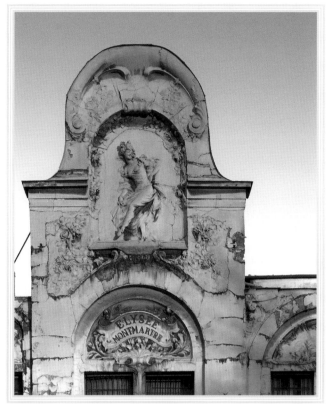

920

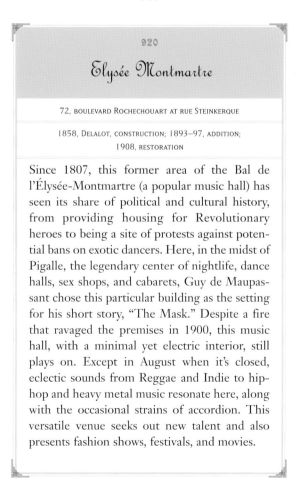

Élysée Montmartre

72, BOULEVARD ROCHECHOUART AT RUE STEINKERQUE

1858, DELALOT, CONSTRUCTION; 1893–97, ADDITION;
1908, RESTORATION

Since 1807, this former area of the Bal de l'Élysée-Montmartre (a popular music hall) has seen its share of political and cultural history, from providing housing for Revolutionary heroes to being a site of protests against potential bans on exotic dancers. Here, in the midst of Pigalle, the legendary center of nightlife, dance halls, sex shops, and cabarets, Guy de Maupassant chose this particular building as the setting for his short story, "The Mask." Despite a fire that ravaged the premises in 1900, this music hall, with a minimal yet electric interior, still plays on. Except in August when it's closed, eclectic sounds from Reggae and Indie to hip-hop and heavy metal music resonate here, along with the occasional strains of accordion. This versatile venue seeks out new talent and also presents fashion shows, festivals, and movies.

921

922

923

924

921
Théâtre de l'Atelier
(FORMERLY THÉÂTRE DE MONTMARTRE)

1, PLACE CHARLES-DULLIN AT RUE D'ORSEL

1822, LOUIS-PIERRE HAUDEBOURG;
1907, GILBERT DURON, TRANSFORMATION

In 1922, Charles Dullin rescued this theater from obscurity and, with his wife, created the Workshop of the Theater behind this simple, Italian-style façade. Prior to this, in 1905, as a young, idealistic actor, he performed here—as did the great Sarah Bernhardt, who dazzled audiences here as the star of *La Dame aux Caméllas* (The Lady of the Camellias). But then, in 1908, the theater fell on hard times, as the popularity of film overshadowed live drama. World War I forced the building's closure in 1914 and, a few years later, it reopened as a cinema. Dullin took over as artistic director in 1922 until 1940. The theater today carries on in his tradition.

922
La Cigalle
(FORMER THÉÂTRE)

120, BOULEVARD ROCHECHOUART AT RUE DES MARTYRS

1887, TRANSFORMATION OF A FORMER BUILDING;
1894, GRANDPIERRE, REBUILT; 1928, DESPREZ ET PRADIER,
NEW FAÇADE; 1987, PHILIPPE STARCK DÉCORATION

This vast venue—at the site of a former theater—rocks to an eclectic music scene. On any given night, you might hear Latin, Jazz, French, Asian, or a mixed program of still another kind. Though the exterior appears to be a faceless, white cement structure with portholes, the interior fills with multi-cultural character bound to entertain.

923
Théâtre Libre de Montmartre

37, RUE ANDRÉ ANTOINE AT RUE VERRON

1887, FOUNDATION

André Antoine—theater innovator, director, manager, and critic in the late nineteenth and early twentieth century, and for whom the street is named—originally founded this theater at another location in 1897, as the Théâtre Antoine. He produced avant-garde productions for ten years, directing plays of Zola and contemporary German, Russian, and Scandinavian playwrights. He advocated naturalistic theater in opposition to what was then advocated by the Paris Conservatory. Théâtre Libre (Free Stage) de Montmartre became a model for experimental productions elsewhere in Europe and in the United States.

924
Saint-Jean-de-Montmartre

19–21, RUE DES ABBESSES AT PLACE DES ABBESSES

1894–1904, ANATOLE DE BAUDOT

Architect Baudot's personal preference for Gothic architecture notwithstanding, he created the first church in Paris to be made of reinforced concrete. Construction took ten years to complete, and the church was almost demolished before it was finished because authorities did not understand the properties of that new material called concrete. In the end, Baudot applied a layer of brick over the concrete skeleton of his neo-Gothic creation. Unexceptional stained-glass panels fill most of the windows and small vaulted openings. The high vaulting, however, gives the acoustics a special quality and makes a church visit worth a trip.

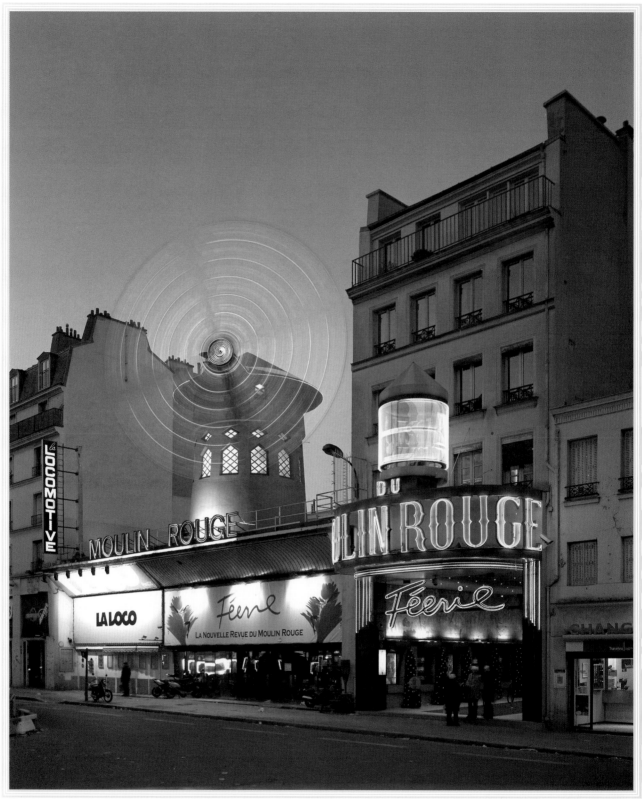

925

926

Moulin Rouge

82, BOULEVARD DE CLICHY AT RUE LEPIC

1889, CREATION

The red windmill sails aren't the only hot items twirling here. Leggy and scantily clad cancan girls kick up their gams in Paris tradition inside the Moulin Rouge (Red Windmill). Although the legendary cabaret—founded by a butcher named Charles Zidler, and his partner, Joseph Oller—opened to great fanfare during the 1889 World Exposition and centenary of the French Revolution, its fame owes a tremendous debt to artist Toulouse-Lautrec who brought it world attention with his posters that depicted its dancers and frolicking customers. In a transitional period between wars and centuries, Parisian society enjoyed cultural expansion and a brief fling with gaiety, carefree thought, and joie de vivre. This vitality expressed itself in various artistic forms, including the emerging sex industry, of which the dancing girls of the Moulin Rouge became symbolic.

926

Cité Véron

94, BOULEVARD DE CLICHY BETWEEN RUE LEPIC AND AVENUE RACHEL

c.1900

Adjacent to the spinning sails of the Moulin Rouge, a blue-and-white enamel sign hangs above a narrow passage less than ten feet wide. Despite its tiny proportions and proximity to Pigalle's wider sexual proclivities, in the early 1920s this cul-de-sac was home to various celebrities from the art world. Playwright Eugène Ionesco and other writers and poets used to hang out on the common terrace, which doubled as the dressing room for the cancan dancers next door. Poet Jacques Prévert and writer Boris Vian lived in apartments opposite each other in this alley, whose name derives from an outstanding mayor of Montmartre, who had held office from 1830 to 1841.

927
Chao-Ba Café

22, BOULEVARD DE CLICHY (OLD CAFÉ PIGALLE LOCATION)
AT VILLA DE GUELMA

1954, MAURICE GRIDAINE, DECORATION

While the surrounding, sordid neighborhood lends itself to sleazy bars, this lounge offers a touch of civilization to the quarter's nightlife. Stirring things up in an environmental mix of Indo-Vietnamese French style, Chao-Ba Café took over the former site of the old Café Pigalle. Illuminated inside and out, this spacious yet cozy restaurant is a friendly place to hang at the border of the 18th and 19th arrondissements after trekking around the strip.

928
Lux-Bar

12, RUE LEPIC AT RUE CAUCHOIS

C. 1830-40, BUILDING; C.1910, DECORATION

In summer or winter, this early–twentieth-century corner tavern expands beyond its narrow interior space to offer sidewalk service. Heated within and protected by plastic covering in cold weather, the cozy atmosphere along the pavement invites lingering. Inside, the eclectic wall décor of sports photos, electronic gear, bottles, and bar ware almost hide the decorative tilework that dates from 1910. The lime-green ceiling moldings and frosted-grape chandeliers add dubiously tasteful finishing touches.

929
Villa des Arts

15, RUE HÉGÉSIPPE-MOREAU AT RUE ETIENNE JODELLE

1888–1900, HENRI CAMBON, BUILDINGS

Henri Cambon designed this arts community, a cul-de-sac near the Montmartre cemetery, using leftovers from the World's Fair and recycled material from construction sites. Once completed, light flowed into about sixty studios, and the villa's wrought-iron gate, with the name Villa des Arts pierced above, swung open to celebrity artists: Paul Cézanne, Raoul Dufy, and Paul Signac were among those who made the area famous. It remained an attractive artistic neighborhood well into the twentieth century.

930
Villa des Fusains

22, RUE TOURLAQUE AT RUE JOSEPH DE MAISTRE

1889, BOURDEAU

Famous artists gravitated to this street, as they did to other areas in Montmartre. Vincent Van Gogh and his brother Théo shared a place at 54, rue Tourlaque. This shady nook of thirty artists' ateliers drew Renoir, Bonnard, and Derain, as well as others. If they didn't live here, they routinely visited one another. Picasso, who lived nearby for a time, was a regular to these studios. Behind the entrance to this artist villa, scattered sculptures decorate the gardens.

931
7, impasse Marie-Blanche

AT RUE CONSTANCE, NEAR RUE LEPIC

C. 1882

In 1835, the comte d'Escalopier, historian and archaeological devotee, commissioned a neo-Gothic hotel on this site. When it was dismantled fifty years later, it was still known from engravings. When Monsieur Eymonaud, who restored old furniture and manufactured replicas, built this picturesque, neo-Gothic house on the site, he repurchased pieces of sculpture from the original *hôtel* and integrated them into the façade of his own house, thus adding character and evoking a bit of the past.

932
14 bis, avenue Junot

BETWEEN VILLA LEANDRE AND PLACE MARCEL AYMÉ

C. 1920

Avenue Junot curves uphill to a residential neighborhood filled with a charming mix of asymmetrical housing and side streets. A cobblestone path leads off this avenue to a delightful jumble of townhouses known as Villa Leandre. Surprisingly quiet, just blocks away from livelier activity, avenue Junot was built between 1910 and 1912, not far from old Roman ruins of temples and villas. The construction of these homes, as well as Moulin de la Galette, used some of the material from these ruins.

927

928

929

930

931

932

933

934

935

936

937

938

933

185, rue Belliard

AT RUE VAUVENARGUES

1913, HENRI DENEUX

Using the technology of concrete, architect Deneux, who planned this complex for himself, developed the building's structure, then applied a weatherproof layer of ceramic to the façade. He prefigured the Modern Movement by about a decade, with his bold design of a flat roof to which he added a tiered garden terrace. This construction was so well-planned and executed that the waterproofing has never needed maintenance.

934

Château des Brouillards
(CHÂTEAU OF THE MIST)

ALLÉE DES BROUILLARDS BETWEEN PLACE CASADESUS
AND SQUARE SUZANNE-BUISSON

C. SEVENTEENTH CENTURY FARM; 1764, CHÂTEAU

A country villa surrounded by trees and greenery, this château was once home to the Casadesus family of musicians, for whom the nearby place is named. In 1764, a court official built a romantic manor house here, replete with farmland and orchards, and named it *Château des Brouillards* (Château of the Mist)—for, whenever storms brewed, mists engulfed it. Nineteenth-century poet Gérard de Nerval celebrated the romance of this place in his writings.

935

Conservatoire Municipal de Musique

29, RUE BAUDELIQUE AT BOULEVARD ORNANO

1985, CLAUDE CHARPENTIER

This happy building is like a party invitation. A composition of five floors in black and white, the façade sports curved glass, set in a thin, hollow space and hung as three-part, metal bay windows. They are separated to avoid sound interference from one room to another. Painted black, they contrast with the white-tiled frontage that has round moldings. The opposition of black on white is also apparent in the black framing around the square windows, and in the joint sealing between the ceramics tiles.

936

Postal center

18–20 BOULEVARD DE LA CHAPELLE AT RUE PHILIPPE DE GIRARD

1993, ARCHITECTURE STUDIO

This asymmetrical, black monolith jazzes up a dreary neighborhood near the elevated subway of la Chapelle and attempts to seam together the urban network. Three separate volumes compose the postal complex connecting administrative offices with its sorting and distribution centers. The frontage conveys a kinetic perception with contrasting planes, tilted angles, window grids, cables, and overhead lines. Only the yellow, emblematic color of the Postal Service winks at pedestrians and offers a clue to the building's function.

937

Maison Tzara

15, AVENUE JUNOT AT VILLA LÉANDRE

1926, ADOLF LOOS

Like a Dadaist painter, Austrian architect Loos attacked the conventional standards of aesthetics. Here, he chose commonplace materials—brick and plaster—to create a harmonious entity. By placing heavy, dark masonry-work at the base, he achieved a balance of lightness with white plaster on the upper half. White beams underline the recessed base and emphasize its solid grounding, while the upper balcony recess resembles a large picture window that provides additional light.

938

Caserne de Pompiers
(FIRE STATION)

132, RUE LAMARCK AT RUE EUGÈNE CARRIÈRE AND RUE CARPEAUX

1995, JACQUES RIPAULT

Composed of red cedar, the sliding shutters of this Mediteranean-style apartment complex are mounted in metal frames. The device gives occupants flexibility to design the look of their own living quarters, from having windows to opaque walls. These apartments accommodate the families of employees from a nearby fire station: Through a vertical gap, a triangular courtyard opens to the central fire brigade in a nineteenth-century building that this apartment complex conceals on the rue Lamarck side of the street.

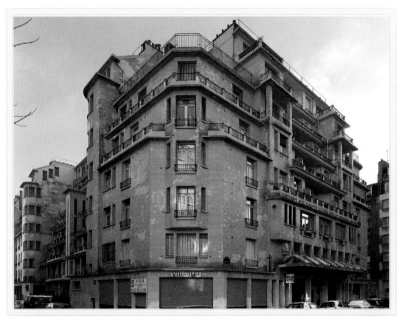

939

940

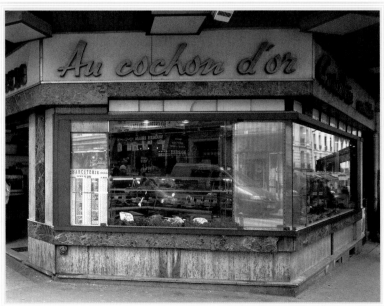

941

13, rue des Amiraux

NEAR MÉTRO SIMPLON BETWEEN
RUE DE CLIGNANCOURT AND RUE BOINOD

1922–27, HENRI SAUVAGE; 1930, SWIMMING POOL, HENRI SAUVAGE;
1982, SWIMMING POOL RECONSTRUCTION, DANIEL AND PATRICK RUBIN

Architect Sauvage turned this entire site into a vertical *cité-jardin* (city garden). His stadium-like gradations—almost the size of the apartments themselves—allowed ample room for terraces. Sauvage—the founder of a society for affordable housing—wanted to develop a living space that symbolized health. His graduated layers opened up space for the natural flow of light and air.

Saint-Denis-de-la-Chapelle with Basilica of Sainte-Jeanne-d'Arc

16, RUE DE LA CHAPELLE AT RUE DE TORCY

C. THIRTEENTH CENTURY, NAVE (CHURCH SAINT-DENIS-DE-LA-CHAPELLE);
1757, FAÇADE (CHURCH SAINT-DENIS-DE-LA-CHAPELLE); 1895, CHOIR
(CHURCH SAINT-DENIS-DE-LA-CHAPELLE); 1933–54, JEAN-EMILE
CLOSSON, THEN ISNARD, BASILICA

In 1920, Pope Benoit XV canonized Joan of Arc, who came to pray here in 1429, and he allowed the construction of a church dedicated to her adjacent to Saint-Denis. The first church on the right, called Saint-Denis-de-la-Chapelle, is at number 16 and was built earlier. The new basilica was supposed to resemble a medieval castle from Sainte-Jeanne's time.

Au Cochon d'Or

23, RUE DES POISSONNIERS AT RUE DEJEAN

C. 1840, BUILDING

Marked by stacks of pigs' hooves in the window and racks of beef hanging inside, this corner charcuterie displays choice cuts at its street stall on rue Dejean, site of a pedestrian market. A surprising touch of north and west Africa emerges along this colorful, short back street which proffers piles of familiar fresh fish, fruit, vegetables, and meat as well as tropical and other exotic produce. Imported fish, such as the Ivory Coast specialties *disk* and *thoif*, are packed on ice alongside fresh, local catfish and the like.

942

942

Residence Universitaire

4–8 RUE FRANCIS DE CROISSET AT PORTE DE CLIGNANCOURT

1996, ARCHITECTURE STUDIO

Designed as two gigantic shields that block the noise from the Périphérique, the Paris beltway, this university housing appears to be several buildings of varying volume. On the traffic side, a black, double-walled monolith rises 33 meters high and 105 meters long. It consists of one curved face and one straight, linear façade. Glass bricks create a woven pattern; and small, external red lights positioned on the freeway façade illuminate it at night, as if it were a vertical airport runway. As proportions go, this housing holds its own within the industrial surroundings. The students who live in its south side are blessed with sweeping views of Paris.

19ᵀᴴ ARRONDISSEMENT

Until the industrial nineteenth century laid waste to this once-rural hamlet outside the city walls, the river Ourcq flowed through meadowlands filled with vineyards, orchards, and fields of grain. In the early part of the nineteenth century, when Napoléon I decided to build beautiful fountains throughout Paris, the water's flow symbolizing the city's prosperity, he developed the Bassin de la Villette and the Canal de l'Ourcq, diverting the water from them to the Seine. Unfortunately, the waterways' strategic locations made them necessary conduits of the Industrial Revolution. By the time the plain of La Villette was annexed to Paris in 1860, docks and small industries had sprung up on the banks, and factories, tanneries, and refineries were dumping waste into the river, while smokestacks spewed filth into the air.

In 1876, the city's main *abattoir* (slaughterhouse) was located here as well. A hundred years later, the site was rejuvenated as a futuristic La Villette, with parkland, cultural venues, and museums. To the south, the magical, manmade Parc des Buttes Chaumont enchants visitors to the Buttes Chaumont quarter. Not far from the park, vine-covered mews on both sides of rue de Mouzaïa are lined with dollsized cottages where workers used to live.

943

944

943

The Géode

OPPOSITE CITÉ DES SCIENCES ET DE L'INDUSTRIE

1985, ADRIEN FAINSILBER

Adjacent to the science museum, La Cité des Sciences et de l'Industrie, this cinema-in-the-round sits in the center of a reflecting pool. Surrounding the viewer with sound on a vast spherical screen, architect Fainsilber used stainless-steel mirrors to create the façade of his sphere—6,500 triangular pieces closely fitted to within a millimeter. The basic form, a "geodesic dome," was inspired by the work of Buckminster Fuller, who pioneered the structure as a super-efficient use of light, space, and energy.

944

La Cité des Sciences et de l'Industrie

30, AVENUE CORENTIN-CARIOU AT ESPLANADE DE LA ROTONDE AND GALERIE DE LA VILLETTE

1964, MAURICE FOURNIER, JEAN SEMICHON AND SERGE WARLAN (FORMER BUILDING); 1980–86, JEAN SEMICHON, EXTERIOR AND ADRIEN FAINSILBER, INTERIOR INSTALLATIONS

A giant, futuristic science and industry museum, this building—constructed where an *abattoir* used to stand—is part of the larger La Villette complex that includes a variety of entertainments ranging from cinema to circus. The museum explores the natural world and the universe through Disneyland-like exhibits that flash and dazzle and sizzle, for maximum appeal to nonscientists. Packed with hands-on exhibits for children, the museum includes the "Cité des Enfants" for three- to five-year olds, an aquarium, a first-rate planetarium, and an Omnimax theater.

945

945

Archives of Paris

18, boulevard Sérurier at Porte des Lilas and boulevard Pérphérique

1989, Henri and Bruno Gaudin

Created to show off pure shape, this building was also designed to shut out the sound from the rush of traffic on the Périphérique beltway. The shape and folds of the building's silos act as protective shells, blocking out the noise. In front of these towers, V-shaped walls with a glass façade form the entrance and identify the main reading room, allowing in plenty of light for research. Well-designed and well-lit, this asymmetrical structure gives the appearance of symmetry.

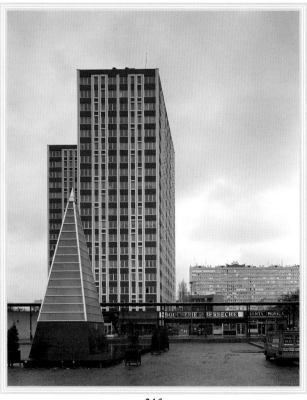

946

946

19, place des Fêtes

At rue de Crimée

1957, first urban planning; 1960–70, construction of the buildings; 1995–96, Bernard Huet, remodeling

A time-traveler from 100 years ago would never recognize place des Fêtes today. Gone are the nineteenth-century circular kiosk and verdant park, replaced by a modern pyramid sculpture surrounded by high-rises of the twentieth century. Despite the brutality of 1960s urban planning, a colorful market still exists at place des Fêtes three days a week, setting up in the shadow of the apartment buildings. This neighborhood today is a melting pot of nationalities and immigrants drawn to Paris for new opportunities.

947

Regard de la Lanterne

JARDIN DU REGARD DE LA LANTERNE AT RUE COMPANS
AND RUE AUGUSTIN THIERRY, NEAR RUE DE BELLEVILLE

C. THIRTEENTH CENTURY; 1583, REBUILT; 1613, RECONSTRUCTED

Part of a water system supplied by the wells of Belleville hill, this current inspection kiosk was rebuilt in the early sixteenth century, and again in the first part of the seventeenth century. The monks from the Abbey of Saint-Marin-des-Champs were probably the first to use a version of this structure as early as the twelfth century. The shape of lantern gave its name to this robust construction. Today, most of the Right Bank in Paris is still fed with natural water sources but, because of Paris's extended city border, the water now flows from much farther away.

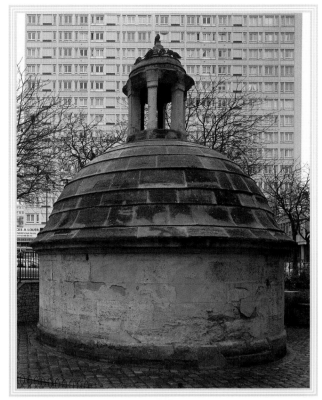

947

948

65–69, rue d'Hautpoul

AT RUE PETIT

C. 1990

Despite its modernism, this office and apartment building adheres to a tradition of Parisian hierarchy in the façade: The ground level is well defined, and the historical height of the cornice is 15.6 meters. It is marked by a horizontal line above, in which a dark color distinguishes the attic and roof. Covered by granite, the façade is punctuated by a rhythm of two large, vertical bay windows.

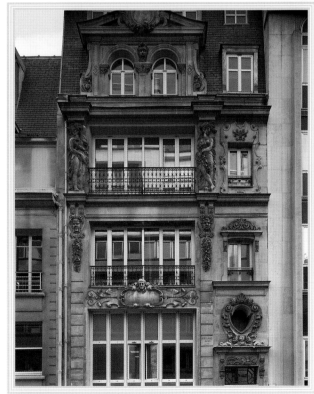

948

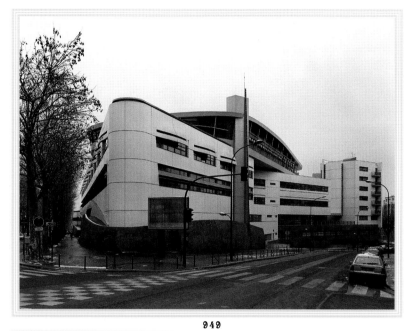

949

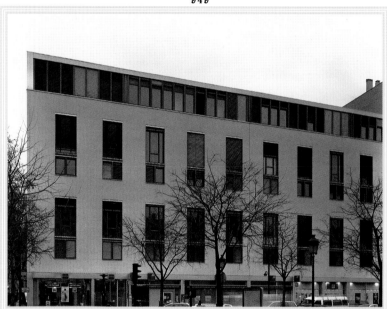

950

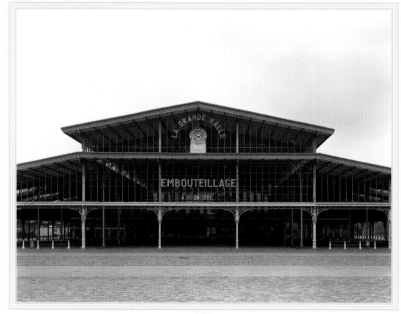

951

Lycée Diderot

Giving the illusion of a vessel poised to launch from a solid base of rocks, this pilot school is dedicated to technical education. The modern complex is well equipped to promote better educational development in a technological culture. Indeed, its sleek and stylish exterior, set onto a contrasting mineral foundation, projects an image of integrated systems about to propel students into the world with a confidence of knowledge and a competitive advantage.

109-115 avenue de Flandre

In this chaotic area, thoroughly transformed in the 1960s and 70s, architect Patrick Berger, who planned the successful Viaduc restoration in the 12th created quiet architecture here that respects the immediate scale of the surrounding buildings. As a testament to Berger's design talents, he manages a sensitivity of proportion even as his construction of three double levels from the street gives the façade a monumental shape.

Grande Halle de la Villette

The Grand Halle, now used for exhibitions and trade fairs, once housed a livestock market, conveniently located near the old La Villette slaughterhouse. Contained within the renovated Parc de la Villette—conceived as a futuristic city for twenty-first century activities—the Grand Halle is as stunning as it is huge. This former covered market sits under an enormous roof that rests on slender cast-iron columns, and its glass-and-metal skylight gables allow natural light to flood in.

952

Parc des Buttes-Chaumont

Bordered by rue Manin, rue de Crimée and rue Botzaris

This rambling and hilly neighborhood park at the north-eastern corner of Paris is an artful, artificial creation. But it's a treat that seems to have everything: greenery, a waterfall, a rock cave with stalactites and stalagmites, a mini-mountain, and a man-made lake. Developed on sixty-four acres, this beautiful park anchors the working neighborhoods of La Villette and Belleville. But, until 1849, this site was a dump. Gypsum quarries (called "quarries of America"), a refuse heap, and even a gallows occupied the area until 1864, when Napoléon III set his landscape engineer, Alphand, to work on designing a park for the people. He blasted the rocky ground with dynamite; filled it with soil to support trees and shrub-bery; pumped in water from the nearby Villette basin and L'Ourcq canal, to create his center lake and 100-foot waterfall. He also built a suspension bridge, created a cliff, and topped off his mountain landscape with a repli-ca of the Sybille temple from Tivoli. Four years in the making, the scenic features of this dramatic and roman-tic park seem to constantly change as you stroll—which is just what Alphand intended.

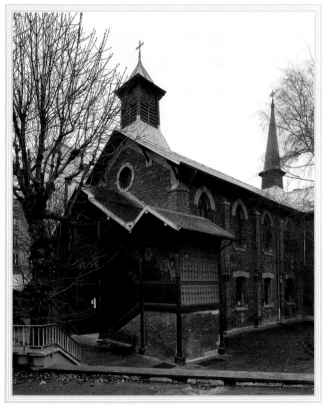

953

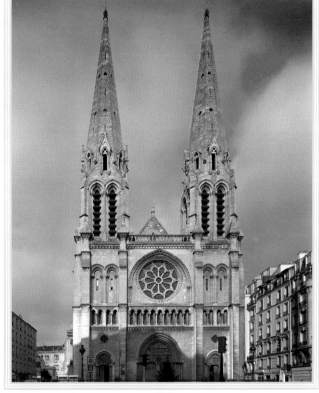

954

Eglise Russe Saint-Serge

93, RUE DE CRIMÉE BETWEEN RUE MANIN AND RUE MEYNADIER

1858–65, FIRST CONSTRUCTION;
1925–27, DIMITRI S. STELLETSKY, DECORATION

Originally a Protestant parish, until 1914 this church was frequented by a German community of Lutherans. The Russian Orthodox Church appropriated it after World War I, and rechristened it in 1925 for the community of Russian immigrants who arrived in Paris after the Russian Revolution. In the mid-1920s, Dimitri S. Stelletsky redecorated this lovely neo-Gothic church to suit its new congregation. It features a double-stairway entrance of brick and painted wood.

Eglise Saint-Jean-Baptiste-de-Belleville

139, RUE DE BELLEVILLE AT RUE DE PALESTINE

1854–57, JEAN-BAPTISTE LASSUS; 1857–59, TRUCHY

During the Revolution, the church lost its autonomy, and its properties became nationalized until the separation of church and state in 1905. Throughout the nineteenth century, church construction was thus the domain of the State, which sought to create a style that would promote a unifying identity for a French national church. To accomplish this, it revived the Gothic style of twelfth-century Paris. Jean-Baptiste Lassus, who worked on the renovation of Sainte-Chapel, Notre-Dame, and Saint-Germain-l'Auxerrois, was one of the "diocesan architects" who took part in this movement. He modeled Saint-Jean-Baptiste-de-Belleville on buildings from the period 1150–1250.

955

956

957

958

959

960

955
Hôpital Robert-Debré

48, BOULEVARD SÉRRURIER AT AVENUE DE LA PORTE DU
PRÉ SAINT-GERVAIS AND BOULEVARD PÉRPHÉRIQUE

1988, PIERRE RIBOULET

Architect Riboulet designed this enormous hospital complex as a series of terraces along the slope of a hill, in almost an embrace of its environment. On one side that faces south, the building seems to welcome the nearby church, and its north side doubles as a sound barrier, helping to alleviate the noise and traffic on the busy Pérphérique motorway.

956
64–66, rue de Meaux

AT RUE ARMAND CARREL

1988–91, RENZO PIANO WORKSHOP
MICHEL DESVIGNE, LANDSCAPE DESIGN

Architect Piano combines good architecture with socially responsible public housing, proving they are not mutually exclusive. He researched and drew inspiration from this area, traditionally filled with workshops boasting a wood-and-brick framework. He then adapted this architecture, using modern technology and a restrained budget, to produce four apartment blocks composed of bricks plus baked clay tiles innovatively hooked onto the façade.

957
Siège du Parti Communiste Français
(FRENCH COMMUNIST PARTY HEADQUARTERS)

2, PLACE DU COLONEL-FABIEN AT BOULEVARD DE LA VILLETTE

1965–71, OSCAR NIEMEYER, JEAN DEROCHE, PAUL CHEMETOV,
JEAN TRICOT, AND JEAN PROUVÉ; 1980, OSCAR NIEMEYER, DOME

A diehard communist, Brazilian architect Niemeyer created this worker's house for free, and dedicated it to a world without injustice or prejudice—what he hoped the French Communist Party represented. Set back from the place du Colonel-Fabien to allow open space around the square, a strange dome rises in front of a massive, curved building. The semi-buried, white dome holds the Central Committee's meeting room, which was added in 1980.

958
Cinéma MK2 Quai Seine

14, QUAI DE LA SEINE AT RUE DE SOISSONS

1880

The revitalization of this urban area brought many activities, such as this movie theater, to the neighborhood. Featuring a variety of programming, the Cinéma has attracted a hip youth following and other signs of life: cultural events, debates, and a café by the water, naturally. Built in 1880 using the former framework of an exhibition hall from the 1878 World's Fair on the Champs-Elysées, this warehouse-size theater is one of several enterprises that have rejuvenated the Villette harbor.

959
Hôtel industriel "Métropole 19"

138–140, RUE D'AUBERVILLIERS AT RUE RAYMOND RADIGUET

1988, JEAN-FRANÇOIS JODRY AND JEAN-PAUL VIGUIER

As a practical matter, an internal street cuts through this industrial site: This clever concept facilitates deliveries and the movement of maintenance equipment without disrupting busy city streets. While the private road is concealed from passersby, the window façade on rue d'Aubervilliers—in an attempt to enliven the main street—gives pedestrians a full view of the daily activities within the building. Also visible are the elevators, which run inside rounded columns composed of a galvanized-metal casing.

960
Cité de la Musique

211, AVENUE JEAN-JAURÈS AT PLACE DE LA PORTE DE PANTIN

1992–94, CHRISTIAN DE PORTZAMPARC

As if conducting a symphony of shapes, architect Portzamparc created multiple asymmetrical buildings toned with curves and triangles and spirals beneath a lyrical rhythm of rising roofs. The left wing contains rehearsal rooms for the use of music students; while the right wing is a public space, with a museum, concert hall, shop, and café. The museum is a masterpiece of sound and fun. It contains an exceptional collection of musical instruments from throughout the ages and is wired for individual interactive acoustics.

961

64, quai de la Loire

AT RUE VINCENT SCOTTO

1985, EDITH GIRARD

Architect Girard gave the residents of this apartment building large bay windows and a lateral view of the La Villette basin. On the other side, they have a U-shaped block that surrounds a courtyard. The building itself seems to hang down from the roof in an inverted stack of levels, making the top heavier than the base. Though created in such a way as to suggest a scale of just three stories, there are, in fact, seven levels.

962

16, quai de la Loire

AT ROTUNDE DE LA VILLETTE AND AVENUE JEAN JAURÈS

1999, PHILIPPE GAZEAU

Le Monde, one of the influential French newspapers, operates behind this dark, glass façade. The building stands out from its neightbors with its swollen belly, as if it had drained the Bassin de La Villetttee that it faces. In front, the broad glass wall reflects the never-ending movement of the sky. Within the area's uniform environment, architect Gazeau respected Parisian scale and structure by the use of traditional stories, but gave his building a clear identity with its unusual and dynamic shape.

963

27, quai de la Seine

AT RUE DE SOISSONS

1990, STANISLAS FISZER

Situated near the Basin de la Villette, this complicated, postmodern structure seems an attempt by the architect to replicate Claude-Nicolas Ledoux's "Rotonde de la Villette," a former tax barrier, built at the end of the eighteenth century. The building is wide open with large bays, and the five-story height is representative of the construction in this neighborhood, which has been transformed since the 1960s to regenerate the northern part of the city.

964

29, avenue de Flandre

AT RUE DU MAROC

1996, TECTÔNE (PASCAL CHOMBART DE LAUWE AND JEAN LAMUDE)

For this postmodern construction, the architects designed interlocking blocks, cut straight as if by scissors. Appearing unstable like a body in tension, each part is treated separately with the repetition of elements, such as balconies and windows, exaggerated. Finally, each expressive part combines to create a sculpture of the entire ensemble.

965

Porte des Flamands and apartments

67–107 OR 69, RUE DES ORGUES DE FLANDRE

1973–80, MARTIN S. VAN TREEK

These futuristic buildings appear to be conversing with one another, as well as defying gravity. Architect Van Treek developed an optical device similar to the medical endoscope, which allowed architects to determine what a pedestrian would view from ground level, and to design exteriors accordingly. His concept for this structure was to move the stories away from each other, to create more open and inviting space inside, while the curves suggest a sense of protection.

966

Cité des Eiders

145–161, AVENUE DE FLANDRE AT RUE DE L'OURCQ

1981, MARIO HEYMAN

Looking as if it just emerged from underwater, this building—with its porthole windows and boxy structures of various proportions—was, perhaps, submerged too long. In an effort to create public housing that realized individual expression, the architect created a monster. Composed of prefab concrete, the structure is still redeemingly playful with regard to its originality and color. It was intended as a departure from the concrete uniformity and repetitive towers in pubic housing…and succeeded.

961

962

963

964

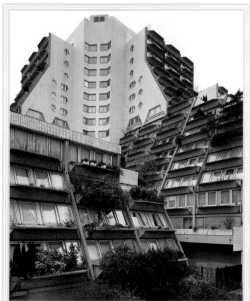

965

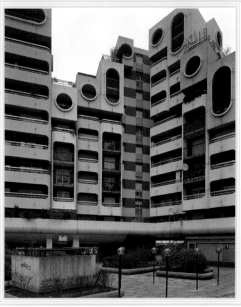

966

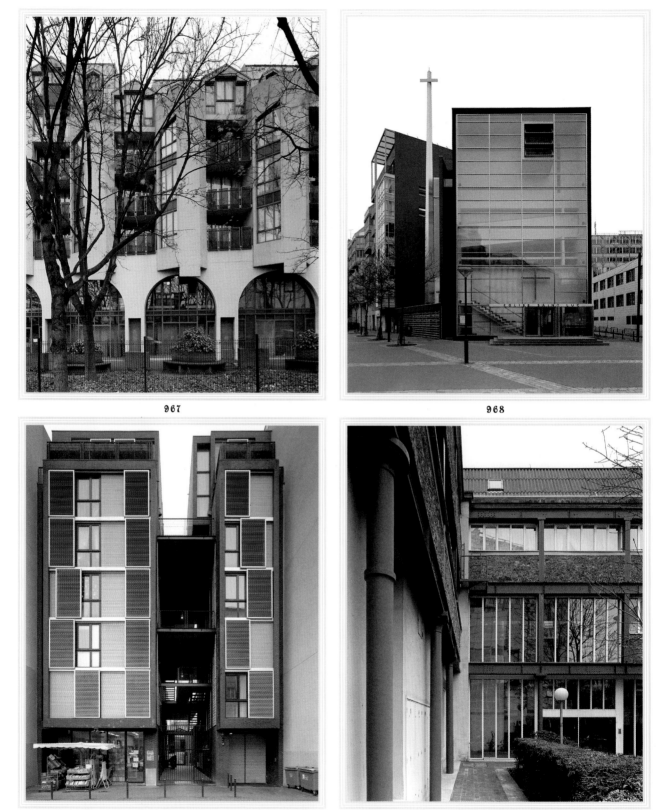

967

968

969

970

967

166–168, rue d'Aubervilliers

AT RUE LABOIS-ROUILLON

1982, MICHEL DUPLAY

Following a long history of obligatory architectural rules set by Haussmann from the mid–nineteenth century, a 1902 regulation freed architects to create more unexpected and animated building frontages. This building expresses a variation in the window construction, which architect Duplay exploits to its fullest potential. One bay window in particular benefited from this new freedom, as did structures that jut from the façade.

968

Eglise Saint-Luke

80, RUE DE L'OURCQ AT RUE ARCHEREAU AND PASSAGE WATTIEAUX

1999, MONTEL AND BASSET

This gleaming, rectangular church, composed of reflective glass, mirrors not only the neighborhood around it, but also the changing sky. In a reaction to the 1960s' impersonal mega-buildings, architects Montel and Basset scaled this church to suit its neighborhood. They faced the challenge of combining apartments with a holy place. They identified the church portion by the use of a public façade—wide-open, monumental, and angled from the street. Behind the glass façade, the sober sign of the cross does not impose itself, and a high pole topped by another small cross also sets off the church from the cubic form of the apartment building. The architects helped revive the concept of building to a human scale.

969

Logements pour postiers

46, RUE DE L'OURCQ AT RUE DE FLANDRE

1993, PHILIPPE GAZEAU

In a break with traditional placement, architect Gazeau attempted to open this architecture to the city by creating a vast, flat space: He designed the entryway to these individual flats as a great hall, and bridged the narrow space between the buildings with an open stairway, as if to take their postmen-tenants on an architectural trek with a view of the city they serve. The narrow passage in the middle recalls industrial times when workshops of different sizes were placed at the back of buildings, hidden hivelike behind the main structure.

970

145, rue de l'Ourcq

AT RUE D'AUBERVILLIERS

1980, CHRISTIAN MAISONHAUTE AND JACQUES LÉVY

Architects Maisonhaute and Lévy developed a first for Paris: an indoor street that provided common light, ventilation, and appropriate communications for an apartment complex. They transformed a nineteenth-century furniture warehouse into residential space. A lovely conversion, this complex features seventy-six apartments within an airy indoor/outdoor green passage that links the homes by a series of metal beams, covered galleries, and winding stairs.

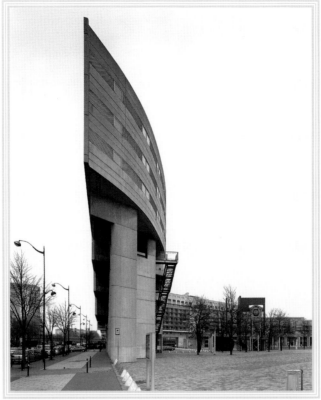

971

971

26–30, avenue Corentin Cariou

AT QUAI DE LA CHARENTE

1988–90, GÉRARD THURNAUER

Situated at the northern edge of Paris, this building is at the confluence of the freeways, the railways, the subway station, and a parking lot. On one side, it is also a main access to the park of the Cité des Sciences et de l'Industrie. The architectural challenge was to develop housing with the intimacy of a neighborhood, while simultaneously protecting it from the aggression of sound from all those competing transport structures. Architect Thurnauer's solution was to erect a high wall at the avenue and the freeway, to block the din from the back section, which has lower proportions. Cube-shaped "villas" stack above a portico, creating a pedestrian street that leads to a quiet place where background noise is already forgotten.

20TH ARRONDISSEMENT

A popular and ethnically diverse neighborhood, the twentieth arrondissement is becoming the new East End, with pockets of gentrification. In a spillover from rue Oberkampf in the eleventh, the hip, the young, and the arty have moved into the areas of Ménilmontant and Belleville, mixing with the culturally diverse population. Before annexation in 1860, the hills of Ménilmontant were part of the village of Belleville, filled with workers' cottages. Maurice Chevalier and Edith Piaf rose to stardom from this working-class neighborhood. Historically, the eastern part of the city was known for its rebellions, and is still a bit of a hotbed of protest. The construction of tenements in the 1960s added to the architectural mix of high-rises, bungalows, and restored artist studios with lofts and gardens. The twentieth arrondissement also contains the famed Père-Lachaise Cemetery.

972

973

974

975

976

977

972

Paris-Carthage

4, CITÉ LEROY AT RUE DES PYRÉNÉES AND VILLA L'ERMITAGE

C. 19TH CENTURY, REBUILT SEVERAL TIMES

Located at the triangular juncture of two narrow, cobblestone alleys, Paris-Carthage is an exotic gem with an interior décor of hand-painted tiling. Although the building itself is somewhat shabby, poured concrete without external decoration, the ground floor restaurant serves up Tunisian specialties such as couscous combinations in colorful earthenware. As a neighborhood restaurant, it seems to fit the tree-shaded ambience of villa l'Ermitage with its private gardens, overgrown ivy and wisteria, and its quaint, vine-carved, iron lampposts.

973

Villa Castel

16, RUE DU TRANSVAAL AT RUE DES COURONNES

C. LATE NINETEENTH CENTURY

Behind an iron gate, ten red-brick townhouses line this tree-shaded street near Parc de Belleville, which served as a setting for scenes in Truffaut's classic film, *Jules et Jim*. A former workers' housing development, it evokes the past and contrasts with the terrifying housing projects nearby on rue Piat. To preserve the *faubourg* (working-class) spirit authorities set the parameters of the subdivisions here, protecting the fragile immigrant population against the incursions of private business interests.

974

Regard Saint-Martin

42, RUE DES CASCADES AT RUE DE SAVIES

C. FOURTEENTH CENTURY

This area, known as Belleville once flowed with an abundance of water, as the street name implies. Before the Industrial Revolution laid waste to this section, it was idyllic, with springs and vineyards. An aqueduct with various water stations along its route supplied the local communities. Regard Saint-Martin served as one of the water inspection chambers between 1583–1613, supplied by la Fontaine de Savies, a local spring used by the monks of Saint-Martin-des-Champs.

975

Logements Sociaux

11–21, RUE DE FONTARABIE AT 74, RUE DE BAGNOLET

1984–87, GEORGES MAURIOS (J. P. ASTIER COLLAB.)

Like a monumental gateway, this development attempts to reinvent an urban area. A powerful column exerts a solid presence as it supports the overhanging volume and marks the entrance to a semi-public courtyard. Creating a pedestrian walkway between rue de Fontarabie and rue de Bagnolet, the interior complex is open and inviting. The wide blocks of windows and low rise of the building enhance the openness of the development even as the building rises sharply to eight stories on the right side.

976

Habitations Au Bon Marché H.B.M.

140, RUE DE MÉNILMONTANT
BETWEEN RUE DE LA CHINE AND RUE HÉLÈNE JAKUBOWICZ

1922–26, LOUIS BONNIER

Thirty low-cost buildings on steep ground contain 580 apartments spread around courtyards and alleyways. Architect Bonnier constructed the units in the 1920s to house poor families living in shacks nearby. Isolated from the street and guarded by two lodges, the complex resembles a medieval fortress. Although it lacks imagination, it nonetheless demonstrates good construction. The ground level is composed of colored stone, called meulière and then glazed bricks fill the façade.

977

Logements sociaux

5, CHEMIN DU PARC DE CHARONNE AT RUE DES PRAIRIES

1989, MICHEL BOURDEAU

As if the architect took a square and said, "be fruitful and multiply," the façades and sides of these two blocks begin and end in squares. Bourdeau then reversed the exterior coloring with what might pass as interior painting: He created a harmonious palette of gray granite, trimmed in white, and then painted the side walls a pale green. If he were a men's clothing designer, his reserved building might be a gray suit trimmed in white, paired with a green shirt and unified by a tie.

978

Gymnase at rue de l'Ermitage

296, RUE DES PYRÉNÉES

C. 1860; 1992, JÉRÔME BRUNET AND ERIC SAUNIER, RESTORATION

Built during Napoléon III's Second Empire, this former covered market symbolized modernity, and gave birth to a new style of architecture: open space, natural light, no supporting internal pillars, and cheap, fast construction. The brick-work fills the walls with different patterns; and the stonework decorates the lintels to express structural support—a style referred to as "constructive rationalism." Converted to a gymnasium with a public bath in the early twentieth century, it was totally restored in 1992.

979

Ecole élémentaire

99, RUE DE PELLEPORT AT RUE DE MÉNILMONTANT

1988, FRANCIS SOLER

Part Expressionistic, part homage to Joseph Cornell, this bold building celebrates the wonders of the unstructured mind of a child. Architect Soler invites your attention and curiosity with his dynamic design for this elementary school. This marriage of concrete, aluminum, and steel contains the institutional framework of state schooling, yet rejoices in unfettered imagination.

980

Maison de Carré de Beaudouin

119–121, RUE DE MÉNILMONTANT AT RUE DES PYRENEES

1770–71, PIERRE-LOUIS MOREAU

Over the hills of Ménilmontant, once the countryside, this old property was bequeathed to Nicolas Carré de Baudouin in 1770. At the time, and until the area became part of Paris in the nineteenth century, the aristocracy enjoyed a quiet retreat here. And so, Baudouin hired Pierre-Louis Moreau, architect of the City of Paris, to build a mansion on the premises. Highly influenced by the architecture of Palladio, Moreau created a comfortable two-story pavilion that resembled an Italian villa.

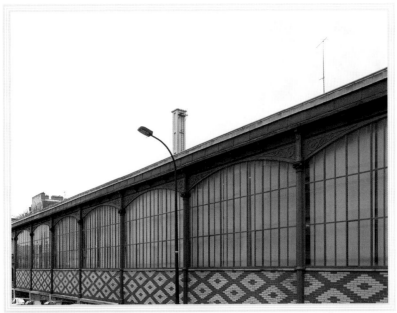

978

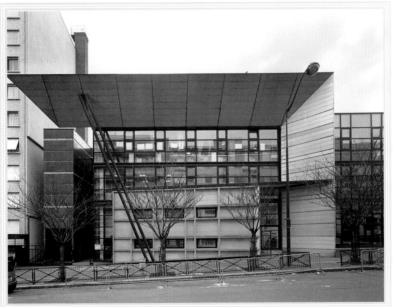

979

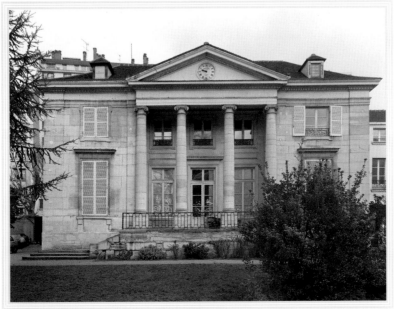

980

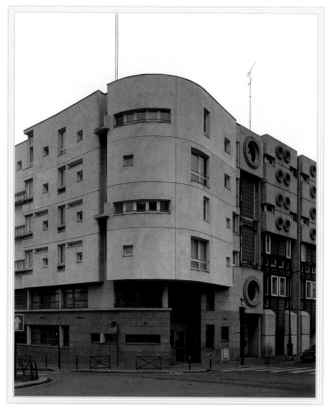

981

981

Musicians' homes and workshops

116, RUE DES PYRÉNÉES AT RUE VITRUVE

1986, YANN BRUNEL AND SINIKKA ROPPONEN

The architects who set out to create in Paris the first residential units and studios specifically designed for musicians eschewed traditional office and housing developments in favor of an allegory to music, creating a structure in which symbolic images play everywhere on the façade. The black and white window framing builds vertical movement like a piano keyboard laid on its side, while the upper portion gives the building horizontal tone. The large, round windows resemble the ends of trumpets; the small windows, the notes of a score; and the concrete elements running horizontally along the top level, the frets on the neck of a guitar. Shaped like a concrete bunker, the structure contains sound-proofed, flexible workshop space.

Père-Lachaise Cemetery

"This is the end, beautiful friend." If Père-Lachaise Cemetery is indeed the end, then it certainly is beautiful. But contrary to what you'd expect, Jim Morrison's grave does not rock. In fact, compared to Oscar Wilde's, the headstone is downright ordinary, save the trinkets left by admiring fans paying homage to the rock icon, lead singer of the Doors, womanizer, and hedonist. Wilde's mausoleum, however, stands out over the 100,000 crypts and monuments in the largest of Paris's twenty cemeteries. Flamboyant, like the writer himself, this huge granite tomb sports a naked, winged Egyptian deity streaking through the air. Sculptor Jacob Epstein originally carved the male deity with all of its anatomical parts, but vandals quickly made off with its manhood. The life-size bronze sculpture of Victor Noir, on the other hand, remains intact, looking out over the 118 manicured acres. A mid–nineteenth-century Parisian journalist and notorious ladies' man, Noir was killed by a jealous aristocrat, and his tomb is adorned with a statue of Noir as dressed at his death, with a noticeable bulge rubbed smooth by visitors who think of it as a fertility symbol.

Other celebrity graves regularly draw crowds and include those of the ill-fated lovers Héloïse and Abélard, as well as Molière, Sarah Bernhardt, Frédéric Chopin, Edith Piaf, Colette, Isadora Duncan, Gertrude Stein, Yves Montand, and Honoré de Balzac, to name just a few. Opened in 1804, the cemetery was originally a dumping ground for guillotined bodies. Balzac made it a popular resting site for celebrities when he began using the setting for dead characters in his short stories. Influenced by English landscape architecture and named for a Jesuit priest, Père-Lachaise Cemetery is also a fabulous stone garden with artwork by great French sculptors and a final resting-place where the unknown and the famous find common ground.

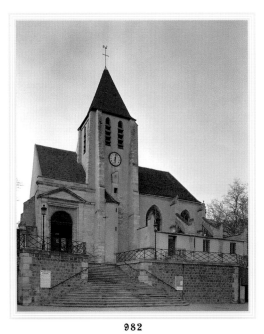

982

983

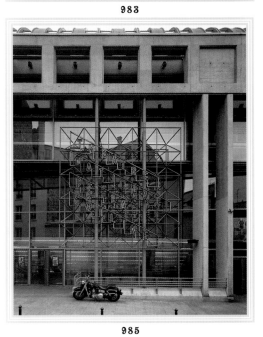

984

985

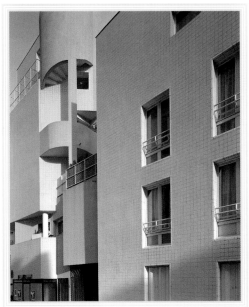

986

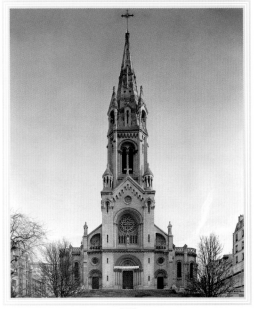

987

Until 1860, this picturesque church and church-yard lay outside the city limits and, therefore, was unaffected by an 1804 law that would have forced its parish cemetery to close. The entrance faces south, and looks down the hill at the quaint, cobblestoned rue Saint-Blaise. The church's name derives from a legend about the Bishop of Auxerre, the future Saint-Germain.

The Petite Ceinture de Charonne railway station, on the outskirts of eastern Paris, closed in 1934. La Flèche d'Or (The Golden Arrow) took over the abandoned space in 1995, and now plays host to a funky music set and a lively bar crowd. If you are going for the grunge, a trek out here will give you an alternative scene and live local bands. Overlooking the old tracks of the now defunct Petite Ceinture (inner beltway) railway line, an enclosed terrace sets the mood for afternoon brunch and an atmospheric glass of wine.

Designed by two architects who live in Finland, this is one of the few contemporary buildings constructed of wood—assembled in only four days. To accomplish their task, the architects used a prefabricated structure of steam-treated and laminated beams. The rest of the composition combines stone for the staircases and brick as a filler. The second-floor corner element is an unusual shape, and is the only indicator that the building is in fact situated on a corner. The overall design was meant to convey a sense of historical ateliers.

This classy, contemporary glass building near place Gambetta, appropriately houses a contemporary theater. In 1962, as part of an effort to bring culture to the deprived, eastern part of Paris, a group of young players known as "The Guild" performed here as a troupe in the Théâtre de l'Est Parisien (TEP-Theater Paris East). In 1985, when work began on rebuilding the theater, Parisian East moved to a location on avenue Gambetta, and this site became the National Theater of the Hill.

Like a runner crouched, waiting for the starting signal, this building seems poised to leap to another dimension. Grounded with a façade aligned to the urban landscape, it nonetheless appears to play with shapes that hang from its main body, stretching from the inside outward. In the process, it almost grows in height and volume with a dynamic movement. Architect Gaudin gives the building dimension on the inside as well, with an uneven courtyard environment that again toys with rhythm and space.

Built on a steep hill, necessitating the construction of fifty-four steps, this neo-Romanesque structure replaced a fifteenth-century church that its working class community had outgrown by the mid–nineteenth century. Constructed with a framework of metal, the spire is the third longest in Paris, after that of Notre-Dame and Saint-Sulpice. During the 1871 Commune de Paris, work upon the church was stopped and the site was used to warehouse food and munitions.

988

989

990

991

988
Temple de Belleville

97, RUE JULIEN-LACROIX AT RUE DE BELLEVILLE

1868–81, CLAUDE-AUGUSTE-LÉON SALLEMON, THEN EMILE VAUDREMER

When Belleville was annexed to Paris in 1860, the Presbyterian Council asked the City to build a church here. Salleman, the architect in charge of the 20th arrondissement, designed the building, but Vaudremer was responsible for religious construction. He changed Salleman's original design plans, and used a stone construction. Believing it should simply convey function, he left it unadorned and lacking in any sacred details.

989
Logements

41–49, RUE PIAT AT RUE DE BELLEVILLE

1990, CATHERINE FURET

Under the auspices of the City of Paris, a redevelopment program for the Parc of Belleville strives to maintain the identity of the diverse neighborhood here. This mixed-use housing project offers studios, apartments, workshops for musicians, a club for teenagers, and a single-family villa. Built on a steep site, this building emerges as a crenellated composition like a protective wall—an allegory of sorts: Bellevelle, a former site of insurrections, can now be seen as a defensive retreat for its residents.

990
Ateliers des artistes

61, RUE OLIVIER MÉTRA AT RUE LEVERT

1982, ALEX WIESENGRUN, PHILIPPE ROCCA, AND ALAIN BEAUNY

Designing this building to accommodate six artists' studios, the architects imagined the space as a three-dimensional abstract composition on a flat, empty canvas. The façade of the building has a smooth, austere coat of tiling and the tinted windows are flush with the façade. The graphic quality of the building is punctuated with an exterior, spiral staircase that breaks the skin of the building and adds a dynamic energy to the otherwise silent shell.

991
Pavillon de l'Ermitage

148, RUE DE BAGNOLET BORDERED BY RUE DES BALKANS, RUE VITRUVE AND BOULEVARD DAVOUT

1734, SERIN

As early as the seventeenh century and later in the eighteenth century, aristocratic families purchased and sold country homes in this quarter. The fresh air and beautiful surroundings drew the Sun King's aunt, the duchess d'Orléans, to the neighborhood. In 1763, Philippe d'Orléans bought the adjacent grounds, divided it up, and sold off parcels. One of the buyers, a royalist, hatched a scheme on this property to save the king and queen from the Revolutionary guillotine, but to no avail. Pavillon de l'Ermitage is all that survives of the country estates from those days. Today, this eighteenth-century pavilion is part of Hospice Debrousse Foundation, and the City of Paris maintains the park and gardens.

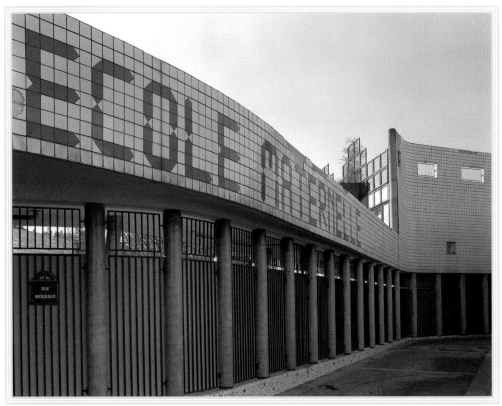

992

Ecole maternelle et élémentaire

992

RUES DE LA CROIX SAINT-SIMON AND MOURAUD

1985, ARCHITECTURE-STUDIO

The low scale of this nursery and elementary school stands in contrast to a district characterized by tall, modern buildings. Despite its stature, though, its significant scale, as seen through a transparent gantry, takes the monumental shape of an open mall and courtyard. The linear, zigzag patterning on the exterior is duplicated inside with a staircase that resembles a paper cutout. Whether one is in the gym or in the reading room, the building welcomes pupils with free, random spaces.

La Défense

In 1933, anticipating a need for new town planning, Le Corbusier along with members of an architectural group issued the Charter of Athens. This document, a major text of the Modern Movement as regarded urban planning in general, spelled out certain standards based on four themes: living (dwelling), working, recreation, and circulation. Inspired by the standards in this monograph, the town planning for La Défense called for the use of flagstone to separate pedestrians from vehicles, and for the creation of high-rises to move Paris into modern times. Instead of designing isolated towers that would have stood out in the midst of Paris's traditional stone buildings, the plan of La Défense, drawn up in 1959–60, mapped out a new 2,000-acre business district that did not offend nineteenth-century Parisian skyline that Baron Haussmann had worked so hard to achieve. And so Paris business expanded westward beyond the wealthy neighborhood in Neuilly, carving out parts of Puteaux and Courbevoie—areas with a view of the Seine, but that were just outside of Paris city limits. Nonetheless equipped with a Parisian postal code as well as metro and rail links, this business district set up shop.

This concept spanned three generations of architecture, and forty years of debate and public and private capital, before today's version of the development was realized. Even now, construction is ongoing. Although a small number of people are living in La Défense today, attempts to turn this space into a utopian residential and working property largely fell flat. Few people wanted to live in a concrete or flagstone jungle with Paris so close by. The original architects' intentions notwithstanding, the initial housing plan was abandoned in the 1970s in favor of building accommodations for business use. Today almost 3 million square meters are devoted to office spaces where over 100,000 people work, employed by 800 companies that include fourteen of the twenty largest French corporations. Thus, the new business district of Paris was born simultaneously with La Défense serving as an experimental laboratory for postmodern architecture.

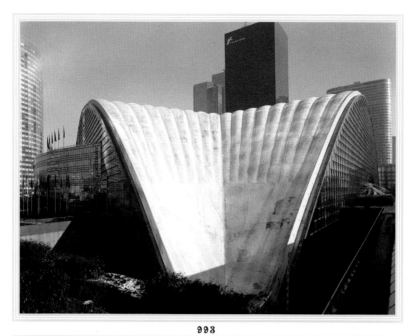

993

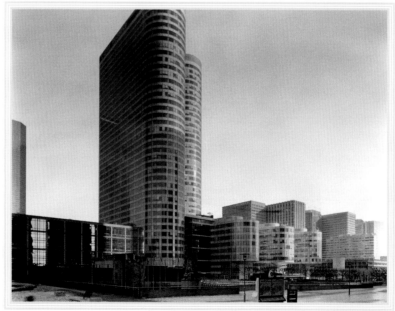

994

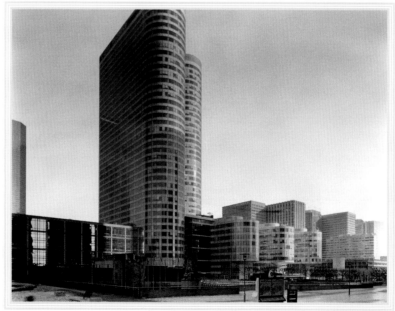

995

CNIT
(National Industrial and Technical Center)

Palais des expositions (Exhibitions Palace)
Parvis de la Défense Esquillan

1958, Bernard Zehrfuss, Robert Camelot, and Jean de Mailly;
1989, M. Andrault, P. Parat, P. Lamy, E. Torrieri, new developments, under supervision, Bernard Zehrfuss

A major technical feat for its time, this exhibition center has the largest concrete vaulting in the world. The architects developed a 22,500-square-meter structure on the triangular site. Its 230-meter wingspan, assembled piece by piece, rests on three support points that are interlinked with steel cables to prevent collapse. Jean Prouvé designed the curtainwall façades, also considered a technical achievement.

Tour La Pacific

Quartier Valmy

1992, Kiso Kurokawa

Kiso Kurokawa sat on the jury that chose architect von Spreckelsen for La Grande Arche, so it is no surprise that the crescent-shaped Pacific tower would bear a close relationship to the Arch, as a gateway symbol. The split in the tower opens out towards the Valmy district and recalls the *Chu Mon*, a symbolic gateway for the tea ceremony. The curved concrete façade is reminiscent of European masonry architecture, while its flat, curtainwall frontage, composed of steel and translucent plastic, resembles a shoji screen.

Cœur Défense

Esplanade de la Défense

2001, Jean-Paul Viguier

One of the third generation office towers built in La Défense, this building replaced the 1960s Esso tower—one of the first of earlier structures to be demolished here. Architect Viguier wanted to construct an extremely slim structure. He configured two curved twin towers of forty levels, one set back slightly from the other. Three lower constructions, similarly curved, are connected to the twin towers by a vast canopy-covered atrium. These lower parts contain technical and common commercial space.

996

Tour Total Fina Elf

2, PLACE DE LA COUPOLE
OPPOSITE TOUR FRAMATOME (FORMER TOUR FIAT)

1974–85, ROGER SAUBOT AND FRANÇOIS JULLIEN

Tour Elf, built in 1985, is eleven years younger than its older brother, Tour Framatome, built in 1974. The architects are the same but, though the buildings have the same height (180 meters) and capacity (100,000 square meters of office space), they are not twins. Inspired by Kubrick's *2001, A Space Odyssey*, the black monolithic Tour Framatome was built at the time when social and economic crisis hit La Défense. The architects designed the Framatome tower to emphasize the monumental environment of La Défense. In contrast, Tour Elf, a third-generation building, is much more sophisticated and self-assured.

997

Hôtel Renaissance

60, JARDIN DE VALMY
BOULEVARD CIRCULAIRE NO. 7

1995, PIERRE PARAT AND MICHEL ANDRAULT

Situated in the center of La Défense business district, at the site of the Grande Arche, this triangular ten-floor building features 331 elegant rooms with many amenities. This hotel is across from the Société Général Tower.

998

Eglise Notre-Dame-de-la-Pentecôte

PARVIS DE LA DÉFENSE
AT COIN EST DU CNIT AND LA DÉFENSE MAIN ESPLANADE

1997–2001, FRANCK HAMMOUTÈNE; 2001, PIERRE SABATIER, FURNITURE

With extremely modest dimensions compared to its neighbors and just a cross to identify its function, this atypical church stresses reflection and meditation. To achieve this quietude, architect Hamoutène devised a sanctuary of simple volume using the effects of scale, material, and lighting as his tools. Inspired by the first Christian communities, Hamoutène organized the layout of the church by surrounding the alter and the pulpit with the congregation on three sides. This active, modern parish tunes in to the preoccupations and the everyday life of those working in La Défense by organizing conferences, debates, and study groups on themes such as working conditions and terrorism.

999

Tour EDF/Tour PB6
(ELECTRICITÉ DE FRANCE)

ESPLANADE DE LA DÉFENSE

2001, PEI, COBB, FREED AND PARTNERS JEAN ROUIT, ROGER SAUBOT

This sleek, postmodern building pyramids up from a circular awning entrance to an angular, conical tower. The simplicity of this design emphasizes purity of form as the mildly reflective glass façades curve gently to a height of forty stories. The architects developed this structure with the employee in mind, creating private and flexible office space while achieving lower maintenance costs for a building that contains 700,000 square feet of offices, over half of which the building co-owner Electricité de France occupies. It also includes a conference center, restaurants, and a sports facility. This twenty-first-century glass tower is typical of the most recent generation of energy-saving buildings developed in La Défense.

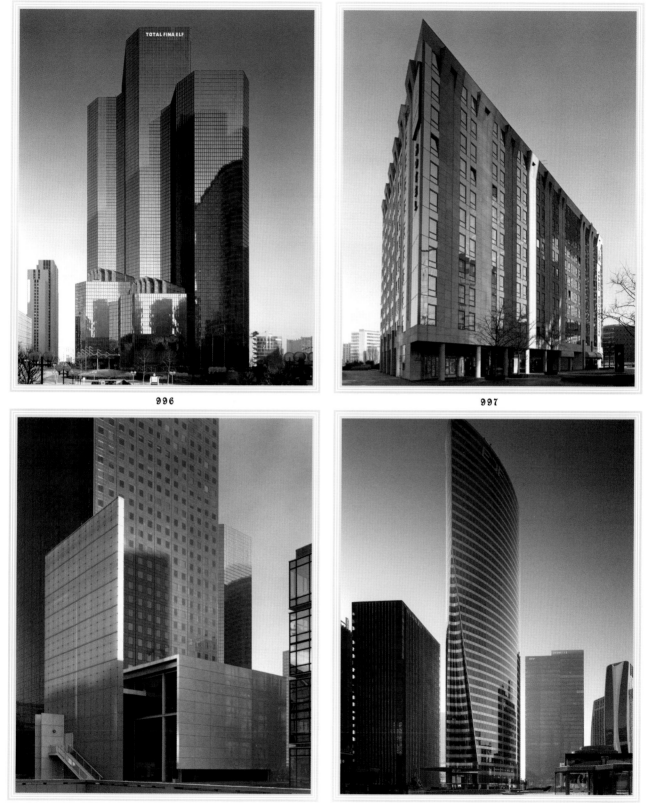

996

997

998

999

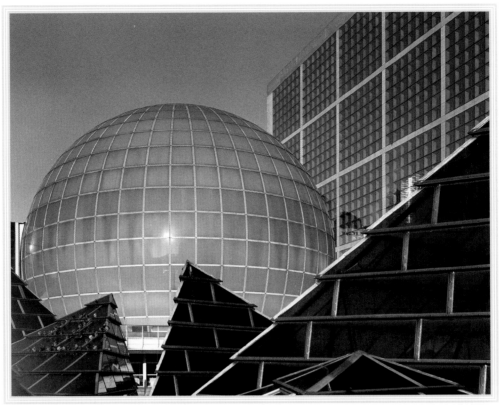

1000

Dôme Imax la colline de la Défense

1, PLACE DU DÔME

1993

Conceived to put the audience in the driver's seat, so to speak, this dome was originally built with a hemispheric screen of 1,144 square meters and a 180° angle of vision with inclined chairs that gave viewers the sensation of being in the midst of action. The Dôme Imax complex also included an antique car museum. Despite the proximity to the adjacent shopping mall "Quatre-temps," both the museum and the Dôme Imax proved economically unwise and went bankrupt in November 2000. Parts of the automobile collection were auctioned off and the Imax theater has been converted to a normal cinema. Yann Kersalé, who created the lighting for Basille Opera, also devised the night light of the dome.

Index